DECORATIVE ARTS AND DESIGN

THE MONTREAL
MUSEUM
OF FINE ARTS'
COLLECTION

DECORATIVE ARTS AND DESIGN

EDITED BY
ROSALIND PEPALL AND DIANE CHARBONNEAU

THE MONTREAL MUSEUM OF FINE ARTS' COLLECTION
VOLUME II

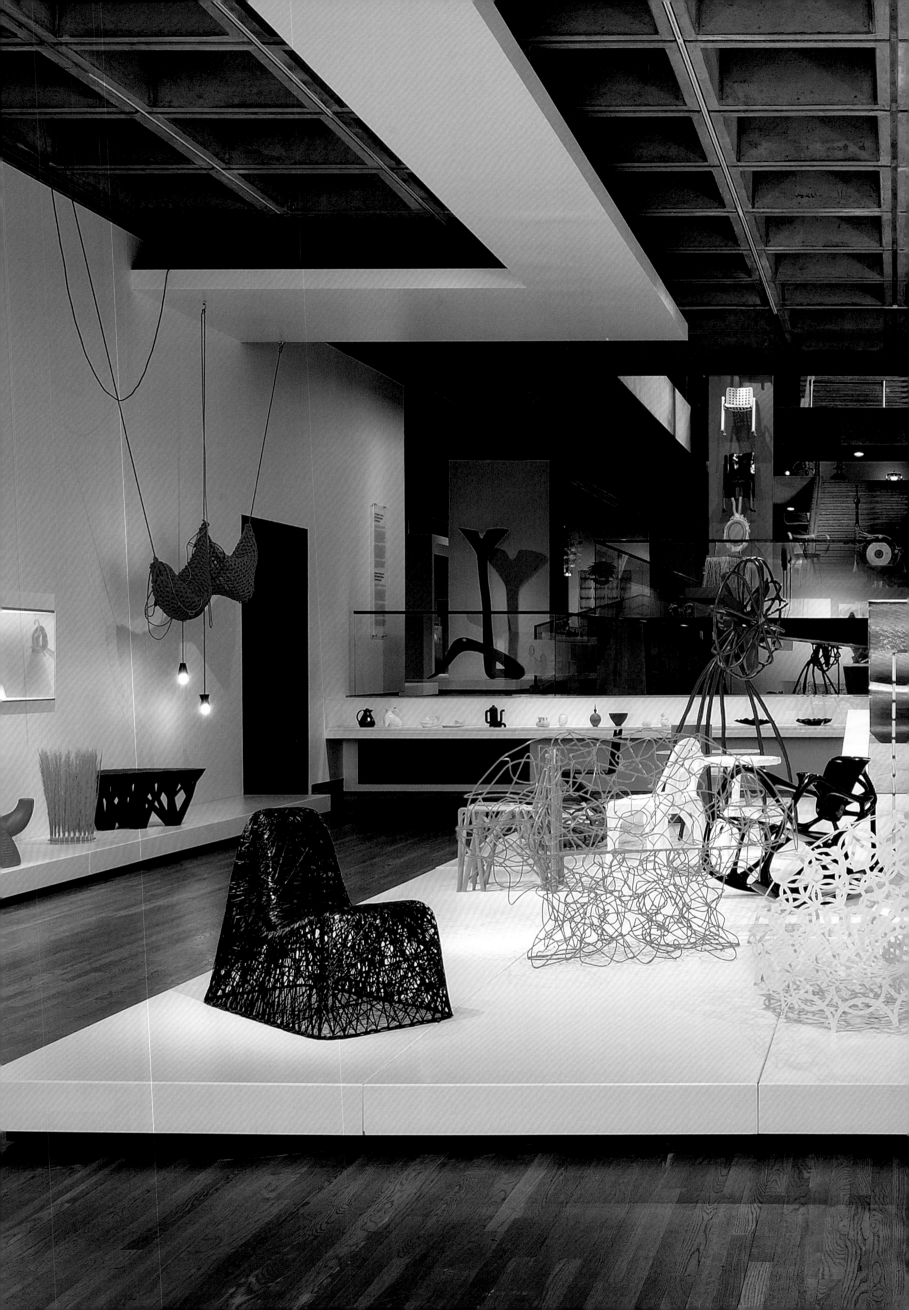

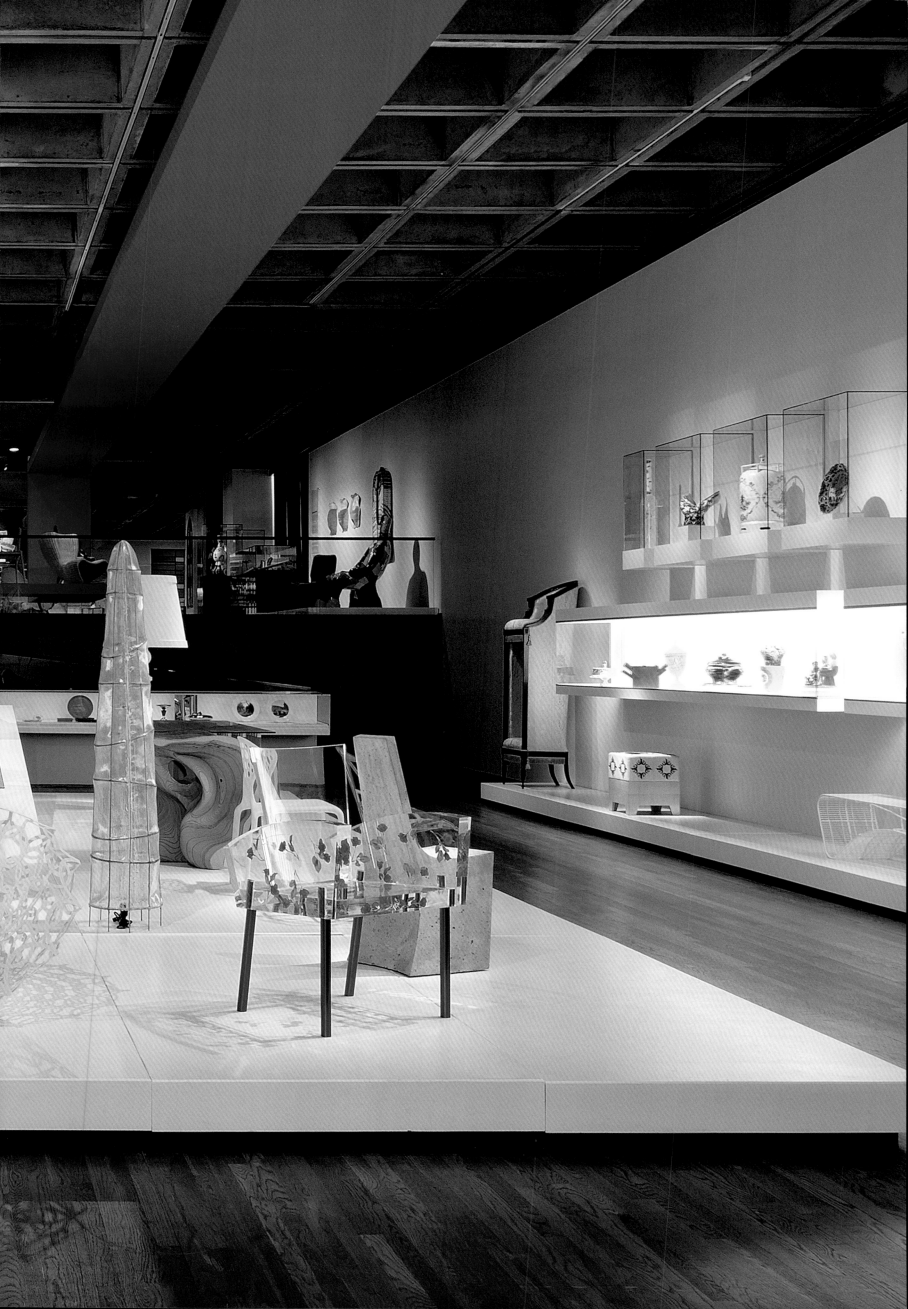

CERAMIC PAPER PLASTIC

■ The Volunteer Association is delighted to be associated with this book on the Montreal Museum of Fine Arts' collection of decorative arts and design. The works included herein represent over seven hundred of the most important items in the collection, and hold a special place of honour inside the Museum's Liliane and David M. Stewart Pavilion. ■ Within these pages is an overview of this international collection, which has grown continually since its founding in 1916 by F. Cleveland Morgan, especially with Liliane M. Stewart's generous gift of over five thousand works of twentieth-century design in 2000. ■ Behind every great museum is a passionate and engaged community. Since 1948, the Volunteer Association of the Montreal Museum of Fine Arts has been committed to stimulating community interest in the Museum while raising funds to support its growth and development. Each year, the Association donates over a million dollars to the Museum, funds raised through events like cultural visits and the annual Museum Ball. ■ The Association is thrilled to support the collection of decorative arts and design, and on behalf of all Museum volunteers, we hope you enjoy the book!

Carolina Gallo Richer La Flèche
Alexandra MacDougall
Co-presidents
Volunteer Association of
the Montreal Museum of Fine Arts
2011–12

■ The Montreal Museum of Fine Arts is a gem on the city's art scene, recognized the world over for its classic and modern exhibitions. Its extensive permanent collection offers its own treasure trove of pieces from across periods and disciplines. ■ This publication showcases the Museum's collection of decorative arts and design, one of the largest in North America. For those who have explored it in person within the Museum's galleries, this volume is a wonderful way to delve further. For those who have not yet had the opportunity, this handsome book provides a compelling introduction to some truly exceptional examples of decorative arts and industrial design in glass, wood, textiles, metal, ceramics and, more recently, paper, plastics and composite materials. ■ Domtar Corporation, one of the world's leading paper manufacturers, is a proud supporter of the arts in Montreal. On behalf of the company and its distribution arm Ariva, it is my pleasure to offer the Museum the paper used to produce this catalogue. ■ I hope you enjoy perusing the talent and masterful craftsmanship illustrated herein!

John Williams
President and Chief Executive Officer
Domtar Corporation

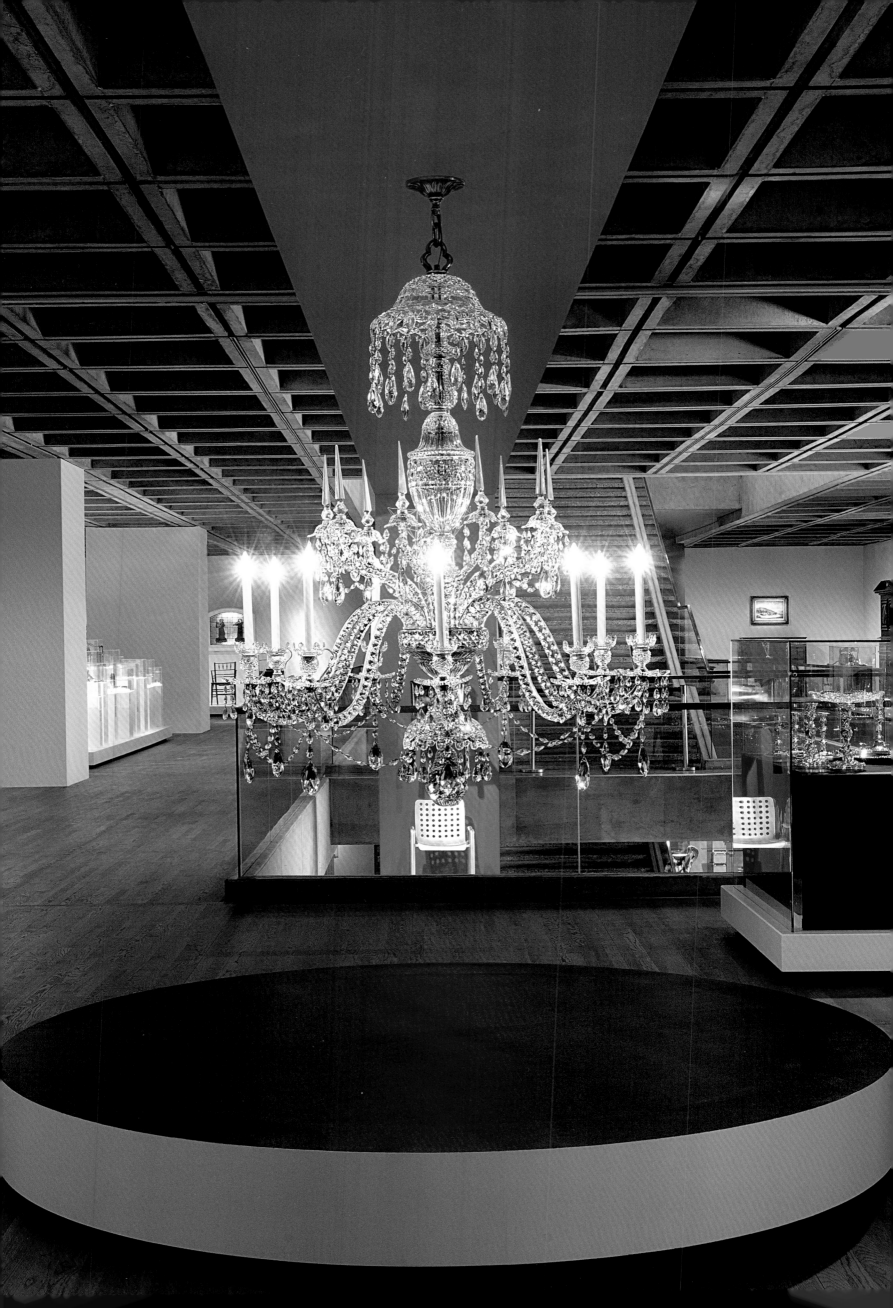

THE MONTREAL MUSEUM OF FINE ARTS

Brian M. Levitt
President

Nathalie Bondil
Director and
Chief Curator

Paul Lavallée
Director of
Administration

Danielle Champagne
Director of
Communications
Director of the
Montreal Museum
of Fine Arts
Foundation

The Montreal Museum
of Fine Arts is
extremely grateful for
the ongoing support
of Quebec's Ministère
de la Culture, des
Communications et de
la Condition feminine.
The Museum would
like to thank the
Conseil des arts de
Montréal and the
Canada Council for
the Arts for their
ongoing assistance.

We would like to
express our gratitude
to the Museum's
Volunteer Association
and the Association
of Volunteer Guides
for their unflagging
support.

We would also like
to acknowledge the
contributions of our
members and the
many corporations,
foundations and
individuals who
support our mission,
especially the Arte
Musica Foundation,
presided over by
Pierre Bourgie,
the Fondation de
la Chenelière,
headed by Michel
de la Chenelière,
and the Paul G.
Desmarais Fund.

And finally, the
Museum would also
like to acknowledge
the contributions of
its media partners,
Astral, *La Presse*
and *The Gazette*,
as well as Air Canada,
its official airline.

**PUBLICATION
The Montreal
Museum of Fine Arts**

Edited by
Rosalind Pepall
Senior Curator of
Decorative Arts
(Early and Modern)
and
Diane Charbonneau
Curator of
Contemporary
Decorative Arts

Publisher
Francine Lavoie
Head
Publishing
Department

Production Assistant
Sébastien Hart
Publishing Assistant
Publishing
Department

Revision and editing
Clara Gabriel
Translator-reviser
Publishing
Department

Photographic Services
and Documentation
Danièle Archambault
Registrar and Head
Archives Department

Graphic design
orangetango
Montreal

Photoengraving
and printing
**Transcontinental
Acme Direct**
Montreal

Pages 4, 5 and 9
Newly reinstalled galleries,
designed by Nathalie Crinière,
in the Liliane and David M.
Stewart Pavillon, 2012.

Page 9
Chandelier, England or
Ireland, 1780–1800 **16**.

AUTHORS

Ellenor M. Alcorn
Associate Curator
European Sculpture
and Decorative Arts
The Metropolitan
Museum of Art
New York

Catherine Arminjon
Conservateur Général
du Patrimoine
Paris

Diane Bisson
Industrial designer
and anthropologist
Montreal

Nathalie Bondil
Director and
Chief Curator
The Montreal
Museum of Fine Arts

Giampiero Bosoni
Professor of
Design and Interior
Design History
Scuola del Design
Politecnico di Milano

Paul Bourassa
Director, Collections
and Research
Musée national des
beaux-arts du Québec

Michael J. Brody
Director and Curator
University of the
Sciences Museum
Philadelphia

Cheryl Buckley
Professor of
Design History
Northumbria
University Newcastle
upon Tyne, England

Marguerite de Cerval
Art historian,
specializing
in jewellery
Paris

Joanne Chagnon
Art historian
Quebec City

Diane Charbonneau
Curator of
Contemporary
Decorative Arts
The Montreal
Museum of Fine Arts

Meredith Chilton
Art historian
Fulford, Quebec

Catherine Chorenzy
Art historian
Montreal

Elizabeth Cleland
Assistant Curator
European Sculpture
and Decorative Arts
The Metropolitan
Museum of Art
New York

Cynthia Cooper
Head, Collections
and Research,
and Curator,
Costume and Textiles
McCord Museum of
Canadian History
Montreal

Valérie Côté
Art historian
Montreal

**Ève De
Garie-Lamanque**
Art historian
Independent curator
Montreal

Jacques Des Rochers
Curator of Quebec
and Canadian Art
The Montreal
Museum of Fine Arts

Denise Domergue
Director
Conservation of
Paintings, Ltd.
Venice, California

Martin Eidelberg
Professor Emeritus
of Art History
Rutgers University
New Jersey

Alan Elder
Curator of Canadian
Crafts and Design
Canadian Museum
of Civilization
Gatineau, Quebec

Yasmin Elshafei
Art historian
New York

Ross Fox
Research Associate
(retired curator)
Royal Ontario Museum
Toronto
Affiliated faculty
member
Department of Art
University
of Toronto

**Philippa Glanville,
FSA**
Former Keeper
of Metalwork
Victoria and
Albert Museum
London

Amy Gogarty
Independent scholar
Affiliated with
Alberta College of
Art and Design
Calgary

Jared Goss
Associate Curator
Department
of Modern and
Contemporary Art
The Metropolitan
Museum of Art
New York

Anne B. Grace
Curator of Modern Art
The Montreal
Museum of Fine Arts

Toni Greenbaum
Art historian,
specializing in 20th-
and 21st-century
jewellery and
metalwork
New York

David A. Hanks
Curator
The Liliane and
David M. Stewart
Program for
Modern Design
Montreal

Anne H. Hoy
Adjunct Associate
Professor
New York University

Lesley Jackson
Design Historian
Independent curator
Hebden Bridge,
West Yorkshire, U.K.

Susan Jefferies
Independent curator
and educator
Toronto

Matthew Kirsch
Associate Curator
The Noguchi Museum,
New York

Albert Leclerc
Designer
Milan
Honorary Professor
Faculté de
l'aménagement
Université de
Montréal

Robert Little
Mona Campbell
Chair of European
Decorative Art
Department of
World Cultures
European Section
Royal Ontario Museum
Toronto

Paul J. Makovsky
Editorial Director
Metropolis
New York

Brian Musselwhite
Assistant Curator
of Decorative Arts
Department of
World Cultures
European Section
Royal Ontario Museum
Toronto

Rosalind Pepall
Senior Curator of
Decorative Arts
(Early and Modern)
The Montreal
Museum of Fine Arts

Michael Prokopow
Associate Professor
OCAD University
Toronto

Helmut Ricke
Former Director
Collections
Museum Kunstpalast
Düsseldorf

Roland Sanfaçon
Professor Emeritus
of Medieval Art
Université Laval
Quebec City
President, Canadian
Committee, Corpus
Vitrearum Medii Aevi

Davira S. Taragin
Art historian,
specializing in glass
Bingham Farms,
Michigan

France Trinque
Art historian
The Montreal
Museum of Fine Arts

Alain Weill
Former Director of
the Musée de l'Affiche
Paris

DECORATIVE ARTS AND DESIGN: A COLLECTION SERVING DEMOCRATIC VALUES

— NATHALIE BONDIL —
Director and Chief Curator
The Montreal Museum of Fine Arts

At present a student could not go, as in the days of Cellini, to a rich man's house and examine his works of art and measure his furniture. What would one of our wealthy men think if a poor designer of furniture came to measure his Chippendale chair? All these advantages, the advantages of seeing the good work of the past, should be open to the artisan. . . . In dwelling on the advantages of such a Museum, Prof. Nobbs stipulated that it should be open on Sundays, as that was the only day that the working-man could profit by it and there should be no free days as all days would be free.

Anyone who knows the manner in which the South Kensington Museum is used by the people will understand the utility of such an institution. It is to be hoped that it will be some day before long realized in Montreal.

—"Professor Nobbs Lectures on Art," *The Montreal Daily Star*, November 24, 1905.[1]

Notwithstanding that during the Renaissance it was relatively easy for an artisan to be admitted to a patrician residence, it nevertheless remains that the will to make "exemplary models" more accessible has always underpinned the creation of museums of art and industry. The stately South Kensington Museum, dreamed into being following the famous Great Exhibition in London in 1851 (today known as the Victoria and Albert Museum), became the beacon for Montreal's Anglo-Protestant elite. Was not the Art Association of Montreal, the first incarnation of the Montreal Museum of Fine Arts, established in 1860, on the occasion of the Prince of Wales' visit to Canada to inaugurate the Victoria Bridge and the Industrial Exhibition of the Province of Canada? Furthermore, inside Montreal's rendition of the Crystal Palace, built the same year, the Art Association assembled the works of the private collectors of the industrious, prosperous metropolis. Subsequently, the philosophy of the Arts and Crafts reform movement quickly made its way from England to Montreal thanks to the city's Anglophone elite, since, in 1892, only four years after the birth of the Arts and Crafts Exhibition Society, the Montreal association exhibited the work of one of its founders, Walter Crane. In 1896, the Province of Quebec Association of Architects showed examples of modern industrial art applied to architecture in order to stimulate quality workmanship. Nevertheless, despite these promising signs, no collection of decorative arts was officially started, despite the pleas, in 1905, of Scottish architect Percy E. Nobbs (1875–1964), professor at McGill University and proponent of Arts and Crafts, and despite the will of his father-in-law and president of the Art Association, Dr. Francis J. Shepherd, who declared at the annual meeting in 1909: "It was the intention of the Council to extent [sic] the scope of the Association by having Industrial Galleries in the new building in which to show the best examples of technical work, to be accessible to the general public; and by opening free to the public on one or more days a week."[2] It was only in December 1916 that the "Museum Section" was created, on the initiative of Frederick Cleveland Morgan (1881–1962), the first "curator" of decorative arts (1916–1962).[3] The undertakings of this remarkable humanist, curious as he was about the world's cultures and techniques, proved to be so seminal for the collections and acquisitions that in 1949, the Art Gallery was officially renamed the "Montreal Museum of Fine Arts," a semantic change laden with meaning, since the institution from then on would embrace its encyclopedic vocation.[4]

In February 1916, the respected president of the Royal Canadian Academy of Arts, William Brymner (1855–1925), who was also head of the Art Association's school, gave a lecture that the press roundly echoed: "Art is not merely a picture, but applies to furniture and articles of everyday use, and all the manufactures depend on it. This was not realized in England until the Great Exhibition of 1851, when the English people saw that articles produced by skilled labor brought better prices than those made in England by men who were not artists of their craft. The foundation of the South Kensington Museum was the result." He was convinced of the economic role of a museum to improve the manufacturing sector's output as a challenge to foreign competition, short of which, Brymner concluded, "we will have to content ourselves with being hewers of wood and drawers of water to our neighbors."[5] In this society structured around deep social, religious and linguistic divisions, the decorative arts appeared to be the key to educating the working classes, particularly the craftsmen, breathing new life by privileging the union of the arts and industry. In honouring the idea of "the beautiful in the useful," the museum reinforced the virtues of accessibility and exemplarity, less, at the time, in consideration of democratic principles than to increase product quality while the West was undergoing a major industrial revolution, founded on a deterministic faith in progress.

The transition from handicraft to design, luxury items to standardized production, relays a history of the appeal of things. Centred on the proliferation of needs, modern society established an economy governed by values ever more hedonistic and materialistic. By integrating the industrial arts, had the museum become caught up in mass culture, or ostentation, subject to a capitalist system in which the merchandise's artistic aura exerts its power over the customer? Had the museum corrupted its mission by offering itself as a shop window for the target market?

Encompassing the big department store consecrated as "the cathedral of modern commerce . . . made for a nation of customers,"[6] according to Émile Zola; the decoration of Parisian arcades where "art enter[ed] the service of the merchant" and universal exhibitions that had become "places of pilgrimage to the commodity fetish,"[7] according to Walter Benjamin; and the commercial strategies of today's art—the major contemporary-art trade fairs, an orchestrated star system of artists and designers, the "iconization" of masterpieces, the explosion of cultural industries—the blurred distinctions between genres and approaches, once regulated by religious or academic traditions and separated by symbolic barriers, had totally scrambled the codes of perception. Since the nineteenth century, cultural institutions, facing the rising power of industry, saw their monopoly on establishing and legitimizing the criteria of excellence—and even the definition of art—increasingly contested. Had they become unwitting accomplices by opening the doors of the temple to the merchants?

Today, in the era of egalitarianism, when the relativist exaltation of "everything cultural" serves as democratic consensus, while hierarchies of subjects, materials and objects are disappearing, brand culture, so characteristic of the current "hypermodernity,"[8] has swept across the planet. Not only does the commercial system appropriate the creative and aesthetic principles of the art world, sometimes with undeniable discernment, to imbue value-added "soul" to its products, but the museums are also cloning themselves for a name. Exhibitions on fashion are sometimes criticized, while, paradoxically, the opportunites to see otherwise inaccessible haute couture first-hand justify the display of the field's exemplary workmanship. It remains true that major luxury brands directly finance the presentation of the brand at museums in order to accrue prestige in a less onerous way than an advertising campaign: but who worries about that sort of thing nowadays?[9]

"[T]hat which withers in the age of mechanical reproduction is the aura of the work of art," wrote Benjamin. Has this dimension, mystical and unique, intrinsic to the authentic work that he defines as the *hic* and

Fig. 1

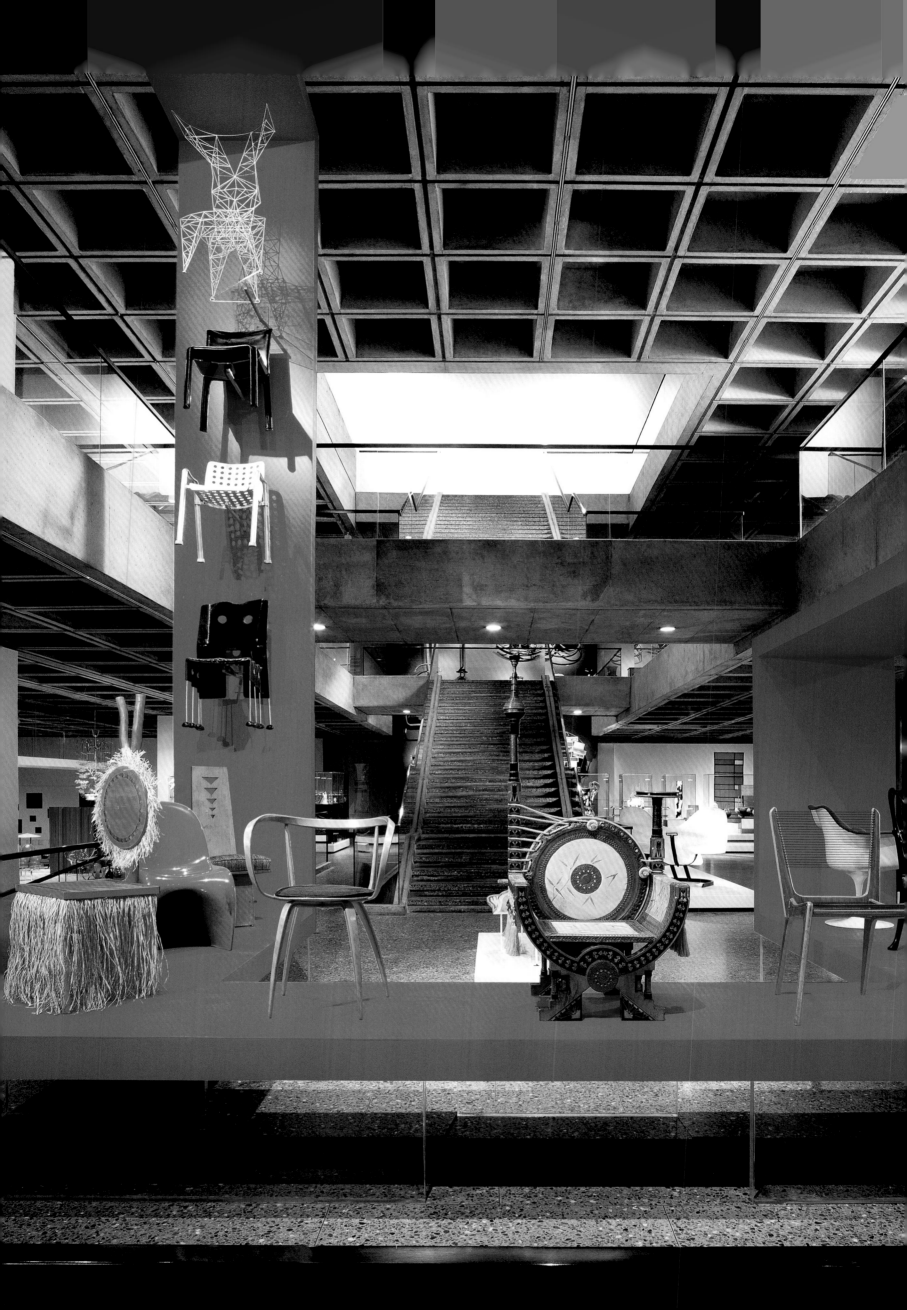

the *nunc*—here and now—destabilized the museum: that which yesterday threw French philosopher Alain into a fit of solipsistic contemplation and today afflicts art historian and polemicist Jean Clair with cynical melancholy? "[T]he masses seek distraction whereas art demands concentration from the spectator. That is a commonplace," Benjamin had already noted in the 1930s.[10]

Relieved of its ritual value, the profane cult of beauty—and by extension of art for art's sake—took over all spheres of activity with the industrial revolution: exposing and being exposed became ends in and of themselves. The imperative to be new, to be different, to be appealing was imposed upon objects produced by our consumer society. "Ugliness does not sell," declared designer Raymond Loewy. For a long time, neo-Marxist criticism sought to demystify—sometimes unjustly—the creative and humanist ideology of design to critique—sometimes blindly—the manipulation of a dominant class that prospers at the expense of the masses subject to the rhythms of the market and of style. This interpretation was rejected by Postmodern thought because it neglected the subjective power of an individual to choose for him or herself. This individualism has grown steadily with the extraordinary abundance of our democratic societies' offerings of the worst . . . but also the best. According to Gilles Lipovetsky, "With the extension of the policy of product lines, the opposition between model and series, which was still quite obvious during the early phases of mass consumption, no longer determines the status of modern objects."[11] He concludes that "the expanded fashion system more than anything else has facilitated the pursuit of the age-old quest for individual autonomy. . . . each individual has become a permanent decision-making center, an open and mobile subject viewed through the kaleidoscope of merchandise."[12] This "empire of fashion," less violent, alienating and totalitarian than seductive, flexible and democratic, replenishes and reduces the options following its own logic. It includes all the avant-gardes, even the functionalist aesthetic fostered by the Bauhaus. This "consummate fashion" has been the driving force behind a modernizing current, not without its pitfalls, in the West and now on a global scale.

This is also the history relayed by decorative arts and design, that of a society sensitive to the "aestheticization" of daily life. Although the laws of profit feed on people's hedonistic narcissism without, of course, sidestepping mediocrity and vulgarity, the decorative arts and design have proved to be a fundamental component of the democratization of art, from handicraft to industry. The highly successful Steve Jobs certainly thought so: "In most people's vocabularies, design means veneer. It's interior decorating. It's the fabric of the curtains and the sofa. But to me, nothing could be further from the meaning of design. Design is the fundamental soul of a man-made creation that ends up expressing itself in successive outer layers of the product or service."[13] Emblematic of this spirit of innovation that modernity so embodies, he asserted, "That's why I think death is the most wonderful invention of life. It purges the system of these old models that are obsolete."[14]

This echoes Paul Valéry, who wrote, "In 1900, the word *Beauty* began to disappear, only to be replaced by another word, which, since then, has got on in the world: the word *Life*."[15]

Today, the Liliane and David M. Stewart Pavilion dedicated to decorative arts and design has been entirely reorganized, with the reinstallation of almost a thousand works (fig. 1). Accessible to all free of charge, this reference collection establishes Montreal as a UNESCO City of Design.

Unique in Canada, internationally renowned, the collection ranks among the largest in North America. Enriched by the exceptional gift of Liliane M. Stewart, the collection serves as an entry point into the Museum, and by extension, to the fine arts. These polyglot objects, whose functions are easily identifiable for the first-time visitor, speak just as well for the creators, styles, techniques and social practices associated with them. They permit trans-historic and interdisciplinary approaches, making it possible to engage easily in a democratic dialogue with visitors, consumers of the market culture, that tends towards general culture. Due to the practice of displaying art "on a pedestal," these objects shape the visitors' critical gaze, saving them from today's tyranny of trends.

Described as "the best friend of Montreal museums," Liliane M. Stewart amassed this vast collection of more than five thousand objects from the twentieth century, the first of which, in 1980, was the famous *LCW* chair 169 by Charles and Ray Eames. Established with a view to creating a museum following the criterion of exemplarity, this collection, carefully constructed with the collaboration of Luc d'Iberville-Moreau and David A. Hanks, benefited from the advice of a committee of expert consultants.[16] Exceptional handicraft as well as industrial design were both considered, following an original approach. Its program of acquisitions, pioneering in this domain, concentrated on the American and Scandinavian schools, then mainly Italian and Japanese, but also Dutch, German, French and others. The visionary work took shape in 1979 with the founding of the Montreal Museum of Decorative Arts. Located in a formerly private residence known as the "Château Dufresne," it moved in 1997—having run out of room—to the Montreal Museum of Fine Arts, into the Jean-Noël Desmarais Pavilion designed by Moshe Safdie in 1991. Its layout was entrusted to Toronto-born architect Frank O. Gehry (fig. 2).[17] The programming established an international reputation, with remarkable contributions including *Design 1935–1965: What Modern Was*; *Designed for Delight: Alternative Aspects of Twentieth-century Design*; *Design 1950–2000*; and *American Streamlined Design: The World of Tomorrow*. Monographic exhibitions on Ron Arad, Ettore Sottsass, Eva Zeisel and Jack Lenor Larsen also provided ample opportunity for acquisitions, sustained by the friendship of the designers and the generosity of art lovers. In 2000, the amalgamation of the two museums and the major gift of the collection permitted its partial installation in the pavilion erected by Fred Lebensold in 1976 (fig. 3), which would now bear the name of its benefactors. In 2001, a committee for the acquisition of decorative arts was struck, presided over by Liliane M. Stewart and supported by Dr. Sean Murphy, perpetuating the mission.[18] The Montreal Museum of Fine Arts went on to present ambitious programming—notably with *Ruhlmann: Genius of Art Deco*, *Il Modo Italiano: Italian Design and Avant-garde in the 20th Century* and *Tiffany Glass: A Passion for Colour* (fig. 4)—and to organize the first retrospectives of fashion designers Yves Saint Laurent, Denis Gagnon and Jean Paul Gaultier (fig. 5).

When she started the collection, Liliane M. Stewart was at the forefront of the re-evaluation of what was considered modern, provocative and noteworthy in twentieth-century design. From the mid-1930s to today, these astonishingly diverse holdings include multiple aspects of design and applied arts, as well as one-of-a-kind pieces, limited editions and examples of industrial design. In contrast to the older decorative arts museums in Europe, the founder and her committee "did not seek to integrate their acquisitions with fine arts of the same period or to divide them

Fig. 1
A newly reinstalled gallery, designed by Nathalie Crinière, in the Liliane and David M. Stewart Pavilion, 2012.

Fig. 2
The display cases in the Montreal Museum of Decorative Arts' galleries designed by Frank O. Gehry in the Jean-Noël Desmarais Pavilion, 1997.

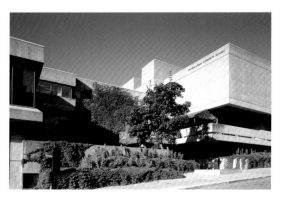

Fig. 3
The Liliane and David M. Stewart Pavilion, Avenue du Musée, built by Fred Lebensold in 1976.

into separate departments. . . . Rather, all design media were displayed together, to allow visual comparisons or contrasts, and they were organized either chronologically or thematically," as David A. Hanks explains.[19] And contrary to the museums of industrial design that cropped up during the 1980s in London and Chicago, modernism was addressed as a global phenomenon.

The avant-garde approach that informed the development of this "model collection," matched by the exceptional gift, fostered the decorative arts at the Montreal Museum of Fine Arts. It completed the "Museum Section" created in 1916, which had as its mission to assemble "all objects tending to the education of the designer and worker."[20] Constituted by F. Cleveland Morgan, the tireless volunteer curator from 1916 to 1962, it provides a panorama of the world's know-how, from early decorative arts through to Quebec handicraft. The Stewart gift enshrines as well as enhances this vocation with its high standards.

Recently, Liliane M. Stewart offered this explanation regarding a new acquisition, "the 'Louis Ghost' armchair by Philippe Starck," of which she was particularly proud: "It is made from translucent polycarbonate and reinvents the Louis XVI medallion. I think the way the chair melds into the room, practically disappearing, is marvellous."[21] Singling out this chair perfectly illustrates the extent of her passionate advocacy for good design: its modest price called for the invention of a particularly sophisticated mould. The gift, thanks to the Stewart program, of Eric Brill's phenomenal collection of American industrial design from between the two world wars, underscores the same decidedly modern interest in tools, often overlooked but nevertheless innovative, which reflected the new American way of life both in the office and the home. And it is in this same daring spirit that Mrs. Stewart said to me, rather facetiously, after the exhibition of gold and silver jewellery from the remarkable collection of "wearable sculpture" in the sumptuous galleries of the Hermitage in Saint Petersburg: "All right then, next time we'll exhibit paper and plastic jewellery!"

More than ever, decorative arts and design is an ace in the hole for the Montreal Museum of Fine Arts, a phenomenal way to reach a new public, because these objects, with their familiar functions, favour trans-historic, formal, technical and stylistic juxtapositions. The new museum layout offers multiple readings, with three hundred works never before exhibited, including many acquisitions added to some six hundred others displayed along the "red band" running through the collection. Devised with our longstanding collaborator, exhibition designer Nathalie Crinière, this metaphoric and architectural ribbon crosses the centuries. This second volume about our collections, and the first related to the decorative art holdings, attests to the brilliant enterprise, which combines the playful with the erudite, made explicit by its deliberately original organization by material.

First and foremost, I must thank our many donors, without whom this collection would simply never have come to be, as well as the designers and art enthusiasts, the Museum's presidents, directors and curators, the art historians and experts of all kinds who succeeded each other throughout the years to enrich, study and exhibit the collection. Among the donors who helped mark the Museum's 150th anniversary, certain exceptional figures must be mentioned, including: the Honourable Serge Joyal, with silver; Joseph Menosky, with Radical Design; Sandra Black and Jeff Rose, with Schneider glass; Power Corporation of Canada; Francis Guttmann; and Albert Leclerc. And we cannot forget Anne and Joe Mendel, whose recent gift greatly increased the number of Studio Glass works in the collection.

Placed under the equally devoted keeping of our curators, Rosalind Pepall and Diane Charbonneau, this publication brings together forty-four authors from here and abroad. It accompanies the complete reinstallation of the pavilion of decorative arts carried out by our excellent teams, notably the Exhibitions Production and Conservation Departments, led by Sandra Gagné and Richard Gagnier. This publication required the perseverance and meticulousness of the Publishing Department and Archives, led by Francine Lavoie and Danièle Archambault respectively, with André Bernier, Linda-Anne D'Anjou, Jeanne Frégault, Clara Gabriel, Christine Guest, Sébastien Hart, Marie-Claude Saia and Natalie Vanier. They were ably assisted by the Curatorial Department's Magdalena Berthet and Manon Pagé. We must also express our sincere gratitude to our faithful partners, graphic-design firm orangetango and printer Transcontinental Acme direct for their expertise and infinite patience, as well as for the indispensable support of Domtar. For coming to the financial aid of this academic publication, I would also like to thank the Volunteer Association of the Montreal Museum of Fine Arts for its tireless support, as well as Jean Rizzuto for his invaluable assistance.

1. Article cited in Norma Morgan, "F. Cleveland Morgan and the Decorative Arts Collection in the Montreal Museum of Fine Arts," Master's thesis (Concordia University, 1985), pp. 12–13. See the introductory chapter.
2. AAM Annual Report, 1909, p. 18.
3. F. Cleveland Morgan was also president, from 1917 to 1925, of the Canadian Handicrafts Guild, founded in 1905, and the Museum's president of the Board from 1948 to 1957. See the article by Rosalind Pepall on F. Cleveland Morgan.
4. It is important to recall that the Montreal Museum of Fine Arts is unique in Canada, in the sense that it is both a "gallery" of fine arts and a "museum" for archeological and decorative objects. It should be noted that the Royal Ontario Museum, Toronto, was established in 1912, and its first director, Charles T. Currelly (appointed in 1914), would become a friend of Morgan's. The Art Museum of Toronto, which would become the Art Gallery of Ontario in 1919, was founded in 1900.
5. "Artists Dined, Honored Confrere," The Gazette, February 7, 1916, cited in N. Morgan, p. 14.
6. Émile Zola, The Ladies' Paradise (London: Vizetelly & Co, 1886), p. 208.
7. Walter Benjamin, "Paris, the Capital of the Nineteenth Century," in Selected Writings, Vol. 3: 1935–1938, eds. Howard Eiland and Michael W. Jennings (Cambridge, Massachusetts; London: Belknap Press, 2002), pp. 32, 36.
8. Gilles Lipovetsky and Jean Serroy, La culture-monde. Réponse à une société désorientée (Paris: Odile Jacob, 2008).
9. In terms of the Museum's retrospectives Yves Saint Laurent, Denis Gagnon and Jean Paul Gaultier, none of these exhibitions, which we initiated independently, were commissioned or financed by the labels. See Suzy Menkes, "Gone Global: Fashion as Art?" The International Herald Tribune, July 5, 2011, p. 10.
10. Walter Benjamin, Illuminations (London: Pimlico, 1999), pp. 215, 232.
11. Gilles Lipovetsky, The Empire of Fashion: Dressing Modern Democracy (Princeton: Princeton University Press, 1994), p. 137.
12. Ibid., p. 148.
13. CNN Money/Fortune, January 24.
14. Playboy, February 1985.
15. Paul Valéry, Œuvres, vol. 2 (Paris: Gallimard, 1960), p. 1554.
16. See the article by Diane Charbonneau on the Stewart Collection.
17. Today occupied by the Studios Art & Education Michel de la Chenelière for the Museum.
18. In parallel, the Macdonald Stewart Foundation created the "Liliane and David M. Stewart Program for Modern Design," which follows an energetic policy of acquisitions, exhibitions and publications.
19. David A. Hanks, ed., The Century of Modern Design (Paris: Flammarion; Montreal: Liliane and David M. Stewart Program for Modern Design, 2010), p. 11.
20. AAM, Reports for 1916 being the fifty-fifth report, 1917, pp. 5–6.
21. Liliane M. Stewart, cited in All for Art!: In Conversation with Collectors, exh. cat. (Montreal: The Montreal Museum of Fine Arts, 2007), p. 236.

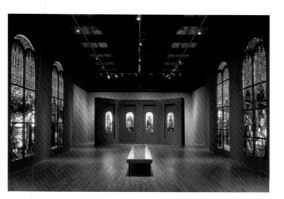

Fig. 4
Gallery view of the exhibition Tiffany Glass: A Passion for Colour, designed by Hubert Le Gall, 2010.

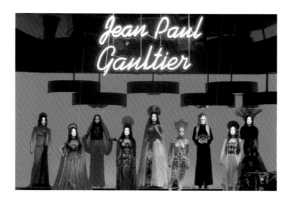

Fig. 5
Gallery view of the exhibition The Fashion World of Jean Paul Gaultier: From the Sidewalk to the Catwalk, designed by Projectiles, 2011. Script and videos for animated mannequins by UBU.

FOUNDING A COLLECTION:
F. CLEVELAND MORGAN AND
THE DECORATIVE ARTS

— ROSALIND PEPALL —
Senior Curator of Decorative Arts (Early and Modern)
The Montreal Museum of Fine Arts

When, in 1949, the Art Association of Montreal (AAM) changed its name to the Montreal Museum of Fine Arts, it was in recognition of the remarkable growth of its collection of decorative arts. The AAM was no longer just an art gallery devoted to paintings and sculpture but, like other young North American museums early in the century, had expanded to include the applied arts of many cultures. Its holdings now ranged from ancient Chinese porcelain to Roman glass and from English furniture to French silver, and included many examples of Quebec material culture.

Even before the AAM moved to its grand white marble building on Sherbrooke Street in 1912, some members had suggested that the collection be broadened to include decorative art works, on the model of those European museums and art societies that had been promoting the applied arts as a form worthy of being exhibited alongside the so-called fine arts. The Victoria and Albert Museum in London[1]—the precursor—had been founded in 1852 with the goal of improving the quality of design by providing craftsmen with outstanding historical examples from periods when a tile, a door latch, a drinking vessel or a wall covering was considered a form of artistic endeavour.

One of the aims of the AAM when it was founded in 1860 was to maintain "Schools of Art and Design."[2] Since moving into its first building on Phillips Square in 1879, the AAM had instituted a Decorative and Industrial Art Committee and had officially opened a School of Art and Design. It is no surprise, then, that the idea of building a collection of applied arts was supported by a number of leading Art Association members, including Percy E. Nobbs, Professor at McGill University's School of Architecture. He lectured at the gallery on the subject in 1905, and his call for "specimens of good industrial work" for the collection was noted in the local press.[3] In a 1908 article on "State Aid to Art Education in Canada," he wrote that museums should have a department of "handicrafts" or "industrial art," which would include "textiles and fabrics, glass and pottery, metal work, wood carving, stained glass and furniture of all periods."[4] Percy E. Nobbs no doubt inspired his father-in-law, Dr. Francis Shepherd, who, in 1909, in his role as President of the AAM, voiced his support for extending "the scope of the Association by having Industrial Galleries" in the soon-to-be-constructed new building.[5] In that same year, the bequest of over a hundred ceramic works from the collection of Agnes Learmont and her brother

Fig. 1
F. Cleveland Morgan, n.d.

Fig. 2
A newly reinstalled gallery, designed by Nathalie Crinière, in the Liliane and David M. Stewart Pavilion, 2012.

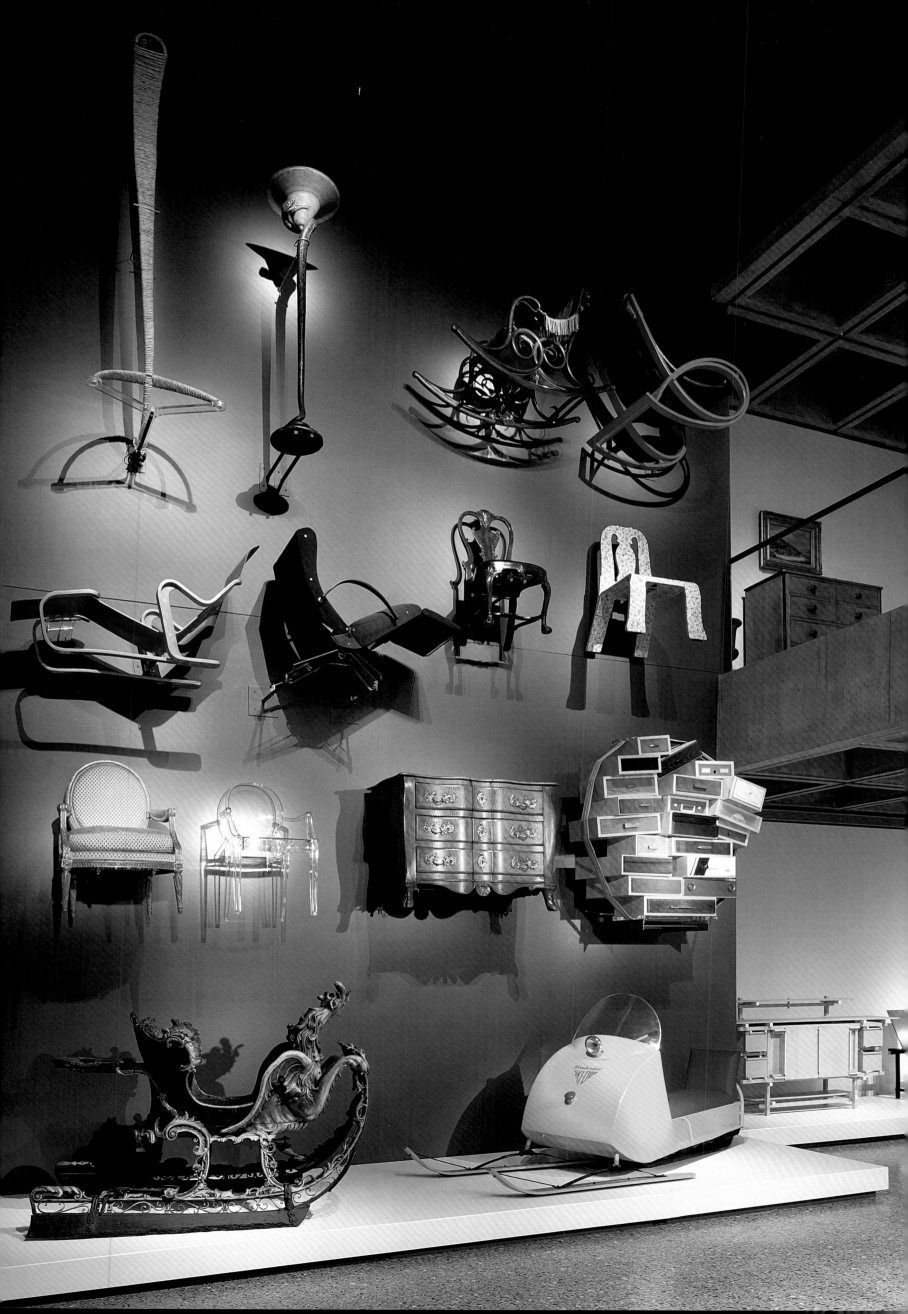

William set a precedent for gifts of decorative arts. It was not until 1916, however, four years after the building on Sherbrooke Street had opened, that then-President H. V. Meredith officially announced the creation of a "Museum Section . . . to be composed of collections of good examples . . . of all objects tending to the education of the designer and worker."[6]

From its inception, the driving force behind the decorative art collection was a young member of the AAM Council, Frederick Cleveland Morgan (1881–1962) (fig. 1). The collection needed someone like Morgan to launch it, to solicit friends for donations and funds, to devote time to acquiring works and to arrange displays. Morgan was a native Montrealer whose education had involved the close study of objects: after reading natural history at Cambridge University, in England, he graduated from McGill in 1904 with a Master's degree in zoology. As a result of losing the sight in one eye as a child, however, he had been obliged to renounce a career in science and enter the family business—the large Montreal department store of Henry Morgan & Co. At the same time, Morgan's insatiable curiosity and eagerness to learn encouraged him to focus on all aspects of art. He travelled widely and became familiar with the great museums of the world. The house he built in Senneville in 1912, "Le Sabot," was filled with his collection of antiques and art objects, eclectically arranged so that Italian maiolica was placed beside old French pewter, or a Quebec pine armoire might stand near a water fountain of Islamic tiles (figs. 3 and 4). The collecting of decorative art works became his preferred occupation and one whose fruits he wished to share with the AAM's members and visitors.

The early years of building up the decorative art collection (known initially as "The Museum") was a struggle. A "Museum Committee" was formed, headed by Morgan and composed of supporters who not only believed in his mission but helped out financially as well. Each AAM annual report included a separate statement on the "Museum" presented by Morgan and accompanied by a list of new acquisitions.

As the project had begun in the middle of World War I, there was little money for purchases. One of the first acquisitions (in 1916, from the metal craftsman and sometime antique dealer Paul Beau) was a collection of historical European ironwork—door latches, key plates, knockers and fire tools—that reflected the AAM's original intention to make the collection an educational tool for the instruction of artisans and workers. Donations of porcelain, textiles and silver trickled in from well-intentioned supporters, but Morgan knew that it was critical to raise funds in order to purchase works of significant aesthetic and historical quality befitting a museum. His yearly reports to the AAM Council revealed his frustration. In 1918, pleading for financial subscriptions to put towards acquisitions, he wrote: "We are on the threshold of a tremendous development in Canada and it is our duty to assist by giving every possible help to Manufacturers and Designers. The Americans are spending millions of dollars in building up their Museums which are recognized as a most essential part of the machinery of Industrial Art."[7]

During the 1920s, funds increased, which allowed Morgan to begin scouting out purchases. The early twentieth century was a boom period for the antiques market, and the great American art collectors, such as J. Pierpont Morgan, Andrew W. Mellon, John D. Rockefeller Sr., Henry Clay Frick and Peter A. B. Widener, were eagerly purchasing tapestries, stained glass, porcelain and furniture to place beside the Old Master paintings that adorned their grand residences, and American museums, too, were now interested in acquiring decorative art works. From the very beginning of his collecting for the Museum, F. Cleveland Morgan was eager to include works from other cultures—Persian and pre-Columbian pieces, for example, and especially Chinese porcelain and Japanese ceramics, which were already being collected by Canadians such as Sir Edmund Walker in Toronto and Sir William Van Horne in Montreal.[8]

By 1943, Morgan was able to declare it a "banner year" for donations to the "Museum," despite the country being once again at war.[9] Over one hundred and fifty donations and purchases were listed in the annual report, covering a wide range of historical objects from every part of the world, including an Egyptian alabaster jar, English silver toddy ladles, Japanese bronze sword guards, antique Persian bronze vessels and Spanish silk brocades. Morgan had expanded his vision of the collection from his early focus on works for the inspiration of the industrial worker to a desire to trace the evolution of design through the centuries (fig. 5). In recognition of his determination and success in building up the gallery's collection and his dedication to the AAM, Morgan was made president of the institution in 1948 and remained so until 1956.

A CURATORIAL APPROACH TO COLLECTING

F. Cleveland Morgan was a born collector and curator who kept detailed accounts of his personal acquisitions. In large record books, he documented the title, date, measurements and description of an object (including its place of purchase and any interesting provenance), often including a drawing or photograph. He would also note where he had seen a similar object or record comments by specialists. For example, the entry for an Egyptian figure of a hippopotamus in blue faience, 2040–1786 B.C. **1**, which he had bought in New York in 1913 and gave to the "Museum" in 1931, includes the following: "Dec. 1913. Sir W. Van Horne. Really remarkable," and "Dec. 1913. C. T. Currelly. 'A very rare and fine thing. I do not know how it got out of Egypt.'"[10]

Charles Trick Currelly (1876–1957) was the first director of the Royal Ontario Museum of Archaeology in Toronto (founded in 1912), and he and Morgan exchanged ideas, visits and sometimes even acquisitions as they built up their respective museum collections.[11] Currelly was an archeologist by training, a specialist in ancient Egyptian artifacts, and had travelled widely. He would undoubtedly have encouraged Morgan to expand his horizons in his efforts to document the world's civilizations. For his part, Morgan referred Currelly to dealers or works he had seen. In a letter dated May 22, 1923, Currelly acknowledged Morgan's help in relation to Egyptian and Indian works: "I'm tremendously grateful to you for forwarding these things to me from time to time, as I am not in touch with New York at all."[12]

Morgan himself travelled frequently to New York, as well as London and Paris, making the rounds of prominent dealers and seeking the advice of specialists in his search for museum-worthy pieces, preferably with a good provenance. He also visited many museums, especially the Victoria and Albert and the British Museum in London. Closer to home, he kept his eye on the major American institutions, notably the Boston Museum of Fine Arts and the Metropolitan Museum of Art in New York, both of which had encyclopedic collections. The Metropolitan Museum, which had been established in 1870 and opened its department of decorative arts in 1907,[13] served as a model for many smaller North American museums. From 1904 until his death in 1913, the president of the Metropolitan Museum Board was J. Pierpont Morgan (1837–1913), one

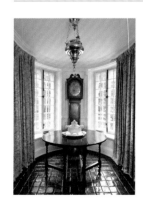

Fig. 3
Brian Merrett
F. Cleveland Morgan's house,
"Le Sabot," in Senneville,
Quebec. Bay window
in the dining room, 2011.

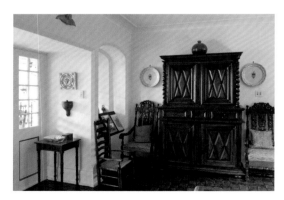

Fig. 4
Brian Merrett
F. Cleveland Morgan's house,
"Le Sabot," in Senneville,
Quebec. A corner of the living
room showing examples of
his collection of decorative
arts, 2011.

of America's most important financiers and art collectors. "His name," one historian has written, "figured in almost every major art rumor of the day and his travel plans received the attention today accorded only rock stars or royalty."[14] J. P. Morgan was no relation to the Montreal Morgans, but F. Cleveland Morgan would no doubt have been aware of his prominence and of the Wadsworth Atheneum in Hartford, Connecticut, which contained his collection of decorative arts. In J. P. Morgan's concentration on acknowledged masterpieces of the great periods of early European art—Renaissance and Baroque—his taste in art was typical of leading turn-of-the-century American collectors, but his keen interest in the decorative arts was more unusual. He would have been an inspiration to F. Cleveland Morgan when the Montreal collector turned his attention to acquiring European decorative arts by masters of the fifteenth and sixteenth centuries.

EXPANDING THE COLLECTION OF EUROPEAN DECORATIVE ARTS: MAIOLICA, STAINED GLASS AND TAPESTRIES

Italian Renaissance maiolica wares—tin-glazed earthenware plates, *albarelli* (apothecary jars) and jugs with bold painted decoration—were highly sought after by informed collectors, who frequently bought pieces from the Paris dealer Jacques Seligmann.[15] Once F. Cleveland Morgan had some funds at his disposal, he set out to acquire examples of early Italian maiolica for the "Museum," engaging his friend and fellow Montreal collector Harry A. Norton (1872–1948) in the venture.[16] In November 1938, Morgan visited the New York branch of the Seligmann firm, Arnold Seligmann, Rey & Co. There he saw a very rare maiolica jug from the first half of the fifteenth century **434** that had belonged to one of the leading experts in the field, Wilhelm von Bode (1845–1929), former director of the Berlin Museums. The asking price was $1,500.[17] A few months later, in April 1939, Morgan was again in New York, this time with Harry A. Norton. After some very shrewd negotiation,[18] Morgan purchased the piece for $1,000, as a gift to the "Museum" from Norton. He then used this price as leverage in the successful purchase of a second maiolica piece that Norton had spied in the New York store of Paris dealer R. Stora—a Deruta plate that had come from J. P. Morgan's personal art collection. After this auspicious start, F. Cleveland Morgan continued to acquire maiolica wares during the 1940s, when lower prices offered further opportunities.

Medieval and Renaissance stained glass was also at the top of Morgan's list for his "Museum" acquisitions, and works in this category were among his earliest purchases of decorative arts. For these acquisitions, he relied on a well-known London dealer in stained glass, Grosvenor Thomas, who had introduced himself to the American market in 1913 by holding two large exhibitions of antique stained glass at the Charles Gallery, in New York.[19] This had acted as a stimulus to North American clients, and, by 1920, Morgan was taking notice but had few funds. Obliged to canvass a group of Montreal friends for a set of small stained-glass panels (Inv. 1920.Dg.4)—Richard B. Angus, William J. Morrice and T. S. Gillespie—he added an amusing postscript to one letter of solicitation: "If you are 'real rich,' you are at liberty to increase the amount."[20]

Another person on whom Morgan could always count in his efforts to build up the AAM's "Museum" collections was Mabel Molson (1878–1973). A fourth-generation member of the prominent Montreal family who made their name and fortune in the brewing business,[21] Mabel Molson was the éminence grise behind the decorative art collection. From very early on,

she provided funds for whatever Morgan wanted to buy, from stained-glass windows to Quebec pine cupboards. She also donated from her personal collection of furniture, silver and porcelain. The two were never on first-name terms—she was unmarried, and older than he (although only by three years)—but she was genuinely interested in helping Morgan with his decorative art projects. In 1929, responding to his gift of a cyclamen that had accompanied a request for funds, she wrote to Morgan: "I really know you appreciate my interest in the Art Gallery. But I don't need thanks. I get more joy out of it than anyone else. I enclose my cheque for $1,000.00." This money was used to acquire a thirteenth-century window **7** .[22] Contemporary research into the Museum's stained-glass collection has confirmed its value as the most important corpus of Medieval and Renaissance windows in Canada.[23]

European pictorial tapestries were also among the works sought most avidly in the early twentieth century by the great American museums and their benefactors. Such tapestries had originally been commissioned by royal families to hang in the great halls of their princely residences. This association would have appealed to the wealthy North American art collectors, who, in the late nineteenth and early twentieth centuries, were building and decorating their own palatial mansions. To find a notable tapestry for the Museum, Morgan went to New York in the autumn of 1950 to visit the best dealer in town—the celebrated Duveen Brothers, who had specialized in antique porcelains, silver and tapestries in London and Paris since the 1870s. The major American collectors—Morgan, Frick, Mellon, Rockefeller—had all bought both decorative arts and paintings from them. Following Morgan's visit to Duveen's New York gallery at 720 Fifth Avenue, a fifteenth-century tapestry was sent to Montreal for approval, and Morgan hung it at the top of the Museum's grand staircase to attract donors. When he later pleaded in a letter to Duveen's that he had few funds for decorative arts and that the Museum was "obliged to beg and borrow" for every piece it purchased, they agreed to lower the price, expressing an interest in commencing business relations with the institution.[24] This work, *Priam Receives Ulysses and Diomedes at the Gates of Troy*, was indeed a fine purchase **196** and its exceptional status has regularly been confirmed.[25]

THE QUEBEC COLLECTION

It was not until the early 1930s that F. Cleveland Morgan began to focus on collecting art objects from Quebec's early history. The lifestyle and traditions of Quebec's rural communities were changing rapidly as populations shifted from country to city. Morgan realized that the AAM should act to preserve Quebec's furniture and silver, some of which dated back to the seventeenth century. He was spurred on in this endeavour by his friends Marius Barbeau (1883–1969) and Ramsay Traquair (1874–1952). Barbeau was an ethnologist with the National Museum of Canada, in Ottawa. Dedicated to preserving artifacts from Canada's Aboriginal cultures, he also recognized the urgent need to document and safeguard Quebec's material culture. Traquair, who had emigrated from Edinburgh in 1913 to teach at McGill University's School of Architecture, took a keen interest in Quebec vernacular architecture and became a specialist in early Quebec silver. Both men believed that a thriving national culture grew out of traditional roots, and that it was essential to preserve the past as an educational tool for the future.[26] Traquair served on Morgan's Museum Committee at the Art Gallery for many years. He also gave frequent lectures to the AAM's members, and there is no doubt that Morgan relied on

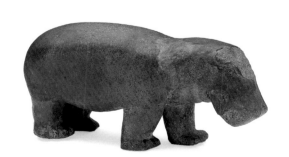

his knowledge and eye in developing the collection of Quebec decorative arts. Morgan also worked closely with the Canadian Handicrafts Guild (established in Montreal in 1906 to encourage and preserve Canadian handicrafts),[27] serving as its president from 1917 until 1924.

Another source of inspiration to Morgan in mounting a collection of Quebec decorative arts would have been the keen interest shown in the New England states for American heritage furnishings—part of the so-called Colonial Revival in American architecture, furniture and silver that occurred early in the twentieth century. The Metropolitan Museum, which was the first American museum to develop the field of American decorative arts, opened its American wing in 1924.[28]

In acquiring historical Quebec decorative art for his "Museum," Morgan did not wait for gifts but purchased early furniture and silver from dealers, guided by his friends Traquair and Barbeau, together with the artist Jean Palardy, who published the first major book on early Quebec furniture in 1963.[29] Morgan began his search at H. Baron, the noted dealer in "antiques, hooked rugs, silver and prints" located on Peel Street in Montreal. His first AAM purchases, made in 1932, consisted of three chairs, an armoire, a corner cupboard and a church chandelier in wood, mostly dating from the eighteenth century. Although a regular at Baron's, Morgan acquired some works from S. Breitman, who ran the Eagle Antique Shoppe, also on Peel Street. Morgan had ties to McGill University, which administered the McCord Museum, and there exists at least one bill in 1934 from H. Baron indicating that he was buying for the McCord and the AAM at the same time (fig. 6). The furniture went to the AAM, while First Nations cradles and other artifacts went to the McCord.

Quebec furniture acquisitions reached a peak in 1934, with a total of twenty-four purchases. Not all the pieces were in good condition. According to the archive file, a buffet from Saint-Pascal, in the county of Kamouraska, that Ramsay Traquair had spotted in Baron's store was "formerly painted white with undercoats of yellow and blue—all chipped and discoloured. The blue remains in the interior" 2 . Once acquired, however, the piece was stripped of its original finish, as was the custom, in order to expose the clean, more attractive solid pine structure.[30] One of the treasures of the Quebec collection, purchased by Morgan from Baron in 1938, is an early eighteenth-century buffet *à deux corps*, which arrived with a heavy coat of green paint over many previous layers. The Museum had these layers removed to reveal the rare original blue-green finish 124 .

The dealer H. Baron was a frequent source for Morgan's acquisitions of Quebec silver as well, one of the first being an eighteenth-century écuelle by Paul Lambert dit Saint-Paul 324 , which was bought with funds from Mrs. T. T. McG. Stoker. The financial support provided by Mabel Molson was often directed to Quebec objects, a fine example being the silver processional cross from about 1820 by Salomon Marion 318 . Ramsay Traquair's expertise helped enhance this aspect of the Quebec collection, and, in recognition of Morgan's support in raising the funds to publish his book on *Old Silver of Quebec*, the Museum was bequeathed thirty-two works of Canadian silver when Traquair died in 1952.[31]

F. Cleveland Morgan was rightly proud of his Quebec collection of decorative arts, which became a favoured source for loans to exhibitions at home and abroad.[32] An exhibition called *The Arts of French Canada*, organized by the Detroit Institute of Arts in 1946, relied on major loans from the AAM, where the show was presented from February 18 to March 10, 1947. Afterwards, Morgan received a gracious letter from E. P. Richardson, director of the Detroit museum, who had visited Montreal: "I must congratulate you on the three galleries of the Arts of French Canada and the American Indian collections downstairs. They make a very beautiful effect."[33]

CONTEMPORARY WORKS

In the early years of the "Museum," F. Cleveland Morgan's great enthusiasm and sense of urgency in mounting a decorative art collection took him in many directions at once. As he sought out historical silver, porcelain, textiles and furniture, Morgan—with remarkable foresight—also began to acquire examples of contemporary design in areas that held particular appeal for him: ceramics and glass. In the "Museum Report" for 1932, he called attention to this aspect of the collection: "Many pieces made today are quite equal in artistic merit to the productions of other ages. As our Museum is essentially one of Design these modern pieces are welcomed."[34] Morgan enjoyed visiting artists' workshops, and he was directly responsible for acquiring works by Bernard Leach and Jean Besnard, two of the most important studio potters working in the 1930s (in England and France respectively). Morgan was also attracted to artist-designed works produced by well-known contemporary manufactories—porcelain from Royal Copenhagen in Denmark, Richard Ginori in Italy and Royal Doulton in England , glass from Orrefors in Sweden and Lalique in France. It is especially interesting for us today, as we survey the Montreal Museum of Fine Arts' extensive twentieth-century collection, to recognize the prescience of Morgan's acquisitions in the field of contemporary applied art design.

THE FOUNDATION IS LAID

As F. Cleveland Morgan travelled the world, examining paintings and sculptures during visits to international museums, exhibitions and dealers, neither the Montreal Museum of Fine Arts nor his "Museum" of decorative arts were ever far from his mind, especially during his term as president from 1948 to 1956. A diary entry from April 1952, when Morgan was in London, gives an idea of a "perfect day" in the life of the president: "Shopped Phillips where I bought silver for the museum (jug, basting spoon, pair of Dutch Trencher salts 4 , 300 pounds). To Partridge where I bought needlework purse and case, 60 pounds for museum. Agnew. To Lunch with Hylda Hodgson at Berkeleys. To Arthur Tooth—Reid and Lefevre to see pictures. Royal Horticultural Society to the Daffodil show—superb. Dined in our room."[35]

Owing to his position at the helm of the Museum and his long experience in the museum field, art institutions sought Morgan out as an authority on the formation and display of their collections. In 1949, E. P. Richardson wrote asking him for advice on the appropriate dimensions for cases in the Detroit Institute of Arts' Japanese gallery, adding: "I enjoyed seeing a museum that is clean and well cared for and one in which the things look as if the staff were fond of them and took pains to make them look well. They look that way in your museum and I must confess there are a great many museums that don't have that atmosphere."[36] A decade later, Lord Beaverbrook, who had established an art museum in Fredericton, New Brunswick, invited Morgan to visit: "Our Gallery," he wrote, "will be expanded shortly. We will try to make it something on the lines of your great success in Montreal. And to avoid blunders and mistakes, I would like to talk to you on some suitable occasion."[37]

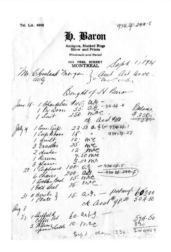

Fig. 6
A bill dated September 1, 1934, listing the Quebec furniture and Aboriginal works that F. Cleveland Morgan bought from the Montreal dealer H. Baron. Morgan had indicated beside each piece "Mc C" if destined for the McCord Museum and "A G" if for the Art Gallery's "Museum."

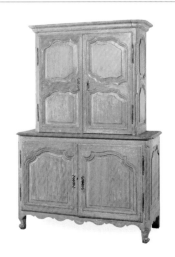

2
QUEBEC
Two-tiered Buffet
Late 18th c.
Pine
194.3 x 130.5 x 54.3 cm
Purchase
1934.Df.5
PROVENANCE
Paul Lévesque, Saint-Pascal-de-Kamouraska, Quebec;
H. Baron; acquired by the Art Association in 1934.

By the time he passed away in 1962, F. Cleveland Morgan had laid the groundwork for the Montreal Museum of Fine Arts' collection of decorative arts. For over forty-five years, Morgan had shared with the members and visitors of the Museum his delight in discovering and admiring the decorative arts from all over the world. With an avid curiosity, he had tended his collection, cajoling his friends into becoming patrons of the Museum and learning with him about the techniques, materials and history of applied arts from all cultures—and he did not forget his own country's heritage. Morgan expanded the vision of the Museum to embrace art in all its forms and mediums. He was a man of his time, at the beginning of a new century—a time of building great museum collections in North America and a time for raising the status of the decorative arts to take their place alongside painting and sculpture. Since Morgan's day, the Museum has developed the breadth and quality of its collections for close to a century. Liliane M. Stewart's remarkable gift in 2000 of some six thousand works of twentieth-century international design was a landmark event. Future donors will continue to build on F. Cleveland Morgan's foundation and share his goal of acquiring the best for the collection, so that visitors may delight in the beauty of form and design from across the world and across the centuries (fig. 2).

1. Known initially as the Museum of Manufactures, the institution was renamed the South Kensington Museum in 1857, and became the Victoria and Albert Museum in 1899. I would like to thank Judith Terry for her invaluable help in the editing of this essay.
2. According to the AAM Annual Report of 1912, p. 16.
3. "Professor Nobbs Lectures on Art," *Montreal Star*, November 24, 1905. Norma Morgan discusses Nobbs' lecture at some length in her Master's thesis, "F. Cleveland Morgan and the Decorative Arts Collection in the Montreal Museum of Fine Arts" (Concordia University, Montreal, 1985), pp. 11–13. This thesis provides a sound starting point for any research into the subject.
4. *Construction*, vol. 1, no. 6 (April 1908), p. 46.
5. AAM Annual Report, 1909, p. 18.
6. H. V. Meredith, Introduction to the AAM Annual Report, 1916, pp. 5–6.
7. "Museum Report," AAM Annual Report, 1918, p. 23.
8. Laura Vigo, "Asian Art at the Montreal Museum of Fine Arts: The Renaissance of a Historic Collection in Canada," *Arts of Asia*, vol. 42, no. 2 (2012), pp. 124–126.
9. AAM Annual Report, 1943, p. 12.
10. Copy of Morgan's Record Book X (MMFA Archives).
11. The R.O.M. building was officially completed and opened in 1914. See *Rotunda*, special issue on Charles Currelly and the history of the R.O.M., vol. 38, no. 3 (spring 2006) pp. 15–29. In his autobiography, *I Brought the Ages Home* (Toronto: Ryerson Press, 1956), Currelly credits his friend Morgan with helping him to acquire a collection of African sculptures (p. 267).
12. McGill University Library, Rare Books and Special Collections, Morgan Family Papers, Ms 647, Correspondence 1920–29. I am most grateful to Ann Marie Holland for her help with this archive.
13. Calvin Tomkins, *Merchants and Masterpieces: The Story of the Metropolitan Museum of Art* (New York: Henry Holt and Co., 1970, rev. ed. 1989), p. 114.
14. Neil Harris, "Collective Possession: J. Pierpont Morgan and the American Imagination," in *J. Pierpont Morgan Collector: European Decorative Arts from the Wadsworth Atheneum*, ed. J. Linda Horvitz Roth (Hartford, Connecticut: Wadsworth Atheneum, 1987), p. 52.
15. See Jörg Rasmussen and Wendy Watson, "Majolica" in Roth 1987, *J. Pierpont Morgan Collector*, pp. 59, 74–76.
16. Letter from F. C. Morgan to New York dealer Joseph Brummer, January 13, 1939: "A friend of mine, Harry A. Norton, and a staunch supporter of the museum is going to New York shortly and I have given him your name . . . I am trying to interest him in Italian Majolica and in Greek Vases" (MMFA Archives, file 1939.Cb.1). Norton's collection of Greek and Roman glass was donated to the Museum in 1953. For more on Norton, see Georges-Hébert Germain, *A City's Museum: A History of the Montreal Museum of Fine Arts* (Montreal: The Montreal Museum of Fine Arts, 2007), p. 78–80.
17. Letter from Paul M. Byk of Arnold Seligmann, Rey & Co., New York, to F. C. Morgan, November 29, 1938 (MMFA Archives, file 1939.Dp.3).
18. Letter from F. C. Morgan to Paul M. Byk, April 6, 1939 (MMFA Archives, file 1939.Dp.3).
19. Marilyn M. Beaven, "Grosvenor Thomas and the Making of the American Market for Medieval Stained Glass," in *The Four Modes of Seeing: Approaches to Medieval Imagery in Honor of Madeline Harrison Caviness*, eds. Evelyn S. Lane, Elizabeth C. Pastan and Ellen M. Shortell (Farnham, England; Burlington, Vermont: Ashton Publishing, 2009), pp. 481–482. My thanks to Jim Bugslag for directing me to this article.
20. Letter from F. C. Morgan to T. S. Gillespie, Montreal, December 22, 1920 (MMFA Archives, file 1920.Dg.4).
21. For a history of the family, see Karen Molson, *The Molsons: Their Lives & Times 1780–2000* (Buffalo, New York: Firefly Books, 2001).
22. Letter from Mabel Molson to F. C. Morgan, December 29, 1929 (MMFA Archives, file 1929. Dg.4).
23. Members of the Canadian branch of Corpus Vitrearum—Roland Sanfaçon, Ariane Isler-de Jongh and Jim Bugslag—have been studying the collection, further documenting it, reassessing attributions and confirming quality pieces.
24. Letter from F. C. Morgan to B. S. Boggis, January 6, 1951; B. S. Boggis to F. C. Morgan, January 8, 1951 (MMFA Archives, file 1951.Tap.21).
25. For example, it was included in the exhibition *Masterpieces of Tapestry from the Fourteenth to the Seventeenth Century*, Metropolitan Museum of Art, New York, 1974.
26. See Nicola J. Spasoff, "Marius Barbeau and Ramsay Traquair: Establishing Authenticity on l'Île d'Orléans," in *Around and About Marius Barbeau*, eds. Lynda Jessup, Andrew Nurse and Gordon E. Smith (Gatineau: Canadian Museum of Civilization, 2008), pp. 95–104.
27. Ellen Easton McLeod, *In Good Hands: The Women of the Canadian Handicrafts Guild* (Ottawa: Carleton University Press, 1999), p. 267.
28. Tomkins 1970, p. 202.
29. Jean Palardy, *Les Meubles anciens du Canada Français* (Paris: Arts et métiers graphiques, 1963). English edition: *The Early Furniture of French Canada* (Toronto: Macmillan, 1963) Palardy had been studying Quebec furniture, silver and textiles since the early 1930s.
30. The two-tiered buffet was illustrated in Palardy's book (ibid., fig. 114, p. 109), in what appears to be its pre-stripped condition. By 1957, F. C. Morgan was advising against furniture stripping: "The craze for stripping everything has gone too far and I think they lose something of their charm," he wrote to the Missouri Historical Society, March 5, 1957 (MMFA Archives, general Df. file).
31. Traquair Bequest file (MMFA Archives). I wish to thank Danielle Blanchette for her help in researching the Museum's archives.
32. The AAM agreed to lend French Canadian furniture to the Canadian presentation at the 1937 Exposition internationale des Arts et Techniques dans la Vie Moderne in Paris; see letter from Marius Barbeau to F. C. Morgan, Ottawa, March 23, 1937 (MMFA Archives).
33. Letter from E. P. Richardson to F. C. Morgan, March 15, 1949 (McGill University Library, Rare Books and Special Collections, Morgan Family Papers, Ms 647, Correspondence 1940–49).
34. AAM Annual Report, 1932, p. 12.
35. McGill University Library, Rare Books and Special Collections, Morgan Family Papers, Ms 647, box C5. Morgan frequently bought silver at S. J. Phillips on New Bond Street. The prestigious art and antique firm of Partridge Fine Art had been in business in London since 1902. Agnew's gallery and Arthur Tooth & Sons were prominent London fine-art dealers. Horticulture was another of his major interests.
36. Letter from E. P. Richardson to F. C. Morgan, March 15, 1949 (See note 33).
37. Beaverbrook to F. C. Morgan, London, July 20, 1959 (McGill University Library, Rare Books and Special Collections, Morgan Family Papers, Ms 647, Correspondence 1950–60).

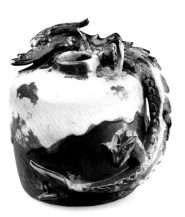

3

Doulton Manufactory
Lambeth, London, 1815–1956
Designed by Charles J. Noke
(1858–1941)
Chang Ware Vase
About 1927
Glazed earthenware
21.7 x 21.1 x 20 cm
Signature, in grey,
on underside: *NOKE. /
CHANG* [vertical] / *.HN.*;
impressed: *L468* (twice);
printed underglaze
black: *Made in England /
Royal Doulton* [crowned,
surmounted by a lion]
Purchase
1931.Dp.10

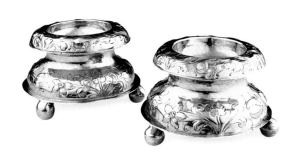

4

NETHERLANDS
Trencher Salts
About 1690–1700
Silver gilt
6.1 x 9.9 x 9.6 cm
Gift of Miss Mabel Molson
1952.Ds.15
PROVENANCE
S. J. Phillips, Ltd.; acquired
by the Museum in 1952.

THE LILIANE AND DAVID M. STEWART COLLECTION

— DIANE CHARBONNEAU —
Curator of Contemporary Decorative Arts
The Montreal Museum of Fine Arts

The Liliane and David M. Stewart Collection, which came into the Montreal Museum of Fine Arts in 2000, was formerly the permanent collection of the Montreal Museum of Decorative Arts. It ranks among the most important North American collections of twentieth-century design. With approximately six thousand works dating from 1935 to the present day, it includes mass-produced objects, prototypes, limited editions and handcrafted, one-of-a-kind pieces from every field of decorative arts and industrial design—ceramics, glass, gold and silver, textiles and furniture—in a wide variety of materials from wood to plastic and paper, together with posters, modern and contemporary jewellery and objects made using the latest digital technology, rapid prototyping. Classics by modern Scandinavian designers—Arne Jacobsen, Finn Juhl, Poul Henningsen, Stil Lindberg and Tapio Wirkkala—are found alongside works by key figures of American design—Harry Bertoia, Ray and Charles Eames, George Nelson, Philip Johnson and Eva Zeisel. The great names of Italian design—Franco Albini, Carlo Mollino, Gio Ponti, Paolo Venini—are given pride of place in the collection, and the Italian proponents of the anti-design movement—Andrea Branzi, Alessandro Mendini, Gaetano Pesce, Ettore Sottsass—became instant favourites. The new generation of designers in Germany, England, France and the Netherlands are equally well represented by Matali Crasset, Konstantin Grcic, Ross Lovegrove and Marcel Wanders, as well as a number of other designers also notable for their audacity and inventiveness.

GENESIS OF A MUSEUM OF DECORATIVE ARTS

The creation in 1979 of a museum devoted to the decorative arts of the twentieth century was the initiative of David Macdonald Stewart and Liliane M. Stewart, Montreal collectors and art patrons (fig. 1).[1] In 1976, at the invitation of the City of Montreal, the Stewarts agreed to restore a Beaux-Arts style building in the town of Maisonneuve (now a Montreal borough) known as the Château Dufresne, originally the magnificent adjoining residences of the brothers Oscar and Marius Dufresne.[2] Once the building was restored to its original splendour and furnished with some of its period pieces, the Stewarts turned it into the ideal setting for a decorative arts collection. The Montreal Museum of Decorative Arts (MMDA) opened its doors in 1979 with David M. Stewart as president and Luc d'Iberville-Moreau as director and chief curator.[3] Under the latter's aegis, this museum would focus mainly on international design from 1940 to 1960, assembling a unique collection of objects that were largely disregarded by curators and collectors at the time.[4]

The Stewarts and Luc d'Iberville-Moreau surrounded themselves with a team of experts. They retained the services of the American curatorial consultant David A. Hanks, president of David A. Hanks & Associates of New York, and set up an advisory committee composed of Stephen Paul Bailey, director of the Design Museum, London; Yvonne Brunhammer, chief curator of the Musée des Arts décoratifs, Paris; Ileana Chiappini Di Sorio, curator at the Museo Correr, Venice; Duke Umberto Pini di San Miniato, artist and designer; Jack Lenor Larsen, textile designer; and R. Craig Miller, associate curator of twentieth-century art at the Metropolitan Museum of Art, New York.

THE 1980s: THE DEVELOPMENT OF THE COLLECTION

The Liliane and David M. Stewart Collection[5] took shape under the informed guidance of Mrs. Stewart, aided by Luc d'Iberville-Moreau and David A. Hanks, who defined its parameters. D'Iberville-Moreau was passionate about objects on the borderline between art and functionality, and was an ardent champion of design, particularly Italian design[6] and contemporary jewellery. Hanks specialized in American design, especially the Herter Brothers and Frank Lloyd Wright. His numerous activities, his knowledge of the art world—artists, collectors, curators, gallery owners and manufacturers—and the location of his agency in New York played a catalyzing role in the expansion and growing reputation of the Stewart Collection. This dynamic duo recruited Martin Eidelberg, a professor of art history at Rutgers University in New Brunswick, New Jersey, and a renowned expert on Tiffany glass and ceramics from the first half of the twentieth century. Eidelberg helped foster scholarly study of the collection by contributing to major exhibitions with accompanying publications that added to our understanding of twentieth-century decorative arts and design.

The growth of the collection led the three colleagues to extend the period covered by the collection back from 1940 to 1935, to take account of the technological and formal advances made in pre-war design, and forward from 1960 to 1965, to illustrate the aesthetic revolution of the first half of that legendary decade. To iconic pieces of American, Scandinavian and Italian design were added key works by master artisans of the 1960s, such as the glass-maker Harvey K. Littleton **78** **91** and the textile artist Magdalena Abakanowicz **242**. But soon, these new chronological parameters were redrawn as ever more post-1965 objects were added to the collection, eventually making a coherent body of works covering the history of the decorative arts and design from 1935 to the present day.

Fig. 1
Liliane and David M. Stewart, 1981–82.

Fig. 2
A newly reinstalled gallery, designed by Nathalie Crinière, in the Liliane and David M. Stewart Pavilion, featuring Gianni Ruffi's *La Cova* **657**, 2012.

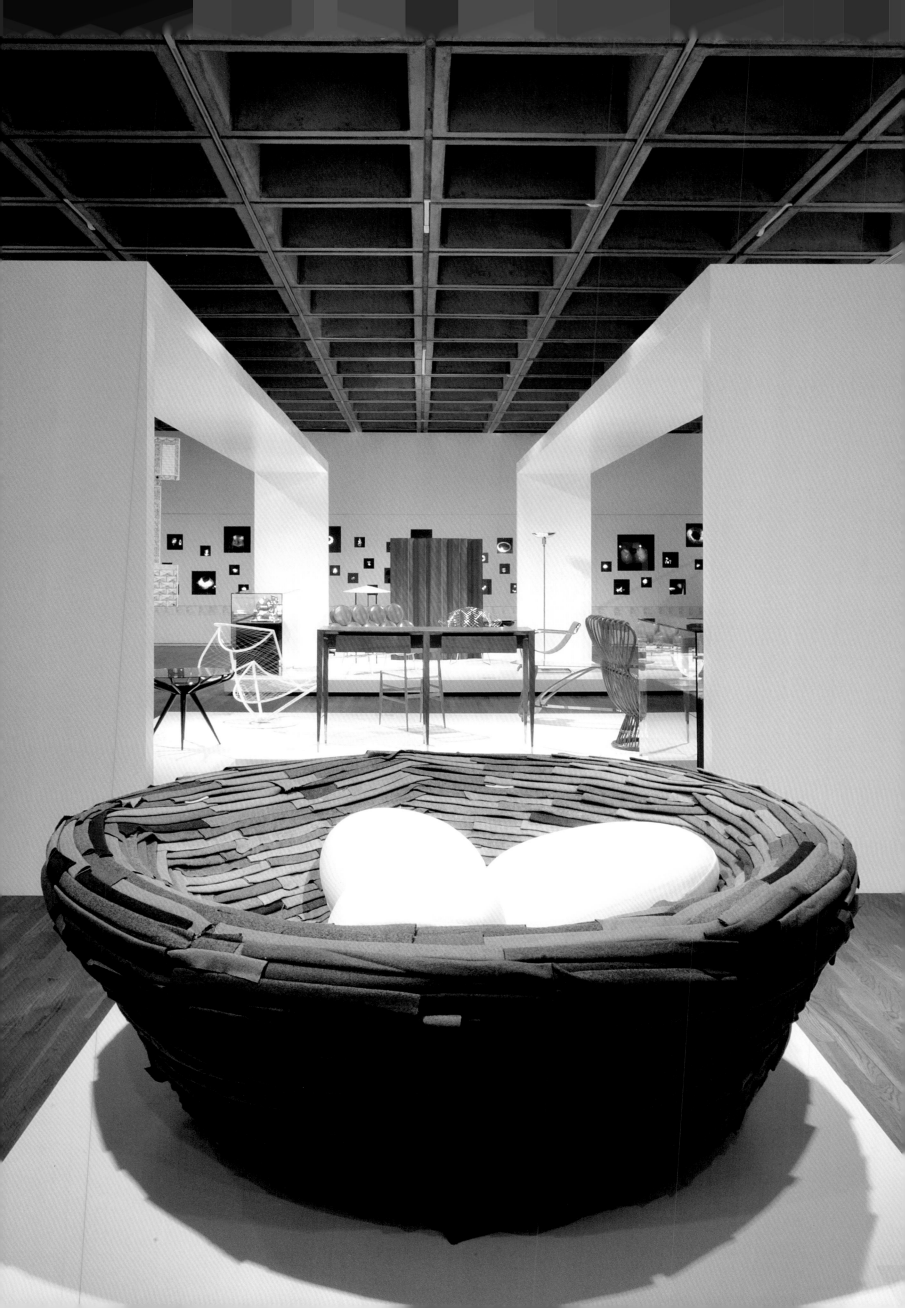

The development of the collection was still tied to the exhibition program of the MMDA, which almost from the start had organized monographic or thematic presentations devoted to international figures. In 1984, *Eva Zeisel: Designer for Industry* presented the work of the Hungarian-born American ceramicist 475. Following the exhibition *Tea & Coffee Piazza: The Alessi Collection* organized in 1987, the Toronto collectors Vivian and David Campbell gave the MMDA a series of prototypes for coffee pots created for Alessi 411 -415 along with a number of other pieces by Italian designers of the Postmodern period. In 1988, *Recent Acquisitions: The Louise D'Amours Bequest* displayed forty-seven items by glass artists left to the MMDA by Louise and Laurette D'Amours,[7] notably works by pioneers of the Studio Glass movement in Canada such as Daniel Crichton 96, François Houdé and Peter Keogh 93. The following year, the MMDA presented *École du Meuble, 1930–1950: Interior Design and the Decorative Arts in Montreal*, with a catalogue that became an indispensable reference tool in terms of the crucial part played by the school in the history of design in Quebec.

THE 1990s: AN INTERNATIONAL REPUTATION

The 1990s saw international recognition for the collection of modern and contemporary design built up by Liliane M. Stewart and her team. In the early 1990s, Mrs. Stewart established another advisory committee made up of businessman George Beylerian, gallery owner and collector Helen Williams Drutt English, architect Toshiko Mori and textile designer Jack Lenor Larsen, who had been a member of the first committee. Members suggested acquisitions according to their areas of expertise: design (Beylarian and Mori), contemporary handcrafted production (Williams Drutt English), textiles (Larsen). Toshiko Mori introduced the work of the Japanese architect Shigeru Ban, still relatively unknown at that time, and proposed the acquisition of a bench and a screen executed for the Italian company Cappellini 580 581.

In 1991, the exhibition *Design 1935–1965: What Modern Was* explored the various aspects of modernism through a selection of some 250 works from the collection, paying tribute to the creativity of those three decades in a theme-based presentation with different types of objects displayed together. The exhibition catalogue is still regarded as the authoritative reference on the period.[8] Opened at the IBM Gallery of Science and Art in New York in 1991, the exhibition toured the United States and Canada until 1993. Ironically, it could not be shown at the Château Dufresne in 1993 because the galleries were too small,[9] so it was presented at the Montreal Museum of Fine Arts. In the fall of 2011, the New York School of Interior Design saluted the twentieth anniversary of the exhibition and its ongoing relevance with a new show and conference under the eloquent title *Modern in the Past Tense: Revisiting the Landmark Exhibition "Design 1935–1965: What Modern Was" at the Montreal Museum of Decorative Arts*.[10]

The exhibition *Design 1935–1965* induced a number of American patrons and artists to donate their works and even entire collections to the Montreal institution. Approaches by David Hanks and the support of the American Friends of Canada played a decisive role in securing these gifts. Generous friends of the MMDA included Herman Miller as well as New York's Fifty/50 Gallery and Gallery 91. In 1999, Jack Lenor Larsen donated twelve hundred samples of fabrics he had designed. In 1992, the gift by Frank O. Gehry and Knoll of a series of prototypes and chairs designed by Gehry 184 185 formed the basis for the travelling exhibition *Frank Gehry: New Bentwood Furniture Designs*. Gifts from private

collectors included some eighty designs for wallpaper and fabrics by the American Peter Todd Mitchell donated by Priscilla Cunningham 562 -567, Italian furniture from Eleanor and Charles Stendig and over eight hundred designs by the Canadian-born artist and designer Rolph Scarlett donated by Mr. and Mrs. Charles Esses.

For his part, Luc d'Iberville-Moreau appealed to Montreal collectors. He persuaded Esperanza and Mark Schwartz to part with their *Charly* and *Clarisse* armchairs by Niki de Saint Phalle 665 666. Jean Boucher donated some unique pieces of furniture 552 designed in 1987 by Ettore Sottsass for the Blum Helman Gallery of New York. Paul Leblanc enriched the modern jewellery collection with seventy-three pieces by American designers, including Alexander Calder 354 -356, Margaret De Patta, Art Smith and Earl Pardon. In 1996, the travelling exhibition *Messengers of Modernism: American Studio Jewelry 1940–1960* provided an overall view of the MMDA's jewellery collection. Lucie and Miljenko Horvat donated their impressive collection of posters, most of them Polish, in two tranches in 1991 and 1999 605 -607 609 610.

The growth of the collection over the years was also partly due to numerous purchases, some of them made during visits to studios. Such was the case with the acquisition of a diptych by the American potter Betty Woodman 514 and of works by the Canadian potter Roseline Delisle 510, then living in California. The meeting with Delisle marked the start of a friendship between the artist and the representatives of the MMDA. In fact, it was at the suggestion of Luc d'Iberville-Moreau that the ceramicist began to create large-format pieces. Frequent trips to New York not only validated the MMDA's interest in designers like Jack Lenor Larsen, Gaetano Pesci, Lella and Massimo Vignelli and Eva Zeisel, but also provided opportunities for visiting galleries and purchasing outstanding pieces such as Salvador Dalí's *The Persistence of Memory* brooch 345. Mrs. Stewart became a regular visitor to Milan's Salone del Mobile. Design Gallery Milano, which sells pieces and furniture in limited editions, continued to be a favoured destination. It was there that the MMDA purchased works by Andrea Anastasio, Andrea Branzi 428 429, Alessandro Mendini and Ettore Sottsass 522.

The late 1990s marked a turning point for the MMDA and the Stewart Collection. The limited exhibition spaces of the Château Dufresne were no longer suitable for a representative display of the permanent collection or for the MMDA's temporary exhibitions. After considering the construction of a new building, Mrs. Stewart rented part of the Jean-Noël Desmarais Pavilion of the Montreal Museum of Fine Arts. The design of the MMDA's new galleries and offices was entrusted to the architect Frank O. Gehry, who created a baroque interior of sloping shapes in plywood arranged on a floor made from wood cut against the grain, providing a striking setting for the MMDA's displayed works (p. 14, fig. 2). In May 1997, the MMDA opened its new premises with the exhibition *Designed for Delight: Alternative Aspects of Twentieth-century Decorative Arts*. The themes of the exhibition—"Body Language," "Inversion and Transformation," "Is Ornament a Crime?" and "Flights of Fancy"—offered a new reading of twentieth-century decorative arts, from Art Nouveau and Art Deco through the Radical Design of the 1960s to the Postmodernism of the 1980s.

The MMDA's new downtown location made it more accessible and boosted attendance figures. This was the start of a rewarding partnership between the MMDA and the Montreal Museum of Fine Arts (MMFA), heralding a more complete integration.

Fig. 3
Installation in the Museum's Design Lab, 2010:
The Tribe and the Hermit,
by Michel Rouleau (b. 1963).

5

Manuel Desrochers
Born in Saint-Zénon,
Quebec, in 1975
For AQUAOVO
OVOPUR
Eco-design Water Filter
2007
Porcelain, glass, metal
Produced for AQUAOVO,
Montreal
H. 65.5 cm; Diam. 26.5 cm
On the valve: AQUAOVO
Gift of Manuel Desrochers
– AQUAOVO
2009.36.1-4

2000–1: TWO GREAT COLLECTIONS BECOME ONE

In 2000, Mrs. Stewart gave her remarkable collection of over five thousand pieces of modern and contemporary design to the MMFA, thus bringing to an end the brave venture of the MMDA.[11] This gift, unparalleled in the history of the MMFA, rounded out its own collection of early and modern decorative arts initiated by F. Cleveland Morgan in 1916. During the following year, in 2001, the Stewart Collection and the decorative arts collection of the MMFA were brought together in the addition built by architect Fred Lebensold in 1976 (p. 14, fig. 3), which was now renamed the Liliane and David M. Stewart Pavilion. The works were exhibited chronologically, displaying seven hundred decorative art objects from the Renaissance to the present day, half of the galleries being devoted to the Stewart Collection.

This amalgamation led the MMFA to focus on decorative arts and design as a significant area of the collection. An acquisition committee for decorative arts was established under the chairmanship of Mrs. Stewart, who was also elected to the Museum's Board of Trustees. She continued to expand the Stewart Collection by means of major gifts,[12] which, notably, included in 2010 the collection of the American Eric Brill, consisting of some nine hundred American and Canadian industrial design objects from the 1930s to the 1960s[13]—and several contemporary masterpieces, including one by Michael Eden 701.

In 2008, the Museum opened the Design Lab (fig. 3) as a showcase for twenty-first-century design produced at home and abroad. Several recent acquisitions were first exhibited in the Design Lab, including the stool by Samare 268 and the eco-design water filter AQUAOVO 5.

The Museum's collection began to focus on several of the developmental goals of the Stewart Collection, such as Italian design, art glass and contemporary jewellery, and attracted some outstanding gifts illustrating the latest trends in contemporary design in these fields. In 2007, the Montreal collectors Anna and Joe Mendel, passionate admirers of the Studio Glass movement, gave the Museum a hundred works by Canadian and foreign glass artists (fig. 4). Thanks to this gift, the Museum is the only institution in Canada to offer a comprehensive survey of international contemporary art glass.[14] The collection is rich in works by young Canadian glass-makers, whom the Mendels wished to encourage by establishing the Houdé-Mendel Bursary, awarded annually to a graduate of the College Studies Diploma at Espace VERRE in Montreal. This kind of support for young artists had a notable precedent in the Museum's history. Between 1963 and 1985, thanks to an annual gift from Saidye and Samuel Bronfman for the purchase of works by young Canadian artists, the collection acquired some exceptional pieces in the fields of glass and ceramics 6.

The Museum also benefited from the generosity of the American collector Joseph Menosky, who in 2007 and 2010–11 donated limited-edition pieces of Italian Radical Design 100 649 687. In 2009, Canadian designer Lily Yung enriched the Museum's collection of modern and contemporary jewellery—mainly composed of jewellery later than 1945 from the Stewart Collection—with a gift of twenty-three of her creations 697. A number of acquisitions illustrated the many facets of Quebec design, such as the fibreglass *Mamma* rocking chair by Patrick Messier (b. in Montreal in 1974), a set of posters by Nelu Wolfensohn 598 and Michel Dallaire's *Bixi* bicycle 401. The Museum also made important purchases internationally in order to present the latest trends in the world of design, such as furniture by the Dutch artist Joris Laarman 549 and the Swedish collective Front 702, and the hanging lamp by Korean designer Kwangho Lee 259.

Today, the Museum is one of North America's leading players in the field of twentieth- and twenty-first-century decorative arts and design (fig. 2). Its remarkable collection not only offers visitors a panorama of early and contemporary decorative arts but it also constitutes a rich source of material for scholars—writers, researchers and curators. Perpetuating the spirit of the Stewart Collection, new acquisitions continue to illustrate the work of designers, artists, artisans and architects from across the globe, including South Korea 259, Brazil 278, Italy and Scandinavia. They illustrate the most recent technological advances and thematic innovations, notably environmental concerns. Examples of industrial design are found alongside one-of-a-kind works that revisit traditional techniques, or pieces of jewellery that reinvent the art of the "found object." These juxtapositions render comprehensible the complexity of twenty-first-century creative processes.

1. The Scots-born Canadian David Macdonald Stewart made his fortune in the tobacco industry as head of Macdonald Tobacco. Passionate about Canadian history, in 1955 he founded the Stewart Museum, bringing together a collection of objects and documents that retraced the story of European civilization in the New World. In 1973, he sold Macdonald Tobacco and with his wife, Liliane, established the Macdonald Stewart Foundation. On his death in 1984, Liliane M. Stewart took over the Foundation, generously supporting a variety of cultural and heritage projects, and taking a particular interest in education and medicine in Montreal, Quebec and Canada. Beginning in 1984, she chaired both the Stewart Museum and the MMDA.

2. Built between 1915 and 1918 by the industrialist Oscar Dufresne and his brother Marius, an architect and civil engineer, in what was then the town of Maisonneuve, laid out according to the principles of the American City Beautiful movement, the Château Dufresne—as it was called by the locals—was notable for the eclecticism of its interior decoration of frescoes and stained-glass windows commissioned from the Italian-Canadian artist Guido Nincheri (1885–1973). The Château Dufresne was declared an historic monument in 1976. See website http://www.chateaudufresne.com/PagesFr/chateau-dufresne-english.htmm (accessed June 13, 2012).

3. Luc d'Iberville-Moreau was general curator of the MMFA from 1966 to 1968, the first French-speaker to hold the position. In 2012, the Museum appointed him emeritus consultant in decorative arts and design in acknowledgement of his invaluable contribution to the formation of the Stewart Collection.

4. On the history of the collection, see David A. Hanks, ed., *The Century of Modern Design* (Paris: Flammarion; Montreal: Liliane and David M. Stewart Program for Modern Design, 2010), pp. 10–15.

5. After David M. Stewart's death in 1984, the collection previously named after Liliane M. Stewart became the Liliane and David M. Stewart Collection.

6. Among his friends and acquaintances, Luc d'Iberville-Moreau numbers several Italian designers including Andrea Branzi, Carlo Forcolini and Gaetano Pesce. He is also friends with Dutch designer Gijs Bakker, French designer Sylvain Dubuisson and the Canadian-born American architect Frank O. Gehry.

7. Beginning in 1975, the Montreal collector Louise D'Amours put together one of the first collections of contemporary Canadian glass. The Louise and Laurette D'Amours Bequest includes a fund devoted to the acquisition of works by young Canadian glass designers.

8. In 2001, Harry N. Abrams published a revised and expanded edition of the catalogue, now out of print.

9. In 1985, the search began for a new location to house the MMDA and its collection, which was expanding more rapidly than had been expected.

10. *New York School of Interior Design (NYSID) Presents Exhibition and Panel Discussion Celebrating 20th Anniversary of Landmark "What Modern Was" Exhibition* (http://www.nysid.edu/page.aspx?pid=717 [accessed March 15, 2012]).

11. The last collaboration between the two museums was the publication of *Design for Living: Furniture and Lighting 1950–2000. The Liliane and David M. Stewart Collection* (Paris: Flammarion, 2000).

12. These gifts were made through the Liliane and David M. Stewart Program for Modern Design created by Mrs. Stewart in 2000. Under the direction of David Hanks, the program collects modern and contemporary design and organizes exhibitions and publications financed by the fund.

13. A selection of works from the Brill donation was exhibited at the Museum in 2007 under the title *American Streamlined Design: The World of Tomorrow*.

14. The Mendel collection was presented in 2010 in the exhibition *Studio Glass: Anna and Joe Mendel Collection*.

6

Marilyn Levine
Medicine Hat, Alberta, 1935 –
Oakland, California, 2005
Jacket
About 1970
Stoneware
76.2 x 50.8 x 11.4 cm
Purchase, Saidye and
Samuel Bronfman
Collection of Canadian Art
1970.Dp.3
PROVENANCE
Acquired from the artist
by the Museum in 1970.

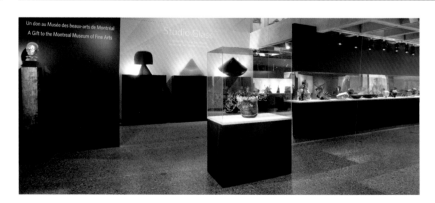

Fig. 4
The exhibition *Studio Glass: Anna and Joe Mendel Collection*, designed by Daniel Castonguay, in the Liliane and David M. Stewart Pavilion, 2010–11.

GLASS

■■■ *noun & adjective* [ORIGIN Old English *glæs* . . .]
A *noun* **I 1** ■ A substance, usu. transparent, lustrous, hard, and brittle, made by fusing soda or potash or both with other ingredients.

■■■ Glass is paradoxical: solid but translucent, it suggests the phenomenon of a liquid suddenly fixed in space and time. Discovered in the Near East about 3,500 B.C., it was originally opaque. Transparent, multicoloured glass only appeared in the Greco-Roman period. ■■■ The art of stained glass—the assembly of flat sheets of coloured glass through which light renders figures and narrative compositions resplendent—reached its peak in religious architecture during the Middle Ages, notably in France and England. The late nineteenth century saw the revival of stained glass in Europe and North America, where glass was not only coloured but streaked, mottled and textured, producing magnificent pictorial effects. ■■■ Hollow glassware was first mould-blown, before the countless plastic qualities made possible with free-blown and hot-worked glass techniques were discovered. In the sixteenth century, Venice was the main centre of glass-making in Europe. The Venetians refined *cristallo*, a clear glass resembling rock crystal often decorated with polychrome enamels and gilding. The seventeenth century confirmed Bohemia's supremacy. The enamelled ornamentation gave way to etched and wheel-engraved decoration, cold-working processes that exploit the hardness of glass. In the late seventeenth century, England produced a lead glass much appreciated by local as well as German and Dutch engravers. ■■■ Under the influence of Art Nouveau, at the turn of the twentieth century, French glass-makers celebrated fluid forms inspired by nature. Some decades later, Italian and Scandinavian artists were instrumental in reviving industrial glass production. While the Italian works kept to the Venetian tradition in terms of their rich colours and the virtuosity of their manufacturing and decorating techniques, the Northern glass-makers favoured clear, opaque and transparent glass, some of them emphasizing mass and weight. ■■■ During the 1960s, the Studio Glass movement, which emerged in the United States, distanced itself from utilitarian or decorative concerns. These artists created pieces that were actual sculptures. The main schools of Studio Glass in the United States, Canada and the Czech Republic exploited traditional methods (working with moulds and blowing) as well as new processes (thermoforming), and sometimes combined glass with other materials. ■■■ More recently, glass has inspired contemporary designers. With this translucent material, they have created not only light fixtures but also furniture of pure lines accentuated by an airy lightness. DC

MEDIEVAL STAINED GLASS

— ROLAND SANFAÇON —

FRANCE
Scenes from the Life of Joachim
The Beheading
of Saint John the Baptist

The Museum houses what is likely the most significant collection of Medieval and Renaissance stained-glass windows in Canada. Among the highlights are two examples of Parisian art from the time of Saint Louis, in the mid-thirteenth century. The rebuilding program of the Abbey of Saint-Denis, the facades of the Notre-Dame de Paris transept and the Sainte-Chapelle of the royal palace, about 1240–45, were once exemplary models for the whole of Western architecture. However, between 1245 and 1247, another building project of exceptional refinement was completed in Paris but unfortunately is no longer extant: the Lady Chapel abutting the cloister of the Abbey of Saint-Germain-des-Prés. Even though this chapel and the Sainte-Chapelle were built about the same time, the differences between the two were striking. The decoration of the Sainte-Chapelle relied entirely on colourful, historiated stained-glass windows, while the windows of the Lady Chapel were of a very distinct nature. In the latter, decorative windows made of uncoloured glass with grisaille painting embellished the nave, and the apse's axial bays had five windows depicting scenes from the lives of Christ and the Virgin Mary, flanked on either side by an historiated window dedicated to the abbey's patron saints. The Museum's panel, *Scenes from the Life of Joachim* 7, was part of one of these axial bay windows.[1]

After 1240, the Sainte-Chapelle workshops were largely responsible for the style of stained-glass windows in France, for example, the clerestory windows of the Cathedral of Tours, about 1260. Several of the heads and architectural elements found there resemble those in the Montreal

stained-glass window *The Beheading of Saint John the Baptist* 8, although the latter is less monumental in nature. It was to be a lower-set window, and one can well imagine it in one of the Notre-Dame de Paris chapels. The original shape of this panel was not necessarily rectangular (the corners show signs of reworking) and, as in *Scenes from the Life of Joachim*, it was to be surrounded by a decorative mosaic ground tying together the various scenes depicted in the window program. Blue and red dominate the colour scheme in both stained-glass windows, and the figures, although not realistically depicted (Joachim does not appear here as the old man he is in the story), no longer display the restless or superhuman bearing seen in figures of the Romanesque period. The drapery work, despite a few curled folds in the Saint Joachim panel, is spare and in keeping with the sweeping lines of Gothic architecture.

The story of the Virgin Mary's parents depicted in the stained-glass window *Scenes from the Life of Joachim* is of great interest. Anne and Joachim are already old and childless—a situation viewed by Jews of the period as a sign of divine displeasure. Seeking grace, Joachim goes to the temple with an offering, which is refused by the temple priest. Later, the dismissed Joachim returns to his flock and is visited by an angel who tells him to meet Anne at the Golden Gate, because Mary, destined for great things, is to be born. The Montreal stained-glass window consists of but one half of each of these two successive episodes.[2] In the panel on the right, which depicts *The Refusal of Joachim's Offering*, the temple priest is shown brandishing ancient Judaic laws, and Joachim would have been facing him inside of a temple or within an abstract framing device. In the left panel, representing *Joachim with His Flock*,

Joachim is in all probability standing before the angel in *The Annunciation to Joachim*, missing from the right, and the lamb he is prepared to sacrifice speaks to his gratitude to God. Both of these scenes were thus the same size as the Montreal stained-glass window, and were surely in close proximity within the same window.

The story—based on second-century apocryphal literature (the Gospel does not mention the Virgin Mary's parents)—stresses the almost divine birth of Mary, as God flouted both Jewish precepts and the laws governing her parents' aging and infertility. It was probably one of the earliest examples of this much space being allocated at Saint-Germain-des-Prés to these episodes. Their underlying theme is divine intervention, but the twelfth and thirteenth centuries saw the rise of a growing interest in the earthly affairs of people; the Montreal stained-glass window testifies to a major shift in religious thinking. RS

1. Jane Hayward, *English and French Medieval Stained Glass in the Collection of the Metropolitan Museum of Art* (London: Harvey Miller; New York: The Metropolitan Museum of Art, 2003 [Corpus Vitrearum, United States of America, Part I]), revised and edited by Mary B. Shepard and Cynthia Clark, vol. 1, pp. 157–178; Virginia Chieffo Raguin, *Stained Glass in Thirteenth-century Burgundy* (Princeton, New Jersey: Princeton University Press, 1982), pp. 67–71 (fig. 23), 106–107. Jacques Moulin and Patrick Ponsot, "La chapelle de la Vierge à l'abbaye Saint-Germain-des-Prés et Pierre de Montreuil," *Archeologia*, no. 140 (1980), pp. 48–55; Robert Branner, *Saint Louis and the Court Style in Gothic Architecture* (London: Zwemmer, 1965), pp. 67–71 (fig. 73), 77–79, 82–83. 2. See report of Corpus Vitrearum Medii Aevi, Canadian Committee, 1995, by Ariane de Jongh Isler and Jim Bugslag (MMFA Archives, file 1929.Dg.4). See also Xavier Dectot's entry on this window in *World Cultures and Fine Arts: The Montreal Museum of Fine Arts' Collection. Volume III*.

7

FRANCE
Gothic
Scenes from the Life of Joachim: Joachim with His Flock The Refusal of Joachim's Offering
Abbey of Saint-Germain-des-Prés, Lady Chapel, Paris
About 1245–50
Pot metal glass, clear glass, silver stain, leading
63.5 x 90.2 cm
Purchase
1929.Dg.4

PROVENANCE
John Christopher Hampp, 1802 (?)–8 (?); Sir William Jermingham, about 1808, installed in Chapel of Saint Augustine (consecrated 1811) at Costessey Hall; Grosvenor Thomas, London, 1918; Roy Grosvenor Thomas (his son), New York; acquired by the Museum in 1929.

8

FRANCE
Gothic
The Beheading of Saint John the Baptist
Northern France
About 1275
Pot metal glass, clear glass, silver stain, leading
37.5 x 34.9 cm
Gift of Miss Mabel Molson
1961.Dg.1
PROVENANCE
William Drake; McGill University, Montreal, about 1942–60; transferred to the Museum in 1960.

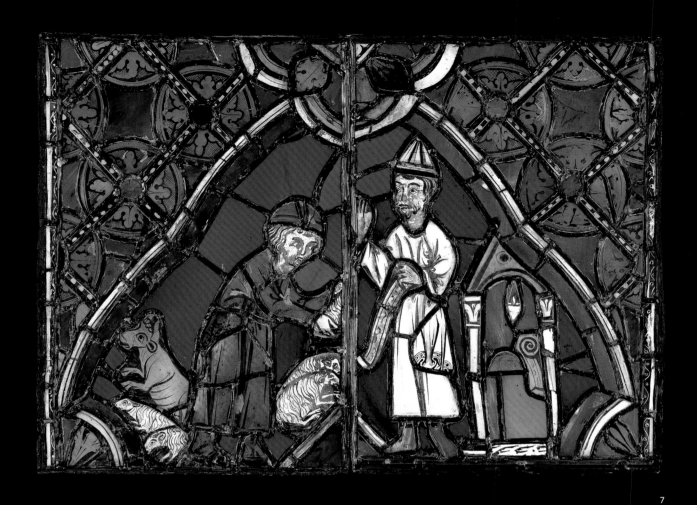

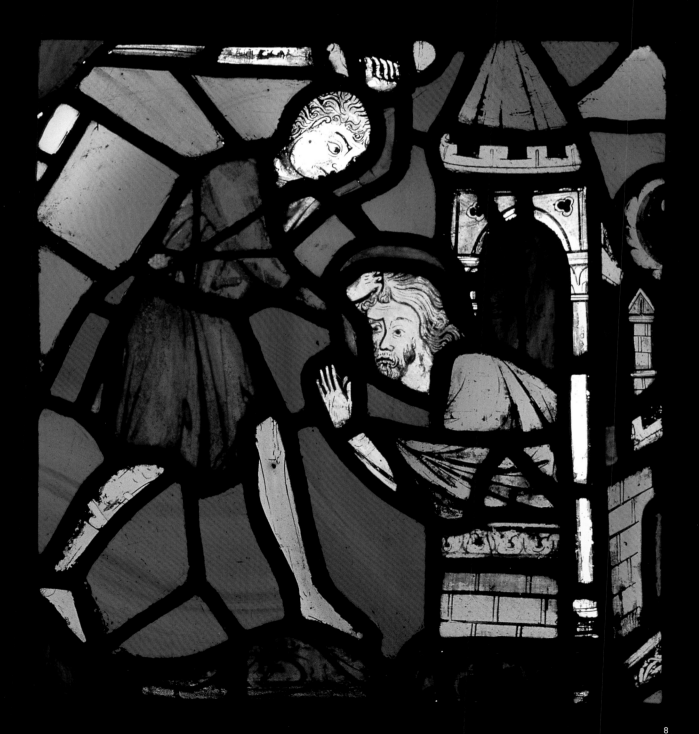

ENGLAND
Saint Anne Teaching the Virgin to Read
Saint Winifred
Saint Thomas Becket

One of three stained-glass windows in the Museum that were formerly installed at Hampton Court, county of Herefordshire, England, depicts *Saint Anne Teaching the Virgin to Read* [9a]. This is the traditional title given to this scene likely devised in England, where it is most commonly found, although the subject is widely depicted in Continental Europe too. It has recently been posited that the story actually portrays Saint Anne teaching Mary that her destiny has been foretold in the holy texts, which predict she is to be the Mother of God. The episode is sometimes referred to as the *Education of the Virgin*, which has the advantage of encompassing the two possible readings. In this case, however, Saint Anne seems to be alone, looking off into the distance. Moreover, the window was originally presented among a retinue of saints, as evidenced by the two other windows from the group in the Museum's collection—each one identified by an inscription, including *Saint Thomas Becket* [9c], Archbishop of Canterbury in the twelfth century, and *Saint Winifred* [9b], an English saint from the seventh century. Murdered in his cathedral for having resisted royal power, Becket came to be venerated

in the West as a model defender of ecclesiastical authority. Winifred was decapitated by a spurned suitor and then brought back to life by a saint who re-attached her head (notice the line around her neck). In Holywell, west of Chester, in the Welsh county of Clwyd, a spring miraculously appeared on the spot where her blood is said to have spilled, becoming a major pilgrimage site.

In 1924, these three stained-glass windows were still installed in the domestic chapel at Hampton Court, south of Leominster, near Hereford.[1] They were purchased in 1928 from the art dealer Thomas and Drake in London by the McConnell family of Montreal. Also in the Hampton Court chapel at this time was a recomposed window of the Apostles' Creed (some apostles are missing), now at the Museum of Fine Arts, Boston. These windows had not been altered when they were removed and sold. However, they had already been considerably reworked—as revealed in the ground of red and blue damask-patterned water vegetation and the architectural settings surrounding the three saints—and most probably moved in the mid-seventeenth century, following the turmoil of the Cromwell period. The Montreal windows greatly resemble the Saint William stained-glass window in York Minster, attributed to John Thornton about 1415.[2] They

may very well have been originally commissioned for Hereford Cathedral, whose bishop between 1421 and 1448, Thomas Spofford, had close ties to Yorkshire through his family and the offices he had held.

In terms of style, the three saints are admirably depicted. They are painted on uncoloured glass with highly sophisticated modelling and fluid lines in the faces and drapery. This restrained use of colour emphasizing draftsmanship is typical of an international style prevalent in France as of the fourteenth century, and most important in fifteenth-century England, while France was enduring the Hundred Years' War. These windows are excellent examples of the production of just one of the many English workshops of the period. The striking expressions and the eloquent and vigorous hands, strangely bearing little nuance, imbue the windows with a strong spiritual quality. RS

1. Madeline H. Caviness, "Fifteenth Century Stained Glass from the Chapel of Hampton Court, Herefordshire: The Apostles' Creed and Other Subjects," *The Walpole Society Publications*, vol. 42 (1968–70), pp. 35–59, pls. 29–41; Richard Marks, *Stained Glass in England during the Middle Ages* (London: Routledge, 1993), pp. 93 and 183. 2. Thomas French, *York Minster: The St. William Window* (Oxford: Oxford University Press, 1999 [Corpus Vitrearum, Great Britain, Summary Catalogue, 5]).

9a-c

York School artist or workshop
Saint Anne Teaching the Virgin to Read
Saint Winifred
Saint Thomas Becket
About 1435
Pot metal glass, clear glass with silver stain, leading
163.5 x 92 cm (each panel)
Painted inscriptions: beneath the figures of Saint Anne and the Virgin: *Sca Ann*; beneath the figure of Saint Winifred: *Sca Wenefreda*; beneath the figure of Saint Thomas Becket: *St. Thomas Cantuar*
Gift of the John Main Prayer Association, by prior gift of the J. W. McConnell Family Foundation
1995.Dg.15-17

PROVENANCE
Hampton Court Chapel, Herefordshire, England, until 1924; Thomas and Drake, London, 1924–28; J. W. McConnell, Montreal, 1928–about 1975; The John Main Prayer Association, Montreal, about 1975–95; acquired by the Museum in 1995.

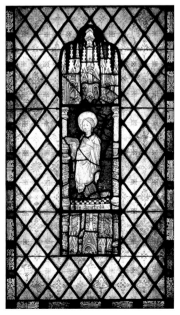

9a

9b

9c

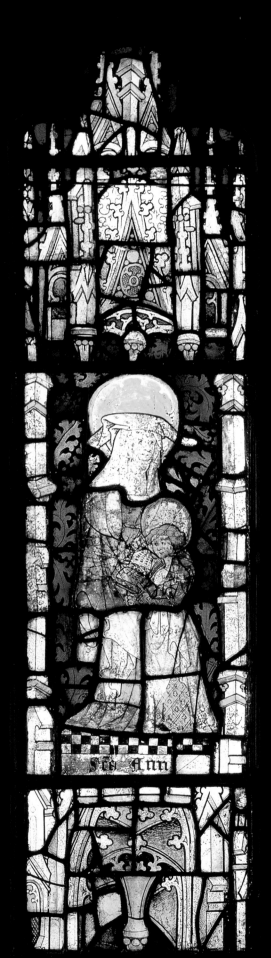

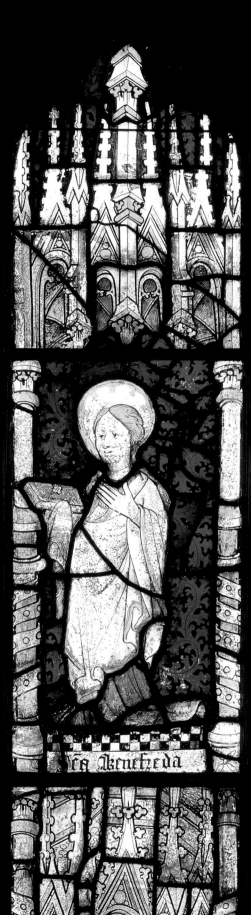

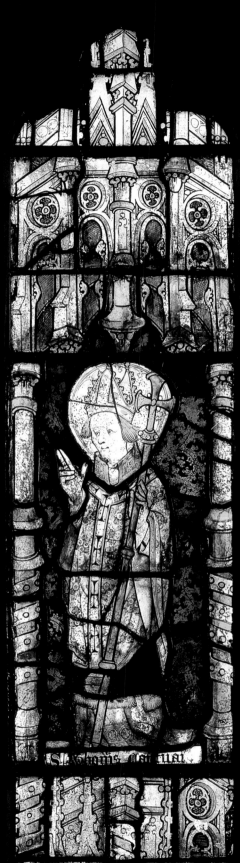

9a 9b 9c

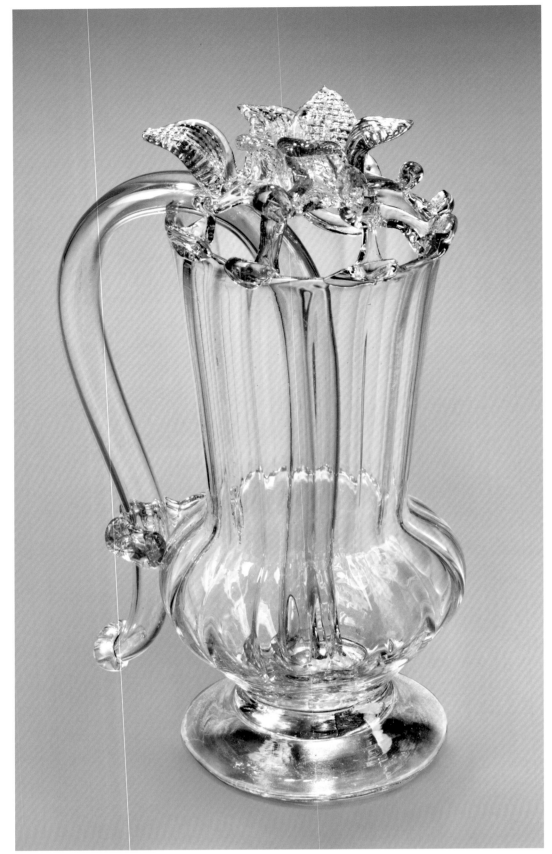

10

11

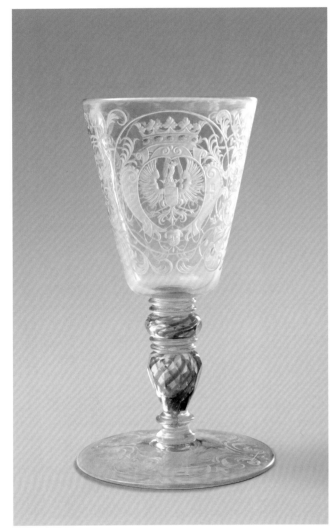

12

GLASS-MAKING TRADITIONS: 16th TO 18th CENTURY

— ROBERT LITTLE AND BRIAN MUSSELWHITE —

In his *Natural History*, Roman historian Pliny the Elder wrote that the origin of glass was first discovered by accident on a sandy beach in Syria when travelling soda (sodium carbonate) merchants cooked a meal and used the blocks of soda from their cargo to support their cooking vessels. The heat from their cooking fires melted together the beach sand and soda, producing a translucent molten liquid. Glass is basically seventy-five percent silica, readily available as sand, quartz or flint, combined with an alkaline flux, like soda or potash (potassium carbonate), which, when heated, lowers the melting point, making molten glass that can be worked. In Europe, different countries, with their particular resources, have used different fluxes to produce their own distinctive types of glass.

Early Venetian glass was made with silica obtained from crushed pebbles from the river Ticino combined with a flux of soda derived from the ashes of marine plants imported primarily from Syria, Egypt or Spain. Although there was some distilling of impurities, manganese from Piedmont was added to decolourize the liquid glass. When heated, this produced a very clear molten medium that could be gathered on a blowpipe, then manipulated and blown very thinly into elaborate shapes. The purifying process, however, removed some essential natural stabilizers, making the unstable glass susceptible to sweating or "crizzling." North of the Alps, the ashes of forest plants provided the potash flux that was purified by leaching in large pots.[1] In France and Germany, this produced a more durable glass that was also more difficult to work because it cooled and hardened more quickly than soda glass. In England, about 1676, George Ravenscroft is credited with developing a red-lead flux that produced a clear, colourless glass of great brilliance that cooled slowly, and, like potash glass, did not lend itself to tooled decoration using pincers.

Glass-making in the vicinity of Venice first appeared in the seventh century, and as the Venetian Republic grew in political and economic power, glass became an important export. From 1173 onwards, the glass-making industry was regulated by the Venetian judiciary power, the Ufficio della Giustizia. By about 1292, the Great Council of Venice decreed that the city's glasshouses be relocated to the island of Murano, north of Venice. This was done to protect the city against fires, and to provide a means of controlling the movements of its glass-workers, thereby guarding the secrets of Venetian glass-making, so vital to the Republic's economy.[2] The technical developments that led to the importance of Venetian glass took place in the 1450s, when Angelo Barovier is credited with introducing a very clear, colourless glass imitating rock crystal, called *cristallo*. The varieties of shapes produced were often based on contemporary gold and silver vessels. Enamel and gilt decoration, as seen in this tazza, or footed bowl **11**, became fashionable in the second half of the fifteenth century. Gold leaf was affixed to the glass surface with gum Arabic, and decorative patterns were scratched into it. Enamel decoration was applied over the gilding, which was then fired; each enamel colour required an additional firing at a different temperature. Glass vessels, such as this Venetian footed bowl, were used to aerate wine before drinking. Prized as status symbols like gold and silver by the few who could afford them, they were depicted on the tables of the wealthy in the paintings of the time.

The traditions and secrets of Italian *façon de Venise* glass-making were continued in France in the late seventeenth century by Bernard Perrot. Born Bernardo Perroto (1619–1709) near Altare, Italy, in 1619, Perrot emigrated to Liège and then to Nevers, France, where he was active by 1651.[3] By 1662, Perrot had established the most important glass factory in France, at Orléans, under the royal patronage of the Duke d'Orléans. There, Perrot developed processes for casting and moulding, and also produced a wide variety of table glass and decorative wares in clear and coloured translucent glass; opaque white, or opaline glass; vessels of clear or opaline glass with applied red or blue translucent glass decoration; polychrome enamelled decorated glass; and marbled or "agate" glass. Perrot received letters patent in 1668 for his translucent ruby glass.[4] However, the influence of *façon de Venise* also spread across Europe to southern Bohemia, in particular, the glassworks established on the Buquoy estate at Nové Hrady, which had an influence on subsequent glass production in Bohemia.[5] This vessel **10**, a rare example attributed to the Perrot glassworks or to Buquoy glass artists, combines clear glass with touches of translucent ruby glass. The work is actually a trick glass, or surprise jug, whose hollow handle is a siphon from which the contents are drawn up, suddenly, onto the unsuspecting drinker.

While Venetian glass produced a soft, thin material suitable for diamond-point engraving, Bohemian glass-makers developed a clear, hard surface suitable for deep cutting and wheel engraving. Inspired at first by Renaissance engraved rock-crystal objects, Bohemian engravers were capable of producing both sculptural and decorative wares. Johann Kunckel (1630?–1703), chief chemist and director of the Potsdam Glass Factory, drawing upon earlier experiments with coloured glass formulae published in 1612 by Florentine chemist Antonio Neri (1576–1614), perfected his own formula, which he published in 1679 in his book *Ars vitraria experimentalis*. The deep ruby colour is obtained with precipitate of colloidal gold. The gold chloride is reheated and the reheating changes the finished greyish object to ruby red.[6] During the late seventeenth and early eighteenth centuries, ruby threads, as illustrated in the Museum's goblet **12**, were highly favoured by Bohemian and Saxon glass-makers. In this example, the ruby is combined with copper powder, creating a decorative effect known as aventurine. This late-Baroque glass, elaborately engraved with an unidentified, possibly Polish coat of arms, was probably originally provided with a cover.

By the late 1600s, numerous glass vessels were decorated with cutting and engraving: The most important of these were stemmed and covered goblets, known in German as the *Gesundheitsglas* or the *Pokal*. In formal court settings, they were used as communal drinking vessels to celebrate both joyful and solemn occasions.[7] Inspired by goldsmiths' covered goblets, stemmed and covered glass goblets first appeared in the 1660s in Nuremberg. Towards the end of the century, they were also used by more common folk. This Dutch glass from the mid-1750s is a fine example of a late Baroque form with Rococo-style wheel-engraved decoration depicting a man at a lathe with the commemorative inscription "Jemkien Cornelis" and the year "1757" **13**.

From 1735 to 1765, more than twenty glasshouses operating in Newcastle-on-Tyne, England, produced some of the finest English Rococo glass. One of the most popular shapes they developed was the Newcastle light baluster wineglass with its characteristic tall, slender knopped stems. "Newcastle" glasses found favour with Dutch and German glass engravers, who achieved better results wheel-engraving on English lead glass than on their own Continental potash-lime glass. In this example , a young woman surrounded by flowers, personifying Flora or the sense of smell, sits beneath an elaborate decorative border inspired by the ornamental engravings of Jean I Berain or Paul Decker the Elder.[8]

Another museum example 15 , an elegantly proportioned English Rococo wineglass appropriately enamel-decorated with a fruiting grape vine, reflects the new fashion for opaque enamelling on glass first documented in 1756.[9] Enamel decoration techniques, as practised at the Bilston factories in Birmingham, were brought by enamel artist William Beilby to Newcastle-on-Tyne in the 1750s. There, he and his sister Mary (1749–1797) soon perfected the art of enamel painting on vessels with the newly fashionable, opaque enamel twist stems, many produced at the local Dagnia-Williams Glassworks. In the eighteenth century, these types of drinking glasses were usually replenished from a side table by a servant. Once its user was done with it, the glass was removed by the servant, rinsed, dried and readied for the next guest who wanted a drink. The tiny bowls of these glasses held only a mouthful of wine, which was then made much stronger than today's wines.

The glass chandelier emerged in France during the late seventeenth century when *pendeloques* or glass pendants began to replace the rock crystal that adorned the branches of hanging light fixtures. In England, simple glass chandeliers with undecorated glass branches became fashionable in the 1720s. By the 1750s, as the art of glass-cutting became firmly established, the glass branches were richly facet cut, hung with numerous cut drops, and fitted with standing obelisk-shaped, cut-glass ornaments. Although the glass components were made in glasshouses, the final appearance of the chandelier was often determined by the numerous London glass-cutting establishments. They successfully exploited the inherent beauty of lead glass, and especially the way cut glass reacted with real or artificial light, as seen in the museum's example 16 .[10]

1. Catherine Hess and Timothy Husband, *European Glass in the J. Paul Getty Museum* (Los Angeles: The J. Paul Getty Museum, 1997), p. 1.
2. Ibid., p. 7.
3. Jacques Bénard and Bernard Dragesco, *Bernard Perrot et les verreries royales du duché d'Orléans 1662-1754* (Orléans: Éditions des Amis du Musée d'Orléans, 1989), p. 23.
4. Ibid., p. 24.
5. Olga Drahotová, "Identifying Glass from the Buquoy Glass Factory at the Nové Hrady Estate (Gratzen) in the Seventeenth Century," *Journal of Glass Studies* (1981), vol. 23, pp. 46–55.
6. Harold Newman, *An Illustrated Dictionary of Glass* (London: Thames and Hudson, 1977), p. 138.
7. Ada Polak, *Glass: Its Makers and Its Public* (London: Weidenfeld and Nicolson, 1975), p. 100.
8. Brigitte Klesse and Hans Mayr, *European Glass from 1500–1800: The Ernesto Wolf Collection* (Vienna: Kremayr and Scheriau, 1987), pl. 187, and Alain Gruber, *The History of Decorative Arts: Classicism and the Baroque in Europe* (New York: Abbeville Press, 1994), p. 189.
9. Charles Truman, *An Introduction to English Glassware to 1900* (London: Her Majesty's Stationery Office, 1984), p. 13.
10. Polak 1975, p. 148.

13

14

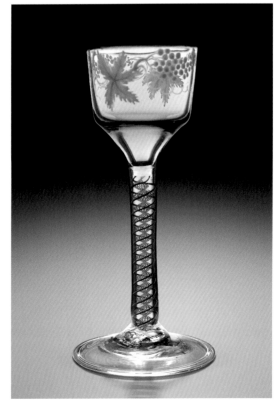

15

NETHERLANDS
Wineglass
About 1757
Glass, wheel-engraved decoration
H. 21.2 cm; Diam. 9 cm
Wheel-engraved inscription, near rim: *JEMKIEN CORNELIS*, at centre of bowl: *NO 1757*
David R. Morrice Bequest 1981.Dg.21

14

NETHERLANDS
ENGLAND
Wineglass
About 1750–60
Glass (Newcastle), wheel-engraved decoration (Netherlands)
H. 18.5 cm; Diam. 8.2 cm
David R. Morrice Bequest 1981.Dg.20

15

Attributed to
William Beilby
England 1740 – England 1819
Active in Newcastle-on-Tyne, about 1762–1778
Wineglass
About 1765–75
Glass, twisted white enamel threads, white enamel painted decoration
H. 14.3 cm; Diam. 6.7 cm
David R. Morrice Bequest 1981.Dg.5

16

ENGLAND or IRELAND
Chandelier
About 1780–1800
Cut glass, brass
157.2 x 121.9 x 45.7 cm
Anonymous gift
1970.Dg.4
PROVENANCE
Nizam Palace, Hyderabad, India;
Charles Glass Greenshields, Montreal; acquired by the Museum in 1970.

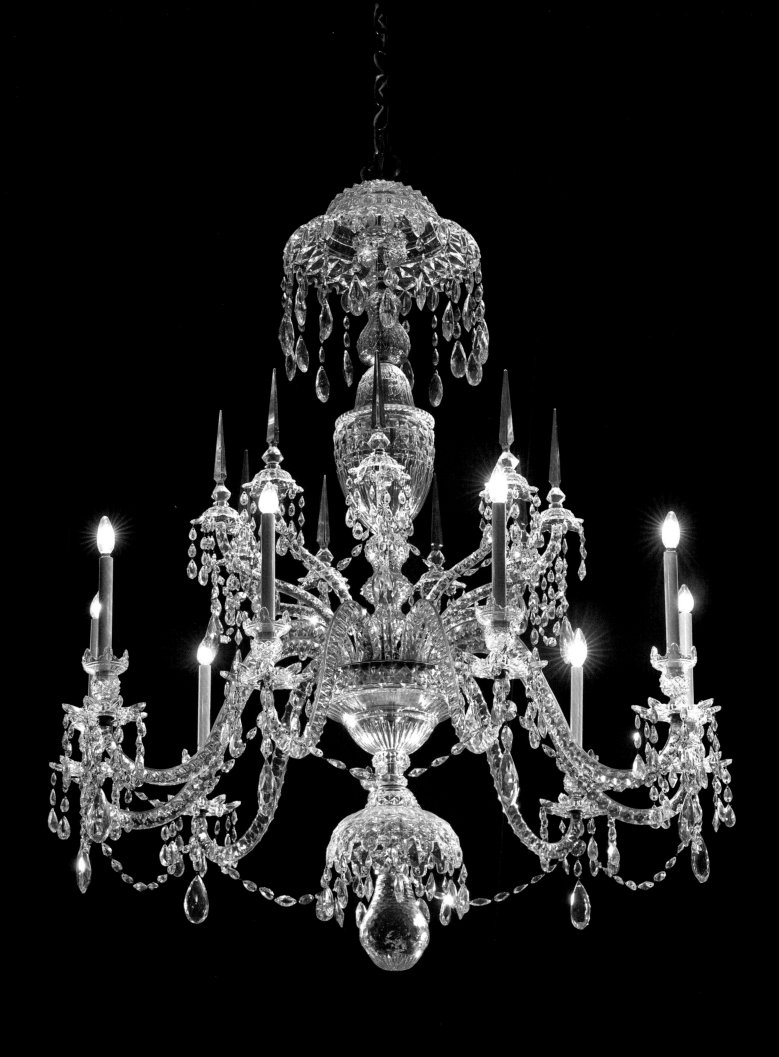

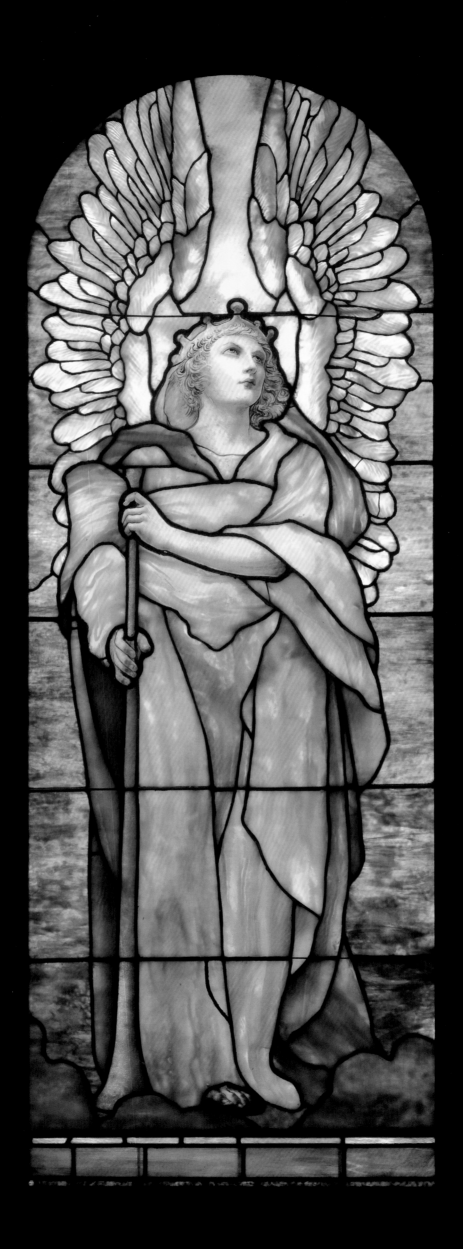

STAINED GLASS IN THE MONTREAL MUSEUM OF FINE ARTS' BOURGIE CONCERT HALL: A SPLENDID HERITAGE

— ROSALIND PEPALL —

LOUIS C. TIFFANY

Louis Comfort Tiffany was famous not only in North America but around the world. He represented the entrepreneurial spirit in America at the turn of the twentieth century, and his firm was celebrated for the original and spectacular effects of colour and light in its stained-glass windows, blown-glass vessels and lamps.

Tiffany had trained as a painter in New York and Paris, but he felt that he could achieve greater effects in radiant colour and light through the glass medium rather than oil on canvas.[1] After many experiments with glass-making, Tiffany opened his own glass factory in Corona, Queens, New York, in 1892–93. His entry into the production of windows coincided with the revival of stained glass in architecture, and with a countrywide boom in the construction of religious and cultural institutions, for which stained-glass windows were commissioned.[2] The Museum is today extremely fortunate to have eighteen documented Tiffany windows in its Bourgie Hall (figs. 3–4).

This series of windows was originally commissioned for the American Presbyterian Church, built in 1866 on the northwest side of Dorchester (now René-Lévesque) Boulevard at Drummond Street. In the late nineteenth century, its members decided to embellish their church in the latest fashion with Tiffany windows, which were installed between 1897 and 1904–5. The church ordered four double-lancet windows, each almost four metres by one and a half metres in size. The first two to be installed, *The Good Shepherd* **19** and *Christ at Emmaus* **18**, were inaugurated in 1897.[3] They were followed in 1901 by *Charity* **21** and *The Nativity* **20** (fig. 1).[4] In 1902, another thirteen smaller single-lancet windows were commissioned and set in place by Tiffany's workmen from New York, and about 1904–5, another Tiffany window, *Angel* **17** was ordered.[5]

In 1934, the American Presbyterian Church amalgamated with the Erskine United Church (built in 1894) on Sherbrooke Street, Montreal, to become the Erskine and American Church, just across the street from the Art Association of Montreal (now the Montreal Museum of Fine Arts). In 1937–38, renovations were undertaken to enlarge the church and to transfer the Tiffany windows to the nave, under the direction of Nobbs and Hyde, architects.[6] In 2008, the Museum acquired the Erskine and American Church, together with the Tiffany windows, and transformed it into a concert hall. All the windows, newly restored and cleaned, are now on permanent display in all their original splendour.

This extensive series was made when the firm was at its height of production in terms of quality, technical achievement and design.[7] The Museum's windows also showcase the work of the head of Tiffany's ecclesiastical department, Frederick Wilson, and two other noteworthy artists who worked for Tiffany, Edward Peck Sperry and Thomas Calvert. Wilson was the star of Tiffany's corps of artists, and he created some of the firm's most popular compositions for windows, for example, the Museum's *The Good Shepherd*. Eight of the Tiffany windows were designed by Wilson, and four others may be attributed to him. Trained as a painter and stained-glass designer in England, he began working for the Tiffany firm in 1893 and remained until about 1923.[8] An excellent draftsman, he drew inspiration from English Pre-Raphaelite models in his rendering of the fluid lines of drapery and delicate facial features of his figures. His original drawing for *The Good Shepherd* was published in an 1896 Tiffany Glass and Decorating Company promotional booklet, *Memorial Windows* (fig. 2). It is likely that the donors of Montreal's American Presbyterian Church had thumbed through it, as seven of the church's window designs appear in this small publication.

All the Montreal windows are created with milky, semi-translucent, opalescent glass, which Tiffany did not invent yet his name is attached to its development and use for stained-glass windows. Tiffany windows also featured a remarkably wide range of textured glass, which created shimmering effects and variations of colour. Traditional stained glass is flat with details and modelling painted on the surface in dark enamel. Tiffany took pride in his firm's spare use of painted brushwork in his windows, and he and his craftsmen invented ways of manipulating the glass medium to render volume and reveal its plasticity; for example, the movement of water was simulated with rippled glass; or marbling of colour in the glass rendered elements such as the bark of a tree without resorting to painted details. To suggest the light flickering through the foliage of a tree, the craftsmen incorporated "confetti glass," hundreds of fractured bits of coloured glass. "Streamer glass"—with its painterly application of abstract lines—was used to express movement in the masses of foliage.

One of the firm's most important innovations was "drapery glass," made by folding and creasing large molten sheets of flat glass to simulate the gatherings of drapery. The individual pieces of drapery glass were thick, up to almost two inches in some places, so great skill was required in the leading process to hold these heavy pieces together. The glass artists also superimposed plates of different coloured glass, sometimes as many as five layers, to achieve the exact variation of tone and shadow they wanted. In the Museum's large windows, chipped or facetted chunks of glass were incorporated into the Gothic canopies to create the jewel-like brilliance of colour and light that Tiffany sought. The careful selection of each piece of glass was crucial for the overall visual effect of a window. **RP**

1. Rosalind Pepall, "Louis C. Tiffany: From Painter to Glass Artist," in *Tiffany Glass: A Passion for Colour*, exh. cat., ed. R. Pepall (Montreal: The Montreal Museum of Fine Arts, 2009), pp. 6-29. 2. See Alice C. Frelinghuysen, "'A Glitter of Colored Light': Tiffany Domestic and Ecclesiastical Windows," in *Tiffany Glass*, pp. 74-95. 3. "Memorial Windows," *Montreal Star*, September 6, 1897, p. 3. 4. Minutes of the Board of Trustees, May 20, 1901 (P603 S2 SS14, folder no. 163), Archives of the American Presbyterian Church, Bibliothèque et Archives nationales du Québec, Montreal. 5. Two later windows, dating from 1906 and 1920 are not of the same quality and may be by other firms. [note] 6. "Erskine and American United Church, Montreal, Quebec," *Journal of the Royal Architecture Institute of Canada*, vol. 16, no. 4 (April 1939), pp. 80-81. 7. The firm's only other documented Canadian commission before 1910 is for a window in Saint Paul's Cathedral, London, Ontario. 8. Diane C. Wright, "Frederick Wilson: 50 Years of Stained Glass Design," *Journal of Glass Studies* (Corning, New York: Corning Museum of Glass), vol. 51 (2009), p. 206.

17

Louis Comfort Tiffany
New York 1848 –
New York 1933
Designed by
Frederick Wilson
(1858–1932)
Angel
Bourgie Hall, MMFA
(formerly the Erskine
and American Church)
1904–5
Leaded glass
190 x 63 cm
Made by Tiffany Studios,
New York

Dedication, at the bottom:
In Loving Memory of /
ALBERT D NELSON /
1843–1904 /
This window is placed by his /
Wife and Children
Purchase, 2008.431
PROVENANCE
American Presbyterian
Church, Montreal, 1904–38;
Erskine and American Church,
Montreal, 1938; acquired by
the Museum in 2008.

Fig. 1
Interior view of Montreal's
American Presbyterian
Church, built in 1866, showing
the four large double-lancet
windows by Tiffany.

Fig. 2
The Lord is My Shepherd,
drawing by Frederick Wilson
illustrated in the Tiffany
Glass and Decorating
Company's *Memorial
Windows* catalogue, 1896.

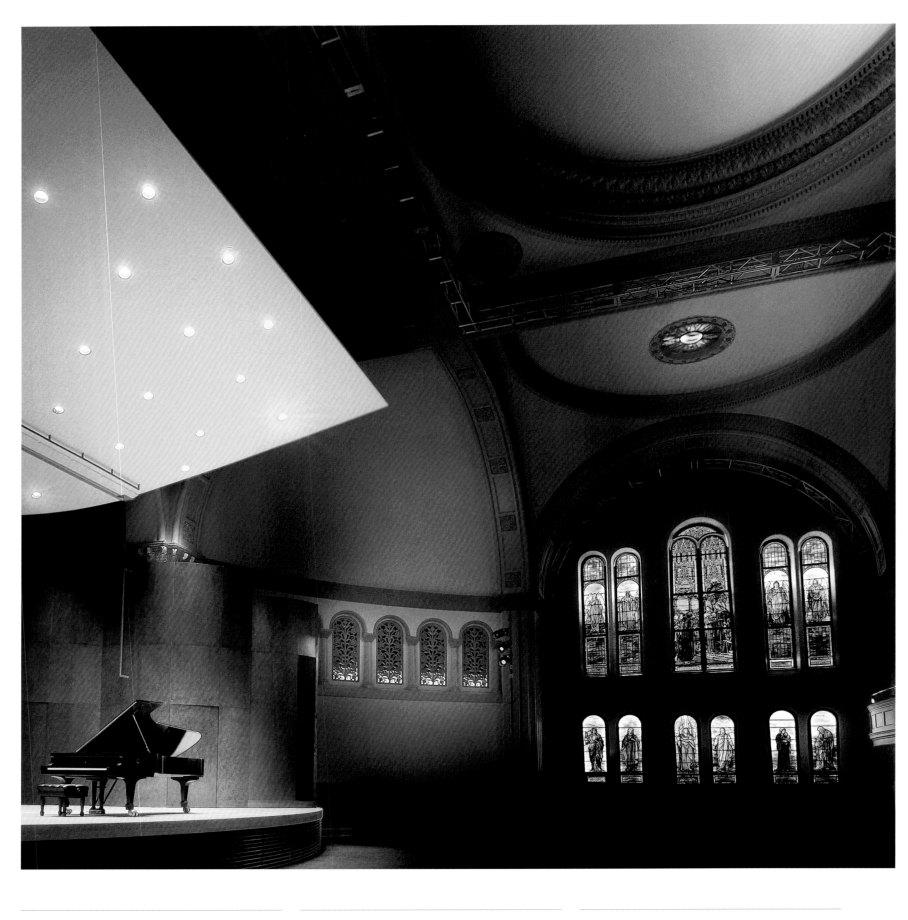

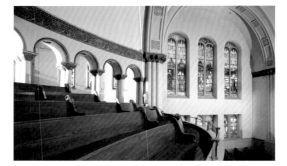

Figs. 3–4
Views of the Montreal
Museum of Fine Arts' Bourgie
Hall (formerly the Erskine
and American Church).
Top: The stage and the
stained-glass windows of
the eastern wall.
Bottom: The gallery and
the stained-glass windows
of the western wall.

18

Louis Comfort Tiffany
New York 1848 –
New York 1933
**Designed by
Edward Peck Sperry**
(1850–1925)
Christ at Emmaus
**Bourgie Hall, MMFA
(formerly the Erskine
and American Church)**
1897
Leaded glass
395 x 152 cm
Made by Tiffany Glass
and Decorating Company,
New York

Dedication, at the
bottom: *IN·MEMORY·OF /
BENJAMIN·LYMAN /
"ABIDE·WITH·US·FOR·IT·
IS·TOWARD / EVENING·AND·
THE·DAY·IS·FAR·SPENT"*
Purchase, 2008.427.1-9
PROVENANCE
American Presbyterian
Church, Montreal, 1904–38;
Erskine and American Church,
Montreal, 1938; acquired by
the Museum in 2008.

19

Louis Comfort Tiffany
New York 1848 –
New York 1933
**Designed by
Frederick Wilson**
(1858–1932)
The Good Shepherd
**Bourgie Hall, MMFA
(formerly the Erskine
and American Church)**
1897
Leaded glass
395 x 152 cm
Made by Tiffany Glass
and Decorating Company,
New York

Dedication, at the bottom:
*IN·MEMORIAM /
GEORGE·H·WELLS·D·D· /
PASTOR·OF·THIS·
CHURCH / 1871·TO·1892*
Purchase, 2008.429.1-9
PROVENANCE
American Presbyterian
Church, Montreal, 1904–38;
Erskine and American Church,
Montreal, 1938; acquired by
the Museum in 2008.

A

B

C

D

E

F

G

H

DIFFERENT TYPES OF TIFFANY STAINED GLASS

MOTTLED, OR "SPOTTED," GLASS

A (19, detail). This type of glass was distinctly Tiffany, as it was developed at the Corona furnace. It resulted from a crystallization created by the addition of fluorine, and the subsequent rolling process produced denser spots at one end of the sheet as well as variations in the size of the mottles. This type of glass was used to render texture in the centres of blossoms, shading in floral compositions, and sun-splashed leaves in landscapes.

FEATHER GLASS

B (17, detail). This glass was developed specially for depicting the wings of angels in windows, and like drapery glass it was also used for natural details in flowers and petals. Making it required rolling by hand on the marver (an iron table on which to work glass).

STREAMER GLASS

C (19, detail). This was made by laying thin rods of coloured glass onto the marver and then fusing them to the surface of molten glass through the rolling process. The resulting thin meandering lines of colour provided another distinct pattern for natural effects.

DRAPERY GLASS

D (17, detail). A great deal of skill and experience was required to produce this type of glass. Paddles were used to manipulate the molten glass sheet into folds and creases, and the resulting texture became rigid when cooled. It was developed to render fabrics, but was also used for volume in other areas.

HAMMERED GLASS

E (28, detail). This type of glass was produced by rolling the molten glass through textured rollers, producing a soft hammered pattern that diffuses light. It was often used in large pieces in leaded-glass windows, and plated over with one or more layers to enhance the illusion of distance.

"JEWELS," OR CABOCHONS

F (28, detail). These pieces were made by pressing molten glass into moulds to create densely coloured nuggets that embellished Tiffany's designs. The moulds were made of cast iron and came in a variety of sizes, shapes and textures. The glass could be one colour or multicoloured. Sometimes "jewels" were simply chunks of glass with rough facets that added sparkle.

RIPPLE GLASS

G (19, detail). This glass was formed on a marver that moved slowly on rollers. The molten glass would be passed through a roller moving slightly faster, which produced a ripple effect on the surface that remained once the glass cooled. It provided the perfect texture for rendering water, and was also used in decorative borders and backgrounds.

FRACTURED, OR "CONFETTI," GLASS

H (19, detail). This type of glass was made by breaking vessels blown thin, spreading the shards on a marver and embedding them into the molten glass in the rolling process. This combination of multicoloured, irregularly shaped fragments against coloured grounds produced visually complex effects. This glass was often used for airy backgrounds and for foliage seen from a distance when plated with other types of glass.

RESTORATION OF THE WINDOWS

The restoration and conversion of the nave of the Erskine and American Church into the Bourgie Hall provided the opportunity for a thorough examination, cleaning and restoration of all the windows in the former church. Some five thousand hours of work and half a million dollars were devoted to restoring the Tiffany windows in 2009–10, the most ambitious project of its kind ever undertaken by the Museum. Richard Gagnier, Head of the Conservation Department, oversaw this entire project, which was carried out in collaboration with Rosalind Pepall, the Museum's Senior Curator of Decorative Arts, and master glass-makers Françoise Saliou and Thomas Belot of Atelier La Pierre de Lune.

During the removal and transfer of the windows from the American Presbyterian Church, in 1938, some of the glass was broken. As a result, the background Tiffany glass in five of the single-figure windows was replaced by Hobbs Glass studios with vividly coloured, non-Tiffany glass, and four other windows received replacement glass at the base. The recent restoration of the windows included repairs with glass from Kokomo Opalescent Glass Works in Indiana, founded in 1888. This firm had supplied glass to Tiffany in his day and its colour range is more in keeping with the original tones of Tiffany glass.

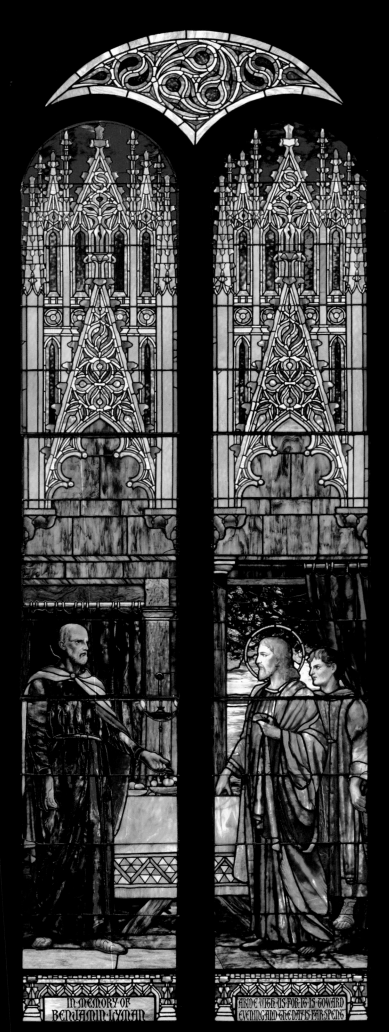

IN MEMORY OF
BENJAMIN LYMAN

ABIDE WITH US FOR IT IS TOWARD
EVENING AND THE DAY IS FAR SPENT

18

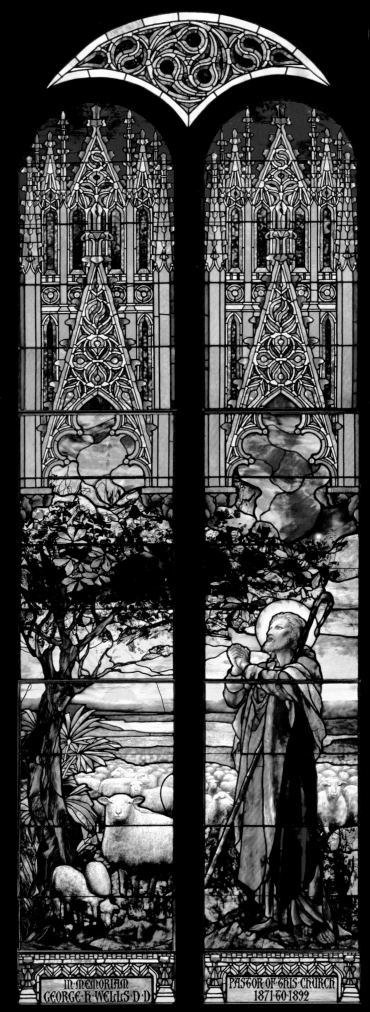

IN MEMORIAM
GEORGE R WELLS D D

PASTOR OF THIS CHURCH
1871 TO 1892

19

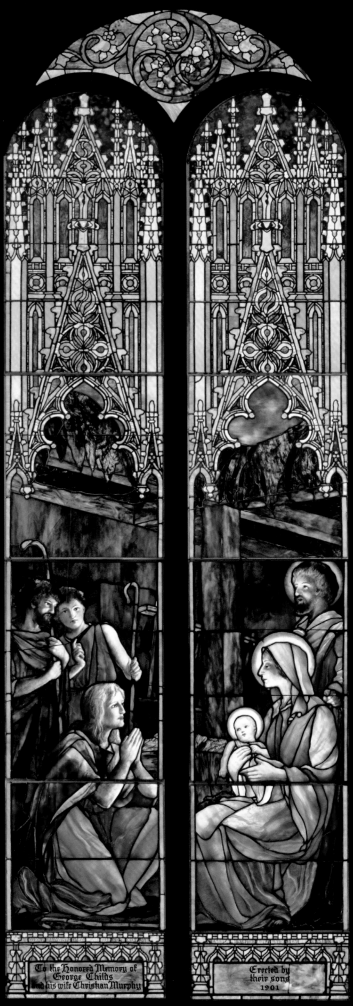

To the Honored Memory of
George Childs
and his wife Christian Murphy

Erected by
their sons
1901

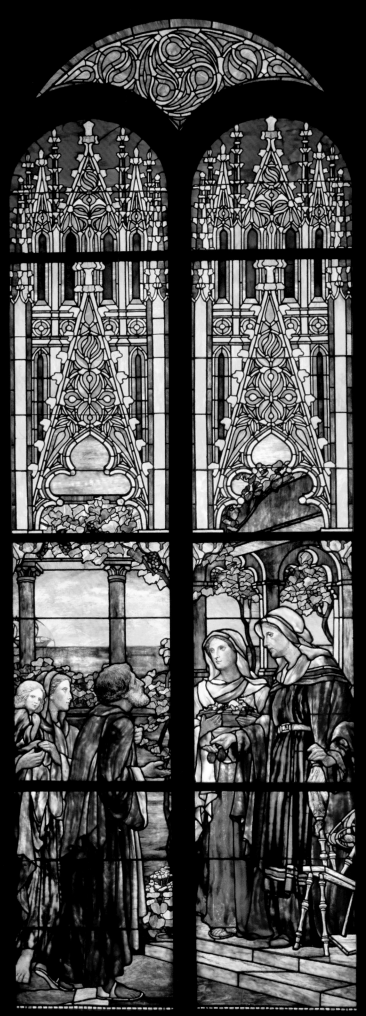

22

24

23

25

27

26

Louis Comfort Tiffany
New York 1848 –
New York 1933

Saint John the Evangelist
Bourgie Hall, MMFA
(formerly the Erskine and
American Church)
1902
Leaded glass
190 x 63 cm
Made by Tiffany Studios,
New York
Dedication, at the bottom:
*IN LOVING MEMORY OF /
MARGARET-OGILVIE-
HASTINGS / 1821-1890*
Purchase, 2008.445
PROVENANCE
American Presbyterian
Church, Montreal, 1904–38;
Erskine and American Church,
Montreal, 1938; acquired by
the Museum in 2008.

**Designed by
Frederick Wilson**
(1858–1932)
Angel of Peace
Bourgie Hall, MMFA
(formerly the Erskine and
American Church)
1902
Leaded glass (background
glass partially restored
in 1938 and 2009–10)
190 x 63 cm
Made by Tiffany Studios,
New York
Dedication, at the bottom:
*THY PRAYERS AND THINE
ALMS ARE COME UP FOR
A MEMORIAL BEFORE GOD /
IN MEMORIAM / H.A.
NELSON – M.D. NELSON /
FROM THEIR CHILDREN*
Purchase, 2008.435
PROVENANCE
American Presbyterian
Church, Montreal, 1904–38;
Erskine and American Church,
Montreal, 1938; acquired by
the Museum in 2008.

**Designed by
Frederick Wilson**
(1858–1932)
Cornelius
Bourgie Hall, MMFA
(formerly the Erskine and
American Church)
1902
Leaded glass (background
glass partially restored
in 1938 and 2009–10)
190 x 63 cm
Made by Tiffany Studios,
New York
Dedication, at the bottom:
*THY PRAYERS AND THINE
ALMS ARE COME UP FOR
A MEMORIAL BEFORE GOD /
IN MEMORIAM / H. A.
NELSON – M. D. NELSON /
FROM THEIR CHILDREN*
Purchase, 2008.437
PROVENANCE
American Presbyterian
Church, Montreal, 1904–38;
Erskine and American Church,
Montreal, 1938; acquired by
the Museum in 2008.

**Designed by
Frederick Wilson**
(1858–1932)
Angel of the Resurrection
Bourgie Hall, MMFA
(formerly the Erskine and
American Church)
1902
Leaded glass (background
glass partially restored
in 1938 and 2009–10)
190 x 63 cm
Made by Tiffany Studios,
New York
Dedication, at the bottom:
*IN LOVING MEMORY OF /
ANNA S. WARREN /
1848 - 1924 / WIFE OF
ALBERT D. NELSON*
Purchase, 2008.433
PROVENANCE
American Presbyterian
Church, Montreal, 1904–38;
Erskine and American Church,
Montreal, 1938; acquired by
the Museum in 2008.

**Design attributed to
Frederick Wilson**
(1858–1932)
Angel of Praise
Bourgie Hall, MMFA
(formerly the Erskine and
American Church)
1902
Leaded glass (background
glass partially restored
in 1938 and 2009–10)
190 x 63 cm
Made by Tiffany Studios,
New York
Dedication, at the bottom:
*IN BELOVED MEMORY OF /
EDWARD K. GREENE /
DECEMBER THIRD 1899*
Purchase, 2008.434
PROVENANCE
American Presbyterian
Church, Montreal, 1904–38;
Erskine and American Church,
Montreal, 1938; acquired by
the Museum in 2008.

**Design attributed to
Frederick Wilson**
(1858–1932)
Angel
Bourgie Hall, MMFA
(formerly the Erskine and
American Church)
1902
Leaded glass (background
glass partially restored
in 1938 and 2009–10)
190 x 63 cm
Made by Tiffany Studios,
New York
Dedication, at the bottom:
*IN MEMORY OF /
THE REV. KENNETH MacLEOD
MUNRO / 1885 - 1931*
Purchase, 2008.432
PROVENANCE
American Presbyterian
Church, Montreal, 1904–38;
Erskine and American Church,
Montreal, 1938; acquired by
the Museum in 2008.

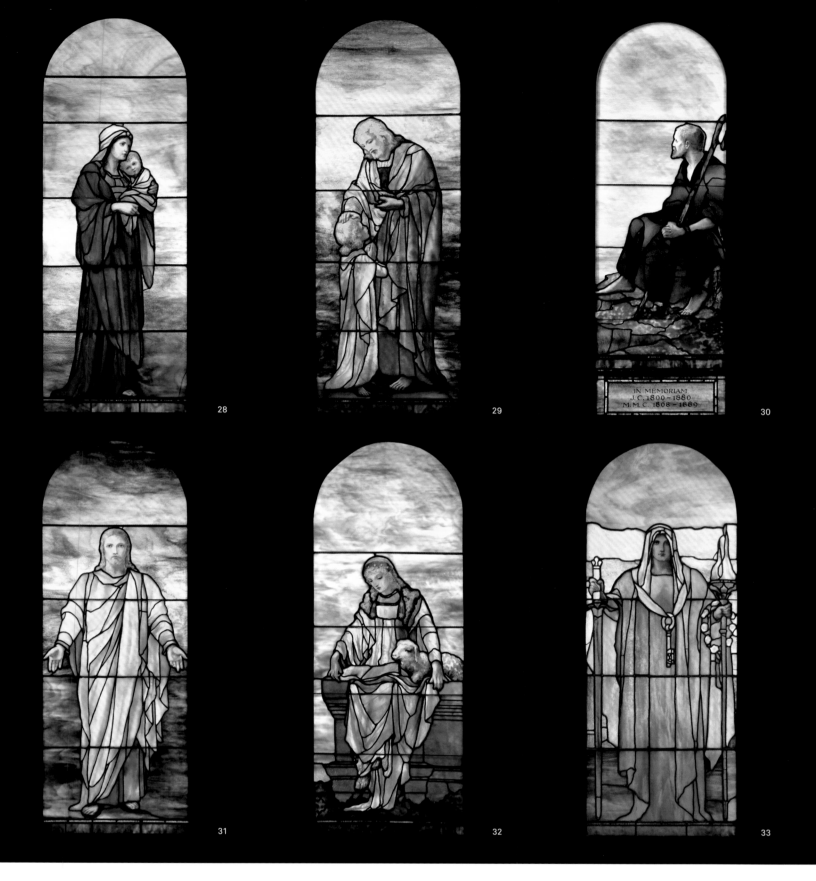

28

**Designed by
Frederick Wilson**
(1858–1932)
Madonna and Child
Bourgie Hall, MMFA
(formerly the Erskine and
American Church)
1902
Leaded glass
190 x 63 cm
Made by Tiffany Studios,
New York
Signed, lower right:
TIFFANY STUDIOS / NEW YORK
Dedication, at the bottom:
*IN MEMORIAM / AMY GRIZEL
CASSILS / 1877 – 1901*
Purchase, 2008.442
PROVENANCE
American Presbyterian
Church, Montreal, 1904–38;
Erskine and American Church,
Montreal, 1938; acquired by
the Museum in 2008.

29

**Designed by
Frederick Wilson**
(1858–1932)
*Christ Blessing
Little Children*
Bourgie Hall, MMFA
(formerly the Erskine and
American Church)
1902
Leaded glass
190 x 63 cm
Made by Tiffany Studios,
New York
Dedication, at the bottom:
*OF SVCH IS THE KINGDOM
OF HEAVEN / THE GIFT OF /
THOMAS S. AND SVSAN N.
Mc WILLIAMS / IN MEMORY
OF TEN HAPPY YEARS*
Purchase, 2008.443
PROVENANCE
American Presbyterian
Church, Montreal, 1904–38;
Erskine and American Church,
Montreal, 1938; acquired by
the Museum in 2008.

30

Saint John the Baptist
Bourgie Hall, MMFA
(formerly the Erskine and
American Church)
1902
Leaded glass (upper
background glass restored
in 1938 and 2009–10)
190 x 63 cm
Made by Tiffany Studios,
New York
Dedication, at the bottom:
IN MEMORIAM / J. C.
[John Cassils] *1800 -1880 /
M.M.C.* [Margaret Murray
Cassils] *1808 – 1889*
Purchase, 2008.439
PROVENANCE
American Presbyterian
Church, Montreal, 1904–38;
Erskine and American Church,
Montreal, 1938; acquired by
the Museum in 2008.

31

**Design attributed to
Frederick Wilson**
(1858–1932)
Come Unto Me
Bourgie Hall, MMFA
(formerly the Erskine and
American Church)
1902
Leaded glass
190 x 63 cm
Made by Tiffany Studios,
New York
Signed, lower right: *TIFFANY
STUDIOS / NEW YORK*
Dedication, at the bottom:
*IN LOVING MEMORY OF /
JEAN MALLOCH GREENE /
1839 -1888 / WIFE OF
GEORGE A. GREENE*
Purchase, 2008.444
PROVENANCE
American Presbyterian
Church, Montreal, 1904–38;
Erskine and American Church,
Montreal, 1938; acquired by
the Museum in 2008.

32

**Design attributed to
Frederick Wilson**
(1858–1932)
Saint Agnes
Bourgie Hall, MMFA
(formerly the Erskine and
American Church)
1902
Leaded glass (upper
background glass restored
in 1938 and 2009–10)
190 x 63 cm
Made by Tiffany Studios,
New York
Dedication, at the bottom:
IN MEMORIAM / A.S.C.
[Agnes Simpson Hossack
Cassils] *1843-1868*
Purchase, 2008.438
PROVENANCE
American Presbyterian
Church, Montreal, 1904–38;
Erskine and American Church,
Montreal, 1938; acquired by
the Museum in 2008.

33

**Designed by
Frederick Wilson**
(1858–1932)
Faith
Bourgie Hall, MMFA
(formerly the Erskine and
American Church)
1902
Leaded glass
(arched segment of glass
restored in 1938 and 2009–10)
190 x 63 cm
Made by Tiffany Studios,
New York
Dedication, at the bottom:
*IN MEMORIAM / WILLIAM
CASSILS / 1832-1891*
Purchase, 2008.441
PROVENANCE
American Presbyterian
Church, Montreal, 1904–38;
Erskine and American Church,
Montreal, 1938; acquired by
the Museum in 2008.

CHARLES WILLIAM KELSEY

The scene taken from the summit of Westmount is the subject of a six-light stained-glass window 34 commissioned for the narthex of the Erskine and American Church (now the lobby of the Museum's Bourgie Hall) in 1939. Ecclesiastical windows usually depict a biblical scene or saintly figures, but here the series of panels presents a view of the Saint Lawrence River and Montreal landmarks seen from afar, as if the viewer were standing in a garden of flowers. The window was designed and created by artist Charles William Kelsey.

Kelsey was born in London, England, in 1877, and received his art training at the Camden School of Art, the Kensington School of Art and the Royal Academy of Art. Afterwards, he acquired a solid background in the art of stained-glass windows and decorative design at the prominent English Arts and Crafts studio of Clayton and Bell, London, where he worked from 1892 to 1906, and with the decorating firm of Burlison and Grylls. He immigrated to New York in 1911, at the age of thirty-four, and found work with the stained-glass studio of the Gorham Manufacturing Company, a leading silver producer. Kelsey remained at Gorham until 1919, when he returned briefly to London before moving to Montreal in 1922.[1]

His first major commission was a large war memorial window, dated 1924, for Saint James United Church on Saint Catherine Street. Kelsey gradually gained a reputation for his stained-glass windows and received commissions from some of Montreal's major architects, including Robert Findlay, Edward and W. S. Maxwell, and Percy Nobbs. Examples of his windows may be seen in almost fifty churches, mostly in Montreal, but also in the Eastern Townships, the Laurentians, Ottawa and Quebec City. In addition to windows, Kelsey executed murals, mosaics, book illustrations and wood carvings. Throughout his life, he painted for pleasure and exhibited his oil paintings and watercolours in the exhibitions of the Royal Canadian Academy of Arts and the Art Association of Montreal (now the Montreal Museum of Fine Arts), where he had a show of his paintings and drawings in March 1925.[2]

This cycle of stained-glass windows in the Erskine and American Church was dedicated to John Millen (1843–1919), who had been an elder of the church and who, according to the memorial inscription, was "A lover of flowers." This explains the prominent place given to blossoming plants, such as delphiniums, tulips, irises and lilies, which spill over stone pathways in the forefront of each window light. Roofs of houses on the edge of the mountain appear in one panel, glimpses of a grain elevator, city buildings, the Victoria Bridge and distant hills south of Montreal appear in others.

Kelsey acquired his coloured glass from commercial glassworks and worked from his own studio, with one or two assistants. The tones here are subdued, with areas of intense red or blue in the flowers or in the sky, which sweep across each light, uniting them in the overall composition. In the tradition of English nineteenth-century stained-glass design, Kelsey has skilfully painted the modelling and details of the forms on the glass in brown enamel. The delineation in brush of each petal and leaf of the flowers reveals his English training. In true Arts and Crafts spirit, Kelsey handcrafted his work from the first design of the window to its final execution (fig. 1).[3] RP

1. Shirley May Baird, "Stained Glass War Memorial Windows of Charles William Kelsey," M.A. thesis (Montreal: Concordia University, 1995), pp. 7–9. 2. Art Association of Montreal, Scrapbook 1902–1929, p. 356 (MMFA Archives). 3. The watercolour renderings and charcoal and pencil cartoons for these windows are in the collection of the McCord Museum, Montreal. My thanks to Conrad Graham and Caroline Ohrt for their help with this research.

PETER HAWORTH

Born in England, a graduate of the prestigious Royal College of Art in London, Peter Haworth worked briefly for the famous English firm of Morris & Company, which adhered to the principles of the Arts and Crafts Movement. In 1923, he moved to Toronto, where he taught at the Toronto Central Technical School and then became director of the art department in 1928. His experience with Morris & Company and his mastery of the art of stained glass won him important commissions in churches and schools in Ottawa, Toronto and Montreal.[1]

When Montreal's Erskine Church merged with the American Presbyterian Church in 1934, a major program of remodelling in the Arts and Crafts style was carried out between 1937 and 1939 under the direction of Montreal architect Percy E. Nobbs (1875–1964) and his firm Nobbs and Hyde. As part of the renovations, Peter Haworth was commissioned to create a series of designs for the half-rose window 35 on the facade. Dedicated to Henry Birks (1840–1928), founder of Montreal's renowned silver and jewellery store, the window is composed of seven round lights depicting the seven days of Creation, and seven drop-shaped windows showing God in the centre, framed by pairs of angels. Below are six arched lights illustrating Biblical figures such as Moses, David and Solomon, and the Holy Family. Haworth also designed six windows on the west wall of the nave and three on the east wall, dedicated to Henry Birks' children and wife, Harriet Phillips Walker.

Peter Haworth is perhaps best known for his landscape paintings inspired by Canada's Group of Seven artists, but he also had a significant reputation for his stained-glass windows in contemporary stylized design. RP

1. Paul Duval, *Glorious Visions: Peter Haworth—Studies for Stained Glass Windows*, exh. cat. (Windsor, Ontario: The Art Gallery of Windsor, 1985).

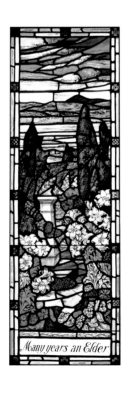
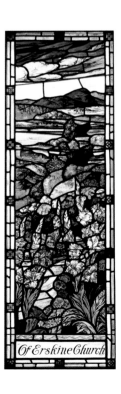
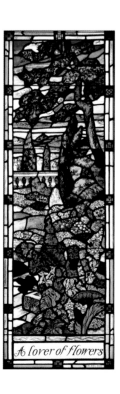

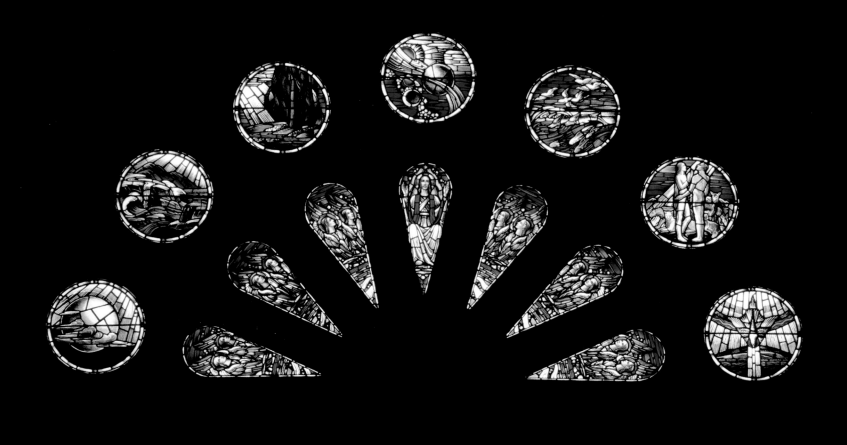

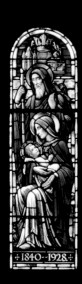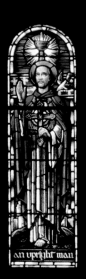

Fig. 1
Watercolour sketch by
Charles William Kelsey for a
light in *View of Montreal from
Westmount Summit*, about
1938–39. McCord Museum,
Montreal.

34

Charles William Kelsey
London 1877 –
Montreal 1975
***View of Montreal from
Westmount Summit***
**Bourgie Hall, MMFA
(formerly the Erskine and
American Church)
About 1939**
Leaded glass
146.7 x 45.5 cm (each panel)
Painted signature, lower right
of right panel: *C. W. Kelsey*
Dedications (l. to r.): *To the
Glory of God / And in loving
memory of / John Millen
1843-1919 / Many years an
Elder / Of Erskine Church /
A lover of flowers*
Purchase
2010.725.1-6
PROVENANCE
Erskine and American Church,
Montreal, about 1939;
acquired by the Museum
in 2008.

35

Peter Haworth
Lancaster, England,
1889 – Toronto 1986
***The Creation of the World
Angels
Biblical Figures***
**Bourgie Hall, MMFA
(formerly the Erskine and
American Church)
1939**
Leaded glass
Various dimensions
Made by Pringle and
London, Toronto
Dedications, at the bottom
(l. to r.): *His sons give
thanks / to God for him /
HENRY BIRKS. / 1840-1928 /
an upright man / and kind*
Purchase
2011.55.1-20
PROVENANCE
Erskine and American Church,
Montreal, about 1939;
acquired by the Museum
in 2008.

19th-AND 20th-CENTURY STAINED GLASS

— NATHALIE BONDIL, ROSALIND PEPALL —

WILLIAM MORRIS

The creation of stained-glass windows was an important part of Morris & Company's production from its beginning in 1861.[1] William Morris was the guiding force behind the company, and he was at the centre of a renewal of the arts and crafts in England, based on medieval traditions. His firm contributed greatly to the revival of stained-glass windows in England and North America in the second half of the nineteenth century, which resulted from a renewed interest in Gothic architecture and design. Many churches commissioned large, pictorial stained-glass windows, and stained glass was integrated into residential and institutional buildings during the late-nineteenth-century building boom. William Morris' concern for good craftsmanship, and his reinterpretation of the colouring and design of stained glass, inspired by medieval examples, placed his firm in the forefront of the revival of the art.

Different artists provided stained-glass designs to the Morris firm, and Morris' friend and associate Edward Burne-Jones ultimately became a major designer for the company's stained-glass windows. However, William Morris himself was responsible for over one hundred and fifty window cartoons, including the drawings for these panels of minstrel figures 37 . Simple in design, each figure holds a musical instrument: a portable organ and a lute in one window, and a harp and a "short clarinet" in the other.[2] Morris returned to the rich colours of English fourteenth-century glass in his choice of deep blue and ruby red for the robes, which stand out against the quarries of clear glass decorated with flat leafy patterns so typical of Morris' designs for wallpaper and textiles.[3] These minstrels turned out to be popular designs, and were reused by the firm for tiles and stained glass, sometimes transformed into angels with wings for religious commissions.[4]

The Museum's windows were ordered directly from the Morris firm in 1882 by the Montreal shipping merchant David Allan Poe Watt for his home. Born in Scotland, Watt had come to Canada about 1846 and was an active member of the Art Association of Montreal. Watt obviously delighted in Morris' designs, as his house on Stanley Street was decorated with Morris wallpaper, curtains and wall coverings, in addition to William De Morgan ceramics.[5] This pair of windows, together with a panel of *Timothy and Eunice*, ordered by Watt four years before, were the earliest Canadian commissions for stained glass from Morris & Company in London. RP

1. The original firm, established in 1861 as Morris, Marshall, Faulkner & Company, was reorganized in 1874 as Morris & Company. 2. A. Charles Sewter, *The Stained Glass of William Morris and His Circle* (New Haven, Connecticut; London: Yale University Press, 1974), p. 215. 3. Original firm records (published in Sewter 1974, p. 215) name the glass painters as one Pozzi for the figures, and Singleton for the quarries. 4. Martin Harrison, "Church Decoration and Stained Glass," in *William Morris*, exh. cat., ed. Linda Parry (London: Victoria and Albert Museum, 1996), pp. 134–135. 5. Rosalind Pepall, "Under the Spell of Morris: A Canadian Perspective," and K. Corey Keeble, "Stained Glass," in *The Earthly Paradise: Arts and Crafts by William Morris and his Circle from Canadian Collections*, eds. Katharine A. Lochnan et al (Toronto: Key Porter Books and Art Gallery of Ontario, 1993), p. 21 and pp. 119–120, respectively. These windows are also illustrated in Robert Little, *L'œuvre de William Morris (1834-1896) de la collection du Musée des beaux-arts de Montréal / The Work of William Morris (1834–1896) from the Collection of the Montreal Museum of Fine Arts* (Montreal: The Montreal Museum of Fine Arts, 1991), p. 27.

CASTLE & SON

This window 36 is a good example of the popularity of stained-glass windows across North America in the last quarter of the nineteenth century. It depicts a passage from Henry Wadsworth Longfellow's epic poem "Evangeline, A Tale of Acadie," published in Boston in 1847. It is a romantic tale centred on the plight of the Acadians, descendants of seventeenth-century French colonists who lived mostly in what is now Nova Scotia and southern New Brunswick. The territory changed hands back and forth during the wars between France and England, to whom Nova Scotia was finally ceded in 1713. Later, in 1755, as war between the two countries was once again on the horizon, the English government deported about ten thousand Acadians from their land to other English colonies.

The American poet Longfellow heard about the plight of the Acadians and composed his tale about a young girl, Evangeline, who loses her betrothed, Gabriel, as a result of the Acadian deportation. She remains true to him, and finally finds him many years later on his deathbed. Longfellow's poem of romance, tragedy and stoicism was an immediate success, and over the years was translated into many languages, its appeal enduring even today. The first North American translation into French appeared in Pamphile Lemay's *Essais poétiques*, published in Quebec City in 1865. To bring the story alive, the American painter Edward Austin Abbey and the British painter Sir Frank Dicksee were both commissioned to illustrate versions of Longfellow's poem in 1879 and 1882, respectively.[1] Even a newspaper established in 1887 for the Acadian people was entitled *L'Evangéline*, as the young girl took on symbolic significance.[2]

The designer of this window was also attracted by the Evangeline story when he portrayed the scene from Longfellow's poem. The young lovers in period dress share an intimate moment away from their elders who play draughts, or checkers, in the back room. Large areas of the coloured glass have been painted in brown enamel, the traditional stained-glass technique used to render volume in the forms. What is especially interesting, however, is that in some small areas, more innovative opalescent or textured glass has been used, for example, the marbling of colour in the hanging lamp in the background. The architectural framework is another traditional element of this window, which design reformers like William Morris eliminated in their stained-glass compositions.

The window is unsigned, but may be attributed to the Castle & Son firm in Montreal, who exhibited a stained-glass window, *Courtship of Gabriel, Longfellow's Evangeline*, cat. 190, in the 1889 annual Spring Exhibition of the Art Association of Montreal (now the Montreal Museum of Fine Arts). The firm of Castle & Son, established by Thomas Castle about 1865–66, had gained a reputation for interior decoration, fine furniture and, especially, ecclesiastical and domestic stained-glass windows, under the direction of William T. Castle, Thomas' son.[3] Oral history concerning the provenance of the window places it in a house in Westmount at 505 Claremont Avenue, which was demolished in 1966.[4] The house had been built in 1896–97 for Robert J. Inglis, a merchant and tailor. The window was listed "not for sale" when exhibited by the firm in 1889, and may have been kept by them until its sale to Inglis. RP

1. Illustrations in the collection of the Musée Acadien of the Université de Moncton, New Brunswick: http://www.mccordmuseum.qc.ca/scripts/printtour.php?tourID=GEP2_1_EN&Lang=2 (accessed March 12, 2012). 2. Naomi Griffiths, "Longfellow's *Evangeline*: The Birth and Acceptance of a Legend," *Acadiensis*, vol. 4, no. 2 (Spring 1982), pp. 28–41. 3. Thomas Castle died in 1884. William T. Castle's son Montague became an artist and stained-glass designer in New York in the 1890s. He worked in the firm as a student, but was probably too young to have designed this window. 4. My thanks to Ruth Khazzam, who through her research was able to piece together a provenance for the window. Information concerning Inglis and his house comes from the research of Katherine Sirois under the direction of Jean-Pierre Labiau (MMFA Archives).

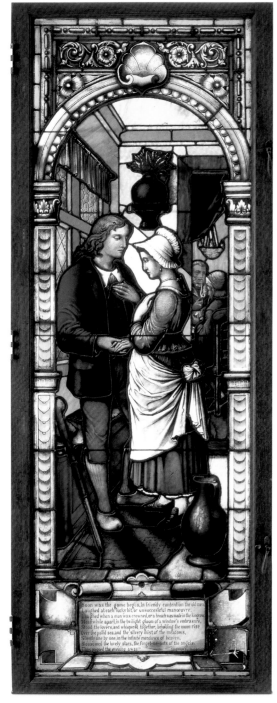

37

Son
1881–1920
e and Gabriel
9
ass, wood
m
h and
zzam

Inscription, at the bottom:
*"Soon was the game begun.
In friendly contention the
old men, / Laughed at each
lucky hit, or unsuccessful
manoeuvre, / Laughed when a
man was crowned, or a breach
was made in the kingrow, /
Meanwhile apart, in the
twilight gloom of a window's
embrasure, / Stood the lovers,
and whispered together,
beholding the moon rise /
Over the pallid sea, and the
silvery mist of the meadows, /
Silently one by one, in the
infinite meadows of heaven, /
Blossomed the lovely stars,
the forget-me-nots of
the angels. / Thus passed
the evening away"*
Longfellow's Evangeline

37

William Morris
Walthamstow, England,
1834 – Kelmscott,
England, 1896
Minstrel Figures
1882
Leaded and painted glass
64.7 x 78.7 cm (each panel)
Made by Morris &
Company, London
Gift of the family of
David A. P. Watt
1918.Dg.3-4

MAVRICE DENIS

ATELIER HÉBERT-STEVENS AND MAURICE DENIS

Convinced of the necessity of bringing living art into churches, Maurice Denis founded the Ateliers d'art sacré with Georges Desvallières in 1919; their goal was to provide training in religious decoration to Catholic artists, in the spirit of a medieval guild. The Ateliers would exert considerable influence until their doors closed in 1948.

Denis considered stained glass to be a symbol of French genius. With its focus on the passage of light, "the main character in a stained-glass window," he thought of it as the symbolic site of the "battle of shadow and light, of coloured shadows against colour-dissolving light."[1] Denis participated in the creation of almost seventy stained-glass windows, including those of Notre-Dame du Raincy, the brilliant "Holy Chapel of reinforced concrete" built by Auguste Perret.

A member of the Ateliers, where he discovered his passion for stained glass, Jean Hébert-Stevens (1888–1943) founded his own workshop in 1924, which was visited by Denis and Desvallières. In 1939, he asked Georges Rouault, Marcel Gromaire and Jean René Bazaine to design their first windows. Moreover, this was where Quebec artist Paul-Émile Borduas created a stained-glass *Annunciation* in 1929, at a time when he was often at the Ateliers.

Following World War I, Denis was commissioned to design a large-scale commemorative stained-glass window for the church of Saint Roch in Paris. In 1922, he had to abandon the project, even though it was already well underway. And yet Hébert-Stevens presented the work **38** (fig. 1), among his workshop's other recent works, in the Stained-glass Pavilion of the famous 1925 Exposition Internationale des Arts Décoratifs et Industriels Modernes in Paris.[2] Did Denis, upon seeing his cartoon for Saint Roch go unused, entrust Hébert-Stevens with the window's execution? This is certainly plausible. Denis, who enjoyed considerable fame, might have also wanted to encourage him.[3]

Marked by the stigmata of the Passion and bearing a shining Sacred Heart, the body of Jesus, with its cadaverous pallor, is held up by his crying mother. Of France's two patron saints who initially surrounded this *Pietà* in Denis' cartoon, the Archangel Michael and Joan of Arc, only the latter is depicted in the window.[4] In the background is a blood-red landscape punctuated by crosses bearing the tri-coloured cockade of those slain on the field of battle; below, the *poilus* (French soldiers in World War I) clad in helmets and sky-blue uniforms with bayonet rifles and haversacks slung over their shoulders. By bringing to date holy iconography, Denis sought to move the faithful bereaved by war.

Compared to the initial project, this smaller window is more successful in terms of its emotional impact. The decorative borders have been eliminated and the view of the *Pietà* brought into tighter focus. The bright colours are dominated by the red and blue typical of medieval stained glass, in particular those of the Cathedral of Chartres, so admired by Denis. The leading forms a mosaic pretending to be primitive, while the simply sketched faces powerfully accentuate the naive character of the window. **NB**

1. Véronique David and Fabienne Stahl-Escudero, "Maurice Denis et le vitrail," *Dossier de l'art*, no. 135 (November 2006), p. 52. **2.** Returned in pieces to the master glass-maker, the window remained there until it was discovered by his grandson, Dominique Bony, and stained-glass experts Véronique David and Fabienne Stahl-Escudero, to whom I extend my sincere thanks. **3.** Véronique David and Fabienne Stahl-Escudero, "'Aux morts de la guerre' de Maurice Denis, projet inédit d'une verrière commémorative pour l'église Saint-Roch," *Aujourd'hui Saint-Roch*, no. 45 (March 2006), p. 17. **4.** Ibid., no. 44 (December 2005), p. 20.

MARCELLE FERRON

Marcelle Ferron's work in stained glass was a logical extension of her predominant interest in colour. Early in her career, Ferron was a follower of Montreal artist Paul-Émile Borduas (1905–1960), and she joined with the Automatiste group he founded in signing their *Refus Global* in 1948. In 1953, she left for Paris, where she lived for the next thirteen years. In her non-figurative works of this period, the dark and light tones painted in expansive, gestural strokes blend and overlap to create a transparency of colour that anticipates her later interest in stained glass. Following the lead of many French artists such as Braque and Léger, who carried out designs for public commissions in glass, Ferron began to study glass-making techniques in Paris with *maître-verrier* Michel Blum. The idea of integrating art with architecture appealed to Ferron's interest in bringing her work to a wide public.[1] Upon her return to Canada in 1966, she exhibited a series of stained-glass panels at the Musée du Québec, and created one of her most important commissions for stained-glass walls in Montreal's Champ-de-Mars metro station (1966–67). Following the success of this project, Ferron went on to carry out public and private commissions, integrating stained-glass panels into exterior walls and architectural interiors.[2]

This five-panelled window **39** was made in 1972 for the home of Dr. Jacques Tardif in the Montreal suburb of Candiac. To carry out the project, Ferron worked with the Superseal Corporation in Douville, near Saint-Hyacinthe, Quebec. Handmade, coloured flat glass was imported from Saint-Gobain, France, and then cut and mounted according to Ferron's designs. The glass was joined together with transparent vinyl in a technique that eliminated the need for traditional lead joints. The coloured glass was then sandwiched between two clear plate-glass panels.

The Tardif window stretched across one entire side of the living room. Arcs of colour in the glass span several panels in a horizontal rhythmic movement of floating round and oval forms. The composition suggests a landscape of colour in which earthy brown and green contrast with the white, blue and yellow tones of the sky. Light passing through the window brings the medium alive, revealing variations in colour intensity and the accidental imperfections of the handmade glass. This landscape in glass confirms that "a 'Ferron' is soaring colour in full flight."[3] **RP**

1. France Vanlaethem, "Le Peintre et l'architecte," in *Marcelle Ferron*, exh. cat. (Montreal: Musée d'art contemporain de Montréal, Les 400 Coups, 2000), pp. 35–47. **2.** Notable examples are windows in the Granby Court House (1979) and the Sainte-Justine Hospital, Montreal (1994). **3.** Andrée Beaulieu-Green, "Une artiste comme on les aime," in *Autour de Marcelle Ferron*, Gaston Roberge (Quebec: Le Loup de Gouttière, 1995), p. 49.

38

Hébert-Stevens workshop
Paris, founded in 1924
After a cartoon by
Maurice Denis (1870–1943)
To the War Dead—Pietà
Cartoon: about 1920
Stained glass: 1924–25
Leaded glass
171 x 109.5 x 2.5 cm
Signed, upper right:
MAVRICE DENIS
Purchase, Société Générale/
Fimat Fund
2006.83

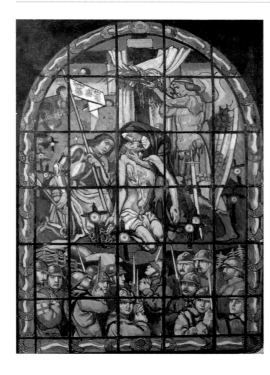

Fig. 1
Maurice Denis, *To the War Dead*, design for a stained-glass window for the church of Saint-Roch, Paris, about 1920, oil on cardboard. Private collection.

39

Marcelle Ferron
Louiseville, Quebec,
1924 – Montreal 2001
Untitled
1972
Glass, PVC
194 x 863.5 x 2.5 cm
Gift of Raymond and
Alicia Lévesque
1996.Dg.1a-e

39

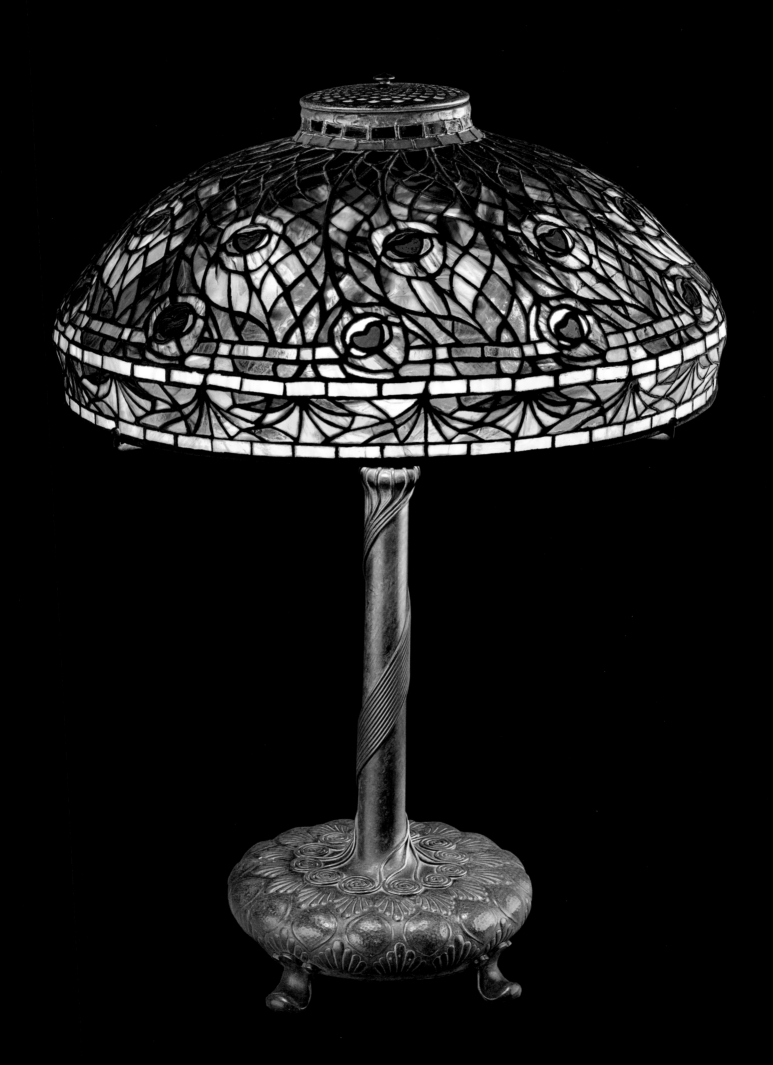

GLASSWARE:
ART NOUVEAU / ART DECO

— ROSALIND PEPALL —

LOUIS C. TIFFANY

Louis Comfort Tiffany was captivated by the brilliance of colour and the spontaneous effects that could be achieved in the medium of glass. In 1892–93, he opened his glass factory under the direction of English glass specialist Arthur J. Nash. With Nash's technical expertise and Tiffany's artistic eye, as well as his drive to experiment and his flare for marketing, the Tiffany firm reached the height of its success in 1900, exhibiting windows and glassware to an international audience at the Exposition Universelle in Paris.

Under Nash, the firm perfected the creation of iridescent glass inspired by the spectrum of colour in ancient Roman and Greek models. It was a huge success and became a signature of the Tiffany firm. Nash's son Leslie later commented on the great amount of golden lustre glassware the company produced, describing it as a "gold rush," and wrote: "To look into our showrooms on a sunny morning with the blast of iridescent colour, was breathtaking... it was literally a fairyland."[1]

Because of his love of the natural landscape and flowers, Tiffany encouraged his artists to focus on nature as a source of ornamentation, and floral designs were a consistent motif in the firm's production 42 . Among Tiffany's earliest vessels in blown glass were his flower-form vases.[2] The vitality and growth of nature was expressed in these pieces through the organic lines of the stem rising up from a bulbous base to the final blossoming at the rim. In the *Jack-in-the-pulpit* vase 41 , the wide flange under the touch of the craftsman's iron tool was turned down to better display the rainbow of colour in the iridescent glass surface.

The jack-in-the-pulpit flower (*Arisaema triphyllum*) is native to North America and grows in shaded woods. Not showy in colour, Tiffany would have been attracted by its irregular, unusual form. **RP**

1. Martin Eidelberg and Nancy A. McClelland, *Behind the Scenes of Tiffany Glassmaking: The Nash Notebooks* (New York: St. Martin's Press, 2001), p. 48. 2. For more on this subject, see Martin Eidelberg, *Tiffany Favrile Glass and the Quest of Beauty* (New York: Lillian Nassau Gallery, 2007).

TIFFANY'S *PEACOCK* LAMP

Lamps were a major part of Tiffany's business from the late nineteenth century on, and the *Peacock* lampshade 40 was one of the most expensive designs that the firm made. Each Tiffany stained-glass lampshade is a unique, handcrafted work, consisting of over one thousand multicoloured pieces of glass. To assemble these pieces, the Tiffany firm devised an original method of leading in which the pieces were edged with paper-thin copper and then joined with the application of molten lead solder along the seams. The assembly of the small pieces of richly coloured blue, green, orange-yellow, mauve and rose-red glass in this *Peacock* lampshade is a veritable tour-de-force, especially in this particularly fine example. Recent research has revealed that Tiffany's *Peacock* lamp was designed by Clara Driscoll, who supervised up to thirty-five women in the glass-cutting department. These "Tiffany Girls" were responsible for selecting, cutting and assembling the glass used for the lampshades.[1]

The bold eye, iridescent colour and fluid lines of the peacock's plume became a signature of Tiffany's work, appearing in many of the firm's windows, vases and mosaics, in addition to lamps. Tiffany would have appreciated that the peacock feather was a recurrent motif in English and French decorative art and painting at the end of the nineteenth century (Oscar Wilde, Aubrey Beardsley, Georges de Feure and René Lalique)—a symbol of beauty as well as vanity.

The bronze bases of Tiffany lamps were made from original designs in the Tiffany firm's bronze foundry. This lamp base with vine tendrils coiling up and around the stem is a particularly fine model, reflecting the organic, swelling forms so typical of Tiffany design. It is one of the first designs produced by the firm in 1899 to accommodate electric lighting.[2]

Canadians were aware of Louis C. Tiffany's renown in America and Europe. In Montreal, Tiffany glass was sold at W. Scott & Sons art dealers, who presented an exhibition of Tiffany's work, including lamps, at the Art Association of

Montreal (forerunner of the Montreal Museum of Fine Arts) in 1906. The provenance of the lamp is of special interest for the Museum, as it belonged to Mary Helena Scott (1872–1958), the daughter of William Scott, founder of W. Scott & Sons. She married Phillips Bathurst Motley in Montreal, and the lamp was passed down through the family. **RP**

1. Martin Eidelberg, Nina Gray and Margaret Hofer, *A New Light on Tiffany: Clara Driscoll and the Tiffany Girls* (New York: New York Historical Society, 2007). 2. Martin Eidelberg, Alice Cooney Frelinghuysen, Nancy A. McClelland and Lars Rachen, *The Lamps of Louis Comfort Tiffany* (New York: Vendome Press, 2005), p. 143.

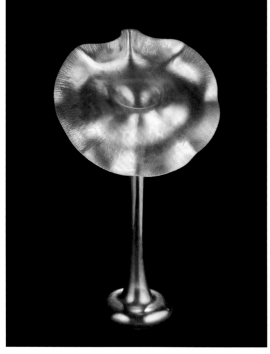

41

40

Louis Comfort Tiffany
New York 1848 –
New York 1933
Designed by Clara Driscoll
(1861–1944)
Peacock Table Lamp
About 1905
Leaded glass, bronze
H. 67 cm; Diam. 47 cm
Made by Tiffany Studios,
New York
Impressed on metal base
plate on underside: *TIFFANY STUDIOS / NEW YORK / 9925*, on inner metal rim of lampshade: *TIFFANY STUDIOS- NEW YORK 1472-3*

Purchase, Claire Gohier
Fund, gift of Gérald-Henri
Vuillen and Christophe
Pilaire in honour of being
granted Canadian permanent
resident status, Ruth
Jackson Bequest, gift of the
International Friends of
the Montreal Museum
of Fine Arts and gift of
Joan and Martin Goldfarb
2011.373.1-2

41

Louis Comfort Tiffany
New York 1848 –
New York 1933
Jack-in-the-pulpit Vase
About 1909–10
Blown glass
51.8 x 27.3 x 13.3 cm
Made by Tiffany Studios,
New York
Engraved on underside:
7754E L.C. Tiffany. Favrile
Purchase, Deutsche Bank
Fund
2009.28

42

Louis Comfort Tiffany
New York 1848 –
New York 1933
Pond Lily Table Lamp
About 1902
Bronze, blown glass
54.5 x 28.5 x 28.5 cm
Made by Tiffany Studios,
New York
Impressed on underside
of base: *TIFFANY STUDIOS / NEW YORK / 382*; engraved on each shade: *L.C.T. Favrile*
Liliane and David M. Stewart
Collection
D94.177.1a-m

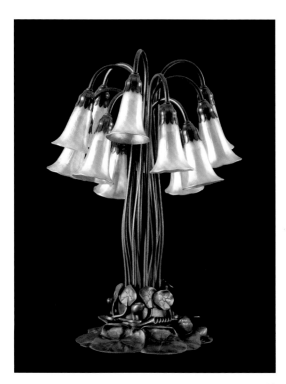

42

VERRERIES SCHNEIDER

The daring yellow, orange-red and violet colour combinations of Schneider glass suited the flare and dazzle of the Art Deco age. The firm run by two brothers, Ernest and Charles, was one of the most successful glass manufacturers in France in the 1920s, shipping almost a third of its production to eager consumers in the booming cities of North and South America.

The Schneider brothers grew up in Nancy, where they both apprenticed with the Daum glass company.[1] In 1913, they launched their own manufactory, Verreries Schneider, at Épinay-sur-Seine, just north of Paris. The eldest, Ernest (1877–1937), was the business manager, and Charles (1881–1953), who had studied art at the École des beaux-arts in Nancy and in Paris, acted as the artistic director. With the interruptions of the war, the firm did not really begin in earnest until 1918. The business was an immediate success, so that at its height of production in 1925, there were about five hundred employees. The firm marketed its glass at international exhibitions, the large Paris department stores, and its shop and showrooms at 54 and 14 rue de Paradis, Paris. The Great Depression of 1929 was a jolt to the luxury-glass market, and the Schneider firm was profoundly affected. The main furnace at the factory was shut down in 1931; by 1935 most production had ceased, and the company declared bankruptcy in 1938.

All the glass vessels produced by Verreries Schneider were made by hand after designs by Charles Schneider. The most distinctive mark of the firm's glass was the infinite variety of colours they achieved by fusing coloured glass powders between two or more layers of clear glass using the cased glass technique. The "Tango" orange-red, another signature feature of Schneider glass, was often combined with a vivid yellow or dark aubergine, colours that were at the height of fashion in Paris in the early 1920s, inspired by the rich tones of the Ballets Russes decor or the costumes of couturier Paul Poiret.

The firm produced two separate lines of glass with different signatures: "Schneider," usually for the early works created before about 1925, and "Le Verre Français," or "Charder"—a contraction of Charles Schneider—for wares produced about 1927 to 1931 and distinguished by the use of acid-etched decoration **54**. The appeal of the latter lay in the contrast of the shiny stylized floral or geometric motifs silhouetted against a light, matte background.

The degree of complexity in the techniques used in making a Schneider glass vessel is evident in the decoration of a small footed bowl **45**. The abstract pattern in the lower part of the bowl was the result of the cased glass powders. The olive branches and leaves were inlaid within the glass by means of a blowtorch, and then wheel engraved. Works like the large bowl on a violet-black stem and foot **52** appear radically modern to our eyes, and compare in form and vibrant colour with the present-day work of Italian designers, such as Ettore Sottsass or Dino Martens.

The Museum's extensive collection of over eighty works by Verreries Schneider traces the development and diversity of the firm's production, and it expands the breadth of the Museum's international twentieth-century glass collection. **RP**

1. Biographical details of the Schneider family have been taken from the Musée des beaux-arts de Nancy's exhibition catalogue *Schneider: une Verrerie au XXᵉ siècle* (Paris: Réunion des Musées Nationaux, 2003), and Marie-Christine Joulin and Gerold Maier, *Charles Schneider. Le verre français – Charder – Schneider* (Augsburg, Germany: Wissner-Verlag, 2004).

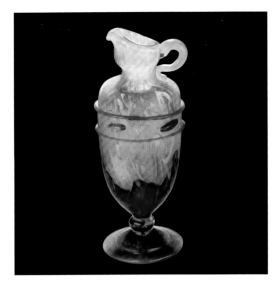

43

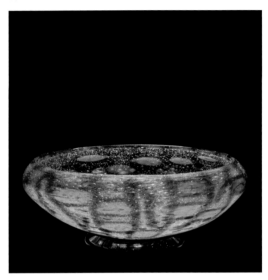

47

51

43

Verreries Schneider
Épinay-sur-Seine,
1918–about 1935

Marbré Jug
1922–24
Blown glass, powdered glass inclusions, threads and cabochons
27.2 x 11.8 x 10.7 cm
Engraved signature on top of foot: [an amphora] *Schneider*
Sandra Black and Jeff Rose Collection, gift in honour of the Montreal Museum of Fine Arts' 150th anniversary
2010.842

44

Vase
1920–24
Blown glass, powdered glass inclusions
H. 31.8 cm
Engraved signature on top of foot with traces of gold enamel: [an amphora] *Schneider*, and on underside: *19*
Sandra Black and Jeff Rose Collection, gift in honour of the Montreal Museum of Fine Arts' 150th anniversary
2011.273

45

Olives Bowl
About 1922
Blown glass, powdered glass inclusions, applied and wheel-ground decoration
H. 8.5 cm; Diam. 11.8 cm (approx.)
Sandra Black and Jeff Rose Collection, gift in honour of the Montreal Museum of Fine Arts' 150th anniversary
2010.839

46

Groseilles Vase
1920–24
Blown glass, powdered glass inclusions, applied and wheel-engraved decoration
H. 40.5 cm; Diam. 9.3 cm
Engraved signature on foot: *Schneider*
Sandra Black and Jeff Rose Collection, gift in honour of the Montreal Museum of Fine Arts' 150th anniversary
2010.840

47

Parmélie Bowl
1925–28
Blown glass, powdered glass inclusions
H. 31.1 cm
Engraved signature, sandblasted using a template, near base: *SCHNEIDER*
Sandra Black and Jeff Rose Collection, gift in honour of the Montreal Museum of Fine Arts' 150th anniversary
2011.271

48

Marbrines Vase
1922–24
Blown glass, powdered glass inclusions
H. 44.5 cm; Diam. 24.7 cm
Engraved signature on foot: *Schneider*
On underside: *FRANCE*
Sandra Black and Jeff Rose Collection, gift in honour of the Montreal Museum of Fine Arts' 150th anniversary
2010.849

44

45

46

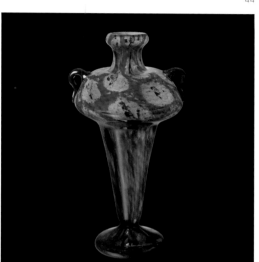

48

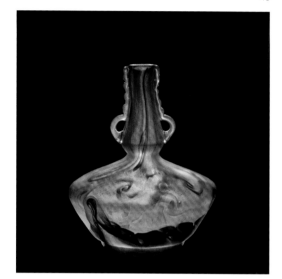

49

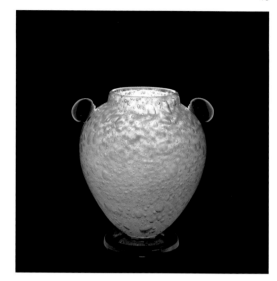

50

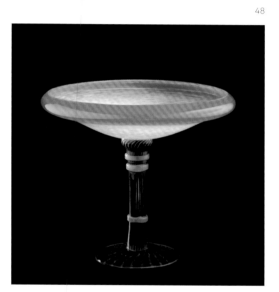

52

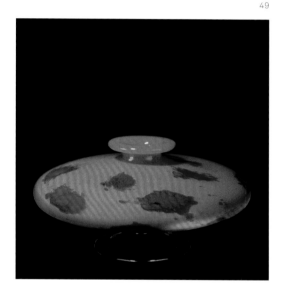

53

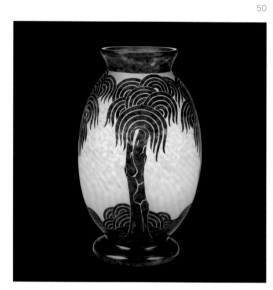

54

49

Vase
1919–25
Blown glass, powdered glass
inclusions
H. 11 cm
Engraved signature
near base: [an amphora]
Schneider / France
Sandra Black and Jeff Rose
Collection, gift in honour
of the Montreal Museum of
Fine Arts' 150th anniversary
2011.245

50

Vase
1924–28
Blown glass, powdered glass
inclusions
H. 20.6 cm
Engraved signature
sandblasted using a
template, on underside:
SCHNEIDER, and *FRANCE*
Sandra Black and Jeff Rose
Collection, gift in honour
of the Montreal Museum of
Fine Arts' 150th anniversary
2011.266

51

Vase
1922–25
Blown glass, powdered glass
inclusions
H. 20.3 cm
Sandra Black and Jeff Rose
Collection, gift in honour
of the Montreal Museum of
Fine Arts' 150th anniversary
2011.247

52

Coupe
1919–22
Blown glass, powdered glass
inclusions
H. 31.5 cm; Diam. 35.3 cm
Engraved signature
on top of foot: *Schneider*
Sandra Black and Jeff Rose
Collection, gift in honour
of the Montreal Museum of
Fine Arts' 150th anniversary
2010.838

53

***Toupie* Vase**
1922–24
Blown glass, powdered glass
decoration
H. 13.2 cm; Diam. 26 cm
Engraved signature on foot:
Schneider
Sandra Black and Jeff Rose
Collection, gift in honour
of the Montreal Museum of
Fine Arts' 150th anniversary
2010.846

54

Vase
1927–29
Acid-etched blown glass,
powdered glass inclusions
H. 47 cm
Engraved signature
on side of vase: *charder*,
on top of foot:
Le Verre Français,
on underside, sandblasted
using a template: *FRANCE*
Sandra Black and Jeff Rose
Collection, gift in honour
of the Montreal Museum of
Fine Arts' 150th anniversary
2011.251

RENÉ LALIQUE

At the time of the 1900 Exposition Universelle in Paris, René Lalique was one of the most prominent jewellers in France. He captured the *fin-de-siècle* mood with his designs and his use of non-precious materials chosen especially for their visual and symbolic effect. Lalique incorporated clear and coloured glass into his jewellery, which led him to experiment further with the medium. He gradually developed his production in glass further, and by the time of the 1925 Exposition Internationale des Arts Décoratifs et Industriels Modernes in Paris, Lalique had his own pavilion and was responsible for the monumental glass fountain at the centre of the fair on the Esplanade des Invalides. He was one of the few designers whose career spanned with equal success the Art Nouveau style associated with the turn of the century and the post-war years of the "Roaring Twenties."

Lalique was able to mass-produce a wide range of wares that retained the sparkle, quality and elegance of unique luxury goods by using mould-blowing and pressing techniques for his semi-crystal (*demi-cristal*) glass. The natural motifs of flora and fauna he used in his jewellery were carried over into his glass designs, and he also introduced geometric stylized patterns that were popular in the Art Deco period. This *Pierrefonds* vase **56** reveals a characteristic play of contrasts between the matte surface of the plain, unornamented body of the vessel and the handles in shiny, transparent glass that rise from the base like huge fern fronds and scroll inwards following the line of the vase. The thickness of the moulded glass gives weight to this impressive piece. Designed in 1926, Lalique was at this time adding colour to some of his pieces by using metallic oxides, although the majority of his overall production consisted of clear or opalescent glass **55** .[1]

Through clever marketing and high visibility at international fairs and at his showroom at 24 Vendome, in the heart of fashionable Paris, Lalique's celebrity spread to other parts of Europe and to North and South America, where he found a ready market.[2] In the 1920s and 1930s, the name Lalique became synonymous with the best in modern French luxury glass. **RP**

1. Felix Marcilhac, *René Lalique, 1860-1945, maître-verrier*, cat. raisonné (Paris: Les éditions de l'Amateur, 1989; revised 1994), p. 436. The *Pierrefonds* vase was featured in Lalique's catalogues of 1928 and 1932 and continued to be produced after 1951. 2. For Canada, see Carolyn Hatch, *Déco Lalique: Creator to Consumer*, exh. cat. (Toronto: Royal Ontario Museum, 2005).

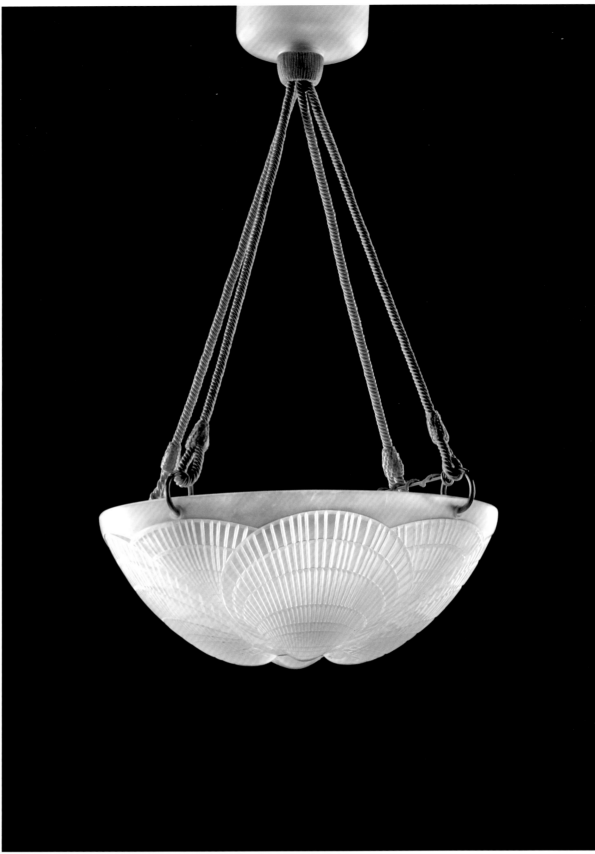

55

55

René Lalique
Ay, France, 1860 – Paris 1945

Coquilles Hanging Lamp
1921
Mould-pressed glass,
silk cords
H. 52 cm; Diam. 30 cm
Produced by René Lalique
et Cie, Wingen-sur-Moder,
France
Engraved signature near rim:
R. LALIQUE / FRANCE
Gift of Dr. Henri Lavigueur
2006.1

56

***Pierrefonds* Vase**
1926
Mould-pressed glass
15.7 x 33 x 17.6 cm
Produced by René Lalique
et Cie, Wingen-sur-Moder,
France
Engraved signature on
underside: *R. LALIQUE /
FRANCE NO. 990*
Liliane and David M. Stewart
Collection
D94.182.1

57

***Oranges* Vase**
1926
Mould-blown glass,
painted enamel decoration
H. 29 cm; Diam. 29.2 cm
(approx.)
Produced by René Lalique
et Cie, Wingen-sur-Moder,
France
Signed in relief, at centre:
R. LALIQUE; engraved
on underside: *R. Lalique
France No 964*
Promised gift of Mr. and
Mrs. Philippe Stora
301.2010

58

***Ceylan* Vase**
1924
Mould-pressed glass
H. 24.1 cm; Diam. 13.2 cm
Produced by René Lalique
et Cie, Wingen-sur-Moder,
France
Engraved signature
on underside: *R. LALIQUE /
FRANCE W8 905*
Gift in memory of
Marguerite E. Scott
1994.Dg.1

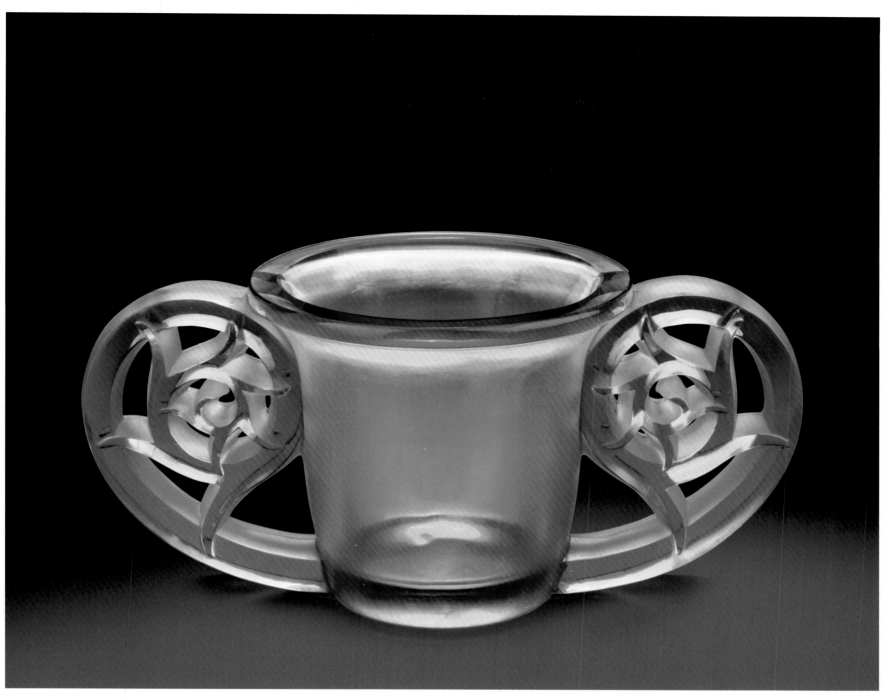

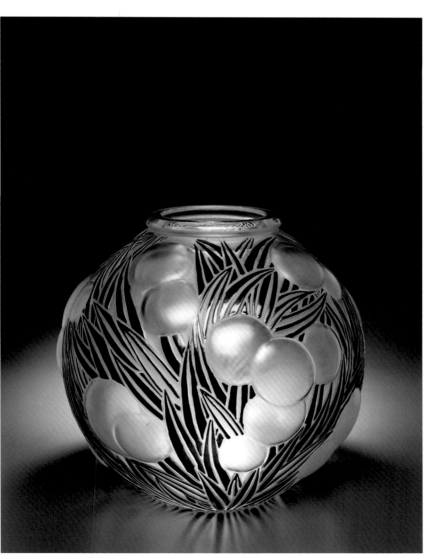

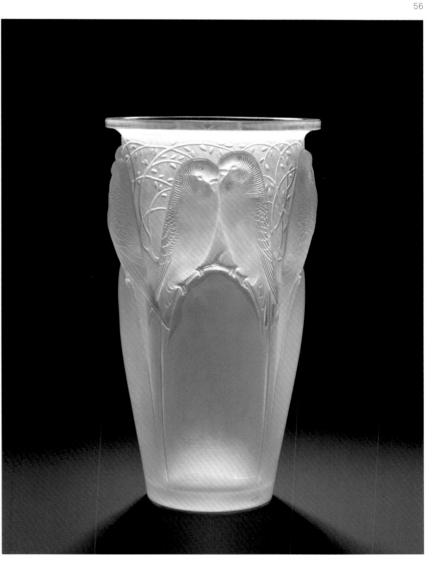

EDWARD HALD

The Paris Exposition des Arts Décoratifs et Industriels Modernes of 1925 brought Swedish design to international attention. As a result of the success of the Swedish pavilion at the Paris show, the Metropolitan Museum of Art in New York presented an *Exhibition of Swedish Contemporary Decorative Arts* in 1927. News of the show and of the outstanding display of Swedish glass reached the Montreal Museum's F. Cleveland Morgan, who went to see the exhibition in New York. He immediately ordered for the Museum a covered vase by Edward Hald from the Orrefors firm—the well-known Swedish glassworks established in 1898—as well as two other Orrefors pieces for himself: a version of Edward Hald's *Fireworks* vase and a Simon Gate bowl and underplate 59, which were both illustrated in the exhibition's catalogue.[1]

The Museum's tall covered vase on a wide circular foot 60 is decorated around the sides with engraved motifs of meandering paths lined with conifers, leading to small pavilions. Figures with parasols stroll along the paths in this scene entitled *Lover's Lane*.[2] Designed in 1923, the lightness of the fanciful engraved motifs matches the thinness and delicacy of the glass. The light-hearted, humorous ornamentation is typical of the designs of Edward Hald, who was a leading artist at Orrefors.[3]

Hald had studied architecture in Dresden, and painting in Stockholm, Copenhagen and Paris (with Henri Matisse in 1909), before becoming a designer at Orrefors.[4] He joined the firm in 1917, the year after artist Simon Gate had also been recruited by the company in order to improve and modernize the design of its glassware. These two designers dominated Orrefors' production for almost twenty-five years. Hald was managing director from 1933 to 1944, and returned as a designer in 1947 until 1977. He and Gate not only raised the standard of Orrefors' mass-produced items, but they also worked with professional craftsmen in reviving traditional copper-wheel engraving for the expensive, engraved-glass pieces that contributed to the firm's international reputation.

One of the most popular creations by Hald was the blown- and engraved-glass *Fireworks* vase and underplate 62, which entered the Museum's collection in 2000. A model of this vase had been exhibited in the Paris exhibition of 1925 and had been hailed as Hald's masterpiece.[5] A circular vase flaring out to a wide rim, its sides are finely engraved with a fantasyland of figures, trees, a shower of pinwheels and exploding stars. The piece, model H 248, was produced over many years by Orrefors, and so has slight variations in the decoration as a result of the different engravers. This one is signed with the initials of Anders Svensson. **RP**

1. Morgan had missed the exhibition but was taken around the show by the Vice-Commissioner after it had closed (Letter from F. Cleveland Morgan to E. Gustafasson, March 19, 1927, MMFA Archives). 2. Illustrated in Derek E. Ostergard and Nina Stritzler-Levine, eds., *The Brilliance of Swedish Glass 1918–1939: An Alliance of Art and Industry* (New Haven; London: Yale University Press for Bard Graduate Center for Studies in the Decorative Arts, New York, 1996), p. 206. 3. The number engraved on the foot, *312.27* [illegible engraver's initials], refers to model number 312 and the date of this actual piece, 1927. 4. *Edward Hald: Målare, Konstindustripionjär*, exh. cat. (Stockholm: Nationalmuseum, 1983), pp. 9 and 147. 5. Erik Wettergren, *The Modern Decorative Arts of Sweden* (London: Country Life, in conjunction with the Malmö Museum, 1927).

MAURICE MARINOT

Maurice Marinot's career as a glass-maker began in 1911, when he first exhibited at the Salon d'Automne in Paris, and ended in 1937 due to poor health, the closing of the glass factory at Bar-sur-Seine and the death of his long-time dealer, Adrien-Aurélien Hébrard. Marinot had trained as an artist at the École des Beaux-Arts and exhibited his paintings in major Paris exhibitions. At age twenty-nine, following a visit to the glassworks of the Viard brothers at Bar-sur-Seine, Marinot turned his attention to glass design when the brothers encouraged him to work with them. His first glass pieces consisted of clear glass vessels with painted decorative motifs in coloured enamels. Another source of support was the Paris painter André Mare, who invited Marinot to exhibit his glass with him at the Salon d'Automne in 1912 and, after 1920, with Louis Süe and André Mare's Compagnie des Arts Français. The enamel motifs of floral medallions and swags on Marinot's glass at that time were in keeping with current decorative designs on furniture, carpets, ceramics and other furnishings of the pre-World War I period.[1]

After 1922, Marinot moved from designing and decorating glass to actually working the medium. As he said: "I immediately wanted to learn the craft and blow my own pieces. It is quite long and arduous yet exciting. It is the only way one can 'think in glass.'"[2] Marinot's real contribution to glass-making came in the late 1920s, when he built up the core mass of glass with layer after layer of the molten material, and sometimes used the technique of acid-etching to create forms in high relief in these weighty glass pieces. His most prized works are those like this small bottle 61, which recalls the shape and design of eighteenth-century Chinese glass snuff bottles, with their marbled colour imitating jade and agate. In this bottle, Marinot has encased the inner mass of glass, flecked with inclusions and streaks of colour, with a final layering of transparent glass made frothy with air bubbles. He spoke of the glass medium as if it were a living force, flowing and bubbling under the heat of the furnace: "It is a rich and robust medium, each layer shifting and pushing against the other, like geological history."[3] The resulting layers were then caught in a frozen suspension of colour and light. **RP**

1. Félix Marcilhac, "Premières années d'un maître ouvrier du verre," in *Maurice Marinot, Penser en verre*, exh. cat., ed. Olivier Le Bihan (Troyes: Musée d'Art moderne de Troyes; Paris: Somogy, 2010), pp. 26–45. 2. Undated quotation from "Notes de Marinot," in *Maurice Marinot*, p. 162. 3. Ibid.

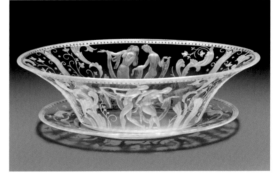

59

59

Simon Gate
Södra Fägelås,
Sweden, 1883 –
Orrefors, Sweden, 1945
**Bowl and Underplate
1920 (example of 1924)**
Glass, wheel-engraved
decoration
Bowl: 11.1 x 37.6 x 22.6 cm
Underplate:
2.3 x 31.6 x 20.8 cm
Produced by Orrefors
Glasbruk, Orrefors,
Sweden
Engraved decoration
by Wilhelm Eisert
Engraved on underside:
Orrefors G. 147.24, WE.
Promised gift from the
F. Cleveland Morgan
Collection, by
Elizabeth Morgan
159.2012.1-2

60

Edward Hald
Stockholm 1883 –
Stockholm 1980
Lover's Lane **Covered
Vase
1923 (example of 1927)**
Glass, wheel-engraved
decoration
H. 41.6 cm; Diam. 13.2 cm
Produced by Orrefors
Glasbruk, Orrefors, Sweden
Engraved on edge of foot:
Orrefors. Hald. 312.27
[illegible engraver's initials]
Label on top of foot:
ORREFORS / SWEDEN /
[grouse within laurel wreath
and three crowns], on
underside: *made in / Sweden*
Gift of F. Cleveland Morgan
1928.Dg.1a-b

61

Maurice Marinot
Troyes, France, 1882 –
Troyes 1960
**Bottle
1929**
Blown and cased glass
14.6 x 11.4 x 8.3 cm
Engraved signature on
underside: *marinot*
Liliane and David M. Stewart
Collection
D94.179.1

62

Edward Hald
Stockholm 1883 –
Stockholm 1980
Fireworks
**Vase and Underplate
1921**
Glass, wheel-engraved
decoration
H. 21.8 cm (with underplate);
Diam. 27.6 cm
Produced by Orrefors
Glasbruk, Orrefors, Sweden
Engraved decoration by
Anders Svensson
Engraved on underside:
Orrefors 248.AS
Liliane and David M. Stewart
Collection, gift of
I. Wistar Morris
D83.143.1a-b

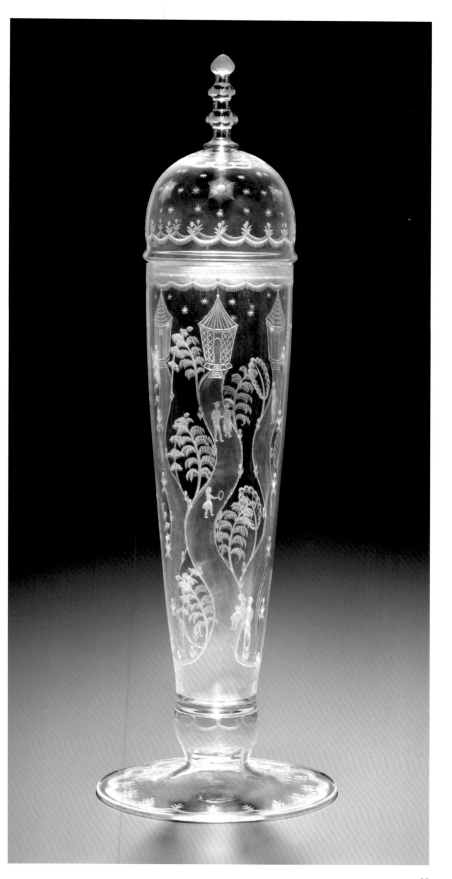

60

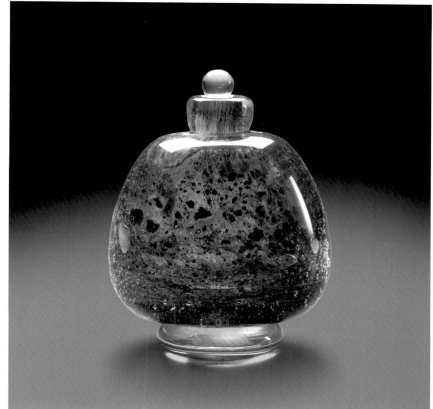

61

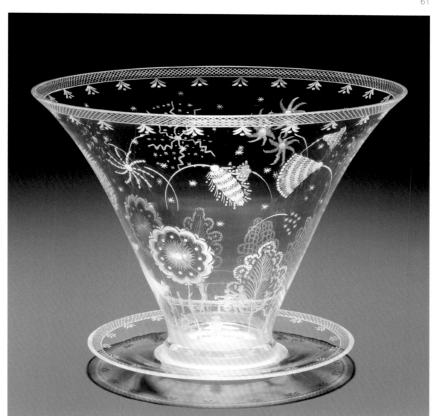

62

MODERN GLASS

— HELMUT RICKE —

Creative variety and sweeping change were the hallmarks of European glass-making in the inter-war years. The dominant centres of the turn of the century—Bohemia and France—continued to make their independent contributions: Bohemia with its intense, Vienna-inspired styles adopted by the glass-making schools in Nový Bor and Kamenický Šenov; and France with the conversion of Art Nouveau's artistic tradition into Art Deco. Leading manufacturers such as Lalique, Daum and Schneider produced trendsetting works, and studios in Paris paved the way for Maurice Marinot's revolutionary new approach.

At the same time, an entirely new order was arising, which was to have a number of consequences. In northern Europe, first Sweden, then Finland developed new centres that hitherto had practically no glass-making tradition. In the south, Murano embraced modernity and returned to its former prominence thanks to Paolo Venini, who founded his glassworks there in 1921 and developed a modern language of form.

These newcomers made their mark on the look of modern glass in the years after 1945. In contrast, France almost completely lost its importance, while Germany focused on industrial design, and Czechoslovakia, for political reasons, had to wait before being able to enjoy the international renown it deserved, despite first-rate achievements.

Glass-making in the modernist era developed in the main on a north-south divide between, on the one hand, Scandinavia and Finland,

and on the other hand, Italy. Yet the relationship between the two new centres was characterized by mutual regard and appreciation, rather than competitiveness. The nineteenth-century role of the designer changed radically in these two regions, indeed in the field of modern glass-making as a whole. The ideas fostered by Deutscher Werkbund, which encouraged artists to work in industry in order to, above all else, enhance the quality of everyday objects, were reinterpreted and built upon during the twentieth century. In the northern countries, this came about gradually: In the leading glassworks—Orrefors and Kosta in Sweden, Holmegaard in Denmark, and Karhula-Iittala and Nuutajärvi in Finland—both the handsome, cheaply produced utility glass object as well as the limited series and unique art-glass piece were designed by the same people. The aesthetic and the functional complemented one another, although the production of art glass was a major image-building factor for these firms, as it enabled them, essentially, to showcase their work.

Northern designers regarded themselves as both industrial designers and artists. In Murano, by contrast, art glass dominated (partly because of the opportunities presented by the many master glass-blowers there), and design concentrated almost exclusively on this type of production, which was then still seen as traditional craft. In both centres, however, the artists and artist-designers established the reputation of the leading glassworks from the 1930s until the 1960s.

63

Tapio Wirkkala
Hangö, Finland, 1915 –
Espoo, Finland, 1985
Iceberg Vase (model 3525)
1950
Mould-blown and cut glass
20.5 x 18 x 16 cm
Produced by Iittala
Lasitehdas, Iittala,
Finland
Engraved signature
on underside:
Tapio Wirkkala 3525
Liliane and David M. Stewart
Collection
2002.343

64

Edvin Öhrström
Burlöv, Sweden, 1906 –
Stockholm 1994
Vase
About 1947
Blown and cased glass
H. 15.3 cm; Diam. 16.5 cm
Produced by Orrefors
Glasbruk, Orrefors, Sweden
Engraved on underside:
Orrefors Sweden Ariel nr:
375 / E. Ohrstrom
Liliane and David M. Stewart
Collection
D87.111.1

65

Vicke Lindstrand
Göteborg, Sweden, 1904 –
Småland, Sweden, 1983
Vase (model LH 1181)
About 1953
Blown glass
28.2 x 16.7 x 8 cm
Produced by Kosta Glasbruk,
Orrefors, Sweden
Engraved on underside:
LH 1181
Liliane and David M. Stewart
Collection, gift of the
American Friends of Canada
through the generosity of
Mr. and Mrs. I. Wistar Morris III
D88.196.1

66

Timo Sarpaneva
Helsinki 1926 – Helsinki 2006
Orkidea Bud Vase
About 1953 (example of 1955)
Mould-blown glass
H. 27.2 cm; Diam. 8.2 cm
Produced by Iittala
Lasitehdas, Iittala, Finland
Engraved signature and
date on underside: *TIMO*
SARPANEVA IITTALA 55
Liliane and David M. Stewart
Collection, gift of the
American Friends of Canada
through the generosity of
Geoffrey N. Bradfield
D85.112.1

67

Tapio Wirkkala
Hangö, Finland, 1915 –
Espoo, Finland, 1985
Kantarelli Vase (model 3280)
1947
Blown glass, machine
engraved
22 x 16.6 x 17.5 cm
Produced by Iittala
Lasitehdas, Iittala, Finland
Engraved signature on
underside: *TAPIO*
WIRKKALA IITTALA
Liliane and David M. Stewart
Collection
D85.134.1

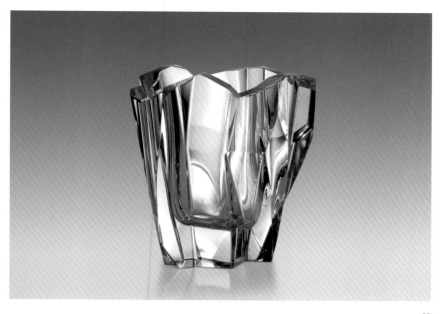

63

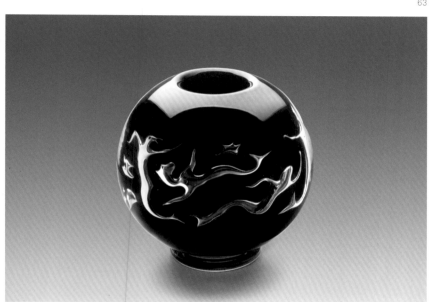

64

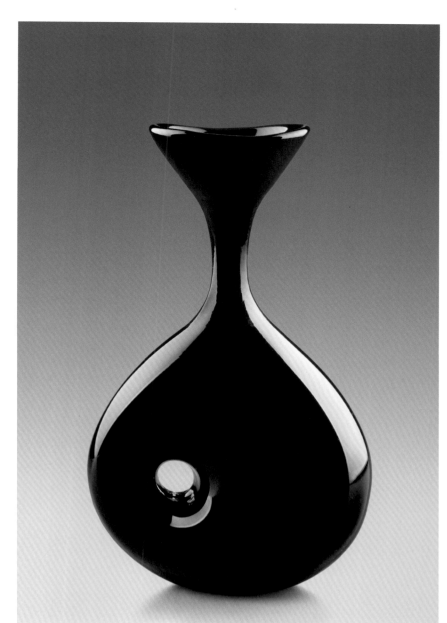

65

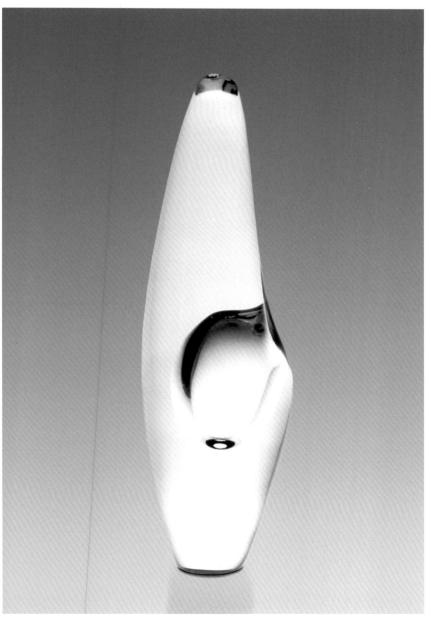

66

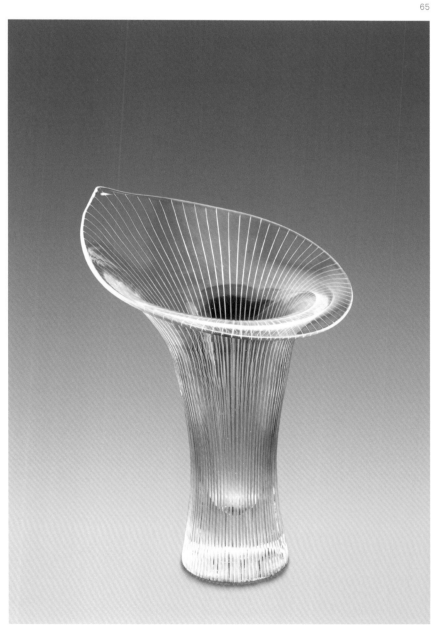

67

SCANDINAVIA

In Sweden, the generation born in the first decade of the twentieth century seized its opportunities in the 1930s and pioneered change. Vicke Lindstrand, the most distinguished among them, struck out in new formal and technical directions at Orrefors, alongside his eminent predecessors Simon Gate and Edward Hald. Together with the sculptor Edvin Öhrström, he designed, about 1936–37, the first of the "Ariel" pieces. Their decoration with air bubbles borrowed from the "Graal" technique, typical of Orrefors, of encasing an ornamental element in two layers of glass 64 .[1] Decorating with air "inclusions" stresses the medium's sense of mass and weight while also lightheartedly playing them off each other. Because of their simply shaped, often geometrically constructed forms, these pieces can be seen as the embodiment of European glass-making in the second half of the 1930s and early 1940s, an art still clearly marked by functionalism. At Orrefors, this approach, through Edvin Öhrström's work, proved to be a connecting thread in ongoing developments until late into the 1950s.

While Öhrström remained closely attached to Orrefors even after World War II and played a fundamental role in the look of the firm's output, Vicke Lindstrand moved on to Kosta in 1950, where he immediately created a formal language that is now regarded as typical of the 1950s. The vase he designed about 1953, with its narrow funnel neck and off-centre hole through the body 65 , transformed the functional vessel into a living sculpture that looks different from every angle, an impression strengthened by the uncommon and complete absence of glass' transparency. This vessel was a clear response to developments in Murano.[2]

The ubiquitous trio of Finnish glass-making—Tapio Wirkkala, Kaj Franck and Timo Sarpaneva—were indebted to Gunnel Nyman, who died prematurely at thirty-nine.[3] Her designs for the Nuutajärvi glassworks just after World War II heralded all the elements that were to establish the reputation of Finnish glass of the 1950s. Her work—like that of her better-known followers—exploited a combination of the physical characteristics of glass, such as transparency, malleability when hot, weight and mass, and to these she added elements taken from nature that have emotional appeal and evoke associations. With this creative approach, she considerably broadened the possibilities for the art glass that had developed during the 1920s and 1930s post-Maurice Marinot, and paved the way, in particular, for Tapio Wirkkala.

Wirkkala's works, like his 1947 *Kantarelli* vase 67 , a sophisticated abstraction of the chanterelle mushroom, speak to this approach to glass design, as does his 1950 *Iceberg* vase 63 , which derives even more closely from natural phenomena. Kaj Franck was a masterly designer of utilitarian forms reduced to their essentials. Works such as his *Kremlin Bells* decanter 68 have revealed him to be a romantic perfectly capable of playfully querying the pure function of the designed object, and hence take his fundamentally functionalist approach to an absurd extreme.

One sees a similar twofold approach in the highly intellectual work of Timo Sarpaneva. Although he devised perfect functional designs, he also explored the possibilities of a design stripped of function—as in his "Hiidenkirnu" series, or Devil's Churn, which reflected the interplay of water and ice. In his most successful creation, the *Orkidea* 66 , he handles the task of designing a bud vase by innovatively reviving the technique of steam-blowing.[4] The result is a sculpture in its own right that became a classic example of art glass, as it illustrates a creative approach that can only achieve its desired effect through a transparent medium such as glass, bringing out the contrast between a clear outer shape and a completely different-natured inner volume.

ITALY

Glass-making in Murano in the 1930s primarily pursued the two dominant trends in Europe: the simplification of form and the emphasis on mass and weight. Typical examples are the designs of architect Carlo Scarpa for Venini and the heavy, sculptural vessels of Ercole Barovier (1889–1974) for Barovier & Toso. However, from the late 1930s, firms such as Aureliano Toso increasingly turned to lively shapes and bright colours, and developed the traditional Venetian techniques of filigree and mosaic glass. Even Venini joined the trend, although more discreetly. Carlo Scarpa was given free rein to design items using the ancient techniques that ultimately dated from the Romans. His *Tessuto* vases 71 , exhibited for the first time at the 1940 Venice Biennale, combine a classical and functional shape with sensitive colouring and a subtle texture evoking fabric, obtained with the filigree-glass technique.

In 1949, the young Fulvio Bianconi, originally a graphic artist, took this approach to new heights with his famous handkerchief in glass, the *Fazzoletto* vase 72 , produced with the support of the company head, Paolo Venini. It became a key work of Venetian glass-making of the second half of the twentieth century. Like Paolo Venini, Bianconi was not from the Murano milieu, which was often conservative and fond of tradition. Nor was Gio Ponti, the influential architect and designer from Milan. Shortly after the war, he set a milestone in the Venini glassworks' design program with items like the *Morandiane* bottle 69 . It quotes the still lifes of Giorgio Morandi, and so acknowledges an affinity between art glass and contemporary painting; but it also hints at a human figure, and so becomes an important impetus for Fulvio Bianconi's revival of Venetian figurative glass sculpture in the 1950s.

Bianconi's personality and work combined everything that characterized glass-making on the island of Murano in the 1950s. The range of this multi-talented artist was almost unlimited. He approached formal questions with a completely open mind, refusing to take the traditional canon as gospel. Uniquely, he followed his own unerring instinct for colour. Almost all his designs express his joy in playing and experimenting with colour and form, particularly impressive in his highly successful series of *Pezzato* vessels 73 in mosaic glass.[5]

Bianconi's arrival had a liberating effect on Murano's glassworks, ready for change. The extraordinary variety of Venetian glass in the 1950s is due in large part to his influence. Yet although he brought developments to their apogee, in many cases the groundwork had already been laid before the war. In fact, other glassworks were already moving in the same direction before Venini, especially with the mosaic glass technique. Ercole Barovier again played an important role, as did Dino Martens (1894–1970), in particular, who, in the 1930s was already making experimental designs using mosaic-type procedures for Aureliano Toso. The exuberant variety of colours and shapes in these pieces prefigured the 1950s, and to some extent even surpassed Bianconi's later works.[6]

Some time later, the painter and graphic artist Anzolo Fuga used a similar combination of techniques—embedding bundled canes of transparent glass and disks of coloured glass in the body—to give his

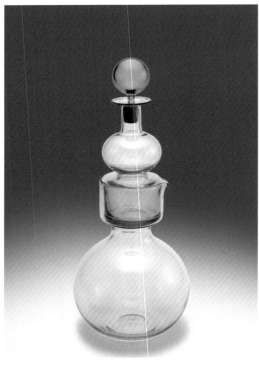

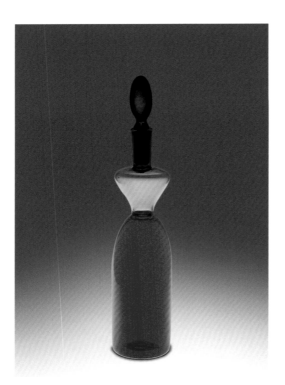

68

Kaj Franck
Viipuri (now Vyborg, Russia)
1911 – Santorini, Greece, 1989
Kremlin Bells **Decanter**
About 1957
Blown glass
H. 39.9 cm; Diam. 14.7 cm
Produced by
Nuutajärvi-Notsjö,
Urjala, Finland
Etched on underside:
Nuutajarvi-Notsjö
Metallic label on underside:
*NUUTAJARVI / NOTSJÖ-1793 /
MADE IN FINLAND*
Liliane and David M. Stewart
Collection
D82.111.1a-c

69

Gio Ponti
Milan 1891 – Milan 1979
Morandiane **Bottle**
About 1950
Blown glass
H. 38.1 cm; Diam. 8.3 cm
Produced by Venini, Murano
Etched on underside:
venini / murano / ITALIA
Liliane and David M. Stewart
Collection
D88.112.1a-b

70

Anzolo Fuga
Murano 1914 –
Murano 1998
Vase
About 1955–56
Blown glass
50.6 x 24.5 x 14 cm
Produced by A.Ve.M.
(Arte Vetraria Muranese),
Murano
Liliane and David M. Stewart
Collection, gift of
Roy Poretzky
2008.101

71

Carlo Scarpa
Venice 1906 –
Sendai, Japan, 1978
Tessuto **Vase**
**1939 (example about
1950–70)**
Blown glass
H. 33.3 cm; Diam. 14 cm
Produced by Venini, Murano
Etched on underside:
venini / murano / ITALIA
Liliane and David M. Stewart
Collection
D88.109.1

blown-glass works a serene, almost monumental appearance `70`. His pieces, designed for A.Ve.M. (Arte Vetraria Muranese), heralded the 1960s.

THE CZECH REPUBLIC

A third centre of innovation in modern glass-making is increasingly gaining recognition today: the Czech Republic. Geographically identical to Bohemia, the old country of glass-making, it had to develop independently due to post-war political unrest.[7] The long East-West conflict of the Cold War prevented the former Czechoslovakia's achievements from being recognized.

The Czech Republic now occupies a major position in the field of art glass, but getting there was not easy: It was the result of hard work on the part of a generation of artists who managed to maintain their artistic freedom in the face of a repressive Socialist regime. Furthermore, with the help of some shrewd politicians, the country managed to preserve a fully functioning educational system of glass-making schools and art academies, a system established in Bohemia in the nineteenth century. The instructors of these institutions became the driving force behind an individual-centred glass-making culture within a system of state-run industry.

As professor at the Prague art academy, Stanislav Libenský was the most influential Czech glass artist post-1945. Before turning completely to glass sculpture, he explored Western developments in graphic arts and painting through a series of enamel-painted vessels `74`. A close look at the decoration of his cylinder vases reveals the Venetian motifs in the abstract designs drawn from Cubism. In his early works, Libenský too sought some connection to the fine arts, although he was already exploiting the inherent qualities of glass whereby colour, even when broken up, is intensified by the interplay of transparency and strong ground luminosity. These experiments came to full fruition with the first sculptural works done with his wife, Jaroslava Brychtová. They would leave their stamp on all his subsequent creations.

Another member of the founding generation of Czech art glass was René Roubíček. His early works feature the glass-cutting and engraving techniques that Bohemian artists had been using for centuries `75`. However, Roubíček made a radical break from the attractive lines and smooth surfaces that traditional engraving demanded for a theme like *Adam and Eve*. Instead, the surface of this piece, as though cut with a blade, lends the work a particularly powerful expressivity. The figures are worked in high relief on the thick glass and appear to be emerging from the material. The vessel is the work of a born sculptor dealing in mass and space, an approach that carried into his later production. His figurative work made way for often large-scale, hollow sculptures in blown glass exploring every conceivable possibility of the medium in relation to space.

While as a rule, modern art glass in northern and southern Europe was the work of artists employed by glassworks, Czech artists were essentially on their own, bringing their ideas to life in their own studios or in state-run facilities. They have therefore been forerunners of studio-based production, as practised by today's glass-makers. In the West, though, the era of modern glass was the last in the history of glass-making in which artistic output was encouraged and promoted by the leading glassworks. In the 1960s, things changed for good. Because of economic pressures, the importance of craft production in the glassworks quickly diminished, as did the role of the artist-designers, who no longer enjoyed the same creative freedom. At the same time, however, the increasing number of independent producers meant a revival of individual glass production, which ultimately led to the extraordinarily diverse glass-making scene we have now.

1. For Swedish twentieth-century glass and the Graal technique, see Helmut Ricke and Ulrich Gronert, *Glas in Schweden 1915-1960* (Munich: Prestel-Verlag, 1987); *Lyricism of Modern Design: Swedish Glass 1900–1970* (Sapporo: Hokkaido Museum of Modern Art, 1992); *The Brilliance of Swedish Glass 1918–1939* (New Haven, Connecticut; London: Yale University Press, 1996). See also "Form, Color and More" in *Design of Form— Design of Color: Finnish and Italian Art Glass from the Losch Collection*, exh. cat., ed. Helmut Ricke (Düsseldorf: Museum Kunstpalast, 2002).
2. An immediate source was certainly the very similar models designed by Fulvio Bianconi about 1951–52 in Murano for Venini; see Anna Venini Diaz de Santillana, *Venini. Catalogue raisonné 1921-1986* (Milan: Skira, 2000), p. 281. The sculptures of Henry Moore may also have been a source of inspiration. Generally, art glass of this time drew strongly on 1930s and 1940s painting and sculpture.
3. On Nyman and Sarpaneva, see Ricke 2002, *Design of Form…*, p. 72 and following pages. For modern glass art in Finland generally, see *Finnish Glass: Brochures from the 1950s* (Riihimäki: The Finnish Glass Museum, 1994); *Nuutajärvi: 200 Years of Finnish Glass* (Tampere: Litopaino, 1993).
4. The procedure fell into disuse. It involved making a hollow in hot glass using the steam pressure generated by inserting a damp wooden rod.
5. The filigree and mosaic glass techniques are similar. In the case of the former, premade glass canes are fused together; with the latter, coloured glass tesserae are fused together to make a decorative sheet that is then rolled into a cylinder using the blowpipe. The cylinder is then closed on the bottom and blown into the desired shape.
6. For Barovier & Toso, see Attilia Dorigato, *Ercole Barovier 1889-1974. Vetraio Muranese* (Venice: Marsilio Editori, 1989); for Archimede Seguso, see Umberto Francoi, *I vetri di Archimede Seguso* (Venice: Arsenale Editrice, 1991); for Dino Martens and Aureliano Toso, see Marc Heiremans, *Dino Martens: Muranese Glass Designer* (Stuttgart: Arnoldsche, 1999).
7. See Sylva Petrová, *Czech Glass* (Prague: Gallery, 2000); Antonin Langhamer, *The Legend of Czech Glass: A Thousand Years of Glassmaking in the Heart of Europe* (Zlin: Tigris, 2003); Helmut Ricke, ed., *Czech Glass 1945–1980: Design in an Age of Adversity* (Stuttgart: Arnoldsche, 2005).

`72`

Fulvio Bianconi
Padua 1915 – Milan 1996
Fazzoletto Vase
About 1949
Blown glass,
white enamel threads
27 x 28 x 22.5 cm
Produced by Venini, Murano
Etched on underside:
venini / murano / ITALIA
Liliane and David M. Stewart
Collection, gift of
Anthea Liontos
D94.122.1

`73`

Fulvio Bianconi
Padua 1915 – Milan 1996
Pezzato Vase
1952
Blown glass
17.5 x 20.8 x 12.1 cm
Produced by Venini, Murano
Etched on underside:
venini / murano / ITALIA
Liliane and David M. Stewart
Collection, gift of
Bombardier, Inc.
D86.162.1

`74`

Stanislav Libenský
Sezemice, Czechoslovakia,
1921 – Železný Brod,
Czech Republic, 2002
Vase
1954
Blown glass, polychrome
enamel decoration
H. 33 cm; Diam. 10 cm
Etched signature and
date on underside:
S LIBENSKY 1954 274/62
Liliane and David M. Stewart
Collection
D83.118.1

`75`

René Roubíček
Born in Prague in 1922
Adam and Eve Vase
1947
Blown and hot-worked glass
H. 33 cm; Diam. 12.5 cm
Etched signature and
date on underside:
*Roubicek 1947 / Specialized
School of Glassmaking*
Liliane and David M. Stewart
Collection
D83.121.1

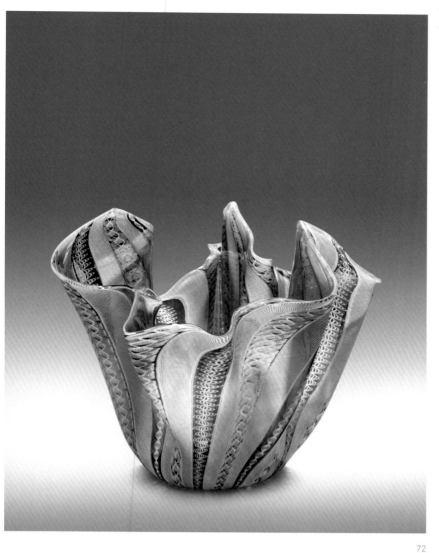

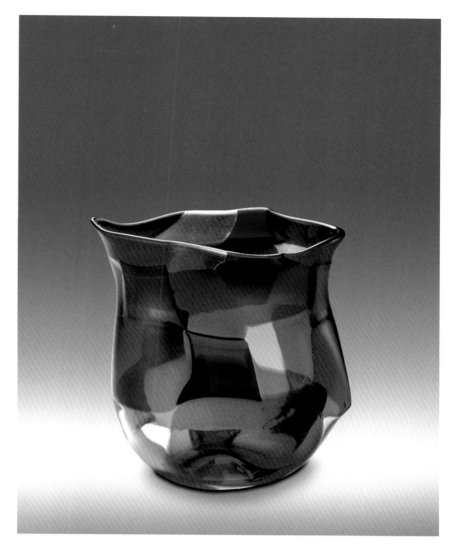

72

73

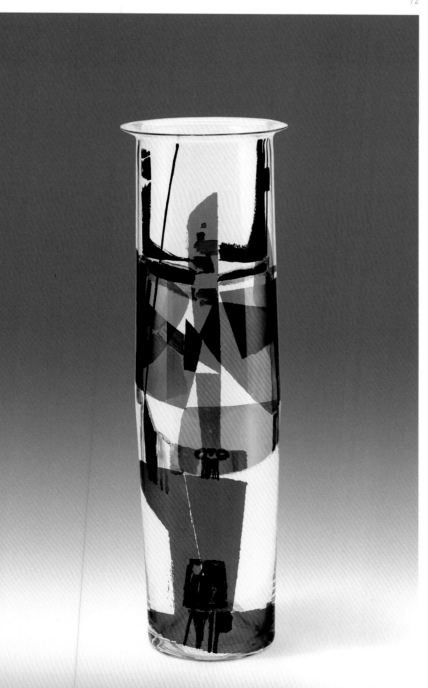

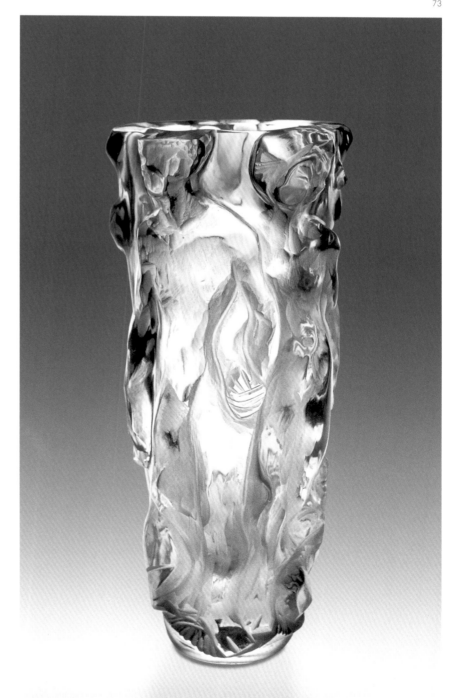

74

75

THE STUDIO GLASS MOVEMENT

— DAVIRA S. TARAGIN —

The Studio Glass movement began as a challenge to the centuries-old separation in glass-making between the creativity of the designer and the hands-on approach of the artisan. Two workshops at the Toledo Museum of Art in 1962 conducted by artist Harvey Littleton **81**, a University of Wisconsin faculty member, with the assistance of Norman Schulman, a museum school instructor, Dominick Labino, a scientist at Johns-Manville Fiber Glass Corporation, and Harvey Leafgreen, a retired glass-blower from Libbey Glass, led to the development of technologies that dissolved the boundaries between these two functions. The vision that emerged from these workshops was for the solitary artist working in blown glass to "create beautiful objects which were completely unsuitable as uniform, mass-produced articles of industry"[1] within the confines of his or her studio or the university by using scaled-down equipment and glass that could be melted at low temperatures. Littleton's *Manganese Prunted Form* vase **78**, executed approximately two years after the first workshop, epitomizes the artist's philosophy. He captures the expressive, fluid nature of glass in the object's slightly drooping form and prunts (the two blobs of glass reminiscent of handles) applied to its opposing walls. At the same time, he tries to achieve scale in order to show the object's relationship with contemporary non-functional sculpture.

The Toledo concept, which clearly disassociated itself from the industrial factory environment, immediately started to undergo modification as the factory began to assert itself within the field. Beginning in the late 1960s, a number of American artists, including James Carpenter, Dale Chihuly, Dan Dailey, Richard Marquis, Benjamin Moore, Thomas Stearns and Toots Zynsky, travelled to Murano, Italy, for residencies at Venini & C. There, they experienced firsthand the advantages of a factory organization that encouraged teamwork and, therefore, specialization of tasks, including a separate area for cold-working and finishing.

Dale Chihuly's vocal endorsement of teamwork following his 1968 stay at Venini is well documented. In retrospect, the white opaque blown-glass goblets **79** executed in 1971 with James Carpenter—at the same time that both artists were working on the *Glass Forest* installation for New York's Museum of Contemporary Crafts (now the Museum of Arts and Design)—and Chihuly's later well-known "SeaForm" series **80** are as much about collaboration as about moving glass from the realm of tableware to environmental sculpture.

Other artists of the period contributed to the evolution of the Toledo concept. Marvin Lipofsky was the first student of Littleton's graduate-level glass program at the University of Wisconsin, Madison, to go on to teach glass-blowing. Since the late 1960s, he has worked not only in university and workshop settings and in summer programs like Deer Isle's Haystack Mountain School of Crafts where *Glass Form* **77** of 1967 was created, but also in glass factories throughout the world. Since first working at West Virginia's Blenko Glass Company in 1968, he has developed a practice of using their facilities to construct the wooden forms into which the glass is then blown with the workers' help. Lipofsky finishes the piece back in his Berkeley studio. Similarly, beginning in 1980 also at Blenko, sculptor Howard Ben Tré has demonstrated the advantages of casting glass in factory environments. He has built his entire career on uniting his own personnel with industrial equipment and factory employees in rented factory spaces to create monumental, architectonic forms **90**, which are brought back to his studio only to have the surfaces worked.

Tom Patti has contributed a different approach. Taking advantage of his industrial-design training, Patti broke from both historic traditions of glass-blowing and the Toledo concept as early as the 1970s by eliminating the furnace and the traditional practice of the glass-blower moving between bench, furnace and glory hole while continually rotating the blow-pipe. Developing a process for inflating an air bubble into laminated sheets of plate, textured, borosilicate and other kinds of commercial glass, Patti creates small, elegant sculptures, such as *Solar Green Riser* **76**, that demonstrate the expressive potential of the medium.

In retrospect, many artists, both in the United States and abroad, expanded the original definition of the Studio Glass movement. Thanks to key figures such as Stanislav Libenský and Jaroslava Brychtová, Richard Meitner, Klaus Moje, Bertil Vallien and Toots Zynsky, glass is no longer solely about the blown form.[2] Encompassing a wide range of processes, it has now been absorbed into mainstream art as a viable vehicle of expression for conceptual art, architecture and design. Furthermore, artists interested in the medium no longer need to rely solely on their own technical expertise, since they can hire other glass artists to realize their concepts. As a result, the Studio Glass movement is now said to be defunct, having expired sometime in the 1990s.

1. Louise Bruner, "Could the Glass Capital Become Glass Arts Center," *Toledo Blade*, April 22, 1962, Section 4, p. 1.
2. Works by Howard Ben Tré, Dan Dailey, Stanislav Libenský and Jaroslava Brychtová, Harvey K. Littleton, Klans Moje, Jay Musler, Jaromir Rybák, Bertil Vallien and Toots Zynsky were shown in the exhibition *Studio Glass: Anna and Joe Mendel Collection*, held at the Montreal Museum of Fine Arts, and are illustrated in the accompanying catalogue published by the Museum in 2010.

76

Tom Patti
Born in Pittsfield, Massachusetts, in 1943
Solar Green Riser
From the series "Solar Riser"
1979
Fused plate glass, blown
11.2 x 6.7 x 5.5 cm
Gift, Anna and Joe Mendel Collection
2011.232

77

Marvin Lipofsky
Born in Barrington, Illinois, in 1938
Glass Form
1967
Blown glass
18.4 x 25.4 x 12.7 cm
Engraved inscription on side of vase:
FOR HELGA / MADE IN MAINE / HAYSTACK / 1967 / Lipofsky
Liliane and David M. Stewart Collection, gift of Lilliana and David Simpson
D91.391.1

78

Harvey K. Littleton
Born in Corning, New York, in 1922
Manganese Prunted Form Vase
1964
Blown glass
31 x 14.7 x 10 cm
Engraved signature and date on side, near bottom:
Littleton 1964
Liliane and David M. Stewart Collection
D87.181.1

79

Dale Chihuly
Born in Tacoma, Washington, in 1941
Goblet
1971
Blown glass
31.2 x 13.7 x 11.7 cm
Handwritten label on underside: *CHIHULY / GOBLET FROM #4*
Liliane and David M. Stewart Collection, gift of Lilliana and David Simpson
D91.390.1

80

Dale Chihuly
Born in Tacoma, Washington, in 1941
Cadmium Red Yellow Seaform Set with Red Lip Wraps
From the series "SeaForm"
1990
Blown glass
43.2 x 61 x 91.5 cm
Engraved signature and date on underside of small closed form: *Chihuly 90*
Liliane and David M. Stewart Collection, gift of the American Friends of Canada through the generosity of Jay Spectre
D90.219.1a-j

76

77

78

79

80

STANISLAV LIBENSKÝ AND JAROSLAVA BRYCHTOVÁ

Stanislav Libenský's and Jaroslava Brychtová's contribution to Studio Glass can be evaluated in terms of the late twentieth–early twenty-first century, mould-melted, abstract, sculptural glass aesthetic they developed. They not only perfected its style and technique, but popularized it through their teaching, exhibitions and travels. Inspired by Czech Cubism, their work evolved over their almost fifty-year collaboration, which lasted from about 1954 through to Libenský's death in 2002. He would use drawing to explore the interrelationship of form, volume and light; in turn, she would then translate his ideas into three-dimensional clay models that were subsequently made into plaster moulds for casting.

Red Horizon 83 epitomizes the aesthetic that marks the last decade of their collaboration. Fascinated by the play of light on simple, translucent, cubic glass forms, Libenský and Brychtová here divide a plane of mould-melted glass with a deeply cut channel. The groove in the glass traps the light, causing it to interact and define the form's interior and exterior. As in much of their work from the mid-1980s onwards, most of the edges remain raw, the result of the glass overflowing the fractures of the mould during fabrication. Unlike the majority of their later collaborative work, intense colour enlivens this sculpture, perhaps celebrating life at a time when both artists were dealing with Libenský's mortality. Its colour is so important that the artists included it in the title. **DST**

BERTIL VALLIEN

Bertil Vallien's contribution to Studio Glass is twofold: he introduced his own brand of sand-casting to glass-making. More significantly, by dividing his time over forty years at Kosta Boda between being a designer and an artist in residence, he demonstrated that these tasks are not necessarily mutually exclusive in a factory environment.

His "Map" series, an example of his unique work, was inspired by a newspaper clipping. Initially thinking it was a graphic depiction of a man's face, he later realized that it was an aerial view of a bombed Iraqi village. This led him to create a series based on grids and superimposed images of men.

This sculpture 84 represents Vallien's response to a 1995 article about the plight of the people of northern Kurdistan. Like the other works in the series, its theme is an imaginary archeological excavation of a city destroyed by a terrible disaster, and the man represents evil. Sand-casting, which involves pouring molten glass into a mould of compacted sand to produce a granular surface, causes the frontal silhouette of a man's upper body with multiple clenched fists to appear in relief against a recessed grid reminiscent of fencing. The figure's worn, hardened demeanour is an effect of the technique, further augmented by the addition of glass fragments, powdered enamels and oxides. It provides a dramatic contrast to the thin, centrally placed rectangle of clear, polished glass, symbolizing hope. **DST**

TOOTS ZINSKY

Fascinated by birds since her childhood in northeastern Massachusetts, Toots Zynsky began the "Exotic Bird" series in 1985, after returning to her home in Amsterdam following a six-month stay in Ghana. Although she had never formally studied colour theory, the explosion of colour that she encountered in every aspect of African life, including its textiles, architecture, music, flora and fauna, heightened her awareness of the colours she saw in paintings in the Netherlands' exceptional art collections.

Despite its relatively early date, this vessel 88, with its simple feathery patterning, epitomizes Zynsky's contribution to the Studio Glass movement. It is constructed of multiple layers of thin glass threads produced in her studio with a machine specifically invented for the artist in 1982. As in much of her work from the mid-1980s through 1992, the tiers of variously coloured threads are laid down in one direction on a flat kiln board with the outer layer forming an abstract composition. The glass strands are then heated in a kiln to form a sheet that, when quickly transferred into a mould, collapses down into a vessel form with no defined flat bottom, a technique known as slumping. Zynsky hand-forms the subtle modulations in the walls during a final phase of fabrication. **DST**

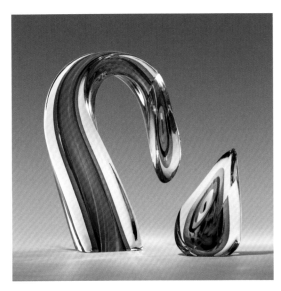

81

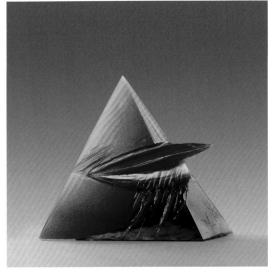

82

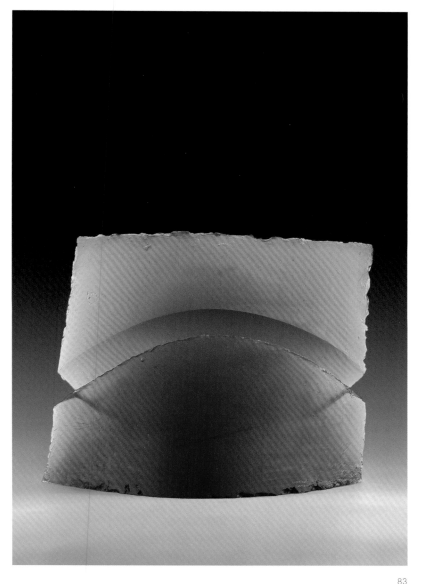

83

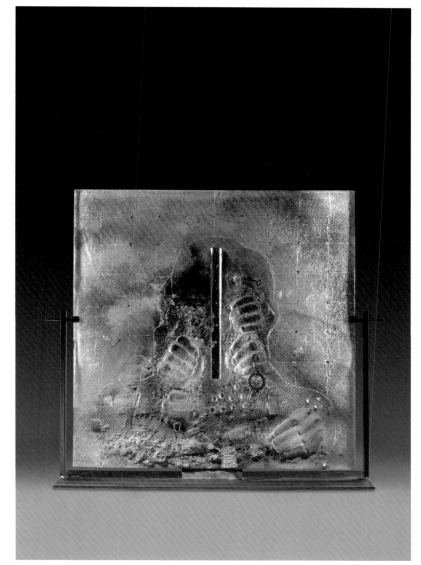

84

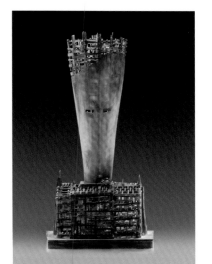

85

86

87

88

87

Dan Dailey
Born in Philadelphia in 1947
Two-heart Woman Vase
From the series "Face Vases"
1991
Blown glass, sandblasted,
acid polished,
vitreous enamel
H. 53.3 cm; Diam. 36.8 cm
Gift, Anna and Joe Mendel
Collection
2007.165

88

Toots Zynsky
Born in Boston in 1951
Vessel
From the series "Exotic Bird"
1988
Fused and kiln-formed glass
threads (*filet de verre*)
H. 10 cm; Diam. 22.9 cm
Initial in glass thread on
underside: *Z*
Gift, Anna and Joe Mendel
Collection
2007.237

DAN DAILEY

Dan Dailey is recognized for his blown, cast and constructed sculptures, frequently augmented with metal, which comment on the human condition. While much has been written about the artist's factory experiences, less well known is the involvement of both the studio and factory in his daily creative process. For example, all the "Face Vases," including *Two-heart Woman* 87 , were initially blown with a team at Benjamin Moore's Seattle studio. They were then cold-worked with the designs drawn and sand-blasted onto the surface at Dailey's New Hampshire studio, acid-polished by Dailey and his team at West Virginia's Fenton Art Glass Company, and returned to Dailey's studio for enamelling.

Since his student days, Dailey has relied heavily on ideas culled from his sketchbooks that were largely drawn from memory after visiting museums, observing nature and people, and travelling in the United States and abroad. Finding inspiration in Greek vases and ancient Chinese bronzes in the 1980s and, at times, in the 1990s, he now utilizes these diverse sources to "transform the vessel into an object of expression through its form."[1]

Two-heart Woman was inspired by the bands of pictorial narrative on Greek vases. On one side of its elongated neck, a stylized, mask-like face symbolizes the universal woman; on the reverse, two hearts facing opposite directions portray the conflicting feelings that surround every decision. A wide horizontal band of upward-reaching vegetation sandwiched between the scalloped sand-blasted base and the images of the face and hearts energizes the vase's entire surface and calls attention to the imagery on the neck. **DST**

1. Dan Dailey, e-mail to the author, April 3, 2010.

KLAUS MOJE

In the 1970s, when the Studio Glass movement was focusing largely on hot-glass techniques, Klaus Moje, then living in Germany, was creating revolutionary statements about intense colour with kiln-forming and cold-working processes. Essentially reviving the mosaic techniques of the ancient Romans, the artist cut, assembled, fused and slumped small pieces of glass cane to form brilliantly coloured, opaque vessels that were then finished by grinding and polishing.

From 1982 onwards, Moje gradually transitioned from the cane to glass sheets fabricated by the Bullseye Glass Company of Portland, Oregon, developing an innovative approach to fusing. Moje's retirement in 1992, after nine years as the head of the first Studio Glass program at Australia's Canberra School of Art, afforded him the opportunity to focus on the enormous colour potential of this material, leading to richer, more painterly compositions.

This vessel 86 is part of a long series of experiments done since 1982 with Bullseye Glass sheets that ultimately led to groundbreaking wall panels and novel vertical mosaic vessels formed by rolling pre-fused mosaic sheets around base disks of glass and then working the forms at the glory hole and bench. Here, Moje pushed the limits of the coloured glass sheets by fusing strips in a kiln at temperatures well beyond those recommended by the company. By creating a tool with a small hook at the end, he was able to marbleize the glass while it was in the kiln, which dramatically modified his characteristic palette and gave the vessel its distinctive coloration. **DST**

RICHARD MEITNER

Richard Meitner has always done enigmatic work. This sculpture 89 belongs to a body of work from the early 1980s that uses enamelling and the vessel form to establish a relationship between the object and the written word. It exemplifies Meitner's career-long dedication to using blown glass to pose questions.

Distributed over the walls of all five vessels, the equation "Intentie + Pretentie = Inventie" offers a reflection on the well-known Shakespeare quotation cited on their bases, which Meitner has modified to read: "To be and not to be that is the answer." Initially a poet, Meitner selected Dutch words that are somewhat similar in meaning to their English equivalents to suggest that "one's intent (*Intentie*), plus the arrogance to assume one could reach very high (*Pretentie*), yields real invention (*Inventie*)."[1]

Meitner reinforces the relationship between the two phrases by segregating the words and symbols within each statement, so that each vessel contains only the correlations. The vessels, which juxtapose transparent and opaque glass, Meitner's trademark, provide a poignant comment on the Dutch phrase and significant insight into the artist. In retrospect, although Meitner feels that this is one of his most important works, he is somewhat critical of it, claiming that the flattened forms, while typical, could have been better formed and interrelated; hence, his "Intention ended up being perhaps closer to Pretense."[2] When the sculpture was first exhibited, negative response to his investigation of the dialogue between word and object caused Meitner to largely relinquish this pursuit. **DST**

1. Richard Meitner, e-mail to the author, March 31, 2010. 2. Ibid.

89

Richard Meitner
Born in Philadelphia
in 1949
***INTENTIE + PRETENTIE =
INVENTIE***
1984
Blown glass, enamel
19.6 x 44 x 9.8 cm
Engraved signature on
underside of each piece:
R. Meitner 84
Liliane and David M. Stewart
Collection, gift of
Gérard Gaveau
D94.301.1a-e

90

Howard Ben Tré
Born in New York in 1949
Lintel I
1985
Sand-cast glass,
oxidized copper
49.5 x 132.1 x 7.6 cm
Gift, Anna and Joe Mendel
Collection
2007.155

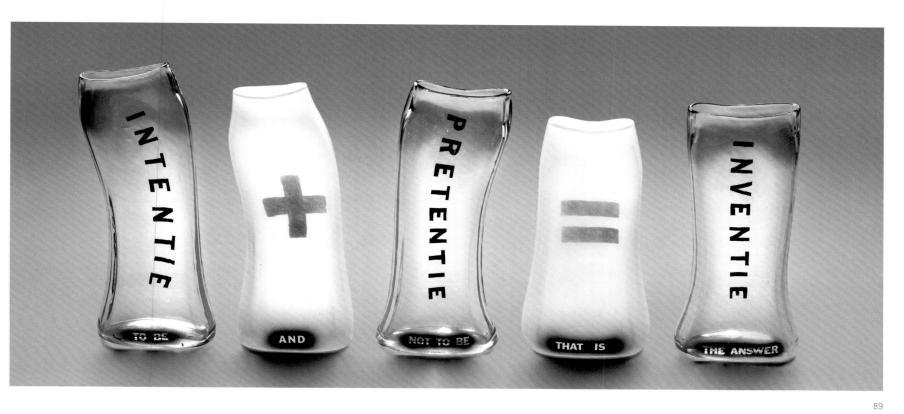

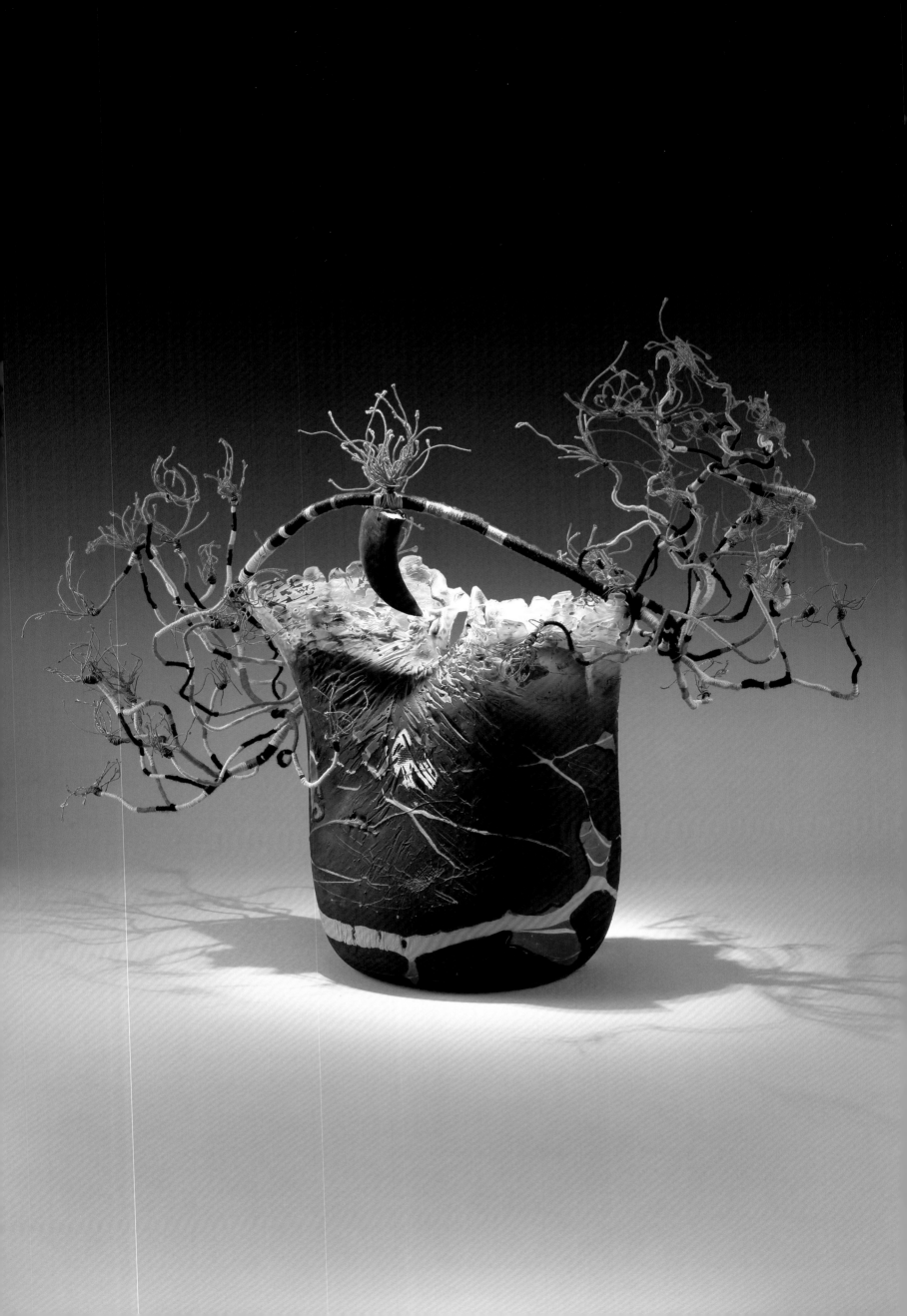

CONNECTIONS: CANADIAN STUDIO GLASS

— ALAN ELDER —

There is much buzz today about social interaction and the ease with which information can be exchanged through new media. And while electronic means of communication may have facilitated connections between individuals, this text looks at how tightly knit the Canadian Studio Glass community has been since its inception in the early 1970s.

The history of the Canadian Studio Glass movement is part of an international exchange of ideas and social interactions. Throughout its short history, Canadian Studio Glass artists have been aware of and influenced directly, and indirectly, by artists from across the country and from around the world. Information has been transmitted through highly structured channels, such as apprenticeships and college and university studies, as well as informal social networks that have been built on friendships within a relatively small community of artists spread across the nation. Both can be seen as affecting the work of several glass artists represented in the Museum collection.

International influences are to be found as early as the 1960s, when several Canadian companies began to address consumer interest in decorative glass pieces. These include Altaglass in Medicine Hat, Alberta, and Chalet Artistic Glass in Cornwall, Ontario. Both companies were founded by glass artists trained in Europe: Czechoslovakia and Italy, respectively. The glass-making traditions of these two countries had strong influences on the look of Studio Glass in Canada. At Expo '67 in Montreal, a display of contemporary glass in the Czechoslovakian pavilion encouraged Canadians—both makers and consumers—to learn more about this underused material. In the early 1970s, Mario Cimarosto, of Montreal's Lorraine Glass, took on a young apprentice, Toan Klein, who—after learning the importance of fine materials and refined techniques from Cimarosto—went on to create his own unique approach to Studio Glass 97 .

About the same time, Studio Glass programs were being introduced at Ontario's Sheridan College School of Crafts and Design and the Université du Québec à Trois-Rivières. Each school looked at different international models: Gilles Desaulnier, who directed the program at Trois-Rivières, had studied in Czechoslovakia, and Sheridan's Robert Held, who founded the college's glass studio in the 1970s, turned to the experimental glass movement in the United States. The American movement was still in its infancy, but was influential, nonetheless, because it looked at the possibility of working in small studio spaces rather than relying on industry, as Italian and Czechoslovakian artists had done.

Among the earliest students of the program at Sheridan College were Peter Keogh and Daniel Crichton. Before arriving at Sheridan, Keogh had studied sculpture at the Ontario College of Art, and was interested in adding glass to his "palette" of traditional sculptural materials. Heaven and Earth 93 , 1984, demonstrates Keogh's ability to combine two materials that share a similar production method (both its glass and bronze components have been cast) yet provide a significant contrast in their visual presence. Keogh expertly joins the two materials to form a coherent statement.

In contrast to Keogh's sculptural approach, Crichton explores a familiar form, the vessel, initially as a functional object and later as a work that references the utilitarian history of his chosen medium. Although many of his early pieces cite past aesthetic movements in glass, his work from the "Strata" series 96 , 1985, demonstrates this interest by combining a traditional vessel with imagery of the layers of the earth, layers that provide the basic material for his work. Like Keogh, Crichton went on to teach at Sheridan for many years; a number of the glass artists discussed herein studied with him.

One of Crichton's earliest students was Francois Houdé. Reflecting the ideas of many of his contemporaries, Houdé, after perfecting his techniques, grew tired of producing precious objects. He began to erode the sensual clarity of his own work by sandblasting the surface of his vessels. Soon, he was breaking and reassembling his works. Perhaps Houdé's best-known series, "Ming," explores the art-historical use of equine imagery. His Ming XVII 92 , 1987, also focuses attention on something that one usually looks through: window glass. And, by naming the work after a well-known period of Chinese history, he questions what is thought of

as important. Houdé went on to join forces with Ronald Labelle to create Le Centre des métiers du verre du Québec / Espace Verre in Montreal in 1987. When Houdé left Espace Verre, his job as pedagogical director was assumed by Susan Edgerley, another of Crichton's former students.

Edgerley shared Houdé's interest in using glass in ways that diverted attention from the medium's formal beauty and subverted ideas of function. She began to explore other glass-making traditions—including lampworking—a technique most popularly used in the production of glass menagerie figures. I Hear Your Whisper 99 , 2003, demonstrates Edgerley's technical expertise, yet attention is not only drawn to the glass itself, but also to the shadows cast by the transparent material, which become as important as the glass. Her colleague Laura Donefer, shares Edgerley's interest in various hot-work techniques; however, she eschews the transparency of the material in favour of opaque coloured glass. In African Witchpot 91 , 1988 the vessel's mysterious contents are hidden by its dark, matte opacity.

Tanya Lyons was another student of Crichton's. She benefited not only from Crichton encouraging his students to find their own voices, but also from her time spent studying outside of Canada—in Finland—as part of an exchange program. Like Edgerley, she turned away from glass-blowing to explore other techniques. In Golden Gown 94 , 2007, Lyons uses hot-worked glass along with brass mesh. Starting with generic forms of women's clothing—for example, sundresses and kimonos—she begins to embellish the garments with three-dimensional imagery rather than with their usual flat, surface decorations. Simultaneously, by borrowing from women's clothing, Lyons addresses her place in the field of Studio Glass. She has consciously placed her work within the sphere of the feminine and domestic rather than in the more familiar, and public, sphere of the male artist.

Brad Copping's networks include not only interactions with Crichton and others as both a former student and then teacher at Sheridan College, but also his involvement with the Glass Art Association of Canada. GAAC, as it is familiarly known, is a volunteer-run organization of glass artists, students, collectors and other interested individuals. Through its informal exchanges and organized activities—publications, exhibitions and conferences—GAAC brings together a social network of those involved in Canadian Studio Glass. As president of the Association, Copping strengthened his understanding of the relationships of those working within the field. At the same time he was volunteering with GAAC, he was able to maintain his own practice. His earlier Rooted 95 , 1994, refers to the natural world through his choice of materials and imagery. Both the cedar and the materials used to produce glass stem from the earth, as does the imagery in Crichton's "Strata" vase.

The natural world has also influenced the work of Jay Macdonell. His large-format works are based on the twisting and turning forms of bulbs and flowers. Allium, from the series "Allium Bulb" 98 , 2008, uses the luminescent qualities of glass—its transparent colour—to represent a natural form that is similarly affected by light. Unlike most of the other glass artists mentioned herein, Macdonell learned about glass-blowing through an apprenticeship rather than formal schooling. From 1992 to 1996, he trained with Robert Held at his studio in Vancouver.

The story of Studio Glass in Canada demonstrates how connected individuals in the Canadian glass community are to each other. In the early years of Canadian Studio Glass, most information was passed from glass master to student. Often, these masters were trained elsewhere and brought specific knowledge with them when they moved to Canada. Today, educational institutions may be where much of our formal education takes place, but interpersonal relationships still provide our artists with invaluable connections to the past and present, both in and outside of Canada.

1. Works by François Houdé and Laura Donefer were shown in the exhibition Studio Glass: Anna and Joe Mendel Collection, held at the Montreal Museum of Fine Arts, and appear in the accompanying catalogue published by the Museum in 2010.

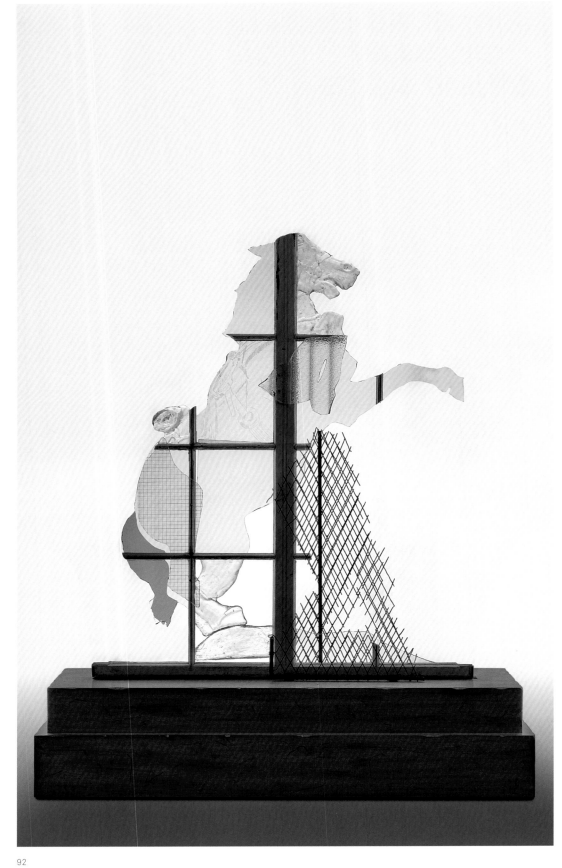

92

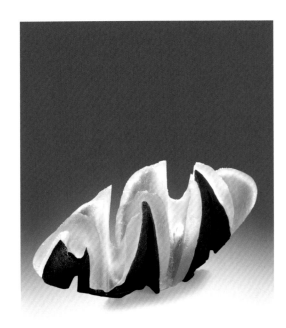

93

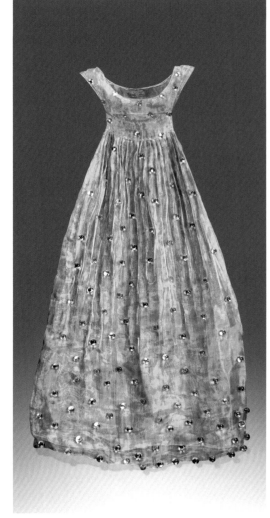

94

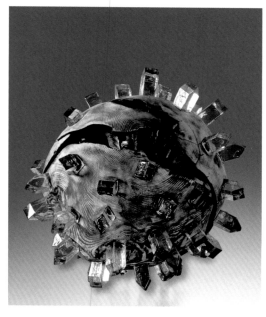

95

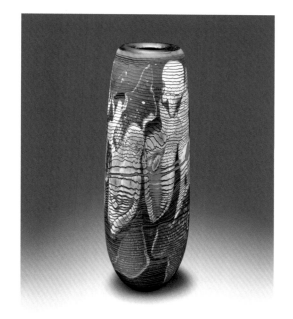

96

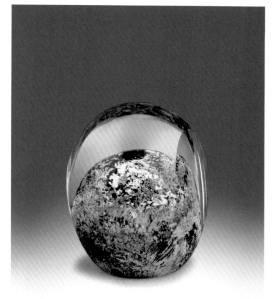

97

98

99

HANDICRAFT AND TECHNOLOGY

— DIANE CHARBONNEAU, ÈVE DE GARIE-LAMANQUE, MICHAEL PROKOPOW —

ETTORE SOTTSASS

Italian designer Ettore Sottsass began to draw inspiration from the plastic qualities of glass in the early 1970s. He designed a first series of functional, unusually shaped objects for Vistosi between 1972 and 1977 **100**. Following an approach that recalled his ceramic work, he emphasized the superimposition of simple geometric elements and made use of various chromatic combinations, while playing with glass' transparency and opacity depending on its thickness. Inspired by the American Abstract Expressionists and the Color-field movement, he wished to explore "the concept of pure sensation and the immediate, 'sensorial' impact of colour and pattern"[1] in his work. Without being minimalist, these first vases, bowls and jars display a surprising simplicity. In the early 1980s, Sottsass created blown-glass objects for the Memphis group, including the *Sol* fruit bowl **102** and the *Altair* vase **101**. The originality of these objects lies in their elaborate ornamentation typical of the Memphis aesthetic. Sottsass worked closely with the glass-blowers of Toso Vetri d'Arte, whose expertise enabled him to design pieces of great complexity composed of a wide range of distinct elements. Some of these elements are purely decorative, such as the fragile superfluous handles and the pointed excrescences resembling rose thorns. **DC and EDL**

1. Penny Sparke, "Ettore Sottsass," in *Design 1935–1965: What Modern Was*, ed. Martin Eidelberg (Montreal: Musée des Arts décoratifs de Montréal; New York: Harry N. Abrams, 1991), p. 325.

ANGELO MANGIAROTTI

Although the product of one of Italy's most lauded industrial designers, the *Lesbo* lamp **103** by Angelo Mangiarotti is not a piece of industrial design in the strict sense of the term. Although it is a technological object—in that it uses electricity to provide illumination—and is tied to the principles of modern design by way of its successful negotiation of form and function, the fact that the glass body of the lamp results from an artisan's efforts renders the lamp a type of super-stylized craft object. And this makes sense in light of Mangiarotti's practice and the era in which *Lesbo* was imagined and made. Designed in 1967 and named after the Greek island of Lesbos, the lamp

has little to do with either the Mediterranean or sexual preference. As a functional object, the lamp is summarized by its coloration, glossy materiality and distinctive shape. As much a mushroom pushing out of the earth, a spaceship from another world, a moon crater or an ethereal omphalos, the *Lesbo* lamp openly displays eclectic stylistic origins and a Pop sensibility. It is easy to imagine Mangiarotti's intimate artifact in the happy company of bean-bag chairs, shag carpeting and campaigns for world peace, or free love, or both. Indeed, the *Lesbo* lamp is an open, joyful rejection of machine aesthetics, the International Style and the humdrum quaintness of middle-class domesticity, where table lamps are supposed to look like ornate candlesticks with shades. In designing the *Lesbo*, Mangiarotti participated in the stylistic and ideological upheavals that characterized the 1960s. And despite the lamp's indebtedness to the fibreglass and polyester resin *Nesso* lamp of 1964 by Gruppo Architetti Urbanisti Città Nuova, the *Lesbo* is an object with a sunny disposition that defied the modernist logic of its predecessors and embraced the swinging design revolution of the counterculture. **MP**

PHILIPPE STARCK

Prolific, witty and provocative, Philippe Starck has turned his brilliance to practically every kind of design challenge. His glass flower vase of 1990 **104** for Daum—whose name describes a small oddity under a wall—embodies interest in both the sculptural capacities of glass and the historical meaning of objects. By using the cornucopia as a repository for flowers, Starck rejects the standard, water-containing recipient of tradition and asks the user/viewer of his vase to ponder ideas of form and beauty, the rituals of domesticity and courtship, and the meanings of representing the natural world. In making the vessel for flowers in the shape of a horn—a less than subtle reference to satyrs and sexuality—Starck also engages ideas about nature and fecundity. However, by mounting the horn/vase onto a plane of clear glass, Starck frames the flowers and, in doing so, invites consideration of what it means to look at nature. Postmodern in its questioning of

representation and form, Starck's vase thus works on two levels. It is a device that transforms picked flowers into a picture, thereby referencing the long art-historical tradition of floral painting. For Starck, the act of picking flowers, bringing them inside, and putting them in some type of vessel is to exercise aesthetic control and meditate on fragile beauty. To gaze upon cut flowers in a vase is to reckon with the mortality that unfolds in the inevitable decay of beauty. **MP**

KARIM RASHID

Even the most cursory examination of the design work of the prolific and imaginative Karim Rashid would lead to an awareness of two things: the designer is fascinated by man-made materials, and he is interested in the interplay of shape and palette. Having designed more than three thousand products—packaging, hotel complexes and all types of household objects—Rashid's work represents a judicious marriage of material and form. His *Aura* coffee table **105** of 1990 for Zeritalia exemplifies his rigorous fascination with and mastery of the material properties of glass, and his always smart and playful interest in the basic shapes of geometry and in the shapes of what might be described as symmetrical biomorphism. Composed of three dismountable sheets of glass covered in polymethyl methacrylate placed within a tapered frame of powder-coated steel, the *Aura* table is a striking piece of design. Its futuristic palette and differentiated yet complementary shapes demonstrate that Rashid set out to challenge conventional thinking about how furniture operates and is used. Embodying the designer's constant wish to remake the way people live— "I want to change the world" is his mantra—*Aura* is innovative because it allows the user to easily change the order of the three pieces of glass. Rashid invites the user to customize the table to their taste. As with so much of his work, the *Aura* table succeeds as a piece of design because of its designer's sensitivity to the relationships of shape and colour. In 1990, the latest developments in glass technology permitted Rashid to create a decidedly avant-garde aesthetic object, albeit one that quickly became stylistically dated. **MP**

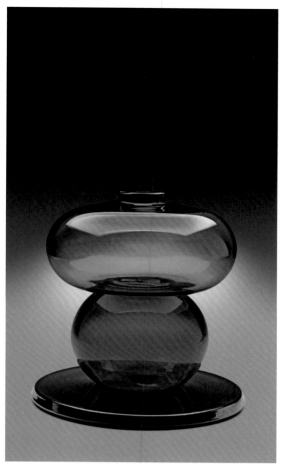

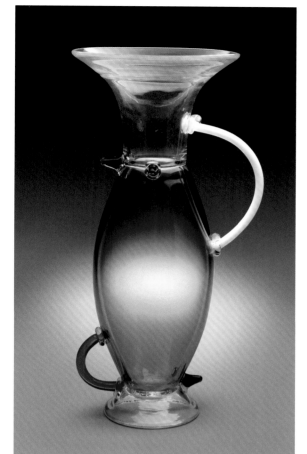

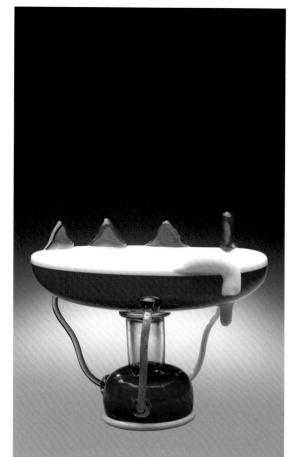

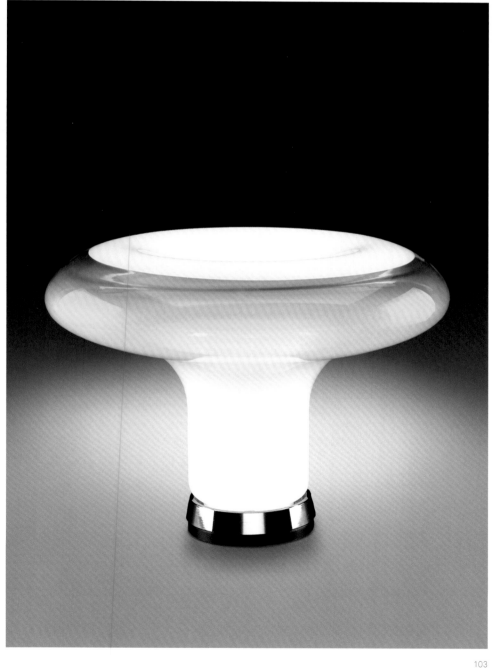

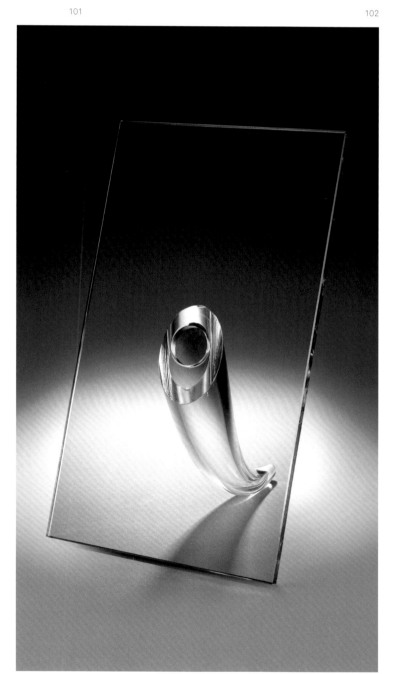

CINI BOERI AND TOMU KATAYANAGI

The *Ghost* chair of 1987 `106` by Cini Boeri and Tomu Katayanagi represents a remarkable technical achievement in the use of glass in furniture design, and gives a rebuff of sorts to the modernist movement's aesthetic and inherently anti-historicist sensibilities. Embracing the language of Postmodern design with its traditional profile and implied, but materially "absent" volume, the chair haunts the modernist science of materiality with a purposeful invocation of the past. For despite pushing the tensile and structural capacity of material to its limits in the tradition of modern design, and despite referencing important, earlier modern chairs—like Gerald Summers' remarkable plywood chair of 1938 for the London-based Makers of Simple Furniture company, and Pierre Paulin's futuristic *Ribbon* chair of 1966—the *Ghost* chair's combination of glass, width and structural configuration, although successful in terms of material, is not as driven by aesthetic concerns as one might first think. With its purposeful rootedness in ironic nostalgia, Boeri and Katayanagi's armchair represents the designers' greater interest in the historically referenced and sculptural possibilities of machine-moulded glass technology rather than the invention of a contemporary stylistic language suited to the ever technologically evolving and manifest future. **MP**

TEJO REMY

In creating "the milk-bottle lamp" `107` in 1991, the designer Tejo Remy, a founding member of Droog, the Amsterdam-based design collective, smartly referenced and aligned two oddly compatible sensibilities: the egalitarian rationalism of early modernist design and design thinking, and the long-standing Dutch penchant for economy (the frequent subject of self-deprecation). Indeed, Remy's lamp pays tribute to the *L40* hanging lamp of 1920 by Gerrit Rietveld, one of the leaders of De Stijl, and to suspicious Dutch thinking about luxury and ostentation. By suspending twelve frosted-glass milk bottles from no-frills black electrical cords—configured as four rows of three bottles reiterating the shape of a rectangular dining table—Remy's chandelier simultaneously engages ideas of domesticity and frugality. As in much of Remy's work—for example, the chest of drawers from 1991 `194` constructed from recycled drawers bound with a jute strap—conformist notions of furniture design are challenged. Remy's whimsical repurposing—using old things to make new, appealing and practical works of art—comments on Dutch thriftiness and on capitalist ideas about innovation and aesthetic worthiness. Remy's milk-bottle lamp is a surprising, thought-provoking encounter with the commonplace. Moreover, the lamp invites consideration of how design must seek to improve life, and how, by responding to social needs, the designer can marry social responsibility and wit. **MP**

FABIO NOVEMBRE

Visually seductive and confounding, Fabio Novembre's *Org* table of 2001 `108` for the global furniture company Capellini is in keeping with the Milan-based designer's smart playfulness. Novembre, who had trained as an architect and studied filmmaking in New York, is known for his intelligent and at times theatrical engagement with materials and space. His *Org* table seems in many ways an encapsulation of his design sensibility because it references a number of historical influences in a strikingly original way. Nodding approvingly towards Italian Surrealism, the short-lived but highly influential Memphis movement of the early 1980s, and Postmodernism (the seemingly lighthearted movement that rejected the dominant, clean aesthetics of modernism in favour of ironically, often sarcastically employed historical references), the table is a three-dimensional equivalent of *trompe l'oeil. Org* does not look like any ordinary table with visible legs or a pedestal base. With its exactingly spaced forest of red cords mounted to the underside of the thick glass tabletop and descending to the floor, the table is as much kinetic sculpture as domestic object. Indeed, the glass top appears to rest on strands of string, thus calling into question the table's functionality. And this is at the heart of Novembre's visual ruse: six structural columns are hidden amidst the 165 hanging ropes that do not touch the ground. When a person sits at the table and pulls their chair forward, the ropes part. When the person pushes the chair back to get up, the ropes fall back into place. **MP**

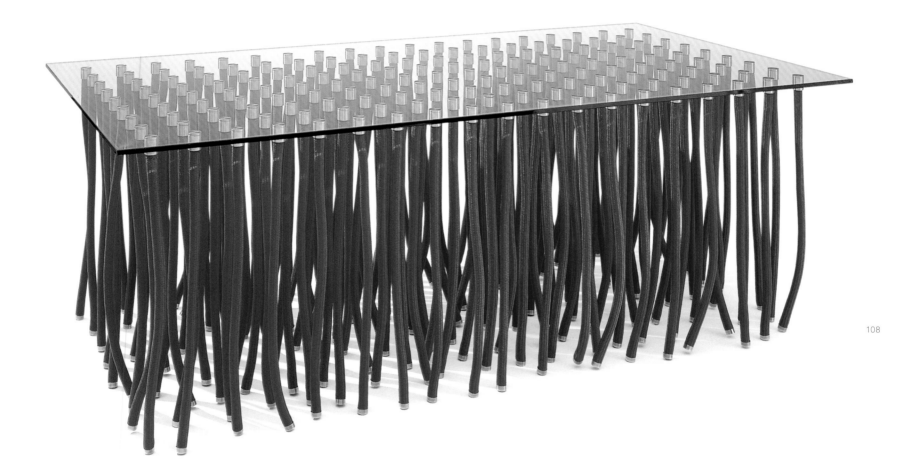

105

Karim Rashid
Born in Cairo in 1960
Aura **Coffee Table**
1990
Glass, polymethyl-
methacrylate, powder-coated
steel canes
48.3 x 91.5 x 69.9 cm
Produced by Zeritalia,
Saltara, Italy
Liliane and David M. Stewart
Collection, gift of Zeritalia
D98.179.1a-d

106

Cini Boeri
Born in Milan in 1924
Tomu Katayanagi
Born in Japan in 1950
Ghost **Armchair**
1987
Kiln-formed plate glass
61 x 93.5 x 63 cm
Produced by Fiam,
Tavelia, Italy
Transparent label, near
the bottom: *FIAM / ITALIA /
MADE IN ITALY / G-1G*
Liliane and David M. Stewart
Collection, gift of
Fiam Italia S.p.A.
D98.121.1

107

Tejo Remy
Born in the Netherlands
in 1960
Melkflessenlamp
Hanging Lamp
1991
Sandblasted glass milk
bottles, stainless steel
28.5 x 36 x 26 cm
Produced by DMD
(Development Manufacturing
Distribution), Voorbug,
Netherlands
Liliane and David M. Stewart
Collection, gift of
Murray Moss
D99.124.1

108

Fabio Novembre
Born in Lecce, Italy, in 1966
Org **Table (model OG/4)**
2001 (example of 2002)
Plate glass, polypropylene,
steel, cord, brushed
stainless steel
73.2 x 100 x 200 cm
Produced by Cappellini,
Arosio, Italy
Liliane and David M. Stewart
Collection
2002.57.1-172

WOOD

███████ *noun & adjective* [ORIGIN Old English *wudu* later form of *widu, wiodu* . . .] **A** *noun* **II 4 a** ■ The substance of which the roots, trunks, and branches of trees and shrubs consist. . . . Also *spec.*, the hard compact fibrous part of this.

██████ The richness of wood's warm tones, the sheen of its polished surfaces, its decorative grains, and even the scent of aromatic wood species have always appealed to furniture makers. The cabinetmakers' choice of wood and decorative treatment help to date a piece of furniture, and suggest the interior decor for which it was intended, whether the light-coloured satinwood models of Georgian England or the solid pine cupboards and chests of rural Quebec. The earliest pieces of furniture in the Museum were made from readily available wood, for example oak and walnut. In the late seventeenth century, sophisticated saws could cut the thinnest of veneers, and the technique of marquetry decoration in contrasting tones of wood was perfected for fine cabinetmaking. Dark mahogany was the wood of choice for furniture in mid-eighteenth century Europe, because of its rich reddish brown colour, striking grain and the ease with which it could be carved. ██████ Nineteenth-century cabinetmakers revelled in the profuse ornamentation created either by hand or machine. In mid-century, a revolution in woodworking occurred with the advent of processes to steam-bend and laminate wood to produce lightweight, elegant bentwood furniture that could be easily and cheaply manufactured in large quantities. There was, however, still room for handcraftsmanship, and the unique, luxury furniture made with exotic wood veneers of the Art Deco style in the 1920s and 1930s complemented the lavish interiors and glamour of the period. Just as innovative ideas in the use of wood were being challenged by the rise of tubular steel furniture and, later on, the development of plastics, leading Scandinavian designers revived appreciation for the tones of natural wood, not only in solid-wood furniture but also in laminated and plywood models. ██████ Today's designers are able to work with a wide array of natural or synthetic materials, although some look back, with humour and invention, to the great ages of walnut and mahogany and use the material in new and provocative ways. RP

✦ MAGNVS ✦ PONPEVS ✦

✦ Q ✦ CVRCIVS ✦

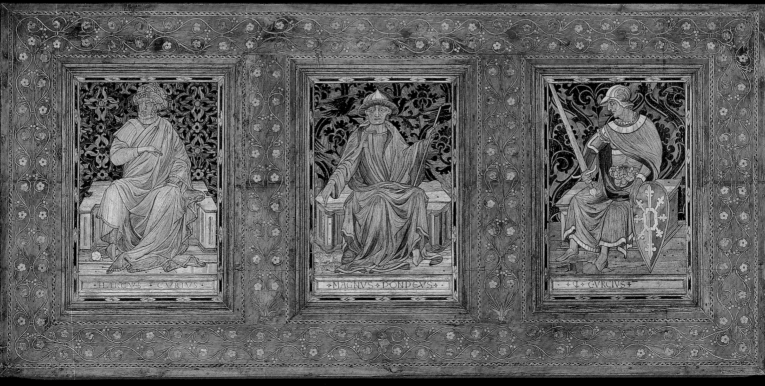

✦ MARCVS ✦ CVRIVS ✦

✦ MAGNVS ✦ PONPEVS ✦

✦ Q ✦ CVRCIVS ✦

THE GOLDEN AGE OF WALNUT AND MAHOGANY

— ROBERT LITTLE, ROSALIND PEPALL —

ITALY
Intarsia Panels

Intarsia is the art of inlaying wood or other materials into a solid wood core in order to create pictures or decorative patterns that visually exploit the colours and textures of the different materials used.[1] In the early fifteenth century, Siena became an important centre for the production of pictorial intarsia, especially under the aegis of master woodworker Domenico Niccolò dei Cori and his pupil Mattia di Nanni.[2]

These three intarsia panels **109** depict personages from the Roman Republic: Curius Dentatus, Pompey and Marcus Curtius. The panels were originally part of a residenza, a bench or seat of civic authority, with as many as ten such panels. Commissioned initially in 1424 from Mattia di Nanni by the city fathers of Siena for the council chamber of the Palazzo Pubblico, it was completed about 1430. The bench, where the city fathers sat in deliberation and dispensed justice and edicts, was placed beneath the fresco *Madonna in Majesty*, or *Maestà*, by Simone Martini, about 1315. The city fathers ruled in the name of their patroness, the Maestà, a symbol of the ultimate source of their power and good governance. Much of the imagery found elsewhere in the Palazzo Pubblico, as in the frescoes of Ambrogio Lorenzetti and Taddeo di Bartolo and works in other media, was intended to amplify the power of the city fathers. The figures depicted on the bench were then perceived as espousing highly moral causes on behalf of the Roman Republic. Siena was thought to have been established during the consulship of Curius Dentatus (about 290 B.C.). The city fathers could thereby manifest the ancient lineage of their good government and republican values at a time when much of the area was in political turmoil.

As an artist, Mattia's extraordinary intarsia technique surpassed that of his master. He used very fine, end-cut laminations of wood, frequently splicing these to achieve more subtle modelling of facial features and gradations of shadows in the folds of the draperies. This is particularly evident in the figure of Curius Dentatus on the left, where Mattia's technique reinforced the sense of volume and depth in the composition, whose early innovative use of perspective reflects the influence of Lorenzo Ghiberti (1378–1455), or the presence of his drawings in Siena. Another outstanding work by Mattia that also shows an awareness of perspective is a figure of Justice, in the Victoria and Albert Museum, which is a panel probably from another furnishing element in the council chamber related to the residenza.[3]

The residenza, of which these panels were a part, remained in the council chamber until January 1809, when it was dismantled and sold. The present panels, along with two others depicting Horace and Cato, which are now lost, have been traced to the early years of the twentieth century.[4] Sometime before the mid-1920s, the present panels were incorporated into another piece of furniture, comprising fifteenth- and sixteenth-century furniture elements and later additions. In 1996, another panel from the residenza depicting Scipio Africanus came to light and was purchased by the Metropolitan Museum of Art, New York (fig. 1). It, together with the Montreal panels and the Justice panel in the Victoria and Albert Museum are highly significant surviving examples of early-fifteenth-century Italian intarsia work. **RL**

1. Antoine M. Wilmering, *The Gubbio Studiolo and its Conservation*, vol. 2, *Italian Renaissance Intarsia* (New York: The Metropolitan Museum of Art, 1999), pp. 3–59. 2. For a full discussion of the relevance of these important panels, see Keith Christiansen, "Mattia di Nanni's Intarsia Bench, for the Palazzo Pubblico, Siena," *The Burlington Magazine*, vol. 139, no. 1131 (June 1997), pp. 372–386, and Antoine M. Wilmering, "Domenico di Niccolò, Mattia di Nanni and the Development of Sienese Intarsia Techniques," *The Burlington Magazine*, vol. 139, no. 1131 (June 1997), pp. 387–397. See also Bruno Santi and Claudio Strinati, *Siena e Roma, Raffaello, Caravaggio e i protagonisti di un legame antico*, exh. cat. (Sienna: Protagon, 2005), pp. 166, 212–215. 3. Christiansen, p. 385. 4. Ibid., pp. 375–376 The present whereabouts of the remaining panels from the residenza are unknown.

ITALY
Cassone

The cassone, or storage chest, remained an essential piece of furniture until the late sixteenth century, when it was gradually superseded by the chest of drawers. Often made for an impending marriage, a cassone might contain the bride's trousseau: sometimes they were made in pairs bearing the armorial devices of the families to be united. Cassoni were arranged along the walls of private rooms, such as a study or bedroom, and some were built into the sides of large beds—fitted with cushions, they served as seating.[1]

Reflecting the sense of style or social status of the owners, cassoni provided an ideal ground for a variety of decorative techniques: inlay, carving, incised and moulded gilt plasterwork, and painted images, often executed by important artists. The pictorial elements of the Museum's piece **110** were delineated by fine lines engraved in the wood in flat relief on a punched background, which was filled in with a coloured paste. The Fountain of Life, an appropriate subject for a marriage chest, is depicted here in a courtly style, whose details, compressed space and composition reflect the influence of Veronese artist Antonio Pisanello and Venetian artists working in the first half of the fifteenth century.[2] These various elements are found in a group of stylistically related cassoni attributed to the area of northeastern Italy delimited by Verona, Venice and the Alto Adige River.[3] **RL**

1. Liubov Faenson, *Italian Cassone from the Art Collections of Soviet Museums* (Leningrad: Aurora Publications, 1983), p. 7. 2. As seen in Pisanello's *Saint George and the Princess*, about 1433, in the Museo Civico, Verona, or his *Vision of Saint Eustache*, about 1440, in the National Gallery, London. 3. Faenson 1983, pls. 137, 141, 146; Frida Schottmüller, *Furniture and Interior Decoration of the Italian Renaissance* (Stuttgart: J. Hoffman, 1928), p. 50, pls. 112–113.

109

Mattia di Nanni
Siena 1403 – Siena 1433
Curius Dentatus,
Pompey and Marcus Curtius
1425–30
Intarsia of walnut, oak, bog oak, various fruitwoods, bone
105.4 x 212 x 3 cm
Gift of the John Main Prayer Association, by prior gift of the J. W. McConnell Family Foundation, 1994.Df.2a-c
PROVENANCE
Palazzo Pubblico, Siena, Sala del Mappamondo (also known as the Sala delle Balestre), about 1429–January 1809; probably Enrico Pelleschi collection, Florence, about 1854–about 1904; Mr. and Mrs. J. W. McConnell, 1924, probably purchased from Giuseppe Salvadori, Florence; The John Main Prayer Association, about 1975–94; acquired by the Museum in 1994.

Fig. 1
Mattia di Nanni, *Scipio Africanus*, 1425–30, intarsia. The Metropolitan Museum of Art, New York.

110

NORTHERN ITALY
Chest (*cassone*)
About 1460
Cedar (?) flat-carved, engraved and punched decoration, traces of pigment, iron
56.5 x 206.5 x 64 cm
Labels on the interior of lid and on the interior of the back panel: *ZEVIO DA VERONA*
Gift of Robert Ferretti di Castelferretto
1998.46
PROVENANCE
Ferretti family, Ancona, Italy, before 1922; Carlo Ferretti, Italy, 1922; estate of Carlo Ferretti, Belgium, 1969; Ferretti Art Establishment, 1992; Robert Ferretti di Castelferretto, London and Pointe-Claire, Quebec, 1998; acquired by the Museum in 1998.

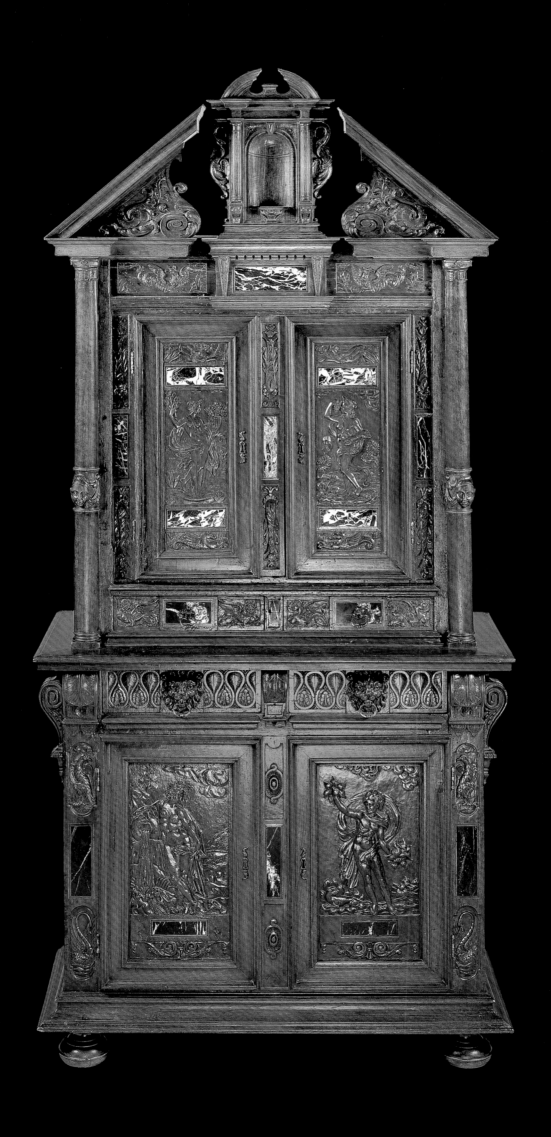

ITALY
Armoire

There was a long tradition in Italy of storing clothes in chests or *cassoni*, but by the late fifteenth century, the armoire, **111** derived from the built-in cupboard found in domestic settings and in church sacristies, had become a furniture type in its own right. Armoires of this kind were also used to store expensive manuscripts and other precious objects. By the time that the armoire had evolved into its large-scale form, intended for prominent placement against the wall of a room, the architectural vocabulary of classical antiquity had been rediscovered by Italian architects and craftsmen, thus early armoires were usually designed in an architectural manner.[1] This type of armoire, with its particular proportions and combination of storage fittings, has been associated with the Emilia-Romagna region of northeastern Italy and the area around Bologna.[2]

The inlaid decoration of the frieze on the armoire's cornice, inspired by architectural elements, depicts a sequence of bucrania (or ox skulls), classical helmets, shields and cuirasses in place of the more customary motif of bucrania alternating with flower heads. Architects who varied the traditional sequence of these designs include Giulio Romano (about 1492–1546), who used helmets, shields and bucrania similar to those found on this armoire in his cornice design for the interior courtyard of the Palazzo del Te, Mantua, of 1524–34.[3] These motifs were used again by Antonio da Sangallo the Younger (1485–1564) in his cornice for the interior courtyard of the Palazzo Farnese, Rome, of 1535–50.[4] These ornamental details became part of the mid-sixteenth century vocabulary of architecture that influenced other designers and craftsmen, and help suggest an approximate date for the making of this armoire. **RL**

1. Silvano Colombo, *L'arte del legno e del mobile in Italia: mobili, rivestimenti, decorazioni, tarsie, dal medioevo al XIX secolo* (Milan: Bramante Editrice, 1981), p. 115. **2.** Giacomo Wannenes, *Mobili d'Italia: Gotico, Rinascimento, Barocco. Storia, stili, mercato* (Milan: Arnoldo Mondadori Editore, 1988), pp. 112–113. **3.** Illustrated in Paolo Portogesi, *Rome of the Renaissance* (London: Phaidon, 1972), pl. 350. **4.** Manfredo Tafuri et al., *Giulio Romano*, exh. cat. (Milan: Electa, 1989), pp. 195, 215, 324–325.

FRANCE
Two-tiered Cabinet

By the time of the Renaissance, when domestic life permitted furnishings of a more stationary type, the plank construction found in earlier movable, trunk-like furniture was replaced by joined panelled construction. More coarsely grained oak was replaced by finely grained walnut, which was better suited to the subtle carving that decorated the larger flat surfaces resulting from panelled construction, as well as to the finely turned components used for structural or decorative elements. Two-tiered cabinets of this configuration, often fitted with a pediment, were made from the second half of the sixteenth century until the early years of the seventeenth.[1] They are often attributed to Paris and the surrounding area of Île-de-France.[2]

The somewhat free use of architectural elements on this cabinet **112** alludes to the vocabulary of contemporary French Renaissance architecture as interpreted in the ornamental designs of artists like Jacques Androuet Du Cerceau (1510–1584). The marble inserts suggest the stone tablets found on the facades of such buildings as the Chateau of Écouen.[3] The smaller carved details of reclining figures, winged dragons, eagles and pelicans derive from engravings by artists working earlier in the century associated with the School of Fontainebleau. The style of the bas-relief decoration on the doors and elsewhere reflects the influence of sculptor Jean Goujon (about 1510–about 1565).[4] The upper doors are carved with allegorical depictions of Summer and Autumn. The lower doors represent Water and Fire, derived from engravings after Hendrick Goltzius (figs. 1 and 2).[5] **RL**

1. Daniel Alcouffe, Anne Dion-Tenenbaum and Amaury Lefébure, *Le Mobilier du Musée de Louvre* (Dijon: Éditions Faton, 1993), vol. 1, p. 38; Daniel Alcouffe et al., *Un Temps d'exubérance. Les arts décoratifs sous Louis-XIII et Anne d'Autriche* (Paris: Éditions des Musées nationaux, 2002), pp. 222–223. **2.** Alcouffe et al. 2002; Jacqueline Boccador, *Le Mobilier Français du moyen age à la Renaissance* (Saint Juste en Chaussée: Éditions d'art Monelle Hayot, 1988), pp. 239–265. **3.** For an illustration of the elevation of the south wing of the interior courtyard facade of the Chateau d'Écouen, see Ivan Cloulas and Michèle Bimbenet-Privat, *Treasures of the French Renaissance* (New York: Harry N. Abrams, 1998), p. 135. **4.** For illustrations of works by Goujon, see Cloulas and Bimbenet-Privat, pp. 183, 203. **5.** Boccador 1988, pp. 262–263.

ENGLAND
Chest of Drawers on Stand

After his period of exile in France and Holland in the mid-seventeenth century, Charles II of England and his court sought to define the style of his restored monarchy by emulating the latest in Continental art, architecture and design then under the artistic dominance of the French court of his cousin, Louis XIV. Expanded trade, through the establishment of a network of trading posts of the Dutch and English East India Companies, fostered greater wealth along with the availability of exotic products including porcelain, lacquer, ivory and wood such as ebony. The Great Fire of London in 1666 precipitated a vast rebuilding program for the central part of the city and an increased demand for furnishings. The 1685 Revocation of the Edict of Nantes brought about an influx of highly skilled craftspeople, with sophisticated tastes and technical skills, from France and Holland.[1] These events ushered in great change as well as artistic and technical innovation with regard to the decorative arts. In the furniture trades, this period saw the rise of the cabinetmaker, whose more sophisticated construction and design skills superseded those of the joiner.

Cabinetmakers could accommodate the tastes of a clientele demanding new furniture forms, such as this chest of drawers on stand **113**. The more traditional technology behind the turned legs is united with dovetail and flat-panel construction of oak or deal, which allows for the elaborate marquetry surface decoration. Thin veneers of European wood like walnut and olive wood were cut on the cross and arranged to exploit the decorative, oyster-like effect of the growth rings. These were combined with more exotic materials, such as ivory and ebony, used for the reserves depicting naturalistic flowers and scrollwork. The subject matter of this marquetry decoration was influenced by *pietra-dura* work, as well as contemporary flower paintings and botanical prints, which reflected a scientific interest in the various exotic species depicted, facilitated in no small measure by expanded trade with overseas colonies. The designs for such cabinets, or chests of drawers on stands, were largely influenced by cabinetmakers like the Dutch-born Pierre Golle (about 1620–1684), who worked in Paris for the French court. **RL**

1. The Edict of Nantes, the 1598 document permitting a degree of religious tolerance to the Protestant community in Catholic France, was revoked by Louis XIV in 1685, thereby making Protestantism illegal. Vast numbers of the Protestant community, which included some of the most highly skilled people in France, left for neigbouring countries, including England, sometimes via Holland.

Figs. 1-2
After Hendrick Goltzius (1558–1617), *Aqua* and *Ignis*, from the series "The Four Elements," 1586, engravings. The Trustees of the British Museum.

111

ITALY
Armoire
About 1535–1600
Walnut, secondary woods, bronze, iron
254 x 254 x 80 cm
Gift of Robert Ferretti di Castelferretto
1998.45.1-18

112

FRANCE
Two-tiered Cabinet
Late 16th century
Walnut, marble, brass
223.5 x 104.5 x 43 cm
Gift of Mrs. Charles F. Martin
1956.Df.6a-e

113

ENGLAND
Chest of Drawers on Stand
About 1680
Walnut veneer inlaid with ivory and various woods, brass
138.5 x 101.6 x 54.3 cm
Gift of Mrs. C. C. Ballantyne
1963.Df.12

ENGLAND
Desk and Bookcase

Usually found in a bedroom or private study, the desk and bookcase combined the functions of storage for clothing and books, a writing desk and fashionable display, while taking up little floor space. This particular example 114 features structural details along with the shaped mirror-glazed doors opening to reveal an elaborately fitted interior and fine burr walnut veneers that are all elements typical of the best London cabinetwork of about 1725–40.[1] It was just this type of well-constructed, practical furniture, conceived essentially for a middle-class market, that established London as a highly successful European cabinetmaking centre in the eighteenth century. **RL**

1. Adam Bowett, *Early Georgian Furniture, 1715–1740* (Woodbridge, Suffolk: Antique Collectors' Club, 2009), pp. 65–81.

FRANCE
Chest of Drawers

The Museum's chest of drawers 115 by Parisian cabinetmaker Jean-Pierre Latz is a superb example of French expertise in design and cabinetmaking in the mid-eighteenth century. It also highlights the Rococo style that characterized interior furnishings and architectural decoration under the reign of Louis XV. The organic lines and exuberance of decoration associated with this style are evident in the commode's serpentine form, the crisp swirls of the rocaille motifs in the marquetry, and the foliated scrolls of the gilt-bronze mounts. The warm red and golden tones of the *Brèche d'Alep* marble top heighten the richness of colour and fine quality of materials used in this piece of furniture.

A typical feature of Latz's work was the marquetry enclosed within whimsical rocaille cartouches and rendered in different hues of wood to give a realistic depiction of every detail in the floral and bird motifs. The light and dark tones of the wood veneer were cleverly juxtaposed to animate the whole surface of the piece. The mounts of gilt bronze—a material well-suited to the robust curves of Rococo design—were a critical element of luxury furniture in eighteenth-century France.

A native of Cologne, Germany, Jean-Pierre Latz arrived in Paris in 1719 at the age of twenty-six, and by 1741 had risen to the title of "Ébéniste privilégié du Roi."[1] He appears to have prospered through the 1740s, as he provided furniture to the royal courts and noble families of Europe. A peculiar twist to his career occurred in 1749, when the Paris guild of metalworkers accused him of illegally producing bronze furniture mounts in his workshop. The casting, chasing and gilding of mounts by specialized artisans were governed by strict rules of the trade. After being brought before the courts, Latz was thereafter obliged to buy mounts from suppliers. The gilt mounts on this commode are less lavish and asymmetrical in design than those made by Latz's own workshop. They have been applied over the marquetry decoration, and were most likely added after Latz's death in 1754. **RP**

1. The main reference for Latz's work is still Henry H. Hawley, "Jean-Pierre Latz, Cabinetmaker," *The Bulletin of the Cleveland Museum of Art*, September/October 1970, pp. 203–259. The author thanks Henry Hawley and Thierry Millerand for their help in the identification of this Latz commode.

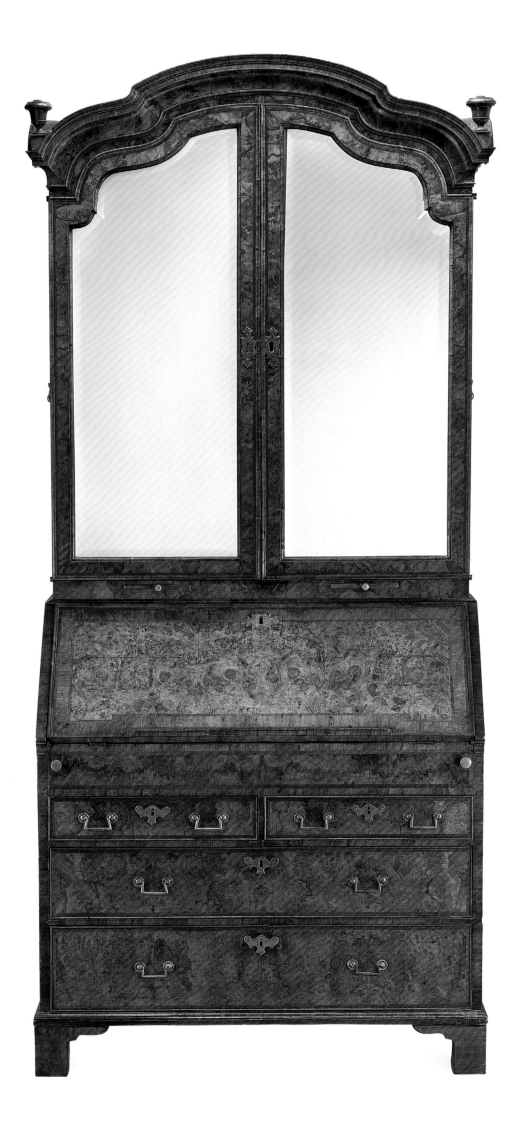

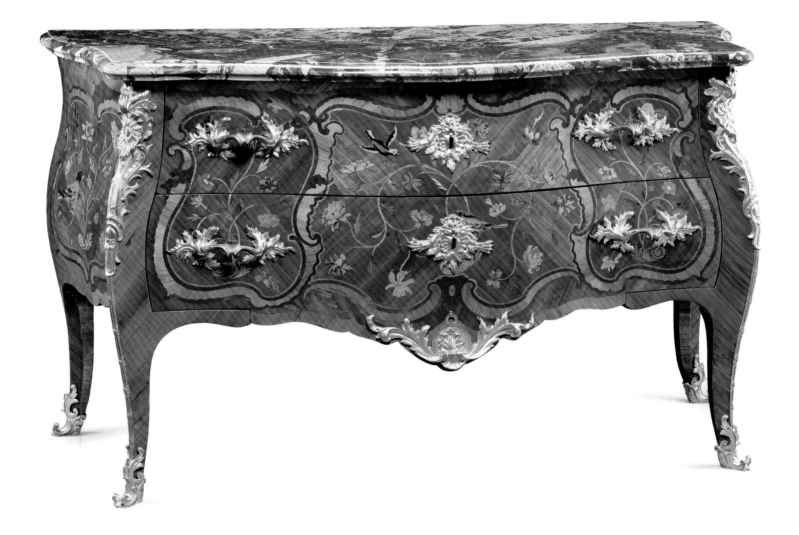

114

ENGLAND
Desk and Bookcase
1705–15
Walnut and burr walnut
veneer on oak carcass,
mirrors (original),
brass hardware
(later drawer handles)
227.3 x 103.5 x 53.2 cm
Purchase, gift of
Sam Steinberg
1956.Df.1
Restoration undertaken
by Canadian Conservation
Institute, Department of
Canadian Heritage, Ottawa,
2011–12.

115

Jean-Pierre Latz
Cologne about 1691 –
Paris 1754
Chest of Drawers
About 1754
Wood veneer and
marquetry, gilt bronze,
Brèche d'Alep marble
86.5 x 148.5 x 66.5 cm
(approx.)
Stamped on bottom
back rail: *I. P. LATZ.* (twice)
Gift of Power Corporation
of Canada in honour of the
Montreal Museum of
Fire Arts' 150th anniversary
2010.43.1-5

(115, detail)

Mahogany increasingly replaced walnut in the making of furniture beginning in the 1740s, primarily as a result of duty-free supplies from British colonies in the West Indies. Mahogany resisted woodworm; it carved well, could be polished to a deep, rich lustre, and had just the right tensile strength for delicate structural members such as the openwork backs of fashionable chairs.[1] Moreover, it had the allure of the exotic. By the mid-1750s, when the Rococo had gained ascendency, mahogany was the wood of choice for better-quality furniture.[2]

The Rococo, one of the most innovative periods in Western art, was a somewhat anti-classical style. It espoused lightness, asymmetry, curvilinear and serpentine lines, and the use of foliage and shell-like motifs with stylistic allusions to the Gothic and the Orient. Although very fashionable in the first half of the eighteenth century in its native France, from whence the style spread across Europe, the Rococo was adopted in England with reservations.[3] There, deemed more appropriate for silver, ceramics and textiles, the style was incorporated into furniture design more as decorative element than as a determining factor in overall form.[4]

The rococo style was disseminated in printed images and pattern books, and embraced by a growing middle-class clientele and its craftsmen suppliers.[5] The best known of these pattern books was Thomas Chippendale's *Gentleman and Cabinet Maker's Director*, first published in London in 1754. Chippendale's book was tremendously successful, both as a public relations stratagem and as a design source inspiring other publications, each promoting new designs.[6] The publisher-designer Matthew Darly, who had engraved many of the designs for Chippendale's *Director*, published his own series of patterns, which incorporated elements devised by another designer, William De la Cour.[7] The looped, open back of this armchair , with its characteristically rococo cabriole legs, was loosely derived from designs by Darly (fig. 1) and De la Cour;[8] the scrolled arm terminals normally found on such chairs have been reshaped. Darly also published a series of designs for one of Chippendale's competitors, the London firm of Ince and Mayhew. A side chair, illustrated on plate IX of their 1759–62 pattern book (fig. 2), was the source for the design of the pierced back splat of this chair , whose outline echoes the shape of a Chinese vase.[9] These pattern books were consulted by furniture makers throughout the English-speaking world, including North America, attesting to their popularity and the demand for novelty. The 1765 pattern book of another English designer, Robert Manwaring, was the source of two patterns for chair backs (fig. 3), whose elements were combined in the design of the back of this chair made in the Boston area, about 1765–80.[10] RL

1. John Hardy, "Rococo Furniture and Carving," in *Rococo, Art and Design in Hogarth's England*, ed. Michael Snodin (London: Trefoil Books for the Victoria and Albert Museum, 1984), pp. 158–159. 2. Michael Snodin and John Styles, *Design and the Decorative Arts: Britain 1500–1900* (London: V&A Publications distributed by Harry N. Abrams, 2001), p. 293. 3. Linda Colley, "The English Rococo, Historical Background," in Snodin 1984, pp. 10–17. 4. Hardy, p. 156. 5. Colley, pp. 13–14. 6. Snodin and Styles 2001, pp. 224–225. 7. Hardy, p. 158. 8. Peter Ward-Jackson, *English Furniture Designs of the Eighteenth Century* (London: H.M.S.O. and the Victoria and Albert Museum, 1959), pl. 19, for chair designs by De la Cour, and pl. 180, for chair designs by Darly. 9. Ince and Mayhew, *The Universal System of Household Furniture* (London, 1759–1762; repr. Chicago: Quadrangle Books, 1960), pl. 9. 10. Robert Manwaring, *The Cabinetmaker's Real Friend and Companion* (London, 1765; repr., London: Alec Tiranti, 1954), pl. 9; Morrison H. Heckscher, in *American Furniture in the Metropolitan Museum of Art: Late Colonial Period. The Queen Anne and Chippendale Styles* (New York: Random House and the Metropolitan Museum of Art, 1985), p. 50, states that Manwaring's pattern book was advertised in the *Boston Newsletter* of January 1, 1767.

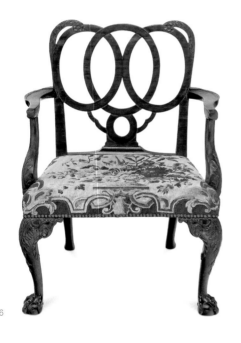

116

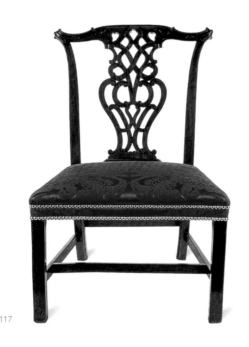

117

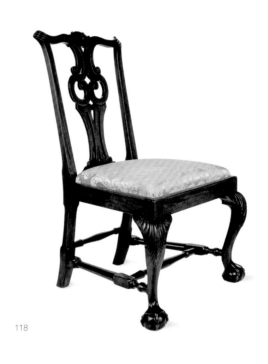

118

116

ENGLAND
Armchair
About 1760
Mahogany, mahogany
veneer, tapestry
93.1 x 70.2 x 61 cm
Anonymous gift
1974.Df.8

Fig. 1
Design for parlour chairs by
Matthew Darly, in Robert
Manwaring's *The Chairmaker's
Guide*, London, 1766.

117

ENGLAND
Chair
About 1765
Mahogany, silk brocade
(not original)
95 x 59.9 x 59.7 cm
Gift of Miss Mabel Molson
1947.Df.1

Fig. 2
Design for parlour chairs
in William Ince and
John Mayhew's *The Universal
System of Household
Furniture*, London, 1759–1762.

118

BOSTON-SALEM REGION
Chair
About 1765–80
Mahogany, silk (not original)
95.7 x 59.3 x 56.9 cm
Bequest of Mrs. William R.
Miller in memory of
her husband
1950.51.Df.27

Fig. 3
Design for parlour chairs
in Robert Manwaring's
*The Cabinetmaker's Real
Friend and Companion*,
London, 1765.

THE NEOCLASSICAL STYLE

— ROBERT LITTLE, ROSALIND PEPALL —

PARIS
Armchair

In Paris, the various guilds involved with the furniture trade encouraged the increased specialization and perfection of the various crafts under their jurisdiction. Sulpice Brizard supervised the making of this chair and stamped it with his mark in accord with the regulations of his guild of *menuisiers* who produced furniture with solid, joined wood, including console tables, certain case pieces and various types of seating furniture. Brizard was, however, only one of several persons involved in producing a chair of this quality and complexity, probably part of a suite of seating furniture of some importance. This type of chair, with a flat back, was customarily meant to be placed along the walls around the perimeter of its intended room setting, where its design complemented the decor (a *siège meublant*). Ensembles of architecture and furnishings of this type were frequently designed by an architect, often in conjunction with an ornamental designer (or *ornemaniste*), as well as a luxury-market dealer-decorator (or *marchand-mercier*). The chair, with its straight legs and compass-drawn curves, sculpted with acanthus leaf and guilloche motif, is in the early neoclassical style. Neoclassicism swept through Europe after the 1760s as the result of the excavations of the ancient cities of Herculaneum (after 1738) and Pompeii (after 1749), which brought classical Greek and Roman architectural and decorative motifs back into fashion.

After determining the design, the chair was put into production. Brizard supervised the making of the frame, determining its shape and providing some simple carving.[1] From his shop on Rue de Cléry, the chair was passed on to several craftspeople, each under a different guild jurisdiction: the carver, or *menuisier-sculpteur*, who carved in its neoclassical motifs; the *peintre-doreur*, who applied its complicated gilded finish; and the *tapissier*, who provided the chair with its upholstery and who may also have sold the chair to the client.[2] Brizard, the only person known in this whole process because of his stamp, may never have come into contact with the client. RL

1. Bill G. B. Pallot, *L'art du siège au XVIIIe siècle en France* (Courbevoie [Paris]: ACR-Gismondi Éditeurs, 1987), pp. 46–52.
2. Pierre Verlet, *French Furniture of the Eighteenth Century* (Charlottesville and London: University Press of Virginia, 1991), pp. 56–63; Pallot 1987, pp. 52–53, 74–89.

PARIS
Desk

The creation of decorative art objects and luxurious furnishings flourished during the early nineteenth century under Napoleon I, crowned Emperor of France in 1804, who placed large commissions with the leading designers of the day for his residences and those of his family. Napoleon's favourite architects, Charles Percier (1764–1838) and Pierre François Léonard Fontaine (1762–1853), provided a basis for the classical vocabulary of the Empire style through their influential publication *Recueil de décorations intérieures* (1801), in which they adapted ancient Roman and Greek design to contemporary architectural interiors and decorative furnishings.

An excellent example of French Empire furniture, this desk **121** is made of mahogany, the preferred wood of the time because of its rich, dark colour and decorative wood grain. Large areas of the desk are left unornamented to show off the quality and lustre of the wood. The front, back and sides of the table are decorated with chased and gilt bronze mounts bearing classical motifs: stylized palm leaves, rosettes and the head of a Gorgon on the central drawer. Two heads of Apollo, the sun god—symbolized by the sunrays around his head—are situated above the front legs and may be swivelled to reveal the locks for the drawers. Panels with their original leather pull out from each end to increase the surface of the desktop. The lyre-shaped legs ending in carved lion feet and resting on high plinths are also characteristic of Empire furniture models. All furnishings of the Empire period, from silver coffee pots to furniture pediments, shared this visual language of classical adornment. Symbols of victory, allegorical references to love and war, and depictions of mythological deities were repeated in architectural ornamentation and decorative objects to give a strong message of a nation united under its powerful leader.[1]

This desk has been attributed to both the well-known Jacob-Desmalter workshop and more probably the rival *ébéniste* Martin-Éloi Lignereux, although there is no firm documentation to prove these attributions.[2] The design of this desk, however, with its strict symmetry, sober geometric lines, monumental appearance, luxurious material and decorative detail, reflects the best of Empire furniture models. RP

1. See Odile Nouvel-Kammerer, *Symbols of Power: Napoleon and the Art of the Empire Style 1800–1815* (New York: Abrams, 2007), pp. 26–39. 2. The Jacob-Desmalter stamps on the piece are not genuine. An almost identical unmarked desk in the Galerie Didier Aaron collection, Paris, is illustrated in Christophe Huchet de Quénetain, *Les styles Consulat et Empire* (Paris: Les Éditions de l'Amateur, 2005), p. 141. De Quénetain attributes the desk to Lignereux based on the description on a bill from this cabinetmaker, submitted to the Duke of Bedford at Woburn Abbey in 1803, for a similar desk (Woburn Abbey Archives, Bedfordshire).

119

Sulpice Brizard
Paris about 1735 –
Paris after 1798
Armchair
About 1770–75
Gessoed and gilded wood,
velvet (not original)
99.2 x 67.3 x 68.5 cm
Stamped on underside of
back seat rail: *S. BRIZARD*
Lady Davis Bequest
1964.Df.3
PROVENANCE
Lady Davis, Montreal;
acquired by the Museum
in 1964

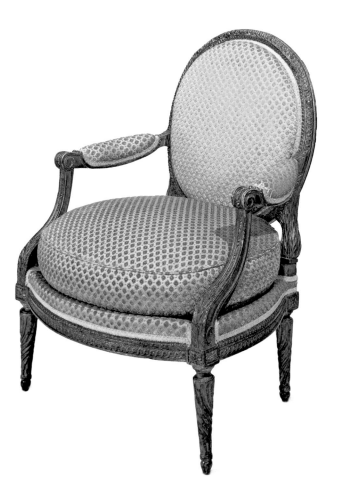

119

This cartonnier 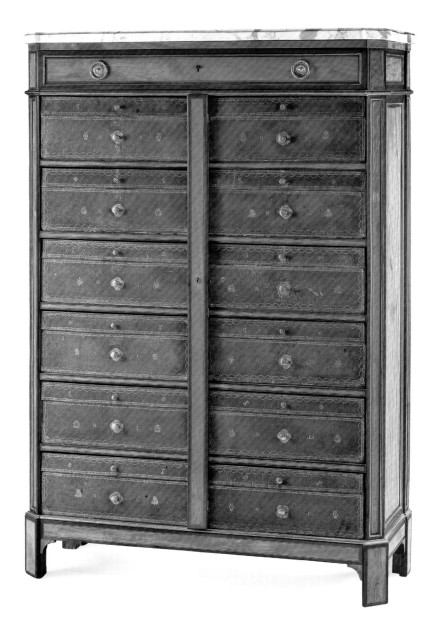, the ancestor of the modern filing cabinet, was used to hold private papers in a wide drawer at the top and twelve individual cardboard drawers. These are faced with their original leather, each one embossed with the letter *N* (for number) and the number one to twelve, as well as an attribute, such as a bow and arrow, a quiver, a lyre, a music stand, a ship, and symbols of gardening and science. Its plain but elegant style in light and dark tones of mahogany with discreet gilt-bronze decoration speaks to the functional purpose of the piece. According to its provenance, it was intended for the Château de Malmaison, and so may have been made by the celebrated Paris cabinetmakers Jacob Frères, although it does not bear their stamped mark. In 1800, Napoleon Bonaparte had commissioned this firm to make all the furniture in the newly renovated Château Malmaison and to design the library where the cartonnier was installed (fig. 1).[1] When Napoleon divorced his Empress Josephine in 1809, he gave her the entire estate of Malmaison and its contents. Josephine maintained it as her residence until her death in 1814.

The cartonnier is included in the estate inventory taken after the death of Josephine de Beauharnais, as No. 476: "one case furniture piece of lemon wood and mahogany with copper trim and white marble top, fitted with twelve cardboard compartments with green Morocco leather and gold lace motifs."[2] In addition to its illustrious provenance—having descended from Napoleon through the family of Josephine's son, Eugène de Beauharnais and his wife, the Duchess of Leuchtenberg (formerly Princess Augusta of Bavaria)—it is interesting that the cartonnier remained in the Beauharnais family and arrived in Canada in the 1950s. According to family history,[3] the furniture remained in the château of the Duke of Leuchtenberg, in Bavaria, throughout World War II. The family fled Germany and arrived in Saint-Sauveur, Quebec, in 1939, and laid claim to the cartonnier after the war.

This piece of furniture was one of the major works in the collection of paintings, sculpture, engravings and decorative arts relating to Napoleon I that had been collected over the years by Montrealer Ben Weider, who was a great authority on the life of the emperor. Many works from this collection were given to the Museum in 2007, including, for example, silver by Martin-Guillaume Biennais [301], one of Napoleon's

familiar hats worn in the Russian campaign, about 1812, and a leather portable writing case inscribed in gilt letters: "Napoléon/Empereur et Roi." RP

1. Information provided to Ben Weider by Bernard Chevallier and Gérald Hubert in correspondence, 1988 and 1989. See manuscript report by France Trinque, "Collection napoléonienne, d'objets d'art décoratifs et d'œuvres d'art offerte en don par Monsieur Ben Weider," September 21, 2007, p. 28 (MMFA Archives). **2.** Serge Grandjean, *Inventaire après décès de l'Impératrice Joséphine à Malmaison* (Paris: RMN, 1964), p. 98, cited in Trinque 2007, pp. 28–29. **3.** Conversation between the author and the Duchess of Leuchtenberg, September 2007.

120

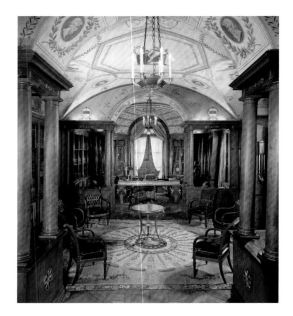

Fig. 1
Napoleon's library, Château de Malmaison, designed by Charles Percier in 1800.

120

Attributed to Jacob Frères
Paris, 1796-1803
Cartonnier Belonging to Napoleon and Joséphine From the Library at Malmaison
After 1796
Mahogany, amaranth, oak, leather, cardboard, marble, copper, gilt bronze
151 x 102 x 41 cm
Numbering on each cardboard drawer: *N1* to *N12*
Ben Weider Collection
2007.602.1-15
PROVENANCE
Joséphine de Beauharnais, La Malmaison; Eugène de Beauharnais (her son), 1814; Duchess of Leuchtenberg (descendant of Eugène de Beauharnais), 1824; private coll.; Ben Weider, Montreal, 1988; acquired by the Museum in 2007.

(120, detail)

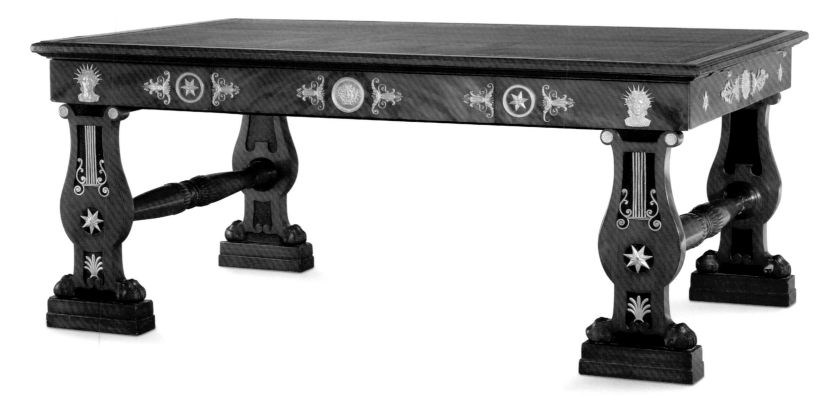

121

121

Possibly Martin-Éloi Lignereux
(1750/52-1809)
Desk
About 1803
Mahogany, mahogany veneer, gilt bronze, leather desktop (not original)
79 x 183 x 113 cm
Gift of Mr. Roger Prigent
2009.13.1-3

(121, details)

VIENNA
Work Table

The playfulness and elegance of Biedermeier design combined with French Empire neoclassicism mark this globe-shaped work table **123** from Vienna. The Biedermeier style flourished in Germany and Austria during a period of peace from the end of the Napoleonic Wars in 1815 to the political upheavals in Europe in the late 1840s. Domestic life became the main focus of attention, and the house was the centre of social activity for musical and literary gatherings, as well as for domestic pastimes. The term "Biedermeier" is coined from the name of a simple-minded character in the literature of the time who believed in the values of sobriety, frugality, comfort and simplicity—values that touched all aspects of culture, although the Biedermeier style is associated primarily with the applied arts.[1]

The main centres of Biedermeier furniture were Vienna and Berlin, yet Russia, Denmark and Sweden had their own regional versions of the style. Houses and apartments of the rising middle class were typically small with modest-sized rooms, necessitating easily movable furniture proportionate to the space. Biedermeier interiors featured an array of graceful, lightweight chairs and a great variety of tables, like this one, for such activities as tea drinking, needlework, writing, games and painting.[2]

The style looked back to the neoclassical models of English late-eighteenth-century furniture featured in the pattern books by designers such as George Hepplewhite and Thomas Sheraton.[3] A graceful English sewing box on a stand in the Museum's collection **122** reveals the simple classical lines, the use of light-coloured wood cleverly contrasted with dark wood, and spare ornamentation and geometric forms, all of which served as inspiration for Biedermeier furniture.

The hinged spherical top of the Biedermeier table opens to reveal inner compartments created in light-toned maple and fruitwood, as well as a miniature stage set, complete with mirrored backdrop, colonnettes, a curved decorative canopy and *trompe l'œil* masonry. The mirrored element may be removed to reveal a hidden set of small drawers for secret documents or valuables. On the work surface are further compartments, some decorated with hand-painted, leaf-scroll motifs in black pen, a frequent decorative feature of Biedermeier furniture. The central compartment with wood bobbins also lifts out to reveal more hidden drawers. These discreet interior spaces, so typical of Biedermeier

furniture, may be seen as a reflection of the desire for privacy and the intimacy of domestic life that characterized the period.

The globe-shape rests on three curved legs with rams' heads and cloven hooves in gilt wood and simulated bronze patina. (The small wooden ring in the centre of the legs is not original). These elaborate classical elements were a carry-over from French Empire design, although the Biedermeier style generally rejected the rich materials and imposing formality of Napoleonic furnishings. **RP**

1. Hans Ottomeyer, Klaus Schröder and Laurie Winters, eds., *Biedermeier: The Invention of Simplicity* (Milwaukee: Milwaukee Art Museum, 2006). **2.** Christian Witt-Dörring, "Cabinet Furniture and Tables," in ibid., p. 82. **3.** An almost identical table is in the British Royal Collection in London, with satyr heads rather than ram heads surmounting the legs and inlaid zodiac signs in a band around the globe. It was purchased in the 1920s by Queen Mary, wife of George V, as a Regency English piece, but was attributed and dated to Vienna, about 1815–20 (Letter to author from Kathryn Jones, Assistant Curator [Works of Art], Royal Collection, Saint James' Palace, London, February 27, 2007).

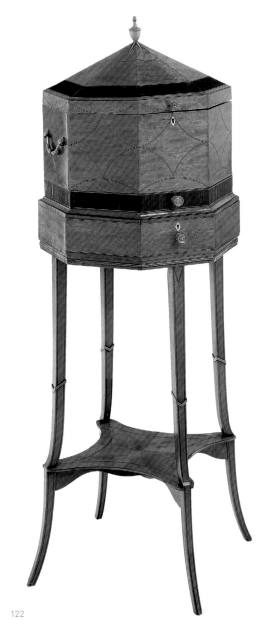

122

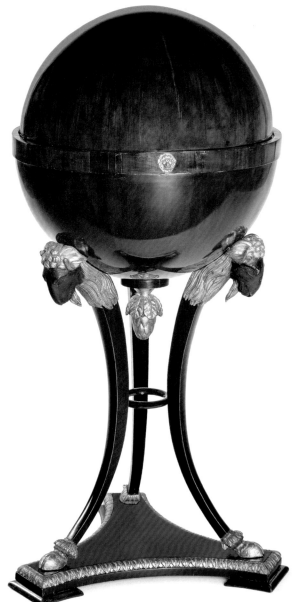

122

ENGLAND
Sewing Box on Stand
1780–1800
Pine veneered with satinwood, rosewood, holly and box, ivory, gilded metal, silk velvet (lining)
H. 115.6 cm; Diam. 51.1 cm
Elizabeth Gillespie
Patten Bequest
1959.Df.2a-b

123

AUSTRIA, VIENNA
Globe-shaped
Biedermeier Work Table
About 1815–20
Maple veneer, bird's-eye maple, various fruitwoods, gilded and painted wood, mirror, brass, penwork
94 x 46 x 40.2 cm
Purchase,
Deutsche Bank Fund
2007.102.1-12

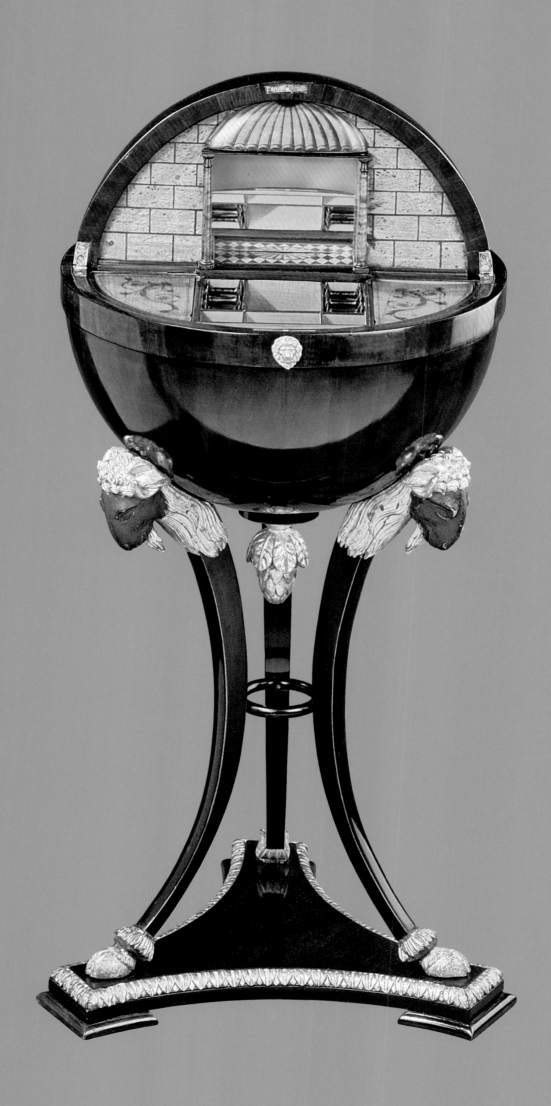

EARLY QUEBEC FURNITURE

— ROSS FOX —

Furniture making was one of the few viable trades in New France because the sheer bulk of furniture rendered its overseas transportation both impractical and costly, whereas a variety and abundance of raw material was immediately at hand. There was pine, yellow birch, butternut, cherry, ash, among many other types of wood. The styles of furniture that predominated reflect the styles of the regions of France the colonists originated from, above all, Île-de-France, Normandy and Poitou-Charentes. Similar to the French provinces, once a style was introduced, it was retained longer than in Paris itself. In the colony, this tendency to longevity was bolstered by its geographic remoteness. The Louis XIII style predominated in New France, although by the mid-eighteenth century it coexisted with more contemporary developments: the Regency and Louis XV styles. A two-tiered buffet **124** —a generalized reinterpretation of a basic Renaissance form with broken pediment—is a rare early example in the Louis XIII style, characterized above all by carved diamond-point motifs.

Case furniture was built of solid wood according to the frame-and-panel joinery system developed in the Middle Ages. It was the domain of the joiner (*menuisier*), rather than the cabinetmaker (*ébéniste*) per se, the former term being applied equally to the house carpenter and furniture maker. In the case of New France, it is especially difficult to distinguish between the two occupations, as both overlapped as a result of necessity and a relaxed craft organization, unlike in France, where the crafts were strictly regulated.

As it was not the custom for furniture makers to apply a signature or label to their products, it is difficult to attribute a piece of furniture to a particular maker. A rare example of a "signed" piece is a side chair bearing the signature "Michel Cureux" for Michel-Marie Cureux, dit Saint-Germain (1698–1780), of Quebec City **125** . If indeed he was the maker, his chair speaks to the versatility of colonial woodworkers, for Cureux appears in records as a cooper, or maker of barrels. By comparison, Germain Villiard (1693–1749), of Quebec City, ranked among the upper echelons of the craft world. Archival records show he was a maker of case furniture, specializing in chests of drawers, or commodes, but he also made seating such as settees.[1] These were high-end forms that were newly introduced into the colony during the eighteenth century: no doubt they were in the Louis XV style. An outstanding piece from this period is a transitional Regency/Louis XV two-tiered buffet with a bonnet top, or *en chapeau*, and carved fruit-basket motif on its upper doors **128** . Its overall design derives from a characteristic type of northern France.[2]

The British ascendancy in Canada that was sealed by the Treaty of Paris in 1763 brought about a gradual transformation in fashion that was driven by new cultural impulses. The American Revolution and later the Constitutional Act of 1791 brought an influx of Americans. Then, in the aftermath of the War of 1812, British policy encouraged immigration from England to counteract American influences in the colony. The coexistence and convergence of these various cultures is echoed in the evolution of three stylistic tendencies in furniture: the French, with the Louis XV style preferred for finer furniture and the Louis XIII for vernacular pieces; the English styles, reflecting major trends in Britain and the northeastern United States; and a hybridization of French and English designs.

A great deal of Quebec furniture retained a French character: the Louis XIII style persisted until the late eighteenth century and was simultaneously superseded by Louis XV designs into the nineteenth century, especially in the Montreal area. Among the more successful forms was the chest of drawers, which, along with the wardrobe, or armoire, tended to proliferate, concomitant with a rapidly growing population and increased prosperity.

The traditional furniture trade in Quebec was gradually transformed as a result of the new British presence. English-style furniture design began to take hold through imports and immigrant cabinetmakers who brought new construction techniques, new forms (such as sideboards

and card tables), and different preferences in wood. True cabinetmaking was introduced, that is, veneer with expensive wood and the dovetail joint as basic to all case furniture. Mahogany was the wood of choice for fine furniture, cherry and maple for middling pieces. Because the French and English techniques of construction were so different, there was limited crossover of furniture makers working in both manners.

Identifiable English-style Quebec furniture dating before the 1820s is relatively scarce.[3] Nevertheless, several dichotomies can be discerned in what survives due to divisions within the Anglophone population itself. In Quebec City, Scots were at the fore in the furniture trade, while, in Montreal, Americans dominated in the fifteen years before the War of 1812. Montreal English-style furniture from the same period often displays a New England cast, indicative of where many of the cabinetmakers originated. The style in Quebec City, on the other hand, is more emphatically English. Samuel Park (1766–1818), a native of Massachusetts, operated a large furniture wareroom (or showroom), which served as a hub of the furniture trade in Montreal.[4] An American Federal-style design aspect can be perceived in a side table, which may be a product of a cabinetmaker from New England.[5] After 1815, a virtual inundation of immigrants from the British Isles ended the reliance on American inspiration, and the English Regency style took hold over the next decade.

In another stylistic direction, English and American design elements were adopted by cabinetmakers who continued to work in Quebec's traditional French styles. These elements were appended to essentially French forms in a hybridization that was a distinctly Quebec stylistic manifestation. The origin of the specific type was probably a workshop such as that of John Devereux (active late 1780s–90s) of Montreal, who advertised in 1787 that he had in his employ "workmen who are capable to execute any commissions . . . either in the English or French taste."[6] While this kind of hybridization began to wane by the third decade of the nineteenth century, it persisted in rural areas.

The chest of drawers, or *commode en arbalète*, with claw-and-ball feet **127** , which was found with some frequency in Quebec during the second half of the eighteenth century, is often said to epitomize furniture in this category—the case as French, the feet as English. But the typically lumpish feet with rudimentary talons actually have their closest parallel in the furniture of Bordeaux, France, and the *commode en arbalète* with claw-and-ball feet would seem to be thoroughly French in derivation.[7]

1. Probate inventory, Archives du Québec, Quebec City, Greffe Claude Barolet, August 29, 1750. Also see Paul-Louis Martin, "A Master Cabinetmaker in the Capital of New France: Germain Villiard (1693–1749)," in Michel Lessard, *Antique Furniture of Québec: Four Centuries of Furniture Making* (Toronto: M&S, 2002), p. 150.
2. "Les buffets deux-corps régionaux," *France Antiquités*, vol. 188 (November 2006), pp. 4–15.
3. According to archival records, a considerable amount of furniture was produced by Anglophone cabinetmakers in Quebec during this period.
4. The size of Park's operation is suggested by an advertisement in the *Canadian Courant and Montreal Advertiser* of February 17, 1812, which listed among his stock: thirty-six desks and bureaus, five secretary bookcases, twenty-five breakfast tables, nine card tables, six hundred Windsor and fancy chairs, among other items.
5. The contrasting of mahogany and maple veneers is associated with northeastern Massachusetts and New Hampshire. The form of the table with two drawers has an equivalent in a group of tables from Vermont. See Kenneth Joel Zogry, *The Best the Country Affords: Vermont Furniture 1765–1850* (Bennington, Vermont: The Bennington Museum, 1995), p. 40.
6. *Montreal Gazette*, September 26, 1787.
7. Louis Malfoy, *Le meuble de port : Un patrimoine redécouvert* (Paris: Les Éditions de l'Amateur, 1992), pp. 87, 119.

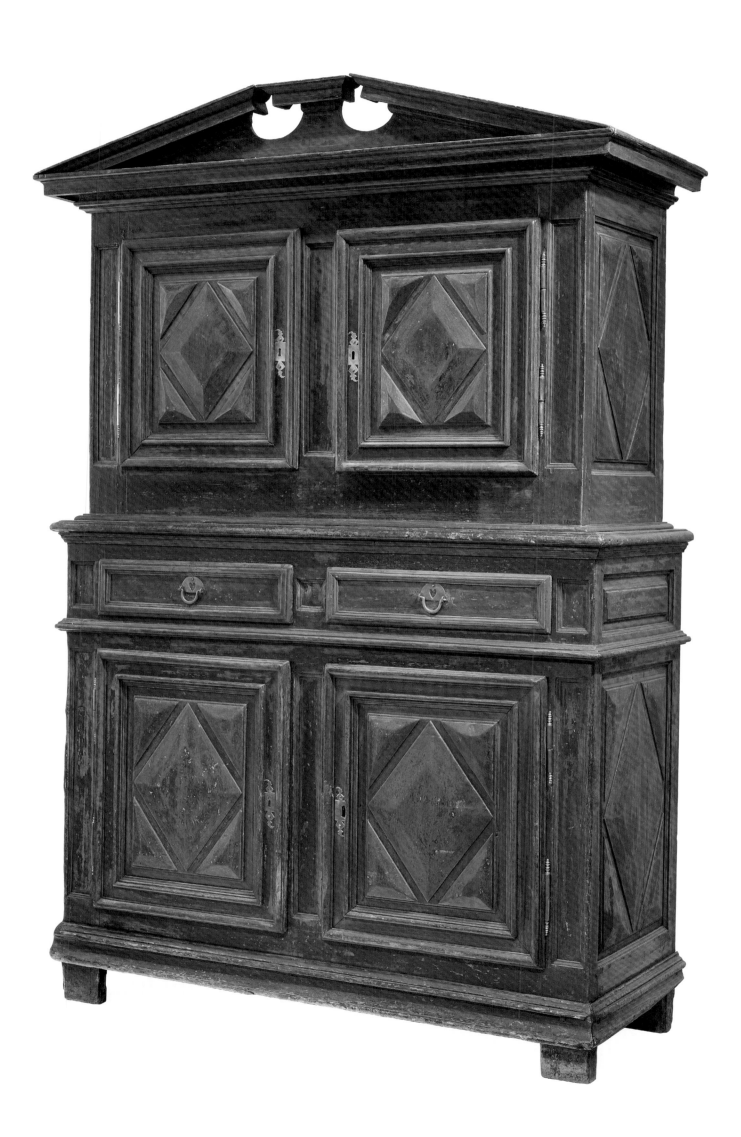

125

126

127

128

PHILIPPE LIÉBERT
Sacred Heart Altar

The Catholic Church, pervasive since the colony's early days, was quick to promote the work of local sculptors for religious purposes. However, few of these works have survived, and often the archives that would have facilitated attribution have disappeared. The Sacred Heart altar of Montreal's Sisters of Charity **129**, known as the Grey Nuns, made for the chapel of their General Hospital, remains an invaluable example of late-eighteenth-century sculpture. Its stylistic qualities and iconographic program make it attributable to Philippe Liébert, a major figure of the period.

Born in Nemours, in the French region of Île-de-France, Philippe Liébert arrived in New France a few years before the British Conquest (1760). Although we know nothing about his training, the high quality of his work suggests that he probably received his instruction in France. His Canadian career began in L'Assomption and Repentigny in 1760, but it was the altars he completed upon his return from the War of American Independence in 1785 that set him apart. His highly contoured altar, described as "à la romaine" and in the spirit of the rococo Louis XV style, was an adaptation of the console table that appeared in France in the first third of the eighteenth century. In terms of both shape and decorative elements, this type of altar in the form of a tomb would serve as a model for the Écores workshop and its apprentices throughout the Montreal region. This vocabulary continued to be used throughout the nineteenth century.

Compared to the high altars richly decorated by Liébert, the Sacred Heart altar is sparer, like traditional side altars. It is admired by Quebec art historians for its balanced proportions and its elegance. Decorative elements and bas-reliefs are judiciously distributed. The three-panelled tabernacle sports a single gradine (altar shelf) adorned with foliage forming a shelf bearing the Eucharistic reserve. In the upper half, order is imposed by the Ionic colonettes flanking the shouldered, semicircular arched panels decorated with narrative bas-reliefs. The pedestal is ornamented with garlands and motifs of leaves and flowers in gilded putty.[1] Two decorative ailerons on either side provide counterpoint to the tomb's curves and add to the symmetry and harmony of the whole. The entablature was probably once crowned by ornamental fire pots (*pots à feu*).

The bas-relief adorning the tabernacle door, surmounted by the three winged heads of cherubs, depicts the Good Shepherd, a recurring motif in Liébert's work. On the left is Saint Margaret of Antioch, called upon by some women in labour, whose first name suggests Marguerite d'Youville, founder of the order of Grey Nuns and the first Canadian to be beatified in 1959 and then canonized in 1990, who ministered to foundlings and orphans. It was Marguerite d'Youville who opened the Sacred Heart Chapel in 1760, which received this altar about 1790. On the right, in keeping with tradition, Saint Augustine is depicted conferring with a child about the mystery of the Holy Trinity. At the bottom centre of the tomb is a relief carving of the infant Saint John the Baptist in a landscape with a lamb and holding a cross, his attributes. Above him is the flaming heart encircled by a crown of thorns and a halo of clouds, a symbol associated with the Grey Nuns. The tomb's convex and concave corners are ornamented with the winged heads of cherubs and lions' claws.

The cleaning and restoration currently being administered to the tomb painted with a bluish marbling, to the gradine's bright red surface and to the mordant gilding[2] that covers the entire piece— perhaps applied by the Sisters, who were gilders— will restore the raised decoration and reflective effects the piece originally displayed.[3] **JDR**

1. Liébert would be the first Quebec sculptor to use putty, composed of chalk and a binder, to create certain decorations in low relief. 2. Mordant gilding requires an oil-based layer to affix the gold leaf onto a surface. The mordant is made mainly with linseed oil combined with a dryer (lead oxide). 3. Claude Payer, Restoration Report, Centre de conservation du Québec, January 22, 2008.

124

QUEBEC, DESCHAMBAULT
Two-tiered Buffet
1700–25
Pine
219 x 142.5 x 56.5 cm
Purchase
1938.Df.6

125

Michel-Marie Cureux,
dit Saint-Germain
(?) 1698 – (?) 1780
Chair
18th c.
Wood, upholstery
(not original)
100 x 50 x 47 cm
Signed in ink,
back of front rail:
Michel CUREUX
Purchase, Marjorie
Caverhill Bequest
1981.Df.1
PROVENANCE
Rosaire Saint-Pierre,
Beaumont, Quebec, 1962;
acquired by the Museum
in 1981.

126

QUEBEC
"Os de mouton"
Armchair
18th c.
Birch, upholstery
(not original)
101 x 69.5 x 55 cm
Purchase
1934.Df.22

127

QUEBEC
Chest of Drawers
Late 18th c.
Pine, maple
89.4 x 115.8 x 62.2 cm
Purchase, gift of
Miss Mabel Molson
1938.Df.8

128

QUEBEC, LOTBINIÈRE
Two-tiered Buffet
Late 18th c.
Pine
255 x 155 x 65.1 cm
Gift of Miss Mabel Molson
1938.Df.13a-b

129

Philippe Liébert
Nemours, France, 1732 –
Montreal 1804
Sacred Heart Altar
The Grey Nuns of Montreal's
General Hospital
1790
Pine, white walnut, basswood,
putty, paint, gold leaf
Tabernacle:
132.5 x 221 x 56 cm;
tomb: 100 x 204 x 96.5 cm
Gift of Concordia University
in honour of the legacy
of the Sisters of Charity
of Montreal, "Grey Nuns"
2009.14

(129, details)

THE VICTORIAN ERA

— ROBERT LITTLE, ROSALIND PEPALL —

THOMAS FOX

The Victorian period (1837–1901) was one of many paradoxes. The increasing use of machine processes made possible the production of a vast supply of manufactured goods, designed in a wide variety of styles, to a broader spectrum of consumers at a reduced cost. However, this often came at the expense of good design, causing better made, foreign imports to dominate the higher end of the market. This situation became evident at the Great London Exhibitions, which showcased British alongside foreign goods. By the end of the century, design reformers like William Morris and his followers in the Arts and Crafts Movement succeeded in making English high-end goods respected throughout Europe, but they found the appropriate use of machines in their production a challenge, which they left to designers and manufacturers in other countries.

London cabinetmaker Thomas Fox had evidently established a reputation for making very high-quality furniture, for according to 1839 trade directories he was "Upholder by Appointment to the Honorable East India Company." His reputation was such that his work merited being exhibited in both the 1851 and 1862 London International Exhibitions.[1] The present piece **130** was featured in the latter exhibition and illustrated in its accompanying catalogue (fig. 1).[2] By this period, international exhibitions were a useful venue for the marketing of both manufactured as well as handmade goods promoting the latest styles. This work, with its finely carved details, delicate arabesque fretwork panels, and elaborate scroll and strapwork inlays applied to both flat and curved surfaces, is a tour de force of the cabinetmaker's skills. Its lower shelves are compartmented with panels of decorative acid-etched glass and are backed with large panels of mirror glass meant to reflect the various *objets de vertu* such a piece was intended to display. The cabinet is topped with a large central mirrored glass panel flanked by smaller, open and enclosed glazed display shelves. This lavish use of glass may reflect the range of goods made by the existing company that Fox apparently purchased in 1839, Cooper, Elliott & Cooper. Originally founded by a Joseph Cooper in 1780, the company was described in 1820 by its then proprietor, Henry Cooper, as "cabinet-makers, upholsterers and looking-glass makers."[3] The cabinet was intended to be placed in a prominent position, as the 1862 catalogue suggests, at "the end or side of a drawing room." Stylistically, the cabinet would fit into the stylistic context of the Renaissance revival, one of several historical styles fashionable during the Victorian period,[4] and one that may have reflected the influence, and presence in England, of Gottfried Semper (1803–1879), the German architect, art theorist, and friend of Prince Albert, who personally promoted the London International Exhibitions. **RL**

1. *The Art-Journal Illustrated Catalogue of the Industries of All Nations* (London: James S. Virtue, 1851), reprinted as *The Great Exhibition London 1851* (New York: Bounty Books a Division of Crown Publishers, 1970), p. 258. **2.** *Art-Journal Illustrated Catalogue of the International Exhibition* (London: James S. Virtue, 1862), p. 255. **3.** Patrick Beaver, "Survival: The Story of Thomas Fox & Company Ltd.," from the Thomas Fox Company website: http://www.thomasfox.co.uk/aboutus%20the%20book.htm (accessed May 10, 2010). **4.** John R. Porter, ed., *Living in Style: Fine Furniture in Victorian Quebec* (Montreal: The Montreal Museum of Fine Arts, 1993)—the Fox buffet is illustrated on p. 410, cat. 362.

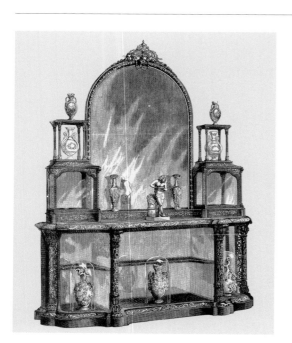

Fig. 1
Thomas Fox's display cabinet, illustrated in the catalogue of the 1862 London International Exhibition.

130

Thomas Fox
Active in London, 1839 or earlier–after 1862
Display Cabinet
About 1862
Walnut, holly, pine, acid-etched glass, metal, mirrors, original velvet
262.6 x 213.4 x 64.1 cm
Made for the 1862 London International Exhibition
Purchase, Dr. and Mrs. Max Stern Bequest
1990.Df.6
PROVENANCE
Godfrey Rhodes, Rawdon Hill, Yorkshire, England, 1862 (Rhodes emigrated from England and in 1905 settled in the Villa Cataraqui in Sillery, near Quebec City); Catherine J. Tudor-Hart (his daughter), Quebec City; estate of Catherine J. Tudor-Hart, 1972; Louis Zaor, Quebec City, 1973; acquired by the Museum in 1991.

(130, detail)

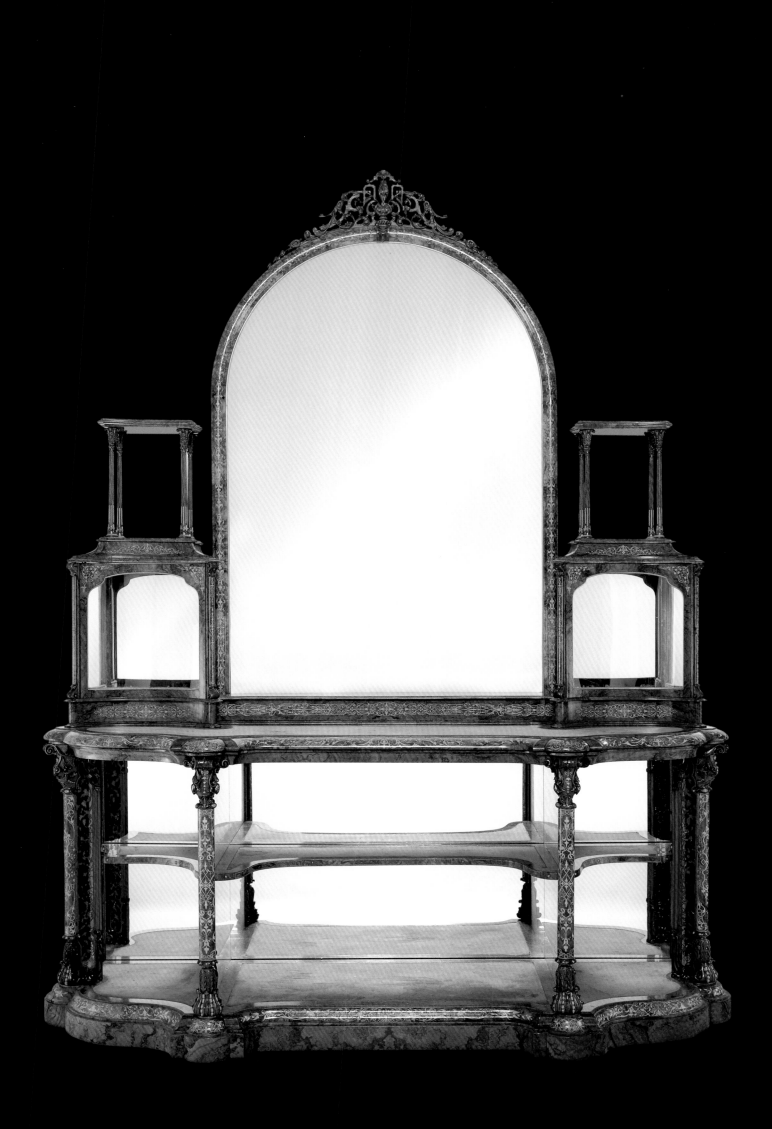

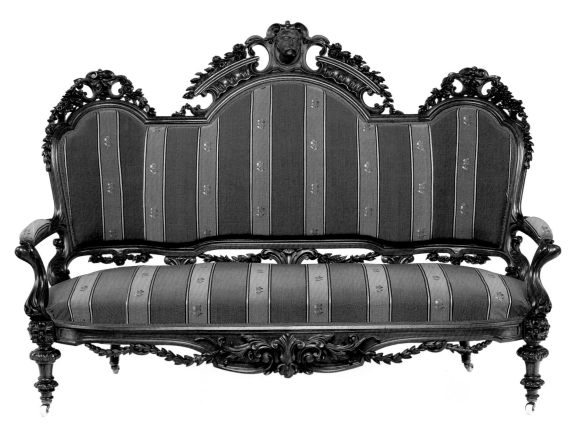

131-132

133

FRANÇOIS GOURDEAU

This gracious drawing-room ensemble **131**-**136** was made by Quebec City cabinetmaker François Gourdeau at the height of the Victorian era. Composed of a settee, or canapé, male and female armchairs, six additional chairs, two game tables, a console table and a mirror, the furniture is made of black walnut, an easily carved wood that lent itself to the elaborate floral and scroll motifs in an eclectic mix of historical references. The hand-sculpted human heads on the crest rails of each piece are typical of the Victorian delight in extravagant ornamentation that graces so much late-nineteenth-century furniture. As in medieval tradition, the craftsman created individual features for each head (perhaps members of the client's family) with a freedom of expression and handcraftsmanship that was lost with the advent of mass production. By good fortune at the time of acquisition in 1986, the chairs retained their original green silk upholstery, and unused swaths of the material had been preserved. It was used to replace the damaged upholstery during the restoration of the suite.

François Gourdeau grew up in a family of furniture makers, and by 1864 was running his own business in Quebec City.[1] According to newspaper accounts of the time, Gourdeau, "meublier-bourreur" [furniture maker–upholsterer], had a thriving business, and was especially noted for his drawing-room furniture. The Quebec census of 1871 reported that fifteen men and one woman were employed by his factory, which produced 800 pieces of furniture annually.[2] Gourdeau was proud to announce in the firm's advertisement of 1870 that he kept up with the French styles: "We are in a position to execute the most considerable and finest commissions. Every three months, we receive from Paris design plates for furniture and furnished rooms illustrating the latest French fashions. The designs are from the famous firm of Gilmard [sic] et Cie."[3]

At the time, Gourdeau was competing with the major Quebec cabinetmaking firms, such as John and William Hilton of Montreal, William Drum of Quebec City, and even the large Toronto firm Jacques and Hay, which carried out commissions for Montreal clients.[4] The rich decoration and materials of this suite met the expectations of its owner, who wished to show his up-to-date taste and status in society. Commenting on Gourdeau's drawing-room furniture in 1870, the editor of the Quebec City newspaper *L'Événement* gushed: "There is no better to be seen in either New York or Paris."[5] **RP**

1. John R. Porter and Yves Lacasse, "François Gourdeau, Furniture Maker," in *Living in Style: Fine Furniture in Victorian Quebec*, exh. cat., ed. John R. Porter (Montreal: The Montreal Museum of Fine Arts, 1993), pp. 299–303. **2.** *Living in Style*, p. 299. **3.** Advertisement published in *L'Événement* (Quebec City), May 7, 1870, reproduced in *Living in Style*, p. 275. The advertisement refers to the lithographic plates of furniture published in Désiré Guilmard, *Garde-meuble ancien et moderne*, Paris, from 1839 to about 1935. **4.** The Museum has the bedroom furniture, by Jacques and Hay, made for the Prince of Wales' visit to Montreal in 1860. See *Living in Style*, pp. 55–58. **5.** *L'Événement*, April 9, 1870, cited in *Living in Style*, p. 299.

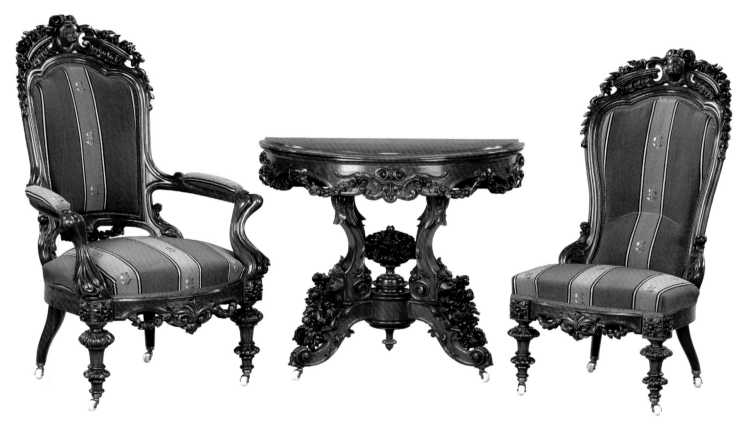

134 135 136

131 - 136

Workshop of
François Gourdeau
Active in Quebec City,
1864–1816
Mirror
About 1870
Walnut, glass
212 x 81 cm
Pier-table
About 1870
Walnut
79 x 82 x 41.5 cm
Sofa
About l870
Walnut, silk upholstery
(restored with the
same vintage fabric)
144 x 180 x 68 cm
Armchair
About 1870
Walnut, silk upholstery
(restored with the
same vintage fabric)
119.5 x 75 x 61 cm

Game Table
About 1870
Walnut, pine
H. 78 cm; Diam. 89.5 cm
(open)
Fireside Chair
About 1870
Walnut, silk upholstery
(restored with the
same vintage fabric)
111 x 75 x 53 cm
Gift of the Succession
J.A. DeSève
1986.Df.10
1987.Df.1
1986.Df.1
1986.Df.2
1987.Df.3
1986.Df.3
PROVENANCE
Théophile Levasseur, Quebec
City, about 1870; Blanche
Brochu (his niece), Quebec
City; Lucille Brochu (her
daughter), Quebec City;
Louis Zaor, Quebec City;
acquired by the Museum
in 1986.

(133, detail)

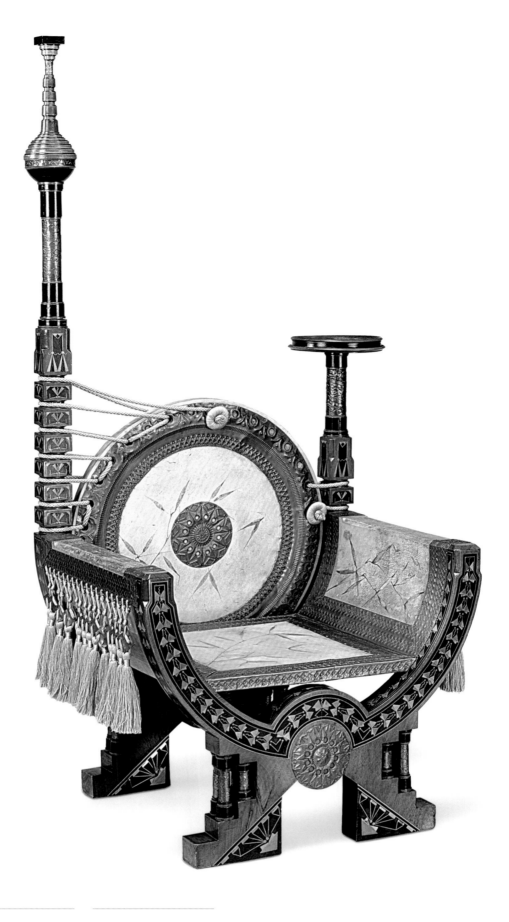

137

137

Carlo Bugatti
Milan 1856 –
Molsheim, France, 1940
Armchair
About 1895
Wood, parchment,
brass, metal, silk
149 x 75 x 58 cm
Purchase, Deutsche
Bank Fund
2002.9.1-2
PROVENANCE
Alain Lesieutre, Paris;
acquired by the Museum
in 2002.

138

Carlo Zen
Verona 1851 –
Lanzo d'Intelvi, Italy, 1918
Cabinet
1902
Mahogany, mother-of-pearl,
silver and brass inlay
198 x 94.5 x 31.8 cm
Purchase, Serge Desroches,
Hermina Thau, David R.
Morrice, Mary Eccles,
Jean Agnes Reid Fleming,
Geraldine C. Chisholm,
Margaret A. Reid, F. Eleanore
Morrice Bequests
2001.73.1-5

139

Duilio Cambellotti
Rome 1876 - Rome 1960
Lectern
1923
Walnut, maple marquetry,
copper plaques
Metalwork: Albert Gerardi
(1889-1965)
116 x 118 x 45 cm
Purchase, the Museum
Campaign 1988-1993 Fund
2004.143

TRADITION AND MODERNITY

— ROSALIND PEPALL —

CARLO BUGATTI

The most original Italian furniture designer in the early twentieth century was undoubtedly Carlo Bugatti. The form and decoration of his works are characterized by contrasts of textures and materials, and by an eclectic array of references ranging from Japanese calligraphy to Islamic architecture. His works are so individual that their style defies classification. The Museum's chair **137** is a showpiece of the one-of-a-kind, handcrafted work that was possible in its day in a country like Italy, where the craft traditions were strong.

After studies in his native city of Milan and in Paris, Bugatti established a cabinetmaking workshop in Milan, and by the 1890s, he was exhibiting in many international exhibitions: Antwerp in 1894, Amsterdam in 1895, Turin in 1898, and Paris in 1900, where he won a silver medal at the Exposition Universelle. Bugatti's work reached a highpoint of exuberance and imagination in the ensembles he created, especially in the Snail Room, shown in 1902 at the Turin Esposizione Internazionale d'Arte Decorativa Moderna, where he was awarded first prize.

This chair combines all the features of the master's work of the 1890s period: the eclectic range of motifs inspired from other cultures; the X-shaped legs based on Roman "curule" seats; the playful use of columnar elements, especially the tall, turned finial that rises like a minaret from the back; and the painted Japanese-style brushwork on the parchment surfaces of the back, arms and seat. The silk cords attached to the back serve a decorative rather than structural purpose by providing a visual link between the seat and the towering finial. (The shorter circular finial once had a fringe of tassels.) The ziggurat-like stepped feet and the stylized patterns of inlaid brass and white metal on the arms and legs may be considered precursors to motifs of the Art Deco style.[1]

Bugatti's extravagant inventions marked the beginning of Italy's break with its classical tradition and its pursuit of new and individual forms of expression at the dawn of the twentieth century. **RP**

1. This chair was included in the Carlo Bugatti exhibition at the Musée d'Orsay, Paris, 2001 (cat. 27).

CARLO ZEN

Carlo Zen had been operating a successful furniture factory in Milan since 1881 when he participated in the Italian section of the Paris Exposition Universelle of 1900. He was quick to respond to the prevailing Art Nouveau style at the exhibition, and two years later Zen exhibited this solid mahogany cabinet **138** with an ensemble of furniture at the Turin International Exhibition of Modern Decorative Art in 1902. It exemplifies the designer's wish to break from a reliance on historical furniture styles and become part of the international design movement in Europe. The flat surfaces are decorated with intricately inlaid filaments of brass and silver, and floral patterns of mother-of-pearl; these were characteristic of Italian work and of Zen's furniture in particular.

In the ensuing decade, the spread of Art Nouveau design through the furniture centres of northern Italy was largely due to manufacturers like Zen, who aimed to please the rising middle class by offering high-quality furniture in the new

style, referred to in Italy as the Stile Floreale or Stile Liberty. As with Art Nouveau in France, emphasis on nature as a source of decoration was a key element. **RP**

DUILIO CAMBELLOTTI

Another later piece that offers a uniquely individual approach in Italian design is a lectern by Duilio Cambellotti **139**, a major figure in the reform of the applied arts in Rome in the early twentieth century. Trained as a sculptor, Cambellotti was also a painter, graphic artist, ceramicist and furniture designer.[1] He presented this lectern as part of a studio ensemble in the first Italian exhibition of international decorative arts at Monza in 1923 (the forerunner of the present-day Milan Triennales). Intended more to display a precious book than to be used for reading, this unique lectern combines many features of Cambellotti's output. His love of the wood medium is apparent in this solid walnut lectern carved like a three-dimensional work of sculpture. Cambellotti was drawn to the rural life, and the people and animals of the Roman countryside often appear as subjects in his pieces. A horse's eyes and muzzle reveal themselves in the actual wood grain of the lectern's book support, and the reference to horses' heads is carried over in the copper plaques at the front. Cambellotti's interest in vernacular, traditional craftsmanship and simple honest construction is evident in this lectern. Even as the country progressed industrially, modern Italian design never fully gave up the ideals associated with handcraftsmanship. **RP**

1. See Irene de Guttry, Maria-Paula Maino and Gloria Raimondi, *Duilio Cambellotti. Arredi e Decorazioni* (Rome: Gius, Laterz & Figli, 1999).

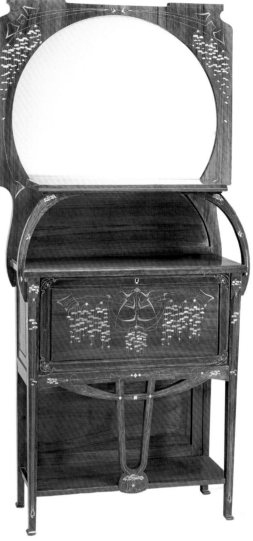

138

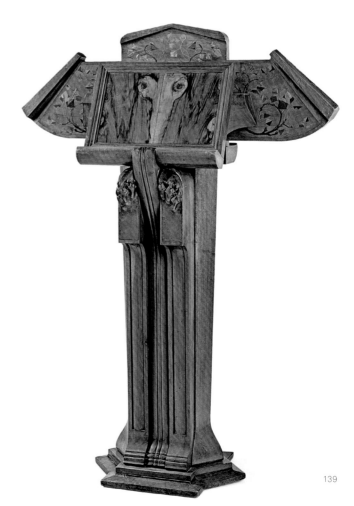

139

LARS KINSARVIK

Decorated along the legs, back, arms and edge of the seat with carved interlaced patterns, human masks and dragon-head finials, and painted in lively colours of yellow, blue, green and red, this handcrafted armchair **140** from Norway is an excellent example of what is referred to as the "Viking Style" or "dragon style" of decoration in Scandinavian applied art of the late nineteenth century. Interest in Viking art was especially pronounced in Norway, where ship-burial grounds from the ninth and tenth centuries were excavated at Tune (1867) and Gokstad (1880). The curvilinear plant and animal motifs of Viking art served as models for the designs of Scandinavian artists of the time working in the traditional crafts of wood-carving, metalwork and tapestry weaving.

In the 1890s, a revival of ancient Nordic culture became equated with the search for a national identity. For many centuries, Norway had been dominated, both politically and culturally, first by Denmark, and after 1814 by Sweden. Leading up to its gaining independence in 1905, Norway expressed its nationalist pride through the rediscovery of its literary, musical and artistic heritage, and through a revival of traditional Norwegian crafts.[1]

More than any of his contemporaries, Lars Kinsarvik helped to revitalize the art of wood-carving. He was one of the founders of the Norske Husflidsforening [Association for Home Arts and Crafts], established in 1891 to stimulate national design by offering technical training in crafts and by promoting ancient folk traditions. Boat building and church construction in Norway have a long history of woodcarving, which gave the revival of carved and painted wooden furniture a firm foundation. The bright painted colours in this chair's decoration were inspired by the richly poly-chromed interiors of traditional Norwegian rural dwellings. This Viking-style chair is similar to one that was exhibited in the Scandinavian section of the 1900 Exposition Universelle in Paris and illustrated in London's *Studio* magazine of December 1900 (fig. 1).[2] **RP**

1. Patricia G. Berman, "Norwegian Craft Theory and National Revival in the 1890s," in *Art and the National Dream: The Search for Vernacular Expression in Turn-of-the-century Design*, ed. Nicola Gordon Bowe (Dublin: Irish Academic Press, 1993), p. 160. **2.** S. Frykholm, "Round the Exhibition: Scandinavian Decorative Art," *The Studio*, vol. 21, no. 93 (December 1900), p. 195.

CHARLES RENNIE MACKINTOSH AND ERNEST A. TAYLOR

The Scottish architect Charles Rennie Mackintosh has been assured a place in the history of modern architecture and design ever since he was included in Nicolas Pevsner's *Pioneers of Modern Design* in 1936. This armchair **141** is an early design by Mackintosh made at the time of his seminal work, the Glasgow School of Art (1897–99). One of Mackintosh's most important patrons was Miss Catherine Cranston, who commissioned him to decorate and furnish four of her tea rooms in Glasgow, which launched his career as a designer of furniture. This model of chair was designed for the billiards room as well as the smoking room at Miss Cranston's Argyle Street Tea Rooms in 1898–99.[1] It is an especially original example of Mackintosh's early furniture in its use of broad, shaped panels, instead of stretchers, to brace the chair. Its simple form and the plain oak wood material were in keeping with the tenets of the English Arts and Crafts Movement, which was at its height in the 1880s and 1890s. Mackintosh was not as concerned with fine cabinetmaking and luxury materials in his furniture as he was with the balanced composition of line and form. It is the chair's simplicity and architectural presence that make it so appealing to modern eyes. This design must have pleased the architect, as he had a model of it (with slightly flared finials) in both the drawing room and the studio of his apartment at 120 Mains Street, Glasgow.[2]

The Museum's chair has an illustrious provenance: it belonged to architect Thomas Howarth, who taught at the Glasgow School of Architecture between 1939 and 1946. Howarth recognized the importance of Mackintosh's work, and in 1952 he wrote his groundbreaking book *Charles Rennie Mackintosh and the Modern Movement*.[3]

Mackintosh was a central figure in the community of artists, architects and designers who gravitated to the Glasgow School of Art and its dynamic director, Fra Newbery. Mackintosh's influence is evident in the Museum's sideboard designed by Ernest A. Taylor, who was an instructor at the school from 1903 to 1905.[4] The sideboard **142** was produced by the well-established Glasgow firm of household furnishings Wylie & Lochhead, for whom Taylor worked from about 1893 to 1906.[5] Taylor's designs for Wylie & Lochhead attracted attention to the firm's displays at international exhibitions in Glasgow (1901) and Turin (1902). The simplicity of construction, the ebonized poplar, the architectural composition, the modest stencil ornamentation and hand-crafted metalwork all suggest Mackintosh's influence, as do the unique touches such as the peak in the flat cornice and the diagonal elements on the lower door panels.

Spare in design but rich in aesthetic appeal, both the chair and the sideboard reflect the Arts and Crafts ideals held by two proponents in one of the centres of progressive design at the turn of the twentieth century. **RP**

1. J. Taylor, "Modern Decorative Art at Glasgow. Some Notes on Miss Cranston's Argyle Street Tea House," *The Studio*, vol. 39 (October 1906), pp. 31–36. **2.** Roger Billcliffe, *Charles Rennie Mackintosh: The Complete Furniture, Furniture Drawings and Interior Designs*, 3rd ed. (London: 1979; New York: E. P. Dutton, 1986), pp. 71–72. **3.** Published by Routledge and Kegan Paul, London. In 1958, Howarth moved to Toronto, where he became head of the architecture department at the University of Toronto. **4.** J. Taylor, "A Glasgow Artist and Designer: The Work of E. A. Taylor," *The Studio*, vol. 23, no. 139 (October 1904), pp. 216–226. **5.** Juliet Kinchin, "The Wylie & Lochhead Style," *The Journal of the Decorative Arts Society 1850–Present*, no. 9 (1985), pp. 4–16.

Fig. 1
Lars Kinsarvik's Viking-style chair, illustrated in *Studio* magazine, December 1900.

140

Lars Kinsarvik
Hardanger, Norway, 1846 – Hardanger 1925
Viking-style Armchair
About 1900
Painted wood
94.5 x 55 x 61.5 cm
Purchase, Deutsche Bank Fund
2005.91

141

Charles Rennie Mackintosh
Glasgow 1868 – London 1928
Armchair
1898–99
Oak
84.5 x 62.4 x 45 cm
Made by Francis Smith & Son, Glasgow
Purchase, gift of Peter and Grier Cundill in memory of their mother, Mrs. Ruth Cundill, Movable Cultural Property grant from the Department of Canadian Heritage under the terms of the Cultural Property Export and Import Act, and Alain Laferrière Fund
2007.64
PROVENANCE
Private coll., Thomas Howarth, Toronto, about 1958; estate, Howarth family, Toronto; acquired by the Museum in 2007.

142

Ernest A. Taylor
Greenock, Scotland, 1874 – Glasgow (?) 1951
Sideboard
About 1900
Poplar, metal, painted stencil decoration
172 x 177 x 66 cm
Produced by Wylie & Lochhead, Glasgow
Purchase, the Montreal Museum of Fine Arts' Volunteer Association Fund and Heather Hope Estate
2001.30.1-12

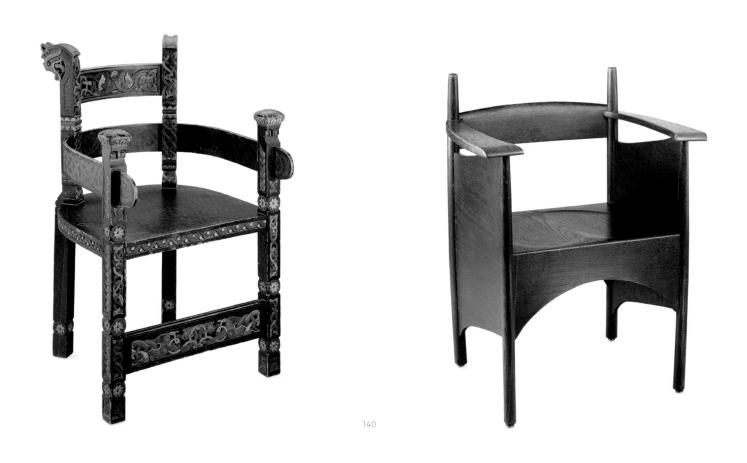

140

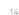

141

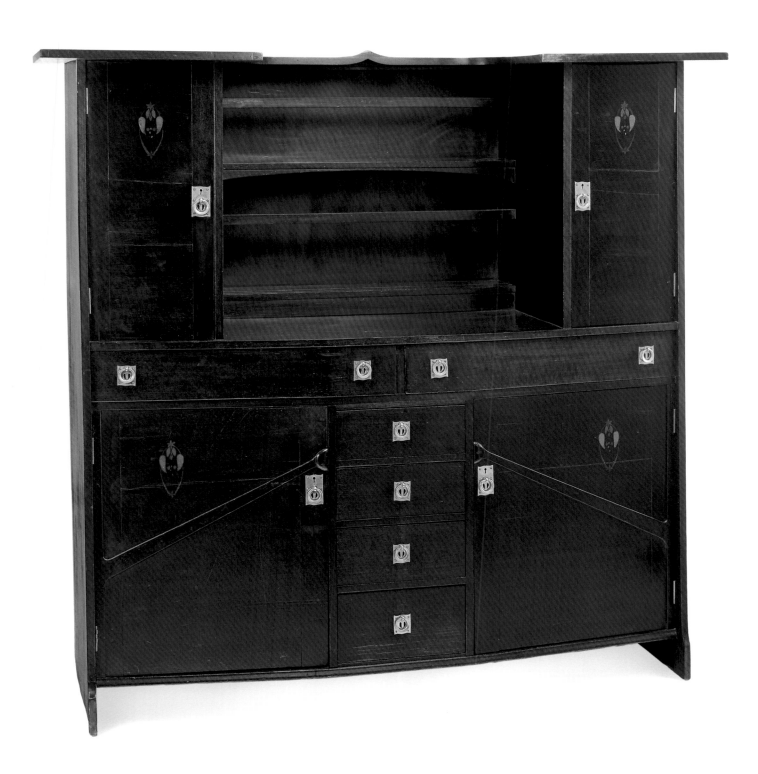

142

Maurice Dufrêne and Paul Follot were among the French designers who successfully made the transition from the organic, swirling lines and asymmetry of the Art Nouveau style, which reached its peak about 1900, to the classical composition and spare geometry of Art Deco 1920s design. They both created one-of-a-kind pieces of furniture with rich wood veneers and decorative details far removed from the concerns of industrial production.

Early in their careers, both men had worked with the influential German art critic Julius Meier-Graefe in his Paris art gallery, La Maison Moderne, opened in 1899. Through Meier-Graefe, Dufrêne and Follot were exposed to the latest design developments in Vienna and Germany, as well as England and Scotland. Each designer went on to head his own interior decoration studio attached to a major Parisian department store. Dufrêne became director of Galerie Lafayette's "La Maîtrise" when it was launched in 1921, and in 1922 Follot headed Bon Marché's "Atelier Pomone." Both designers played an active role in the annual exhibitions of the Société des Artistes Décorateurs and at the pivotal Paris Exposition Internationale des Art Décoratifs et Industriels Modernes in 1925.

In this piano 144, which Follot exhibited at the Société's 1908 salon, he maintained the French tradition of high-quality cabinetmaking by using elegant satinwood veneer with ivory and wood marquetry and by incorporating gilt-bronze mounts. The attenuated lines and stylization of the floral marquetry reflect the sober rectilinear version of the Art Nouveau style after the Scottish and Viennese models. The bronze mounts were inspired by the naturalism of Art Nouveau motifs, although their ordered arrangement heralds the transition to the symmetrical composition of Art Deco design. The piano had belonged to one of Montreal's major early-twentieth-century architects, Joseph-Omer Marchand, who studied at the École des Beaux-Arts in Paris from 1893 to 1902 before setting up his practice in Montreal.

Maurice Dufrêne was also able to bridge the two centuries with works like the fall-front desk of about 1912–13 143. It displays elements of Art Nouveau design in the arching lines and curvilinear floral motifs of the central doors and handles. At the same time, the rounded forms of the drawers and sides, the overall symmetry and rectilinearity of the piece anticipate more modern design. At the Salon d'Automne in 1911, Dufrêne presented white-painted bedroom furniture with very similar forms and decorative motifs as this secretary.[1] An identical fall-front desk was illustrated as part of a "loge d'artiste" by Dufrêne in *L'Art Décoratif*, November 20, 1912 (fig. 1). Dufrêne's use of white paint is of special interest, as white furniture was favoured over traditional dark, heavy woods for modern room interiors from early in the twentieth century by such progressive architects as Charles Rennie Mackintosh, Henry van de Velde and Peter Behrens.[2] Dufrêne would undoubtedly have been familiar with the work of these seminal figures of European design through his association with Meier-Graefe and through international exhibitions. The gilt rosettes and the original gold-leaf interior of the desk's compartments are in keeping with the French traditional taste for expensive, luxury materials.

Paul Poiret's chair 146 in the Museum's collection also reflects the sober, elegant design of the Art Deco style, which emphasized superb detailing in the cabinetmaking. This model of chair was used for a private dining room on the famous *Île-de-France* ocean liner launched in 1927. RP

1. Alastair Duncan, *The Paris Salons 1895–1914*, vol. 2, *Furniture* (Woodbridge, Suffolk: Antique Collectors' Club, 1996), ill. p. 164.

2. The original white with blue trim was restored before the secretary entered the Museum's collection.

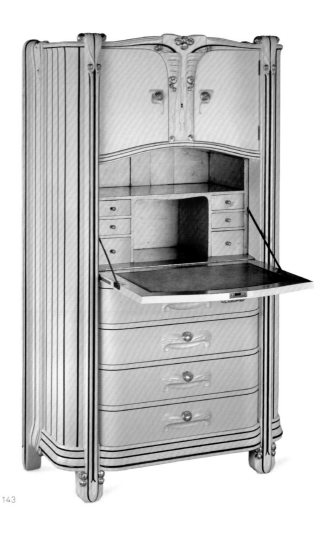

143

143

Maurice Dufrêne
Paris 1876 –
Nogent-sur-Marne 1955
Fall-front Secretary
About 1912–13
Painted wood, gold leaf,
leather (original)
156.5 x 91 x 41.5 cm
Purchase, Société
Générale/Fimat Fund
2005.40.1-1

144

Paul Follot
Paris 1877 – Sainte-Maxime,
France, 1941
Piano and Stool
About 1908
Satinwood and ivory
marquetry, inlay of various
woods, gilded bronze,
brass, velvet
Piano: 98.2 x 142 x 162 cm
Stool: 57.7 x 46.4 x 46.5 cm
Executed by Dumontier
(cabinetry) and Pleyel, Wolff,
Lyon et cie (action)

Inscribed inside fallboard:
PLEYEL / PARIS; Stamped
inside case: *PWL & Cie*,
and on underside of piano:
32 F 545 / DUMONTIER
Gift of Raymonde Marchand,
in memory of her father,
J. Omer Marchand,
architect, the Montreal
Museum of Decorative Arts
and an anonymous donor
1992.Df.9a-b
PROVENANCE
Joseph-Omer Marchand,
Westmount, Quebec;
Raymonde Marchand Paré
(his daughter), Outremont,
Quebec; acquired by the
Museum in 1992.

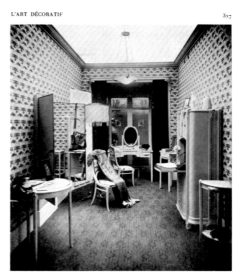

Fig. 1
Maurice Dufrêne's
"Loge d'artiste," a dressing
room ill. in the magazine
L'Art Décoratif, Paris,
November 20, 1912.

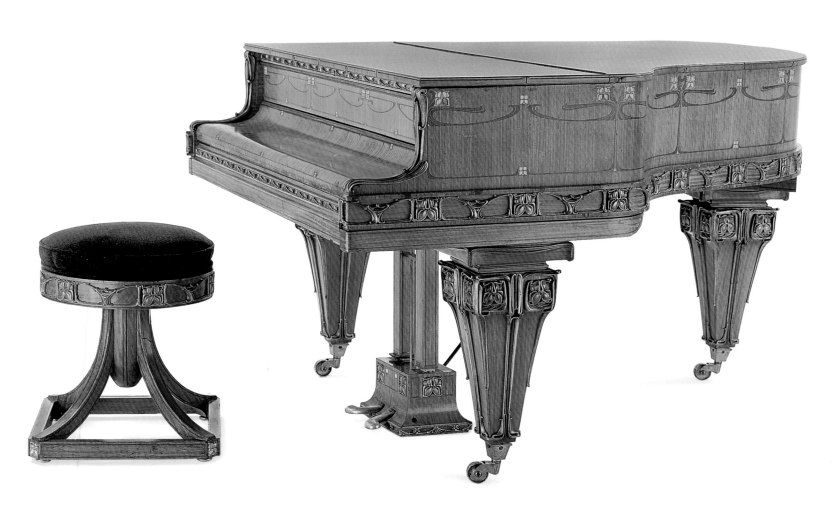

144

145

146

LOUIS MAJORELLE

Among the French designers associated with the Art Nouveau style at the end of the nineteenth century, Louis Majorelle stands out. He was one of the Nancy school of designers who made their name not only in Paris but also internationally.

In 1880, Majorelle took over his father's furniture and decorating business, and by 1905 it had grown into a large international concern, with stores in Paris, Lyons, Lille, Berlin and London. These chairs **145**, made about 1898–1900, when Majorelle was at the peak of his career, show many features of his personal design. The Japanese-inspired sprays of lilacs and lilies in dark and light coloured wood marquetry are shown off to full effect on the tall chair-back panels. The pulled and twisted forms of the wood supports were inspired by the organic movement and rhythms of nature. Close observation of plants and flowers was one of the guiding principles of Art Nouveau design, and Majorelle is known to have said, "My garden is my library."[1] Although these chairs are in the most

fashionable Art Nouveau style of the period, their design is still traditional in terms of symmetry and technique, revealing that Majorelle did not completely break with his past and the ideals of fine French cabinetmaking. **RP**

1. Roselyne Bouvier, *Majorelle: une aventure moderne* (Paris: La Bibliothèque des Arts, 1991), p. 174.

OTTO WAGNER

The Museum's collection includes furniture by leading Viennese reformers of design who rose to prominence in the first decade of the twentieth century. In his influential book *Moderne Architektur* of 1896, Otto Wagner renounced historicism and called for an architecture of new materials and technologies based on the requirements of modern living.[1] One of his architectural masterworks that reflects his ideals is the Österreichische Postsparkasse, a postal savings bank built in 1904 at Georg-Coch-Platz in Vienna.[2]

To underline the new aesthetic of this building, Wagner used aluminum, a most innovative material for construction at the time. The facade of the building is clad in white marble panels affixed to the reinforced concrete frame by large visible bolts with aluminum heads. The cornice and entrance canopy supports are also made of aluminum. The use of this material extends into the interior in the lighting fixtures, door fittings, heating grids and furniture, all designed by Wagner in the spirit of the *Gesamtkunstwerk*, or the total work of art.

Not only were Wagner's aluminum fittings radical, but his use of bentwood furniture throughout the bank was without precedent in office buildings. This armchair **148** is a variant of the bentwood chairs with aluminum mounts that Wagner designed for the boardroom of the postal savings bank. A single length of bentwood, square in section, forms the front legs, arms and top back rail. The rear legs are separate

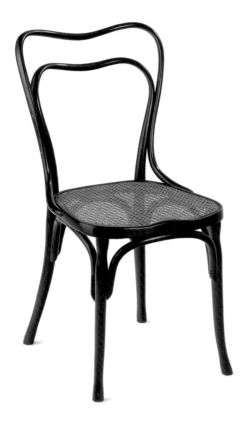

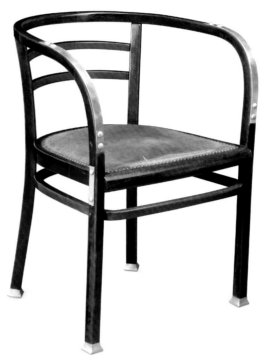

147

148

components that rise to join the back rail. Narrow aluminum strips are visibly bolted to the curved arms and to the outside front legs, marking the point of juncture with the seat frame. These plates serve a decorative as well as practical purpose, and the aluminum rivets echo the postal savings bank's exterior and interior aluminum bolt heads. The bottom of the four chair legs are protected by aluminum *sabots*. Modified versions of the boardroom chair design were used in other private offices in the building.

The Museum's armchair was made by the well-known Viennese firm of Gebrüder Thonet, who had perfected the bentwood technique for the production of chairs in the mid-nineteenth century. Thonet's printed-paper label and stamped mark appear under the chair's seat frame, which retains its original, though damaged, caning under the upholstery.

Both Thonet and its competitor Jacob & Josef Kohn submitted bids for the furnishings of the postal savings bank. Although Wagner's boardroom chairs were manufactured by the Kohn firm, other versions of it became part of Thonet's sales catalogue. This version appears as model number 718 F in the Thonet catalogues of 1906 and 1911/1915. The rounded shape of the armchair is believed to have been borrowed by Wagner from a bentwood chair designed by Gustav Siegel for the J. & J. Kohn display at the 1900 Exposition Universelle in Paris.[3]

Other examples of Kohn-manufactured chairs after architect's designs are in the Museum's collection: Adolf Loos' *Café Museum* chair 147 and the Hoffmann *Sitzmaschine* reclining chair 162. The Kohn firm led the way in recognizing the benefit of associating a mass-produced item with a well-known architect to turn it into an exclusive piece.[4] Lightweight yet sturdy, functional yet elegant, bentwood chairs were economically practical and ideally suited for cafés, hospitals, restaurants and hotels. **RP**

1. August Sarnitz, *Otto Wagner 1841–1918: Forerunner of Modern Architecture* (Cologne: Taschen, 2005), p. 10. **2.** Berthe Blaschke and Luise Lipschitz, *Architecture in Vienna 1850–1930* (Vienna; New York: Springer-Verlag, 2003), pp. 110–111. **3.** Derek Ostergard, ed., *Bentwood and Metal Furniture: 1850–1946* (New York: The American Federation of Arts, 1987), ill. p. 237. Gustav Siegel, director of Kohn's design department, was responsible for many of the firm's bentwood furniture designs; however, he did not receive public acknowledgement for it. **4.** Christian Witt-Dörring, "Bent-wood Production and the Viennese Avant-garde: The Thonet and Kohn Firms 1899–1914," in Ostergard, p. 95.

147

Adolf Loos
Brno, Czechoslovakia, 1870 –
Kalksburg, Austria, 1933
Chair
1899, designed for
the Café Museum,
Vienna
Beechwood, cane
87.9 x 43.5 x 52.1 cm
Produced by J. & J. Kohn,
Vienna
Purchase, Horsley and
Annie Townsend Bequest
1982.Df.7

148

Otto Wagner
Penzing, Austria, 1841 –
Vienna 1918
Armchair (model 718 F)
About 1905–6
Beechwood, aluminum,
original caning
under upholstery
78.4 x 57 x 55 cm
Produced by
Thonet Brothers,
Vienna
Under seat frame,
stamped in ink: *THONET*,
and two labels: *THONET*
Purchase,
Deutsche Bank Fund
2008.192

Jacques-Émile Ruhlmann ran the most prestigious and successful cabinetmaking and decorating firm in Paris during the 1920s. He created interiors that epitomize the richness and luxury of the Art Deco style. Ruhlmann's clients included leading politicians, entrepreneurs, as well as fashion and entertainment stars. At the celebrated Exposition Internationale des Art Décoratifs et Industriels Modernes held in Paris in 1925, Ruhlmann presented his own pavilion, the Hôtel du Collectionneur, which was a sensation. The Paris exhibition made him famous, and his designs greatly influenced the fashion for the French Art Deco style both in Europe and in North America.

Over the years, Ruhlmann refined his design for a tripod table, a favourite feature in his interior furnishings, and this model **151** was displayed in Ruhlmann's presentation bedroom at the Salon des Artistes Décorateurs in 1928 (fig. 1). Itemized in the Ruhlmann firm's record books as model No. 1161a, its use as an exhibition piece reflects the importance Ruhlmann gave to the design. The table is especially notable for the technical complexity of the rosewood veneering. A radial placement of narrow triangular strips of veneer creates a decorative pattern on the top of the table. Even the underside of the circular top is veneered in rosewood, and the

legs, usually of solid wood, have in this case been meticulously veneered in small horizontal strips of rosewood, painstakingly laid piece by piece to follow the rounded form of each leg. Ruhlmann was an exacting master and would supervise the application of these subtle details in the execution of his furniture. It is probably because of the time-consuming veneer technique that this model is rare in Ruhlmann's work. Although modest in size, its elegant form and technical perfection are typical of the best in his design and production.[1]

Following in Ruhlmann's footsteps, André Arbus continued the French tradition of tasteful, exquisitely crafted furniture made of exotic wood and other luxurious materials. The Museum's corner cabinet **149** is covered with parchment, which contrasts in tone with the striking abstract pattern of the tortoiseshell veneer on the front doors. The bronze heads at the top corners of the door panels were designed by Arbus' frequent collaborator, the sculptor Vadim Androusov (1895–1975). Arbus went on to create ensembles in spare neoclassical design for French ministerial offices. **RP**

1. Table illustrated in Emmanuel Bréon and Rosalind Pepall, eds., *Ruhlmann: Genius of Art Deco* (Boulogne-Billancourt: Musée des Années 30; Montreal: The Montreal Museum of Fine Arts; Paris: Somogy, 2009), p. 215, cat. 33.

JULES LELEU

Jules Leleu was one of the major French designers in Paris from the 1920s to 1940s, offering works that typified the elegance, luxury and glamour of the Art Deco period. One of the main activities of the Leleu firm was the decoration of rooms in a number of ocean liners, such as the *Île-de-France* (1927), the *Normandie* (1935) and *La Marseillaise* (1949).[1] Other major commissions for the designer were the furnishings for the Grand Salon des Ambassadeurs (1936) at the Palace of the League of Nations in Geneva, and the dining room (1947) at the Palais de l'Elysée in Paris.

The *coiffeuse* was an especially popular furnishing for the bedroom, and an identical model of the Museum's vanity table and chair **150** designed by Leleu was illustrated in the June 1938 issue of the magazine *Plaisir de France*. The central mirror was the key element of such a table, and in Leleu's dramatic design the whole tabletop and sides are mounted with mirrors. The elegant scroll-top legs joined with metal crossbars anticipate the spare neoclassical designs of the 1940s. **RP**

1. Françoise Siriex, *Leleu, Décorateurs Ensembliers* (Saint-Rémy-en-l'Eau: Éditions Monelle Hayot, 2007), pp. 265–306.

149

150

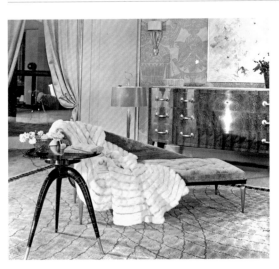

149

André Arbus
Toulouse 1903 – Paris 1969
Corner Cabinet
1938
Parchment, tortoiseshell, bronze
99.7 x 60.9 x 39 cm
Signature, handwritten on bottom shelf: *andrearbus*
Purchase, Société Générale/ Fimat Fund
2001.101.1-2

150

Jules Leleu
Boulogne 1883 – Paris (?) 1961
Dressing Table
About 1938
Mahogany, sycamore, metal, mirrors
(some are replacements)
75 x 99 x 47 cm
Signature in ink on an ivory plaque inlaid in the wood, back right leg: *J. Leleu*
Purchase, Horsley and Annie Townsend Bequest
2001.11.1-4

151

Jacques-Émile Ruhlmann
Paris 1879 – Paris 1933
Tripod Table
1928
Rosewood veneer over oak, brass
H. 64.5 cm; Diam. 50 cm
Branded on underside of tabletop: *Ruhlmann*, and under shaft:
B [within a circle]
Purchase, Société Générale/ Fimat Fund
2003.90

GERRIT RIETVELD

In a lecture on "Interiors" given at the Academy of Fine Arts in Rotterdam in 1948, Dutch designer and architect Gerrit Rietveld stated: "The artist needs to feel free from pre-established guidelines . . . so that he can find the right way spontaneously; no hankering after prettiness—no extra appendages with the pretext of so-called ornamentation—no noble forms as opposed to base forms—no quest for beauty—because clarity of purpose is the basic means in architecture for creating a new space if what is involved is an experience of space."[1]

In his furniture, as in his architecture, Rietveld focused on spatial relationships and linking art, architecture and design in a radically new approach to materials and forms for furniture. Space filters through Rietveld's furniture, made up of loosely assembled, interlocking wooden elements. In his pieces constructed of inexpensive, painted or stained wood, the material is secondary to the form. The lines are simple and the components are rectangular so that the design may be easily applied to serial production. His iconic *Red-Blue* chair **152** is stripped down to the basics: thirteen wooden supports for the frame and two boards for the back and seat all joined by wooden dowels (and in the case of the panels by nails). By painting the back, seat and frame each a different colour, Rietveld highlights the independence of each element, transforming the chair into a sculptural colour composition.

The use of primary colours was inspired by Rietveld's association with the artists and architects of the Dutch De Stijl movement, named after the magazine first published in 1917 under the editorship of painter Theo van Doesburg. The aim of De Stijl members, among the most famous being Piet Mondrian, was to bring together the arts in the creation of a total environment for the modern world. They sought harmony through strict abstraction, and based their visual expression on the fundamental geometry of line, flat planes and the three primary colours. Rietveld's *Red-Blue* chair became the first three-dimensional work to embody the De Stijl principles.

The *Red-Blue* chair, as well as a Rietveld sideboard **155** and *High-back* chair **153** in the Museum's collection, represent his exploration of furniture as part of the architectural interior space. In each work, the horizontal and vertical lines of the posts and rails criss-cross each other and appear to extend out into space, denying volume to the mass. Their painted end-grains emphasize the severing of this linear motion and stress the independence of each element. The sideboard is one of the few reproductions of the original, which was published in the March 1920 issue of *De Stijl* but was finally destroyed in a fire.[2] In this work, Rietveld ingeniously renounces the traditional massive form of a buffet by leaving open spaces between the components, so that the drawers and doors appear to be suspended within the framework.

These pieces, including the Rietveld-designed *Zig-Zag* chair **154**, were built by Gerard van de Groenekan for a Canadian couple, Cees and Anita van Groll. Van de Groenekan had begun working with Rietveld as his apprentice in 1917 (fig. 1) and took over the running of the furniture workshop in 1924.[3] He was a family friend of the Van Grolls, who settled in Toronto in 1959 and furnished their house with Rietveld-designed furniture made by Van de Groenekan under his own mark "Het Goede Meubel" (H. G. M.).

Even though Rietveld was drawn increasingly to architecture in his later years, he continued to experiment with materials to create functional, easily manufactured furniture. **RP**

1. Marijke Küper and Ida van Zijl, *Gerrit Th. Rietveld: The Complete Works* (Utrecht: Centraal Museum, 1992), p. 43. 2. Peter Vöge, *The Complete Rietveld Furniture* (Rotterdam: 010 Publishers, 1993), p. 10. 3. Ibid., p. 63.

152

153

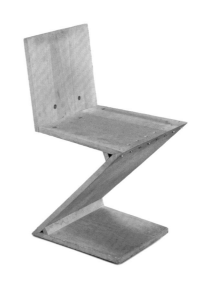

154

Fig. 1
Gerrit Rietveld, sitting, and Gerard van de Groenekan, standing on the left, in front of Rietveld's workshop at 25 Adriaen van Ostadelaan, Utrecht, 1918.

MONTREAL'S ÉCOLE DU MEUBLE

— ROSALIND PEPALL —

Over the years, the Museum has assembled an important collection of works created by the instructors and students of Montreal's École du Meuble, a school unique in the history of Quebec and Canadian design. The École grew out of the cabinetmaking section of Montreal's École Technique and was officially established as a separate school in 1935. Following a fire, it moved into its new premises at the former Académie Marchand, and in 1941–42 an addition was built by architect Marcel Parizeau (fig. 1), who was part of the teaching staff. The main purpose of the École du Meuble was to train Quebec's future cabinetmakers and designers to execute furniture of high quality and modern design. Jean-Marie Gauvreau was its first director and its principal driving force for twenty-three years. He had spent four years (1926–30) at the École Boulle in Paris, and he planned his École on this French model. He and his staff were very much influenced by French Art Deco furniture of the 1920s and 1930s, and Gauvreau invited prominent Parisian designers such as André Fréchet and Louis Sognot as guest lecturers at the school. In addition to cabinetmaking, students were instructed in painting, architecture, interior decoration, metalwork, ceramics and textile production. Some of Quebec's most prominent artists, architects and designers taught at the school, including Paul-Émile Borduas, Marcel Parizeau, Henri Beaulac and Julien Hébert (figs. 2–4).

The first furniture related to the École to enter the Museum's collection was Jean-Marie Gauvreau's personal bedroom suite of his own design **156**. It was inspired by furniture he had seen in Paris at the annual exhibitions of the Salon des Artistes Décorateurs, especially the designs by Léon Bouchet with whom Gauvreau had studied at the École Boulle.[1]

Gauvreau's principal collaborator in the creation of his furniture was Alphonse Saint-Jacques, who directed the school's carpentry and cabinetmaking workshops. On account of Gauvreau's close ties with Quebec administrators, the École's students, under the supervision of Saint-Jacques, sometimes made furniture for government offices. Also, Gauvreau's friends would commission furniture from the school; for example, the Museum has a dining-room set made in 1947 by Saint-Jacques and his students for Jacques and Madeleine Melançon. The side table **158**, part of this ensemble, may be folded against a wall as a console table or, when opened and pivoted on its base, can serve as an extension to the accompanying dining table. The cream-coloured, painted surface over oak is in keeping with the modern taste for light tones, in contrast to the dark mahogany furniture traditionally used for the dining room. Gauvreau encouraged the use of native Canadian wood in furniture production, and even promoted the use of Quebec wood among French furniture designers during lectures in Paris in 1930.[2]

Another central figure in the early days of the École was Marcel Parizeau, one of Montreal's most important modernist architects. After spending ten years in Paris (1923–33), Parizeau returned to Montreal and, from 1936 until his death in 1945, taught architecture and furniture design at the École.[3] His domestic projects were inspired by contemporary French architecture, and his semi-detached homes of 1935–36 for brothers Maurice and Marc Jarry—with their modernist horizontal lines and unadorned metal balcony railings—were among the first modern residences built in Quebec.[4] Parizeau often designed furniture that was influenced by French Art Deco models and that had the same spareness of form, undecorated surfaces, and concentration on geometry as his architecture, for example, the Paul Laroque house (fig. 6) of 1937 for which the Museum has the bedroom furniture. Parizeau also supervised students in the production of church furnishings, which became part of the school's program following Father Marie-Alain Couturier's visit from France in 1940 (fig. 5). An art critic and director of the French magazine *L'Art Sacré*, Couturier lectured the students on the latest designs in French modern ecclesiastical art and encouraged the revival of wood-carving for church decoration.

After World War II, the École's teachers looked for inspiration beyond France to Scandinavia and America. Two tables—one by Parizeau **160**, the other by Henri Beaulac **161**—reflect the biomorphic shapes that had become fashionable in New York, inspired by the paintings and sculptures of Joan Miró and Jean Arp. The lightweight chairs made by the École students in 1955, under the direction of André Jarry as part of a dining ensemble for the Fernand Rochon family, followed European furniture models of the time **157**. In the 1950s, with the urging of students, courses in industrial design began to be offered under Julien Hébert.

For more than twenty years, the École served as a foundation for the development of Quebec design. Then in 1958, the school was reorganized and became the Institut des arts appliqués de la province du Québec, and was finally incorporated into the Cégep[5] du Vieux-Montréal in 1968.

1. Illustrations of Bouchet's work appear in Gauvreau's book *Nos intérieurs de demain* (Montreal: Librairie d'action canadienne-française, 1929).
2. Gloria Lesser, *École du Meuble 1930–1950* (Montreal: Montreal Museum of Decorative Arts, 1989), p. 15. See also Louise Chouinard, "École du Meuble de Montréal (1935–1958)," M.A. thesis (Université Laval, 1988).
3. Marie-Alain Couturier in *Marcel Parizeau* (Montreal: L'Arbre, Collection "Art Vivant," 1945).
4. France Vanlaethem, "La maison des frères Jarry à Outremont," *Bulletin* (Docomomo Québec), no. 5 (Winter 1995), p. 1.
5. General education and professional training college. My thanks to Jean-Marie Dior and Lucie Dubois, of the Service de la gestion documentaire, Cégep du Vieux-Montréal, for their assistance.

Fig. 1
Montreal's École du Meuble, about 1941–42, in the former Académie Marchand, at the corner of Berri and Dorchester (now René-Lévesque). On the right, Marcel Parizeau's addition.

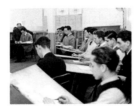

Fig. 2
Paul-Émile Borduas with his students, 1941–42.

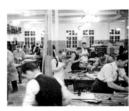

Fig. 4
Cabinetmaking workshop, 1941–42.

Fig. 3
Marcel Parizeau with his students, 1941–42.

Fig. 5
Father Marie-Alain Couturier, a student and Jean-Marie Gauvreau, about 1941.

Fig. 6
House of Paul Laroque, Outremont, Quebec, built by Marcel Parizeau, 1937.

156

Jean-Marie Gauvreau
Rimouski, Quebec, 1903 –
Montreal 1970
Dressing Table and Pouffe
1928–30
Amboyna, secondary woods, upholstery
Dressing table:
115 x 149 x 38 cm
Pouffe: H. 33 cm; Diam. 43 cm
Purchase, Horsley and
Annie Townsend Bequest
1981.Df.5.5, 7
PROVENANCE
Marguerite Rioux Gauvreau
(artist's widow), Montreal,
1970; acquired by
the Museum in 1981.

157

André Jarry
Montreal 1926 –
Montreal 2007
Dining Set
1955
Mahogany, brass, leather
Table: 76 x 216.5 x 110 cm
Captain chairs: 91 x 52.8 x 53 cm
Side chairs: 91.1 x 44.5 x 53 cm
Sideboard: 106.5 x 360.5 x 50.5 cm
Small sideboard: 44.7 x 180 x 43.4 cm
Made by the École du Meuble, Montreal
Purchase, the Montreal Museum of Fine Arts'
Volunteer Association Fund
1992.Df.1a-e

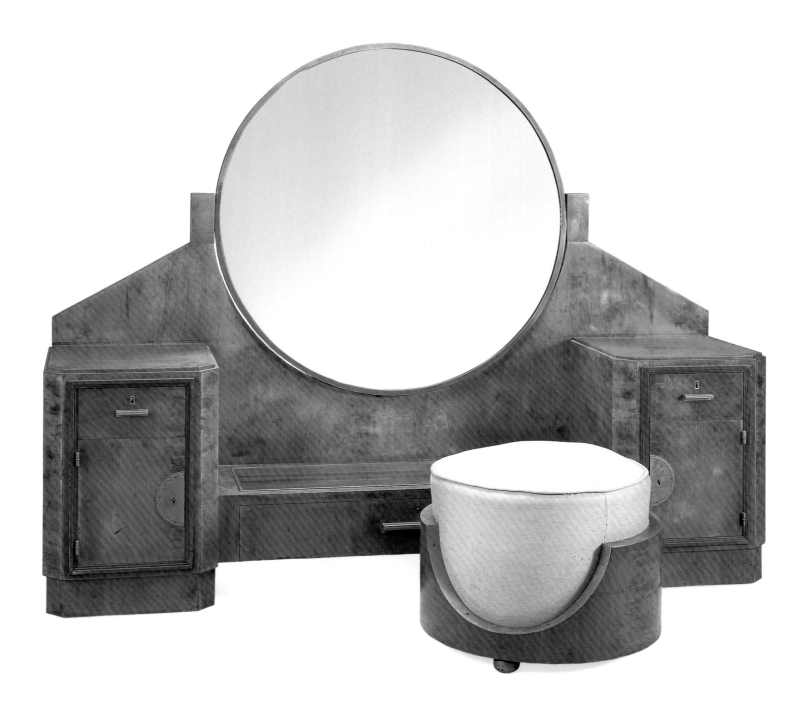

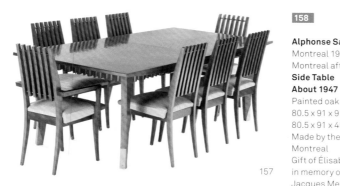

157

158

Alphonse Saint-Jacques
Montreal 1911 –
Montreal after 1996
Side Table
About 1947
Painted oak
80.5 x 91 x 91 cm (open)
80.5 x 91 x 45.4 cm (closed)
Made by the École du Meuble,
Montreal
Gift of Élisabeth Melançon
in memory of Madeleine and
Jacques Melançon
2008.9

159

Marcel Parizeau
Montreal 1898 –
Montreal 1945
Dressing Table and Chair
1936–37
Mahogany, upholstery
(not original)
Dressing table:
78.5 x 74 x 49.5 cm;
chair: 71 x 45 x 44 cm (approx.)
Gift in memory of
Madeleine and Maurice Jarry
2008.224.1-2

160

Marcel Parizeau
Montreal 1898 –
Montreal 1945
Coffee Table
About 1940
Rosewood, glass, brass
41 x 11.5 x 84 cm
Produced by G. H. Randall,
Montreal
Gift of Maurice Corbeil
Estate
2006.143.1-2

161

Henri Beaulac
Trois-Rivières, Quebec, 1914 –
Montreal 1994
Coffee Table
About 1947–50
Rosewood,
white mahogany, brass
36.5 x 121 x 98 cm
Gift of the artist
1993.Df.1

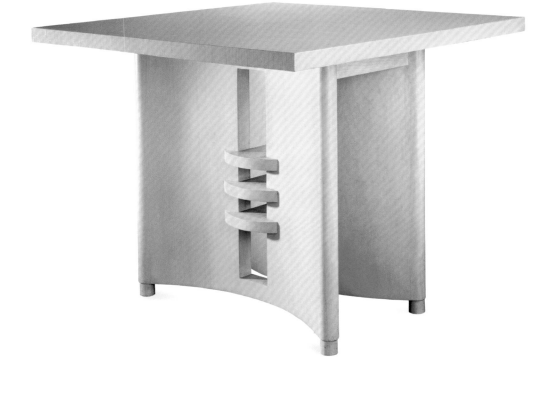

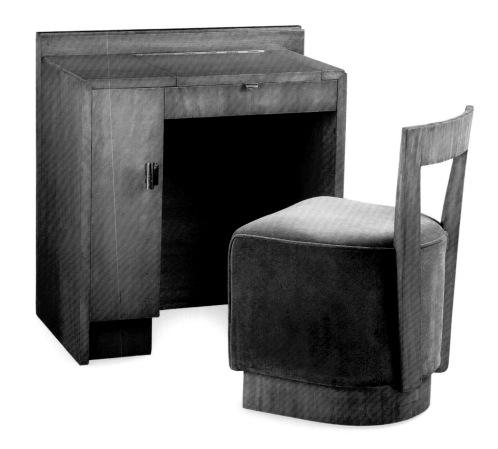

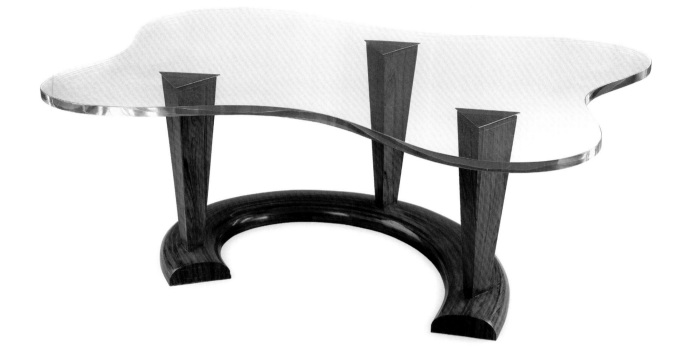

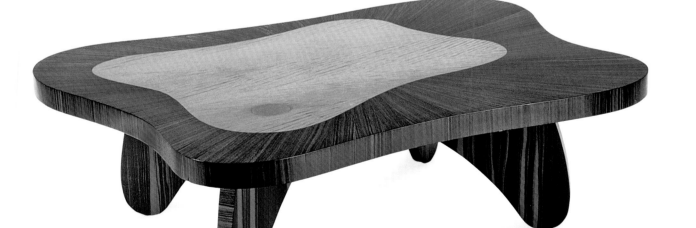

NEW TECHNIQUES: BENTWOOD AND PLYWOOD

— JARED GOSS —

From the mid-nineteenth to the mid-twentieth century, furniture manufacturers bent and laminated wood to mass-produce durable, economical, aesthetically pleasing and often radically innovative furniture. It can be argued that no other techniques are as synonymous with the production of progressive furniture in the modern era, when technology, aesthetics and business developed together. Each piece of furniture discussed herein represents a distinct step in that evolving process.

The practice of bending wood for utilitarian objects began with hunting bows, wheelwrighting, boatbuilding and barrel-making. Bentwood was not commonly used in furniture until the introduction of "Windsor" chairs in the second quarter of the eighteenth century.[1] Laminating thinly cut sheets of wood together had its roots in antiquity. The period of greatest invention and development in the bentwood industry came with industrialization, when machine production replaced traditional handcraftsmanship, and furniture-making evolved from a small-scale business, laboriously and expensively carried out by guild-trained artisans, to a large-scale mechanized industry capable of cheaply mass-producing standardized pieces for a growing middle class. The advent of mechanization meant new tools, notably saws that could cheaply and easily cut logs into long sheets of pliable veneer and steam-operated machines for bending wood.

These developments were particularly evident in Germany and Austria, where beech forests were plentiful and woodworking had been a long-established specialty. Michael Thonet, who worked in both countries, is considered the first industrial producer of bentwood furniture beginning in the late 1830s.[2] He recognized the technique was especially well-suited to chairs, being stronger and more economical than traditional carved wood. With bentwood, complicated joinery can be avoided, little material is wasted, and the medium's strength and flexibility make it effective in countering weight stress. Thonet's early success led him to further experimentation with not only bending and laminating wood, but also with the machines and processes associated with these mediums.

Thonet became an innovator in all aspects of the furniture-making industry, inventing ways to improve production (developing pre-fabricated, interchangeable components used for multiple furniture models), marketing (introducing designs at international exhibitions, publishing illustrated catalogues, and establishing showrooms abroad) and distribution (shipping packaged parts for assembly at points of destination). His efforts ensured his dominance of the industry and brought his firm patents, imperial commissions, the exclusive right to produce bentwood furniture in the Austro-Hungarian Empire and the envy of his rivals. By the twentieth century, Thonet's factories were producing over four thousand pieces of furniture daily. So prominent was the manufacturer's name that the firm's designers were never identified—"Thonet" was brand enough.

Although Thonet manufactured a wide range of furniture, the firm was best-known for its inventive seating,[3] exemplified by the sturdy and comfortable No. 3 rocking chair 163 .[4] The medium is suited to the form (especially the curved runners), which falls squarely within the Thonet canon: the frame is made from scrolling pieces of bentwood screwed or dowelled together. The extravagantly upholstered seat is slung from the frame, lending the chair an air of high-style novelty.

Other Austrian manufacturers wasted no time following Thonet's lead, closely imitating the firm's distinctive forms and practices. A serious competitor was J. & J. Kohn, which eventually rivalled Thonet's size and production levels.[5] It was founded in 1850 as a lumber company by Jacob Kohn, and his son Josef joined the business in 1867, renaming it J. & J. Kohn. A notable shift occurred in 1899 when Gustav Siegel was appointed design director. In an effort to broaden the domestic appeal of Kohn's products, he approached well-known architect-designers, including Koloman Moser and Josef Hoffmann, as collaborators. Kohn soon developed a reputation for stylish, up-to-date ensembles conceived in the then popular spirit of the *Gesamtkunstwerk*, or total work of art, in which architectural interiors and furniture were unified in their use of bentwood.

162

Josef Hoffmann
Pirnitz, Moravia,
1870 – Vienna 1956
Sitzmaschine
Reclining Armchair
About 1908
Beechwood, laminated wood
112 x 68 x 123 cm
Produced by
J. & J. Kohn, Vienna
Stamped under seat:
J. & J. KOHN
Purchase,
Deutsche Bank Fund
2002.51.1-2

163

Thonet Brothers
Founded in Vienna in 1853
Rocking Chair No. 3
About 1867
Bentwood, upholstery
84 x 60.5 x 130 cm
Gift of the American Friends
of Canada through the
generosity of David A. Hanks
1996.Df.1

164

Alvar Aalto
Kuortane, Finland, 1898 –
Helsinki 1976
Armchair (model 31)
1932
Birch-faced plywood,
laminated birch
66 x 61.5 x 78.2 cm
Produced by Artek,
Helsinki
Stamped under each
runner: *379*
Liliane and David M.
Stewart Collection
D85.113.1

165

Bruno Mathsson
Värnamo, Sweden,
1907 – Värnamo 1988
Eva **Chair**
About 1933–36
(example of 1939)
Beechwood, jute
79.8 x 49.4 x 72.4 cm
Produced by Firma Karl
Mathsson, Värnamo, Sweden
Label, on underside of
seat, bearing handwritten
inscriptions: *Komp. /*
Bruno Mathsson /
Tillv. / Karl Mathsson /
Värnamo / B[?]M 1936 / KM 39
Liliane and David M.
Stewart Collection
D83.135.1

166

Waclaw Czerwinski
Poland 1900 –
Canada (Ontario?) 1989
Hilary Stykolt
Poland 1894 –
Canada (Ontario?) 1974
Chair
1946
Bent laminated wood,
plywood
84 x 41.5 x 53.5 cm
Produced by the Canadian
Wooden Aircraft Company,
Stratford, Ontario
Stamped, on underside of
seat: *AERO __ UR FURNITURE /*
MADE IN Canada /
CANADIAN CRAFT LTD
Gift of Mieczyslaw and
Jadwiga Marcinkiewicz
2005.89

167

Marcel Breuer
Pécs, Hungary, 1902 –
New York 1981
Isokon **Lounge Chair**
1935–36
Birch-faced plywood
78.2 x 62.8 x 138.5 cm
Produced by Isokon
Furniture Company,
London
Liliane and David M.
Stewart Collection
D81.116.1

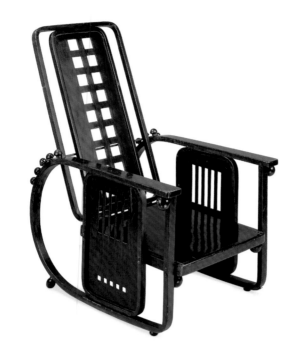

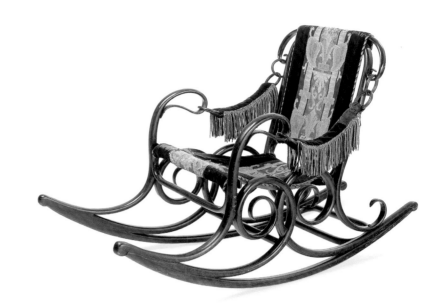

162

163

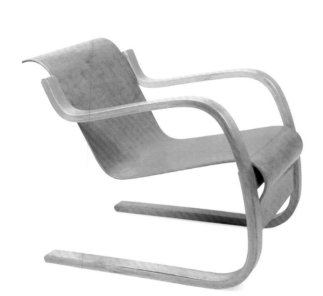

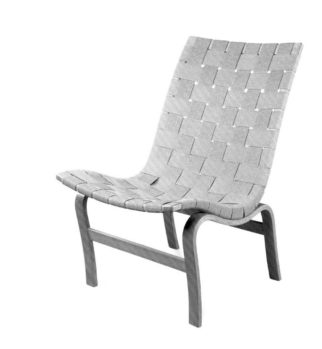

164

165

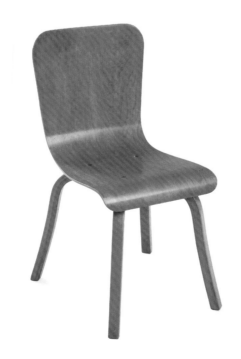

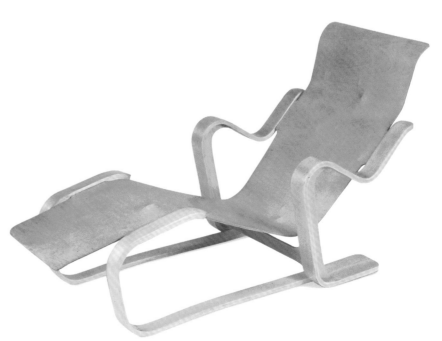

166

167

168

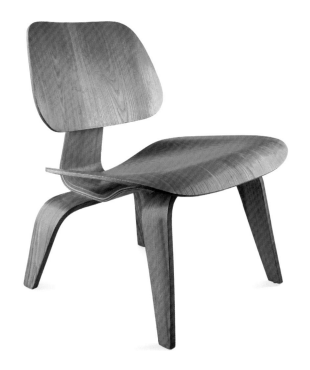

169

In 1903, several Austrian avant-garde designers who developed a strict and vigorous geometric aesthetic vocabulary banded together in the Wiener Werkstätte [Vienna Workshops], a designers' cooperative, directed by Hoffmann, that strove to raise design standards. Hoffmann's *Sitzmaschine*[6] [machine for sitting] **162** embodies their aims. Perforated laminated wood panels (for ventilation) are set into bentwood frames. Turned wooden balls, both decorative and functional, accentuate the structural junctures and provide stops for the adjustable backrest. The synthesis of utility and aesthetics makes this chair a landmark in architect-designed furniture, Kohn's particular specialty.

Austrian domination of the bentwood industry was challenged following World War I, especially after the founding of the influential German Bauhaus design school in 1919. Bauhaus experimentation with tubular steel as a sturdy yet flexible material for furniture led to revolutionary new forms like the cantilevered, two-legged chair. Although metal preoccupied the avant-garde furniture designers in the 1920s, it proved to be more admired by them than by consumers, who preferred the softness and warmth of wood. Accordingly, as a substitute for metal, many forward-thinking designers embraced plywood—an inexpensive laminate in which the multiple layers of wood veneer are glued together, with the grain of each layer at right angles to the grain of the adjacent layer. Since the late nineteenth century, plywood had been favoured as an economical material for commercial crating or tram benches, or for the drawer or back panels of furniture.

Alvar Aalto was one of the first to explore the possibilities of using plywood for domestic furniture.[7] His designs, among the most sophisticated and influential of the modern era, reconcile Bauhaus innovation with a love for natural materials. The Model 31 armchair[8] **164** celebrates plywood's aesthetic and technical potential: a single, curving sheet serves as both seat and back, suspended between laminated wood and bentwood armrests, legs and runners. Plywood's innate flexibility and strength are exploited in the cantilevered seat, which provides spring and thus increases its comfort. This elegant, organic design is at once strikingly avant-garde yet approachable. Unlike earlier designers, who provided work-for-hire services to manufacturers, Aalto established his own company, Artek,[9] to produce his designs.

Aalto's work, influenced by Bauhaus innovation, would in turn influence Bauhaus designers. The school closed in 1933, after which many of its members emigrated abroad. Walter Gropius and Marcel Breuer went to England, where—through Gropius—in 1935 Breuer met Jack Pritchard,[10] founder of the Isokon Furniture Company, a manufacturer of plywood furniture. Pritchard and Gropius encouraged Breuer to design for Isokon, and he adapted an aluminum chaise longue he had originally produced in 1932–33. While the *Isokon* lounge chair **167** was conceptually faithful to the earlier model, the change of material fundamentally transformed the design. The seat's original metal slats were replaced by an unbroken length of curved plywood supported between bent plywood arms and legs, evoking Aalto. Although the health-giving properties of its ergonomic curves were touted as a selling point, the chair was not popular in conservative Britain. Working at the same time as Aalto, Swedish designer Bruno Mathsson used bent- and laminated wood to create a comfortably curved seat that followed the lines of a seated person **165**.

With World War II, the centre of avant-garde design shifted to America, especially since many European designers emigrated there. The pressing post-war need for inexpensive housing and informal, adaptable furnishings led to a boom in production and innovation. The American bentwood and plywood industry had been invigorated by wartime commissions from the U.S. Navy for items like stretchers and splints. Designers Charles and Ray Eames experimented with compound bending to create ergonomic splints. Their success marked an important advance in the plywood industry, allowing designers to mould volumes instead of planes, resulting in their innovative range of ergonomic seating, epitomized by their *LCW* chair **169**. Assembled from five separate plywood components, its soft-edged compound-moulded seat and back lend the chair comfort

and an elegant, lighthearted modernity. Dimensional complexity also characterizes their *FSW* screen **168**, with its six identical, curved plywood panels hinged together with canvas. Intended as a room divider, it could be irregularly configured at will for a decorative sculptural effect; it could also be easily folded and stored.

Although the Eameses first explored the three-dimensional possibilities of plywood in a work like this screen, they were followed by others who took the idea to levels verging on art. Isamu Noguchi was an established and respected sculptor when he was approached by the Herman Miller Furniture Company to design furniture.[11] His chess table **171**, created for a 1947 exhibition at the Julian Levy Gallery in New York, is one of the most abstract design objects of its time—neither its purpose nor its material is immediately apparent. Its dynamic form—conceived in the round—recalls the biomorphic shapes favoured by Surrealist artists such as Jean Arp and Joan Miró. Its free-form top is inlaid with red and yellow plastic dots, minimally suggesting a chessboard; the plywood is ebonized, obscuring the medium's natural qualities; and an aluminum cavity conceals storage for chess pieces. Herman Miller developed a post-war reputation for well-designed, affordable, high-quality modern furniture. The majority of the firm's products reflect the period's taste for rationalist functionalism. Because of its artistic conception, Noguchi's table is an anomaly.

Italians also sought to establish themselves in the lucrative post-war international marketplace for domestic furnishings. The architect Carlo Mollino was especially inventive, designing fantastic furniture that repudiated the sterility of modernism. Evoking Noguchi, he looked to Surrealist sculpture for inspiration. His *Arabesco* table **172** marries art and utility. Its frame, formed from a single length of undulating, perforated plywood, suggests a primeval organic creature with bolts for eyes, pads for feet, and a fishtail termination. The irregularly shaped glass shelves purportedly mimic the outline of a female torso. In the end, however unconventional, this table remains eminently functional.

In Canada, engineers who had developed the use of plywood for aircraft during the war turned their expertise to furniture design, following European and American precedents. The Canada Wooden Aircraft Company of Stratford, Ontario, was the first Canadian company to successfully introduce moulded plywood and laminated wood furniture to the consumer market **166**.

Although experimentation with wood for furniture has continued unabated for millenia, the modern era represents a period of exceptional innovation.

1. For a complete overview, see Derek E. Ostergard, ed., *Bent Wood and Metal Furniture: 1850–1946* (New York: The American Federation of Arts, 1987).
2. In 1852, he made his sons partners in the firm, renaming it Gebrüder Thonet (Thonet Brothers); today the company is known as Thonet.
3. Each chair had a model number; the most common was the No. 14 café chair: by 1914, over forty million were produced (Alessandro Alverà, "Michael Thonet and the Development of Bent-wood Furniture: From Workshop to Factory Production," in Ostergard 1987, p. 47).
4. Rockers—never especially popular in Europe—were customarily used by the elderly or infirm. Thonet first showed this chair at the 1867 Exposition Universelle in Paris; it remained in production until about 1904.
5. In 1922, Kohn merged with Thonet (Graham Dry, "The Development of the Bent-wood Furniture Industry 1869–1914," in Ostergard 1987, p. 57).
6. The model was produced from 1905 until 1916.
7. Gerrit Rietveld was probably the first to purposely exploit the material in his *Red-Blue* chair of 1918.
8. Sometimes referred to as the *Springleaf*, this model was introduced in 1932; it is still produced.
9. Aalto founded the firm with his wife, Aino Aalto, and his business partner, Marie Gullichsen.
10. Pritchard previously worked for the Venestra Plywood Company in Estonia.
11. Something he would later downplay, although today his furniture ranks among his best-known creations.

171

168

Charles Eames
Saint Louis, Missouri, 1907 –
Saint Louis 1978
Ray Kaiser Eames
Sacramento, California,
1912 – Los Angeles 1988
FSW **Screen**
About 1946
Stained ash-faced
plywood, canvas
172.1 x 153.8 cm
Produced by Molded
Plywood Division,
Evans Products Company,
Venice, California
Liliane and David
M. Stewart Collection
D81.134.1

169

Charles Eames
Saint Louis, Missouri, 1907 –
Saint Louis 1978
Ray Kaiser Eames
Sacramento, California, 1912
– Los Angeles 1988
LCW **[Low-Chair-Wood] Chair**
1945–46
(example about 1946)
Laminated ash, ash-faced
plywood, rubber
69.2 x 57 x 62 cm
Produced by Herman Miller
Furniture, Zeeland, Michigan
Liliane and David M. Stewart
Collection
D80.100.1

170

Charles Eames
Saint Louis, Missouri, 1907 –
Saint Louis 1978
Lounge Chair and Ottoman
About 1956
Rosewood, metal, leather,
rubber, polyurethane, down
Chair: 86.5 x 82 x 84.6 cm
Ottoman: 43.6 x 55.1 x 66 cm
Produced by Herman Miller
Furniture, Zeeland, Michigan
Under seat, label with Herman
Miller patent numbers, and
circular foil label with Herman
Miller logo surrounded by
inscriptions: *DESIGNED*
BY CHARLES EAMES-
HERMAN MILLER
FURNITURE COMPANY
Liliane and David M. Stewart
Collection, gift of the
American Friends of Canada
through the generosity
of Dr. and Mrs. Robert L.
Tannenbaum
D81.127.1a-b

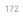

171

Isamu Noguchi
Los Angeles 1904 –
New York 1988
Chess Table (model IN 61)
About 1947
Ebonized plywood,
aluminum, plastic
48.8 x 86 x 77.6 cm
Produced by Herman Miller
Furniture, Zeeland, Michigan
Liliane and David M. Stewart
Collection, gift of
Jay Spectre, by exchange
D85.132.1a-d

172

Carlo Mollino
Turin 1905 – Turin 1973
Arabesco Table
1950
Maple-faced plywood,
glass, brass
50.2 x 122 x 49.5 cm
Produced by
Apelli e Varesio, Turin
Liliane and David M.
Stewart Collection
D88.128.1a-c

SCANDINAVIA: A PASSION FOR TEAK

— ANNE H. HOY —

Thwarted passion burns the more brightly, as was the case twice with teak in the twentieth century. This beautifully grained exotic hardwood (*Tectona*) was virtually unobtainable in Scandinavia during World War II, but the lack only made it more desirable afterwards. In the heavily forested Nordic countries, where some craft traditions have persisted for centuries, the use in furnishings of indigenous wood, like birch, beech, oak and ash, carried cultural and near-spiritual weight, yet the imported wood—moisture- and pest-resistant, and simple to clean—readily migrated indoors from its use in boat building and garden furniture in the 1950s because of its easy care and allure.

Danish designer and architect Finn Juhl's obsession with teak has been credited with bringing the wood into wide use from 1953 among contemporary buyers worldwide. That year, Juhl's furniture manufacturer, C.W.F. France, fitted his profiling machines with blades of tungsten-carbide alloy, which made possible wide industrial production of works using the resistant, low-density wood.[1] At the end of the 1940s, curators and critics such as Edgar Kaufmann, Jr., had written of Juhl's teak furnishings,[2] and his work was richly represented in exhibitions of saleable designs co-organized by New York's Museum of Modern Art and Chicago's Merchandise Mart under Kaufmann's direction. At the 1947 and 1951 Milan Triennales, the first after the war, Scandinavian designers were the major prizewinners, and their preference for teak as well as light-hued indigenous wood was unmistakable. These types of wood were distinct from the darker, varnished or waxed mahoganies and walnut of traditional furnishings, and because of their lighter cultural connotations, they became hallmarks of Nordic modernism. Even before 1953, the conviction was widespread that this progressive design could reach comfortable middle-class consumers.

The Scandinavians proclaimed that this was their target audience, nationally and internationally. The 1963 survey *Modern Scandinavian Furniture* asserted in the chapter "Four Countries—One Furniture Ideal" that "Scandinavian furniture production aims basically at putting quality furniture within the economic reach of every citizen."[3] Whatever the size of the production run or whether some designs were in fact partly or wholly handmade, "Danish modern" (and progressive Scandinavian design in general) was presented as affordable and democratic in its values.[4]

The swift critical and commercial success of Nordic design in the mid-twentieth century[5] is exemplified by the works illustrated here, all but one of which are by Danish creators. Each of these designs is functional without looking mechanistic, thanks to the warmth of the wood and the references to handicraft, regardless of production method.[6] Although such pieces were immediately integrated into traditional as well as vanguard interiors, they are modern in their aesthetics by relying on the form and intrinsic properties of the material employed rather than on applied ornament. Their differences indicate the flexibility of the Scandinavian design idiom, which appealed internationally to various progressive tastes.

173

Hans Wegner
Tønder, Denmark, 1914 –
Copenhagen 2007
Peacock Armchair
(model J. H. 500)
1947
Ash, teak, Manila kraft paper
107.9 x 76.3 x 71.7 cm
Produced by Johannes
Hansens Møbelsnedkeri,
Copenhagen
Branded on underside of seat,
back: *JOHANNES HANSEN /
COPENHAGEN / DENMARK*;
J H [superimposed]
Liliane and David M.
Stewart Collection
D88.137.1

174

Hans Wegner
Tønder, Denmark, 1914 –
Copenhagen 2007
Round Armchair
1949 (example about
1949–50)
Teak, cane
75.9 x 58.2 x 52.7 cm
Produced by Johannes
Hansen, Søborg, Denmark
Stamped on opposite sides
of central rail, under seat:
MADE IN DENMARK,
and *JOHANNES HANSEN /
COPENHAGEN*
Liliane and David M.
Stewart Collection
D85.156.1

175

Hans Wegner
Tønder, Denmark, 1914 –
Copenhagen 2007
Chair
1951–52
Teak, laminated wood
72 x 54.5 x 43.5 cm
Produced by Fritz Hansen,
Copenhagen
Stamped under seat: *FH*
[within a circle] / *DENMARK*
Gift of Astrid Schoenauer
in memory of her husband
Norbert Schoenauer
2002.100

176

Finn Juhl
Copenhagen 1912 –
Copenhagen 1989
Chieftain Armchair
(model P4-107)
1949
Teak, polyurethane
foam, leather
93 x 101.5 x 89 cm
Produced by Niels Vodder,
Copenhagen
Upholstery by Ivan Schlechter,
Gilleleje, Denmark
Stamped on back side of
front rail: *NIELS VODDER
CABINETMAKER /
COPENHAGEN DENMARK /
DESIGN FINN JUHL*
Liliane and David M.
Stewart Collection
D85.122.1

177

Hans Wegner
Tønder, Denmark, 1914 –
Copenhagen 2007
Y Chair
1949–50
Oak, rush
72.4 x 53.6 x 52.1 cm
Produced by Carl Hansen &
Son, Odense, Denmark
Branded on underside of
back seat rail:
MADE IN DENMARK
Liliane and David M. Stewart
Collection, gift of the
American Friends of Canada
through the generosity of
Mr. Sherman Emery
D82.119.2

178

Hans Wegner
Tønder, Denmark, 1914 –
Copenhagen 2007
Valet Chair (model J. H. 250)
1953
Teak, brass, leather
96.2 x 51.2 x 51.3 cm
Produced by Johannes
Hansens Møbelsnedkeri
(1953-1986) and
P. P. Møbler (1987 to today)
Liliane and David M.
Stewart Collection,
gift of Edward J. Wormley
D83.103.1

173

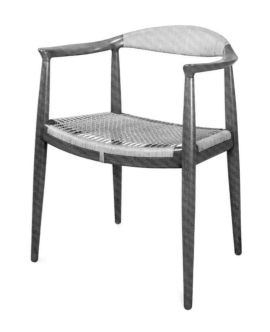

174

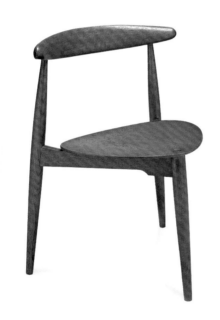

175

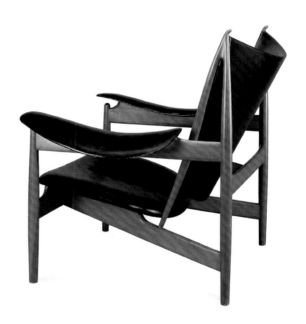

176

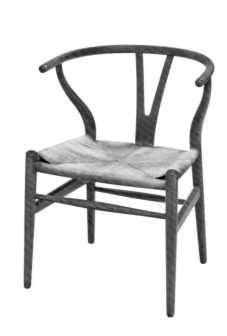

177

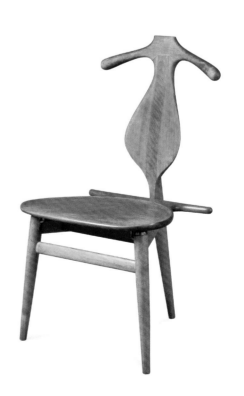

178

The organic metaphor, found in abstract art from the 1920s (Arp, Miró, Calder) and accepted in design from the 1940s, appears in Tapio Wirkkala's laminated birch platter **182**, a leaf-for-the-tree synecdoche. In contrast, Finn Juhl's broad teak salad bowl **180**—which was turned on a lathe, the time-honoured tool of woodworking—has generic primitivist associations. Of folkloric flavour, Jens Quistgaard's teak ice bucket **179** was constructed of curved staves, elements of a technique used to make traditional wood buckets or the hulls of Viking ships, which the designer claimed he studied.[7] The bucket's bridge-like handle recalls the yokes of milk-pail carriers or ox teams.[8]

The differences between these demonstratively modern wares go further. Quistgaard's bucket has an orange plastic liner, and Wirkkala's platter depends on the manufacture of airplane plywood and his diagonal slicing of the resultant blocks to produce the piece's "veins" of birch in varied tones laminated with dark glue.[9] Juhl's bowl, more than a foot in width and shaped from a single piece of teak, is a technical achievement, which enriches the bowl's sculptural ethos by contrasting the tactile form with the teak's graphic grain. Nonetheless, Juhl stopped production in 1973, when it was decided that increasingly scarce teak had become too expensive.[10] The use of wood in all three designs, rather than silver or porcelain, signals the intention of the designers to make practical objects that could be of service in unpretentious lifestyles. The water resistance of teak makes it a natural choice of material for an ice bucket, and the wood's natural oils make it suitable for wares containing oily and salty food, like salads.

Masterpieces of the Museum's collection, the chairs by Juhl and Hans Wegner dramatize the variety of styles among leading Danish designers and display these men's sensitive use of wood. A prizewinner at the 1951 Milan Triennale, Wegner was famous from the 1940s on for his suave updating of time-tested chair types. Both his *Y* chair **177** and his *Round* armchair **174** derive from ancient Chinese models.[11] The light-hued wishbone shape of the back splat in his *Y* chair represents Wegner's departure from his darker sources, and the continuous crest rail in both the *Y* and the *Round* chairs recalls Chinese chairs with U-shape rails. At the same time, the *Y* chair's horizontal crest rail and tapering legs allude to the 1914 *Faaborg* chair by Denmark's "grand old man" of furniture design, Kaare Klint, itself derived from British models.[12] Wegner's two airy chairs contrast drastically with Juhl's *Chieftain* armchair **176**, so-called after Denmark's King Frederick IX sat in it at an exhibition opening.

Juhl's name choice, rather than "King's Chair," was apt, given the chair's tribal aura as a broad, low, sculpturally articulated throne. Lest the viewer miss the associations of *Chieftain*'s shield, blade and spear-like forms, the chair was displayed by the Copenhagen Cabinetmakers' Guild in 1949 against a background with a longbow and blow-ups of a Cycladic head and a petroglyph representation of a hunter. Juhl's seating and Wegner's *Round* chair, both of teak, promise comfort—Juhl through leather upholstery and Wegner with caning. But where the Wegner is all Olympian linear clarity, the Juhl espouses complexity and even mystery, for the multi-part structure contrasts with the moulded, apparently floating parts it supports. While Wegner's light and leggy chair combines Chinese Chippendale and modern elegance, Juhl evokes the sculpture of Henry Moore. The *Round* chair displays the long grain of teak; *Chieftain* conjures up the wood's exotic origins.

Eight of the designs shown here are of teak, which is now an endangered wood in Myanmar (Burma), the Philippines, and sub-Saharan Africa; the wood is presently government-controlled and government-farmed around the world. The passion for teak that Scandinavian design was a part of igniting may not be thwarted, but the price tag for satisfying the taste for its mid-century designs is no longer within the reach of the middle class.

1. Frederik Sieck, *Contemporary Danish Furniture Design* (Copenhagen: Nyt Nordisk Forlag Arnold Busck, 1990), p. 39; Chris Lefteri, *Wood: Materials for Inspirational Design* (Mies, Switzerland: Rotovision, 2003), p. 65.
2. Edgar Kaufmann, Jr., "Finn Juhl of Copenhagen," *Interiors*, vol. 108 (November 1948), pp. 96–99, and "Finn Juhl," *Interiors*, vol. 110 (September 1950), pp. 82–91.
3. Ulf Haard af Segerstad, *Modern Scandinavian Furniture* (Copenhagen: Gyldendalske Boghandel Nordisk Forlag, 1963), p. 8.
4. Ibid., p. 11: Scandinavian design is "a democratic-individualistic alternative . . . to government policies . . . in some other countries."
5. At the 1951 Milan Triennale, Scandinavian design took the most medals, and the exhibition *Design in Scandinavia* toured twenty-two North American cities in 1952–53. For an extensive bibliography, see David R. McFadden, ed., *Scandinavian Modern Design 1880–1989* (New York: Cooper-Hewitt Design Museum, 1992).
6. Although Scandinavian designers used metal and synthetics, the preference for wood distinguished them from designers pursuing most Bauhaus models.
7. According to Frederica Todd Harlow in *Design 1935–1965: What Modern Was*, ed. Martin Eidelberg (Montreal: Musée des arts décoratifs de Montréal; New York: Harry N. Abrams, 1991), p. 132 and note 191.
8. Ibid., p. 132: Harlow cites Japanese ceramic vessels as a prototype, although wood buckets on yokes appear to be the common ancestor of the ceramic she mentions and Quistgaard's container.
9. See Aniki Toikka Karnoven, "Plywood Sculpture: Tapio Wirkkala Uncovers a New Decorative Medium," *Craft Horizons*, no. 5 (September–October 1952), p. 12, and Christine W. Laidlaw in *Design 1935–1965*, pp. 156–57.
10. David A. Hanks and Jennifer Tuoher Teulié in *Design 1935–1965*, p. 188 and note 321.
11. See Sieck 1990, p. 37; and R. Craig Miller in *Design 1935–1965*, pp. 123, 185.
12. See Sieck 1990, p. 14.

181

Hans Wegner
Tønder, Denmark,
1914 – Copenhagen 2007
Occasional Table
About 1950
Teak, oak
60 x 67 x 59.8 cm
Produced by Andreas Tuck,
Odense, Denmark
Stamped on underside of
tabletop: *FABRIKAT ANDRAS*
TUCK / ARKITEKT HANS
J.WEGNER / DENMARK /
MADE IN DENMARK
Gift of Anne and
George MacLaren
2011.218

182

Tapio Wirkkala
Hangö, Finland, 1915 –
Espoo, Finland, 1985
Platter
About 1950
Birch plywood
4 x 58.5 x 8.9 cm
Made by Martti Lindqvist
for Soinne et Kni,
Helsinki
Monogram incised
on underside
of platter: *TW*
Liliane and David M.
Stewart Collection
D87.108.1

FRANK LLOYD WRIGHT: DINING-ROOM FURNITURE FOR WOODSIDE

— DAVID A. HANKS —

In 1937, at the age of seventy, Frank Lloyd Wright designed the first of his influential Usonian[1] houses, relatively inexpensive dwellings for middle-income families. In these homes, Wright lowered costs by ingeniously simplifying heating, lighting and sanitation requirements, while creating inventive, individually designed houses with gracious, open living areas.

Wright's 1950 design for Woodside, Dr. Richard Davis' house in Marion, Indiana, is a late Usonian house (fig. 1).[2] Built on a wooded lot, the steep teepee-form roof echoes the outline of the coniferous trees in the surrounding forest.[3] The interior, in keeping with Usonian ideals, provides a dramatic, open, two-storey space for the living area, and, in contrast, secondary rooms are scaled down.

Furniture for the Usonian house was also designed to be inexpensive. Made of the same native wood used in the house itself, pieces such as the Davis ensemble of dining table and chairs **183** were often fabricated by contractors working onsite from the architect's drawings (fig. 2). For the chairs, Wright returned to the high-back form he had used at the beginning of the century, but the construction is now much more angular and even Cubist in orientation. The Davis chairs echo the outline of the house

exterior in their tapering backs, the supporting rear fin and the perforated inverted triangles, all of which echo the motif of the pine tree.

At the turn of the century, Wright had provided a separate room for dining, and set the table and chairs at the centre of the room, as was then customary. In the Davis house, he incorporated the dining area within a larger living space, and the dining ensemble abutted the wall. In short, Wright's later designs reflected the new informal American lifestyle.

1. A term derived from the abbreviation of United States of North America (USA).
2. For illustrations and drawings of the Davis house, see Yukio Futagawa, ed.,
 Frank Lloyd Wright, vol. 7, *Monograph, 1942–1950* (Tokyo: A.D.A. Edita, 1988), pp. 318–19.
3. The origin of this form is seen in Wright's 1922 Lake Tahoe project. See Futagawa,
 Frank Lloyd Wright, vol. 4, *Monograph, 1914–1923* (Tokyo: A.D.A. Edita, 1985), pp. 208–209.

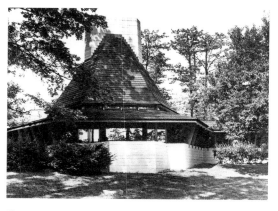

Fig. 1
House of Richard Davis, "Woodside," in Marion, Indiana, 1950.

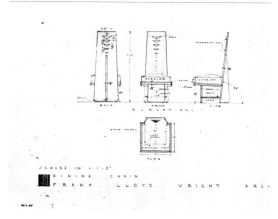

Fig. 2
Frank Lloyd Wright, working drawings of dining-room chairs for "Woodside," about 1950.

183

Frank Lloyd Wright
Richland Center, Wisconsin, 1867 – Phoenix, Arizona, 1959
Dining Set
1950
Laminated pine, fabric
(not original)
Table (2 sections):
69.3 x 183.5 x 122.5 cm
69.3 x 212 x 122.5 cm
Chairs: 107.7 x 45.5 x 53.8 cm
Label on underside
of each cushion: *Horacio
Machado / ATELIER*
Liliane and David M.
Stewart Collection
D82.108.1-7

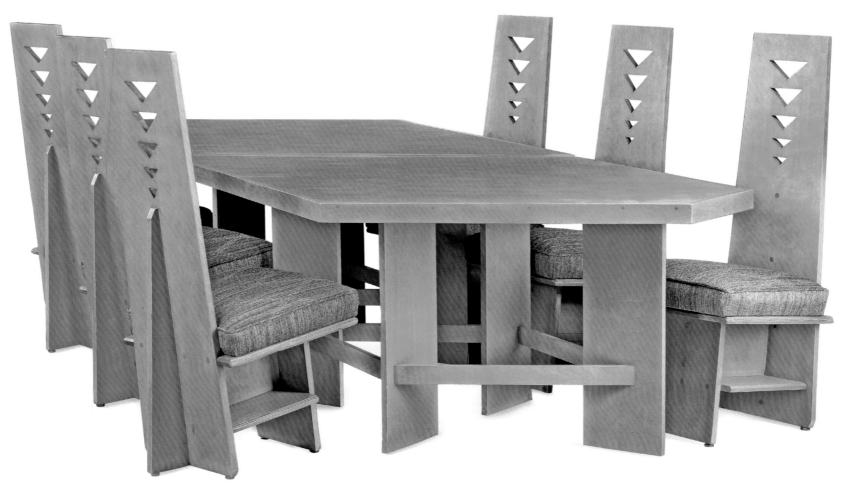

FRANK O. GEHRY'S
DESIGNS IN WOOD

— DAVID A. HANKS —

Before his name was associated with titanium, computer-aided design and the Guggenheim Bilbao, Frank O. Gehry was already experimenting with industrial materials and sculptural forms unexpected in architecture—just not yet on a global stage. When the Montreal Museum of Decorative Arts (MMDA) approached him to conceive a new museum building in 1992, he was perhaps most widely known for his own rakish postmodern home in Santa Monica, California (1977–78), and the Vitra Design Museum, Weil am Rhein, Germany (1989). A subsequent economic downturn required a revision of the plan, and although it was no longer a new building but a new exhibition space within an existing museum, his design of new spaces for the MMDA in the Jean-Noël Desmarais Pavilion of the Montreal Museum of Fine Arts was nonetheless his first important commission in his native Canada.

In progress from 1992, this facility opened in 1997, and Gehry's design served to establish a strong identity for the MMDA within its sheltering museum (fig. 1).[1] The new home consisted of two galleries providing approximately ten thousand square feet for permanent and temporary exhibitions, and staff offices overlooking this space. Most striking were Gehry's installation structures, which would exhibit objects as diverse in scale and nature as jewellery and furniture groupings. Using glass and plywood—familiar, sturdy and inexpensive materials—the architect designed platforms and sculptural display cases with forcefully canted towers clustered like trees, some reaching nearly five metres in height, most containing lighted display spaces of various sizes. The tones provided by the unconcealed wood grain gave visitors a sense of warmth and welcome, and the tall, sweeping, slanted forms defied the white cubes of conventional gallery spaces.

Gehry also used unpainted plywood for the offices upstairs, where the wood grain provided intrinsic visual interest and harmonized with the exhibition furniture below. Among the furnishings was a bold conference table in pine plywood **186** with a thick, square top supported by angled slabs at each corner and a square pedestal at the centre. This stout table was a far cry from the airy bentwood furniture Gehry designed for the Knoll Group and introduced in 1992.

To advance its offerings of bentwood furniture, Knoll supplied Gehry with a studio adjacent to his Santa Monica office and the services of a project manager and prototype maker. The Montreal Museum of Decorative Arts organized and circulated an exhibition of this furniture, entitled *Frank Gehry: New Bentwood Furniture Designs* (fig. 2), internationally to great acclaim.[2] This collaboration among the museum, the architect and Knoll led to the donation of a selection of eight of the seating prototypes to the MMDA.

A comparison of the *Steam-bent Pillow Chair* **185**, named by the studio craftsmen, and the *Power Play* armchair **184**, for which the former was a prototype, illustrates Gehry's astonishing creative process. The prototype is composed of two "pillows" woven from resilient ribbon-like strips of maple on a plywood base enclosed by maple strips, unifying structure and support. Much of the chair's volume consists merely of the air between the bentwood strips and, although it looks too fragile to support an adult, the seat is actually strong and resilient. The final version of *Power Play*, however, is as baroque as the *Pillow Chair* is classical. The laminated maple bands are no longer closed into ovals but left open, and their repeated curves seamlessly form the arms, legs and seat of the woven chair accompanied by an ottoman. Knoll put the armchair into production with other bentwood designs by Gehry, all named with terms used in ice hockey, the architect's favourite sport.

Gehry's inspiration for this furniture was the common bushel basket, and he recalled, "When I was a kid, my father used to bring home a lot of wicker furniture, and maybe that stuck in my memory."[3] The lightness combined with the structural strength of the material and its weaving appealed to the architect. Martin Filler has traced the historic precedents for his woven furniture from the webbing of Shaker seating to Thonet's bentwood furniture and the moulded plywood employed by modernist designers such as Alvar Aalto.[4] Gehry's designs were different, however, as he pointed out: "All of the bentwood furniture to this point . . . always had a heavy substructure and then webbing, or an intermediary structure for the seating. The difference in my chairs is that the support structure and the seat are formed of the same lightweight slender wood strips, which serve both functions. The material forms a single and continuous idea."[5] The Knoll prototypes are among Gehry's most interesting experiments in furniture design, and the line is still in production today.

1. In 2000, the collection of the Montreal Museum of Decorative Arts (MMDA) was gifted to the Montreal Museum of Fine Arts. The collection is now named after the founders of the MMDA, Liliane and David M. Stewart. Up until 2000, the MMDA exhibited in the galleries designed by Gehry. They are now used by the Montreal Museum of Fine Arts' Education and Community Programmes Department.
2. The MMDA's travelling exhibition and its accompanying catalogue showcased the sequence from the design drawings and experimental prototypes to the finished products: *Frank Gehry: New Bentwood Furniture Designs*, exh. cat. (Montreal: Montreal Museum of Decorative Arts, 1992).
3. Frank O. Gehry in an interview with David A. Hanks, Consulting Curator, MMDA, May 24, 1991, cited in *Designed for Delight: Alternative Aspects of Twentieth-century Decorative Arts*, exh. cat., ed. Martin Eidelberg (Montreal: Montreal Museum of Decorative Arts; Paris; New York: Flammarion, 1997), p. 161.
4. Martin Filler, "Frank Gehry and the Modern Tradition of Bentwood Furniture," in *Frank Gehry*, pp. 101–02.
5. Frank Gehry, "Commentary," in *Frank Gehry*, pp. 42–43.

Fig. 1
The sign designed by Frank O. Gehry at the entrance to the Montreal Museum of Decorative Arts' galleries at the Montreal Museum of Fine Arts, 1997.

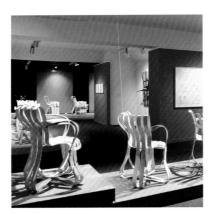

Fig. 2
Installation by Réjean Tétreault of the exhibition *Frank Gehry: New Bentwood Furniture* for the Montreal Museum of Decorative Arts at the Château Dufresne, 1992.

184

Frank O. Gehry
Born in Toronto in 1929
***Power Play* Armchair
and Ottoman**
1991 (examples of 1992)
Laminated maple
Armchair: 82.5 x 80.5 x 81 cm
Ottoman: 30.5 x 59.5 x 59.5 cm
Produced by the Knoll Group,
New York
Liliane and David M.
Stewart Collection,
gift of the Knoll Group
D92.185.1a-b

185

Frank O. Gehry
Born in Toronto in 1929
Steam-bent Pillow Chair
1989
Maple, basswood,
birch plywood
96.5 x 69.8 x 99.1 cm
Prototype produced by the
Gehry Studio, Los Angeles
Liliane and David M. Stewart
Collection, gift of Frank Gehry
and of the Knoll Group
D92.110.1

186

Frank O. Gehry & Associates
Founded in 1962
Conference Table
About 1997
Pine plywood, laminated
71.5 x 132.5 x 132.5 cm
Produced by Ébénisterie
Renouveau, Laval, Quebec
Liliane and David M.
Stewart Collection
D99.135.1

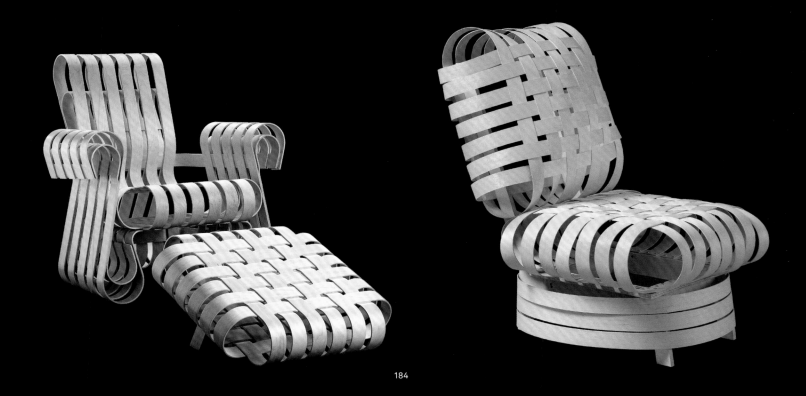

184

185

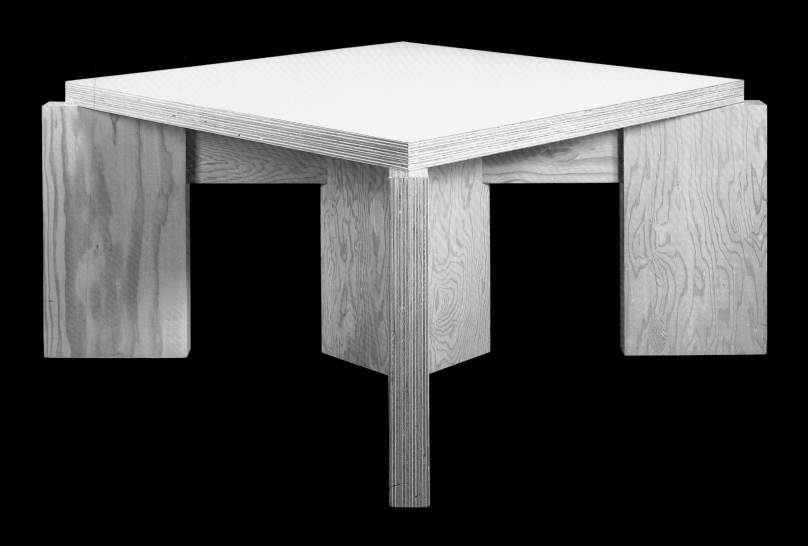

186

CLEVER APPROPRIATIONS

— DIANE CHARBONNEAU —

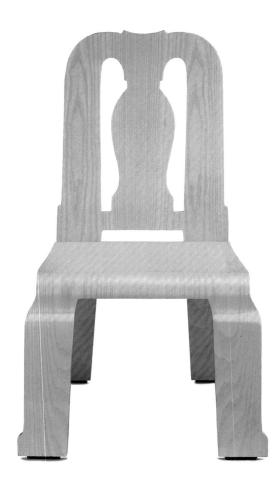

187

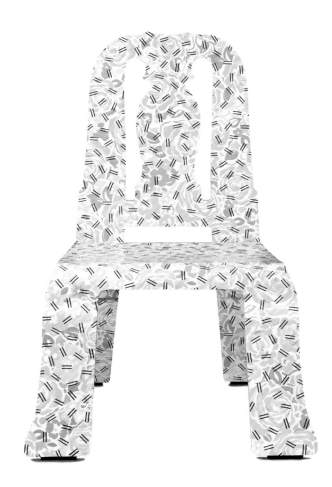

188

ROBERT VENTURI AND DENISE SCOTT BROWN

The design of the 1970s and 1980s is characterized by multiple styles and groups that broke with the perceived elitism of the modernist movement, challenging its utilitarianism and spare aesthetic. References abound, stemming as much from art as from architecture. Popular culture, vernacular styles and the use of ornamentation all inform the unreserved production of objects wherein the symbolic displaces the practical.

In this so-called Postmodern movement, architects contributed to renewing the aesthetic norms of functional objects. In response to an invitation from Knoll International, Robert Venturi and Denise Scott Brown, of the architectural firm Venturi, Scott Brown and Associates, designed a collection of furniture that included chairs, tables and a sofa between 1974 and 1984. After revisiting American and European heritage styles, the pair devised original pieces parodying some of the most influential, including Chippendale, Queen Anne, Sheraton, Empire, Gothic Revival, Art Nouveau and Art Deco. They combined references drawn from the realms of both high and mass culture. Although the chairs may seem familiar, they are rather evocations of a style, as they reproduce, without volume, only the outline of an original chair. The choice of plywood for this cut-out piece **187** serves as an allusion to a material favoured by modernist designers. At the same time, by covering a number of these chairs in laminate, Venturi and Scott Brown reintroduce decoration. Whereas the quaintly outmoded tablecloth pattern of the *Queen Anne* chair **188** touches on nostalgia, the motifs of the *Art Deco* chair **189**, with its organic forms and soft tones, poke fun at the geometry and vibrant colours associated with modernism. **DC**

MICHEL PARENT

In the history of modern and contemporary design, very few objects express as much as the chair. Its evolution has been closely tied to stylistic trends, technical innovations and ergonomics, as much as to social and cultural change. Although, for some

designers, the chair is the perfect embodiment of style, for others, it is commonplace. These days, this seemingly ordinary piece of furniture is being flaunted in every way.

Today's ever-changing trends include the reinterpretation of the past, an approach that can be seen in various guises. In this vein, Quebec artist and designer Michel Parent recycles scrap materials and found objects to make unusual pieces of furniture. At first glance, *Opulence désenflée* **190** from 2009 looks like an oval-back chair in the Louis XVI style **119**, but this is a ruse, as the piece is but a simple metal and wood school chair transformed by upholstery consisting of inner tubes quilted with linen thread, creating the impression of elegant style. Without losing its utilitarian quality, this chair challenges the notion of opulence associated with this old type of lavishly upholstered seat, while providing a critique of society's appetite for luxury. **DC**

189

190

HUBERT LE GALL

Hubert Le Gall is at once a sculptor, painter, designer and exhibition designer. In his enthusiasm for the decorative arts, he creates furniture, rugs and light fixtures among other items, both one-of-a-kind pieces and limited editions. His hybrid furniture is neither strictly art object nor strictly functional object, as he simultaneously values both. Playing with contrasts, Le Gall expertly marries materials such as wood, resin and bronze.

Covered in a layer of resin engraved with floral motifs, the *Anthémis* chest of drawers **191** is decorated with patinated bronze chamomile flowers (anthemis is a genus closely related to chamomile). These elements imbue the piece with sculptural power and attest to Le Gall's ingenuity, technical prowess and whimsical pœtry. With this chest of drawers evoking a field of spring flowers, Le Gall takes pleasure in plant forms and the textures of living matter. This piece also illustrates his preoccupation with the beautiful and with contemporary taste. True to the spirit of his times—rife with stylistic interactions and ruled by the notion of individual creativity—Le Gall ultimately harks back to eighteenth-century cabinetmaking, much like a number of French Art Deco designers before him, including Jacques-Émile Ruhlmann **151** , Jules Leleu and André Arbus **149** . The manner of expression Le Gall has invented transcends fashion while showing deference to the opulence of French cabinetmaking. DC

DANFUL YANG

The globalization of markets and ideas has fostered a reinterpretation of Western design from the second half of the twentieth century. New actors from all over the world are introducing new stylistic concerns. Designers from Asia, in particular, are redefining design through their working methods and aesthetic codes.

XYZ Design, a Hong Kong collective founded in 1997, brings together designers and artists who work from the principles that art is an inclusive means of expression and that creators must experiment, giving free rein to their ideas and exploring different materials and techniques. Their works express an aesthetic that combines a contemporary approach with centuries-old craftsmanship.

Danful Yang's *Fake* armchair **192** is a good example of the group's principles. Here, Western luxury meets the best of China. The armchair fuses a gilded Louis XV-style armchair with a traditional Chinese, black-lacquered chair. The upholstery is a patchwork of knock-offs of designer handbags—Louis Vuitton, Chanel and Burberry—and the apron is signed "Coach." Like other pieces by Chinese designers that combine traditional elements with Western symbols, this chair not only harks back to bygone styles of royal or imperial furniture, but it also parodies the "Made in China" label. *Fake* was produced in a limited edition of twenty; each armchair is covered with unique trimmings and bears the signature of its creator. DC

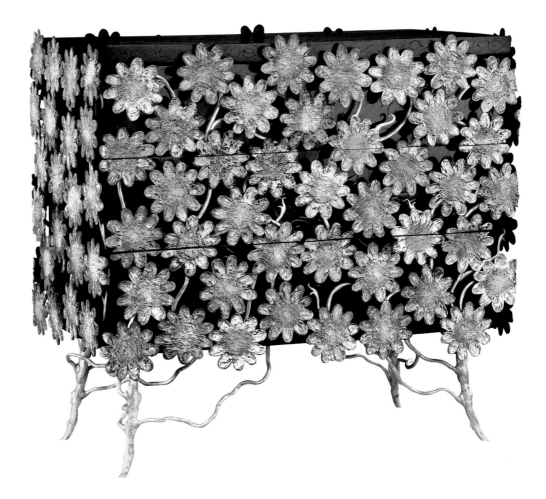

191

191

Hubert Le Gall
Born in Lyons in 1961
Anthémis Chest of Drawers
1999
Pressed wood covered
with pigmented, incised,
painted, varnished and
waxed polyester, beechwood,
patinated bronze, 9/25
105 x 110 x 60 cm
Purchase, gift of the
Macdonald Stewart
Foundation and the Museum
Campaign 1988-1993 Fund
2001.79.1-5

192

Danful Yang
Born in Shanghai in 1980
Fake Armchair
2007
Stained and varnished
wood, wood covered in gold
leaf, fragments of handbag
knock-offs (leather, vinyl,
cotton, Ultrasuede, polyester,
polyester velour, lacquered
metal rings, brass, and
chrome-plated metal chains,
clasps and rings)
94.8 x 76.5 x 77.3 cm
Produced by XYZ Design,
Shanghai
Signature, incised on central
rail, under seat: *Danful*
Purchase, the Museum
Campaign 1988-1993 Fund
2009.10.1-2

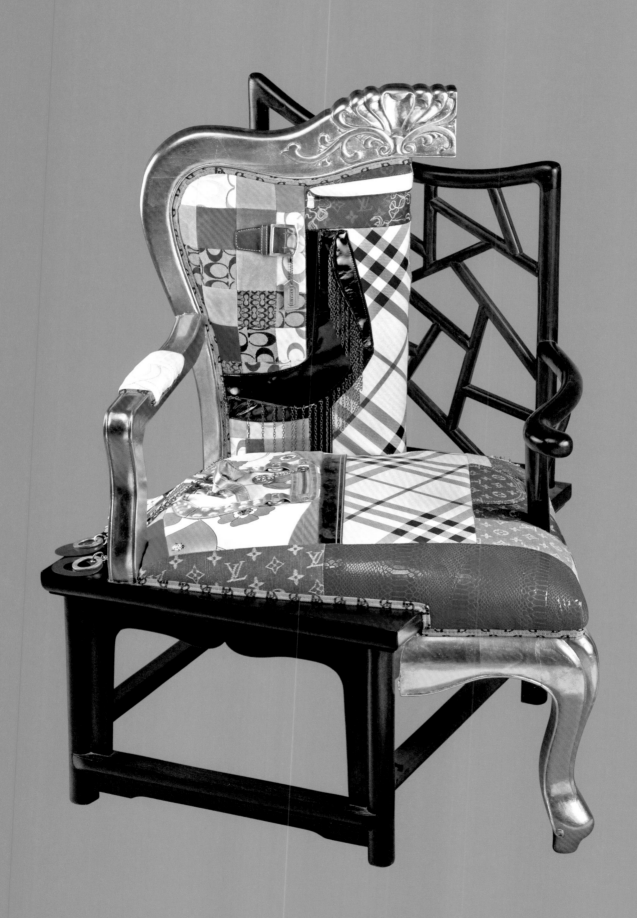

MAARTEN BAAS

Maarten Baas belongs to a generation of designers who employ various creative strategies whereby communication rather than function informs the objects they make. Evoking symbolism to imbue his pieces with meaning, Baas creates handcrafted furniture in limited editions that stand at the cutting edge of art and design.

One of his graduation pieces for the academy of design in Eindhoven, which established his name in the Netherlands, consisted of ordinary furniture burned with a blowtorch. The presentation of "Smoke," his first burned pieces, at the trade fairs in Milan, London and Paris launched his international career. In 2003, Baas was offered a unique opportunity when Murray Moss of the eponymous New York gallery commissioned him to design the collection "Where There's Smoke," made from serially produced pieces. After acquiring the chairs he needed for the *Zig-Zag (Reitveld)* chair 193 from Cassina,[1] Baas set about changing their shapes with flames, making a new model of each one. He then applied epoxy resin and polyurethane lacquer to make the object sturdy enough to be used. For Baas, scorching Rietveld's chairs is in no way disrespectful—quite the opposite, in fact: "I think it's quite a respectful approach. I don't want to burn down Rietveld. I always try to make it functional again."[2] DC

1. Cassina reissues pieces by some of the twentieth century's greatest designers for its "I Maestri" Collection. 2. Linda Hales, "Maarten Baas's Claims to Flame," *Washington Post*, May 22, 2004.

TEJO REMY

A social conscience and environmental concern have been at the forefront of design's preoccupations since the early 1990s. Many designers, notably those from the Netherlands, have chosen to reduce the massive ecological footprint and overabundance that characterize our society, instead adopting strategies for a creative practice with strict economy of means. Salvage, re-appropriate and hybridize are very much the rallying cries of the Droog collective,[1] which presented its first collection at the Salone Internazionale del Mobile di Milano in 1993. The group of fourteen pieces, including the hanging lamp *Melkflessenlamp* (1991) 107 and the chest of drawers *You Can't Lay Down Your Memories* 194 by designer Tejo Remy, neatly summarize the features of new conceptual design from the Netherlands, which has drawn international attention for its formal audacity—one might say its eccentricity—laced with a touch of humour, while nevertheless remaining functional.

Thus *You Can't Lay Down Your Memories* is actually a dresser, despite its sculptural quality and the drawers' odd arrangement, which suggest "installation" more than "furniture." It is made of recycled drawers, taken from home or office furniture, which are embedded in separate compartments of made-to-measure maple. These drawers are then bundled and held in place by a strap in an unlikely balancing act. With this work, the designer has rehabilitated the chest of drawers, the small upright piece of furniture with stacked drawers that appeared in the mid-seventeenth century. The designer's intervention is meant to be minimal, his approach recalling Duchamp's ready-mades or Armand's accumulations. According to Remy, the chest of drawers represents the need we have to create our own paradise out of the objects that surround us, like Robinson Crusoe. Its drawers contain our memories, even our most intimate secrets. Produced in a limited edition of two hundred, each of these pieces is unique—as are the drawers used for their construction. *You Can't Lay Down Your Memories* is essential Droog as well as an icon of conceptual design.[2] DC

1. Droog was co-founded in Amsterdam in 1993 by designer Gijs Bakker and design historian Renny Ramakers. The collective upholds these values: a minimalist aesthetic, an interest in materials and innovation, humour (but a dry or "droog" humour). 2. "Studio Work, Chest of Drawers by Tejo Remy," http://www.droog.com/store/studio-work/chest-of-drawers (accessed December 12, 2011).

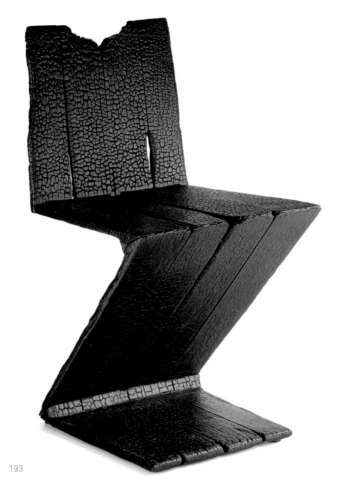

193

193

Maarten Baas
Born in Arnsberg,
Germany, in 1978
Zig-Zag (Reitveld) Chair
From the series
"Where There's Smoke"
2003
Cherrywood, burnt and
finished with an epoxy resin
and a polyurethane lacquer
with UV-filter
74 x 37.5 x 44 cm
Produced by Baas & den
Herder, 's-Hertogenbosch,
Netherlands
Inscribed in metallic lettering,
back, below: *BAAS*
Purchase, the Museum
Campaign 1988-1993 Fund
2007.134

194

Tejo Remy
Born in the Netherlands
in 1960
*You Can't Lay Down Your
Memories* Chest of Drawers
1991
Maple, recycled drawers,
cotton
Produced by Droog Design,
Amsterdam
Signed and titled inside
a drawer: *Tejo Remy /
You Can't Lay Down
Your Memories*
Liliane and David M.
Stewart Collection
D99.159.1.1-41

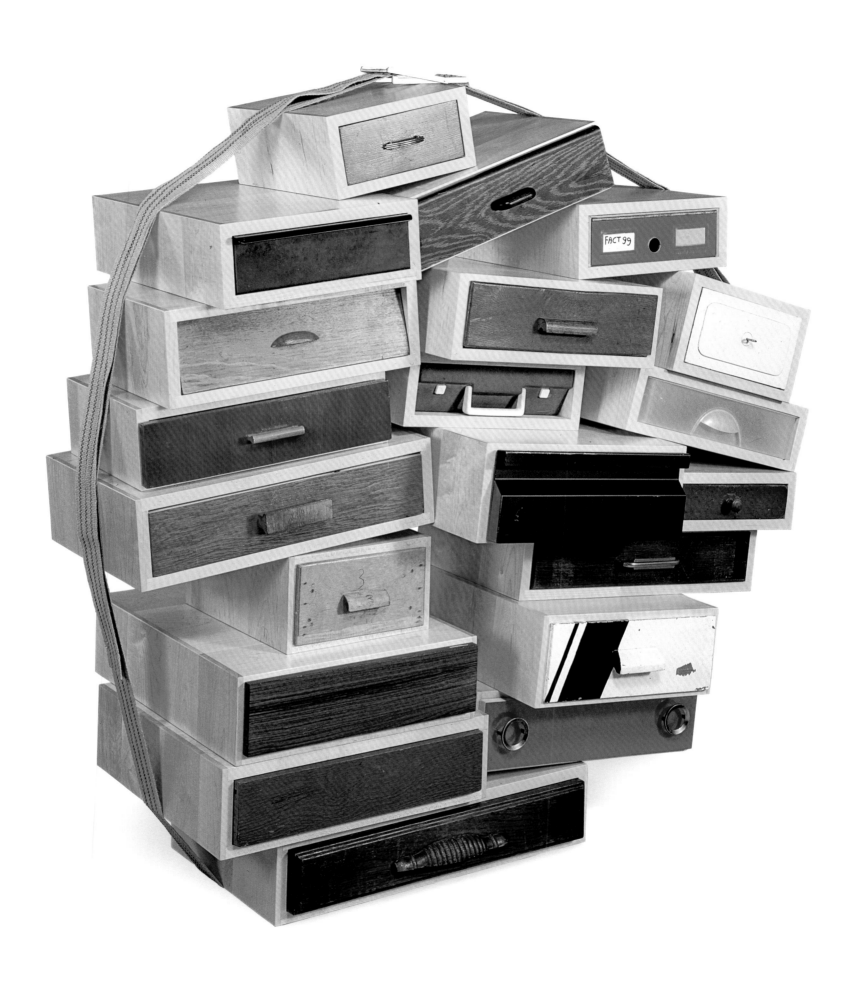

FIBRE

noun [ORIGIN Old French & mod. French from Latin *fibra*.]
noun 6 *collect.* ■ Any material consisting of animal, vegetable, or man-made fibres; *esp.* one that can be spun, woven, or felted.

━━━ For thousands of years, fibres have been woven, braided or knitted to be used in clothing, tapestries and furniture coverings. The complex techniques of medieval loom weaving led to the creation of highly refined tapestries and fabrics, exemplified by the rich decorations of the oldest pieces in the collection. ━━━ In the twentieth century, a number of designers emerging from a wide range of stylistic trends helped transform the textile industry. As innovations changed printing techniques and the way colours were produced, printed patterns gained importance, while synthetic fibres were soon combined with natural fibres. ━━━ Traditionally associated with the decorative arts, textile materials would be used, in the latter half of the twentieth century, as the support for original artistic practices: whether mural or three-dimensional works, these creations are artworks in their own right. ━━━ Furniture designers have explored unusual uses for fibre in a number of ways. Carbon fibre, nylon and rush are used innovatively to make lightweight seating. The use of babiche and leather serves as a reminder that humans worked the hides and skins before removing the coat to weave the first fabrics. Other designers invert trim and frame, covering one with the other in painted patterns, inventing solidified felt, or even playfully employing a profusion of stuffed animals. DC

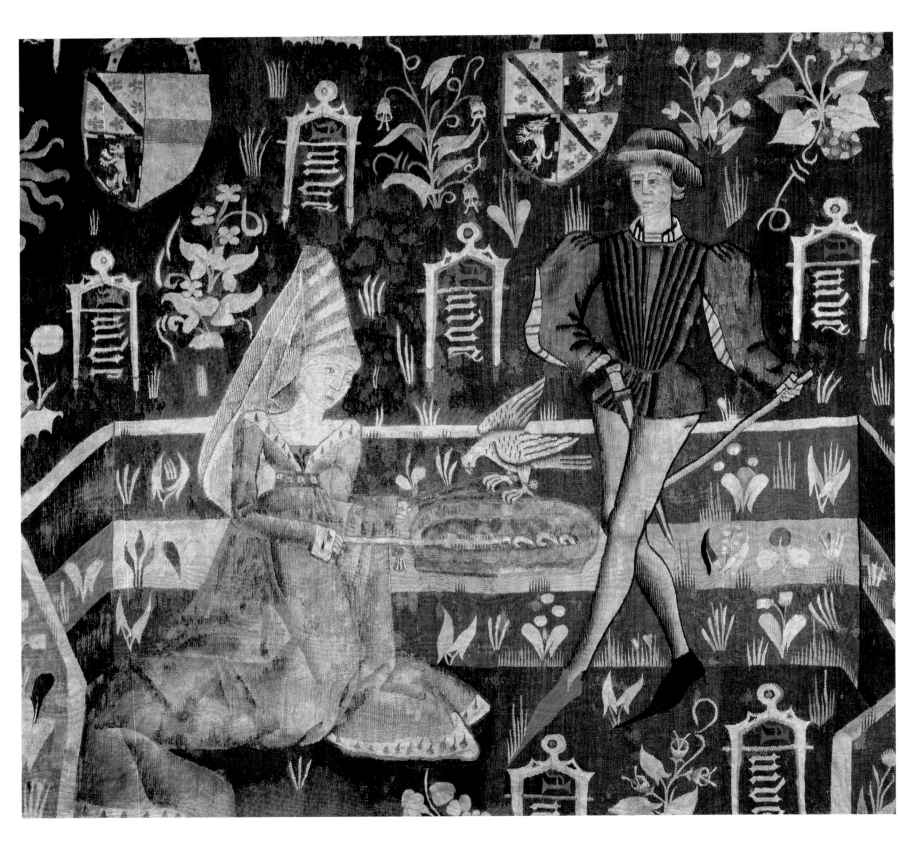

(195, detail)

EARLY TAPESTRY

— ELIZABETH CLELAND —

THE TRAINING OF A FALCON

This tapestry is a rare survival in terms of its large scale and content **195**. A lady and gentleman in courtly dress are engaged in the fashionable art of training a falcon. The lady encourages the tethered bird, which she gently splashes with a rod,[1] to bathe in a basin of water, while the gentleman stands awaiting the lady's command as faithfully as the bird, demonstrating that her activity is a metaphor for her power over him, as she has tamed his heart.

A handful of tapestries echoing this romantic theme survive.[2] However, this is the only one in which the generic figures are given specific identities thanks to the armorials hanging above them and to the heraldic devices surrounding them. This tapestry was probably made to commemorate a marriage. Considerably rewoven, the coat of arms above the gentleman is that of the Beaufort-Canillac family. When the tapestry was first published in 1888, it was suggested that it represented Louis de Beaufort and Jeanne de Norry, married in 1426.[3] This identification must be rejected on grounds of date. The gentleman's very short skirt, the pleated and padded V-shaped silhouette of his doublet, pointed shoes and long dagger hanging modishly between his legs would have been fashionable from the late 1450s until the early 1480s. The lady's wide-necked, high-belted velvet robe, trimmed with ermine, and her pointed hennin (fifteenth-century headdress) date to the mid-1460s at the earliest.[4] It is likely that the armorial above the gentleman is of one of Louis and Jeanne's offspring. Although the couple had three sons, only one, Jacques-Rogier, took a wife. Circumstances suggest that his union with Jacqueline de Créquy took place in the 1460s or early 1470s.[5] Unfortunately, the physical degradation to the uxorial side of the lady's coat of arms renders the heraldry unidentifiable.

Most of the devices dotting the surface of the scene currently read "A mue," meaning to moult (shed hair). However, the similarity of the letters "e" and "r" in black-letter script, combined with the substantial reweaving throughout, suggests that the few instances (for example, top right) where the device ends with an "r" more faithfully reflect the original meaning: "A mur." This was probably a canting motto playing on the French word for wall, which, since obscured, must have had some significance for the patron's family (as a fortification device—implying "beau fort"—was used in some surviving armorial tapestries made for Jacques-Rogier's great-uncle, Guillaume III Rogier de Beaufort).[6] The orthographic and phonetic association of "Amur" to "Amour" comments on the tapestry's romantic subject. The special association of "mur" would also explain the inclusion of the pair of masons' compasses framing the device and the otherwise puzzling walled enclosure in which the protagonists find themselves.

This most secular piece would have hung in a domestic setting, like the great hall of a castle. Evidently used and exposed to the light and abrasions of such a location, the tapestry suffered some wear and tear and was cut down on all sides. In the late fifteenth century, many tapestries were produced on speculation by dealers and sold on the open market; the conspicuous inclusion of the armorials and heraldic compass and flaming-sun devices on this tapestry emphasized to all that this had been a much more costly special commission. Given the relatively high quality of those areas of original weaving, still appreciable in some of the sinuous clumps of flowers, the tapestry was probably woven in the Southern Netherlands, the leading production centre by this date. Lack of documentation and vagaries of stylistic attribution make it impossible to narrow the location

down further: Brussels, Bruges and Tournai, for example, are all possibilities. Both families had easy access to the best weaving workshops: Jacqueline's father, Jean V de Créquy, was councillor and chamberlain to Philip the Good, Duke of Burgundy. She herself is known to scholars of Burgundian court culture, having owned a manuscript of Wauquelin's *La Belle Hélène*.[7] Jacques-Rogier's father, Louis de Beaufort, enjoyed similar high standing in the French court as chamberlain to Charles VII. **EC**

1. Process described in Frederick II of Hohenstaufen's thirteenth-century falconry treatise *De arte venandi cum avibus* (Biblioteca Apostolica Vaticana, MS Pal. Lat. 1071). **2.** New York, Metropolitan Museum of Art, Inv. 46.58.1; 43.70.2; 64.277, and Paris, Musée du Louvre, Inv. OA3131. Stylistic parallels with *Couple under a Dais*, Paris, Musée des Arts Décoratifs, Inv. 21121. **3.** Ambroise Tardieu, "No. 5," *L'Auvergne Illustrée (ancienne et moderne)*, vol. 5 (May 1888), pp. 34–35; Alfred Darcel discussed Tardieu's publication of the tapestry in "Séance du 9 juillet 1888," *Bulletin archéologique*, vol. 2 (1888), pp. 231–232. **4.** See Margaret Scott, *A Visual History of Costume: The Fourteenth and Fifteenth Centuries* (London: B. T. Batsford, 1986), pp. 92, 100, pl. 115. **5.** Jacqueline, eighth child of Jean de Créquy and Louise de la Tour (married in 1430), died in 1509. For the Créquys, see M. l'Abbé Fromentin, *Fressin: histoire, archéologie, statistique* (Lille: Salésienne, 1892). Jacques-Rogier's elder sister, Isabeau, married Jean de Montboissier in 1459. For the Beauforts, see V. Gueneau, "Notes pour servir à l'histoire de la Commune de Vandenesse (Nièvre)," *Bulletin de la Société Nivernaise*, 2nd series, vol. 6 (1874), pp. 498–575 (pp. 511, 512). (The addition to Schlesinger's edition of De la Chenaye-Desbois' *Dictionnaire de la noblesse* [Paris: Schlesinger Frères, 1863], col. 628 that Jacqueline and Jacques-Rogier married in 1425 is erroneous.) **6.** For example, New York, Metropolitan Museum of Art, Inv. 46.175; Glasgow, Burrell Collection, Inv. 46.50, 51, 52. **7.** See Bernhard Sterchi, *Über den Umgang mit Lob und Tadel* (Turhout: Brepols, 2005), p. 343.

195

SOUTHERN NETHERLANDS
The Training of a Falcon
About 1470
Wool (5-6 warp
threads per cm)
193 x 403 cm
Purchase, D. W. Parker Fund
1949.50.Tap.16
PROVENANCE
Montboissier-Canillac family,
Auvergne, about 1470;
Mrs. de Lagarde, Toulouse;
Duveen Brothers, New York;
Otto J. Kahn, New York;
Joseph Brummer Ancient Art,
New York; French & Company,
New York; acquired by the
Museum in 1950.

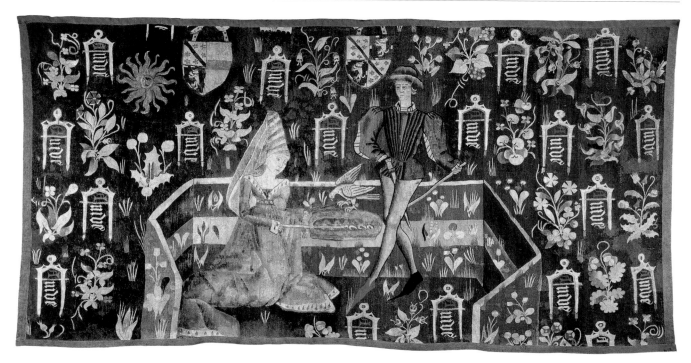

PRIAM RECEIVES ULYSSES AND DIOMEDES AT THE GATES OF TROY

Inscriptions identify Trojan King Priam (right foreground) receiving insincere offers of peace from the Greek ambassadors Ulysses (centre foreground) and Diomedes (centre, to Ulysses' left), while Aeneas (centre, just behind Diomedes) and Antenor (just behind Priam) watch **196**. Behind, soldiers mass around the battlements, part of the gates of the fortified city of Troy. The Greek encampment lies beyond and, to the right, is a glimpse of Troy itself, complete with gabled roofs and casement windows more akin to fifteenth-century Bruges. Above the principal scene, traitorous Antenor and Aeneas reappear, admitting the Greeks into Troy on condition that the pair escapes the city unscathed. The antithesis to the plot of Homer's *Iliad*, this episode reflects postclassical versions of the legend, popular in the fifteenth century, such as the *Roman de Troie* (late twelfth century) by Benoît de Sainte-Maure and *Historia destructionis Troiae* (1280–87) by Guido delle Colonne.

Despite its striking height, this is a fragment from a considerably larger wall hanging, originally approximately five times this width. Representing *The Death of Penthesilea and Treachery of Antenor and Aeneas*, the monumental tapestry had already been dismembered by 1838, when the French scholar Achille Jubinal published drawings of three other fragments (then in the courthouse at Issoire) which, together with the Montreal piece, had originally formed one huge tapestry.[1] Thanks to Jubinal, we know that this had been part of an eleven-piece set of tapestries illustrating the *Story of Troy* hanging in the château of Aulhac, in the Auvergne region of France. After the set was dismembered, other pieces eventually reached the

Metropolitan Museum of Art and a private collection in Paris.[2]

There were at least seven editions of the *Story of Troy* woven, all after the same cartoons. The full-size painted cartoons have not survived, but some of the *petit patrons* (initial designs) have. These designs are attributed on stylistic grounds to a Parisian artist called the Coëtivy Master (fig. 1), who was also active as a manuscript painter.[3] The cartoons were owned by a dealer-entrepreneur called Pasquier Grenier, sometimes erroneously believed to have been a weaver himself. He and his son Jean caused the cartoons to be reused numerous times and sold tapestry editions of this *Story of Troy* to an astonishingly impressive roll call of collectors: Charles the Bold, Duke of Burgundy (delivered by 1472); Federico da Montefeltro, Duke of Urbino (delivered 1476); Henry VII, King of England (delivered 1488). Moreover, editions were soon recorded in other collections: Charles VIII, King of France (documented by 1494); Matthias Corvinus, King of Hungary (documented 1495); Ludovico Sforza, Duke of Milan (documented 1496); James IV, King of Scotland (documented 1503).

Unfortunately, very few of these tapestries survive. Comparing those that have, it is apparent that the Greniers used different weaving workshops to produce the various editions, as the colours and quality of weaving differ considerably. This probably reflects the range of costs of the sets and the compromises given the production time frame. Since each tapestry took approximately eight months to complete and the Greniers were selling so many, they needed to have sets on looms simultaneously to meet demand. Although

there is no firm evidence, it is likely that the Greniers used weavers based in their own city of Tournai, which was a bustling tapestry-production centre during this period.

The edition of which Montreal's piece was a part has a distinctive predominantly red and blue palette. Despite the expected areas of repair and reweaving, there are still original passages that attest to the skill of the first weavers, such as the use of slits in the weaving to provide depth and relief, discernible around Diomedes' hand, in Antenor's red hat as he appears at the top of the tapestry and in the horseman's doublet. From charming details like the foreground strawberries, to the almost caricatural expressive faces and gestures, to the range of patterns and textures of the exotic costumes, the effect when this imposing set hung in its entirety must have been awe-inspiring. Positioned side by side to create a chamber, the almost life-size foreground figures must have seemed, in the flickering candlelight, to step into the viewers' actual space. **EC**

1. Achille Jubinal, *Les anciennes tapisseries historiées* (Paris: chez l'éditeur de la Galleries d'Armes de Madrid, 1838), vol. 2, pp. 9–10.

2. New York, Metropolitan Museum of Art, Inv. 55.39; 39.74; and, possibly, 52.69. For the different editions, see Scot McKendrick, "The *Great History of Troy*: A Reassessment of the Development of a Secular Theme in Late Medieval Art," *Journal of the Warburg and Courtauld Institutes*, vol. 54 (1991), pp. 43–83, and Adolfo Cavallo, *Medieval Tapestries in the Metropolitan Museum of Art* (New York: Metropolitan Museum of Art; Harry N. Abrams, 1993), cat. 13.

3. Nicole Reynaud, "Un peintre français cartonnier de tapisseries au XVᵉ siècle : Henri de Vulcop," *Revue de l'Art*, vol. 22 (1973), pp. 6–21 analyzes the drawings (Paris, Louvre and Bibliothèque Nationale), suggesting the Coëtivy Master was Henri de Vulcop or (more recently) Colin d'Amiens.

Fig. 1
Coëtivy Master, *The Trojan War: Death of Penthesilea and Treachery of Antenor and Aeneas*, 1465, pen and ink, watercolour highlights. Musée du Louvre, Paris.

196

Attributed to the Coëtivy Master
Active in Paris, 1455–75
Priam Receives Ulysses and Diomedes at the Gates of Troy
About 1475–about 1495
Wool, silk (5–6 warp threads per cm)
439.5 x 188 cm
Made for Pasquier Grenier, Tournai
On the hats of the figures at the top, left to right: *anthenor*; *eneas*; on bottom of central arch, left to right: *ulixes*; *diomedes*; *eneas*; *athenor*; *le roy priam*; on the central arch: *CONVENTIO: SIMVLATE: CONCO*
Purchase, D. W. Parker Fund
1951.Tap.21

PROVENANCE
Château d'Aulhac, Auvergne, France; Count Schouvaloff, Saint Petersburg; Countess Benckendorff, Berlin; Duveen Brothers, New York; acquired by the Museum in 1951.

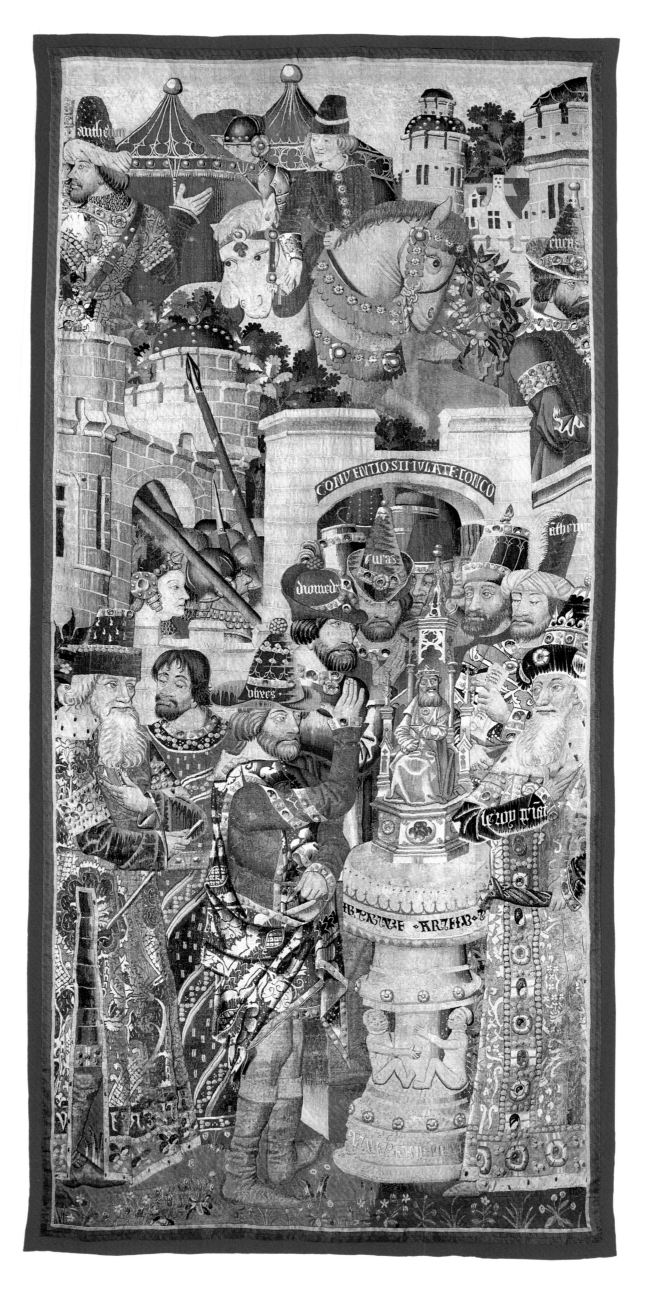

BROCADES, VELVETS AND SILKS: DEVELOPING A TEXTILE COLLECTION

— ROSALIND PEPALL —

Textile art had been a focus of attention from early on in the development of the Museum's collection of decorative arts. Judging from the annual reports before 1940, when acquisitions were listed by medium, a very wide range of "textiles" was either donated or purchased. For example, entries included: "Embroidered ecclesiastical stole—Italian," "Bed cover in silk and linen—Greek islands," "Strip of floral brocade—Persia, circa 1600," "Kashmir shawl—India, late 18th century," "Eight pieces of Peruvian Textiles from Paracas and the Valley of Chancey [sic]," "Embroidered peasant's cap, Brittany," "Child's ceremonial hood, Mongolian," "Twelve fragments of Italian cut velvets, 15th–16th centuries," "Three fragments of Coptic Weaving—5th–6th century A.D."

The director of the collection, F. Cleveland Morgan, who had a keen interest in textiles, soon followed the example of major collectors and museums by acquiring existing collections, thus benefiting from the knowledge and eye of a collector who had already spent years of study gathering and consulting to amass a significant group of works. In keeping with the original educational purpose of the decorative arts collection, in 1939 a donation of 382 lace works from the great Flemish and French lacemaking centres was offered by David Warren Parker (1886–1948). He had been chief of the Manuscript Division at the Public Archives of Canada from 1916 to 1923 and was known for his publications relating to the classification of government documents.[1] The works in this collection of lace date from the seventeenth to the twentieth centuries, and include collars, lappets, edging motifs and fans, all of which illustrate the history and development of the art of lacemaking.[2] Parker also left a generous bequest of $50,000 for the purchase of textiles, with which exceptional works were added to the collection, for example the Museum's two most important tapestries 195 and 196 .[3]

The next year, in 1940, the "outstanding acquisition of the year," according to the annual report on the decorative arts, was a collection of 326 Spanish textiles from the fourteenth to the eighteenth centuries, which F. Cleveland Morgan had purchased from the widow of Arthur Byne (1883–1935), an American expatriate who had moved to Madrid in 1916 197 198 . Byne was an architect, artist, author and curator of New York's Museum of the Hispanic Society of America, an authority on Spanish art and sometime dealer.[4] Morgan purchased Spanish furniture from Byne in 1928 for the Montreal Museum.[5] During negotiations for the Byne works, Morgan heard about another collection up for sale in New York: the estate of Herman A. Elsberg (1869–1938), which was being split up among different major museums. The Museum purchased about ten thirteenth- and fourteenth-century Hispano-Moresque fragments from the Elsberg collection. They were of the highest quality, and some of them had been illustrated in the book *Silk Textiles of Spain: Eighth to Fifteenth Century*, by Florence Lewis May, published by the Hispanic Society of America in 1957. A small group of Elsberg's ancient Peruvian textiles were purchased by the Detroit Institute of Arts;[6] and French eighteenth-century textiles were bought by the Metropolitan Museum of Art in New York, whose *Bulletin* claimed that Elsberg had "long stood for one of the leaders in this special field" of historic textiles.[7]

These early textile acquisitions were often purchased with funds from Mabel Molson, and she continued to support F. Cleveland Morgan in buying other works for the textile collection, including examples of early Quebec bed coverlets and hooked rugs, as well as English dress silks. Donations kept coming in as well, such as five examples of printed cottons and linens by Morris & Company, London, given in 1941, by Mrs. J. Kippen 205 - 208 . According to labels attached to the works, they were purchased after Morris & Company had moved to 17 George Street, Hanover Square, in 1917 and maybe as late as 1940, which showed the continuing appeal of Morris' work, even after his death in 1896.[8]

Some works turned out to be other than as identified when purchased; for example, when the curator of textiles from the Museum of Fine Arts, Boston, Gertrude Townsend, suggested that a small tapestry classed as Peruvian 199 in Montreal's collection might be English,[9] it was sent for inspection to Boston for an analysis of fibres and a comparison with works in the Boston museum. For many reasons, but especially the fact that the wool analyzed in the work turned out to be European sheep's wool and not alpaca wool from which Peruvian specimens were invariably made, the piece was judged to be a very fine, small example of seventeenth-century English tapestry weaving.[10]

All textiles, whether fragments of cloth, dress silks, drapery brocades, tapestries or furniture coverings, are fragile and may be exhibited for only short periods of time; thus the Museum's collection has many hidden treasures illustrating the history of textile design and technology.

1. Carman V. Carroll, "David W. Parker: The 'Father' of Archival Arrangement at the Public Archives of Canada," *Archivaria*, vol. 16 (Summer 1983), pp. 150–154. Parker resigned from the Archives in 1923 and went to Cambridge, Massachusetts. He died in 1948 and is buried in Mystic, Quebec, very near his native town of Bedford. My thanks to Library and Archives Canada for their help in confirming his dates.
2. Report of Marijke Kerkhoven, dated 1983 (MMFA Archives).
3. The Art Association of Montreal's annual report for 1949–50 listed twenty-six silks, velvets, brocades and rugs from all over the world, bought with the Parker Purchase Fund, p. 40.
4. Research.frick.org/directoryweb/browserecord.php?-action=browse&-recid=7121 (accessed April 6, 2012).
5. Bill from Arthur Byne to the Art Association of Montreal, Madrid, June 14, 1928 (MMFA Archives, file 1928.Df.5).
6. "The Elsberg Collection of Peruvian Textiles," *Bulletin of the Detroit Institute of Arts*, vol. 19, no. 4 (January 1940), p. 34.
7. Frances Little, "Textiles from the Elsberg Collection," *Bulletin of the Metropolitan Museum of Art*, New York, vol. 34, no. 6 (June 1939), p. 142.
8. Katharine A. Lochnan, Douglas E. Schoenherr, Carole Silver, eds., *The Earthly Paradise: Arts and Crafts by William Morris and his Circle from Canadian Collections* (Toronto: Art Gallery of Ontario; Key Porter Books, 1993). See pp. 159–164 for the Museum's fabrics.
9. Letter from Gertrude Townsend, Boston, to John Steegman, Director of the Museum of Fine Arts, Boston, April 12, 1957 (MMFA Archives, file 1956.Tap.7).
10. Letter from Gertrude Townsend to F. Cleveland Morgan, Boston, October 3, 1957, and letter from Adolph S. Cavallo, Assistant Curator of Textiles, Museum of Fine Arts, Boston, October 14, 1957 (MMFA Archives, file 1956.Tap.7).

197

SPAIN
Textile Fragment
1500–50
Silk
48 x 23 cm
Purchase, gift of
Miss Mabel Molson
1940.Ea.71

198

SPAIN
Textile Fragment
1500–50
Silk
35 x 18 cm
Purchase, gift of
Miss Mabel Molson
1940.Ea.8

199

ENGLAND
Tapestry Panel
Early 17th c.
Wool, silk,
silver-wrapped thread
18.4 x 26 cm
Purchase
1956.Tap.7

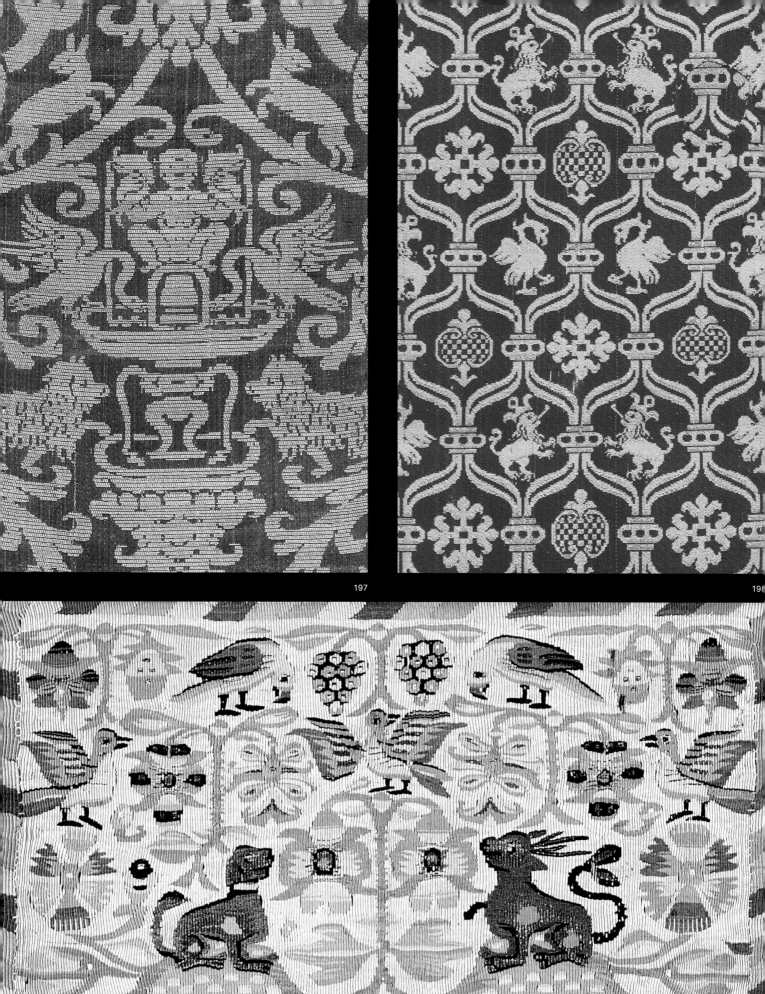

201

202

203

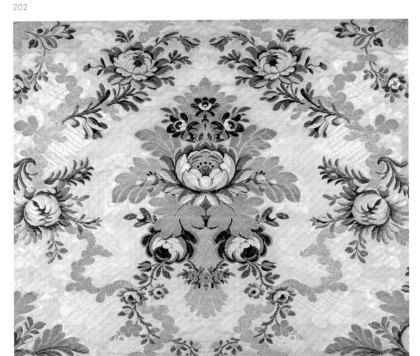

204

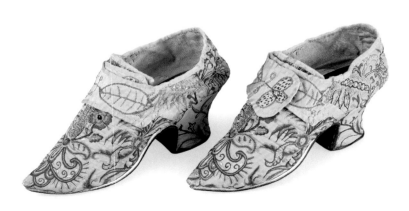

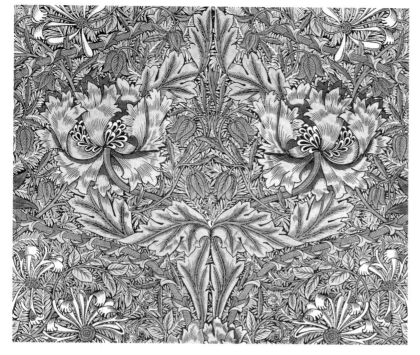

205

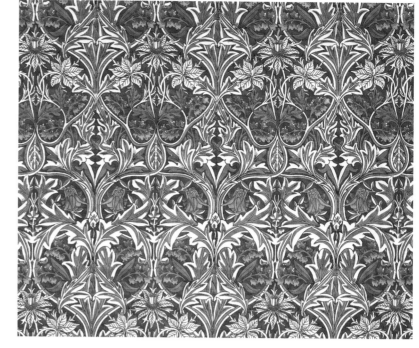

206

207

208

203

PROBABLY LYONS
Textile Fragment
About 1715
Silk
54.6 x 39.4 cm
Purchase, gift of
Miss Mabel Molson
1940.Ea.118

204

FRANCE
Textile Fragment
About 1765
Silk
54.8 x 44.1 cm
Gift of F. Cleveland Morgan
1941.Dt.3

205

William Morris
Walthamstow, England,
1834 – Kelmscott,
England, 1896
Honeysuckle Fabric
**1876 (example produced
between 1917 and 1940)**
Printed linen
68.5 x 98 cm
Produced by Morris &
Company, London
Block-printed by Thomas
Wardle, Leek, England
Printed on selvage: *Rec'd
Morris & Company*
Gift of Mrs. J. Kippen
1941.Dt.5

206

William Morris
Walthamstow, England,
1834 – Kelmscott,
England, 1896
Bluebell or *Columbine* Fabric
**1876 (example produced
between 1917 and 1940)**
Printed cotton
89 x 99 cm
Produced by Morris &
Company, London
Block-printed by Thomas
Wardle, Leek, England
Printed on selvage:
Rec'd Morris & Company
Label formerly attached to
selvage: *NO. / PRICE $4.00 AW*
[inscribed in pencil] / *WIDTH
/ MORRIS & COMPANY / ART
WORKERS LTD. / 17, GEORGE
STREET, / HANOVER SQUARE,
/ W.1*; on verso, inscribed
in ink: *BLUEBELL 6693 /
PRINTED CRETONE*
Gift of Mrs. J. Kippen
1941.Dt.7

207

William Morris
Walthamstow, England,
1834 – Kelmscott,
England, 1896
Honeysuckle Fabric
**1876 (example produced
between 1917 and 1940)**
Printed linen
90 x 97.5 cm
Produced by Morris &
Company, London
Block-printed by Thomas
Wardle, Leek, England
Printed on selvage: *Rec'd
Morris & Company*
Gift of Mrs. J. Kippen
1941.Dt.6

208

William Morris
Walthamstow, England,
1834 – Kelmscott,
England, 1896
Cray Fabric
**1884 (example produced
between 1917 and 1940)**
Printed cotton
133 x 97 cm
Produced by Morris &
Company, London
Block-printed at
Merton Abbey
Printed on both selvages:
Rec'd Morris & Company
Label formerly attached to
selvage: *NO. 41.Dt.8* [inscribed
in ink] / *PRICE / WIDTH /
MORRIS & COMPANY / ART
WORKERS LTD. / 17, GEORGE
STREET, / HANOVER SQUARE,
/ W.1*; on verso, inscribed in
ink: *CRAY 2109 / PRINTED
CRETONE / 3.00* [corrected
in pencil for .50]
Gift of Mrs. J. Kippen
1941.Dt.8

MODERN ARTIST-DESIGNED TEXTILES

— ALAN ELDER, ANNE B. GRACE, ROSALIND PEPALL —

WIENER WERKSTÄTTE TEXTILES

The textile department of the Wiener Werkstätte became a critical part of the workshop of artists and artisans in Vienna established in 1903 by Josef Hoffmann, Koloman Moser and financier Fritz Wärndorfer. Their aim was to bring artists and craftsmen together to work in the spirit of reform and the integration of all the arts. The textile section was begun about 1910, and consisted mainly of hand-printed patterns on linen, cotton or silk, sometimes by outside firms, like Gustav Ziegler of Vienna in the case of two textiles in the Museum's collection. The fabrics were used primarily for interior decoration—curtains, furniture upholstery, wall coverings and carpets—but also for clothing. The architect Josef Hoffmann, long-time director of operations, would use the workshop's textiles for the interiors of his architectural commissions.

Carl Otto Czeschka was one of the principal designers of the early Wiener Werkstätte community, providing designs for jewellery, bookbinding, silver, graphics and textiles from 1905 until 1914, even though he moved to Hamburg in 1907 to teach at the school of arts and crafts (Kunstgewerbeschule). The fabric in the Museum's collection entitled *Bavaria* 210 features a tightly arranged pattern of flat, stylized, bell-shaped flowers in off-white against a dark grey ground. Each bold motif is decorated with a two-tone pattern in blue and light grey, now very faded, and resembles a paper cut-out, which is typical of Czeschka's textile designs and which inspired a number of his colleagues. A popular pattern, *Bavaria* was used for wall coverings, chair upholstery and even lampshades, as well as for coats and dresses.[1] For example, it was chosen for the interior bedroom furnishings at the Primavesi country villa in Winkelsdorf, Moravia, in 1913.[2]

Mäda Primavesi, wife of the financier and industrialist Otto Primavesi, was an enthusiastic supporter of the Wiener Werkstätte, and her husband acted as its administrative director for about ten years, from 1915. The Primavesis also selected the vibrant patterns by Ludwig Heinrich Jungnickel for the decoration of their library and dining room. Jungnickel's *Jungle* fabric 209 is a dense composition of monkeys and birds amid tropical trees and plants. Typical of his designs is the stark contrast of off-white motifs on a dark grey background, with touches of colour here and there.

Despite the success of the textile and fashion department in the 1920s, the Wiener Werkstätte never fully recovered economically from the war, and the change in taste and push to be more commercially viable finally brought about the closure of the workshop in 1932. RP

1. Angela Völker, *Textiles de la Wiener Werkstätte 1910-1932* (Paris: Flammarion, 1990), ills. pp. 80–81. 2. Ibid., p. 54.

RAOUL DUFY

This unique wall hanging by Raoul Dufy 211 , created during his brief collaboration with the great fashion designer Paul Poiret (1879–1944),[1] reveals the artist's talent as a printmaker and textile designer at an early stage in his career. Trained as a painter in Paris, Dufy took a particular interest in the art of wood engraving, and in 1907 began creating simple prints, inspired by the revival of printmaking in France and other parts of Europe. In 1910, Dufy executed four prints—*Fishing*, *The Hunt*, *The Dance* and *Love*—which were exhibited that same year at the Salon des Indépendants in Paris.[2] They came to the attention of Paul Poiret, who suggested that the artist transfer the wood-engraving technique to cloth. Thus their partnership began in 1910 for about a year, under the

name of La Petite Usine, the workshop Dufy set up in Paris at 141 Boulevard de Clichy. There Dufy created four wall hangings that combined hand-painted and printed designs on linen: *Fall*, *Still Life with Fruit*, *The Hunt* and the Museum's piece, *The Dance*. The latter two designs had been taken from his 1910 set of prints (fig. 1).

The Dance shows a sailor and a woman swaying to the rhythms of an accordion player amid a verdant tropical landscape that suggests the French Caribbean islands.[3] The design has the flatness and bold linear quality of a print. The outlines and hatching of the figures have been hand drawn in brown and painted over with broad washes of colour. Some coloured areas, such as the small green leaves, have been printed, as has the broad, dark brown border of roses, tulips and anemones that recall the stylized floral designs of the Austrian Wiener Werkstätte group of artists.[4]

Such was Dufy's success in these first experiments in printed textile design that from 1911 until 1928, he worked with the Lyons silk manufacturing firm of Bianchini-Férier to create designs that could be mass-produced by machine and widely diffused. Dufy continued to create prints and tapestries,[5] and, later on, murals, ceramics and theatre decoration, which required his skills as both artist and designer. RP

1. This hanging was exhibited in *Poiret le magnifique* at the Musée Jacquemart-André, Paris, in 1974, cat. 393. 2. Dora Perez-Tibi, *Dufy* (Paris: Flammarion, 1989), ill. p. 53. 3. When Dufy later repeated this image in textile design for Bianchini-Férier, he called it *Le voyage aux Îles*. 4. Paul Poiret had visited Vienna and had been inspired by the Wiener Werkstätte artists to open a school of decorative arts for girls called "Martine." 5. For example, *Homage to Mozart*, 1934, in the Museum's Liliane and David M. Stewart Collection, D87.189.1.

Fig. 1
Raoul Dufy, *The Dance*,
1910, wood-block print.
Musée natinal d'art moderne
long-term loan to Musée
des Beaux-Arts de Nice,
Mrs. Raoul Dufy Bequest,
Paris, 1963.

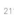

211

Raoul Dufy
Le Havre 1877 –
Forcalquier, France, 1953
***The Dance* Wall Hanging**
1910–11
Painted and printed linen
214 x 236 cm
Monogram, painted on
lower left: *RD*
Gift of Paule Regnault
2004.136

PROVENANCE
Luce Gerbaud;
Paule Regnault, 1975;
acquired by the
Museum in 2004.

HENRI MATISSE

When Henri Matisse was asked in the late 1940s by William F. Cochran Ewing, president of Alexander Smith & Sons, to create a design for a rug to be produced by this prominent American carpet manufacturing company to mark its one hundredth anniversary,[1] it was an undertaking for which the artist was well disposed.

Matisse abandoned illusionistic space for flattened and more abstract forms in 1930, when he created a mural for the Barnes Foundation outside Philadelphia. To work out the composition, he used sheets of coloured paper, which he cut and pinned to the mural's surface. He later began to use cut paper as a medium in itself, no longer working from direct observation, but from memory and imagination.[2]

This paper cut-out technique extended his use of broad areas of vivid flat colour and simple expressive contours to its ultimate conclusion. The new use of this medium, which provided the pattern for the *Mimosa* carpet **212**, allowed him to employ colour while virtually eliminating the painting process. From sheets of coloured paper—almost always painted by an assistant, as Matisse was eighty years old at the time and in ill health—he cut out sinuous organic shapes.[3] Because of its two-dimensional nature, the paper cut-out design for *Mimosa* was ideally suited to be transferred to a carpet design.

Its composition, with its cut-out leaf motifs placed before a series of rectangles, is similar to that of *Polynesia, The Sea* of 1946, one of his four large screen-printed wall hangings on linen showing the influence of Tahitian textiles, namely the appliqué quilts known as *tifaifai*, which Matisse admired during his visits to the French colony.[4] In contrast to his work on linen, as if responding to the greater rigidity of the support, the paper cut-outs for *Mimosa* consist of a dense concentration in the centre of colourful leaves from the mimosa—a tree closely identified with the Côte d'Azur—becoming more sparse as they extend to the four corners of varying shades of red-orange.

Matisse's affinity for textile design came to him naturally, as his native town, Le Cateau-Cambrésis, was situated in the industrial region of northern France. For many generations, his forebears lived in an area where wool, lace and luxurious textiles were produced. Even with limited financial means as a student, Matisse collected fabrics he purchased at flea markets, and he continued to collect textiles up until the last years of his life. Persian rugs, embroideries, fabrics and tapestries from Algeria, Morocco and Polynesia filled his studio, comprising what he considered his "working library" and inspiration for his art.[5] Thus, it is perhaps surprising that *Mimosa*, produced in an edition of five hundred from the artist's design of 1949 (fig. 1) is the first and probably the only pattern specifically designed for a carpet.[6] ABG

1. Christa C. Mayer Thurman in *Design 1935–1965: What Modern Was. Selections from the Liliane and David M. Stewart Collection*, exh. cat., ed. Martin Eidelberg (Montreal: Le Musée des arts décoratifs de Montréal; New York: Harry N. Abrams, 1991), p. 238. 2. Jack Flam, *Matisse: Image into Sign* (Saint Louis, Missouri: The Saint Louis Art Museum, 1993), p. 12. 3. Ibid. 4. John Klein, "Matisse after Tahiti: The Domestication of Exotic Memory," *Zeitschrift für Kunstgeschichte*, vol. 60, no. 1 (1997), pp. 44–89. Klein provides an extensive study of the influence of these textiles made by women in Tahiti on Matisse's art. 5. Letter from Henri Matisse to Marguerite Duthoit, dated November 29, 1943 (Archives Matisse, Paris), quoted by Hilary Spurling in *Matisse, His Art and His Textiles: The Fabric of Dreams* (London: Royal Academy of Arts, 2004), p. 16. 6. *Design 1935–1965*, p. 238. The carpets were sold for $100 each.

MATHIEU MATÉGOT

Following his training in theatre design in Budapest, Mathieu Matégot moved to Paris in 1931, where he worked variously as a set designer, window dresser and fashion designer. After World War II, he set up a workshop to produce hand-made furniture made from metal, perforated sheet steel, glass and plastic laminate. He became one of the best-known French designers of his time, exhibiting at the Salon des arts ménagers and the Salon des Artistes Décorateurs.

Matégot's first tapestries were woven in Aubusson in 1945, helping the area's ailing weaving industry, which looked to contemporary designers, led by Jean Lurçat, to breathe new life into it. In the early 1960s, Matégot accepted a job teaching at the École nationale des beaux-arts de Nancy. At the same time, he turned his complete attention to his tapestry designs.

Acapulco **213**, designed in 1958, was the third of a series of four tapestries that Matégot designed for Tabard Frères & Soeurs. His tapestry works were abstract, and their limited palettes and broad areas of uninterrupted colour broken up by thin lines reflected the artistic ideas being explored by his contemporary Colourfield painters. *Acapulco* captures the eponymous city's vitality, with its colours and the rugged landscape in its jagged forms. It was one of several tapestries designed by Matégot to evoke modern life, particularly the ability to travel far and wide. AE

EDWARD MCKNIGHT KAUFFER

Although Edward McKnight Kauffer had strong ties to the United States—he was born and died there and had a solo exhibition at the Museum of Modern Art in 1937—he was best known in Britain for his work in graphic design between the world wars.[1]

McKnight Kauffer studied painting in San Francisco, where he met painter Joseph McKnight, who encouraged him to travel to Europe and whose name Kauffer adopted, as a gesture of gratitude for his patronage. He attended New York's Armory Show of modern European art in 1913, which captured his interest, and continued to be influenced by modernism after he arrived in Europe. En route back to the United States at the outbreak of World War I in the summer of 1914, McKnight Kauffer stopped in Britain, where he felt immediately at home and decided to settle. He was introduced to Frank Pick, who worked as the publicity manager for the London Underground Railway, and was soon designing posters as part of the Underground's progressive marketing campaigns. In addition to his poster designs, he is also known for his illustrations, stencilling, photomurals, theatre, and ballet costumes and sets.

Amid the economic upheavals of the late 1920s and 1930s, the Wilton Royal Carpet Factory began to produce hand-knotted carpets, like this one **214**, for its well-to-do clients. These rugs were intended to add colour to the often monotone modern interiors of the time. McKnight Kauffer's design reflects his long-time interest in modern abstract art movements. In this carpet, the designer brings dynamic, biomorphic forms, reminiscent of those by sculptor Jean Arp, to an everyday product. Many of his rug designs could be customized. AE

1. Mark Haworth-Booth, *E. McKnight Kauffer: A Designer and His Public* (London: V&A Publications, 2005).

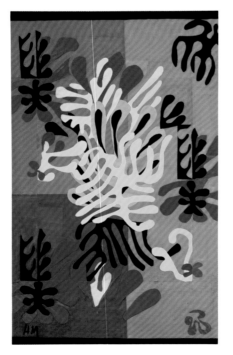

Fig. 1
Henri Matisse, paper cut-out design for the *Mimosa* carpet, 1949, Ikeda Museum of 20th Century Art, Itoh City, Japan.

212

Henri Matisse
Le Cateau-Cambrésis,
France, 1869 – Nice 1954
Mimosa Carpet
1949, example of 1951
Wool, 163/500
148.5 x 92.1 cm
Produced by Alexander
Smith & Sons, New York
Monogram, woven
on lower left: *HM*
Printed and handwritten
on label, on back:
*This rug designed / BY / H.
Matisse / and named /
Mimosa by him, / has been
woven by Alexander Smith
in a / limited edition of 500
of which this is number / 163*
Liliane and David M.
Stewart Collection
D85.111.1

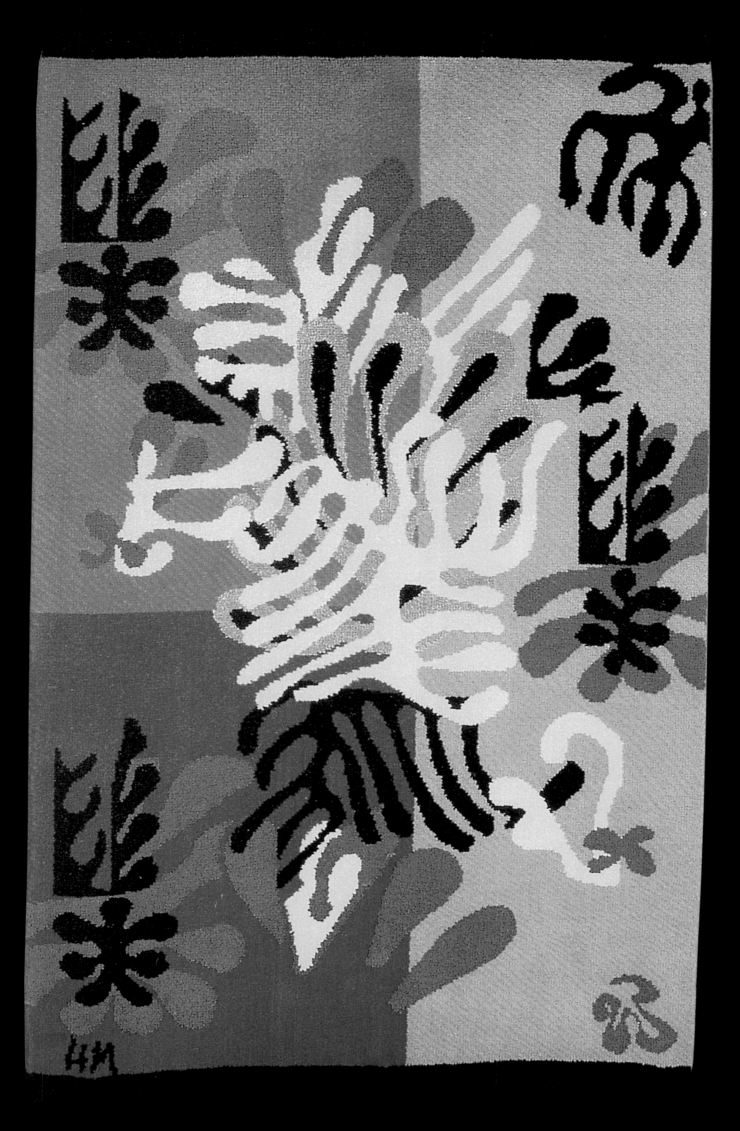

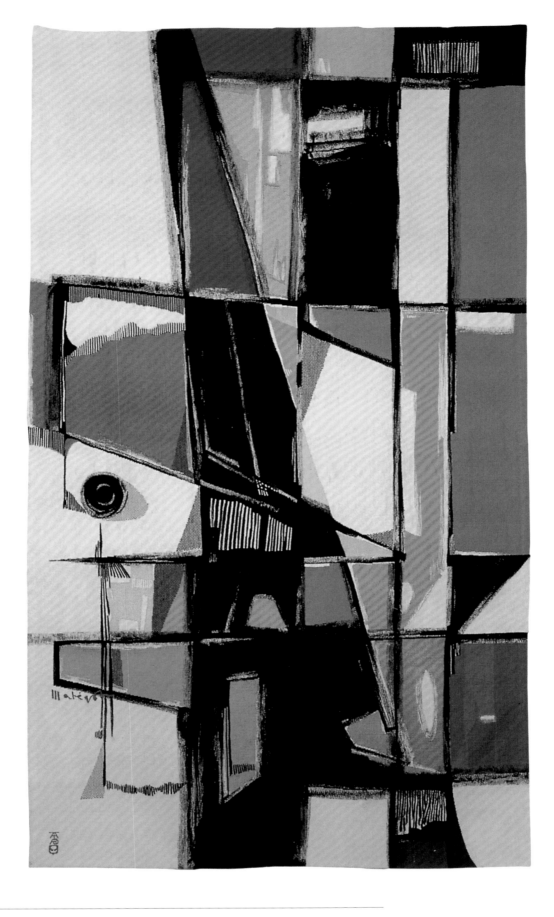

213

213

Mathieu Matégot
Tapio-Sully, Hungary, 1910 –
Angers, France, 2001
Acapulco Tapestry
1958
Wool
216 x 124.5 cm
Produced by Tabard Frères &
Sœurs, Aubusson, France
Signature, woven
on lower left: *Mategot*
Logo, woven on lower left:
[two A's superimposed
over the letter *T* above
a stylized flower];
Label, on back: *"Antimite
définitif" MITIN / "ACAPULCO" /
H: 2m20 L : 1m29 = 2mg83 /
Carton de MATHIEU MATEGOT /
édité par TABARD FRÈRES
& SOEURS / AUBUSSON /
Mathieu Matégot / No 655*
Liliane and David M.
Stewart Collection,
gift of Paul Leblanc
D91.105.1

214

Edward McKnight Kauffer
Great Falls, Montana
1890 – New York 1954
Carpet
About 1935
Wool
229 x 151 cm
Produced by the Wilton
Royal Carpet Factory,
Wilton, England
Monogram, woven
on lower right: *EMcKK*
Liliane and David M.
Stewart Collection,
gift of Paul Leblanc
D89.119.1

JEAN-PAUL MOUSSEAU

This full skirt by Montreal artist Jean-Paul Mousseau is decorated with painted motifs resembling fantastical insect forms that appear to fly across the expanse of fabric 215 . Rendered in fine black lines, these aerial creatures are highlighted with yellow and daubs of red to delineate their trajectories. These designs recall Mousseau's drawings of the 1940s, filled with organic, linear forms 216 .

Trained as a painter, Mousseau was part of the circle around Paul-Émile Borduas, leader of the Automatiste movement in Montreal and instigator of the 1948 manifesto *Refus global.* Mousseau was one of the signatories of this declaration by a group of Quebec artists who rebelled against the conservative attitudes of the province's art institutions, and against the social and political values of Quebec society. Mousseau shared the Automatistes' interest in Surrealism and their exploration of the subconscious in spontaneous, non-figurative compositions. From early in his career, Mousseau was also attracted to decoration and interior design. In fact, his first solo exhibition was *Tissus peints à la main de Mousseau* [Mousseau's Hand-painted Fabrics], presented

May 15–28, 1948, at the studio of his colleagues Guy and Jacques Viau.[1] The works bearing surrealistic titles, such as *Merle disséqué par son ramage* [Thrush Dissected by Its Song] and *Les fibrécoptères* [Fibrecopters], included hand-painted wall hangings and clothing. Linked with his artistic experiments were the handmade costumes he created for the dance performances of Françoise Sullivan, such as *Black and Tan Fantasy*, 1948, and *Femme archaique* [Archaic Woman], 1949.[2]

Through the late 1950s, Mousseau continued to paint non-figurative compositions, turning to more structured interrelationships of colour and form than found in his earlier Surrealist-inspired works. But he became disillusioned with what he perceived as the limitations of easel painting and the isolation of the artist from the general public. He expanded his vision of art to include murals and decorative objects, experimenting with fibreglass and coloured resin to create shimmering effects of colour in large-scale murals and hanging lamps labelled "lighting sculptures." He also worked with ceramic artist Claude Vermette on tile designs for architectural projects such as the Peel Street Metro station in Montreal.

In 1966, Mousseau achieved the ultimate synthesis of movement, light and music in his *Mousse-spacthèque* and *Le Crash* discotheques, in which the public became part of the theatrical decor of sculptures, projected images and roving lights. As Mousseau claimed, "in that environment there was no longer a distance between the stage and the audience, but rather a merging . . . the spectators inhabited the work I had made."[3] The Museum's skirt anticipated this direction in the artist's career.[4] Unlike a canvas, a skirt, when worn, is not static; the decorative motifs and colour are observed in motion. The wearer of the skirt is, in a sense, collaborating with Mousseau by giving his art vitality through movement. **RP**

1. The Viau brothers had recently set up a business in interior design in Montreal at 425 Saint-Joseph Boulevard West. This skirt was made for Suzanne Viau, wife of Guy Viau, who became an art critic and museum administrator. **2.** Illustrations p. 24 and p. 120 in *Mousseau*, exh. cat., ed. Pierre Landry (Montreal: Éditions du Méridien; Musée d'art contemporain de Montréal, 1996). These costumes are in the collection of the National Gallery of Canada. **3.** Francine Couture, "Mousseau et la modernité globale," ibid., p. 54. **4.** This skirt was included in the 1996 exhibition at the Musée d'art contemporain de Montréal, cat. 82.

215

Jean-Paul Mousseau
Montreal 1927 –
Montreal 1991
Skirt
About 1948
Mercerized cotton,
decorative motifs
painted in gouache
73 x 153 cm
Purchase, Horsley and
Annie Townsend Bequest
2009.16
PROVENANCE
Suzanne Viau;
acquired by the Museum
in 2009.

216

Jean-Paul Mousseau
Montreal 1927 –
Montreal 1991
The Awakening of
the Milky Way
1946
Pen and ink
27.7 x 21.5 cm
Signed, dated and titled,
lower right: *Mousseau 46 /*
"La voie lactée se réveille."
Purchase, Harold Lawson,
Marjorie Caverhill,
Harry W. Thorpe and
Mona Prentice Bequests
Dr.1989.5

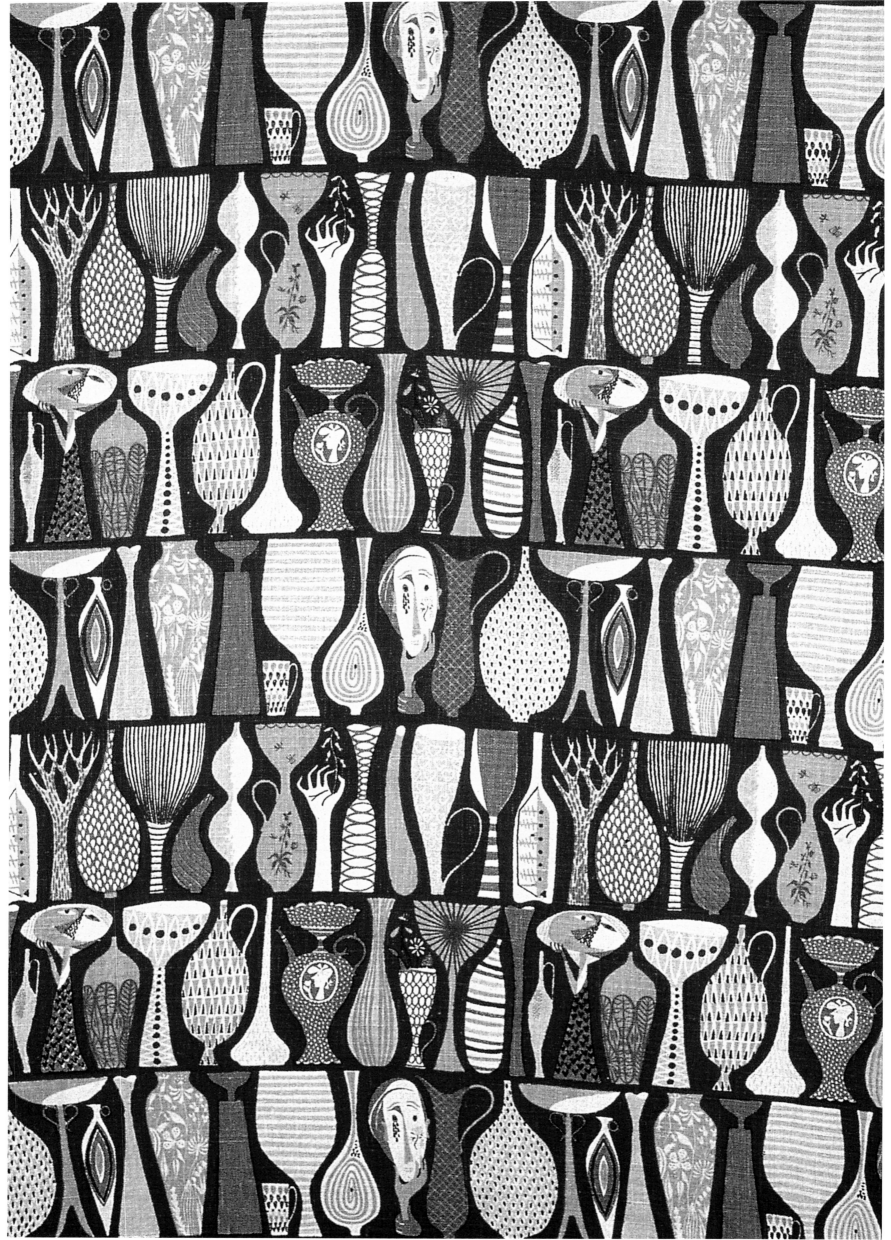

DESIGNERS FOR THE TEXTILE INDUSTRY: 1940s AND 1950s

— LESLEY JACKSON —

During the decade following World War II, many countries, particularly Great Britain, Sweden and the United States, experienced a surge of creativity in the textile industry. There were three reasons for this: significant changes in the structure of the textile industry; the enthusiasm of a young generation of designers; and a new spirit of optimism and daring among designers, manufacturers and consumers—the zeitgeist, in a word.

The war had severely disrupted the operations of the textile industry, affecting both production and trade. Even countries that remained neutral, such as Sweden, were not immune from its economic impact. In Britain, the limited number of mills that had remained in operation were requisitioned for war-related production (for example, blackout material, camouflage fabrics and blankets). Austerity measures to cope with shortages of raw materials, such as the government "Utility" scheme, remained in place until the late 1940s. When free-market conditions finally prevailed, there was a great sense of relief. But the war had changed the textile industry irrevocably, creating a vacuum and opening up new opportunities for small, design-led companies set up by entrepreneurs.

A fresh start was needed: new imagery for a new age. One of the most intriguing design initiatives of the period was the Festival Pattern Group, a flagship project at the Festival of Britain, a national showcase for art, science and technology held in London in 1951. The Festival Pattern Group brought together leading scientists from the field of X-ray crystallography and twenty-eight major applied art manufacturers. The crystallographers supplied diagrams of atomic structures that inspired the patterns on an innovative range of furnishings and fashion fabrics, including silk ties, spun rayon, leather cloth and lace. The project was initiated by Dr. Helen Megaw, a crystallographer from the world-famous Cavendish Laboratory at Cambridge University, and coordinated by Mark Hartland Thomas from the newly formed Council of Industrial Design. Several noted scientists contributed diagrams, including three future Nobel Prize winners—Dorothy Hodgkin, Max Perutz and John Kendrew—although they all remained anonymous at the time.[1]

It was Dr. Megaw's rendition of the crystal structure of afwillite (the mineral calcium hydroxide nesosilicate) that provided the inspiration for the woven textile Surrey 218 designed by Marianne Straub for Warner & Sons. Straub translated the organic contour-like linear diagram (a Patterson map of interatomic distances) into a complex jacquard-woven wool, rayon and cotton furnishing fabric. With its large-scale pattern, Surrey was used to dramatic effect as curtains in the Regatta Restaurant at the Festival.[2]

Lucienne Day, who spearheaded the "Contemporary" design movement in Britain after the war, made her breakthrough at the Festival of Britain, where her groundbreaking screen-printed linen furnishing fabric, Calyx (1951), was first shown. The success of this design cemented her relationship with Heal Fabrics, a subsidiary of the London department store Heal and Son, originally established as a wartime trading unit called Heal's Wholesale and Export, in 1941. Heal Fabrics was run by the enlightened Tom Worthington, its managing director from 1948–71. Acting as a converter, the company bought patterns from freelance designers then used commission printers, such as Stead McAlpin in Carlisle, to print the cloth. The textiles were sold not only through Heal's own shop, but through furnishing retailers elsewhere, and even abroad. It was Worthington's faith in young designers such as Lucienne Day that put the company on the map.

Day had completed her training at the Royal College of Art as early as 1940 but had been unable to establish herself properly until the end of the decade, when restrictions on textile manufacturing were finally relaxed. Heal Fabrics was one of the first companies to recognize her talents. She rewarded them with patterns of genius such as her Spectators 219, of 1953, one of four of her textiles to win a Gran Premio at the Milan Triennale in 1954. Influenced by her favourite artist, Paul Klee, Spectators shows Day at the height of her powers. A supremely witty abstract pattern expressing all the ebullience of the early post-war era, the design evokes a crowd of attenuated Giacometti-esque stick figures, some wearing spectacles (hence the punning title).[3] Over the course of twenty-five years, Day designed over seventy patterns for Heal Fabrics, many of which were bestsellers, clear evidence of the commercial benefits of a close creative partnership between a gifted designer and an astute textile firm. "It is not enough to 'choose a motif,' nor enough to 'have ideas' and be able to draw," declared the designer. "There must also be the ability to weld the single units into a homogenous whole, so that the pattern seems to be part of the cloth rather than to be printed upon it."[4]

Heal's equivalent in Sweden was Nordiska Kompaniet (NK), the most stylish department store in Stockholm. They too set up a pioneering textile division, NK Textilkammare, in the early post-war period, run along similar lines to Heal Fabrics. NK's textiles were hand-screen-printed on high-quality cotton or linen by the master printers Ljungbergs Textiltryck. Astrid Sampe, an outstanding textile designer, ran NK's textile studio. As well as feeding her own work into the collection, Sampe gave opportunities to young Scandinavian textile designers, such as Viola Gråsten. She also forged links with cutting-edge contemporary artists and professional designers from other spheres.

One of NK's most successful collaborations during the late 1940s was with the ceramic designer Stig Lindberg, an imaginative and playful artist who freely crossed over between figurative fantasies and organic abstract patterns. Lindberg's principal creative outlet was the ceramics firm Gustavsberg, for whom he designed both tableware and decorative vessels. His screen-printed linen furnishing fabric Pottery 217, of 1947, fuses his two areas of artistic activity. The rows of vases depicted in the pattern are the distinctive hand-painted vessels that he was designing contemporaneously for Gustavsberg, decorated with coloured stripes and leaf motifs. The vessels have a biomorphic quality and are interspersed with human figures. The lighthearted mood of this design captures the upbeat spirit of the time. Lindberg's self-conscious use of self-referential imagery was a novelty at the time, but quickly caught on and soon became synonymous with "Contemporary" design.

The wave of creativity unleashed in Britain and Sweden after the war was paralleled in the United States, where a plethora of small entrepreneurial artist-led companies, such as Laverne Originals, successfully launched their fabrics on the market. Established in 1942, Laverne Originals was the brainchild of two painters, Erwine and Estelle Laverne, who had met at the Art Students' League in New York, in 1934. Originally, they intended to specialize in wallpaper, but soon discovered that hand-screen-printing was ideally suited for textiles as well.

The main impetus behind the company was to facilitate cross-fertilization between the fine and applied arts. Alongside their own patterns, the Lavernes printed textiles and wallpaper by a diverse array

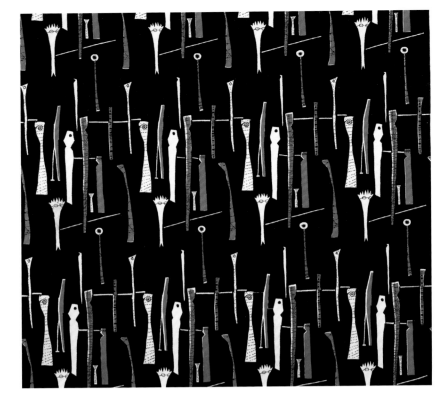

218 219

220 221

of artists, architects and designers, including Alexander Calder, Oscar Niemeyer and Alvin Lustig. Praising the couple for their boldness, Lustig attributed the company's success to the fact that it was artist-led: "Designers themselves, they have placed an emphasis upon creative freedom which they extend to any artists they employ."[5]

In 1949, Alexander Calder designed two patterns for Laverne Originals, apparently at his own initiative: *Splotchy* (1949) and *Calder #1* 221.[6] The latter not only evokes the artist's mobiles, but it also conjures up atomic structures through its ball and stick motifs. *Masks* 220, of 1948, by graphic designer Ray Komai draws on different subject matter (African tribal masks). Produced as part of the Lavernes' "Contempora" series, its spidery graphic style links it with the wiriness of Calder's mobiles. It also shares the same lightheartedness: the masks suggest people pulling faces. This design is printed on fibreglass, a new synthetic material that was both glossy and textured, an experimental product typical of the post-war era.

Whereas Laverne Originals was an independent enterprise, Schiffer Prints, created by Milton Schiffer in 1945, was an offshoot of an existing firm, Mil-Art Company. They adapted a similar artistic model, however, with designs commissioned from artists and designers from outside the textile industry in the hope of injecting fresh ideas. The resulting fabrics were aimed at the booming modern architecture sector. Many were created by architects themselves, such as *Fractions* 222, by Bernard Rudofsky, in 1949. Produced as part of the Stimulus Collection, *Fractions* is an extremely clever design. An example of Rudofsky's "typewriter art," the artwork originated on an Olivetti typewriter. The pattern features rows of fractions, full stops, apostrophes, asterisks and letters, including the word "oxo" repeated continuously. Viewed from a short distance, the lines of numbers, letters and symbols are transmuted into a textural abstract design, almost like a weave.

The refreshingly open-minded attitude towards modern textiles in early post-war America is indicated by the fact that two leading furniture manufacturers, Knoll and Herman Miller, branched out into furnishing fabrics. Knoll Textiles was created in 1947, initially to produce upholstery fabrics for the firm's furniture. Hungarian-born Eszter Haraszty, the firm's director from 1949–55, was equally knowledgeable about both prints and weaves, however, so she developed their printed fabrics as well. Her screen-printed linen, *Fibra* 224, of 1953, is a knowingly self-referential design. The title evokes textile fibres, but the pattern depicts heddles, the wires through which the warps are threaded on a loom. Haraszty was renowned as a colourist, and this fabric, with its strategic positioning of colour, demonstrates her skills. Like most furnishing fabrics, it was produced in several colourways, sometimes printed on white cloth, sometimes with a coloured ground, as here. A tour de force of "Contemporary" pattern design, *Fibra* won a string of prizes, including a Good Design Award from the Museum of Modern Art, New York.

Herman Miller, whose legendary partnership with Charles and Ray Eames began in the 1940s, set up a textile division in 1952. Whereas other companies drew on a pool of designers, Herman Miller's textile operation was the vision of one man, the architect Alexander Girard. Girard had a passion for folk art, and it spurred his adventurous and inspired use of colour, harnessed to great effect in both prints and weaves. Many of his designs are radically simple. *Feathers* 223, of 1957, a screen-printed cotton and linen fabric, consists of a single overlaid motif. Five colours are used, each printed with a separate screen. The dyes are translucent, so hybrid colours are created where the motifs overlap. Girard brilliantly exploited the screen-printing process, using it to create layered effects, suggesting depth, even though the motifs are flat. "The design of a fabric must be an integral part of the fabric and not a superficial application," he observed. "Fabric design is not easel painting or illustrating. It has its own specific desirable qualities and limitations."[7]

Artist-designed fabrics were a popular phenomenon in the post-war textile industry. Fuller Fabrics, established by Daniel B. Fuller in 1933 as a manufacturer of women's sportswear, typified the approach of mainstream American firms. Its "Modern Master" prints of 1955 exploited the appeal of "signature" collections. Five internationally famous artists—Miró, Picasso, Dufy, Léger and Chagall—licensed the company to adapt elements from their paintings, drawings or prints as miniaturized motifs on dress fabrics. Roller-printed in large quantities at the company's mill in Northampton, Massachusetts, these designs were sold through retailers nationwide as affordable pocket-size versions of avant-garde art. *Textures* 225, of about 1955, based on a lithograph called *Derrière la mirroir* [*Behind the Mirror*], by Joan Miró in 1953, was one of their most successful interpretations. The print works well as a textile pattern, cleverly disguised as a half-drop repeat.

Whereas some artists adopted an arms-length approach to the reproduction of their work, others, such as Fernand Léger, engaged more proactively in the design process. Léger had a keen design sense, as demonstrated by his mosaics, murals, stained glass, tapestries and rugs. The screen-printed cotton dress fabric that he designed, about 1950, for the Italian manufacturer Bossi benefited greatly from his direct input 226. The pattern is extremely dynamic, composed of intersecting crescents, suggestive of leaves or petals, shooting off in various directions, juxtaposed with butterflies. Painted in an exaggeratedly decorative, almost cartoon-like style, the design consists of a single self-contained unit of pattern. The jagged asymmetry of the motif makes it particularly effective as a repeat pattern.

The 1940s and 1950s marked a highpoint in artist-designed textiles. The plethora of initiatives in both furnishing and dress fabrics reflected a genuine desire on the part of many artists for the democratization and dissemination of their art.

1. Lesley Jackson, *From Atoms to Patterns: Crystal Structure Designs from the 1951 Festival of Britain* (Shepton Beauchamp, United Kingdom: Richard Dennis, 2007). This book fully documents the work of the Festival Pattern Group.
2. Jackson 2007, pp. 20, 29–30, 50, 61, 86–87, 98–99. Several different diagrams of afwillite were used in the project. *Surrey* was based on "Afwillite 8.44." The original dyeline drawing is in the Warner Textile Archive, Braintree, Essex, United Kingdom.
3. Lesley Jackson, *Robin and Lucienne Day: Pioneers of Contemporary Design* (London: Mitchell Beazley, 2001), pp. 54, 88.
4. Lucienne Day, "Plain or Fancy?" in *Daily Mail Ideal Home Book* (London: Daily Mail, 1957), pp. 82–87.
5. Alvin Lustig, "Modern Printed Fabrics," *Design* (July 1952), pp. 27–30.
6. Jean Lipman, *Calder's Universe* (New York: Viking Press, 1980), p. 334.
7. Alexander Girard, *American Fabrics*, no. 38 (Fall 1956), p. 33, quoted in Lesley Jackson, *20th Century Pattern Design: Textile and Wallpaper Pioneers* (London: Mitchell Beazley, 2002), p. 114.

222
Bernard Rudofsky
Vienna 1905 – New York 1988
Fractions **Fabric**
About 1948–49
Cotton twill weave, photo-silkscreen printed
270 x 195 cm
Produced by Schiffer Prints, Division of Mil-Art Company, New York
Printed on right selvage (twice): *SCHIFFER PRINTS VAT DYE HAND PRINT*; printed on left selvage (once): *"FRACTIONS" by BERNARD RUDOLFSKY*
Liliane and David M. Stewart Collection, gift of Geoffrey N. Bradfield, by exchange
D85.130.1

223
Alexander Girard
New York 1907 – Sante Fe, New Mexico, 1993
Feathers **Fabric**
1957
Cotton and linen, silkscreen printed
73.1 x 66.7 cm
Produced by Herman Miller, Zeeland, Michigan
Liliane and David M. Stewart Collection, gift of Herman Miller Furniture Co.
D84.109.1

224
Eszter Haraszty
Budapest 1923 – Malibu, California, 1994
Fibra **Fabric**
About 1953
Linen, plain weave, silkscreen printed
364.1 x 205.8 cm
Produced by Knoll Textiles, New York
Liliane and David M. Stewart Collection, gift of the American Friends of Canada through the generosity of Lita Solis-Cohen
D83.141.1a

225
Joan Miró
Barcelona 1893 – Palma de Mallorca 1983
Textures **Fabric**
About 1955
Cotton, plain weave, roller printed
100.2 x 59.4 cm
Produced by Fuller Fabrics, New York
Liliane and David M. Stewart Collection, gift in memory of Mrs. Daniel Barnard Fuller
D88.104.1

226
Fernand Léger
Argentan, France, 1881 – Gif-sur-Yvette, France, 1955
Fabric
About 1950
Cotton, plain weave, silkscreen printed
87.6 x 138.6 cm
Produced by Bossi, Cameri, Italy
Signature, printed on lower left: *F. Leger*
Liliane and David M. Stewart Collection, gift of the American Friends of Canada through the generosity of Barbara Jakobson
D88.166.1

222

223

JACK LENOR LARSEN: DEAN OF AMERICAN TEXTILE DESIGN

— DIANE CHARBONNEAU —

Jack Lenor Larsen, who was born in Seattle in 1927 to parents of Norwegian descent, is rare among designers for having chosen to bridge the gap between art and industry. An outstanding entrepreneur and a man of his time, drawn to natural fibres but also interested in the properties of synthetic materials, he possesses a comprehensive knowledge of weaving techniques that enables him to experiment without restriction. His innovative approach had a profound impact on contemporary textiles during the twentieth century. For some years now, close ties have existed between Larsen and the Liliane and David M. Stewart Collection, to which, in 1999, he donated part of his textile archive in the form of over 1,200 fabrics.[1]

Since the establishment of his firm in 1952, Larsen's name has been associated with residential and commercial furnishings alike, and his fabrics have become famous for their complexity—the way their combinations of pattern, colour and texture appeal both to the emotions and to a sense of order. The motifs can be geometric, curvilinear, abstract or figurative, and their sources are multiple, encompassing art history, ancient cultures, aboriginal techniques and nature. *Remoulade* **231**—a fabric from the "Spice Garden" collection whose name evokes the zesty mayonnaise-based sauce—is composed of a dozen or so different natural (cotton, silk, wool, jute) and synthetic (Lurex) yarns that have been interwoven to create a random pattern. The fabric was initially made in Larsen's studio, but its popularity eventually obliged him to adapt its production to a power loom, which he did in collaboration with a small mill in New Jersey.[2]

In the mid-1950s, Larsen became interested in textile printing and began working with several members of his team on creating patterns in saturated colours. He also developed a technique for hand printing on velvet furnishing fabric, which was in great demand among interior decorators during the 1960s. The fabric called *Samarkand* **232**, from the "Kublai Khan" collection, is a velvet print whose pattern is inspired by the spring flowering of the Asiatic steppes. The fabric was manufactured for twenty-one years in nine colours ranging from the brilliant tones of the 1960s to the more subdued versions produced in the following decades.[3]

During his career, Larsen has collaborated on public projects with several of the period's foremost architects and designers. The stage curtain commissioned in 1970 for the Symphony Hall in Phoenix, Arizona, required 550 metres of a specially created material, which replicated Indian embroidery and incorporated mirror work in colours reminiscent of the Kachina dolls originating in the southwestern United States. After extensive research and experimentation, the Larsen studio came up with a fabric that could be mechanically embroidered: open squares were sewn onto an under layer of Mylar, which reflected light through the gaps like a mirror. Employing this technique, the fabric, named *Magnum* **229**, was introduced into the Larsen range of furnishing textiles the following year, and the firm continued producing it in different colours until 1992.[4]

Ever the innovator, Larsen has been creative in dressing the broad horizontal windows of modern architecture, eschewing the opacity of traditional drapes in favour of light and transparency. He took advantage of the expertise at Continental Mills, which was capable of producing fabrics close to three metres wide (the height of an average room), making it possible to cover extensive areas of glass without using seams. His *Seascape Sheer* fabric **230** was made using a process developed by French printers with one of their patterns. Composed of cotton and polyester, the material was printed using the dévoré technique, which involves the chemical "eating away" of some of the fibres to produce a decorative etched effect. In this case, each section of fabric shows a single pattern formed by a series of lines that conjure the image of a deserted beach—an allusion to nature conceived for a primarily urban environment.[5]

1. The remainder of his archive was divided that same year between the Minneapolis Institute of Arts and the University of Minnesota.
2. David Revere McFadden, et al., *Jack Lenor Larsen: Creator and Collector* (London; New York: Merrell Publishers, 2004), pp. 114–115.
3. Ibid., p. 117.
4. Ibid., p. 112.
5. Ibid., p. 59.

Fig_65_01.tif

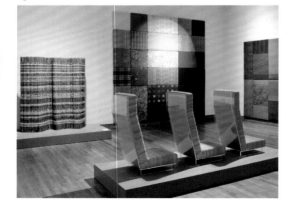

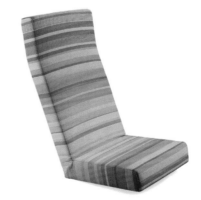

Fig. 1
The *Jack Lenor Larsen: Creator and Collector* exhibition at the Montreal Museum of Fine Arts, June to August 2005.

227

228

230

231

229

232

227

Jack Lenor Larsen
Born in Seattle,
Washington, in 1927

Screen
1951
Redwood, jute, cotton,
wool, Lurex
175.8 x 211.2 cm
Liliane and David M.
Stewart Collection, gift of
Geoffrey N. Bradfield
D86.242.1

228

Aircraft Seat Fabric
for Braniff Airlines
1969
Wool
89 x 51 x 134 cm (approx.)
Mock-up seat made for
Larsen's 1979–80 exhibition
at the Louvre, Paris
Liliane and David M.
Stewart Collection,
gift of Jack Lenor Larsen
D99.232.2

229

Magnum Fabric
1970
Mylar, cotton, vinyl,
nylon, polyester
140.7 x 136.5 cm
Produced by Jack Lenor
Larsen, New York
Liliane and David M.
Stewart Collection,
gift of Jack Lenor Larsen
D86.110.1

230

Seascape Sheer Fabric
1977
Printed polyester,
cotton, dévoré printing
Made in France for
Larsen Design Studio
300 x 289.7 cm
Liliane and David M.
Stewart Collection,
gift of Jack Lenor Larsen
D86.103.1

231

Remoulade Fabric
"Spice Garden" Collection
1956
Cotton, wool, Lurex,
jute, silk, rayon
138.5 x 128.1 cm
Produced by Bolan Mills,
United States
Liliane and David M.
Stewart Collection,
gift of Kelvyn Grant Lilley
D81.136.1

232

Samarkand Fabric
"Kublai Khan" Collection
1967
Printed cotton velvet
106 x 106 cm
Made in the United States
and Germany for
Jack Lenor Larsen, New York
Titled, on back: *Samarkand*
Liliane and David M.
Stewart Collection,
gift of Jack Lenor Larsen
D99.232.40

THE INFLUENCE
OF OP ART
AND POP ART

— LESLEY JACKSON —

The cross-fertilization between the fine and applied arts that had reaped such positive rewards in the textile industry during the 1940s and 1950s continued into the following decade. Now though, instead of the spidery lines and organic forms of Calder and Miró came the geometrical precision and technical wizardry of Op art. The circle and the square provided a new vocabulary for textile designers, mirrored in the buildings and forms created by 1960s architects and product designers.[1]

Many of the optical ideas explored by textile designers during the early 1960s can be traced back to the Hungarian artist Victor Vasarely (1908–1997), the progenitor of Op art. Vasarely's paintings were strongly graphic and translated effectively into print form. Indeed, the artist himself often produced limited-edition screen prints closely related to his paintings. In 1962, two of Vasarely's prints, *Kernoo* and *Oeta*, were used as the basis for textile designs for Edinburgh Weavers.[2]

The first textile designer to capitalize on the potential of Op art was the Danish architect Verner Panton. Though best known for his furniture and lighting, Panton practised in many other fields. In 1960, he designed a stunning series of Op art textiles called *Geometry 1* **236**, composed of a grid of circles within squares. Manufactured by the Danish firm Unika Vaev (Unique Weave), the textiles included both printed furnishing fabrics and high-pile wool carpets resembling traditional Scandinavian rya rugs. In addition to black and white, the carpets were also produced in striking colourways such as orange/yellow and red/violet.

Whereas Panton interpreted Op art literally, the Finnish designer Maija Isola operated in a more indirect and personal way. Collaborating with Marimekko, whose screen-printed cotton furnishing fabrics were produced in tandem with their highly successful print-based fashion line, Isola created bold painterly patterns on a gigantic scale. *Kaivo* **233** (1964), meaning "well," features compressed ovals spanning the full width of the cloth. With its forceful use of black bands, it has all the graphic punch of Op art, but a simpler, more pared down structure and freer, more fluid lines. Although intended as curtain fabrics—ideal for the new floor-to-ceiling picture windows of modern buildings—Isola's textiles were so strong artistically and architecturally that they could also be used as wall-hangings.[3]

Op remained a potent force in textiles until the mid-1960s, but later in the decade pattern design became increasingly eclectic as other influences came into play. "Pop" textiles are less easy to define stylistically in comparison with Op, as the latter has such a clear-cut identity. In design, "Pop" is a catch-all phrase denoting not only the impact of Pop art, but the pop scene and popular culture in general. Stylistic idioms derived from graphics and advertising were key elements of Pop patterns. Cartoons and animations proved a particularly rich source of inspiration for textile designers.

The architect Alexander Girard, although in his sixties by the end of the decade, was perennially young at heart. The vibrant pinks and oranges he introduced into textiles during the 1950s set the tone for the Pop era. Girard had a real flair for pattern, which he applied to textiles, wallpapers and graphics. His printed linen furnishing fabric *Love* **234**, of 1967, produced by Herman Miller, perfectly captures the mood of the Beatles' "All You Need is Love," the anthem of the Summer of Love. Consisting of the word "Love" repeated in numerous languages, the design is entirely typographical. The script is hand-drawn in an eccentric and flamboyant style, with idiosyncratic flourishes such as a heart-shaped letter "Y." Hearts also featured prominently in Girard's printed textile hangings.

German-born Pop artist Peter Max, who settled in the United States in 1953, achieved phenomenal success during the late 1960s as a poster designer. His brightly coloured paintings and graphics encapsulate the spirit of American youth culture during this exciting and tumultuous decade. In 1968, Max designed a printed fabric for Cameo Curtains, a short-lived New York firm. The stylized flowers in this pattern **235** are depicted in a melted, fragmented style, redolent of the laid-back psychedelic era. "I remember once looking down into a pool and seeing images reflected from leaves on the floor," the artist recalled in 1994. "That was the beginning of . . . these particular [petal] shapes which I used to call 'zooples'— these beautiful little shapes that move."[4] The reference to movement conjures up film animation. It is no coincidence that *Yellow Submarine*, the famous Beatles cartoon of 1968, with its distinctive Pop graphics by Heinz Edelmann, appeared the same year as Peter Max's textile.

As the epicentre of Pop culture during the 1960s, it is no surprise that Britain should have produced some remarkable Pop-inspired textiles. Surprisingly, though, some of the most radical patterns of the decade were produced by one of the more conservative firms, Warner and Sons. Eddie Squires, the maverick designer responsible for these avant-garde patterns, went on to become the firm's art director. At the time, however, he was their colourist. Squires created genuine, authentic Pop textiles that embody the iconoclastic vision of his generation. *Archway* **238**, of 1968, was one of four screen prints from the evocatively named "Stereoscopic Range." An ebullient design featuring radiant sunburst motifs in bright clashing colours, it fuses the ongoing preoccupation with Op art (reflected in the dot motifs) with the new vogue for Art Deco revivalism, reinvented in Pop art guise. "Several factors influenced this design," explained the designer; "1930s cinema architecture, the painter Roy Lichtenstein, [and] colour blind test charts."[5] This kind of rampant and irreverent eclecticism—blending inspirations from divergent, "incompatible" sources—was a vital aspect of Pop design.

In 1969, Warner produced two space-age textiles—*Space Walk* **237** by Sue Palmer and *Lunar Rocket* **240** by Eddie Squires—in anticipation of the first manned Apollo mission to the moon. Both patterns were created before the actual moon landing on July 20, 1969, however, so there is a strong element of sci-fi fantasy. *Space Walk* accurately conveys the impression of gravitational force on a floating astronaut. Palmer studied NASA photographs of spacecraft while working on the design.[6] Eddie Squires' *Lunar Rocket* also required a lot of preliminary research: the design is extraordinarily detailed, almost hyper-real. Resembling a photomontage, the pattern juxtaposes columns of rockets in full thrust with poetic images of the moon and the earth viewed from space. Printed in arresting colours, *Lunar Rocket* is more like a book illustration than a furnishing fabric. A remarkable testament to an awe-inspiring scientific achievement, these imaginative and sophisticated textiles marked the coming of age of Pop design.

1. See Lesley Jackson, *The Sixties: Decade of Design Revolution* (London: Phaidon, 1998), pp. 54–119.
2. See Lesley Jackson, *Alastair Morton and Edinburgh Weavers: Textiles and Modern Art* (London: V&A Publishing, forthcoming 2012).
3. See Lesley Jackson, "Textile Patterns in an International Context—Precursors, Contemporaries and Successors," in *Marimekko: Fabrics, Fashion, Architecture* (New York: Bard Graduate Center; London and New Haven: Yale University Press, 2003), pp. 52–62.
4. Peter Max, quoted in *Designed for Delight: Alternative Aspects of Twentieth-century Decorative Arts*, exh. cat., ed. Martin Eidelberg (Montreal: Montreal Museum of Decorative Arts; Paris and New York: Flammarion, 1997), p. 199.
5. Eddie Squires, quoted in *Designed for Delight*, p. 235.
6. Ibid., p. 263.

MAIJA ISOLA DESIGN "KAIVO" © MARIMEKKO OY SUOMI FINLAND 1965

MAIJA ISOLA DESIGN "KAIVO" © MARIMEKKO OY SUOMI FINLAND 1965

233

234

235

236

237

238

239

233

Maija Isola
Riihimäki, Finland, 1927 –
Riihimäki 2001
Kaivo Fabric
1964, example of 1965
Printed cotton
275 x 138.2 cm
Produced by Marimekko,
Helsinki
Printed continuously
on selvage: *MAIJA ISOLA
"KAIVO" © MARIMEKKO
OY SUOMI FINLAND 1965*
Liliane and David M.
Stewart Collection
D87.167.1

234

Alexander Girard
New York 1907 – Sante Fe,
New Mexico, 1993
Love Fabric
1967
Printed linen
61.5 x 63 cm
Produced by Herman Miller,
Zeeland, Michigan
Printed on left selvage:
*"LOVE" designed by
Alexander Girard
© Herman M*
Liliane and David M.
Stewart Collection,
gift of Herman Miller
Furniture Co.
D84.117.1

235

Peter Max
Born in Berlin in 1937
Fabric
1968
Printed cotton
102.9 x 149.9 cm
Produced by Cameo
Curtains, New York
Signature, printed in
an oval in the repeat
of the design: *peter max ©*
Liliane and David M.
Stewart Collection
D88.153.1

236

Verner Panton
Gamtofte, Denmark, 1926 –
Kolding, Denmark, 1998
Geometry 1 Fabric
1960
Printed cotton
117.5 x 368.5 cm
Produced by Unika Vaev,
Denmark
Printed continuously on
selvage: *"GEOMETRY I"
DESIGNED BY VERNER
PANTON FOR UNIKA-VAEV A/S*
Liliane and David M. Stewart
Collection, gift of the
American Friends of Canada
through the generosity
of Geoffrey N. Bradfield
D87.187.1

237

Sue Palmer
Born in Slough, England,
in 1947
Space Walk Fabric
1969
Printed cotton
112.4 x 121 cm
Printed by Stead McAlpin &
Co., Carlisle, England,
for Warner & Sons,
Braintree, England
Printed continuously along
both selvages: [three vertical
dots] *SPACE WALK* [three
vertical dots] *DESIGNED FOR
WARNER'S BY SUE THATCHER*
[three vertical dots]
Liliane and David M.
Stewart Collection,
gift of Eddie Squires
D90.136.1

238

Eddie Squires
Anlady, England, 1940 –
London 1995
Archway Fabric
1968
Printed cotton
91.5 x 125.8 cm
Printed by Stead McAlpin &
Co., Carlisle, England,
for Warner & Sons,
Braintree, England
Liliane and David M.
Stewart Collection,
gift of Eddie Squires
D90.142.1

239

Maija Isola
Riihimäki, Finland, 1927 –
Riihimäki 2001
Lokki [Seagull] **Fabric**
1961
Printed cotton
158 x 132 cm
Produced by
Marimekko, Helsinki
Printed, on selvage:
MAIJA ISOLA "LOKKI"
© MARIMEKKO OV SUOMI
FINLAND 1961
Liliane and David M.
Stewart Collection
2004.151

240

Eddie Squires
Anlady, England, 1940 –
London 1995
Lunar Rocket **Fabric**
1969
Printed cotton
125.1 x 125.1 cm
Printed by Stead McAlpin &
Co., Carlisle, England,
for Warner & Sons,
Braintree, England
Printed continuously
along both selvages:
[three vertical dots] *LUNAR*
ROCKET [three vertical dots]
DESIGNED FOR WARNER'S
BY EDDIE SQUIRES
[three vertical dots]
Liliane and David M.
Stewart Collection,
gift of Eddie Squires
D90.138.1

ART TO ITS VERY FIBRE

— ALAN ELDER, CYNTHIA COOPER —

MARIETTE ROUSSEAU-VERMETTE

A weaver, a teacher, a role model and mentor, a collaborator with architects and a painter with wool: the late Mariette Rousseau-Vermette was all of these. After graduating from the École des beaux-arts de Québec, she continued her studies in the United States, Europe and Japan.

She began working with other artists—including Guido Molinari, Fernand Leduc, Jean-Paul Mousseau and her husband, Claude Vermette—to produce a series of works in the tradition whereby artists conceived designs made by master weavers. While her interest in working with other artists never waned, her reliance on others was soon replaced by her own aesthetic ambitions.

Using locally produced raw materials—wool from sheep on Isle-aux-Coudres, and dyes from the École des textiles de Saint-Hyacinthe—she began exploring the formal structure of weaving and the gentle modulations achieved by manipulating the surface of the work. *Rose, Rose, Rose* **241** reflects her adept handling of the subtle variations of the rose colour referred to in the title—from hot pink to a murky black mix. Her works acknowledge abstract art movements, but—unlike most paintings—are meant to be touched as well as seen. The soft surface here—made from brushing the finished work with a wire brush—enhances the delicate colour gradations. **AE**

MAGDALENA ABAKANOWICZ

Magdalena Abakanowicz's "Abakan" series contrasts with her earliest art production. After graduating from the Academy of Fine Arts in Warsaw in 1956, she and her husband were forced to live in a one-room apartment, and because the small space had to serve as studio as well as home, she began working with watercolour on canvas, which could be rolled up for easy storage.

Although she wanted to make larger statements, her restricted workspace and government surveillance of artistic activity ruled out working in traditional sculptural materials such as stone or bronze. The malleability of textiles interested her, and soon she was collecting heavy ropes left on

the nearby riverbanks. Abakanowicz's initial fibre works were cocoon-like "constructions," as she preferred to call them. She resisted learning how to weave, developing her own method of crossing one rope over the other.

Using her last name as the basis for her title, the "Abakans" were completed between 1965 and 1975, making *Abakan biz* **242** an early work in the series. It garnered a great deal of attention, in part because it reconstructed tapestry as a three-dimensional rather than two-dimensional art form. The "Abakans," which anticipate the rebellious and passionate feminist art practices of the 1970s, are sensually organic and envelop the viewer with their large size. **AE**

SHEILA HICKS

During her studies at Yale University, Sheila Hicks was influenced by the colour theory of former Bauhaus master Josef Albers and the weavings of his wife, Anni. After completing her undergraduate degree, she travelled to South America, where her interest in textiles blossomed.

Returning to Yale for her Master's degree in fine arts, Hicks chose to focus on pre-Columbian textiles. Upon graduation, she taught at the Universidad Nacional Autónoma de México while working with local weavers. In Mexico, she received her first commission from noted architect and colourist Luis Barragán: he remained a mentor to her until his death.

Hicks synthesized the many different influences on her life and her work, including her experiences in South and Central America, European traditions and her interest in the formal qualities of textiles. *Banisteriopsis* **243** reflects many of these influences. For this work—which owes its name to a hallucinogenic Amazonian plant that produces brightly coloured visions—forty-seven bundles of yellow "ponytails" were constructed off the loom. They are piled on the floor, allowing the work to change every time it is installed. *Banisteriopsis* is part of Hicks' "Evolving Tapestry" series. Another work from the series, *He/She*, is

part of the collection of the Museum of Modern Art, New York. **AE**

HELENA HERNMARCK

Swedish-born Helena Hernmarck studied weaving at Stockholm's Handarbetets Vänner [Friends of Handicraft] and the Konstfackskolan [University College of the Arts, Crafts and Design]. In 1963, she moved to Montreal, where she began a series of large-scale tapestry works.

While in Montreal, she chose to work in a Pop-art style, often using photographs under her loom's warp threads as guides for her realistic works. Her imagery set her apart from many other modern textile artists—and artists in general. At a time when many people involved in the textile arts were advocating for an expressive use of their materials, Hernmarck rebelled against abstraction and instead embraced imagery. However, her approach did not extend to the hyper-realistic, as she manipulated colour and perspective in her work.

Crystal Glasses **244** was one of several tapestries woven by Hernmarck in Montreal for the Sheraton Stockholm Hotel. Intended as a room divider, each side depicts a different image. In order to capture the transparent and reflective qualities of her subject matter, Hernmarck combined shiny, synthetic materials with her natural wool and cotton. The use of different materials and many coloured strands allowed Hernmarck to create images with a rich yet subtle surface variation and an illusion of movement. **AE**

MARCEL MAROIS

After studying at the École des beaux-arts de Québec and Université Laval, Marcel Marois participated in the Fibre Exchange at the Banff Centre School of Fine Arts. He uses the *haute-lisse* technique, wherein the warp threads are held vertically, rather than horizontally, as with most looms, allowing him to compose his works the way painters approach a canvas hanging on the wall.

241

Mariette Rousseau-Vermette
Trois-Pistoles, Quebec, 1926 –
Sainte-Agathe-des-Monts,
Quebec, 2006
Rose, Rose, Rose
1982
Wool, cord
221 x 147 cm
Handwritten on a leather
patch sewn on back:
#523 = 1982 / 7'2 x 5' =
2m 80 x 1m 50 /
"Rose Rose Rose" / Mariette
Rousseau Vermette
Gift of Crédit Lyonnais Canada
2000.120

242

Magdalena Abakanowicz
Born in Falenty, Poland,
in 1930
Abakan biz
1965
Sisal
185.5 x 180.4 x 30.5 cm
Handwritten signature
and inscription on leather
patch sewn on back:
MAGDALENA ABAKANOWICZ /
"ABAKAN BIZ" 150 x 180 cm
1965 / M. Abakanowicz
Liliane and David M.
Stewart Collection,
gift of Paul Leblanc
D88.258.1

243

Sheila Hicks
Born in Hastings,
Nebraska, in 1934
Banisteriopsis
From the series
"Evolving Tapestry"
1965–66
Linen, wool
Variable dimensions
Liliane and David M.
Stewart Collection
D89.102.1-47

Marois' time-consuming technique is contrasted with the source of much of his imagery: our fast-paced world as it is shown through electronic and print news media. Many earlier works addressed human interventions with nature, drawing our attention to our detrimental actions. More recently, he has reinterpreted traditional ways of portraying nature, combining natural and human-made elements.

Marois has gathered a large collection of news photographs. He takes these images and enlarges them, edits them, collages them and layers them. *Burst–Light* 245 presents a landscape that may be intimate in scale but is also distant, as its source picture has been fractured and pixelated for the purposes of consumption by the mass media. The pixelation of the original image is replicated by the stitches of the warp and weft. Marois also alludes to the place of tapestry within the fine arts by "framing" his landscape within a woven border. **AE**

NORMA MINKOWITZ

Norma Minkowitz's interest in textiles began at an early age when her mother taught her to crochet. Minkowitz remembers that she moved away from crocheting flat circles and began creating three-dimensional forms—forerunners of her later interests. Despite this early introduction to the technique, Minkowitz did not begin to turn her professional attention to crocheting until the 1980s.

In 1955, Minkowitz began her formal training, in the traditional fine-art media of pen and ink and pencil drawings, at the Cooper Union Art School in New York. Her approach to portraiture and human figure studies was graphic and linear. After graduating, she worked for several years designing commercial textiles.

Several years later, Minkowitz started making sculptural textiles. She experimented with different techniques but returned to crochet because of its simplicity and adaptability. *The Invaders* combines her childhood experiments in creating three-dimensional forms from strands of yarn with the interest in the human form she developed at Cooper Union. Using a technique associated with the domestic setting—crochet—and everyday materials—fibre and paper—Minkowitz touches on the tension between art and craft. This work uses a flexible material to mould the three torsos 246 subsequently submitted to varnish, shellac and paint. The torsos evoke the unknown assailants who attack and terrify innocent people. **AE**

MASAKAZU KOBAYASHI

The late Masakazu Kobayashi was part of the Japanese textile art scene from the 1970s until his death in 2004. Although he is best known for his expressive textile-based installations, Kobayashi started out studying lacquer at the Kyoto University of the Arts. He was married to Naomi Kobayashi, also a textile artist.

Masakazu and Naomi Kobayashi exhibited both on their own and together. Most often, they would create works separately and then collaborate on their installation, providing both continuity in their philosophies and differences in their individual expressions. Uniting the two were similar interests in space, light, and harmony of form and colour.

Masakazu Kobayashi frequently examined the nature of textile construction in his oeuvre. *Bows* 247 uses an element common to many of his works. To create its components, thread is coiled around a flexible core made of a material like aluminum or reed, as is the case here. The wrapped element is then pulled into tension, as with an archery bow. Although each bow is relatively short and can be seen as an autonomous unit, it is the sheer number of them brought together in the work that most strongly affects the viewer. Layers of lightweight bows are interwoven to produce a dense structure. Kobayashi's tensile bows are arranged in a variety of configurations to create both freestanding and wall-mounted works that simultaneously evoke a sense of well-mannered control and chaotic frenzy. **AE**

ADELLE LUTZ

Adelle Lutz is an artist and performer whose film credits include both acting and costume design. The *Ivy Suit* 248 was one of a series of costumes she designed for the 1986 David Byrne film *True Stories*. Her "Urban Camouflage" collection played on the historical concept of clothing in colours and patterns whose likeness to the environment could visually absorb the wearer into it, reducing threats to personal safety posed by being visible. To create the *Ivy Suit*, Lutz camouflaged a brown tweed suit jacket with hundreds of plasticized leaves from fake plants and painted the trousers with an imitation wood grain. Other garments in the collection transformed the ubiquitous urban business suit with painted textures of faux-wood panelling and brick.

While *True Stories* briefly featured the garments in a fast-paced runway fashion show, it is a series of Annie Leibovitz photographs taken the same year and published in *Vanity Fair*[1] that brought out the perceptual ironies of Lutz's creations. Performative images by Leibovitz highlighted Lutz's commentary on the urban environment, materials imitative of nature, and their distance from their origins. Byrne was photographed wearing a wood-grained suit facing a wall of faux-wood panelling. A man and a woman and two child mannequins modelled Astroturf clothing on a lawn, of the same material, replete with barbecue, chain-link fence and kitsch lawn ornaments. Leibovitz also highlighted Lutz's references to the uniformity of urban architecture and the notions of animate versus inanimate. On a brick-wall background, subjects faced the camera in brick-and-mortar-patterned garments, flanking Lutz in a dress inspired by an Ionic column. Leibovitz's image of Byrne in the *Ivy Suit* stood in contrast, however, as she placed ivy-clad Byrne against a background referencing Renaissance portraiture with a backdrop of red curtains framing a blue sky with wisps of clouds. The image drew attention to the paradox of camouflage built into Lutz's work, and its futility and utter incongruity outside the setting it was intended for.

Lutz's "Urban Camouflage" series can be seen as a precursor of some of her later artistic interventions in the medium of clothing. Her work from 2001 featured "Corporate Adam and Eve," flesh-coloured office clothing with body and pubic hair, as well as "Velvet Pelvis" and "Velvet Spine" evening clothing printed with images of the interior body, including "Velvet Burka/Womb" on which figures an image of a developing fetus in utero. **cc**

1. James Wolcott, "The Big Stare," *Vanity Fair* (October 1986), pp. 104–109.

(verso)

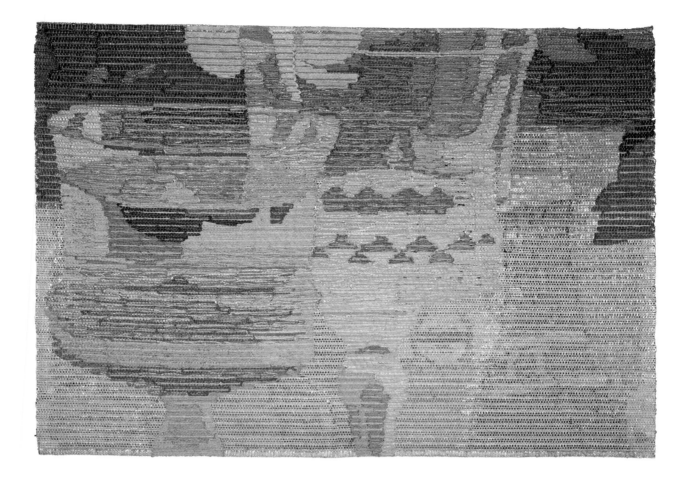

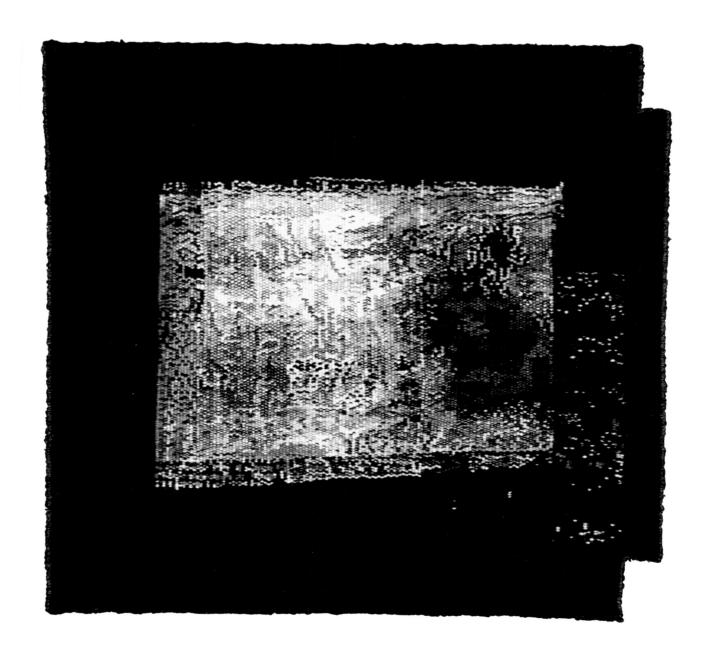

246

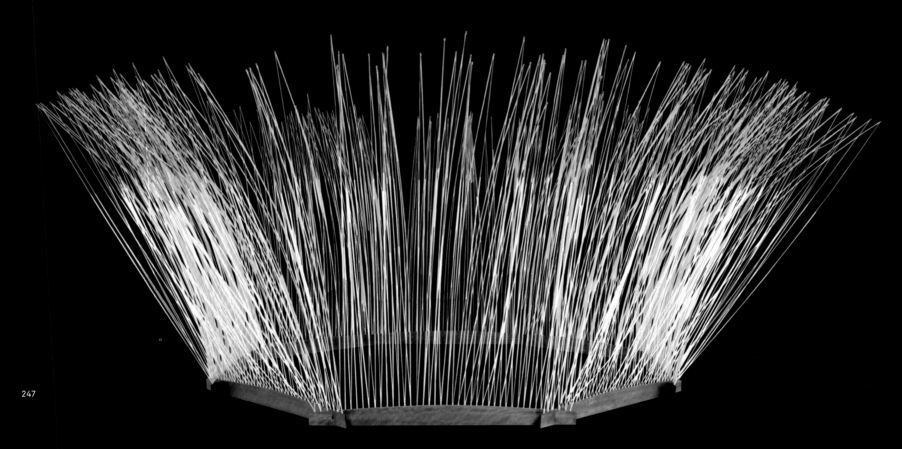

247

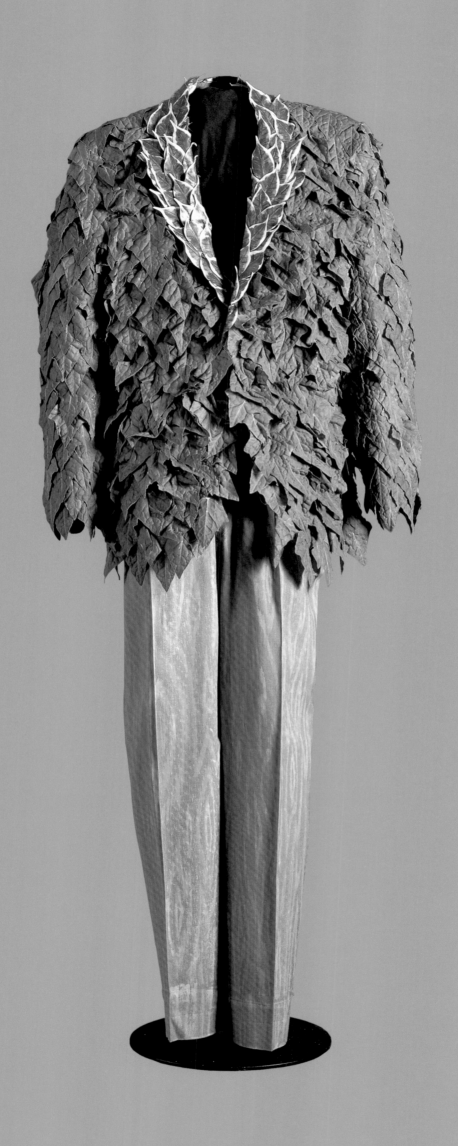

TEXTILE INNOVATION: JAPAN

— DIANE CHARBONNEAU —

The age-old fascination with the textiles of Japan is rooted in the passion of its artists and artisans for materials and textures. Heirs to an aesthetic legacy founded on principles of beauty and good taste, they are today breathing fresh life into traditional skills by employing new fibres and high-tech fabrication techniques. The Nuno Corporation, founded in 1984 by Junichi Arai and Reiko Sudo and recognized worldwide for its experimental methods and innovative approach, produces textiles aimed principally at the fashion and interior decoration markets. The Japanese word *nuno* actually means "functional fabric."[1]

Junichi Arai has been working in the textile industry since the mid-1950s. Between 1979 and 1987, under the Anthologie label, he created sensuous and unusually structured fabrics for such leading fashion designers as Issey Miyake and Rei Kawakubo. Although his work is informed by tradition, Arai has pioneered the use of computers and scanners in adapting complex designs for the loom.[2] The fabric called *Nuno me Gara* **249**, which means "woven pattern," was created for the Nuno Corporation. Its motif is derived from cotton scarves that resemble the strips of cloth worn by the people of Mali and Togo. After being arranged in a bundle, the scarves were photocopied, and this image was then digitized and reproduced using a Jacquard loom. In fact, the fabric's name is self-referential since it evokes the woven scarves that are the source of its pattern.[3]

Reiko Sudo, who has been at the helm of the Nuno Corporation since 1987, creates fabrics whose boldness and originality reflect the imagination of someone who is at once an artist and a skilled artisan—someone who can arrive at extraordinary effects via the most unusual means. For example, barbed wire, nails and iron plates served as printing tools for the cloth in her "Scrapyard" series. For the fabric called *Nails* **250**, nails treated with iron oxide were used to make impressions that vary according to how they were placed and how long they were left. When the polyester organdy *Agitfab* **251** was first produced, scraps of newspaper were scattered over the cloth and these sections were heat sealed under polyurethane pouches. This textile is still made to order, but now the newspaper fragments are steeped in liquid plastic before being heat set. The textile called *Shutter* **252** is the product of a radically new type of embroidery, for its meandering strips and tendrils are the result of elimination rather than addition: the nylon tapes are sewn onto a fabric and then chemically dissolved, leaving a pattern of lines that according to the designer was inspired by the rolling steel shutters that cover storefronts.

1. Lesley Jackson, *Twentieth Century Pattern Design* (New York: Princeton Architectural Press, 2002), p. 214.
2. Ibid.
3. Martin Eidelberg, ed. *Designed for Delight: Alternative Aspects of Twentieth-century Decorative Arts* (Montreal: Montreal Museum of Decorative Arts; Paris: Flammarion, 1997), p. 157.

249

Junichi Arai
Born in Kiryu,
Japan, in 1932
Nuno me Gara Fabric
1983
Woven cotton
284.5 x 99.1 cm
Produced by Nuno
Corporation, Tokyo
Liliane and David M.
Stewart Collection
D92.145.1

250

Reiko Sudo
Born in Niihari,
Japan, in 1953
Nails Fabric
From the series
"Scrapyard"
1994
Rayon
384 x 110 cm
Produced by the Nuno
Corporation, Tokyo
Purchase, Mitsui Canada
Foundation Fund
2001.83

251

Reiko Sudo
Born in Niihari,
Japan, in 1953
Agitfab Fabric
1992
Polyester, newsprint
392 x 123 cm
Produced by the Nuno
Corporation, Tokyo
Purchase, Mitsui Canada
Foundation Fund
2001.80

252

Reiko Sudo
Born in Niihari,
Japan, in 1953
Shutter Fabric
1997
Nylon
85 x 87 cm
Produced by Nuno
Corporation, Tokyo
Purchase, Mitsui Canada
Foundation Fund
2001.82

249

250

251

252

FURNITURE: COVERINGS AND STRUCTURE

— DIANE CHARBONNEAU —

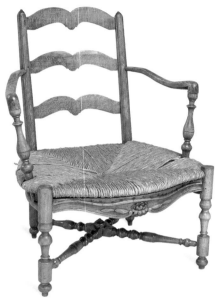

253

254

255

NATURAL FIBRES: CANE, RUSH, STRAW, RAFFIA

Straw, rush and cane have been common components of European seating since the eighteenth century. Although the first two materials have generally been restricted to vernacular furniture, caning has been used for seats and backs as a less expensive alternative to fabric or leather. In eighteenth-century France, straw was employed in the fabrication of the chairs "à la capucine,"[1] whose turned uprights, stretchers and legs were completed by a woven straw seat 253 .

Caning was first linked to modernity by the Viennese firm of the Thonet Brothers, which in the late nineteenth century produced a series of bentwood-and-cane seats that were followed later, in the 1930s, by cantilevered chairs in tubular steel—like Marcel Breuer's *Cesca* armchair[2] 254 —that also had caned inserts. In its minimalist style, which includes no decoration beyond the properties of the materials themselves, Breuer's iconic chair is the perfect embodiment of modern design. The *Margherita* armchair 255 by architect and designer Franco Albini represents a period in post-war Italy when frugality and migration were widespread and furniture manufacturers turned frequently to traditional materials and artisanal techniques.

The form of this chair, whose seat resembles a truncated sphere, can be related to Albini's suspended spiral staircases. Designed for use on a terrace or balcony, it also blends well with indoor furniture.[3] Lightness, purity of line and an interest in unencumbered space combine to define Gio Ponti's *Superleggera* chair 256 , which is the quintessential expression of the architect's rationalist vocabulary and interest in the vernacular. *Superleggera*'s pared-down form and cane seat echo the *chiavarina*, a traditional chair of beechwood and woven straw made in Chiavari, on the Ligurian coast.

253

FRANCE
Armchair
About 1775–85
Oak, beechwood, rush
86.3 x 66.5 x 64.8 cm
Gift of David Y. Hodgson
1945.Df.8

254

Marcel Breuer
Pécs, Hungary, 1902 –
New York 1981
Cesca **Armchair**
1928 (example about 1975)
Tubular stainless steel,
ebonized wood, cane
80 x 56.9 x 58.4 cm
Produced by Knoll
International, New York
Furniture acquired in 1976
with the opening of the
Museum's new addition
(now the Liliane and
David M. Stewart Pavilion)
1979.Df.2

255

Franco Albini
Robbiate, Italy, 1905 –
Milan 1977
Gino Colombini
Born in Milan in 1915
Margherita **Armchair**
1950
Malacca and Indian cane,
viscose rayon, foam rubber
99.1 x 78.8 x 78.8 cm
Produced by Vittorio
Bonacina, Lurago d'Erba, Italy
Liliane and David M. Stewart
Collection, gift of the
American Friends of
Canada through the
generosity of Jay Spectre
D84.177.1a-b

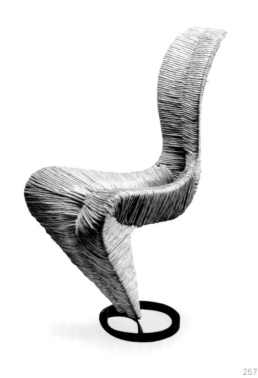

256

257

258

Towards the late 1980s, Tom Dixon combined soldered steel and rush to create the *S-Chair* `257`, the *Fat* armchair and the *Cobra* floor lamp, all of which feature in the Museum's collection. The steel elements of these pieces were soldered together in Dixon's studio and then sent to a basket-maker for completion. About sixty copies of the original *S-Chair* were made, including a few prototypes with variations inspired by the moment. The chair, whose name is an obvious allusion to its form, can be seen as a lighthearted, organic tribute to the *Zig-Zag* chair by Rietveld `154` and the similarly shaped chair by Verner Panton `630`. Dixon's *S-Chair* is currently manufactured in several different versions by Cappellini (Italy).

As seen in their *Imperial Prince* chair `258`, with its neo-primitive style and makeshift construction, the French designers Élisabeth Garouste and Mattia Bonetti possess a penchant for ornamentation and "cultural borrowings." Composed of branches and panels of wood trimmed with raffia, the chair evokes African culture in general, but the title points to a specific historical event: the tragic death of Eugène Louis Napoleon Bonaparte, Prince Imperial, killed by South African Zulus in 1879. **DC**

 1. The name comes from the modest furniture and furnishings used by the Capuchins in Paris, during the eigteenth century, where they lived on charity. **2.** Named for Breuer's daughter Francesca, the *Cesca* chairs were manufactured by the Thonet Brothers from 1931 and by Gavina, Italy, from 1962 to 1968; Knoll (which bought Gavina) has continued producing them from 1968 to the present. **3.** This chair is still being produced by Vittorio Bonacina.

256

Gio Ponti
Milan 1891 – Milan 1979
***Superleggera* Chair (model 699)**
1955
Ash, cellulose fibre
85.3 x 40.4 x 44.9 cm
Produced by Cassina, Meda, Italy
Liliane and David M. Stewart Collection
D83.115.1

257

Tom Dixon
Born in Sfax, Tunisia, in 1959
S-Chair
1988
Steel, rush
95.9 x 41.9 x 53.3 cm
Prototype produced by Tom Dixon
Liliane and David M. Stewart Collection
D93.248.1

258

Élisabeth Garouste
Born in Paris in 1949
Mattia Bonetti
Born in Lugano in 1952
***Imperial Prince* Chair**
1985
Stained wood and branches, painted decoration, polyurethane varnish, raffia
132.7 x 43.5 x 44.8 cm
Produced by Neotu, Paris
Initials, painted on front edge of seat: *B.G.*
Liliane and David M. Stewart Collection
D93.251.1

KWANGHO LEE

The young Korean designer Kwangho Lee is interested in craftwork and the symbolism of everyday items. He investigates the potential of such objects for transformation and imbues them with new meaning, producing one-of-a-kind pieces and limited editions. His inspiration springs from his memories of childhood: the hanging lamp *C+* `259`, for example, harks back to his mother's favourite hobby, knitting.

Kwangho Lee transforms the wires from household electrical appliances, braiding, knotting or weaving them to create sculptural light fixtures that look like natural organic forms. He generally uses a single wire, which can vary in length from 10 to 300 metres, in a single colour. *C+* is unusual in that it combines two colours, blue and red. It suggests the shape of a hammock or a fishing net, depending on the viewer's imagination. This unique light fixture was executed for the designer's 2008 solo exhibition *Like a Forest of Wire*, at the Montreal gallery/boutique Commissaires, which was the first time his lighting was shown outside of Korea. DC

CORD AND ROPE

By eliminating superfluous ornamentation, the space aesthetic of modern furniture aimed to put the emphasis on purity of form and integrity of material. As well as respecting the "form follows function" principle, the furniture had to be amenable to mass production. Solidity, lightness and low cost were essential criteria of each design. True to this approach, a number of creators conceived openwork seats made of natural or synthetic fibres.

The Danish master cabinetmaker and designer Hans Wegner is famous for his solid wood furniture `173` `174` `175` `177` `178` `181`, but also for his ingenious experiments with such new materials as steel and plywood. In 1949, he designed a series of armchairs consisting of a plywood shell supported on a steel base. The following year, pursuing the idea, he designed the *Flag Halyard* chair `262`,[1] which combines tubular steel with the type of rope used to hoist a sail or a flag (hence the name). Manufactured initially by Getama, in Gedsted, it is currently produced by PP Møbler, in Allerød, and, in 2002, the Danish magazine *Bo Bedre* awarded this new edition its Classics prize.

The *Nylon* chair `261` by Quebec designer Jacques S. Guillon was originally designed as a dining chair. The wooden structure of laminated walnut and birch (or maple) is complemented by a seat and back made of nylon cord. Designed in 1952 and patented in the United States that same year, the chair was produced jointly by Modernart, of Montreal, which made the frame, and the tennis racquet manufacturer Alexis D. Andreef (owner of A. A. Sporting Goods in Rouse's Point, New York), who was responsible for assembly and distribution.[2] The nylon cord, chosen for reasons of economy, has the added qualities of being light and strong: the chair weighs only about 3.18 kilograms but can easily support a weight of over 1,500 kilograms. An icon of Quebec modern furniture, the *Nylon* chair received a Design Merit Award from the National Industrial Design Council when it was presented at the Canadian National Exhibition in Toronto and at the Milan Triennale in 1954. Production of this timeless design recommenced in 2009, when it was reissued by the Toronto firm Avenue Road.

In their response to a commission for a chair suitable for both outdoor and indoor use that would also blend well with traditional furniture in a modern house, the creators of the *Antiquariato* chair[3] `260` fused the experimental with the aesthetic. The chair, which was designed in 1962 by the Italian architect Luciano Grassi in collaboration with Sergio Conti and Marisa Forlani, is part of the "Monofilo" series, begun in 1952–53, which was inspired by observation of the properties of soap bubbles—particularly their elasticity and tension.[4] Each of the curvilinear chairs in the series is composed of a network of nylon threads stretched over a framework of lacquered tubular steel. Although the flexible nylon moulds itself to the shape of the sitter's body, it is extremely strong. These extraordinarily light and airy chairs seem to appear in, rather than to take up space.

The Dutch designer Marcel Wanders was made famous by his *Geknoopte Stoel* [*Knotted Chair*] `263`, which uses the macramé technique[5] to weave a rope of aramid fibre with a carbon core. This blend of craft and high-tech was the product of a collaboration between the Droog collective and the aeronautical department of the Delft University of Technology. The chair was developed as part of Droog's Dry Tech I project (1996), and the group made a number of tests before finalizing the materials and fabrication technique. The shape of the *Knotted Chair* is created by hand, as the rope is woven and formed into flat knots. This flexible net is then impregnated with epoxy resin and placed on a frame to harden. The result is a delicate chair that resembles a piece of old lace. Manufactured by Cappellini since 1996, it is currently produced in a chrome-finished version called *Knotted Future*. DC

1. A naval term for rope or tackle used for raising or lowering a sail or yard. **2.** Paul Bourassa, "Design industriel," in Marc H. Choko, Paul Bourassa and Gerald Baril, *Le design au Québec* (Montreal: Les Éditions de l'Homme, 2003), p. 55. **3.** The first prototypes were exhibited at the Milan Triennale in 1954, and the *Artigianato* model was awarded a Compasso d'Oro in 1955. **4.** Luciano Grassi, "Esperienze Sulle Strutture Monofilo," brochure, n.p., n.d. **5.** A form of textile using knotting that originated among Arab weavers. Introduced into Europe following the Moorish conquest, it underwent something of a revival in the 1960s under the impetus of the craft movement.

`259`

Kwangho Lee
Born in Seoul in 1981
C+ Hanging Lamp
From the series "Knot, beyond the Inevitable"
2008
Electrical wires
250 x 200 x 95 cm
Purchase, the Museum
Campaign 1988-1993 Fund
2009.2.1-2

`260`

Sergio Conti
Florence 1927 –
Florence 2001
Luciano Grassi
Active in Florence
Marisa Forlani
Born in Bologna in 1928
***Antiquariato* Chair**
From the series
"Monofilo"
1962
Enamelled steel, nylon
87 x 112 x 90 cm
Produced by Emilio Paoli,
Florence
Liliane and David M.
Stewart Collection
2006.52.1-2

`261`

Jacques S. Guillon
Born in Paris in 1922
***Nylon* Chair**
1952
Walnut, birch laminate, nylon
83 x 48 x 40.5 cm
Produced by Modernart
of Canada, Montreal
Liliane and David M.
Stewart Collection,
gift of Jacques Guillon
D82.103.1

`262`

Hans Wegner
Tønder, Denmark, 1914 –
Copenhagen 2007
***Flag Halyard* Armchair**
(model GE-225)
1950
Chromed and painted steel,
halyard, wood, cotton
80.5 x 105 x 116.2 cm
Produced by Getama,
Gedsted, Denmark
Liliane and David M.
Stewart Collection
D97.173.1a-b

`263`

Marcel Wanders
Born in Boxtel,
Netherlands, in 1963
***Geknoopte Stoel* Chair**
1996
Aramid fibres with a
carbon core, epoxy resin
74.8 x 50.5 x 66 cm
Produced by Cappellini,
Arosio, Italy
Liliane and David M.
Stewart Collection,
gift of Cappellini S.p.A.
D99.138.1

259

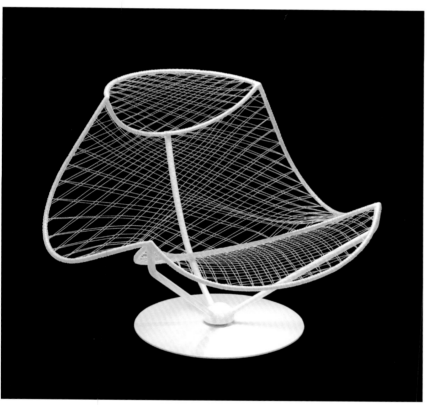

260

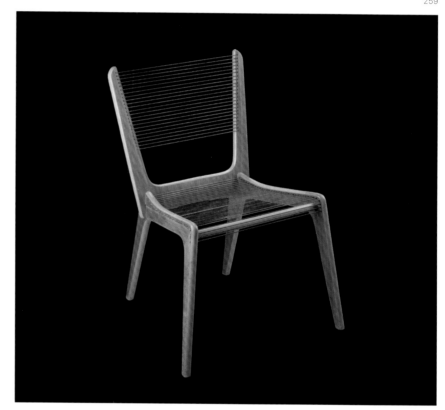

261

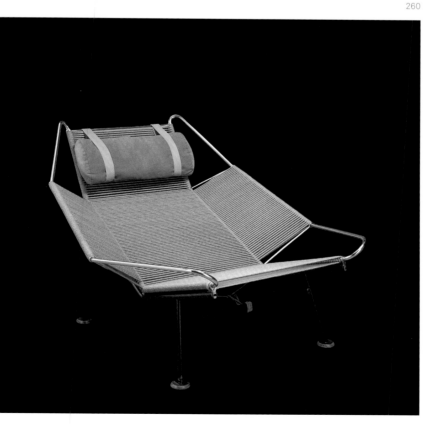

262

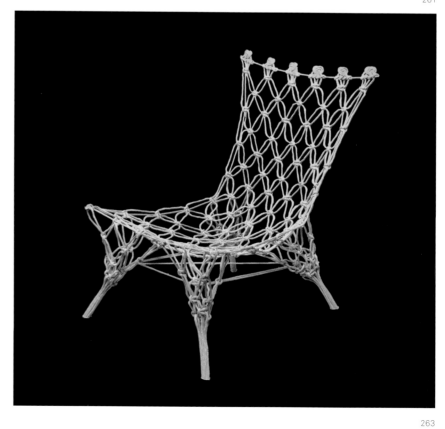

263

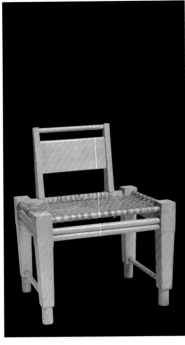

264

265

266

267

BABICHE

Babiche, derived from the Montagnais word *sisibachiche* used by the first French traders who came to Canada, was made of green (untanned) leather that was stretched during drying. This leather was then cut into thin strips that could be woven together to serve in the making of various objects related to fishing, hunting or snow transport, the best known of which are snowshoes. In the nineteenth century, babiche was also used in the chair seats found in rustic-styled homes, particularly in the Montreal region (fig. 1).

Babiche made history through the pen of Montreal artist and furniture designer Louis Jaque. The "bench" chair **264**, designed about 1947, goes with his dining-room furniture, which would end up in the studio of sculptor Louis Parent, near Saint Joseph's Oratory in Montreal. But, at the time, this piece was made simply for the pleasure of creating it; this chair alone has survived, as Parent's studio was destroyed by fire. The chair's style is a synthesis of Quebec farmhouse furniture and the modern taste championed by Montreal's École du Meuble, shaded by

a certain Art Deco historicism with a particular interest in Egypt.

In 2008, the Montreal gallery/boutique Commissaires presented the exhibition *New Babiche*, under the direction of Pierre Laramée, bringing together the Samare collective's "Awadare" furniture and the works of seven other creators invited to adapt the babiche farmhouse chair to contemporary taste. These designers and artists[1] invested this chair with poetic notions reflecting their respective artistic practices. Sylvie Laliberté underscored the anthropomorphism of the chair by adding miniature snowshoes under the legs **265**. She attached a humorous inscription to the chair back's upper rail: "La chaise qui a du nerf" [A Chair with Vigour]. Guy Pellerin appropriated the chair to make a work recalling his objects/tableaux **267**. He dismembered it, removing the babiche seat, which he attached to the wall. The new object was then painted the colour of the gallery wall—whence comes the *chameleon* in the title—inviting the viewer to rethink the chair's raison d'être. François Morelli

transforms the chair into an armchair by adding a U-shaped wire-mesh construction **266**. The tin-glazed earthenware bowls that he placed inside might suggest a cupboard, a chamber-pot stand, a cage and other such things. The sculptor was interested in the object as a bearer of memory, but also in its narrative potential. *Fauteuil fautif* [Faulty Armchair] raises the question of the sculpture/furniture hybridity inherent in art furniture.

The Samare collective's "Awadare" collection involves a series of chairs and tables in which the organic and the spare come together harmoniously. Composed of traditional babiche and a modern material, steel, the *Mountie* stool **268** evokes the Royal Canadian Mounted Police (RCMP): the red of the steel refers to the uniform, while the handle suggests the pommel of the saddle. The stool was produced in an edition of fifty. DC

1. A group of four designers or architects (Étienne Hotte, Michel Parent, Collectif Rita and Guillaume Sasseville) and three artists (Sylvie Laliberté, François Morelli and Guy Pellerin).

Fig. 1
Wood chair with babiche
seat, Quebec, mid-19th c.
Musée de la civilisation,
Quebec City

264
Louis Jaque
Montreal 1919 –
Montreal 2010
Chair
About 1947
Oak, babiche
76 x 57 x 42 cm
Purchase, Dr. Francis J.
Shepherd Bequest
1989.Df.2

265
Sylvie Laliberté
Born in Montreal in 1959
La chaise qui a du nerf
2008
Recycled babiche-seat chair,
miniature showshoes
80.5 x 53.5 x 70 cm (approx.)
Engraved on a metal
plate affixed to the upper
transverse rail of back:
*Une chaise qui a du nerf
(1708 - 2008) Sylvie Laliberté*
On the snowshoe's tail:
MADE IN CANADA
Purchase, T. R. Meighen
Family Fund
2008.168.1-5

266
François Morelli
Born in Montreal in 1953
Fauteuil fautif
2008
Recycled babiche-seat
chair, steel, ceramic bowls
79 x 90 x 48 cm (approx.)
Purchase, T. R. Meighen
Family Fund
2008.167.1-2

267
Guy Pellerin
Born in Sainte-Agathe-
des-Monts, Quebec, in 1954
no. 389 – the chameleon
2008
Recycled chair, babiche, paint
80.5 x 41.5 x 45 cm (approx.)
Purchase, T. R. Meighen
Family Fund
2008.166.1-2

268
Samare
Founded in Montreal
in 2006
Mountie Stool
2007
Painted steel, babiche
63 x 46 x 46 cm (approx.)
Produced by Samare,
Montreal
Purchase, T. R.
Meighen Family Fund
2008.169

Designers of modernist furniture have often employed leather or animal skins in the upholstery of different types of seating. These materials, which became widely available during the twentieth century, bring distinction to mass-produced furniture.[1]

Eero Saarinen's *Womb* armchair 269, covered in calfskin, is characteristic of the designer's fusionist approach, for it combines new materials and technical innovation in an organic seat that encourages lounging.[2] The moulded shell is made of polyester-reinforced fibreglass, which at the time of the chair's conception was an experimental material whose uneven surface had to be concealed beneath a layer of foam and upholstery fabric—or, as in this case, vellum.

At the Scandinavian Airlines System (SAS) Royal Hotel in Copenhagen, built between 1956 and 1960, the architect Arne Jacobsen also did the plans for the hotel's reception area and rooms, and designed all the furniture, including the iconic chairs *Swan* and *Egg* 270.[3] They owe a great deal to the experiments carried out by Finnish-born American architect Eero Saarinen and Norwegian designer Henry Klein with moulded plastic shells.[4] Jacobsen made the prototype for the *Egg* armchair in his garage, giving it the shape of a "smoothly broken eggshell,"[5] hence the chair's name. Calling to mind the traditional armchair with winged back, *Egg* was a new manifestation that unified the back, wings, seat and armrests in an unbroken line, creating the impression of a cocoon, its modern look enhanced by the lone swivelling steel foot upon which the shell sits. The *Egg* armchair, produced since 1958 by the Danish manufacturer Fritz Hansen, may be covered in leather or a variety of fabrics and accompanied by a cushion and footrest. To this day, an upholsterer fixes the covering to the frame, a complex operation that means only six or seven pieces are produced a week. The sculptural quality of the highly curved armchair fitted with leather conjures luxury, comfort and cosiness.

The *Non-stop* sofa 273 was created in 1968 by designer Eleonore Peduzzi-Riva, assisted by Ueli Berger, Heinz Ulrich and Klaus Vogt, for the Swiss manufacturer of leather furniture de Sede. Like the typical user-friendly styles of 1960s seating, *Non-stop* can be arranged in a number of configurations according to the user's wishes and finished off at the ends with armrests to make anything from a sofa to a single-seat armchair. The modules (very narrow seats) are shaped by a wooden frame covered in nylon and upholstered with polyurethane foam and leather. Sections are individually linked to each other by way of hinges and zippers hidden under leather bands. The sofa continues to be produced by de Sede. The Museum's example was made for American importer and manufacturer Charles Stendig, who presented it to the Montreal Museum of Decorative Arts in 1994.

Mario Bellini has also exploited the notion of covering, but his goal has been to provoke an emotional response. Minimalist in both structure and design, his *Cab* chair 272 is covered with a "skin" of saddle leather that zips together at the legs like a sheath. This way of concealing the welded steel frame was strikingly original, since the use of zippers in furniture had previously been restricted to fabric slipcovers. The chair's outer envelope of leather transforms it into an object of considerable sensuality.

Perpetuating the tradition of such modern French masters as André Arbus—whose work is marvellously represented by a corner cabinet designed in 1938[6] 149—Sylvain Dubuisson chose a combination of leather and parchment to cover the wooden framework of his *1989* desk 271. Manufactured by the cabinetmakers at Fourniture, the desk is available in three models and in a number of different veneers.[7] The epitome of luxury, the piece of furniture is nonetheless understated, the purity of its curves enhanced by the exquisite skill with which the facing has been applied. DC

1. Judith Miller, *Furniture* (London: DK Publishing, 2005), p. 423. 2. The piece was created at the request of Florence Knox Basset, who was seeking a comfortable chair in which to relax. One version comes with an accompanying ottoman (model no. 74, about 1950). 3. Jacobsen followed in the tradition of architects and designers like Frank Lloyd Wright and Josef Hoffmann, who created all-encompassing works (architecture and furniture). 4. Henry Klein perfected a moulding process that he let various manufacturers use under licence, including Fritz Hansen, maker of the *Swan* and *Egg* chairs (Kevin Davies, "Egg Chair," in *Phaidon Design Classics, Vol. 2: 334–666* (London; New York: Phaidon Press, 2006), no. 498. 5. Ibid. 6. The name *1989* relates to the year the desk was created. 7. In the 1980s, Fourniture commissioned desks from various designers, including Sylvain Dubuisson, Olivier Gagnère, Élisabeth Garouste and Mattia Bonetti. Dubuisson's desk came in three models of different sizes and surfaces: the "Direction" model, of 1989; a second model, the "Ministre," made in collaboration with Mobilier national for the desk of Jack Lang, Minister of Culture and Communications, in 1990; and the "Appartement" model (the Museum's model), in 1991. For more on the latter, see: "Bureau '1989,' modèle 'Appartement,'" *Les Arts Décoratifs*, http://www.lesartsdécoratifs.fr (accessed July 22, 2012).

269

Eero Saarinen
Kirkkonummi, Finland, 1910 – Ann Arbor, Michigan, 1961
Womb **Armchair (model 70)**
1946 (example about 1950)
Fibreglass-reinforced polyester, steel, vellum
92.3 x 102.5 x 91 cm
Produced by Knoll Associates, New York
Liliane and David M. Stewart Collection, gift of the American Friends of Canada through the generosity of Muriel Kallis Newman
D83.109.1

270

Arne Jacobsen
Copenhagen 1902 – Copenhagen 1971
Egg **Armchair**
1958
Polyurethane foam, steel, aluminum, leather
106.2 x 87 x 78.7 cm
Produced by Fritz Hansen, Copenhagen
Monogram, on foot: *FH*; stamped on underside of seat: *S* and label: *FURNITURE MAKERS / DANISH*
Liliane and David M. Stewart Collection
D87.131.1

271

Sylvain Dubuisson
Born in Bordeaux in 1946
1989 **Desk**
"Appartement" model, 1991 (example of 2002)
Patinated parchment and leather on wood
72.5 x 150.5 x 82.5 cm
Produced by Fourniture, Ivry-sur-Seine, France
Liliane and David M. Stewart Collection
2002.56.1-2

272

Mario Bellini
Born in Milan in 1935
Cab **Chair (model 412)**
1976
Enamelled steel, polyurethane foam, leather
80 x 47 x 42 cm
Produced by Cassina, Meda, Italy
Label, on underside of seat: *Cassina@ / MADE IN ITALY*
Liliane and David M. Stewart Collection, by exchange
D93.254.1a-b

273

Ueli Berger
Bern 1937 – Ersigen, Switzerland, 2008
Eleonore Peduzzi-Riva
Born in Basel in 1939
Heinz Ulrich
Born in Waltalingen, Switzerland, in 1942
Klaus Vogt
Born in Winterthur, Switzerland, in 1938
Non-stop **Modular Sofa (model DS-600)**
1968
Wood, metal, styrene and urethane foam, Dacron, leather upholstery
74 x 24 x 100 cm
(each module)

Produced by de Sede, Klingnau, Switzerland
Labels, on underside of two sections: *ORIGINAL DESIGN / Stendig / MADE IN SWITZERLAND* and under one armrest: *80% rigid styrene foam / 10% urethane foam / 10% dacron; MADE IN SWITZERLAND FOR / INTREX. INCORPORATED / 1000 FIRST STREET / HARRISON, NEW JERSEY 07029*
Liliane and David M. Stewart Collection, gift of the American Friends of Canada through the generosity of Eleanore and Charles Stendig in memory of Eve Brustein and Rose Stendig
D94.156.1a-l

269

270

271

272

273

274

275

UPHOLSTERY FABRIC

The history of upholstery fabric goes back to the Middle Ages, when drapers and tapestry-makers made bed curtains, quilts, hangings and tapestries. From the sixteenth to the nineteenth century, tapestry-makers also made seat coverings. Their trade was built on inherited know-how transmitted from generation to generation, from master to apprentice. In the twentieth century, the proliferation of forms, materials, processes and styles appears to have relegated traditional furniture coverings to the sidelines, but various contemporary designers have taken a newfound interest in upholstery and found ingenious ways of covering foam stuffing: Christian Ghion (patterned fabrics 277, Toshiyuki Kita (colourful covers 274, Marc Newson (bi-elastic fabrics 275 and Masaroni Umeda (plush velvets 276). For their part, Gaetano Pesce, Alessandro Mendini and the Campana brothers have appropriated upholstery to playful ends. DC

THE CAMPANA BROTHERS

The Campana brothers, Fernando and Humberto, have been garnering attention on the international scene since the late 1990s for their highly original creative practice, which combines the playful and the ethnological in furniture design. They live and work in São Paulo, a city vibrant with textures and colours, a constant source of inspiration. Their marked interest in materials, followed closely by form and function, has resulted in furniture informed by a teeming imagination while reflecting Brazil's socio-economic reality. The designers favour traditional techniques, demonstrating a passion for "poor" or salvaged materials, which they enjoy accumulating to excess even when designing furniture for the Italian company Edra.

These notions of appropriation, accumulation and hybridization inherent in their aesthetic have led the brothers to rethink the chair upholstery. Different types of materials appeal to them particularly, such as scraps of fabric, carpet and rubber, or the stuffed animals of their childhood. Although the classic structure of the chair is revisited and revised, comfort is never neglected. Several chair collections—all handcrafted and produced in limited editions—illustrate these

preoccupations, such as the chairs designed with "Made in China" stuffed animals found in São Paulo's stores and flea markets. The *Banquet* chair (2002), of which only 150 copies were produced, is composed of exotic animals, in a sort of menagerie we naturally associate with the world of childhood. However, the Campana brothers make use of this obvious association in order to underscore the serious side of this assemblage: that of the food chain.[1] In the same vein, but this time in a limited series of thirty-five copies, they created the *Alligator* (2002), *Dolphins and Sharks* (2002), *Teddy Bear Banquet* (2004), *Panda Banquet* (2005) and *Cartoon* (2007) chairs.

Cake Stool 278, from 2008, displays the same "organic" characteristics as the *Banquet* chair. It is made from an assortment of stuffed animals sewn together on a canvas fixed to a steel base. Each of the 150 copies has a different, seemingly random, arrangement. At once funny and disconcerting, *Cake Stool* has all the qualities of a baroque object that attracts and holds the gaze,

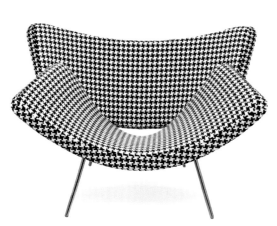

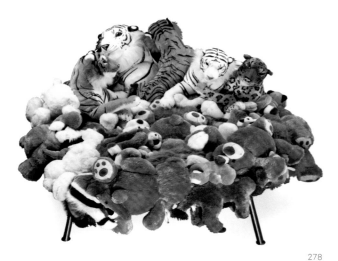

276 277 278

particularly if we forget the synthetic fauna's allusions to the food chain. DC

1. Darrin Alfred et al, *Campana Brothers: Complete Works (So Far)* (New York: Rizzoli and Albion Gallery, 2010), p. 186.

ALESSANDRO MENDINI

In the objects created by Alessandro Mendini, a leading proponent of the Italian radical design movement, symbolism tends to take precedence over functionality. His vision, which owes more to art than to design, is both an invitation to cast off industrial constraints and a critique of contemporary consumer society. As a partner in Studio Alchimia (a collective founded in 1976), Mendini developed his concept of "redesign," which is based on a very simple observation: since everything has already been invented, nothing remains but to reinterpret or transform existing objects. The *Poltrona di Proust* armchair **279**, for example, from the irreverent "Bau.Haus" collection, is a clear refutation of the functionalist legacy. Although in its form it reinterprets a "classic," its upholstery is extravagantly and deliberately kitsch.

The whole piece—wood, trimmings, fabric—has been painted to mimic a detail from a pointillist painting by Paul Signac. Between 1979 and 1987, Studio Alchimia produced some thirty chairs (dated but not numbered). The decoration was executed by the painter Franco Miggliaccio, and a few of the chairs were signed by Mendini. In 1988, the designer took up production of the *Poltrona di Proust* armchair himself, and each chair is one of a kind, signed and accompanied by a certificate of authenticity. The Museum's example, which was produced by the Atelier Mendini and bears the inscription *Mendini / 2001*, was painted by the designer's niece, Claudia Mendini. DC

GAETANO PESCE

Renowned for the formal eloquence of his objects, furniture and interiors, designer Gaetano Pesce is also recognized for his experimentation with innovative materials and new manufacturing techniques. The main component of the "I Feltri" series **280**, produced by Cassina, is felt—an inexpensive traditional material, more or less amorphous, made of matted and bonded fibres. Each of the chairs in the series, which are simple to make, consists essentially of a large semicircle cut from a sheet of industrial felt. After having been impregnated with polyester resin (to varying degrees, depending on the stiffness required), the felt is placed in a mould and subjected to a very high temperature for hardening, thus solidifying the base but leaving the upper part flexible. The hemp stitching on the outer surface reinforces the felt and gives the chair a "handmade" look. The brightly coloured, quilted fabric is attached with snaps, allowing it to be easily removed for cleaning or replacement. The back of the chair can either be curled to the rear like a huge collar or brought down to envelop the occupant like a cloak. This contemporary reinterpretation of a wing chair is the very embodiment of comfort, warmth and relaxation. DC

276

Masanori Umeda
Born in Kanagawa, Japan, in 1941
Getsuen **Armchair**
1990
Steel, polyurethane foam, cotton velvet, Dacron, polyethylene, lacquered iron
83.2 x 100.4 x 92.1 cm
Produced by Edra, Perignano, Italy
Liliane and David M. Stewart Collection, gift of Maurice Forget
D93.259.1

277

Christian Ghion
Born in Montmorency, France, in 1958
Butterfly Kiss **Armchair**
2004
Plywood, polyurethane foam, chromed steel, cotton upholstery
86 x 116 x 78 cm
Produced by Sawaya & Moroni, Milan
Purchase, the Museum Campaign 1988-1993 Fund
2005.5

278

Fernando Campana
Born in Brotas, Brazil, in 1961
Humberto Campana
Born in Rio Claro, Brazil, in 1953
Cake Stool
2008
Stuffed animals, canvas, steel, 63/150
55 x 120 x 120 cm (approx.)
Produced by Estúdio Campana, São Paulo
Signature, embroidered on a stuffed animal:
Campanas N°63 / 150
Purchase, Memorial Funds
2011.38

279

Alessandro Mendini
Born in Milan in 1931
Poltrona di Proust
[Proust's Armchair]
From the series "Bau.Haus"
1978 (example of 2001)
Painted wood and fabric, polyurethane foam, passementerie
106 x 102 x 92.5 cm
Painting: Claudia Mendini
Produced by Atelier Mendini, Milan
Signature and date, inside of front seat rail:
Mendini / 2001
Purchase, the Museum Campaign 1988–1993 Fund
2005.88

280

Gaetano Pesce
Born in La Spezia, Italy, in 1939
I Feltri **Armchair**
1986 (example of 1987)
Wool felt impregnated with polyester resin, hemp, stainless steel, cotton
127.6 x 105.4 x 67.3 cm
Produced by Cassina, Meda, Italy
Liliane and David M. Stewart Collection
D98.159.1a-b

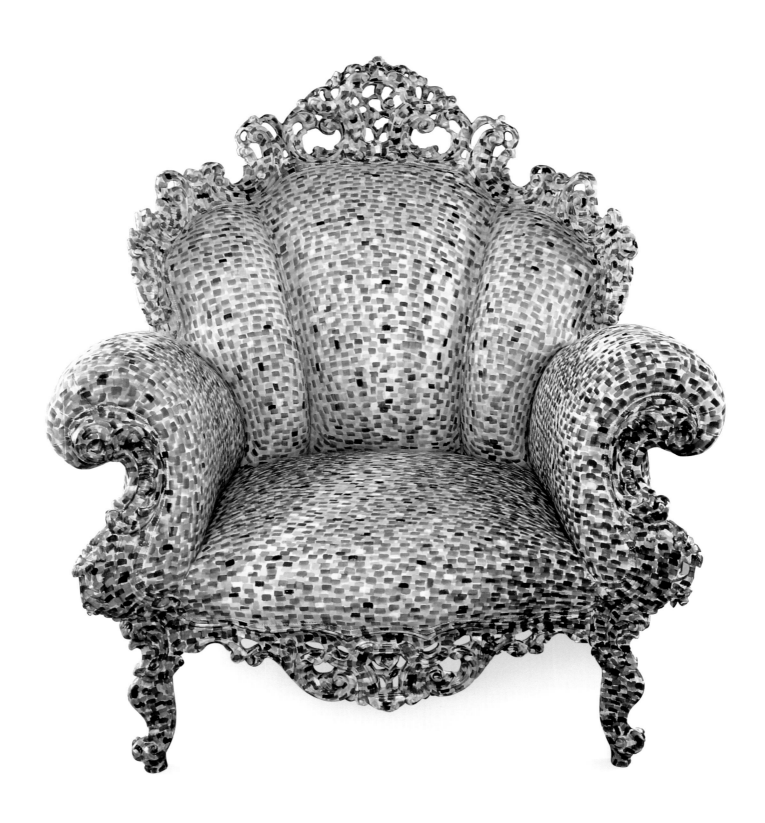

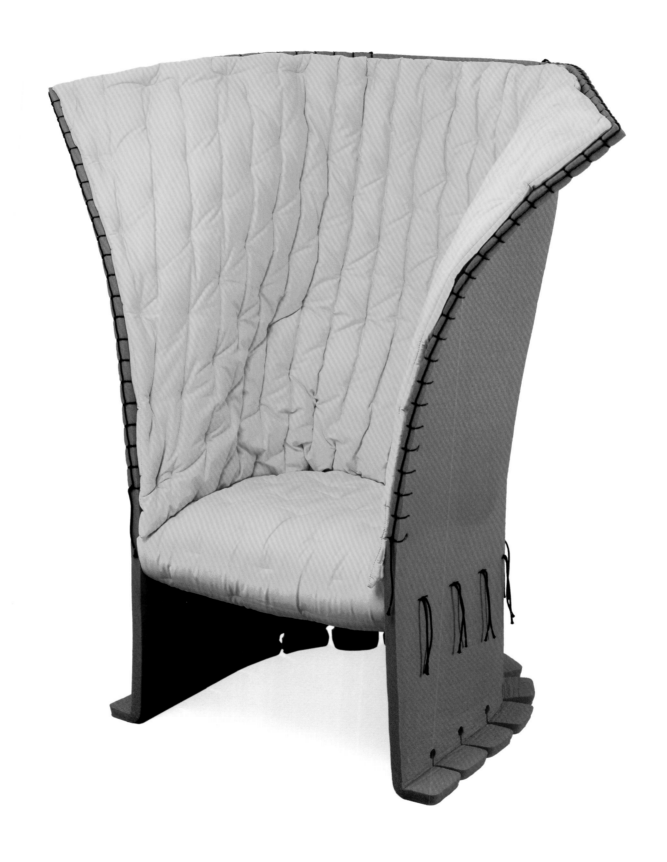

METAL

█████ *noun & adjective* [ORIGIN Old French & mod. French *métal*, †*metail* or its source Latin *metallum* . . . from synon. Greek *metallon*.] **A** *noun* **I 1** ■ Any of the class of substances including the elements gold, silver, copper, iron, lead, and tin, and certain alloys (as brass and bronze), characteristically lustrous, ductile, fusible, malleable solids that are good conductors of heat and electricity.

██████ The brilliance of metal has an appeal that transcends form and decoration. The allure of gold or silver, their tactile quality, brilliance and lustre, as well as economic value have ensured their appeal over the centuries. A malleable metal, silver was traditionally shaped or raised into its final form by hand hammering and decorated by chasing, using a variety of small hammers or punches to model the surface or render embossed or repoussé designs. Early European silver, both ecclesiastical and secular, displays masterful craftsmanship in the elaborate chased decoration and cast sculptural elements. █████ As silver reached a wider market in the nineteenth century, the silversmith relied more on mechanical methods, for example, spinning the silver into a hollow form with a lathe rather than hand hammering. Also, new techniques were introduced, such as electroplating, whereby a thin layer of silver was applied using electrolysis to a baser metal, usually copper. Later in the century, the shiny hammered surfaces of brass and copper drew the attention of admirers of handcraftsmanship, for whom invention of form and richness of tone overrode concerns for a metal's financial worth. ██████ The twentieth century saw metal used in new ways; for example, in the 1930s, aluminum was favoured for industrially designed objects because it was easily worked, lightweight, resistant to corrosion and had an attractive silvery sheen. The industrial age also brought chrome-plated tubular steel furniture into the home, followed by pieces in stainless steel, an alloy of iron with chromium and nickel, which also resisted corrosion and polished to a fine bright surface. █████ In contemporary design, many forms of steel—enamelled steel, nickel-plated steel, sheet steel, steel wire and steel mesh—have often replaced wooden furniture. Similarly, jewellery designers no longer restrict themselves to gold and silver, the traditional luxury metals, and now take advantage of the qualities of a variety of other types of metal, including bronze and galvanized steel wire, or incorporate the most unlikely metal objects, such as brass safety pins. RP

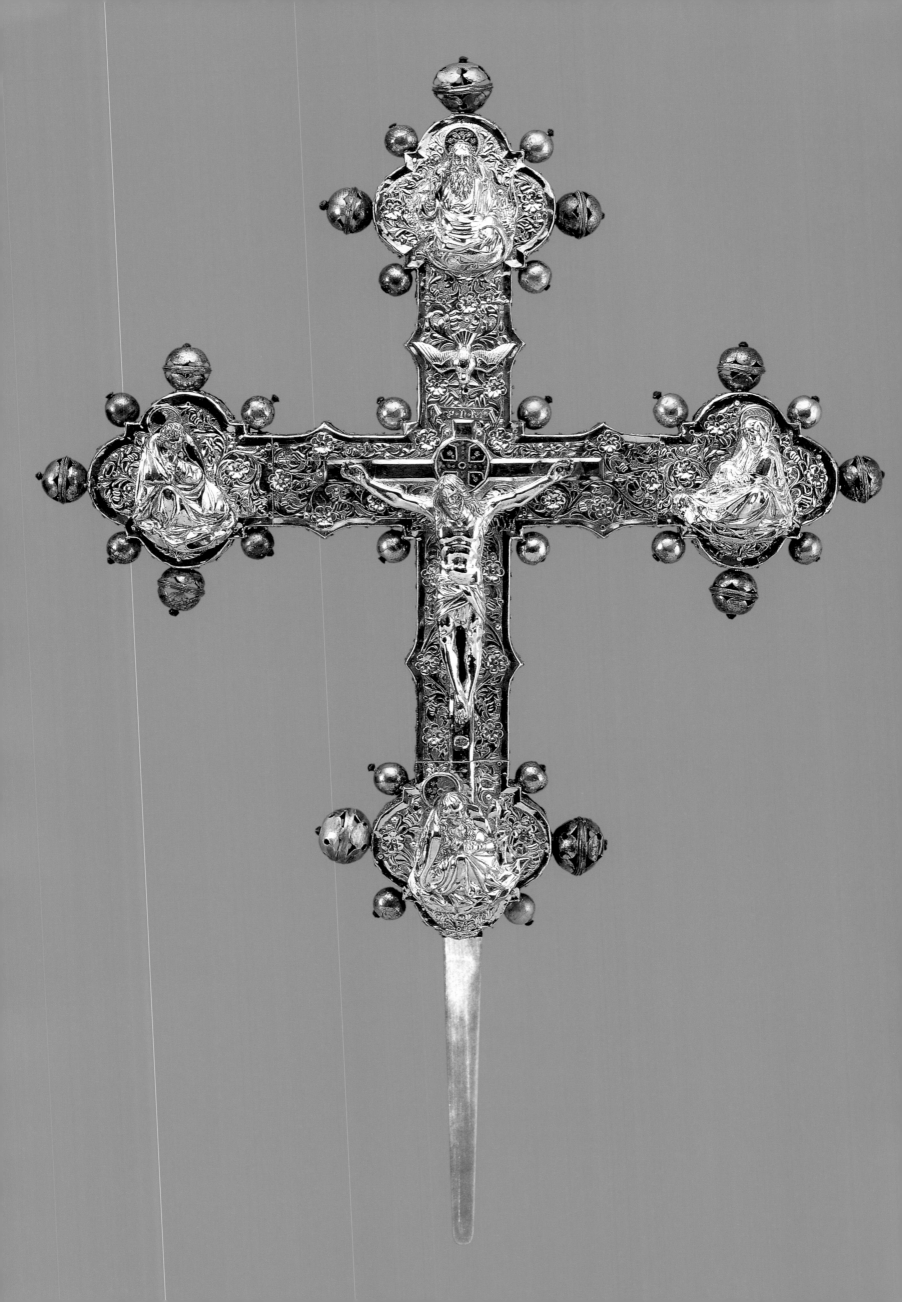

EUROPEAN
SILVER

— JOANNE CHAGNON, ROBERT LITTLE, ROSALIND PEPALL —

ITALY
Processional Cross

This cross [281] was originally fitted with a mount attached to a long staff and was borne in processions associated with Catholic liturgy. This particular processional cross was made between 1468 and 1483, in Sulmona, in the Abruzzi region of Italy, an important centre for the production of ecclesiastical silver in the fifteenth century.[1] Characteristically, these late-Gothic-style crosses with quatrefoil arm terminals outlined with copper balls and bells were made of a series of silver-relief plaques attached with nails to a wood core. The figures of Christ Crucified on the front, and that of Christ in Majesty, normally on the reverse but missing here, were made separately and then attached.

Goldsmiths from the Abruzzi, like those from other centres during this period, were much influenced by the artistic climate that flourished in Florence, as exemplified by the works of sculptor and goldsmith Lorenzo Ghiberti (1378–1455). Ghiberti and his contemporaries imbued their pieces with a compelling liveliness based on an understanding of human anatomy and a

knowledge of classical antique sculpture. Their influence brought about a new, more organic way of representing the human form and situating it in a realistically rendered space.

Of the Sulmona goldsmiths working during this period, only three names are known thus far: Nicola Della Franca, Giacomo di Paolo and Giovanni Rigio, any one of whom could have made this cross.[2] They represented the generation that followed the most important goldsmith active in the Abruzzi in the early fifteenth century, Nicola da Guardiagrele (about 1395–before 1462), who was evidently familiar with the work of Ghiberti and his contemporaries. The influence of Ghiberti's compositions—his handling of anatomy, fabric draping and facial expressions—has almost exact parallels in Guardiagrele's work and in the work of the latter's successors, as seen on the figures of this present cross.[3]

The depictions on the front of the cross of the Virgin, Saint John and Mary Magdalene, all seated on the ground grieving in reaction to the Crucifixion, are probably derived from

the thirteenth-century *Meditationes Vitae Christi* (*Meditations on the Life of Christ*), a text relating the life and Passion of Christ that lays particular emphasis on the human sufferings of these three holy survivors.[4] The reverse of the cross bears portrayals of the four Evangelists and two small engraved roundels (with traces of their original enamel) representing the Angel Gabriel and the Virgin of the Annunciation flanking the now lost Christ in Majesty of the Last Judgement, and Saint Anthony Abbott, regarded as the father of monasticism. The presence of the latter on this cross may be an allusion to a monastic order for which this cross was ostensibly made. **RL**

1. Valentino Pace, "Per la storia dell'oreficeria abruzzese," in *Bolletino d'Arte*, vol. 57 (1972), pp. 78–84, mark on p. 79, sixth figure from the top. 2. Ibid., p. 88. 3. See Charles Seymour, *Sculpture in Italy 1400–1500* (Baltimore: Penguin Books, 1968), p. 44; see also Richard Krautheimer, *Lorenzo Ghiberti* (Princeton, New Jersey: Princeton University Press, 1970), p. 116, note 7. 4. Apollonia Schofield, "The Prior's Cross," in *Monastic Studies*, no. 15, Advent 1984 (Montreal: The Benedictine Priory of Montreal), pp. 224–229.

[281]

ITALY, SULMONA
Processional Cross
1468–83
Silver, silver gilt, enamel,
gilded copper, iron, wood
72 x 48.5 x 7.5 cm
Town mark, on each silver
element: *SUL* (for Sulmona,
1468–1483)
Gift of the John Main Prayer
Association, by prior gift
of the J. W. McConnell
Family Foundation
1994.Ds.1
PROVENANCE
Mrs. Julia Galusha Whitcomb,
New York, purchased in
Italy; Mr. and Mrs. J. W.
McConnell, 1928.

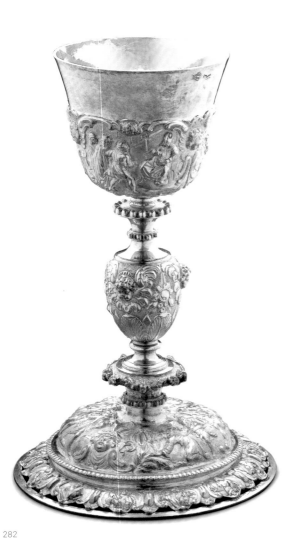

282

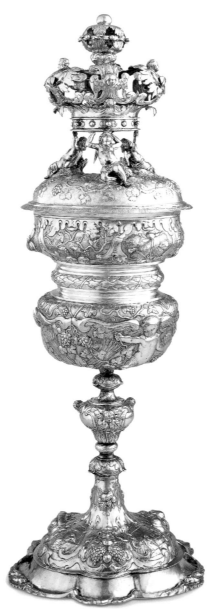

283

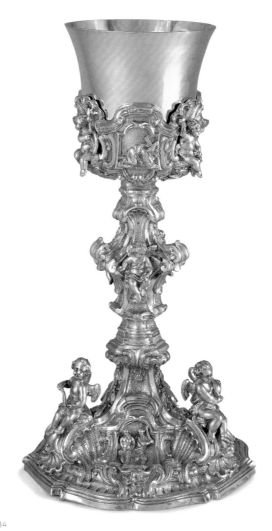

284

ATTRIBUTED TO FRANÇOIS LEBRET

The chalice 282 attributed to Paris master François Lebret, governor of the guild of Saint Anne and Saint Marcel,[1] might be one of the oldest pieces of silver conserved in Quebec's religious communities and a number of parishes. It displays the same formal vocabulary characteristic of the Baroque style: the circular foot with jagged-edged band fused to a foot ring, the ovoid knop set between two collars, the finely wrought calyx that covers two thirds of a large, slightly flared bowl.

The iconographic program of this sacred vessel clearly follows the precepts of the Council of Trent by featuring religious depictions. Thus the busts of the apostles accompanied by their attributes adorn the band on the base, while scenes of the Passion decorate the top of the foot and the calyx. This chalice reveals Lebret's mastery of repoussé and chasing, skills for which Paris silversmiths of the seventeenth century were renowned. JC

1. On Lebret, see Michèle Bimbenet-Privat, *Les orfèvres et l'orfèvrerie de Paris au XVIIᵉ siècle* (Paris: Commission des travaux historiques de la ville de Paris, 2002), vol. 1, pp. 196 and 390–391; vol. 2, pp. 332–333 (ill.).

CIRCLE OF JOHANNES LUTMA THE YOUNGER

A ciborium is a covered liturgical vessel used to store or distribute the consecrated wafers, or hosts, in the context of the Sacrament of the Eucharist. This particular example 283, with its waisted cup, resembles a large *bokaal* or *pokal*, a type of standing cup with cover used in Germany for ceremonial and presentation purposes. However, the depictions of scenes from the Life and Passion of Christ arranged around the base, the motifs of grapes and wheat sheaves around the cup (alluding to the wine and bread of the Eucharist), and the tripartite articulation of the base and knop (alluding to the Holy Trinity), leave no doubt as to the sacred use of this vessel.

The elaborate chasing and repoussé work on this ciborium combines different styles of decoration with the more naturalistic depictions of putti, wheat, grapevines and scrolling foliage typical of the Baroque. The more organic, sinuous, curvilinear framing devices, or cartouches, surrounding the scenes from the Life of Christ, however, show traces of the auricular style, so called because of its curved and rippling forms resembling the human ear: it was popular in Holland in the early decades of the seventeenth century. This particular style was developed by goldsmiths like Paulus (about 1570–1613), Adam (1568/69–1627) and Christian Van Vianen (about 1600–1667), and Johannes Lutma the Elder (about 1584–1669), among others. Lutma came to Amsterdam from his native Germany, attracted by its financial power and thriving cultural life.[1] He was a friend of Rembrandt. His son, the artist, engraver and goldsmith Johannes Lutma the Younger, published a series of his father's designs for silver in the auricular style in the 1650s, attesting to the enduring popularity of the style.[2] This ciborium has very close stylistic affinities to a 1663 chalice in Amsterdam's Rijksmuseum that has been attributed to Johannes Lutma the Younger, and was possibly made by someone in his circle.[3] A putto bearing a shell once crowned the acanthus finial, and is now replaced by a sphere. RL

1. J. Verbeek, "Nederlands zilver / Dutch Silver 1580–1830," in *Nederlands zilver / Dutch Silver 1580–1830*, exh. cat., ed. A. L. den Blaauwen (Amsterdam: Rijksmuseum, 1979), pp. XXII–XXVIII. 2. Christiaan Schuckman, "Lutma," "Johannes Lutma (i)," "Johannes Lutma (ii)," in *The Dictionary of Art*, vol. 19 (New York: Groves Dictionaries, 1996), pp. 817–818. 3. See den Blaauwen, pp. 146–147.

ATTRIBUTED TO GIUSEPPE NEPOTI

The maker's mark on this chalice 284 was used from 1702 to 1774 by three successive goldsmiths. This chalice, a tour de force of late Baroque art, was most likely made by the first of them, Giuseppe Nepoti, who was active in Rome from 1702 to 1753.[1] The chalice is replete with symbols and scenes related to the Passion of Christ: the panels around the base depict the Flagellation, the Crowning with Thorns and Ecce Homo; the panels around the calyx depict the Agony in the Garden, the Carrying of the Cross and the Deposition. The triangular plan, an allusion to the Holy Trinity, is embodied in a complex interplay of convex and concave elements that owes much to the Baroque architecture of Francesco Borromini (1599–1667). Other details, such as the half-shell framing devices and the "C" scroll pediments over the panels, show the influence of Pietro da Cortona (1596–1669).[2] More immediate influences can be found in the designs of Roman goldsmith Giovanni Giardini (1646–1722). His highly influential pattern book, *Designi Diversi* (1714), synthesized elements of the vocabulary of Roman Baroque sculpture and architecture, and translated these for the metalworker. Nepoti incorporated features from Giardini's design for a hanging lamp into the base and central knop of this chalice.

The chalice was probably a commission for an important, now unknown, patron. This is evident in the high quality found even in hidden details such as the scroll and strapwork motifs, and the three types of matte chasing decorating the underside of the base, which would have been seen by the celebrant patron only when the chalice was raised upward during Mass. RL

1. The mark was notarized in 1734 and used by successive goldsmiths: between 1702 and 1753, Giuseppe Nepoti; between 1753 and 1756, succeeded by co-worker Gabriele Mariani; between 1756 and 1759, the widows of Nepoti and Mariani ran the atelier; succeeded by Mariani's son-in-law Gregorio Spinazzi, active between 1759 and 1774. See Costantino Bulgari, *Argentieri, Gemmari e Orafi d'Italia*, 5 vols, Rome (1958–1974), 1980 printing by Fratelli Palombi editori, vol. 1, p. 20, no. 89, vol. 2, pp. 95, 198 and vol. 3, p. 434. 2. Rudolph Wittkower, *Art and Architecture in Italy 1600–1750* (Harmondsworth; Baltimore: Penguin Books, 1958), pls. 69B, 71, 74, 84a, 91. These elements were part of the decorative vocabulary of an artist such as Pietro da Cortona as found in the details of the church of Saints Martina and Luca, Rome, of 1635–1650, and the Sala di Apollo of the Palazzo Pitti, Florence, of 1647.

282

Attributed to
François Lebret
Master in Paris from 1643,
died in 1682
Chalice (1642–43)
Inner Cup (1644–45)
Silver
H. 28.2 cm; Diam. 17 cm
Weight: 242.9 g
Maker's mark: a crowned
fleur-de-lys / two pellets /
F L B / a chisel mark; Paris
guild master of 1644–1645:
A crowned; Paris guild master
of December 1642: *Y* crowned
Gift of the Honourable Serge
Joyal, P.C., O.C., in honour
of the Montreal Museum of
Fine Arts' 150th anniversary
2010.761.1-2

283

Circle of
Johannes Lutma the Younger
Amsterdam 1624 –
Amsterdam 1689
Ciborium
1671
Silver, silver gilt
(original finial missing)
H. 65.4 cm; Diam. 23.31 cm
Weight: 1,709.2 g (vessel),
1,110.4 g (cover)
Town mark for Amsterdam,
heart-shaped mark, and
date letter *I*; standard mark
(4 times)
for 835/000: *Z II*
Purchase, special
replacement fund
1975.Ds.1a-b

284

Attributed to
Giuseppe Nepoti
Rocca Contrada, Italy, 1677 –
Rome 1753
Chalice
About 1735–50
Silver gilt
H. 30 cm; Diam. 15.1 cm
Weight: 1,093.8 g
Maker's mark: three mullets,
in a trefoil cartouche (most
probably for Giuseppe
Nepoti); town mark: crossed
keys and papal umbrella, in an
oval (for Rome, Papal States,
for the period about 1725
and later); standard mark
Gift of the Honourable Serge
Joyal, P.C., O.C.
1996.Ds.16a

DENYS FRANKSON

Denys Frankson was initially allowed to practise as a goldsmith in 1765 by reason of his service with the Hôpital de la Trinité in Paris, a foundling hospital established by Francis I in 1545. In lieu of the usual steps of apprenticeship demanded of an aspiring goldsmith prior to becoming a practising guild member, this arrangement required a young, trained goldsmith like Frankson to teach his craft to the children at the hospital for eight years while allowing him to practise his trade. After the period of service to the hospital, the aspiring goldsmith could register his mark with the Paris guild, which Frankson did in 1773.[1]

The overall shape of each candlestick **285**, with its clearly delineated candle socket, stem and base, is a restrained interpretation of the rococo style, displaying none of the asymmetrical decoration and twisted, atectonic elements associated with the extremes of the high-rococo style. The swags of stylized bellflowers, the fluted bell-shape base and symmetrical shell and scallop motifs around the foot are evidence of the newly emerging Neoclassicism. In the late 1750s, a reaction against what had been perceived as the excesses of the Rococo came about partly as a result of the rediscovery of antiquity, which created a new interest in classical design, and partly as the result of critical writings, including the 1754 *Supplication aux orfèvres* [Petition to Goldsmiths] by designer-critic Charles-Nicolas Cochin.[2] Cochin urged goldsmiths to reject the exorbitance of the Rococo and to return to more classically proportioned design. These candlesticks exemplify a measured approach to the acceptance of Neoclassical design. RL

1. Faith Dennis, *Three Centuries of French Domestic Silver* (New York: The Metropolitan Museum of Art, 1960; 2nd ed. (San Francisco: Alan Wolfsey Fine Arts, 1994), vol. 2, pp. 10–11, 62.
2. Svend Eriksen, *Early Neo-Classicism in France* (London: Faber and Faber, 1974), pp. 233–237.

CHARLES-JOSEPH FONTAINE

This sponge box **286** by Parisian silversmith Charles-Joseph Fontaine would have been part of a shaving set in the eighteenth century, and accompanied by a similar spherical silver box for soap, which was made in a round ball form in that period. The only difference between the two was that the sponge box had a perforated cover to allow air to circulate to dry the sponge. The rest of the set would have included a water jug and shaving basin, a mirror and assorted bottles and accessories for the *toilette*. They were made in silver so that they could be attractively displayed on the dressing table. RP

GUILLAUME PIGERON

This écuelle **287** is traditional in form, appropriate for its function as a vessel for hot broth or semi-liquid food. The shallow, wide bowl with generous, shaped handles has a domed cover decorated overall in a regular arrangement of motifs. What distinguishes this écuelle is its rococo embellishment, especially the four leaf-scroll forms in high relief placed equidistantly around the flange, each rising in a swirling motion up the cover. The date of the piece, 1771, is rather late for the Rococo style, which was at the height of fashion between 1730 and 1765, inspiring all manner of designs, from porcelain services to interior architectural decoration.

The tactile, sculptural quality of silver was an ideal medium with which to express the organic lines and vibrancy of Rococo design. The sparkle of light as it plays across the surface of the silver adds to the feeling of agitated movement that was part of the style's appeal. Among the French designers, Juste-Aurèle Meissonier (1695–1750) was the most visible proponent of the Rococo, publishing his designs for interiors and decorative art objects with swirling rocaille lines and exuberant asymmetrical compositions. Published prints and engravings by other designers of ornamentation ensured that the style spread quickly from Paris to the French provinces as well as to other countries.

There is little documentation on the écuelle's silversmith, Guillaume Pigeron; however, this piece is a fine example of expert silversmithing in eighteenth-century France. The coat of arms engraved on the side belongs to the De Neufville de Villeroy family: "Azure a chevron between three crosslets anchory or." They were an aristocratic family from the Lyons area, going back to the sixteenth century, and this écuelle was made during the lifetime of Gabriel Louis François (1731–1794), the fifth and last Duc de Villeroy and Gouverneur du Lyonnais, who was guillotined during the French Revolution.[1] The family's Château d'Ombreval is now the town hall of Neuville-sur-Saône. RP

1. "Les Gouverneurs de Villeroy," on the website of the Musée d'histoire militaire de Lyon et de la région Rhône-Alpes, http://www.museemilitairelyon.com/spip.php?article34 (accessed February 13, 2012).

JEAN FAUCHE

Ewers were usually made *en suite* with a basin. Both were traditionally used for the ritual washing of hands before dining. By the eighteenth century, with the acceptance of eating with forks and knives, ewers and basins became ceremonial display objects. The type of ewers illustrated here **288 289** was more commonly used at the dressing table as part of a toilet set: fashionable ladies of the eighteenth century often received their guests during their *toilette*. Great care was thus lavished on the design and making of these equipages, as they were displayed to guests as signifiers of rank and status.

The simple pear shape of Fauche's ewer is enhanced by elements in a fully developed rococo style such as the asymmetrical rocaille decoration below the spout, on the cover and hinge, and in the shell-like thumb-piece on the handle. The asymmetrical wavy moulding on the upper body, along with the shape of the spout and the S-shape handle, convey a sense of undulating motion, also typically rococo.

The ewer is engraved with the impaled arms of the Le Gardeur de Repentigny and the Chaussegros de Léry families. In April of 1750, at Quebec City, Louis Le Gardeur de Repentigny married Marie-Madeleine Chaussegros de Léry, both born in New France.[1] The couple may have ordered this work or it may have been sent from Paris as a gift. High-quality French silver is well documented in family and parish inventories in New France. Surviving examples of domestic silver are, however, quite rare. RL

1. Jean Trudel, *Silver in New France*, exh. cat. (Ottawa: National Gallery of Canada, 1974), cat. 32, ill. p. 94.

285

Denys Frankson
Active in Paris, 1765–1791
Pair of Candlesticks
1765
Silver
H. 26.4 cm; Diam. 14.1 cm
Weight: 711.4 g, 711.5 g
Maker's mark: a crowned fleur-de-lys / D [two pellets] F / a triangle; warden's mark 1765: crowned B; charge mark, 1762–1768: A crowned with a laurel branch; discharge mark, 1762–1768: a dog's head; discharge mark, 1762–1768: a rose
Gift of Mrs. Duncan M. Hodgson
1961.Ds.25a-b

286

Charles-Joseph Fontaine
Active in Paris, 1769 – about 1789
Sponge Box
1774–75
Silver
8.9 x 9.1 x 8.2 cm
Weight: 279.2 g
Maker's mark: a fleur-de-lys / two pellets / C [a butterfly] J / F; warden's mark 1774–1775: a crowned L (twice); charge mark 1775–1781 (twice): a crowned A
Gift of Mrs. Duncan M. Hodgson
1961.Ds.19

287

Guillaume Pigeron
Active in Paris after 1762, died in 1775
Écuelle and Cover with the Arms of the Duc de Villeroy
1771
Silver
12 x 30.6 x 18.3 cm
Weight: 1013.9 g
Maker's mark (4 times): a crowned fleur-de-lys / a pellet; a pigeon, a pellet / G [a pellet] P in a conforming cartouche; warden's mark 1771 (twice): crowned H; charge mark 1768–1774: (twice): crowned and jewelled A; discharge mark 1768–1774: a woman's head in profile
Gift of the Honourable Serge Joyal, P.C., O.C.
2011.278.1-2

288

Jean-Baptiste Troquet
Active in La Rochelle, 1742–1778
Ewer
1750
Silver
24.1 x 18 x 12.7 cm
Weight: 1.092.1 g
Maker's mark, on underside: a crowned fleur-de-lys / two pellets / J [a cock] B / T in a conforming cartouche; warden's mark, La Rochelle 1750: a crowned H / S; charge mark, La Rochelle 1740–1774: a fleur-de-lys / a tower / a pellet
Gift of Dr. and Mrs. Charles F. Martin
1952.Ds.4

289

Jean Fauche
Paris 1706 – Paris 1762
Ewer with the Arms of the Families of Louis Le Gardeur de Repentigny and Marie-Madeleine Chaussegros de Léry
1754–55
Silver
24.6 x 17.6 x 12 cm
Weight: 957.4 g
Maker's mark (3 times): a crowned fleur-de-lys / two pellets / a bee / JCF; warden's mark, 1754–1755 (twice): crowned O; charge mark: A crowned with a palm and a laurel branch; discharge mark, 1750–1756 horse's head; countermark, 1750–1756: a duck's head
Ramsay Traquair Bequest
1952.Ds.45

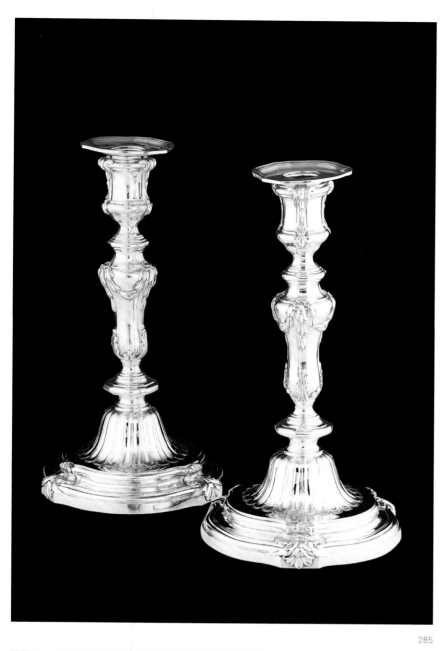

285

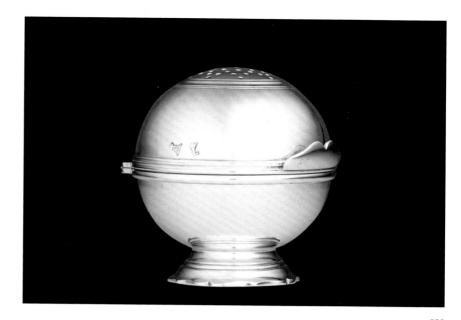

286

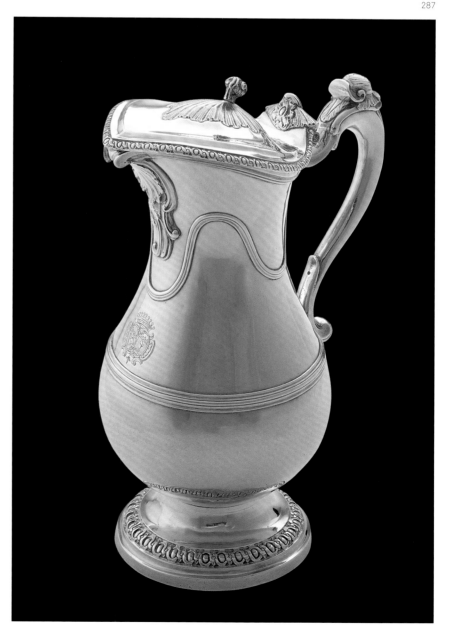

287

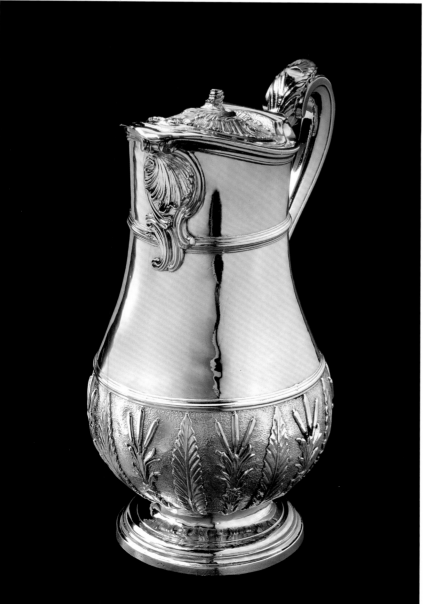

288

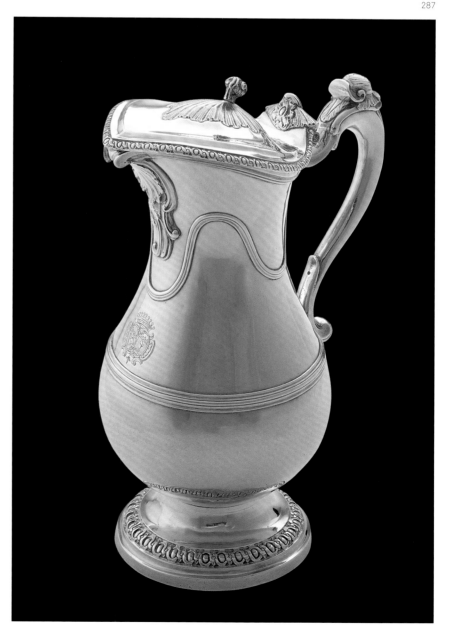

289

ROCH-LOUIS DANY

The soup tureen with accompanying stand by Roch-Louis Dany **290** is one of the finest examples of Neoclassicism in the Museum's collection of French secular silver. The fabrication of this display piece, which weighs over six kilograms, spanned the end of the Ancien Régime and the early days of the Revolution: the tureen, the lining and the lid all bear the 1788 mark, employed until September 4, 1789, while the stand bears the 1789 mark, which came into use on September 5 of that year. Remarkably, the piece escaped both the melting down of silverware decreed during the first year of the Revolution and the many other threats to its survival that marked these turbulent times.

Stylistically, this large serving dish is typical of the late Louis XVI period, which anticipated the Empire style. The restrained ornamentation leaves most of the surfaces plain, thereby focusing attention on the beauty of the metal itself. The double handles—cast and decorated with acanthus leaves where they attach to the body—allowed the heavy tureen and its stand (which is affixed by screws and nuts) to be firmly held and safely carried. A cast and applied openwork frieze of scrolling foliage adorns the largely plain lid, whose raised central section is decorated with acanthus leaves and surmounted by a finial of leaves and seeds. The stand, supported on claw feet, is simply decorated with a torus of laurel leaves and a broad ring of moulding.

The tureen and stand, with their cast and applied bas-relief and in-the-round decorative elements, were made using the most advanced techniques being practised in Paris at the time. Like the bronze appliqués that adorned furniture of the period, the ornamental features have been attached with screws and nuts—a technique that by the early nineteenth century would also be standard practice among silversmiths. **JC**

LOUIS-SIMON BOIZOT

In the eighteenth century, French clocks ceased to be merely functional and became showpieces for the work of sculptors and bronzesmiths. This mantel clock **291**, horizontal in composition, was intended for the mantelpiece of the drawing room or library. Only the finest materials—marble, bronze and gilding—were used in order to ensure the piece harmonized with the polished veneers and gilded mounts of the furniture and

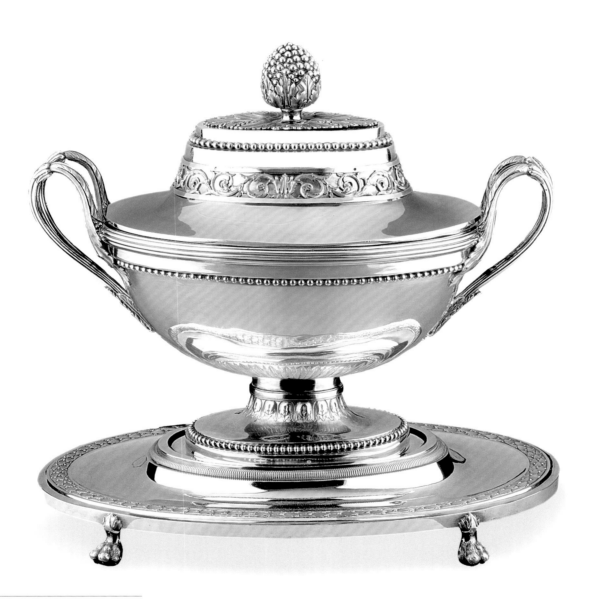

290

the gilt-framed paintings in the refined interiors of the Louis XVI neoclassical style.

The clock dial is surmounted by a gilt bronze eagle and flanked by two bronze classical figures representing *La Philosophie* (a young man writing), and *L'Étude* (a woman reading). These figures were produced after models created in 1776 by the Paris sculptor Louis-Simon Boizot. A student at the Académie royale de peinture et de sculpture, Boizot completed his training at the Académie de France in Rome from 1765 to 1770.[1] He was typical of the sculptors of this period, who were called upon to create designs for all kinds of decorative art objects, from wall sconces, candelabra and furniture mounts to clocks. Boizot served as director of the Sèvres porcelain manufactory's sculpture studios from 1773 to 1800, where he

specialized in small sculptures suitable for serial production. He had a special talent for portraits and received many commissions for marble busts of sovereigns and celebrated figures of the day.

Boizot collaborated with some of the best-known bronzesmiths in France, including François Rémond, who designed this clock in 1784. To give an idea of the work of a master bronze founder and gilder like Rémond, a bill he submitted in 1785 for the creation of a clock for the top of a large desk includes work for the "casting, wax model, wood, design drawing, execution of the bronze, chasing, mounting, gilding and providing an enamel clock face and hands."[2] This clock was obviously a popular model, as there are a number of variants, including one in the Château Versailles.[3] The decorative vocabulary of the clock reflects

the neoclassical taste at the end of the eighteenth century, which developed into the Republican symbols and motifs of the Empire style under Napoleon. **RP**

1. See Catherine Gendre, *Louis-Simon Boizot (1743-1809): Sculpteur du roi et directeur de l'atelier de sculpture à la Manufacture de Sèvres*, exh. cat. (Versailles: Musée Lambinet; Paris: Somogy éditions d'art, 2001). **2.** Ibid., p. 286. **3.** *La Pendule française dans le monde, 2ᵉ partie: Du style Louis XVI à la période Louis XVIII-Charles X*, 5th ed. (Paris: Tardy, 1981), p. 21 (1st ed. published in 1949).

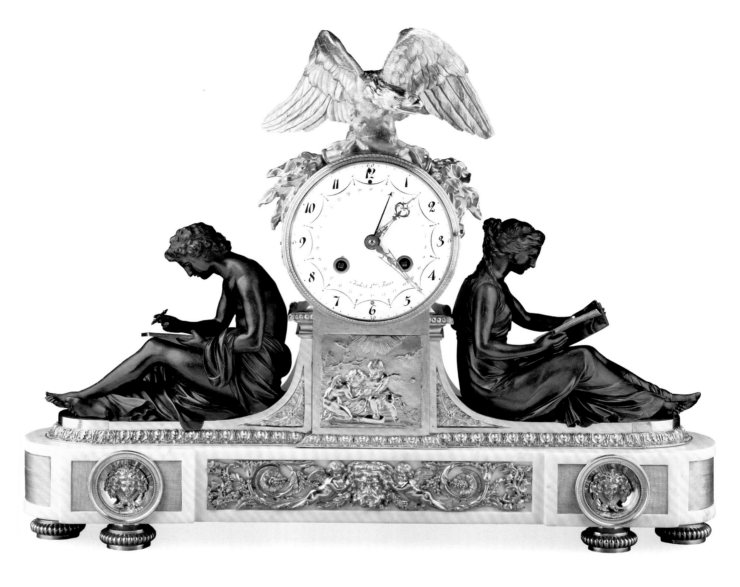

291

291

Louis-Simon Boizot
(sculpture)
Paris 1743 – Paris 1809
François Rémond (design)
Paris 1747 – Paris 1812
Mantel Clock Representing
Philosophy and *Study*
About 1784
Bronze, gilded bronze, marble
Clockmaker: Aubert, Paris
50 x 70 x 18 cm (approx.)

Gift of Francis Gutmann
and family, in honour of the
Montreal Museum of Fine
Arts' 150th anniversary
2009.202
PROVENANCE
Gustav Block-Bauer, Vienna;
descended in the family,
arriving in Canada in 1939;
Francis Gutmann, Montreal;
acquired by the Museum
in 2009.

FRENCH EMPIRE SILVER

— CATHERINE ARMINJON —

Despite the many economic and political problems that had plagued the declining French monarchy, the decade prior to the Revolution (1789) witnessed the extraordinary revival embodied in the neoclassical style—an outcome of the fascination with Antiquity that had begun to develop in the mid-century.

As in the past, most commissions in silver had been for tableware, seen as a symbol of opulence and a reflection of its owner's social and economic status. But during the Revolution, hundreds of kilos of silver and gold objects had been melted down, and many others were stolen, sent abroad for safekeeping or sold.

During the Directory (October 1795–November 1799), French silverware production was disrupted by the abolition of guilds prescribed by the Le Chapelier law of 1791. However, although there was a reduction in commissions, silversmiths who had trained and worked under the Ancien Régime continued to produce despite the industry's deregulation. In the period from 1793 to 1797 (Brumaire, year VI), some silversmiths used the same master's mark they had employed previously, some adapted their mark by removing any references to royalty (such as the fleur-de-lys and the crown, which was sometimes replaced by a Phrygian cap), while others applied their mark two or three times, in a row.

The Brumaire law aimed at regulating the manufacture of objects made of gold and silver and at establishing official trade standards was passed in November 1797, and the new regulations came into force the following year: for both gold and silver, the master's mark was replaced by a maker's mark in a horizontal or vertical lozenge.[1] Silver pieces made under the Directory, the Consulate and the Empire all illustrate the new "Empire" style. In accordance with the changed regulations, moreover, they all bear the new marks, making it possible both to date them and to identify the maker.[2]

The industry would benefit enormously from the training and expertise of such pre-revolutionary master silversmiths as Henry Auguste and Jean-Baptiste Claude Odiot—the two most famous—who carried on working until the end of the First Empire. This ensured a certain continuity, lessening the impact of the rupture caused by the Revolution. Since the work of these already highly renowned silversmiths was in great demand among the new clientele, silverware production did not change appreciably until the advent of the Bourbon Restoration.

Once Napoleon, who became emperor in 1804, set about replacing the silver that had been lost through a number of sumptuous commissions. The other courts of Europe followed suit, placing extravagant orders with the silversmiths of Paris, in order to renew or update their table services. Soon, the rising bourgeoisie, the Empire's nobility and a growing number of nouveaux riches from diverse backgrounds developed a taste for the glitter of silver, adding their influence to a period marked by splendour, lavishness and sometimes ostentation. As the architect Pierre-François-Léonard Fontaine noted in his journal: "The century is nearly over, silver dares to show its face once more and already there are moves toward luxury."

Aside from a few unique, isolated pieces, gold tableware was no longer manufactured; however, vermeil (gilded silver) became hugely popular, its golden colour perfectly in tune with the passion of the period for overt signs of wealth. Napoleon's vast table settings were unfortunately later melted down, but about thirty of the most spectacular pieces from the service known as the *Grand Vermeil* have survived and are currently on view at the Château de Fontainebleau.

The major commissions were shared among three silversmiths—Henry Auguste, Jean-Baptiste Claude Odiot 294 298 299 and newcomer Guillaume Biennais 301 . The latter was a *tabletier*, or maker of fancy goods, who specialized in articles for toilet, travel and writing (for both men and women). These silver items became as popular under the Empire as the huge tea and coffee services commissioned in France (by both court and commoners) as well as by foreign royalty.

The Empire style was inspired principally by a vision of Antiquity defined, published and disseminated by the architects Charles Percier and Fontaine, whose models were based on their studies and their sojourns in Rome. In 1812, they published their famous and enormously successful *Recueil de décorations intérieures*, which included numerous designs for items in silver and gold. In both the form and structure of many of the pieces, the influence of sculpture and architecture is clear. Also striking is the similarity of the ornamental elements to those adorning contemporary furniture and *bronzes d'ameublement* (furnishing bronzes): the decorative motifs stand out in relief against plain, shiny surfaces, often offering contrasts of colour powerfully enhanced by varying degrees of lustre. The embossing and casting techniques used to create these applied ornamental elements allowed for all sorts of variations, for each motif could be reproduced as many times as required—a process that heralded the mass production that would become the keystone of industrialization. Palmettes, lotus leaves, swans, sphinxes, mythological figures, dolphins, draped women and handsome youths began appearing on a wide variety of objects.

The influence of sculpture is equally evident in the skilful rendering of the cupids, satyrs and bacchantes used to support all sorts of recipients—bowls, soup tureens, cruets—or to adorn handles and knobs in a masterful fusion of the functional and the decorative. These relief ornaments were made separately and attached to the surfaces by means of screws inserted from the back or interior of the silver objects. Vessels designed to hold liquids or food were often equipped with a plain liner (sometimes removable), which concealed the attachment fittings.

Sumptuous Empire dining tables were enhanced by candelabra, candlesticks, vases, fruit bowls and centrepieces incorporating large mirrors, as well as the serving dishes and tureens whose functions and names dated back to the time of Louis XIV. Before long, ice buckets and monteiths also became a part of any large table service. Among the first glass objects to appear were carafes, which can be seen (not yet with accompanying glasses) in a painting of the wedding banquet marking Napoleon's marriage to Marie Louise in 1810. Glasses soon followed, invariably in matching sets featuring different sizes appropriate to the various types of wine served. This new practice, which reflected developments in the burgeoning glass and crystal industry and accompanied a number of other modifications to the traditional *service à la française*, wrought radical changes in both the appearance and the protocol of early nineteenth-century dining.

The expansion of the basic place settings and the proliferation of silver objects required for service was another indication of changes in the food eaten and the customs surrounding it: special cutlery for oysters, fish and cake began to make its appearance on the table, along with a wide range of cruets and sauceboats 293 . These latter evidenced the requirements of the new sauce-oriented gastronomy practised by Antonin Carême, the celebrated "chef of kings," and disseminated by him in a number of recipe books. This innovative approach to food, taken up by society at large, would have a direct influence on the silver industry, whose workshops and factories already enjoyed the support of the Emperor and the court.

At the third Exposition des produits de l'industrie, held in 1802 at the instigation of the Emperor, silver items were presented for the first time, bearing witness in spectacular fashion to the renaissance taking place in the field.

Today, very fine examples of silver produced during the Empire can be found in major museums, and the Montreal Museum of Fine Arts has its own remarkable collection of almost seventy silver works in the neoclassical style that marked this period in France. The collection comprises the work of thirty-eight Parisian silversmiths, including renowned masters who created ensembles of secular and ecclesiastical silver, like Biennais Odiot, Jacquart 297 ,Lorillon, Giroux 295 , Courant 293 296 and Cahier 292 who took over Biennais' workshop. It features a great variety of tableware, flatware and ornamental pieces, fruit of a period that so influenced the decorative arts in France.

1. The law also required that each piece be stamped with a standard (or title) mark and a guarantee mark; for silver, there were henceforth two standard marks: a rooster, accompanied by the figures 1 for the first standard and 2 for the second. The guarantee mark, which proved that dues had been paid, consisted of the face of a man in an oval cartouche, accompanied by a department number—for example, 85 for Paris. (Owing to the Napoleonic conquests, there were more departments at this period than there are today.) These early marks, employed between 1798 and 1809, were modified in 1809 and then again in 1819. In 1838, they were finally combined into a single mark—the famous Minerva, which is still used for silver to this day.

2. Catherine Arminjon, James Beaupuis, Michèle Bilimoff, *Dictionnaire des poinçons de fabricants d'ouvrages d'or et d'argent de Paris et de la Seine 1798–1838* (Paris: Imprimerie nationale, 1991).

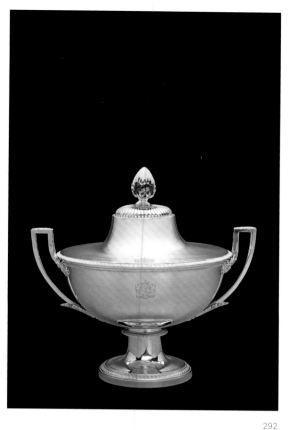

292

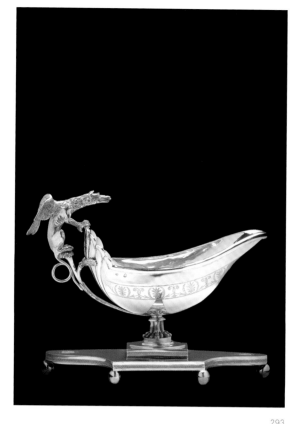

293

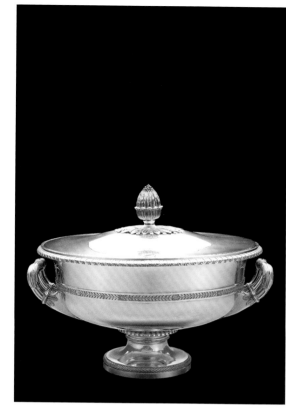

294

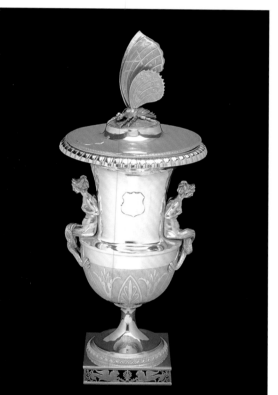

295

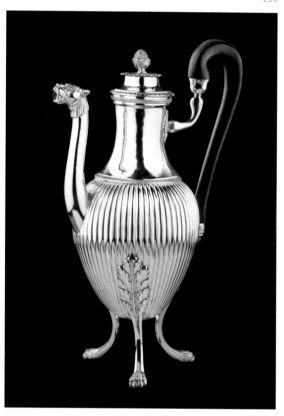

296

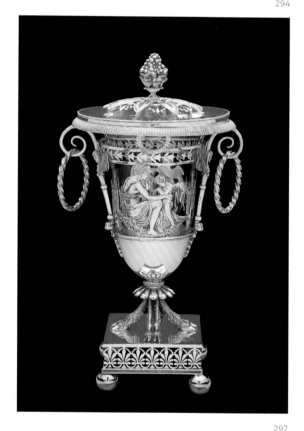

297

292

Jean-Charles Cahier
Soissons, France, 1772 –
Soissons 1849
Soup Tureen
Between 1809 and 1819
Silver
35 x 36 x 27.7 cm
Weight: 2,483.2 g
Maker's mark (5 times):
Jehovah letters / a horizontal
stroke / JC / C, in a lozenge;
standard mark (5 times):
head of a Greek woman and
1, in an oval; standard mark
(twice): a cock, in an octagon;
excise mark: (twice): a head of
Minerva, in a circle; recense?:
a head of a boar with
conforming silhouette; excise
mark: a bundle and an axe

Engraved on both the body
and cover: two different
crowned coats of arms on
each element
Gift of the Honourable Serge
Joyal, P.C., O.C., in honour
of the Montreal Museum of
Fine Arts' 150th anniversary
2010.777.1-2

293

Furcy-Antoine Courant
Active in Paris from 1798
Sauceboat with Stand
Between 1798 and 1809
Silver
28.8 x 30 x 11.2 cm
Weight: 1,321.2 g
Maker's mark (5 times):
a pellet / F [a column] A / C,
in a lozenge; excise mark
(4 times): a head of an old man
facing front and 8 and 5, in an
oval; standard mark
(4 times): a cock crowned
and 1, in an octagon
Gift of the Honourable Serge
Joyal, P.C., O.C., in honour
of the Montreal Museum of
Fine Arts' 150th anniversary
2010.828.1-2

294

Jean-Baptiste Claude Odiot
Paris 1763 – Paris 1850
Soup Tureen
Between 1798 and 1809
Silver
26.2 x 33.5 x 30.4 cm
Weight: 4,283.3 g
Maker's mark (4 times): B / J
[a bellows] C / O, in a lozenge;
standard mark
(3 times): a cock crowned
and 1, in an octagon; excise
mark (3 times): a head of an
old man facing front with
8 and 5, in an oval; recense?
(4 times): a head of a boar with
conforming silhouette; excise
mark: a bundle and an axe
Gift of the Honourable Serge
Joyal, P.C., O.C., in honour
of the Montreal Museum of
Fine Arts' 150th anniversary
2010.765.1-3

295

Abel-Étienne Giroux
Active in Paris from 1798
Covered Vase
Between 1798 and 1809
Silver
H. 38.5 cm; Diam. 16.4 cm
Weight: 1,416.2 g
Maker's mark (3 times):
a plume / AEG, in a lozenge;
standard mark (3 times):
head of a Greek woman and
1, in an oval; standard mark:
a cock crowned and 1, in an
octagon; excise mark:
a head of an old man facing
front and 8 and 5, in an oval;
recense?: a head of a boar
with conforming silhouette;
excise mark:
a bundle and an axe
Gift of the Honourable Serge
Joyal, P.C., O.C., in honour
of the Montreal Museum of
Fine Arts' 150th anniversary
2010.829.1-2

296

Furcy-Antoine Courant
Active in Paris after 1798
Coffee Pot
Between 1798 and 1809
Silver, ebony
30.5 x 18.5 x 11.2 cm
Weight: 964.3 g
Maker's mark (6 times):
F, a column, A / C, in a lozenge;
standard mark (6 times):
head of a Greek woman and
1, in an oval; standard mark
(twice): a cock and 1; excise
mark (twice): a head of an old
man facing front with 8 and 5
Gift of the Honourable Serge
Joyal, P.C., O.C., in honour
of the Montreal Museum of
Fine Arts' 150th anniversary
2010.785

JEAN-BAPTISTE CLAUDE ODIOT

Jean-Baptiste Claude Odiot was born into a family of silversmiths.[1] After qualifying as a master in 1785, he took over his father's workshop and soon became one of the most famous silversmiths of his day, noted for the fine workmanship and originality of his creations. Early in his career, he received major commissions from Napoleon (before he was emperor) and also did work for Czar Alexander I and Maximilian I of Bavaria. After the Restoration, he became silversmith to Louis XVIII and his successors before handing the business on to his son Charles. Among Odiot's illustrious clients was one of Napoleon's equerries, Count Villoutreys, who purchased the lovely silver-gilt mustard pot now in the Museum's collection 299 and had it engraved with his coat of arms (which appears on the body, the lid and the lining). By making the Villoutreys arms the principal ornamental feature of the piece, whose form echoes that of the Medici vase, Odiot gave full prominence to the splendour of the metal.

Another piece by Odiot in the Museum's collection, a remarkably simple candle holder 298, bears standard and guarantee marks from 1798, the year in which the French state introduced new marks to replace those employed before the Revolution of 1789. These already rare marks are especially so on the candle holder because the number in the Paris customs house hallmark appears backwards: evidently, the number was the right way round on the punch used to apply it, whereas it should have been backwards in order to appear correctly on the piece. Very few of these reversed numbers have been observed, as the mistake was quickly rectified. JC

1. For more on Odiot, see Jean-Marie Pinçon, *Odiot l'orfèvre* (Paris: Sous le vent, 1990).

MARTIN-GUILLAUME BIENNAIS

Martin-Guillaume Biennais attained unmatched renown in French silverware with the proclamation of the Empire in 1804. He received the commission for the imperial insignias of Napoleon I's coronation: the gold crown of laurel leaves, immortalized in the painting by Jacques-Louis David, and the great gold necklace of the Order of the Legion of Honour. He would serve as the Emperor's personal silversmith between 1810 and 1814. Recognized as the Empire's most accomplished silversmith, his reputation spread beyond France's borders, and it was his tableware that served the main courts of Europe.

Biennais had a reputation for what was commonly referred to as the "nécessaire," a travelling

case made of rare woods that could contain a profusion of items in a compact space. The story goes that in 1798, the silversmith sold a *nécessaire* on credit to the man who was then but General Bonaparte. The silver gilt milk jug 301 from the Weider collection probably comes from a travelling set that was broken up.[1] During his exile on Saint Helena, due to the "insufficient pension allotted him by the English government, Napoleon had to part with pieces in the set and sell some of his silver; some pieces, however, were kept: beakers, flatware and knives all bearing coat of arms, made by Biennais, Lorillon and Grangeret . . . coffee pot, sugar bowl and milk jugs."[2]

The shoulder of this vase-shaped piece is decorated with a frieze of winged sea horses flanked by gorgon-headed medallions alternating with acanthus and piastre motifs. On the front of the body are engraved the coat of arms of the Emperor Napoleon and the Empress Marie Louise surmounted by the imperial crown. FT

1. Bernard Chevallier, ed., *Napoleon* (Montreal: David M. Stewart Museum, 1999), p. 147, no. 171. 2. Gérard and Nicole Hubert, *Musée national des châteaux de Malmaison et de Bois Préau : guide* (Paris: Réunion des musées nationaux, 1986), pp. 154–155.

MARC-AUGUSTIN LEBRUN

The decorative arts flourished under Napoleon's reign, stimulated by the taste of the new ruling classes for luxury and pomp. The simple, architectural forms of the silver objects created during this period focus attention on the iconography then in vogue—the plant motifs, fantastic animals and mythological characters that adorn even the most trifling piece in the so-called Empire style.

The ewer and basin by Marc-Augustin Lebrun 302 combine restraint and elegance in a way that highlights both the quality of the metal and the ornamentation of mythological figures and fantastic creatures. The raised rim of the basin and the body of the ovoid ewer are decorated with sea horses alternating with medallions showing the sea god Neptune astride a whale and Amphitrite, his wife, being drawn by two more sea horses. The ewer's decorative program is completed by a gorgon's head. Lebrun chose to make the handle in the form of a figure of Psyche, the mortal wife of Cupid, god of love and son of Venus. Their story was a fashionable subject of the Empire period, which sought to celebrate the beauty, youth and lightheartedness symbolized by Psyche. JC

298

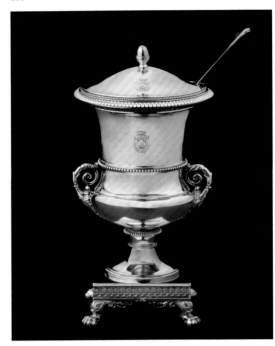

299

300

297	**298**	**299**	**300**
Marc Jacquart	Jean-Baptiste Claude Odiot	Jean-Baptiste Claude Odiot	Thomas-Michel Bary
Active in Paris after 1798	Paris 1763 – Paris 1850	Paris 1763 – Paris 1850	Active in Paris between
Sugar Bowl	**Candle Holder**	**Mustard Pot with**	1798 and 1813
Between 1798 and 1809	**1798**	**the Arms of Count**	**Pair of Candlesticks**
Silver, crystal	Silver	**Villoutreys, and Spoon**	**Between 1798 and 1809**
29.4 x 16 x 14.3 cm	4.3 x 19.2 x 16.5 cm	**1809–19**	Silver, silver gilt
Weight: 883.5 g	Weight: 209.4 g	Silver gilt	H. 28 cm; Diam 14.2 cm
Maker's mark (4 times):	On the shaft: maker's mark:	Mustard pot: H. 17.6 cm;	H. 27.8 cm; Diam. 14.4 cm
a pellet / M, a thyrse, J,	B / J [a bellows] C / O;	Diam. 8.8 cm	Weight: approx. 600 g (each)
in a lozenge; standard mark	standard mark: a cock	Spoon: 12.8 x 3 x 2.1 cm	Maker's mark (3 times):
(4 times): head of a Greek	flanked by A and 1; excise	Weight: 534.8 g	a millrind / T M B, in a lozenge;
woman and 1, in an oval;	mark: a head of an old man,	(mustard pot and spoon)	standard mark (3 times):
standard mark (twice): a cock	flanked by 8 and 5	Maker's mark (3 times):	head of a Greek woman and
crowned and 1, in an octagon;	[reversed and inverted]	B / J [a bellows] C / O;	1, in an oval; standard mark
excise mark (3 times):	Gift of the Honourable Serge	standard mark (4 times):	(twice): a cock crowned and
a head of an old man facing	Joyal, P.C., O.C., in honour	a cock and 1; excise mark	1, in an octagon; excise mark
front with 8 and 5, in an oval;	of the Montreal Museum of	(4 times): a head of Minerva	(twice): head of a forward-
engraved on the base:	Fine Arts' 150th anniversary	On the side, centre:	facing old man with 8 and 5,
crowned coat of arms	2010.798	crowned coat of arms	in an oval; recense?:
Gift of the Honourable Serge		Gift of the Honourable Serge	a head of a boar with
Joyal, P.C., O.C., in honour		Joyal, P.C., O.C., in honour	conforming silhouette
of the Montreal Museum of		of the Montreal Museum of	
Fine Arts' 150th anniversary		Fine Arts' 150th anniversary	
2010.775.1-3		2010.767.1-3	

Gift of the Honourable Serge Joyal, P.C., O.C., in honour of the Montreal Museum of Fine Arts' 150th anniversary 2010.786.1-2

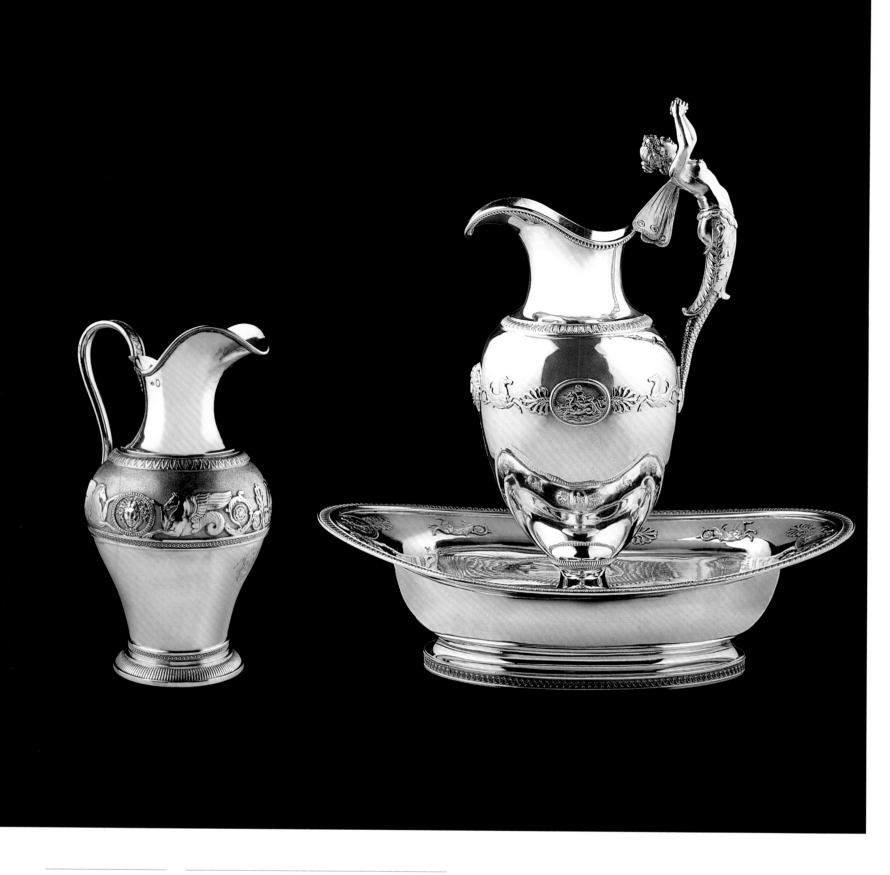

301

Martin-Guillaume Biennais
La Cochère, France, 1764 –
Paris 1843
**Milk Jug with the Arms of
Napoleon I and Marie-Louise
About 1810–14**
Silver gilt
18 x 10.4 x 9.5 cm
Maker's mark: a monkey /
two pellets / *B*, in a lozenge;
excise mark: a head of Ceres,
in a circle; standard mark:
head of a Greek woman,
in an oval; standard mark:
a cock and *1*
Engraved on the body: the
Arms of Emperor Napoleon
and Empress Marie-Louise.
Ben Weider Collection
2008.405

302

Marc-Augustin Lebrun
Active in Paris after 1808
**Ewer and Basin
1821–38**
Silver
Ewer: 37.2 x 18 x 13.9 cm
Basin: 10.9 x 36.7 x 24 cm
Weight: 1,080.7 g (ewer),
1,095.4 g (basin)
Ewer: Maker's mark:
a weather vane / *ML* / an eagle
[in lozenge]; excise mark:
a head of Ceres, in a circle;
standard mark:
a head of Michelangelo,
in an octagon; countermark:
an insect
Basin: Maker's mark: a
weather vane / *ML* / an eagle,
in a lozenge; standard mark:
a head of Michelangelo,
in an octagon; excise mark:
a head of Ceres, in a circle;
countermark: a fly

Promised gift of the
Honourable Serge Joyal, P.C.,
O.C., in honour of Nathalie
Bondil's being named
Chevalier of the Ordre
des Arts et des Lettres
de la République française
1122.2008.1-2

SILVER
IN ENGLISH
SOCIETY

— PHILIPPA GLANVILLE —

The monetary and symbolic value of silver have traditionally been determining factors in people's appreciation of the medium. In 1664, the young Samuel Pepys was sent two richly chased silver-gilt flagons as a bribe by a contractor. He had the flagons appraised only to be disappointed that the worth of their design outweighed that of their silver content. "Weighed my Two Silver Flagons at Stevens'; they weigh 212 oz. 27 dwt—which is about £50 at 5s per oz.; and then they judge the fashion to be worth above 5s more. Nay some say 10s an ounce the fashion—but I do not believe; but yet am sorry to see that the fashion is worth so much and the silver is come to no more."[1]

For all owners of silver, both the quality and condition of their plate mattered, although attitudes to decorative treatments varied. William Fitzhugh of Virginia, ordering silver from his London agent in 1688, stipulated that it "be strong and plain, as being less subject to bruise, more serviceable, and less out for the fashion." He excused his extravagance in commissioning silver by arguing that to collect it was both "reputable" and "politic."[2] In hard times, even his plates, forks and tankards could be melted into hard cash.

As the raw material for coinage, silver was a vital national resource. Old plate could be turned in to pay taxes, because its weight had a quantifiable value. Most famously, Louis XIV in 1689 and in 1708, and Louis XV in 1759, were both driven to melt their personal plate, as well as call on the aristocracy to sacrifice theirs, to fund French military campaigns against the Dutch, English and Germans.

When Charles I had no access to the official Mint in 1643/4, his officials were reduced to cutting up serving dishes and plates into crude silver coins to pay his soldiers. Infinitely recyclable, private and institutional plate was a reserve to be called on by the Crown. During the English Civil Wars and again in the 1690s, the Mint offered a premium for old plate, which explains why English domestic silver made before the late seventeenth century is very rare **304**. In the county of Norfolk, for example, there were many silversmiths but a mere handful of Norwich-marked domestic objects survive, although the county's Anglican churches retain five times as much.[3]

From the Restoration of Charles II, decorative floral chasing, as represented by the brandy bowl in the Museum **305**, became fashionable. These types of objects were each a hand-raised and chased "one-off," a unique piece, and the chaser was the highest paid workman. However, by the late 1690s, heavy cast and applied work was admired, drawing on silver designs from Paris and exploiting the superior technical skills of French-trained artisans, who arrived as economic and religious migrants. Once the initial casting patterns had been carved, copies were easily produced and were more economical for the manufacturer to make. Examples of these new techniques are seen in the cut-card work on the chocolate pot **309** or the gadrooned stems of the set of four table candlesticks **308**. In the evenings, candle reflections falling on the silver's ornamentation and the elaborate cast motifs of pieces, such as the rococo cake basket **312**, brought twinkling light to the social table.

Labour costs were much lower than the price of the raw material, and old silver could also be turned in to pay the bills. In the 1760s, four-fifths of the account holders with a leading London retailer, Parker and Wakelin

of Panton Street, off Haymarket, paid their bills partly with old plate. It was always possible to buy from stock at London's many retailing silversmiths, or to buy second-hand. Advertisements by Stafford Briscoe in the 1760s show how this market too was dominated by drinking vessels, tea ware and tableware, sold by the ounce.[4]

A cheaper alternative was to buy silver-plated wares or, as man of letters Horace Walpole termed it, "doubled plate," from Birmingham or Sheffield, that is silver rolled onto copper, "equal in everything except durability and intrinsic value to silver."[5] For household plate that was to be handled only by servants, such as dish covers, stands for dishes, large candlesticks and the like, plated ware looked like the precious metal and was as sturdy but less costly. Mixing silver tableware with plated goods from Sheffield or Birmingham was quite acceptable.

Drinking vessels and tableware predominate in all collections of historic silver, and such items were the core business of the silversmith. From the mid-seventeenth century, the English were conscious of the contrast between French and English table culture, and at their most elite social levels, French chefs were called upon. French innovations in tableware, including sauceboats, tureens and *surtouts-de-table*, had a lasting impact on English silver, although designs might be simplified for a wide market. The art of food was as much a display of connoisseurship as a prince's horsemanship or a nobleman's ability to design a garden pavilion. Although the Duke of Richmond's maître d'hotel might devise the table settings and the forty or sixty dishes making up a formal dinner menu, it was ultimately the host's taste that would be judged.[6]

Diplomats attending state occasions discussed and compared the quality and quantity of plate set out on buffets or laid on the top table. In a combination of English pride and self-promotion, showy, spectacular silver, such as the massive wine cistern ordered from London silversmith Paul Crespin by King João V of Portugal, in 1724, or the English services ordered by successive Russian tsarinas, was shown to the public in a West London pleasure garden, Spring Garden. In 1731/2 James, 1st Earl Waldegrave, the English ambassador to Paris, needed to impress the French. He wrote to Thomas Pelham Holles, Duke of Newcastle, Secretary of State, pleading for a new dinner service and asking for a Privy Seal to discharge the King's plate so he could order a new service. His official issue as ambassador, made up largely of many scalloped dishes, basins, plates and salvers for serving chocolate, was worn out: "It has been almost 5 years in use and a good deal of it must be so battered and worn out by frequent journeys that it is only fit to be melted down." The silver's design was also unfashionable, because the French court was rapidly adopting curvilinear rococo forms, and so the service reflected badly both on him and his monarch, George II.[7]

In their accounts of major dinners, the London newspapers often noted the plate, as in the report of the patriotic ball to encourage British support for the campaign against Napoleon, organized by George III at Windsor Castle in February 1805. On this occasion, the King's exceptional silver furniture and tableware from Hanover, on show for the first time, attracted warm praise. The general public also enjoyed going to see its statesmen's plate. After coronation dinners at Westminster Hall, the plate was exhibited to the public for three days. The Duke of Wellington's

304

305

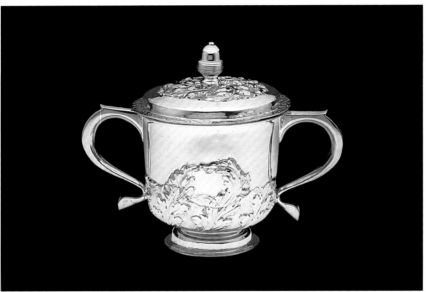

306

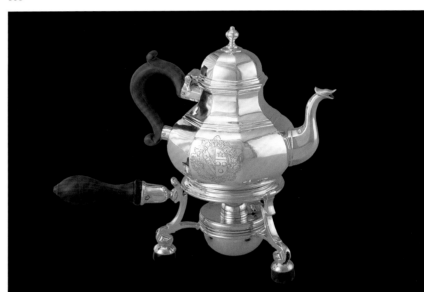

307

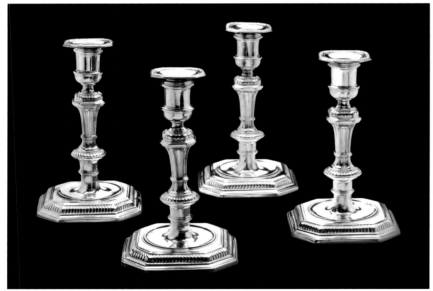

308

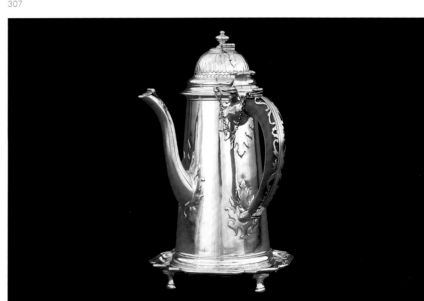

309

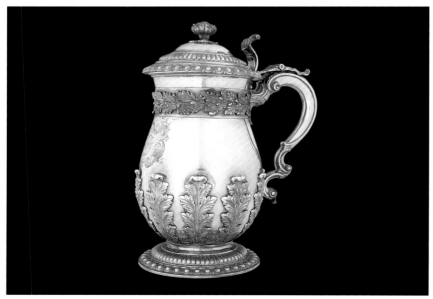

310

311

Portuguese Service, a gift from the Portuguese Crown following the Napoleonic Wars, was displayed for three days at Garrards, the London luxury jewellery and silver company. Queen Charlotte even had a private evening viewing of Wellington's prestigious gift consisting of over one thousand pieces. The service has been on show ever since at Apsley House, with the Duke's other presentation services of porcelain and silver.[8]

SILVER FOR DRINKING VESSELS

Wine was a dessert or occasional drink, whereas beer was a daily staple for all classes, because it was nourishing, full of vitamins and calories, and made with boiled water, hence a safe drink. Drinking vessels were often large, for passing around, because conviviality was a social duty, drinking challenges were popular, and solitary drinking was considered suspicious and even dangerous. Comparing behaviour in France and England, a 1678 guide to etiquette commented, "If we be many in a company, we make no scruple to drink all out of a Glass or Tankard, which they are not used to do. If a servant would offer to give them a glass before it was washed, they would be angry at it."[9] Showy large tankards and flagons, and impressive jugs for the sideboard, were part of every occasion, whether in the home or at gatherings of trade guilds, city and college councils, and clubs.[10]

A quart of beer was the normal serving size for a man, with a pint-sized vessel for women and children. Children took small, silver tankards to boarding school, and gentle-born boys entering colleges at Oxford or Cambridge in their early teens were sent with distinctive silver drinking vessels for beer, graded by size according to their rank, and set out in Hall each day, available to wash down the beef and bread at dinner.

Although posset and caudle are no longer regularly consumed, there was once a time when showy silver vessels with two handles were called for to serve these nourishing mixtures of ale or sack, sugar, milk, eggs and nutmeg 306 . Posset, a hearty hot drink, was a treat for a winter supper party, and a celebration at the bedside of a new mother. In 1763, morning visitors to Queen Charlotte at her lying-in enjoyed cake and caudle (warm wine or ale mixed with bread or gruel, eggs, sugar and spices), even though this traditional delicacy was challenged from the mid-seventeenth century by new hot drinks: Tea, coffee, chocolate (all non-alcoholic) and punch (a mixed drink based on rum, brandy or arak) arrived in Northern Europe. New vessels—pots with heaters, jugs, bowls, spoons, canisters—were invented for preparing and serving these stimulants. Gilded teaspoons, milk jugs and sugar bowls made popular small gifts, available from London toy-sellers such as John Deards.[11] Tea drinking evolved into a social occasion dominated by women, whereas men engaged in drinking punch, which required a large bowl, a strainer for fruit juice, a ladle, and smaller bowls and goblets for individual parties. Practical, easily cleaned and prestigious, silver was the best material for the items associated with new social activities.

A RICH TRAIL OF EVIDENCE

A special characteristic of silver is its inherent worth: it was not only controlled through "assay and touch," or by sampling for the standard of the alloy and hallmarked, but also carefully recorded by weight. Inventories, bills, assay office records and private papers create a rich paper trail for the social historian, giving plate a unique status in the decorative arts. We can track the context of particular objects, reconstruct patterns of taste and fashion and establish the sociology of silver. For example, from the archives of the ancient London craft guild, the Goldsmiths' Company archives and local records, it is clear that three hundred years ago, almost every market town had silversmiths supplying modest drinking vessels, salts and spoons.

Thanks to the practice of hallmarking by guilds or assay offices to attest to the quality of the metal, the place and date of making is literally struck into the object. For the past 160 years, this convenient system has driven silver studies in England. Many directories of silversmiths have been published, notably Arthur Grimwade's classic *London Goldsmiths 1697–1837: Their Marks and Lives*, as well as guides to silver marked in Chester, Exeter, York, Norwich and elsewhere. However, the long-standing focus on the "maker's mark" and the individual workshop, a convenient system for collectors, curators and dealers, is now recognized as overly simplistic.

In London from at least the sixteenth century, the silver craft was complex and multi-layered, involving many subcontractors, so that the mark may identify a goldsmith-retailer, an agent or a wholesaler selling wares to regional silversmiths. For example, a London retailer in the 1690s, Thomas Jenkins, supplied plate to a wide range of customers. The happy survival of a pair of jugs, one with the mark of a Huguenot silversmith, the other overstruck by Jenkins, demonstrated this reality.[12] Striking wares with the retailer's mark was standard practice by the late eighteenth century. In Birmingham, the enterprising silver manufacturer Matthew Boulton supplied to Edinburgh retailers, such as Patrick Robertson, wares that had already been struck with the retailer's mark. In the nineteenth century, the large manufacturers, notably Edward Barnard's, held punches for retailers as far afield as India and Montreal. Since 1975, the term "sponsor's mark" has been adopted at Goldsmiths' Hall, in recognition of the complexity of the industry.[13]

Plate is without rival as a material memory, because it reflects the owner's status and often contains dedicatory references, such as coats of arms or inscriptions, as on the Museum's eighteenth-century teapot and stand 307 . Objects have escaped the melting pot because they were decorative or because of their links to donors, particularly in long-lived associations such as regiments, colleges, livery companies and city councils.

303

Samuel Hood
Active in London,
after 1693–1727
Communion-wine Flagon
1695–96
Silver
37.4 x 27.8 x 20.7 cm
Weight: 2,142.8 g
Maker's mark (3 times):
SH (in monogram) / a pellet;
date letter *S*; a lion passant;
a leopard's head crowned;
on underside: a lion passant
Unidentified coat of arms
on side with inscription:
*CHRISTO & ECCLESIA
WIGGENHALL STi GERMANI
CONSECRAUIT*; below the coat
of arms: *THO: FENN: GEN*
Purchase, gift of
F. Cleveland Morgan
1962.Ds.2

304

Master "R.B."
Active in London,
about 1610–1640
**Tankard with Arms of
the Beresford Family**
About 1620–40
Silver
21.3 x 19.2 x 14 cm
Weight: 1,069.8 g
Maker's mark (unidentified),
partially effaced on
underside: *RB* / a star (?)
Gift of Miss Barbara B.
Buchanan
1996.Ds.88

305

Master "A.H."
Active in London
Bowl
1675–76
Silver
14 x 36.7 x 28.5 cm
Weight: 1,272.2 g
Maker's mark (unidentified)
on side of bowl near handle
and below rim: [a mullet]
A / H [a mullet] in a quatrefoil
cartouche; date letter *S*;
a lion passant gardant;
a leopard's head crowned
Gift of Mr. and
Mrs. Neil B. Ivory
1982.Ds.1

306

Attributed to
Samuel Dell
Active in London
after 1679
Posset Cup
1691–92
Silver
19.3 x 24.2 x 14.6 cm
Weight: 775.3 g
Marker's mark, on side,
below rim: *S* [a pellet] *D*;
a lion passant; a leopard's
head crowned; date letter *O*.
Gift of Mrs. Duncan
M. Hodgson
1961.Ds.9a-b

307

William Spackman
Active in London after 1714
Teapot and Stand
1716–17
Silver, wood
22.7 x 26.1 x 13.6 cm
Weight: 9,800 g (set),
484.2 g (teapot)
Maker's mark on underside
of teapot: two pellets /
S [a pellet] *P*; date letter *A*;
a lion's head erased; Britannia
On underside of stand:
a lion's head erased
(3 times); Britannia (twice);
date letter *A* (twice)
Armorial device engraved
on side of body of teapot
Gift of Mr. and
Mrs. Neil B. Ivory
1983.Ds.1a-d

308

Paul de Lamerie
Bois-le-Duc (now
's-Hertogenbosch,
Netherlands), 1688 –
London 1751
Active in London after 1713
**Set of Four Table
Candlesticks with
the Arms of the Robert
Knight Family**
1727
Silver
H. 19.7 cm; Diam. 11.9 cm
Weight: 628.6 g
Maker's mark, on underside
of each piece: crowned star /
LA / a fleur-de-lys;
date letter *M*; Britannia;
a lion's head erased
Gift in memory of Neil B. Ivory,
presented by his family
1995.Ds.13-16a-b

Anglican churches preserve the largest body of old plate, from steeple cups donated to the church to celebrate Communion, to rosewater basins given as alms dishes. These items, carrying the memory of the donor, have been treasured and prominently displayed in churches, the oldest buildings of the community. Many large flagons for Communion wine, such as the one from Wiggenhall Saint Germans, Norfolk, with Thomas Fenn's arms **303**, survive. Until liturgical reforms of the 1830s and even later, Communion was celebrated infrequently—four times a year or possibly once a month, and up to a gallon of wine might be consecrated in a large country parish. The market demand for antique plate has grown, hence infrequently used church plate has been sold and its liturgical purpose forgotten. Thomas Fenn's Communion wine flagon probably left church ownership in the 1870s, when an antiquarian rector sold medieval plate to the British Museum, replacing it with Victorian "Gothic" substitutes.[14]

NINETEENTH-CENTURY INNOVATIONS

Table culture in the Regency period (about 1811–20) is associated with conspicuous consumption. Glittering *plateaux* of glass mirroring candelabra incorporating flower baskets, compotes for fruit and elaborate *pièces montées*, present a paradox in that they are in the French style. Although Britain was at war with France in the 1790s, and again until 1815, and the economy struggled for more than a decade, fashionable English dining remained acutely responsive to French fashions. The desire to be in the latest fashion increasingly led to lifting designs from earlier periods. For example, the 12th Duke of Norfolk, in 1815, had a new Rococo-revival dining room built at Norfolk House, and ordered two heavy dinner services from the leading London retailer, Rundell's of the Golden Salmon, Ludgate Hill. One of these services was modelled after the rococo style of a service created seventy years earlier by Charles Frederick Kandler, a German-born English silversmith. This service, two serving dishes of which are housed in the Museum **311**, cost the Duke £10,000, with one centrepiece alone priced at a substantial £1,500. The Duke's account of £12,000 was still outstanding in 1820, including accrued interest.[15]

The Napoleonic Wars transformed the English table. From Vienna to Saint Petersburg, the top echelons of society at diplomatic dinners commented on new recipes, poached top chefs and shared novel ideas in meal presentation. The Paris *pâtissier* Marie-Antoine Carême found a keen audience for his inventions of vol-au-vent, large meringues and fish cooked in champagne. A fourfold increase in the price of flour stimulated the adoption of substitutes and cooking alternatives, such as potato toppings and ceramic pie dishes. Silver bread baskets vanished and bread never regained its place in the British diet.

International hostilities dictated changes in drinking habits too. Napoleon's blockade of the West Indies cut the supply of rum for after-dinner punch. Brandy, champagne and French wines, already highly taxed, became hard to come by, and even the English staples, port and Madeira, were unobtainable. Strong old English ales drunk from goblets and canns of silver appeared on smart London tables as a gesture of national pride.

Many variants of simple drinking vessels, such as the tankard marked by Emes and Barnard **310**, are depicted in a drawing book started in 1808 by this manufacturer.[16]

From the first decades of the nineteenth century, the London manufacturing firm run by Rebecca Emes and Edward Barnard became the largest producer of silver in the world, exporting to South Africa, India, Canada and the United States. As early as 1820, Rundell's was exploiting electrotyping—the electrical deposition of metal in a mould—as a way to reproduce medals, although the large silverware manufacturers did not take up the technique for large-scale production until the 1840s. Alongside the taste for old buffet plate was a growing aesthetic disdain for commercial tableware in versions of French baroque or rococo designs— "*tous les Louis.*"

1. Robert Latham and William Matthews, eds., *The Diary of Samuel Pepys* (London: Bell, 1971), vol. 5, p. 301.
2. Richard Beale Davis, ed., *William Fitzhugh and His Chesapeake World* (Chapel Hill: University of North Carolina Press; Virginia Historical Society, 1963), pp. 170–173, 245–246.
3. Christopher Hartop, ed., *East Anglican Silver: 1550–1750* (Cambridge, England: John Adamson, 2004), p. 11. John S. Forbes, *Hallmark: A History of the London Assay Office* (London: Goldsmiths' Company and Unicorn Press, 1999).
4. Helen Clifford, *Silver in London: The Parker and Wakelin Partnership, 1760–1776* (New Haven: Yale University Press, 2004), p. 205.
5. Robert Hirst, MSS, about 1829, "Account of the Sheffield Trade," and Philippa Glanville, *Silver in England* (London: Unwin Hyman, 1987), p. 110.
6. James Lomax and James Rothwell, *Country House Silver from Dunham Massey* (London: National Trust Books, 2006), and Tessa Murdoch, ed., *Noble Households: Eighteenth-century Inventories of Great English Houses* (Cambridge, England: John Adamson, 2006).
7. The National Archives, London, State Papers (France), vol. 186, folio 169.
8. Angela Delaforce and James Yorke, *Portugal's Silver Service: A Victory Gift to the Duke of Wellington* (London: Victoria and Albert Museum, 1988).
9. Jean Gailhard, *The Compleat Gentleman: or Directions for the Education of Youth as to Their Breeding at Home and Travelling Abroad*, 2 vols. (London: printed by Thomas Newcomb for John Starkey, 1678).
10. Philippa Glanville and Sophie Lee, eds., *The Art of Drinking* (London: Victoria and Albert Museum, 2007).
11. Moira Buxton, "Hypocras, Caudels, Possets and Other Comforting Drinks," in *Liquid Nourishment: Potable Foods and Stimulating Drinks*, ed. Anne C. Wilson (Edinburgh: Edinburgh University Press, 1993).
12. Our better understanding draws on research by many enthusiasts, including Tim Kent on Tudor and Stuart spoon-makers, Elaine Barr and Helen Clifford's analysis of the eighteenth-century London retailer George Wickes and his successors Parker and Wakelin, as well as David Mitchell, with his forthcoming work on the minute books of the Goldsmiths' Company, as yet unpublished.
13. See *Silver Studies: The Journal of the Silver Society* (London), and Kenneth Quickenden, "Matthew Boulton's Silver and Sheffield Plate," in *Matthew Boulton: Selling What All the World Desires*, ed. Shena Mason (Birmingham, England: Birmingham City Council; New Haven, Connecticut; London: Yale University Press, 2009).
14. Timothy Schroder, ed., *Treasures of the English Church* (London: Goldsmiths' Company and Paul Holberton, 2008).
15. Timothy Schroder, *The Gilbert Collection of Gold and Silver* (Los Angeles: Los Angeles County Museum of Art; New York: Thames and Hudson, 1988), p. 425, and Christopher Hartop, ed., *Royal Goldsmiths: The Art of Rundell and Bridge, 1797–1843* (Cambridge, England: John Adamson, 2005).
16. Drawing Book, Archives of Art and Design, Victoria and Albert Museum. John Fallon, "The House of Barnard," *Silver Studies: The Journal of the Silver Society* (London), vol. 25, 2009, pp. 42–62.

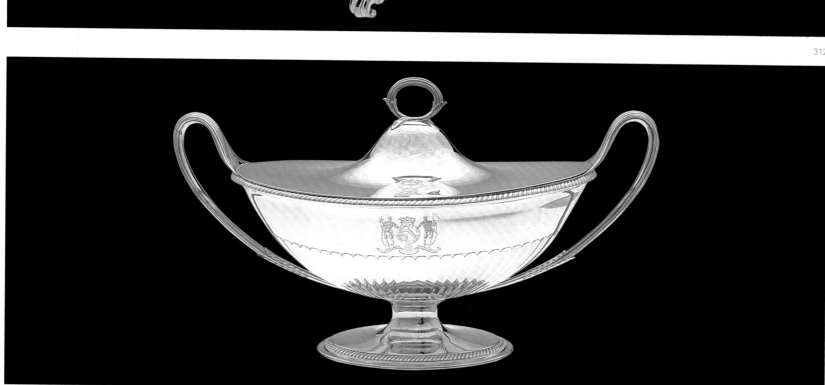

309

Robert Cooper
Active in London after 1675
Chocolate Pot
1705–6
Silver, wood
24.1 x 16.8 x 14.2 cm
Weight: 732.7 g
Maker's mark, near base:
CO. / two pellets / a star of
David / a mullet / a star;
date letter *I*; Britannia;
a lion's head erased
Gift of Miss Mabel Molson
1950.51.Ds.16a-b

310

Rebecca Emes
Active in London after 1808
Edward Barnard
Active in London after 1789
Tankard
1818–19
Silver
26.4 x 20.8 x 13.3 cm
Weight: 1,722 g
Maker's mark on body and
under cover (twice): *RE / EB*,
in a quatrefoil cartouche;
a lion passant (twice);
a leopard's head crowned;
date letter *C* (twice);
king's head
Monogram engraved on
upper body: *LTD*; inscription
engraved on underside:
The Gift of John Carter
of Chelmsford
Gift of Mrs. J. B. D'Aeth
1952.Ds.18

311

Philip Rundell
Bath 1743 – London 1827
Active in London after 1819
Pair of Covered
Serving Dishes
1820–21
Silver
H. 15.9 cm; Diam. 26 cm (each)
Weight: 865.8 g (dish),
1,021.2 g (cover)
Maker's mark, under covers:
PR, in rectangle cartouche;
a lion passant; date letter *e*;
sovereign's head in profile
Gift of Mrs. W. C. Cottingham
1972.Ds.1a-b, .2a-b
PROVENANCE
12th Duke of Norfolk; Holmes
Antique Dealer, London;
Mrs. W. C. Cottingham,
Montreal; acquired by
the Museum in 1972.

312

Peter Archambo II
Peter Meure
Active in London after 1749
Cake Basket with
the Arms of the Lowndes
Family, Cheshire
1749–50
Silver
31.5 x 40 x 35.9 cm
Weight: 2,651.6 g
Maker's mark, on underside:
P / P [a star] *A / M*, in a
quatrefoil cartouche;
date letter *O*; a lion passant;
a leopard's head crowned
Purchase, gift of
David Y. Hodgson
1961.Ds.4

313

Robert Makepeace II
Active in London after 1776,
died in 1827
Thomas Makepeace II
Active in London 1778 – 1794
Tureen with the Arms of Lord
Jeffery Amherst (1717–1797)
1794–95
Silver
25.8 x 49 x 23 cm
Weight: 3,689 g
Maker's mark, on tureen's
foot rim and under cover:
RM / TM; date letter *t*;
a lion passant; a leopard's
head crowned; sovereign's
head in profile
Gift of the Honourable
Serge Joyal, P.C., O.C.
2011.277.1-2

19TH-CENTURY INNOVATIONS

— ELLENOR M. ALCORN, ROSS FOX, ROSALIND PEPALL —

ELKINGTON, MASON & CO.

Elkington, Mason & Co. first produced the moulds to make this electroformed ewer and basin `314` in the late 1840s. They were working from a pewter original in the Louvre made by the Nuremberg pewterer Caspar Enderlein (1560–1633), who in turn was closely borrowing from another master, the French metalworker François Briot (about 1550–1612). Briot's dense compositions, with classicizing figures enclosed in cartouches and separated by panels of arabesques and masks, exemplify the Mannerist style of the Fontainebleau school.[1] At the centre of the basin is the seated figure of Temperantia (Temperance), who holds a wine cup and a ewer (containing water to dilute the wine). Surrounding her are figures representing the four elements: Earth, Air, Fire and Water. The rim of the basin is filled by figures symbolizing the Liberal Arts. The ornamental panels of the ewer are similarly treated, with panels representing the Continents and the Seasons.

At the time this piece was produced, the Birmingham-based firm of Elkington, Mason & Co. was reaping the benefits of its patents on the technologies of electroplating and electrotyping. The first experiments with using an electrical charge to deposit metal in solution onto a conductive surface—electrometallurgy—were undertaken in the early years of the nineteenth century. The base metal object and a silver ingot are suspended by wires in a bath of silver cyanide. When an electrical current is applied, the negative charge of the base metal object attracts the positively charged silver ions in the solution, which are replenished by the ingot.[2]

Experiments undertaken in both Russia and England in 1838 showed that the same technology for electroplating could be used to create an object by plating into a negative mould and allowing the thickness of the plated metal to accumulate, forming a substantial wall.[3] This process, called electrotyping, was particularly suitable for making reproductions because all the minute details captured in the mould are meticulously rendered in the final metal version. This ewer and dish were electrotyped in copper and then silver -plated and partially gilded.

The model for this basin was also used as a tabletop in one of the firm's many ambitious Mannerist-revival creations. The base of the table, designed by George C. Stanton, incorporated crouching panthers, masks and the sculptural figure of Pomona, repeated three times around the stem (fig. 1).[4] Prince Albert purchased the table as a gift for Queen Victoria on her birthday in 1850, and it remains in the British Royal Collection. In 1851, Elkington received accolades when the firm exhibited the table at the Great Exhibition of the Industries of all Nations in the Crystal Palace, which attracted more than six million visitors.[5]

From 1856, they began to produce copies of the basin for commercial sale. Soon afterwards, they greatly expanded their offerings of reproductions when they made an agreement with the South Kensington Museum (now the Victoria and Albert Museum) to manufacture electrotypes of the great examples of silver in European treasuries.[6] This project was part of a campaign to make those collections available for study to artists, designers and the general public. Newly formed museums from Sydney to New York purchased the electrotypes along with plaster casts and photographs. The fame of this model was assured when the All England Lawn Tennis Club purchased a second-hand dish in 1886 to serve as the trophy for the Wimbledon Ladies tournament. **EMA**

1. Timothy Schroder, *British and Continental Gold and Silver in the Ashmolean Museum*, vol. 3, 2009 (Oxford: Ashmolean Museum, 2009), pp. 1200–1204. **2.** Alexander Watt, *Electro-metallurgy, Practically Treated* (London, 1860), is one of many texts of the time that describe in detail the process and its discovery. **3.** See Cyril Stanley Smith, "Reflections on Technology and the Decorative Arts in the Nineteenth Century," in *Technological Innovation and the Decorative Arts: Winterthur Conference Report, 1973*, eds. Ian Quimby and Polly Anne Earl (Winterthur, Delaware: The Henry Francis du Pont Winterthur Museum, 1974), pp. 25–64. **4.** Jonathan Marsden, ed., *Victoria and Albert: Art and Love*, exh. cat. (London: Royal Collection Publications, 2010), p. 276. **5.** See *Official Descriptive and Illustrated Catalogue of the Great Exhibition of the Works of Industry of All Nations* (London, 1851). **6.** *Illustrated Catalogue of Electrotype Reproductions of Works of Art from Originals in the South Kensington Museum* (London, 1873).

EDWARD BARNARD & SONS

By the mid-nineteenth century, Edward Barnard and Sons was the largest silver manufacturer in Britain, supplying wares including luxurious centrepieces to such well-known silver firms as Hancock, Elkington and Company, and Hunt and Roskell. This particular centrepiece `315` was made in 1850 for Barber and Smith, retail silversmiths and jewellers in London, England, on behalf of unidentified Canadian clients.[1] It was presented to George Okill Stuart (1807–1884) through a public subscription of the people of Quebec City to commemorate his retirement from the office of mayor, which he had held for four years (1846–50).

Three figures on the base of the centrepiece personify the virtues of Civic Dignity, Justice, and Liberality (or Generosity). Civic Dignity wears a mural crown and holds a sword in her right hand, a shield in the other. By wearing a mural crown, she is invested with a second meaning, representing Quebec City, which is a walled city. Justice holds a sword in her left hand, and, originally, a scale, now lost, in the right; Liberality holds a cornucopia filled with coins and another filled with fruit and vegetables rests by her side.

In one cartouche of the triangular base is an inscription[2] in English, in another it is in French. Both speak of Stuart's "able, assiduous, and impartial discharge of the [important] duties" of his office and the "high regard" in which he was held. In the third cartouche is a coat of arms accompanied by the motto *Justitiae Propositique Tenax* [steadfast in justice and resolve]. These were borrowed from Stuart's uncle, Sir James Stuart, chief justice of Lower Canada, who was created a baronet in 1841.

Silver testimonials replete with symbolism were a sophisticated art form in which Victorian England excelled. This example is imbued with distinctly Canadian content appropriate to its destination. The stem of the centrepiece resembles the trunk of a maple tree surmounted by a small canopy of maple leaves. Above it is an openwork basket with roses, thistles and shamrocks, which originally supported a glass bowl. These symbols represent the citizens of English, Scottish and Irish ancestry. Below, three cast beavers appear to run up the base. By 1850, the combination of the beaver and maple leaf motifs had become symbols of French Canadians, a significance that would soon be extended to Canada.[3] **RF**

1. Victoria and Albert Museum, Archive of Art and Design, Edward Barnard and Sons Ltd., Daybook, AAD 5/65–1988 (1848–1850), fol. 704. **2.** Ibid. Although the inscription is dated February 4, 1850, the day Stuart officially stepped down as mayor, the centrepiece was presented much later that year, for it was not completed until June 20. **3.** Ross Fox, "Design, Presentation Silver and Louis-Victor Fréret (1801–1879) in London and Montreal," *Material Culture Review*, vol. 67 (Spring 2008), pp. 36–38, ills.

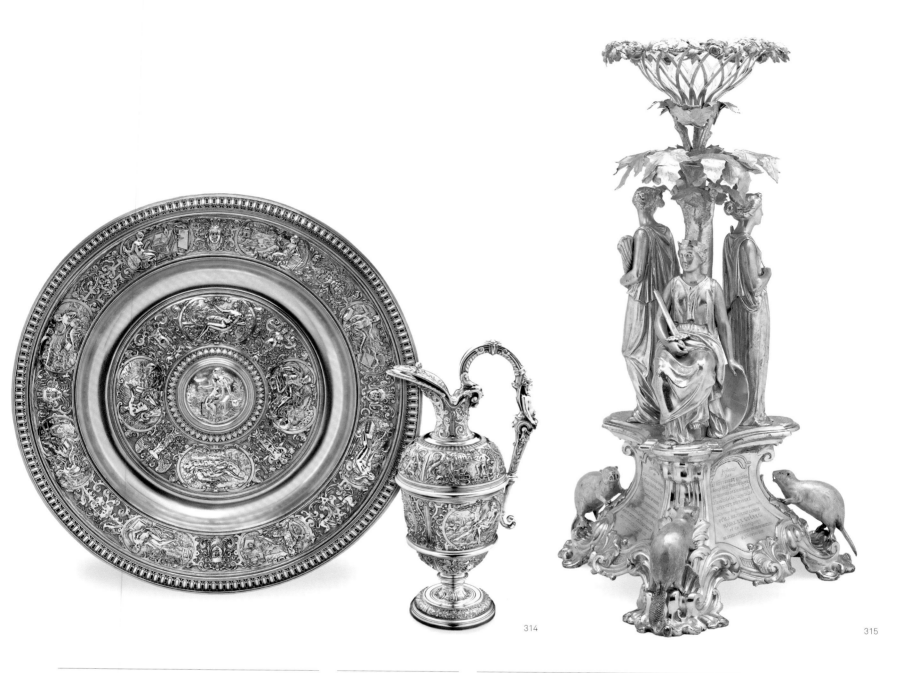

314

315

314

Elkington, Mason & Co.
Active in Birmingham
before 1836
After a design by François
Briot (about 1550-1612)
Ewer and Basin
1856
Electrotyped copper,
electroplated in silver
and gold
Ewer: 31.3 x 12.1 x 15.4 cm
Basin: H. 3.7 cm;
Diam. 47.7 cm
Impressed on underside
of basin: *978 / E & C°*;
manufacturer's mark:
crowned *E & Co,*
in a shield / date letter *Z /
ELKINGTON & CO*
Robert A. Snowball Bequest
1982.Ds.2a-b

315

Edward Barnard & Sons
London, 1829–1910
Presentation Centrepiece
1850
Silver
58.5 x 33 x 30.5 cm
Weight: 5,466.2 g
Presented to George Okill
Stuart (1807–1884),
Mayor of Quebec City
Maker's mark, on the figures
and base (3 times): *E / J, B, E /
W* [in quatrefoil cartouche];
a lion passant (3 times);
queen's head facing left
(3 times); leopard's head;
date letter *P* (twice)

Engraved on the base,
opposite French inscription:
*Presented / BY / THE CITIZENS
OF QUEBEC, / to George
Okill Stuart Esq. / on the
occasion of his retirement
from / THE OFFICE OF MAYOR
/ TO COMMEMORATE THEIR
SENSE / of his able, assiduous,
and impartial discharge / of
the duties of that important
office, / AND TO TESTIFY
THE HIGH REGARD /
THEY ENTERTAIN FOR HIM /
4th February 1850*
Coat of arms with the motto:
*JUSTITIAE PROPOSITIQUE
TENAX*
Gift of the Honourable Serge
Joyal, P.C., O.C., in memory of
the Right Honourable Pierre
Elliott Trudeau
2004.269

CHRISTOPHER DRESSER

This teapot **316** is one of Christopher Dresser's most striking and innovative designs. Its simple geometry and playful shape make it visually appealing to twenty-first-century eyes. Created in Victorian England, when taste demanded richly decorated surfaces, the teapot's unusual form and lack of ornament were radical for the period, and anticipated the industrially produced designs of the 1920s and 1930s. The only other example of this teapot known to exist is in the collection of the Victoria and Albert Museum, London.

The recognition of Christopher Dresser's originality in the history of international design has taken a leap in the last twenty years with exhibitions and major publications devoted to his work.[1] Typical of his time, Dresser relied on an eclectic range of sources, especially Japanese art and design, and he became one of the leading figures in the introduction of "Japonisme" to the West. His admiration of the Japanese economy of means in design and their aim to create artistic objects, no matter how small and ordinary, inspired this small teapot.

An author of four books on design, Dresser was at the centre of English reform in the applied arts from the 1860s to the 1880s.[2] He supplied drawings for wallpaper, textiles, ceramics, carpets and metalwork to manufacturers in Britain, and because of his emphasis on simplicity, function and the economical use of materials, he has been hailed as a forerunner of industrial design.[3]

Between 1879 and 1882, Dresser produced many silverware designs for the Sheffield firm of James Dixon and Sons. This teapot is one of the most progressive of his designs for Dixon, and it has become an iconic example of his work.[4] According to company records, the creation of this teapot involved many hours of handwork, because of the hardness of the base metal composed of an alloy of nickel, copper and zinc. This lozenge-shaped model 2274 appears in the firm's costing book, which reveals that three-quarters of the total cost of production was labour alone.[5] A piece requiring so much handwork would not have been profitable for serial production, and this model never appeared in any trade catalogues of the Dixon firm. This may explain why only two examples of the teapot have been discovered.[6]

A unique work for its time, unlike traditional silverware for which the value of a piece was determined by its weight in sterling silver or by the amount of elaborate decoration, this teapot represents with humour and simplicity an aesthetic value far beyond its worth in metal and man-hours of production. **RP**

1. Widar Halén, *Christopher Dresser* (London: Phaidon Press, 1993); Michael Whiteway, *Christopher Dresser 1834–1904* (Milan: Skira, 2001); Michael Whiteway, ed., *Shock of the Old: Christopher Dresser's Design Revolution* (New York: Cooper-Hewitt, National Design Museum; London: V&A Publications, 2004). 2. Stuart Durant, "Dresser's Education and Writings," in Whiteway 2004, *Shock of the Old.* 3. Most recently, Dresser was included in Charlotte and Peter Fiell's *Industrial Design A–Z* (Cologne: Taschen, 2000), p. 84. 4. It graces the cover of three publications devoted to Dresser's work. 5. Judy Rudoe, "Design and Manufacture Evidence from the Dixon & Sons Calculation Books," *The Decorative Arts Society Journal* (2005), pp. 66–83. My thanks to Eric Turner for this reference and his help in the research of this teapot. 6. This teapot, discovered in Canada, had been sent from a private collection in England to relatives in the province of Quebec in the mid-1960s.

GORHAM MANUFACTURING COMPANY

The Gorham Manufacturing Company was one of the largest American silver producers in the late nineteenth century, having grown from a small family business established in 1831 specializing in silver spoons, to a large commercial enterprise in silver and silver-plated tableware with sales outlets across the United States. In the 1880s, the Gorham company went through a period of expansion, building a new plant on six acres in Providence, Rhode Island, and opening a new headquarters in New York at Broadway and Nineteenth Street.[1]

It is interesting for Canadians to note that Gorham had an outlet in Montreal early in the twentieth century to serve their Canadian clients. "The Gorham Co. Ltd." is listed as silversmiths in the annual city directories from 1901 to 1906–7 at 36 Saint Antoine Street, George Chillas, president. Gorham may have produced silver there as a way of avoiding the high Canadian import duties on American silver.[2]

This vase **317** is striking for its ornate, intricately chased decoration applied to the smooth surface of the cylindrical vessel. On each shoulder of the piece are two naturalistic scalloped shells, cast in the round and entangled in strands of kelp and seaweed that extend down the sides. Other types of algae and clam shells have been caught up in the roped netting that hangs from the out-turned rim and forms a diaper pattern around the neck. A band of flowers and scroll motifs in relief around the base gives balance to the decorative composition.

The highly realistic rendering of marine motifs on this vase, probably modelled on the sea plants and shells found on the beaches of Rhode Island, may be attributed to the interest in the detailed renderings of nature found in Japanese design so popular at the end of the nineteenth century.

The designer of the vase, which dates from the late 1880s, has not been identified, as it was a period when Gorham's main designers crossed paths. George Wilkinson (1819–1894), chief designer for many years, was replaced by William C. Codman (1839–1921) from England in 1891, and French silversmith Antoine Heller (about 1845–1904) worked for the firm from 1881 until his death in 1904. The freedom of expression in the expertly chased motifs of this vase seems to pre-date the florid yet restrained works of Codman or the company's later Art Nouveau "martelé" line of wares. Other Gorham examples from this period display a similar exuberance in the application of tangled seaweed fronds and shells, for example, a punch bowl and ladle, dated 1885, in the Museum of Fine Arts, Boston.[3] **RP**

1. Charles H. Carpenter, Jr., *Gorham Silver* (San Francisco: Alan Wofsy Fine Arts, 1997), p. 111. 2. Charles L. Venable, *Silver in America 1840–1940: A Century of Splendour* (Dallas: Dallas Museum of Art, 1994), p. 100. My thanks to Samuel Hough, Cranston, Rhode Island, for pointing out the Canadian connection. 3. Carpenter 1997, p. 82, fig. 93. A presentation vase with a very similar decoration, the Mackinaw Cup, by Gorham is in the collection of the Royal Canadian Yacht Club, Toronto, awarded in 1888 (illustrated in the *Silver Society of Canada Journal*, vol. 7 [2004], p. 35).

316

Christopher Dresser
Glasgow 1834 –
Mulhouse, Alsace, 1904
Teapot
About 1879
Silver plate, ebony
16.9 x 25.1 x 5.4 cm
Weight: 563.7 g
Produced by James Dixon & Sons, Sheffield, England
Signature, impressed on underside: *Chr Dresser*; and *EP, J, D, & S*, a horn / *2274*
Purchase, Movable Cultural Property grant from the Department of Canadian Heritage under the terms of the Cultural Property Export and Import Act, the Museum Campaign 1988–1993 and the Deirdre Stevenson Funds 2011.35

317

Gorham Manufacturing Company
Providence, Rhode Island, founded in 1831
Vase
Late 1880s
Silver
41.5 x 23.5 x 17 cm
Weight: 2,983.3 g
Stamped on underside: a lion passant facing right; an anchor; *G / 1025* [in an oval] / *STERLING* / profile of a woman's head facing right surmounted by a star, all in a beaded oval
Liliane and David M. Stewart Collection
D94.188.1

317

QUEBEC SILVER

— JOANNE CHAGNON —

In 1720, there were 26,000 people living in New France's Saint Lawrence Valley, concentrated principally in the cities of Quebec and Montreal. Hitherto, the population had not been sufficient to support local silversmiths, and the first items of silver used in the region—some domestic, but most ecclesiastical—had been brought from France. Included in the luggage of the Augustine and Ursuline sisters who arrived together at Quebec City in 1639 were two chalices, with their accompanying patens, made by the Parisian silversmith Pierre II Rousseau (mastership granted 1614), which were destined for use in the chapels of the communities the nuns had come to establish. These pieces, very similar to one another, were typical examples of the Baroque style currently in vogue in France. Other items of silver (made mostly in Paris) that were imported regularly throughout the French regime proved to be of great value as models and sources of inspiration to local silversmiths. These pieces, which survived the edicts issued by Louis XIV in 1689 and 1709 ordering the melting down of silver in order to finance the wars of the League of Augsburg and the Spanish Succession, constitute today a corpus whose value is not widely recognized in Quebec. In fact, Quebec is home to the largest collection of seventeenth-century Parisian silver outside of France, representing more than one fifth of all known works in the category.[1]

In New France, since there were neither guilds nor official organizations regulating the various professions and their membership, trade practices were entirely free. As in the mother country, training was acquired through an apprenticeship of several years, whose duration was the subject of an agreement between master and pupil. Silversmiths generally made objects out of silver, but the content level was not subject to standards. Supplies were obtained principally from the melting down of existing objects and of silver coinage circulating in the colony, despite prohibition of the practice. In 1731, for example, the Augustines of Quebec City's Hôpital Général gave the crozier formerly belonging to Bishop Saint-Vallier to Jean-Baptiste Deschevery dit Maisonbasse (Bayonne about 1695–Quebec City 1745) with instructions to make a sanctuary lamp;[2] later, in 1787, they would commission François Ranvoyzé to transform this same lamp into a chalice.[3] A single piece of metal might be reused several times over, and silversmiths would also make money by purchasing silver items (by weight value) from owners wishing to sell. Occasionally, part of the original object was retained, for example, in the chalice by Ignace-François Delezenne **327**, the knop is of French origin but the foot and the bowl were melted down and refashioned. This practice enabled the parish or congregation to save money on the manufacture of a new piece.

Although the names of some fifty silversmiths appear in archival documents dating from the French regime, about thirty of these have no works attributed to them.[4] Michel Le Vasseur (active in Quebec City 1700–1712), who settled in the colony in 1700, took on two apprentices: Pierre Gauvreau (France about 1676–Quebec City 1717), who was already a gunsmith and seems not to have practised as a silversmith after his training under Le Vasseur, and Jacques Pagé dit Quercy (Quebec City 1682–1742), who has about twenty works attributed to him. The Museum's collection includes a shoe buckle **319** by Jacques' brother, Joseph Pagé dit Quercy, one of only two known pieces by this silversmith, together with a wine taster that is one of the very few works given to Guillaume Baudry dit des Buttes (Quebec City 1656–Trois-Rivières 1732). These isolated examples were the products of a profession that was still in its infancy and about which, prior to the 1730s, we know little.

The arrival in the colony of silversmiths who had learned the rudiments of their art in France would eventually provide the impetus needed for the profession to develop here. Roland Paradis, Paul Lambert dit Saint-Paul and later Ignace-François Delezenne were all able to make a living in New France working exclusively as silversmiths. Paradis' works are generally plain, with little in the way of chasing—the beaker with a moulded rim enhanced by a few simple lines is typical **321**. His liturgical vessels are characteristically small in proportion and their formal vocabulary somewhat archaic. Paul Lambert's works tend to be more ornamented, although the chasing is not deep, the decorative motifs having been created using flat engraving rather than the repoussé technique, which results in designs with greater relief. Lambert's secular work is more similar to that of his colleagues, as illustrated by the écuelle with

two cast and applied handles **324**, which is a common model of the time. The principal domestic items made by silversmiths working during the French regime were beakers, écuelles, spoons and forks.

Ignace-François Delezenne was the only silversmith of any importance working under the French regime who continued to practise after 1763, when New France came under English rule. Delezenne's production still reflected the French manner in which he had been trained, but he modified his mark to match British usage. An increasing number of local silversmiths began imitating the English marks that guaranteed the standard and quality of silver objects, even though these pseudo-marks had no legitimacy. Delezenne produced a corpus of domestic and church silver that reflects his technical skill, his originality, and the range of his formal and decorative vocabulary. He was also the first silversmith to obtain major commissions for silver items traded by the North West Company and other merchants with the Aboriginals in exchange for furs. Up until the 1820s, this highly lucrative activity did much to stimulate the region's silver industry, which soon saw the establishment of full-fledged craft businesses in trade silver like those run by Robert Cruickshank and Pierre Huguet dit Latour, which produced a wide array of the jewellery, crosses and ornaments that greatly appealed to Aboriginals. The production of some silversmiths—Joseph Tison, for example, who created a frontlet in the Museum's collection **323**—consisted almost exclusively of trade silver.[5]

This was certainly not true of Delezenne's most celebrated apprentice, François Ranvoyzé, although the Museum's collection does include a trade-silver cross of Lorraine that bears his mark. Ranvoyzé's name is associated principally with religious silver, and he is unique in having created three liturgical vessels in solid gold for the parish of L'Islet. Drawing inspiration both from the Baroque spirit of French seventeenth-century silver and from neoclassical pieces, Ranvoyzé left behind an oeuvre of great charm whose occasionally whimsical spirit is reflected in the frieze of flowers and fruit that adorns the rim of the Museum's cruet tray **322**. Like a number of other silversmiths, he was also influenced by the Louis XVI style disseminated in the colony by Laurent Amiot, who completed his training in Paris, where he lived from 1782 to 1787 and whence he returned well versed in the latest stylistic and technical trends.[6] Although the influence of French Neoclassicism tended to take precedence in Amiot's ecclesiastical work, for his domestic silver he often employed the English Neoclassical vocabulary introduced into Lower Canada by such British silversmiths as Robert Cruickshank **328**. The British also brought with them their elaborate table manners, which were rapidly adopted by the local population in the early nineteenth century. The range of domestic silver grew larger and a silversmith such as Amiot soon adapted his production to suit the new customs of his clientele in Lower Canada. The teapot inspired by English models dating from about 1805 **326** offers a fine example.

Up until the mid-nineteenth century, before the Victorian taste for eclecticism and historical precedent took hold, local silversmiths borrowed freely from Neoclassical models, whether French or English, guided by their own tastes or the requirements of the commission. Church silver, on the other hand, generally remained more faithful to French models, as evidenced in the elegant processional cross by Salomon Marion **318**, author of a number of original and exquisitely executed works.

1. Michèle Bimbenet-Privat, *Les orfèvres et l'orfèvrerie de Paris au* XVIIe *siècle* (Paris: Commission des travaux historiques de la ville de Paris, 2002), vol. 2, pp. 6–7.
2. Archives de l'Hôpital général de Québec, "Délibérations du Chapitre (1699-1822)," 13.3.1/1.8.3, pp. 51–52.
3. Archives de l'Hôpital général de Québec, "Journal de l'administration (1692-1910)," 13.14.3.1/1.9.13, p. 40.
4. For more information, see Jean Trudel, *Silver in New France* (Ottawa: National Gallery of Canada, 1974), and Robert Derome, *Les orfèvres de Nouvelle-France – Inventaire descriptif des sources* (Ottawa: National Gallery of Canada, 1974).
5. Robert Derome, *Les orfèvres montréalais des origines à nos jours. Catalogue chrono-thématique* (Montreal: Université du Québec à Montréal, 1996), pp. 49–50.
6. For a study of stylistic developments in the field, see René Villeneuve, *Quebec Silver from the National Gallery of Canada* (Ottawa: National Gallery of Canada, 1998), especially chapter 2.

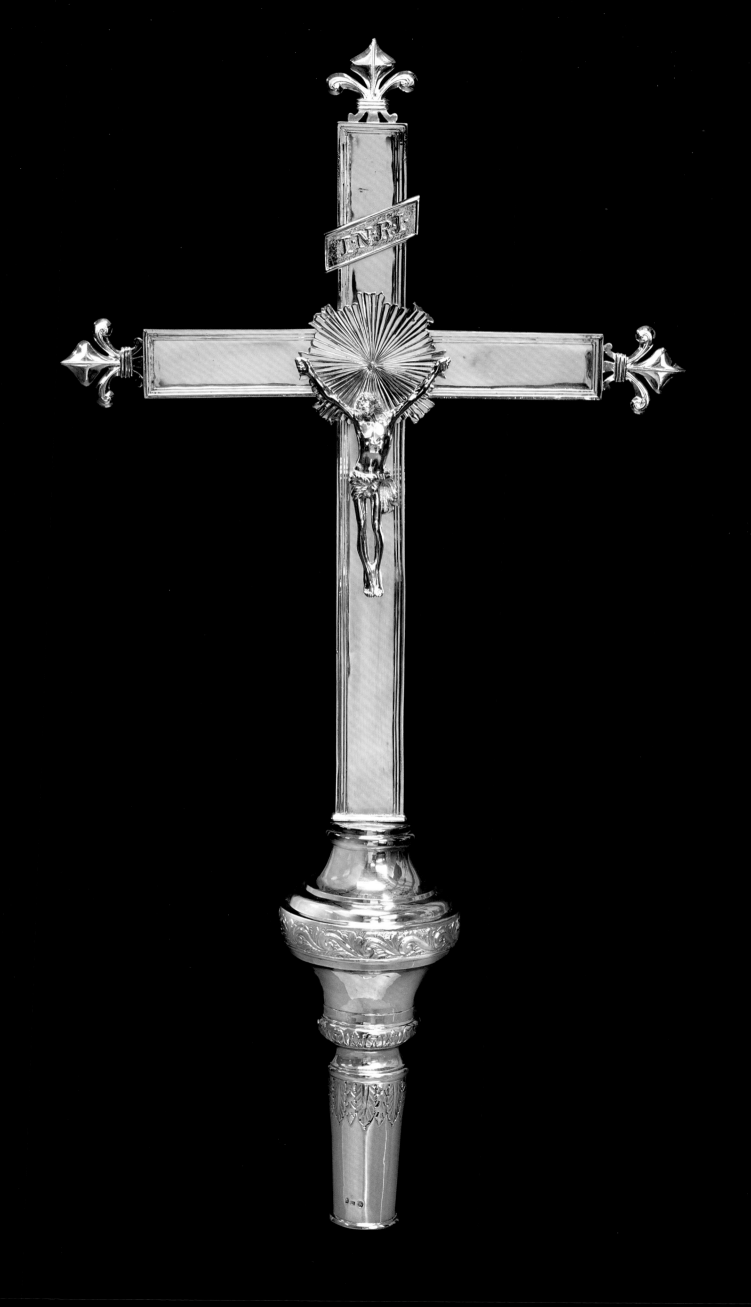

319

320

321

322

323

324

325

326

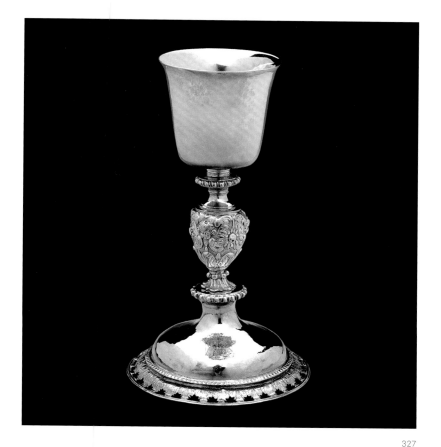

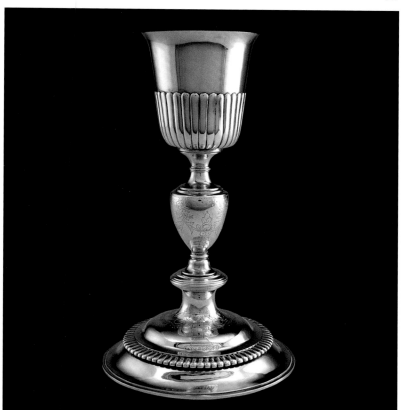

327

328

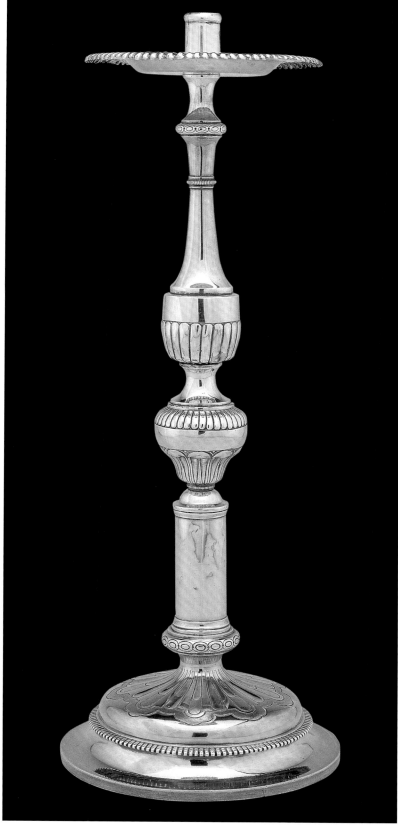

329

ART NOUVEAU
AND ART DECO

— YASMIN ELSHAFEI, ROSALIND PEPALL —

ALBIN MÜLLER

The designer Albin Müller was a member of the Deutscher Werkbund, which was established in Munich in 1907 with the aim of improving German design by reconciling craftsmanship and quality of material with commercial industrial production. Müller also became a central figure in the Mathildenhöhe artists' colony in Darmstadt, where architects Peter Behrens and Joseph Maria Olbrich led efforts to create a new, universal style of art, design and architecture for the new century.[1]

Even though Müller designed a range of applied art, he was best known for his metalwork. Like the English Arts and Crafts reformers of the late nineteenth century, the Deutscher Werkbund designers promoted the use of less expensive, less luxurious metals than silver. This teakettle and stand **330** in the attractive combination of brass and copper has a handcrafted look, even though it was industrially produced. It represents one of Müller's most admired designs, because of the successful way he integrates into a single unit the kettle and its burner. The ovoid shape of the kettle is echoed in the loop of the handle, which is simply screwed into the metal above the spout and on the side so that the attachments are visible, and the construction becomes part of the design. The base is cleverly married to the kettle's form through the graceful arm rising up in an organic line to create the hanging hook. Art Nouveau-style strapwork motifs give visual weight to the lower body of the kettle and repeat the arched lines of its handle and cover finial.

This teakettle, or "Teemaschine," as it is called in German, was produced by the metal manufacturing company Eduard Hueck, in Lüdenscheid, Germany. Albin Müller designed many vessels for the table in pewter, silver plate and copper for the Hueck company. This teakettle is a masterful design that represents the transition from the craft ideal to an acceptance of industrial production. **RP**

1. See Renate Ulmer, *Museum Kunstlerkolonie Darmstadt, Katalog* (Darmstadt: Institut Mathildenhöhe Darmstadt, 1990), pp. 155–181, for a section devoted to Müller's work.

RAOUL LARCHE

Trained at the École des Beaux-Arts in Paris, and best known for his monumental works, Raoul François Larche was awarded a gold medal for sculpture at the Exposition Universelle in Paris in 1900. With the burgeoning Art Nouveau movement, many turn-of-the-nineteenth-century sculptors in France embraced the sinuous contours of the natural world and shifted their focus from costly one-of-a-kind pieces to small-scale sculpture and functional objects. Founders like Siot-Decauville serially produced these objects in affordable materials—notably pewter or bronze—and catered to the bourgeoisie. They published sales catalogues of available works, and exhibited at international and universal exhibitions. A Siot-Decauville catalogue from the early 1900s features over twenty decorative-art objects by Larche, making his work widely accessible and commercially viable.[1]

Along with many of his contemporaries, Larche found his muse in Loïe Fuller, an American performer famous in Paris for her provocative dances and fluid movements with large diaphanous veils. Fuller experimented with the use of electricity, still in its infancy, by dancing with veils she manipulated with long wooden rods under projected beams of light, which lent the illusion that luminous colour emanated from within her and contributed greatly to her mystique.[2] Wildly popular, Fuller performed at the Exposition of 1900 in her namesake theatre, and her likeness appeared in virtually every art form at the time.

Nowhere are the elements of Fuller's art more successfully conveyed than in Larche's sculptural table lamp **331**. At least four variations of this "Lampe à Lumières" exist—each depicting a different moment of Fuller's dance.[3] Here, the filament bulbs are hidden within billowing metal folds. Their light is cast inwards, bathing Fuller in the golden-bronze hues of the metal that immortalizes her. A luminescent femme fatale, Fuller embodied Art Nouveau ideals, and Larche's lamp was the quintessential manifestation of the movement's motifs. In a single object, the artist succeeded in capturing the essence of the *Belle Époque*. **YE**

1. Siot-Decauville, *Bronzes et objets d'art* (Paris: Devambez, Impressions Artistiques & Commerciales, n.d.). 2. Valérie Thomas, ed., *Loïe Fuller, Danseuse de L'Art Nouveau*, exh. cat. (Nancy: Musée des Beaux-Arts de Nancy; Paris: Réunion des Musées nationaux, 2002), p. 37. 3. For two versions, see ibid., pp. 100–101.

330

Albin Müller
Dittersbach, Germany, 1871 –
Darmstadt, Germany, 1941
Teakettle and Stand
About 1903
Copper, brass
33.5 x 20 x 16 cm (approx.)
Produced by Eduard
Hueck Metallwarenfabrik,
Lüdenscheid, Germany
Monogram, impressed
on underside: *AM*, and
EDUARD HUECK / 2029
Purchase, Deutsche
Bank Fund
2009.11.1-5

331

Raoul Larche
Saint-André-de-Cubzac,
France, 1860 – Paris 1912
Loïe Fuller **Table Lamp**
About 1898
Gilded bronze
46 x 19.4 x 19.5 cm
Cast Siot Decauville, Paris
Signature, impressed
on base, lower right:
RAOUL.LARCHE; lower left:
SIOT-DECAUVILLE /
FONDEUR / PARIS,
in a circle; on back: *N573*
Liliane and David M.
Stewart Collection
D94.309.1

330

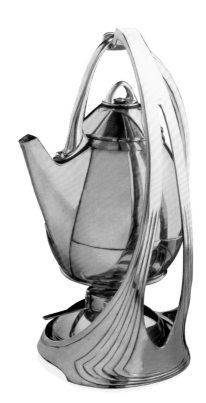

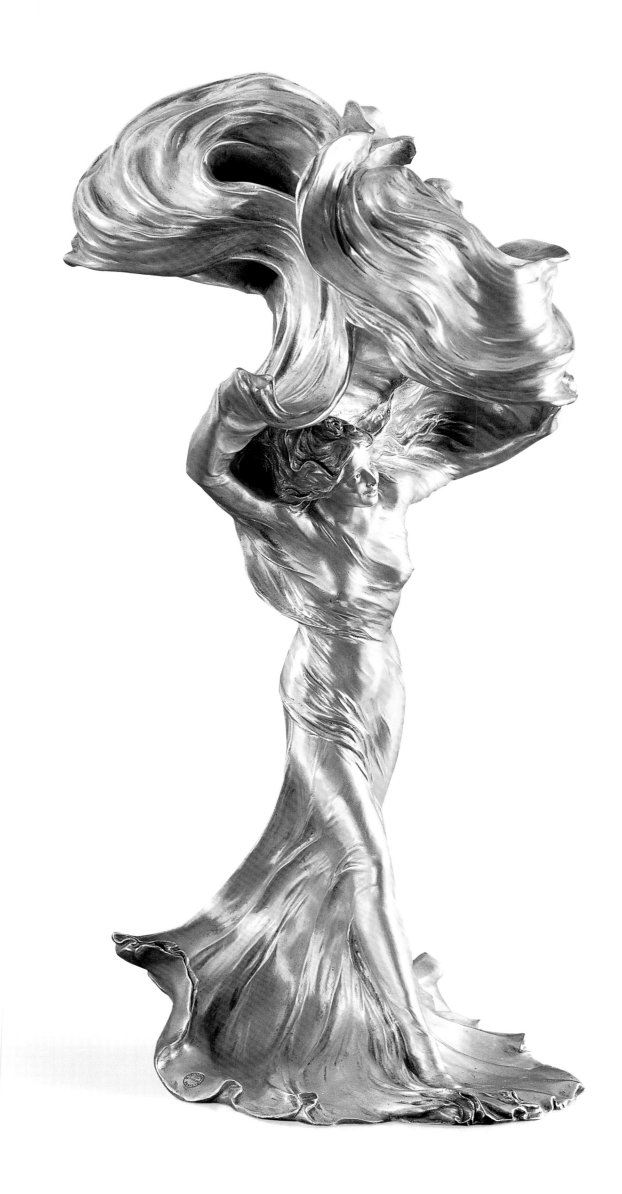

JOSEF HOFFMANN

The architect Josef Hoffmann was the driving force behind the Wiener Werkstätte, which he founded with colleague Koloman Moser and financier Fritz Wärndorfer in Vienna in 1903.[1] The workshop aimed to combine the talents of artists and craftsmen in the creation of artistic and functional designs for every aspect of interior furnishing. Hoffmann was above all an architect, but he designed furniture, glass, metalware, ceramics and textiles that were often integrated into his buildings, for example, his masterpiece the Palais Stoclet in Brussels (1905–1911).[2] As his contemporary, the German architect Peter Behrens remarked, "All [Hoffmann's] conceptions are based on architectural proportions. His designs, even those for the most simple objects of everyday life, have been conceived as part of an architectural whole."[3]

The silver and metal workshop was the first division of the Wiener Werkstätte to open, and metalware figured prominently in the group's output. In Hoffmann's own production, his designs for metal objects—whether tableware, lamps or jewellery—outnumber all others. The Museum's pair of flower vases **332** with glass liners were made from sheets of sterling silver that were machine-perforated with a regular pattern of squares enclosing a stylized floral motif. The elliptical form of each basket with graceful strap handle could be perfectly adapted to a serial method of fabrication. These two vases represent the spare geometry of Hoffmann's designs for utilitarian wares in silver or painted sheet iron in the early years of the Wiener Werkstätte.

Hoffmann used silver for luxury models, but he felt that more affordable metals such as copper, iron and brass also had special qualities—an idea in line with the English Arts and Crafts Movement whose principles he admired. The hand-worked brass centrepiece **333** in the Museum collection reflects the British ideals of the honest use of materials and good craftsmanship.[4] Brass is easily worked, and its pliability is evident in the hand-hammered fluting and the fanciful loops of the ribbon-like handles. These metal swirls also give visual weight to the upper part of the piece, as good proportion was a critical element of Hoffmann's designs. **RP**

1. Moser left the Wiener Werkstätte in 1907, and Hoffmann continued as artistic director until it closed in 1932. 2. See Eduard Sekler, *Josef Hoffmann: The Architectural Work* (Princeton, New Jersey: Princeton University Press, 1985). 3. Cited by Rainald Franz, "Josef Hoffmann and Adolf Loos: The Ornament Controversy in Vienna," in *Josef Hoffmann Designs*, ed. Peter Noever (Munich: Prestel-Verlag for MAK–Austrian Museum of Applied Arts, 1992), p. 12. 4. The design drawing for this piece is in the archives of the MAK–Museum für Angewandte Kunst, Vienna, ibid., p. 110. It was also produced in silver.

GILLES BEAUGRAND

The console table by Gilles Beaugrand is a rare Quebec example of handcrafted wrought-iron furniture. After training at the École des Beaux-Arts in Montreal, Beaugrand won a three-year Quebec government bursary in 1928 to study the art of wrought iron in Paris. There, he had the great fortune of apprenticing in the studios of three of the foremost designers of ironwork in France: Edgar Brandt, Adalbert Szabo and Richard Desvallières, spending a year in the workshop of each.[1] Brandt's workshop was the largest and most celebrated at the time, with three hundred men including about fifty student apprentices. The other two studios were much smaller, but Beaugrand's experience there rounded out his training. In 1920s Paris, traditional hand-wrought iron was in great demand for lamps, decorative grilles, furniture structures and decorative objects. However, when Beaugrand returned to Montreal in 1931, in the middle of the Depression, there was little demand for ornamental ironwork, and after about four years he turned to silversmithing.[2]

In Beaugrand's console table **334**, the supports rise up in continuous loops of iron in a technical tour de force accentuating the pliability of wrought iron under heat. Around the central finial, the elements end in elegant leaf scrolls with a golden patina. Light in spirit and decorative in composition, the table very much reflects Beaugrand's French training. In 1940, École du Meuble director Jean-Marie Gauvreau wrote an article on Beaugrand, subtitled "Ferronnier d'art et orfèvre," [Wrought-iron Craftsman and Silversmith] but by the time it was published, Beaugrand was devoting his career to the numerous commissions he received for ecclesiastical and domestic silver.[3] **RP**

1. Julien Déziel, "Gilles Beaugrand, Orfèvre," *Arts et Pensée*, no. 2 (March 1921), p. 26. All three Paris designers had been featured in the 1925 Exposition Internationale des Arts Décoratif et Industriels Modernes in Paris. 2. Paul Bourassa, "Gilles Beaugrand, de ferronnier à orfèvre," *Ornementum* (Fall–Winter 2008), pp. 14–16. 3. Jean-Marie Gauvreau, *Artisans du Québec* (Montréal: Editions du Bien Public, 1940), pp. 191–196.

EDGAR BRANDT

Renowned for his work in wrought iron, Edgar William Brandt was selected to create the grilles for the Porte d'Honneur at the Paris Exposition Internationale des Arts Décoratifs et Industriels Modernes of 1925. Brandt's gallery at the fair included his *chef-d'oeuvre*, the *Oasis* screen handcrafted in iron and brass.[1] Trained as a blacksmith, he began his career as a jeweller particularly adept at rendering flora and fauna motifs with accuracy and stylized expression. As early as 1905, he collaborated with the Nancy glass firm Daum Frères, integrating their glass with his bronze.

Fashioned around the time of the famed Exposition Internationale, this *Temptation* floor lamp **335** reveals lingering Art Nouveau tendencies in Brandt's work, as well as a nascent Art Deco aesthetic. The naturalism of the snake's scaly skin, and sinuous lines of its body grasping the base and shade—manifestly Art Nouveau traits—are countered by the stylized elongation and rigidity of its mid-section and the geometric simplicity of the shade. Inspired by *Animalier* sculpture, Brandt created two basic designs for this lamp. The *Temptation* came in standard floor and table models, while the *Cobra* was primarily a table model available in two heights. In each model, the chilling, uraeus-like serpent supports an alabaster, pâte de verre, metal or plastic shade that is not unlike a highly stylized papyrus or lotus flower.[2] Although Brandt was not alone in pairing snakes with vessels, his renditions of these design elements were far bolder in scale than any other of his time, and remain amongst the most enduring. **YE**

1. Jean Clair, ed., *The 1920s: Age of the Metropolis*, exh. cat. (Montreal: The Montreal Museum of Fine Arts, 1991), p. 182, no. 51. The screen was exhibited for the first time since 1925 in this Montreal show. 2. Joan Kahr, *Edgar Brandt: Master of Art Deco Ironwork* (New York: Harry N. Abrams, 1999), p. 156.

332

Josef Hoffmann
Pirnitz, Moravia, 1870 –
Vienna 1956
Pair of Basket-shaped Vases
About 1905–13
Silver, glass
25.5 x 10 x 13.5 cm
Weight: 189.4 g and 187.9 g
Produced by the Wiener
Werkstätte, Vienna
Monogram, impressed on
underside of each piece:
WW; standard mark: a head
of Diana facing right with *2*
Purchase, the Museum
Campaign 1988–1993 Fund
2002.96.1-2

333

Josef Hoffmann
Pirnitz, Moravia, 1870 –
Vienna 1956
Centrepiece
1924–25
Brass
19 x 28.8 x 18.5 cm
Produced by the Wiener
Werkstätte, Vienna
Impressed near top rim:
MADE / IN / AUSTRIA, in a
square; *JH* (in monogram):
WIENER / WERK / STÄTTE
Liliane and David M.
Stewart Collection,
gift of Paul Leblanc
D93.307.1

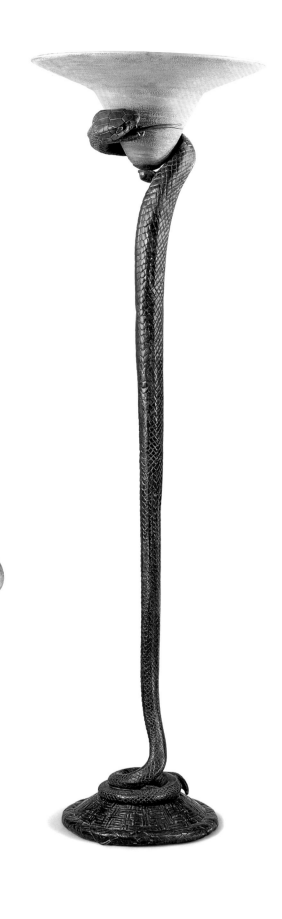

334

 334

Gilles Beaugrand
Montreal 1906 – Laval,
Quebec, 2005
Console
1931
Wrought iron, marble
101 x 165 x 55 cm
Liliane and David M.
Stewart Collection,
gift of Gilles Beaugrand
D90.121.1a-b

335

Edgar Brandt
Paris 1880 – Geneva 1960
The Temptation **Floor Lamp**
About 1925
Bronze, glass
161.3 x 47 x 47 cm
Made by Edgar Brandt, Paris
(base), and Daum Frères,
Nancy (shade)
Signature, impressed on top
of foot: *E. BRANDT*; engraved
on shade, near rim: *DAUM*
[cross of Lorraine] *Nancy*
Liliane and David M.
Stewart Collection
D94.286.1a-b

335

GUSTAVE KELLER FRÈRES

Founded in 1857 as a producer of leather dressing cases, Gustave Keller Frères branched out into the production of silver toilet sets and hollowware about 1880. By 1900, it was one of the important Paris silver manufactories, along with Aucoc, Boucheron, Cardeilhac and Christofle. Keller Frères was especially recognized for its modern silver designs with smooth, undecorated forms accentuating the gleam and lustre of the material 336 .[1] While its designs were modern, the firm used traditional techniques of silversmithing, emphasizing handcraftsmanship.

Keller Frères exhibited in all the major exhibitions both at home and abroad, from the Paris Exposition Universelle in 1900 until the later Paris Exposition Internationale des Arts et Techniques in 1937. **RP**

1. Annelies Krekel-Aalberse, *Art Nouveau and Art Deco Silver* (New York: Harry N. Abrams, 1989), p. 64.

CARL CHRISTIAN FJERDINGSTAD

Brought up and trained in Northern Denmark, Carl Christian Fjerdingstad moved to Paris in 1918 and set up in L'Isle-Adam, just north of Paris. In 1924, he began a long association with the large silverware firm Maison Christofle, with whom he collaborated until 1941.[1] In the 1925 Exposition Internationale des Arts Décoratifs et Industriels Modernes in Paris, Fjerdingstad exhibited in both the Danish display and the Christofle pavilion. The French reviewer in *Art et Décoration*, Gabriel Mourey, wrote enthusiastically about

Fjerdingstad's work at the time: "The vegetable dishes, the tea and coffee sets, the bowls, the coupes signed Fjerdingstad have a frankness of line, beautiful detail, a perfect technique that to my eyes, with certain pieces by Puiforcat, are more worthy of admiration than any other metalwork in the Exhibition of 1925."[2]

Fjerdingstad's silver forms have the streamlined simplicity of Danish design from the 1920s. Because of his youth spent in the rural areas of Denmark, his work reflects his love of nature and animals. The decorative references in this piece 337 to a swan's form take nothing away from the clarity of line and the function of the piece. It has been stamped "GALLIA," the Christofle firm's trademark for its silver plate made from an innovative alloy that resembled pewter. Gallia metal was ideally suited to casting and less expensive to manufacture and plate with silver. **RP**

1. Biographical details are taken from David Allan, "Fjerdingstad: A Franco-Danish Silversmith of the Twentieth Century," *The Journal of Decorative and Propaganda Arts 1875–1945*, vol. 20 (1994), pp. 78–83, revised translation. 2. Gabriel Mourey, "L'Exposition des Arts Décoratifs. La section danoise," *Art et Décoration* (October 1925), unpag.

JEAN PUIFORCAT

In 1937, Jean Puiforcat exhibited a model of this soup tureen 338 at the Exposition Internationale des Arts et Techniques in Paris, where a pavilion was entirely devoted to his work, confirming his reputation as one of France's leading goldsmiths.

The tureen represents Puiforcat's intensive study of the geometry of three-dimensional forms, which drew his attention during the 1930s. Its form is based on the perfect shape of a circle that appears to swell in bands around the body of the piece from the base up to the cover finial. All superfluous ornamentation has been eliminated, reducing the tureen to its most functional yet sculptural form, a study in volume and proportion.

Puiforcat excelled at setting off the brilliance of silver with materials such as lapis lazuli, dark wood or ivory. In this case, the reflective silver surface contrasts with the glowing warmth of vermeil to enliven the visual impact of the tureen.

Puiforcat was a member of the Union des Artistes Modernes, founded in 1929 by a group of French architects and designers who spoke out against reliance on historical sources and the excesses of lavish ornamentation and luxury materials in favour of industrial production.[1] Despite the fact that Puiforcat's pieces were unique and handmade, his colleagues appreciated the spare mathematical perfection of a work like this tureen, which looked to the machine-made forms that could be industrially produced in baser metals. **RP**

1. Yvonne Brunhammer, *Les Années UAM 1929-1958*, exh. cat. (Paris: Musée des Arts Décoratifs, 1988), p. 238, and Françoise de Bonneville, *Jean Puiforcat* (Paris: Éditions du Regard, 1986), pp. 63–65.

336

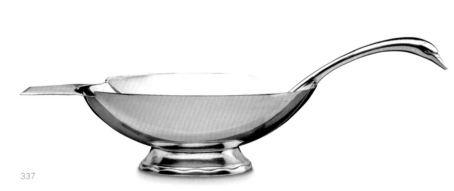

337

336

Gustave Keller Frères
Founded in Paris in 1857
**Seven-branch
Candelabrum (Menorah)**
Early 20th c.
Silver
45.6 x 58.8 x 17.8 cm
Weight: 4,250 g
On underside (7 times):
profile of a woman with a
helmet and *1*; impressed:
G. KELLER / PARIS
Gift of the Honourable
Serge Joyal, P.C., O.C.,
in memory of Ben Weider
2009.178

337

Carl Christian Fjerdingstad
Christiansø, Denmark, 1891 –
Paris 1968
Sauceboat and Spoon
About 1935
Silver plate
Sauceboat: 6.2 x 20.1 x 10 cm
Spoon: 3.5 x 20.5 x 4.8 cm
Produced by Orfèvrerie
Christofle, Paris
Manufacturer's mark,
on the sauceboat's foot
and the spoon's handle:
O [a knight chess piece] *C*;
and *GALLIA, 0422*
Gift of Guy Plamondon
2010.985.1-2

338

Jean Puiforcat
Paris 1897 – Paris 1945
Soup Tureen
About 1935
Silver, silver gilt
H. 25.4 cm; Diam. 27.6 cm
Weight: 2,554.3 g
Produced by Puiforcat
orfèvre, Paris
Maker's mark (twice):
E [a knife] *P*; standard mark:
a head of Minerva; and:
*JEAN E. PUIFORCAT /
MADE IN FRANCE*
Liliane and David M.
Stewart Collection
D87.239.1a-b

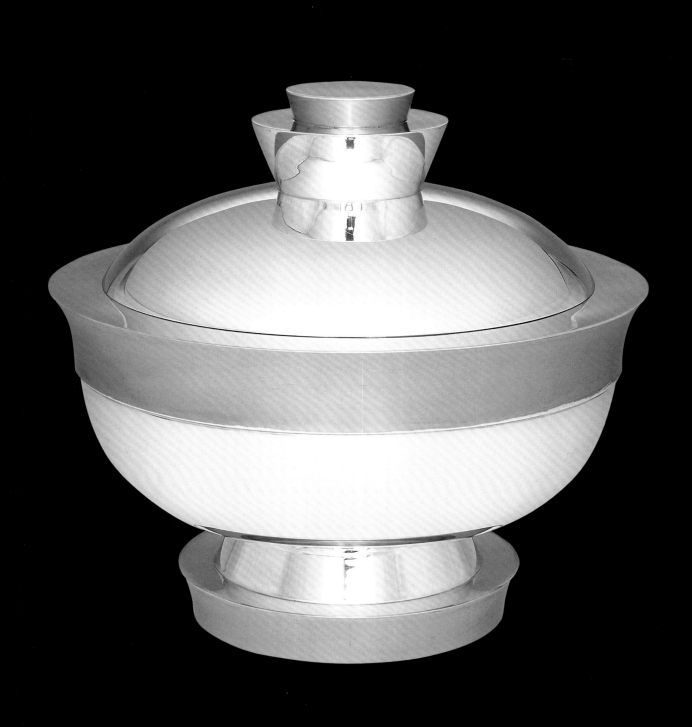

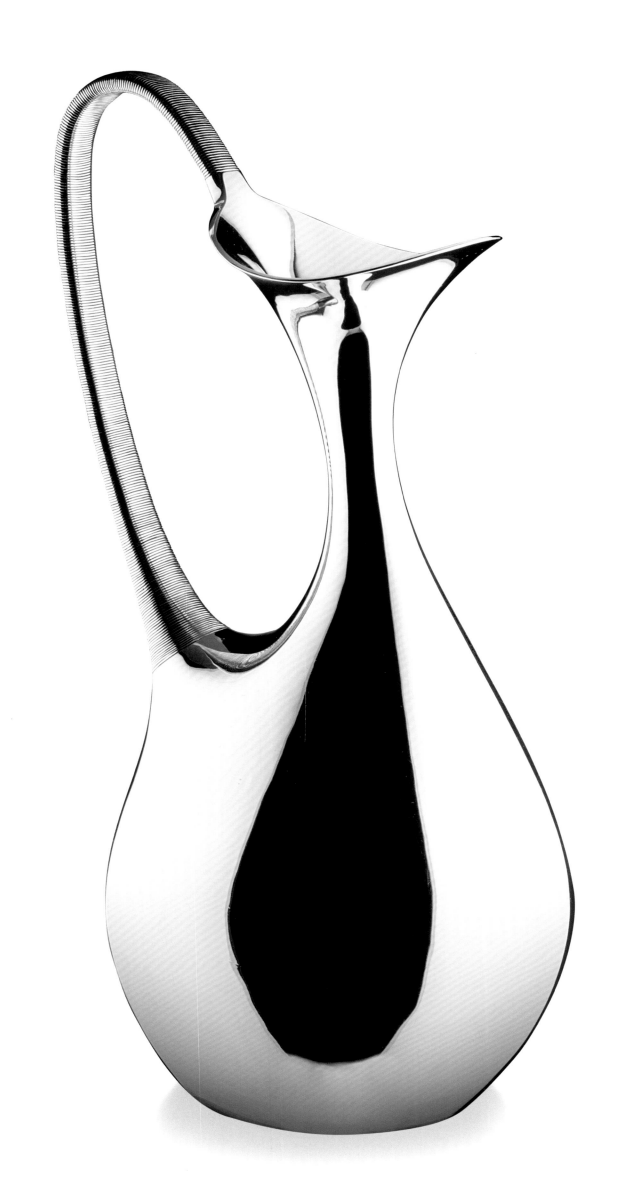

EXPLORING FORM

— DIANE CHARBONNEAU, ROSALIND PEPALL —

HENNING KOPPEL

When Scandinavian design dominated the international market in the 1950s, Denmark was noted for its modern silver, largely as a result of the Georg Jensen firm. Jensen had opened his silversmithy in 1904 in Copenhagen, and the business grew rapidly, with stores in Berlin, Paris, London and New York. It offered silverware and jewellery combining traditional Danish craftsmanship with modern elegance and simplicity. Many artists contributed to the firm's success, including Henning Koppel, who was one of its leading designers after World War II.

Koppel had studied sculpture at the Royal Danish Academy of Fine Arts (1936–37) and the Académie Ranson, Paris (1938–39). During the war, he lived in Stockholm and carried out designs for jewellery.[1] Then, in 1945, he joined the Georg Jensen silversmithy, where he created progressive modern designs, following the lead of Jensen designers such as Johan Rohde and Harald Nielsen.

This silver wine pitcher **339**, model 978, is a superb example of the sculptural forms of Koppel's holloware.[2] The high swoop of the handle melds into the organic lines in the body of the piece, which narrows at the neck and flares out again at the lip. The silver wiring around the handle provides the only decorative element. Koppel's early training in sculpture is evident in the tactile quality of this pitcher. It was his practice to model an object first in clay from drawings. The piece would then be raised by hammering, the silversmith working the material into sensuous

curves. The gold medal Koppel won at the Ninth Milan Triennale in 1951 for this design set him on the course to international recognition.

Inspired by the biomorphic shapes in the work of such artists and sculptors as Joan Miró, Jean Arp and Henry Moore, Koppel's sculptural silver as well as his jewellery linked the Jensen firm with contemporary art. The Museum's collection includes two Koppel brooches and a necklace made up of abstract, organic shapes. The curves of the necklace catch the light as it plays across the surface of the silver, the voids remaining in shadow. Like a sculptor, Koppel understood how to express the feeling of movement and energy in his works. **RP**

1. Biography by David A. Hanks and Jennifer Tober Teulié in *Design 1935–1965: What Modern Was*, ed. Martin Eidelberg (New York: Harry N. Abrams; Montreal: Musée des arts décoratifs de Montréal, 1991; reprint 2001), p. 380. 2. Examples are illustrated in Janet Drucker, *Georg Jensen: A Tradition of Splendid Silver* (Atglen, Pennsylvania: Schiffer Publishing, 1997 and 2001), pp. 204–205 and 244–245.

LINO SABATTINI

In the mid-1950s, as Italy's economy was still recovering from the war, Lino Sabattini left his job in a brassware shop in Como and set himself up in a small metalwork studio in Milan to begin his career in the field of silver design. Thanks to the encouragement of Gio Ponti—who published his work in *Domus* magazine and helped him to exhibit in the Milan Triennali of design, beginning in 1954—Sabattini's career was assured.[1]

At the time that this tea and coffee service **340** was made, he was director from 1956 to 1963 of a line of silver works, "Formes Nouvelles," at the Milan plant of the French silver manufacturer Christofle.

Made of silver-plated brass, the service reflects Sabattini's appreciation of handworked pieces, even as Italy was moving rapidly in the industrial production of design. The gentle organic curves of the pieces and their irregular shapes are far removed from the geometric designs of pre-war European silver. The elongated, stretched-out forms of the pieces seem whimsical, but bear a relation to the exaggerated shapes of some Italian ceramics of the period, for example the designs of Antonia Campi. Pure and plain in their unornamented surfaces, the raffia-covered handles of the set contrast with the cool brilliance of the silver. More quirky than Sabattini's other designs for Christofle,[2] the *Como* service won a prize in Paris at the exhibition *Formes et Idées d'Italie* in 1957.[3] During these years, Sabattini provided designs for industrial ceramics and metal for companies like Rosenthal and Zani & Zani. In 1964, he moved back to the area of Como and established his own firm, Argenteria Sabattini. **RP**

1. Enrico Marelli, *Lino Sabattini, Suggestione e funzinone / Intimations and Craftsmanship* (Milan: Edizioni Metron, 1979), pp. 5–8. 2. "In legno e argento: Lino Sabattini," *Domus*, vol. 356 (July 1959), pp. 33–34. 3. Entry by Toni Lesser Wolf in *Design 1935–1965: What Modern Was*, ed. Martin Eidelberg (Montreal: Musée des arts décoratifs de Montréal; New York: Harry N. Abrams, 1991), p. 166.

339

Henning Koppel
Copenhagen 1918 –
Copenhagen 1981
Wine Pitcher
1948
Silver
35.2 x 20.6 x 14.9 cm
Weight: 1,421 g
Produced by Georg Jensen,
Copenhagen
Impressed on underside:
DESSIN / HK / DENMARK,
GEORG / JENSEN,
STERLING / 978
Liliane and David M. Stewart
Collection, by exchange
D86.244.1

340

Lino Sabattini
Born in Correggio,
Italy, in 1925
Como Tea and
Coffee Service
1957
Silver-plated brass,
plastic, raffia
Teapot: 14.5 x 30 cm
Coffee pot: 22 x 16.5 x 6.5 cm
Sugar bowl: 8 x 15 x 6 cm
Creamer: 12 x 7.5 x 4.5 cm
Produced by Christofle, Paris

Impressed on underside
of teapot and creamer:
[a rooster facing left] *GALLIA /*
FRANCE / O [a pawn] *C /*
PROD. / CHRISTOFLE;
on underside of sugar bowl:
SABATTINI; on underside of
tray: [square box in a circular
device, with two horizontal,
heraldically reversed club-like
motifs] *SABATTINI / ITALY,*
Lino Sabattini 1957/1989
Liliane and David M.
Stewart Collection
D86.164.1-4

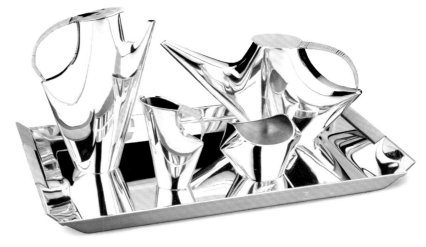

BOŘEK ŠÍPEK

Czech architect and designer Bořek Šípek is renowned for his eclectic approach, which draws from the diverse design trends that have emerged since the early 1980s. A remarkable creator of table accessories, light fixtures and furnishings, he designs luxury items—single or limited-edition pieces—mostly in glass, in the Bohemian glass-making tradition, but also in porcelain, metal and wood. He favours expression without ignoring function. His objects are engaging, eliciting an emotional response. He borrows from the past to imbue the object with the magic of yesteryear—an antidote to the anonymity of the industrial object. He pays homage to handicraft while making good use of new technologies to bring his most eccentric fantasies to life.

Šípek is partial to the union of opposing elements, whether materials, colours, forms, surfaces or decoration. In the *Simon* candelabra 341, geometry and superfluous ornamentation cleverly coexist. The symmetrical body of the piece is composed of two conical forms (Šípek's favourite motif), held together with three rings. The upper cone features a bell-mouthed opening with a festooned edge perforated at regular intervals. A conical receptacle is inserted in such a way that the candelabra could also be used as a flower vase or candy dish. The lower cone is pierced with a number of holes from which emerge seven branches that undulate, giving the impression of movement. Each branch is topped with a double drip pan and a socket to hold the candle. Designed in 1988 for the "Follies" collection by the Driade studio of Italy (founded in 1968), the candle holder has been in production since 1989. DC

ETTORE SOTTSASS

Throughout his career, Ettore Sottsass defied the status quo by proposing new forms and provocative images for everyday objects. Despite his rationalist training, which emphasized a purely formal approach, he favoured spontaneous creativity, which enabled him to redefine the relationship between object and user. Although the 1960s, when he led Italian anti-design, were important for Sottsass, it was the 1980s, as founder of the Memphis design group, which saw him earn immediate international acclaim.

The Milan-based group's unconventional creations shocked the design world from its very first exhibition in 1981. The Memphis group's objective was to re-energize the design industry, which its members considered profoundly conventional and predictable. The collective took up the challenge of colour, decoration and form by seeking to introduce these elements in a domestic context, along with materials considered rich or poor, traditional or industrial, or from wildly divergent styles and cultures. Furniture, objects and textiles became more emotional than functional, more artistic than commercial. Perched on six zigzagging feet, the *Murmansk* fruit dish 342 is one of the first high-end objects designed by Sottsass and expertly rendered by experienced craftspeople on behalf of the Memphis group. In keeping with the group's pluralistic aesthetic, the architect combined his interest in popular culture, Eastern traditions and the developing world with his love of pristine Nature. Refined and functional, this dish evokes the port city of Murmansk, situated far north in western Russia's arctic zone. DC

ZAHA HADID

Founded in 1984 by William Sawaya and Paolo Moroni, the Italian firm Sawaya & Moroni is both a design studio and gallery. It relies on international architects who freely create its collections of furniture and silver. The pieces reflect the diverse styles of contemporary architecture.

Born in Baghdad and now established in London, internationally acclaimed architect Zaha Hadid is a visionary with futuristic and radical ideas on a tireless quest to reinvent space and change our notion of buildings and landscape. Her Deconstructivist style is characterized by a preference for interlaced straight and curved lines, acute angles, superimposed planes, all of which lend her creations complexity and lightness. She essentially invokes the Russian Suprematists. For Sawaya & Moroni, Hadid designed two furniture series, "Z-Scape" (2000) and "Z-Play" (2002), which demonstrate an interest in morphological creations. In 1996–97, she designed a tea and coffee service produced in a limited edition of ten by Milanese silversmiths 343. The set reveals a formal logic based on the relationship between the object and its setting through the interplay of various transformations and configurations. The architect exploits the characteristics of silver, with its reflective surfaces lending the set its fluidity. The different oblique and angular pieces thus feature smooth, unembellished surfaces. Nesting pieces, they create a monolithic sculpture evoking rock crystal. DC

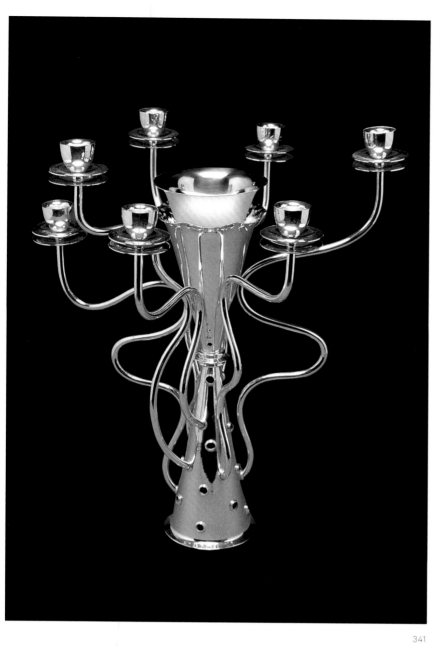

JEWELLERY
BY ARTISTS:
AN INTIMATE ART

— MARGUERITE DE CERVAL —

The *International Exhibition of Modern Jewelry 1890–1961*, presented in 1961 by the Goldsmiths' Company at London's Victoria and Albert Museum, included pieces by Jean Arp, Alexander Calder, Salvador Dalí, André Derain, Max Ernst, Lucio Fontana, Alberto Giacometti, Ibram Lassaw, Henri Laurens, Jacques Lipchitz, Bruno Martinazzi and Giò Pomodoro. Jewellery made by artists, hitherto something of a novelty, had come of age.

Since it is not always designed primarily to be worn, jewellery by artists transcends the traditional notion of jewellery-as-adornment to become the expression of a creative vision. The style of some visual artists—painters, but especially sculptors—is transposable to jewellery, and their creations in this form are thus exemplary of their oeuvre. Is the jewellery of Lassaw, Pomodoro and Picasso simply a miniaturization of larger works? Are Ernst's pieces transcriptions in precious materials? Are Dalí's wearable artworks? Was jewellery, for Calder, a field for experimentation? Although all these aims may play a role in a single piece, they primarily stem from jewellery's principal premise: to be wearable art, manifested as a culturally recognizable object. Creating jewellery allows artists to translate their creative impulse into intimate expressions while maintaining the coherence of their aesthetic vision. Consequently, materials tend to be overshadowed by concept: the idea is all, and it speaks particularly to the artist's immediate circle—the family and friends for whom the earliest pieces are frequently made as gifts.

The Spanish Surrealist painter Salvador Dalí approached jewellery like a jeweller, thereby asserting a creative eclecticism he shared with the artists of the Renaissance. Dalí lived for several years in the United States, and it was there, in 1948, that he produced his first collection of jewellery, for the New York firm of Alemany & Ertman. This initial series, acquired by the Catherwood Foundation in 1953, would be followed by a number of limited-edition pieces. One of these, *The Persistence of Memory* brooch **345**, reiterates his image of a "soft watch" draped over the branch of a tree—a metaphor for the fluidity of time that the artist first employed in a 1931 painting bearing the same title (Museum of Modern Art, New York). The transposition of image into object was one of the artist's favourite devices, inspiring him to create sculptures, items of furniture and an array of other objects. The chess pieces **344** executed in tribute to Marcel Duchamp were moulded from the fingers of Dalí's own hand, which thus became the symbolic embodiment of creation. The originality of Dalí's surrealist language gave added impetus during the 1950s to the emerging field of jewellery by artists.

The gold pieces made by Bruno Martinazzi, a stone carver and jewellery maker trained in Florence and Rome, prove that he was a master of the traditional techniques of repoussé, chasing and burnishing. His entire production reflects a desire to return to the unadorned essence of things, and he worked almost exclusively with stone and gold, materials he appreciated for their immutability and timelessness.

He focused on a realistic study of the human body—the mouth, the eye and especially the hand, which he saw as a symbol of creation and "an instrument of knowledge and invention, meant to establish a relationship with others."[1] The magnificent gold bracelet in the form of a hand that grasps the wrist **351** was made in 1969. Martinazzi drew his motifs and forms from ordinary things, to which he attributed mystical properties quite unrelated to everyday life: for him the generous and harmonious shape of an apple, for example, conjures an ideal beauty that transcends the contours of the object itself.

Bruno Martinazzi's jewellery has been exhibited in London, Munich, Vienna, New York, Kyoto and, in 1997, at the Schmuckmuseum in Pforzheim, Germany.

The Italian sculptor Giò Pomodoro was trained as a painter and printmaker. Although close to his brother Arnaldo—four years older and himself a sculptor and jewellery maker—Giò took his own artistic path, concentrating principally on sculpture. He made a number of monumental works in bronze and stone, several of which can be seen in the streets of Turin and Florence. He was awarded prizes at the Paris Biennale in 1959 and at the Venice Biennale in 1962.

In 1950, he began making jewellery, conceiving each piece as a miniature sculpture. After exploring the styles of the past, from Antiquity to the Renaissance, he moved towards a more surrealist approach. Symbolically, he interpreted such concepts as the life force, growth, fertility and multiplication: the necklace seen here illustrates the human sexual organs, both male and female **346**. The bracelet in red and yellow gold **347** shows an elegant abstract design that juxtaposes curves and sharp edges. Pomodoro made his material part of the suggestion process, fashioning the metal or stone into soft, sensual forms or aggressive, tortured surfaces that create a sense of energetic tension. He frequently applied the discoveries made in his sculptural practice, showing a particular propensity for the subtle interplay of relief resulting from contrasts between smooth and rough surfaces.

As a pioneer of Dada and Surrealism, the German painter, sculptor and printmaker Max Ernst conducted a number of artistic experiments.

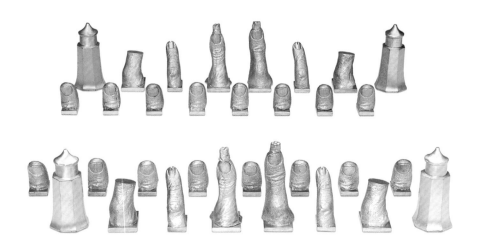

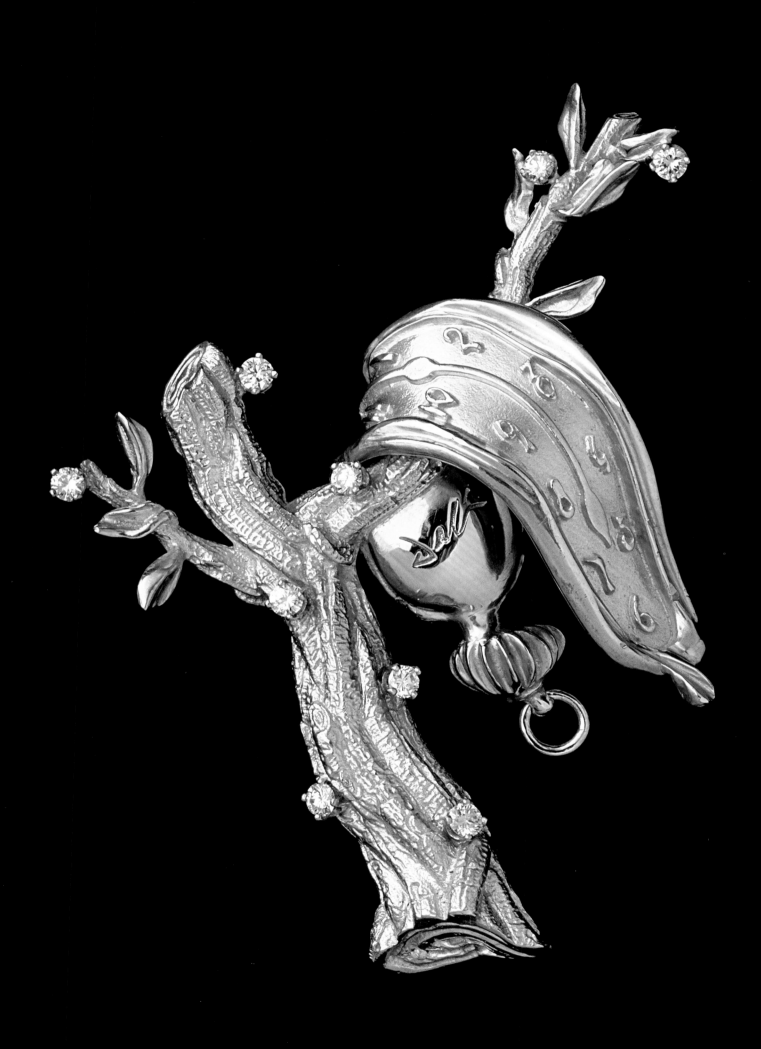

346

347

348

349

350

351

Interested in texture and the surface appearance of matter, he developed a singular creative approach by transposing the traces of physical objects onto paper or canvas, using techniques that came to be known as *frottage* (rubbing) and *grattage* (scraping). In 1934, he began sculpting figures with faces composed of geometric forms. During the 1940s, Ernst left France for the United States. On his return, he began revisiting his early sources of inspiration—human and animal figures—creating forms reminiscent of totems and African masks, but above all building a unique visual vocabulary grounded in his own inner world. A fruitful partnership with the goldsmith François Hugo, begun in 1954, resulted in several editions in gold and silver based on models executed by the artist in plastiline, a malleable material that could later be used to make cast-iron moulds and dies for hammering. Statuettes, chessmen and small masks wearable as pendants were all made in gold, in editions of six or eight. The *Head* pendant **348**, with its minimalist facial features, is a typical example of the jewellery created by Max Ernst.

After exploring the realms of glass and ceramic, the Spanish painter and sculptor Pablo Picasso turned his attention to precious metals. His works in this medium are certainly the least known of his vast oeuvre. In 1956, Picasso began collaborating with François Hugo on the production of repoussé pieces in gold and silver made after his own designs. Together, artist and goldsmith developed a technical expertise. In 1958, they began producing silver plates (*Jacqueline's Profile, Faun's Face, Bull's Head*), which were followed by other dishes and bowls. Then came a series of gold medallions, in editions of twenty, which reproduce in miniature the motifs adorning the dishes and bowls. Picasso maintained control over the development of this production, as he signed them, thus determining the designs that would be reproduced, into the 1970s, in the form of

jewellery. Although the accuracy with which these pieces translate the painter's spirit and personality is quite remarkable, Picasso did not make this aspect of his practice public until 1967, when he finally gave Hugo permission to publicize the various pieces. The medallions that form the *Faune Cavalier* **350** and *Face in the Form of a Clock* **349** pendants can be seen as small-scale evocations of the artist's aesthetic vision.

The Italian-born artist and designer Harry Bertoia, who moved to the United States in 1930, was active in diverse disciplines. Although a maker of sculpture and a designer of furniture and other objects, he was also a master metalworker, and he taught this subject at the Cranbrook Academy of Art, Bloomfield Hills, Michigan. Starting in 1936, and with growing frequency during the war years, he produced jewellery in hammered brass, aluminum and silver. His favoured motifs resemble either cellular forms drawn from the plant and animal realms—greatly magnified to reveal their striking beauty—or parabolic shapes inspired by certain physical properties of the material. Both are illustrated here in pieces executed in 1943: the former by a silver brooch composed of five articulated elements **353**, and the latter by a hatpin whose silver shaft traces a complex orbital path **352**.

Bertoia was a close friend of Calder's and the two often showed together, notably at the Museum of Modern Art's landmark 1946 exhibition *Modern Handmade Jewelry*. After a highly productive period devoted to design—he was the author of the famous *Diamond* chair **421**, marketed by Knoll—Bertoia began making sound sculptures out of folded and stretched steel. He returned to jewellery towards the end of his life, however, creating a series of bronze pieces featuring what would become his preferred forms: cubes, spirals and crosses.

The American painter and sculptor Alexander Calder made approximately 1,800 items of jewellery throughout his lifetime, starting at the

346

Giò Pomodoro
Orciano di Pesaro, Italy,
1930 – Milan 2002
Koinos Hermes! Necklace
1963
Pink and white gold,
rubies, emeralds, agate
L. 41.9 cm
Signature, on back:
Gio Pomodoro
Liliane and David M.
Stewart Collection
D88.124.1

347

Giò Pomodoro
Orciano di Pesaro, Italy,
1930 – Milan 2002
Bracelet
1959–60, made in 1965
Red and yellow gold
Diam. 8 cm
Signature and date,
on inside: *Gio Pomodoro 65*
Gift of Cécile and
Gérard Baillargeon
1995.Ds.10

348

Max Ernst
Brühl, Germany, 1891 –
Paris 1976
Head Pendant
1959, made in 1977
Gold, 3/8
8.2 x 7.2 x 2 cm
Executed by François Hugo
(1899–1981)
Signature, on back: profile
and eye / *max ernst* / *3/8*;
maker's mark: *F* [a cross] *H*,
in a lozenge; first standard
mark, Marseilles assay
office mark, in an octagon
Gift of Cécile and
Gérard Baillargeon
1995.Ds.7

349

Pablo Picasso
Málaga, Spain, 1881 –
Mougins, France, 1973
Face in the Form of a Clock
Pendant
1956–67
Gold, 16/20
Executed by Atelier François
Hugo, Aix-en-Provence
Diam. 5 cm
Signature, on back: *Picasso,
16/20, 1 4 2 5*; maker's mark:
P [a cross] *H*, in a lozenge
cartouche
Gift of Mrs. Suzanne Laberge
1996.Ds.1

350

Pablo Picasso
Málaga, Spain, 1881 –
Mougins, France, 1973
Faune Cavalier Pendant
1956–67, made in 1975
Gold, maker's example
Diam. 5.2 cm
Executed by Atelier François
Hugo, Aix-en-Provence
Signature, on back:
*Picasso, EXEMPLAIRE
D'AUTEUR,
1 4 0 6*; maker's mark:
P [a cross] *H*, in a
lozenge cartouche
Gift of Cécile and
Gérard Baillargeon
1995.Ds.9

351

Bruno Martinazzi
Born in Turin in 1923
Goldfinger Bracelet
1969
Yellow and white gold, 3/12
7.5 x 6.5 x 5.5 cm
Signature, behind thumb:
MARTINAZZI III / XII
Liliane and David M.
Stewart Collection
D93.203.1

age of eight. In his creations, he approached the body as a performer with which the mobile-like jewellery could interact. The linear, quasi-abstract forms of his pieces create a sense of movement that is entirely consistent with the main tenets of his artistic approach.

What strikes one first about Calder's jewellery is its handcrafted look. It was an effect he deliberately sought and enhanced with a spontaneous, almost naive facility that often included a touch of humour. The wedding ring the artist fashioned for his adored Louisa took the form of a ribbon of gold that wound in a spiral around her finger. He used the same approach for the small brass pendant from 1940 **354**, a simple coil of seductive spareness. It was a recurring technique: wire made of steel, brass, silver or gold would be bent into a fluid line with no break, no soldering. The metal would generally be hammered flat, sometimes riveted, but there was no attempt at artifice. In their blend of power and pliability, two large brooches from the same period **355 356** further illustrate Calder's style. When he added elements to his ornamental jewellery, he chose recycled materials—a few shards of glass or ceramic—and used the wire to anchor and attach the pieces, like the string securing a parcel.

Completely unfazed by contrasts of dimension, he moved easily from the monumental to the realm of jewellery: his wearable pieces are large, echoing the sculpture, while the sculptures display a delicacy that suggests they were influenced by the jewellery. Calder first exhibited his jewellery in 1929, in New York, and he continued to make new pieces regularly until the early 1950s, often as gifts for friends. *Calder Jewelry,* a major exhibition organized by the Calder Foundation that travelled between 2008 and 2010 to several venues in the United States and Ireland, vividly revealed his jewellery work as intuitive, unaffected, and the product of a mind open to experimentation.

The artistic objective of the sculptor and painter Ibram Lassaw—who was of Russian extraction but became an American citizen in 1928—was to express the spiritual source of creation. He began making sculpture in 1930, and after a strong early interest in Constructivism he adopted a more abstract expressionist approach. In 1936, he was a founding member of the American Abstract Artists group but later aligned himself with the New York School of Abstract Expressionism, whose goals corresponded more closely to his own. He saw his jewellery pieces as wearable sculptures, miniaturized versions of his large-scale works. Lassaw produced around a thousand items of jewellery, many as gifts for those close to him—including the necklace seen here **357**, which was made for his daughter. In jewellery that bears his unmistakable stamp, created concurrently with the sculpture, he experimented with different metals, obtaining highly original effects through fusion and chemical patinas. The shapes that make up his web-like pieces of bronze, copper, steel or nickel are sometimes geometric, sometimes organic. Working the materials directly, without any preconceived plan, he achieved a characteristic style based on the balance between empty space and the filaments of fused metal that flow like the strokes of some exotic calligraphy.

1. Bruno Martinazzi, quoted in *Designed for Delight: Alternative Aspects of Twentieth-Century Decorative Arts*, exh. cat. (Montreal: Montreal Museum of Decorative Arts; Paris; New York; Flammarion, 1997), p. 88.
2. See Martin Eidelberg, ed., *Messengers of Modernism: American Studio Jewelry 1940–1960*, exh. cat. (Paris; New York: Flammarion; Montreal: Montreal Museum of Decorative Arts, 1996), pp. 48–51.

352

Harry Bertoia
San Lorenzo, Italy, 1915 –
Bally, Pennsylvania, 1978
Hatpin
About 1943
Silver, stoneware
7.5 x 9.2 x 4.7 cm
Liliane and David M.
Stewart Collection,
gift of Paul Leblanc
D94.213.1

353

Harry Bertoia
San Lorenzo, Italy, 1915 –
Bally, Pennsylvania, 1978
Brooch
About 1943
Silver
5.5 x 6.8 x 0.6 cm
Liliane and David M.
Stewart Collection,
gift of Paul Leblanc
D94.212.1

354

Alexander Calder
Philadelphia 1898 –
New York 1976
Pendant
About 1940
Brass
1.8 x 1.2 x 0.5 cm
Liliane and David M.
Stewart Collection,
gift of Paul Leblanc
D94.216.1

355

Alexander Calder
Philadelphia 1898 –
New York 1976
Brooch
About 1940
Brass
14.3 x 6.2 x 0.4 cm
Liliane and David M.
Stewart Collection,
gift of Paul Leblanc
D94.217.1

356

Alexander Calder
Philadelphia 1898 –
New York 1976
Brooch
About 1940
Silver
13.5 x 6.1 x 0.4 cm
Liliane and David M.
Stewart Collection,
gift of Paul Leblanc
D94.218.1

357

Ibram Lassaw
Alexandria 1913 – East
Hampton, New York, 2003
Necklace
1956–57
Bronze, galvanized
steel wire, smoky-emerald,
amethyst, topaz
26 x 28 cm
Liliane and David M.
Stewart Collection
D87.219.1

353

354

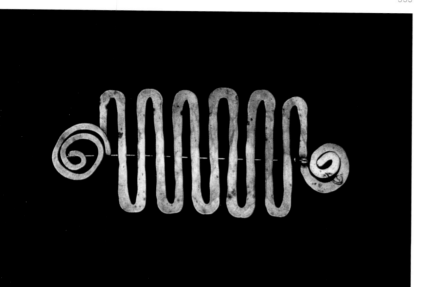

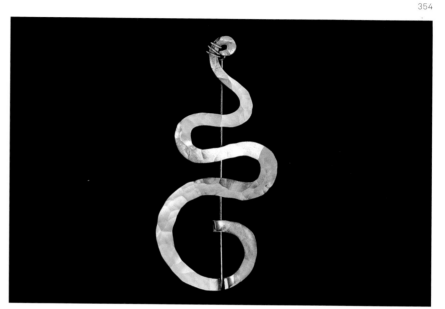

355

356

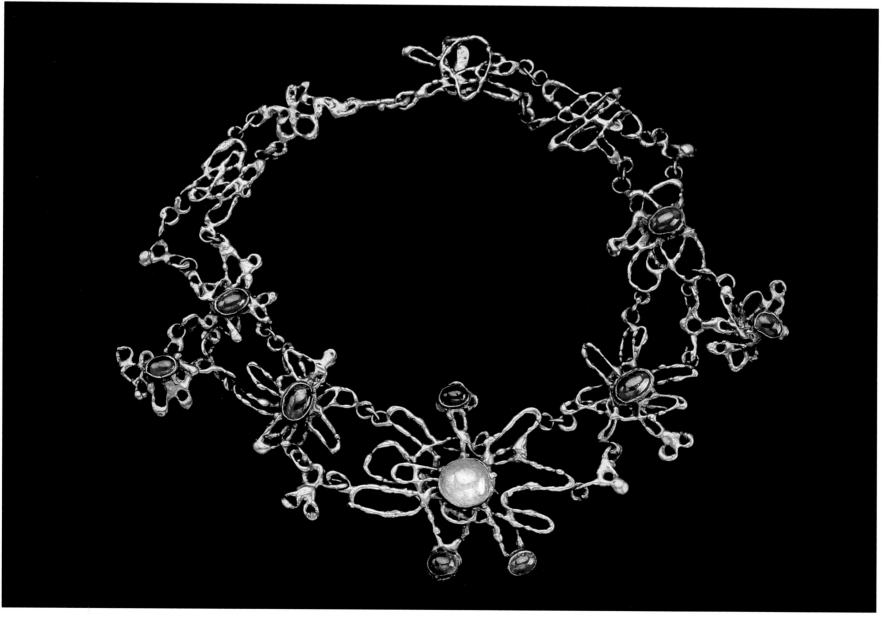

357

MODERN
QUEBEC SILVER
AND GOLD

— ROSALIND PEPALL —

The production of domestic silver in Quebec in the mid-twentieth century was dominated by the Montreal silver retailer and manufacturer Henry Birks and Sons, which had a long history going back to its founding in 1879. The company sold imported silver and, under its own name, produced quality silverware in historic revival styles for the luxury market. In Montreal in the late 1940s, customers who wanted a more modern look in table silver than what Birks offered turned to the Danish-trained silversmith Carl Poul Petersen. He had worked for Birks upon his arrival in Montreal from Copenhagen in 1929, then opened his own studio in 1939, offering handcrafted, Danish-style silver modelled after the designs of the renowned Georg Jensen, with whom he had apprenticed.[1] In the 1950s, when Scandinavian design was the latest trend in interior furnishings, Petersen purposely promoted his Danish heritage, which was an attraction for clients. They also enjoyed visiting the Petersen showroom and workshops at 1221 Mackay Street.

The Museum has the largest and most representative collection of Petersen silver, ranging from compotes, bowls and tea services to elegant flatware, each piece hand-wrought from a flattened ingot of silver (fig. 1). The main body of a Petersen work is rarely decorated, thus drawing all attention to the lustre and brilliance of the metal. Ornament is reserved for finials, handles and bases that are decorated with motifs from nature, such as grape clusters, berries and leaves 358 . The silversmith emphasized the craftsmanship of his pieces by adding the words "hand made" to his impressed signature. Petersen filled a niche in the Montreal market for unique domestic silver with an up-to-date look 360 .

Traditionally, Quebec silversmiths could count on commissions for liturgical silver from churches and religious orders. Just as the Birks firm held the market for domestic tableware, Desmarais & Robitaille, founded in 1909, were the main retailers for church silver. However, there were independent silversmiths, such as Gilles Beaugrand and Marcel Poirier, who were encouraged by the renewal of liturgical art in post-war Quebec.[2]

World War II prevented importations of silver from France, and this gave Quebec silversmiths the opportunity to develop the market for religious silver. The demand for contemporary liturgical art was given a boost by the arrival of Père Marie-Alain Couturier, a Dominican priest who had trained at the Ateliers d'Art sacré in Paris. Couturier had been stranded in New York at the outbreak of war, and in the spring of 1940 arrived in Montreal, where he began teaching and promoting modern religious art. He was supported by the director of Montreal's École du Meuble, Jean-Marie Gauvreau, who even considered forming an "institut d'art religieux."[3] The cultural review Arts et Pensée, founded in 1951 under Père Déziel and Abbé Lecoutey,[4] also provided an impetus to the revival of the applied arts in the province, both religious and domestic. This bi-monthly magazine included articles on Quebec modern church architecture, painting, stained glass, murals, ceramics and tapestry. Gilles Beaugrand's silver was featured in the second issue of March 1951.[5]

Gilles Beaugrand actually began his career in wrought-iron work after studies at the École des Beaux-Arts in Montreal and spending three years in Paris learning the techniques.[6] Upon his return to Montreal in 1931, however, it was a struggle to find commissions for artistic wrought-iron work during the difficult economic times. He finally decided to turn to silversmithing in order to take advantage of the renewal of the religious arts in Quebec, especially when World War II abruptly halted importations from France. The revival of Quebec silver-craft traditions proved propitious for Beaugrand's business, which grew from three employees in 1938 to twenty craftsmen by 1951, employed in all aspects of silver production including engraving, gilding, silver plating, casting and stone setting.

The firm also had an important market in the American cities like Boston and Chicago, as well as Europe.[7] Even though the creation of chalices and other liturgical pieces was the main focus of Beaugrand's business, he also designed domestic silver, such as the Museum's coffee pot 359 , which reflects his awareness of the spare geometric forms that characterized French contemporary silver. Beaugrand acknowledged his debt to the work of Jean Puiforcat, one of the most visible and influential of the French master silversmiths.

The inspiration of Puiforcat and of other French designers, like Jean Fouquet, is evident in the simplicity of design in the cigarette box by Montreal gold- and silversmith Georges Delrue 361 . Its geometric ornamentation and the contrast of tone and texture of the materials reflected contemporary French design. Delrue had set out to be a jeweller at the age of sixteen, when he apprenticed with the Parisian goldsmith Gabriel Lucas, in Montreal, and he finally opened his own studio in 1947. The first works by Delrue to enter the Museum's collection were a gold cross 364 and accompanying amethyst ring made for Monsignor Gérard Couturier, Bishop of Golfe Saint-Laurent (Rimouski). Delrue regarded each piece he composed as a unique creation, like individual works of sculpture. In this cross, the design is kept very simple to set off the sparkling colour of the amethyst. He was the only Canadian designer to be included in "the world's first international exhibition of modern jewellery," organized by the Worshipful Company of Goldsmiths of London at the Victoria and Albert Museum in 1961 365 .

An example of the best work that resulted from the promotion of modern design in Quebec religious silver is the chalice 362 by Montreal native Maurice Brault. Inspired by European models, the only decorative element in the chalice is the gilt wire framework laid over the white enamel base in an attractive juxtaposition of colour and medium. After studies at the École des beaux-arts de Montréal, Brault attended the École nationale d'Architecture et d'Art décoratif at the Abbaye de la Cambre in Belgium, and in 1956 he learned the art of enamelling at the leading Norwegian silver firm, Tostrup, in Oslo.[8] Brault, like Delrue, pursued a career in jewellery, although he continued to carry out commissions for liturgical works and domestic silver. A brooch by Brault shows his delight in contrasting the rich tones of red coral and turquoise with gold in a humorous, Surrealist-inspired composition 366 .

By the 1960s, the demand for domestic silver, which required constant cleaning, was greatly reduced, and goldsmiths Delrue and Brault concentrated on jewellery design. They were joined by other jewellers, like Walter Schluep and Hans Gehrig, who went on to take full advantage of the showcase of Quebec arts at Montreal's Universal and International Exhibition in 1967.

1. For information on the life and work of Petersen, see Gloria Lesser, Carl Poul Petersen: Silversmith, exh. cat. (Montreal: The Montreal Museum of Fine Arts, 2003).
2. Pierre L'Allier, Le renouveau de l'art religieux au Québec 1930-1965, exh. cat. (Quebec City: Musée du Québec, 1999). The Beaugrand studio was integrated into the firm of Desmarais & Robitaille in 1983, and Beaugrand continued to work there until his death in 2005.
3. François-Marc Gagnon, Paul-Émile Borduas (1905-1960) (Montréal: Fides, 1978), p. 91.
4. Lecoutey had also studied at Maurice Denis' Ateliers d'Art sacré. The publication only lasted until 1955, in good part as a result of its conservative approach to art.
5. Julien Déziel, "Gilles Beaugrand, Orfèvre," Arts et Pensée, no. 2 (March 1951), pp. 46–49.
6. Jean-Marie Gauvreau, Artisans du Québec (Montreal: Editions du Bien Public, 1940), pp. 191–196.
7. Déziel, "Gilles Beaugrand," p. 48.
8. Julien Déziel, "Maurice Brault, orfèvre-émailleur," Vie des Arts, no. 4 (September–October 1956), chalice illustrated on p. 19.

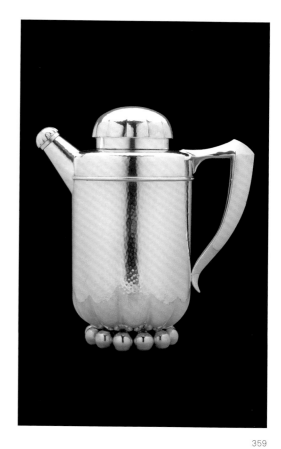

358

359

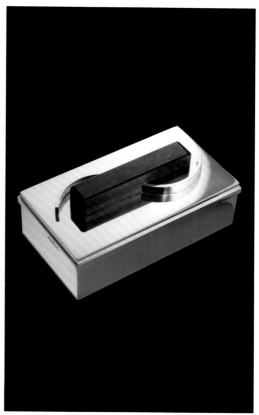

360

361

Fig. 1
Stages in the crafting of a
sterling-silver spoon by Carl
Poul Petersen, Montreal, n.d.

358

Carl Poul Petersen
Copenhagen 1895 –
Montreal 1977
Pair of Compotes
About 1945–55
Silver
20.4 x 21.8 x 19.5 cm
Impressed on underside:
PP / HAND MADE / STERLING;
a head of a lion in a *C*
(the Canadian silver
standard mark)
Gift of the Honourable
Serge Joyal, P.C., O.C.
2004.281.1-2

359

Gilles Beaugrand
Montreal 1906 –
Laval, Quebec, 2005
Coffee Pot
Late 1930s
Silver
23.5 x 21 x 11.5 cm
Impressed on underside:
a head of a lion in a *C*
(the Canadian silver
standard mark);
BEAUGRAND, STERLING
Gift of the Honourable
Serge Joyal, P.C., O.C.
2004.181.1-3

360

Carl Poul Petersen
Copenhagen 1895 –
Montreal 1977
Tea and Coffee Service
1950s
Silver
Teapot: 16.5 x 25 x 16 cm
Coffe pot: 22.5 x 25.5 x 12.5 cm
Sugar bowl: 9.8 x 15 x 10 cm
Creamer: 9.8 x 15 x 10 cm
Impressed on underside
of each piece:
PP / HAND MADE / STERLING;
a head of a lion in a *C*
(the Canadian silver
standard mark)
Gift of the Honourable
Serge Joyal, P.C., O.C.
2006.40.1-4

361

Georges Delrue
Tourcoing, France, 1920 –
Montreal 2010
Cigarette Box
About 1948
Silver, ebony
6.8 x 15.6 x 9 cm
Signature, on side
of cover: *delrue*
Gift of Cécile and
Gérard Baillargeon
1995.Ds.3a-b

WALTER SCHLUEP

Walter Schluep belongs to the generation of foreign-born Montreal jewellers who injected new life into the Quebec tradition. Born in Spain in 1931, Schluep grew up in Switzerland, where he received his training as a jeweller and diamond setter. After arriving in Montreal in 1954, he worked some years as a setter, and then, greatly inspired by the artistic movements of the time, he gave his imagination free rein, lavishly and spontaneously crafting jewellery as well as silverwork.[1]

In the early 1960s, his creations assumed a sculptural character. The lost-wax process, which proved to be a real revelation for Schluep, enabled him to achieve solid shapes with rough, contrasting surfaces. Since then, he has championed imperfection and impulse as essential elements of his approach, perfectly illustrated by the Museum's brooch of 1965 **368**. Set with five rubies, a diamond and a pearl, this piece combines oxidized gold and silver. The organic inspiration of the form—a flower—reflects the artist's desire to find balance in asymmetry. The flattened petals bear the jeweller's fingerprints.

During this same decade, Schluep also became interested in the casting possibilities presented by polystyrene foam, a material used in sculpture as of the mid-1960s. This material can be incised, fashioned and perforated through hot work; the resulting shape can then be reproduced in metal using a process similar to that of lost wax. The Museum possesses a wine goblet **363** in silver and silver gilt whose foot was produced using this technique, which we could call "lost styrofoam." The artist cast a simple DixieCup coffee cup that he had earlier surface-heated to obtain a motif of vertical lines. Once cast in silver, the cup was placed upside down, defying its intended function, to form the foot of the goblet.

Schluep's sculpture-bracelet No. 1 **369** alone sums up all the playing with shapes permitted by the application of the styrofoam technique to jewellery. After casting the shape of the bracelet sculpted in a piece of styrofoam, Schluep subtly added some tubular elements produced using the lost-wax process. One of them hides the way the bracelet is attached to its accompanying wood base. Designed in 1967, this bracelet was presented at the exhibition *Perspective 67*,[2] organized by the Art Gallery of Ontario, where it was awarded first prize in its category. The bracelet was intended as a nod to Canadian Confederation: the special place occupied by Quebec within Canada is symbolized by a black

pearl, while the other provinces are represented by white pearls.

A synthesis of Schluep's work, the gold pendant from 1971 **367** brings together various technical processes and symbolic elements employed by the jeweller. Here, Schluep used the lost-wax process to shape the three lower tubes, while the central, rectangular part, as well as the upper ring, were made using the styrofoam casting technique. Other elements, such as the wheel, were forged. The surface of the three tubes was worked over with a drill. Lastly, these elements, once assembled, assumed the shape of the imaginary individual Schluep used to inspire his figurative brooches and pendants. **vc**

1. Upon his arrival in Montreal, Schluep worked as a setter for Gabriel Lucas and Georges Delrue. **2.** *Perspective 67: The Ontario Centennial Art Exhibition*, exh. cat. (Toronto: Art Gallery of Ontario, 1967), p. ?.

GEORGES SCHWARTZ

Born in France, Georges Schwartz settled in Montreal in 1951, after starting off his career as a jeweller with Paris luxury firm Van Cleef & Arpels. In 1955, he established his own workshop and gradually adapted traditional jewellery-making techniques and principles to contemporary tastes.

The *Œillade* [Eyeing] brooch **370** consists of silver wire forming a trapezoidal mesh box and a tiger-iron emerging out of this cage, creating an allusion to the review of the rights of detainees during Canadian correctional reforms in the early 1970s. This piece is representative of the narrative approach founded in social realities taken by Schwartz as early as the late 1960s. **vc**

362

363

362

Maurice Brault
Born in Montreal in 1930
Chalice
About 1956
Silver, silver gilt,
enamel on copper
H. 10.7 cm; Diam. 10.8 cm
Gift of the Honourable
Serge Joyal, P.C., O.C.
1996.Ds.3

363

Walter Schluep
Born in San Feliu de Guixols,
Spain, in 1931
Wine Goblet
About 1967
Silver, silver gilt
H. 13.4 cm; Diam. 10 cm
Impressed on a plaque
on underside: *Sterling /
SCHLUEP / WS*
(in monogram)
Gift of the Honourable
Serge Joyal, P.C., O.C.
1996.Ds.11

364

Georges Delrue
Tourcoing, France, 1920 –
Montreal 2010
**Bishop's Cross
with Chain**
1957
Gold, amethyst
12.5 x 8.2 x 1.3 cm
Signature, on back:
delrue / 18K
Gift of the artist
1992.Ds.1a-b

365

366

367

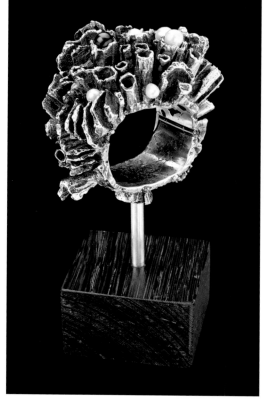

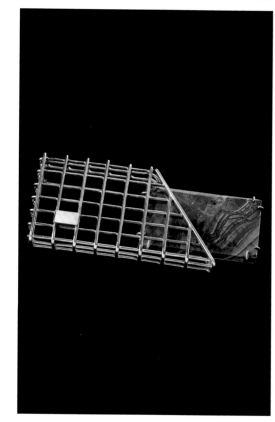

368

369

370

365

Georges Delrue
Tourcoing, France, 1920 –
Montreal 2010
Brooch
1960
Gold
5 x 4.3 x 1.4 cm
Signature and date,
on back: *delrue / 18K / 60*
In the 1961 exhibition of
the Worshipful Company of
Goldsmiths at the Victoria
and Albert Museum, London
Gift of Cécile and
Gérard Baillargeon
1995.Ds.6

366

Maurice Brault
Born in Montreal in 1930
Venus de Cagliari **Brooch**
1960
Coral, turquoise,
irregular pearl, gold
6.2 x 3.1 x 1.5 cm
Signature, on clasp of
brooch: *M BRAULT / 18K*
Gift of Maurice Brault,
C.M., jeweller, goldsmith
1998.50

367

Walter Schluep
Born in San Feliu de Guixols,
Spain, in 1931
Pendant
1971
Gold
13.2 x 7.2 x 3 cm
Signature and date,
on back: *SCHLUEP '71 /
WS* (in monogram) */ 18 K*
Gift of Yolanda Favretto
in memory of her husband,
Angelo
2009.111.1-2

368

Walter Schluep
Born in San Feliu de Guixols,
Spain, in 1931
Brooch
1965
Gold, oxidized silver,
diamond, pearl, rubies
5.7 x 5 x 2.8 cm
Signature, on back:
SCHLUEP, WS (in monogram)
STERLING, 14K
Gift of Nina Bruck
2008.233

369

Walter Schluep
Born in San Feliu de Guixols,
Spain, in 1931
Sculpture-bracelet No. 1
1967
Silver, pearls, exotic
wood (base)
16.9 x 9.4 x 7 x 7 cm
Signature and date, on
inside: *STERLING / WS.* (in
monogram) *SCHLUEP. 1967*
Engraved on a silver plaque
on presentation box:
*Walter Schluep / Gold &
Silversmith / Montreal*;
record of identification
inside of box: *CENTENNIAL
VISUAL ARTS COMPETITION /
CONCOURS D'ARTS PLAS-
TIQUES DU CENTENAIRE /
Perspective '67*
Gift of Walter Schluep in
homage to Michael McConnell
2011.231.1-3

370

Georges Schwartz
Born in Paris in 1929
Œillade **Brooch**
About 1972–73
Silver, yellow gold, tiger-iron
2.6 x 6 x 1.8 cm
Monogram, on back of gold
plaque: *GS* and *18K*; on the
back of the stone's mount:
SCHWARTZ and *STER*
Gift of Georges Schwartz
2010.569

THE ADVENT OF TUBULAR-STEEL FURNITURE

— ROSALIND PEPALL —

More than eighty-five years after the first experiments with tubular-steel furniture, metal furniture is now taken for granted, and the most progressive furniture designers have moved on to new technological processes, producing chairs and tables with computer-generated designs. In the 1920s, architects Marcel Breuer and Mies van der Rohe were at the forefront of the development of tubular-steel furniture.

Once the seamless, extruded steel tube had been invented in the late nineteenth century in Mannesmann, Germany, a tubular-metal frame for a chair seemed a possibility. Marcel Breuer launched the idea with his first tubular-steel chair in 1925—inspired by the bent metal handlebars of his Adler bicycle—while he was teaching at the Bauhaus school in Dessau.[1] Breuer went on to perfect this club chair (fig. 1), and designed other models for tubular-steel chairs and tables, which were included in the groundbreaking *Die Wohnung* housing exhibition of the Deutscher Werkbund, held on the Weissenhof grounds in Stuttgart in 1927. Sixteen leading modernist architects were represented, and the interiors included tubular-steel furniture by Breuer and by Dutch architect Mart Stam, who is recognized as having invented the first cantilevered tubular-steel chair in late 1926 or early 1927.[2] In the same exhibition Mies van der Rohe exhibited a more elegant and springy cantilevered chair than Stam's version.[3] The Mies van der Rohe *MR* chair **371** and a Breuer 1928 cantilevered chair, model B32 **254**, subsequently became the most popular models of tubular-steel furniture.[4]

Assembled like a machine with standardized parts, tubular-steel furniture was functional, lightweight, easily cleaned, and could be used in any room. As Breuer wrote: "Metal furniture is part of a modern room. It is 'styleless,' for it is not expected to express any particular styling beyond its purpose and its construction."[5] Airy in appearance, tubular-steel furniture did not have the visual mass of traditional wooden furniture and it suited modern, open-plan architectural interiors. In a cantilevered, tubular-steel chair, the sitter seemed to be floating on air, as Breuer illustrated in his famous Bauhaus film strip of 1926, depicting the evolution of the chair in the 1920s from a decorative wooden, throne-like model to his tubular-steel club chair of 1925, and ending with a figure simply sitting on air.[6]

Despite the integration of tubular-steel furniture into the most progressive architecture of the time, it was initially expensive and appeared cold and uncomfortable for domestic living. It was only considered appropriate for areas such as bathrooms, sunrooms, kitchens or commercial cafés and bars, where cleanliness was a consideration. It was just a matter of time before the Thonet brothers' furniture empire, famous for its lightweight, bentwood furniture, began to produce tubular-steel pieces that were more durable than bentwood. In 1929, Thonet began selling on the international market tubular-steel designs by the most prominent designers, and this greatly increased the distribution and acceptance of metal furniture.

The year 1930 represented a benchmark for the promotion of tubular-steel furniture, when the Paris Salon des Artistes Décorateurs exhibited a series of model rooms by the Deutscher Werkbund under the direction of former Bauhaus director Walter Gropius. Breuer's furniture produced by Thonet was used throughout the German display, at the same time that French designers like Louis Sognot, René Herbst, Le Corbusier, Pierre Jeanneret and Charlotte Perriand were exhibiting their metal furniture. Once the potential benefits of the shiny, chrome-plated, tubular-steel furniture became obvious, many imitations and interpretations of the original Bauhaus designs were made by furniture manufacturers in Europe and North America.

Fig. 1
Marcel Breuer's *Wassily* Chair (model B3), 1925, example of 1926–27 by Standard Möbel Lengyel & Co., Berlin. Vitra Design Museum, Weil am Rhein.

Fig. 2
Alfred Barr's living room, Beekman Place, New York, about 1933–34, with Philip Johnson's chair and Mies van der Rohe's table.

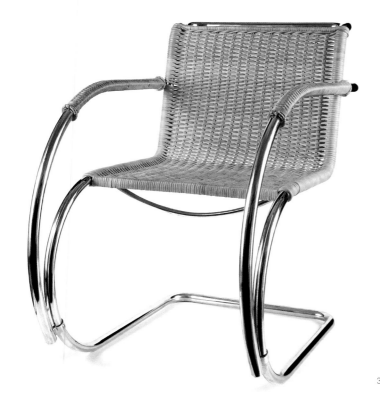

371

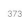

372

373

The simpler the design, the more precise the construction and detailing of a metal chair had to be, as the American architect Philip Johnson would have discovered when he designed a tubular-steel chair about 1932 **372** .[7] Johnson had visited the Bauhaus in Dessau in the autumn of 1929 and had met Mies van der Rohe on another visit to Germany in 1930.[8] This began an enduring admiration for Mies Van der Rohe's architecture that led to a monograph and exhibition by Johnson on the German architect's work.[9] It is no surprise then that Johnson's graceful chair owes its inspiration to Mies van der Rohe's cantilevered chair of 1927. Johnson eliminated the bend in the tubing at seat level by using a slung canvas seat, like a traditional deck chair. A minimalist example of a cantilevered chair, with no screws visible, Johnson's chair successfully achieved Breuer's original aim to give the visual impression of a continuous length of tubular metal for back, arms and base.

Johnson designed this chair and a tubular metal lamp, also in the Museum's collection **373** , for the apartment of Alfred Barr, Jr. (1902–1981), at 424 East Fifty-second Street, New York. Appointed the first director of New York's Museum of Modern Art (MoMA) at its founding in 1929, Barr had spent four days at the Bauhaus school at Dessau in 1927.[10] The impact made upon him had been profound and marked his early tenure at MoMA. He became an ardent proponent of modern architecture, which became known as the "International Style," and he championed the Bauhaus principle of including all aspects of art, including photography, film and industrial design, in the New York Museum's collection. As he wrote, "It is harder to design a first-rate chair than to paint a second-rate painting—and much more useful."[11]

Barr had met Johnson in 1929 and encouraged his interest in modern architecture and design, and in 1932 brought him into the MoMA as head of the Department of Architecture. As director of the institution, Barr set out to change public attitudes to architecture and design by presenting challenging exhibitions, such as his first groundbreaking show, *Modern Architecture: International Exhibition*, in 1932, organized by Henry-Russell Hitchcock together with Johnson. In 1934, an exhibition on *Machine Art*, curated by Johnson, included tubular-steel furniture by Breuer and Le Corbusier, along with industrial appliances and tools.

Barr is recorded as telling Johnson that he wanted modern furniture for his apartment, but that the designs by Le Corbusier, Breuer and Mies van der Rohe were too expensive.[12] Johnson stepped in with the offer of his chair and lamp. Different photographs of the Barr apartment do, however, show a range of tubular-steel furniture by different designers, including Johnson's armchair and Mies van der Rohe's circular coffee table (fig. 2), as well as Breuer's set of shelves marketed by the Thonet company as *B22* in 1928,[13] now in the Montreal Museum's collection **374** .

Interest in tubular-steel furniture reached as far away as Montreal, where a young interior decorator, Jeannette Meunier Biéler, was inspired by the photographs in the German publication *Innen Dekoration* and by the works she saw on a visit to Europe in 1931. The Museum's glass and tubular-steel desk by Meunier Biéler **375** is a rare example of Bauhaus influence in Canadian design of the early 1930s (fig. 3). The only place the decorator could find skilled workers to make the tubular-steel supports for the desk, modelled after Breuer models, was at a Montreal aircraft manufacturer.[14] In 1932, most Canadians, like Americans, were furnishing their houses with revivals of English period furniture. Meunier Biéler was ahead of her time in her awareness of the most progressive designs emerging from Europe.

It is ironic that after five years of designing tubular-steel furniture, and just as the world was paying attention to this new development, Marcel Breuer moved on to experiment with aluminum,[15] and ultimately, he developed plywood furniture—which preoccupied him along with his architectural projects until his death, in 1981. In the World War II years, when any available metal was directed towards war production and tubular-steel furniture seemed less original, attention turned to new developments in plywood furniture, and a renewed appreciation for the warmth and tone of wood, resulting in a great demand for Scandinavian wood furniture in the 1950s.

The re-edition of the metal furniture of Breuer, Mies van der Rohe, Le Corbusier and Perriand in the 1960s, which continues today, shows the popularity of the minimalist, lightweight, tubular-steel designs, especially for the office and dining areas. Breuer's achievement in creating furniture from slender lines of steel "as if drawn in space"[16] prepared the way for the radical twenty-first-century digital rapid-prototyping designs of the Swedish collective Front **702** , whose pieces are literally produced from their drawings performed in the air.[17]

1. Christopher Wilk, *Marcel Breuer: Furniture and Interiors* (New York: Museum of Modern Art, 1981), p. 37.
2. Christopher Wilk, "Sitting on Air," in *Modernism 1914–1939: Designing a New World*, ed. Wilk (London: Victoria and Albert Museum, 2006), p. 230.
3. The Mies chair was actually inspired by a sketch by Stam of his cantilevered chair. Wilk 2006, p. 236.
4. Mies van der Rohe's cantilevered chair was manufactured by Berliner Metallgewerbe Joseph Müller, Berlin (1927–1930), Bamberg Metallwerkstätten, Berlin, 1931, MR10 (without arms), MR20 (with arms); Thonet made a version, MR533 and MR534, from 1932 to present, and Knoll International, 256 and 256A, from 1964 to present. (Ludwig Glaeser, *Ludwig Mies van der Rohe: Furniture and Furniture Drawings from the Design Collection and the Mies van der Rohe Archive* [New York: Museum of Modern Art, 1977], pp. 20–23.)
5. Marcel Breuer, "Metallmöbel und moderne räumlichkeit," *Das Neue Frankfurt*, vol. 2, no. 1 (1928), p. 66.
6. Published in *Bauhaus* (July 1926), cited in Wilk 1981, p. 41.
7. The date and authentication of this chair and a tubular metal lamp by Philip Johnson is in the correspondence between Johnson and David Hanks, September 13 and October 4, 1988 (MMFA Archives, file D88.143.1).
8. Franz Schulze, *Philip Johnson, Life and Work* (New York: Alfred A. Knopf, 1994), pp. 67–68.
9. Philip C. Johnson, *Mies van der Rohe* (New York: Museum of Modern Art, 1947).
10. Rona Roob, "Alfred H. Barr, Jr: A Chronicle of the Years 1902–1929," *The New Criterion*, special issue (Summer 1987), p. 14.
11. Alfred H. Barr, Jr., Preface to the exhibition catalogue *Bauhaus 1919–1928* (New York: Museum of Modern Art, 1938), as cited in eds. Irving Sandler and Amy Newman, *Defining Modern Art: Selected Writings of Alfred H. Barr, Jr.* (New York: Harry N. Abrams, 1986), p. 100.
12. Margaret Scolari Barr, "Alfred H. Barr, Jr., and the Museum of Modern Art: A Biographical Chronicle of the Years 1930–1944," *The New Criterion*, special issue (Summer 1987), p. 25.
13. Thonet model *B22*, Illustrated in Wilk 1981, p. 79.
14. Rosalind Pepall, "Jeannette Meunier Biéler, Modern Interior Decorator," *Journal of Canadian Art History*, vol. 25 (2004), pp. 126–145. In a 1988 interview with the designer, she could not remember the company that had made the desk or her tubular-metal chairs.
15. This was partly as a result of a long series of court suits between Thonet and furniture manufacturer Anton Lorenz over the rights to the design of a cantilevered tubular-steel chair. See Alexander von Vegesack and Mathias Remmele, *Marcel Breuer: Designer and Architect* (Weil am Rhein: Vitra Design Museum, 2003), pp. 88–94.
16. Marcel Breuer, "Metallmöbel und modern Räumlichkeit" (1928), cited in *Bauhaus 1919–1933: Workshops for Modernity*, eds. Barry Bergdoll and Leah Dickerman (New York: Museum of Modern Art, 2009), p. 230.
17. See p. 392, fig. 1.

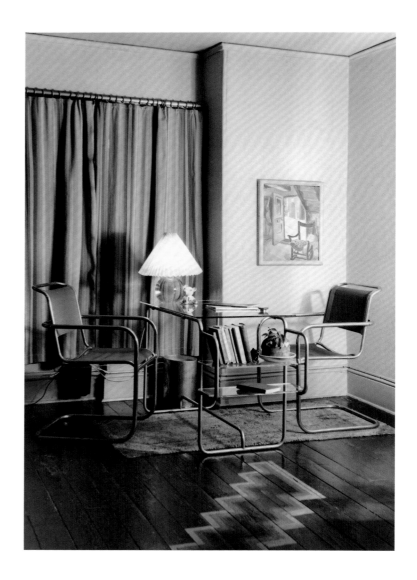

Fig. 3
Tubular metal furniture
in André Biéler and Jeannette
Meunier Biéler's apartment,
Peel Street, Montreal, 1933.

374

Marcel Breuer
Pécs, Hungary, 1902 –
New York 1981
B22 **Set of Shelves**
1928
Chrome-plated steel,
wood, plastic
60 x 75.1 x 40 cm
Produced by Thonet Brothers
Metal label attached to
tubular steel, on back:
MADE IN CZECHOSLOVAKIA
Liliane and David M. Stewart
Collection, gift of American
Friends of Canada through
the generosity of Victoria Barr
from the estate of Mr. and
Mrs. Alfred H. Barr, Jr.
D88.142.1

375

Jeannette Meunier Biéler
Sainte-Anne-de-Sabrevois,
Quebec, 1900 –
Kingston, Ontario, 1990
Desk
About 1932–33
Tubular chrome-plated steel,
glass (not original)
71 x 135 x 54 cm
Gift of Philippe Baylaucq
and Sylvie Biéler Baylaucq
2001.186.1-4

AMERICAN INDUSTRIAL DESIGN: 1930s AND 1940s

— ROSALIND PEPALL —

Modern industrial design is said to have been introduced into the American household through the kitchen, bathroom and garage. The increased use of electricity and the development of mass-produced industrial appliances brought about dramatic changes in everyday living in the home but also in the office, in the workshop and in recreational activities.

The Museum has a large collection of American industrial design works from the period between 1930 and 1950 as a result of a generous gift from American collector Eric Brill to the Liliane Stewart Program of Modern Design in Montreal. Brill began acquiring American industrial design in 1970, spurred on by his boyhood memories of trips on Boeing-made Pan American Stratocruiser propeller airplanes, which date from 1949. By the time the collection was given to the Montreal Museum of Fine Arts by Mrs. Stewart, it had grown to include over nine hundred examples of American and Canadian industrial design.[1]

The majority of objects in this gift were made for the kitchen, a room that dramatically increased in importance as family life revolved more and more around this centre of meal preparation and housekeeping activities. Appliances such as coffee makers, toasters, mixers, and containers for serving or storing food are all represented in the collection. Manufacturers of these products felt that a pleasing design made a happy customer. In fact, a whole range of industrial appliances—irons, heaters, electric fans, vacuum cleaners, sewing machines, scales, hairdryers and radios—were transformed into attractive designs to suit the householder.

In the period following the Great Depression, manufacturers were actively competing to reach the middle-class consumer, and they quickly realized that a functional object had to be not only efficient, but also smartly packaged to win over the customer. The goal of the industrial designer was to create an aesthetically pleasing object, be it a radio or refrigerator.

The look of sleek ocean liners, silvery, aluminum aircraft and bullet-shaped trains (fig. 1) captured the American imagination in the 1930s. Machines with smooth, continuous surfaces and rounded corners made of shiny industrial materials were thought to perform with great speed and efficiency. The aerodynamic forms of airplanes and trains thus inspired the popular "streamlined" style in consumer products, architecture and interior decoration during the Depression years until the mid-1940s. Many of the works in the Museum's collection have names like *Zephyr*, *Speedmatic*, *Streamliner* and *Airflow*. In addition to streamlined forms, new materials, shapes and colours in industrial products provided novelty and humour, so that an ordinary soda-water bottle, branded "Sparklet," could brighten a party with its bright red, enamelled-steel cover **378**; an office duplicator in black Bakelite had the appearance of a fast-moving

train; a potato baker **380** could resemble a work by Brancusi; and an iron **384** seemed ready for lift-off from the ironing board.

THE DESIGNERS

The 1930s marked the emergence of professional industrial designers, many of whom had trained in illustration or advertising and knew how to lure the customer through packaging and promotion. Some of America's most distinguished early industrial designers are represented in the Museum's collection, for example, Walter Dorwin Teague (1883–1960), who was the founder and first president of the American Society of Industrial Designers. Although he worked for major corporations such as Ford, U.S. Steel and Corning Glass, he was most identified with his designs for his lifelong client, Eastman Kodak Company **379**. Henry Dreyfuss (1904–1972) was one of the most successful American industrial designers of the 1930s, noted for his streamlined designs for New York Central Railroad's Twentieth Century Limited train and his interiors for Pan American Airlines. Raymond Loewy (1893–1986) grew up in France, but moved to New York in 1919 and became America's most prolific industrial designer. He opened his own industrial design firm in 1929, and had as clients some of the most important American companies: Westinghouse Electric, Coca-Cola, United Airlines, Shell Oil and International Business Machines (IBM), to name a few.

Harold van Doren (1895–1957) introduced industrial design to the Midwest through the firm he opened in 1931 with John Gordon Rideout (1898–1951) in Toledo, Ohio, and through his book *Industrial Design: A Practical Guide*, published in 1940. Norman Bel Geddes (1893–1958), whose book *Horizons* (1932) was influential in the promotion of Streamline design, was later celebrated for his Futurama display ride in the General Motors pavilion at the 1939 New York World's Fair. The works in the Museum's collection by John Morgan (1903–1986), chief designer for Sears, Roebuck and Company from 1934 to about 1944, range from a sewing machine to air compressors and outboard motors.

The decades of the 1930s and 1940s represent a critical period in the development of American industrial design, and this collection reflects its evolution and the inventiveness of the country's designers and manufacturers.

1. A selection of these works was shown in the travelling exhibition organized by the Liliane and David M. Stewart Program for Modern Design: accompanying catalogue by David A. Hanks and Anne Hoy, *American Streamlined Design: The World of Tomorrow*, exh. cat. (Paris: Flammarion, 2005). The exhibition was presented at the Montreal Museum of Fine Arts in 2007.

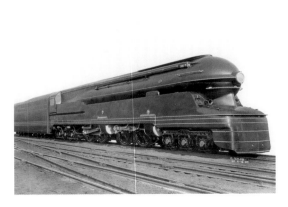

Fig. 1
Raymond Loewy's S1 Locomotive for Penn Central Corporation, 1939.

376

Walter Dorwin Teague
Decatur, Indiana, 1883 – Flemington, New Jersey, 1960
Executive **Desk Lamp (model 114)**
1939
Bakelite, aluminum, cellulose film
32.7 x 29.5 x 25 cm
Produced by Polaroid Corporation, Cambridge, Massachusetts
Liliane and David M. Stewart Collection
D82.113.1

377

Barton T. Setchell
Minnesota 1907 – Boynton Beach, Florida, 1995
Radio
1946
Bakelite, plastic
17.5 x 25.5 x 17 cm
Produced by Setchell-Carlson Inc., Saint Paul, Minnesota
Liliane and David M. Stewart Collection, gift of Eric Brill
2010.1500

378

David Chapman
Gilman, Illinois, 1909 – Chicago 1978
Siphon
1940
Chrome-plated and enamelled steel
20.5 x 12 x 12 cm
Produced by Sparklet Devices, Inc., Division of Knapp-Monarch Company, Saint Louis, Missouri
Liliane and David M. Stewart Collection, gift of Eric Brill
2010.1340

376

377

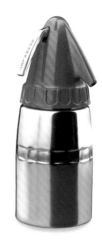

378

379

380

381

382

383

384

379

Walter Dorwin Teague
Decatur, Indiana, 1883 –
Flemington, New Jersey, 1960
Bullet Camera
1937
Bakelite, enamelled
steel, glass
7 x 12 x 5 cm
Produced by Eastman
Kodak Company, Rochester,
New York
Liliane and David M. Stewart
Collection, gift of Eric Brill
2010.1640.1-2

380

Na-Mac Products
Corporation
Los Angeles, California
Top-O-Stove Potato Baker
About 1935
Aluminum
10 x 18.5 x 11 cm
Liliane and David M. Stewart
Collection, gift of Eric Brill
2010.1306

381

Anonymous
Mercury Flyer
Toy Train Engine
About 1938
Painted steel
21.5 x 61.5 x 16.7 cm
Liliane and David M. Stewart
Collection, gift of Eric Brill
2010.1974

382

Henry Dreyfuss
New York 1904 –
South Pasadena,
California, 1972
**Thermos Pitcher
and Tray (model 539)**
1935
Aluminum, enamelled steel,
glass, rubber
14.9 x 15.6 x 12 cm
Produced by American
Thermos Bottle,
Norwich, Connecticut
Liliane and David M.
Stewart Collection
D81.155.1-2

383

Lurelle van Arsdale Guild
Syracuse, New York, 1898 –
Darien, Connecticut, 1985
Vacuum Cleaner (model 30)
About 1937
Aluminum, chrome-plated
and enamelled steel,
vinyl, plastic
18.5 x 58.5 x 21.5 cm
Produced by Electrolux
Corporation, Old Greenwich,
Connecticut
Liliane and David M. Stewart
Collection, gift of Eric Brill
2010.1856

384

Clifford Brooks Stevens
Milwaukee, Wisconsin, 1911 –
Thiensville 1995
Edward P. Schreyer
Romania 1896 –
Boca Raton, Florida, 1981
Petitpoint Iron
About 1941
Chrome-plated steel,
steel, Bakelite
12.8 x 26 x 12.5 cm
Produced by Waverly Tool
Company, Sandusky, Ohio
Liliane and David M. Stewart
Collection, gift of Eric Brill
2010.1825

RICHARD BUCKMINSTER FULLER'S *DYMAXION* BATHROOM

— ROSALIND PEPALL —

Montrealers are especially aware of the significance of American designer Richard Buckminster Fuller, as the city's skyline includes his celebrated geodesic dome, which served as the American pavilion at the 1967 Universal and International Exposition in Montreal[1] (fig. 1). Fuller was issued a patent in the United States for his geodesic dome in 1954, and the technical feat of building such a radical structure represented the culmination of his utopian visions for architecture of the future.

An irrepressible personality and enthusiastic inventor, Buckminster Fuller began experimenting in 1927 with plans to make a prefabricated shelter readily mass-produced and easily installed in any urban or rural environment. When he exhibited a model of his 4D Tower in a *House of the Future* show at Marshall Field's department store, Chicago, in 1929, the name "Dymaxion" was coined to promote it. In his own words: "Because they [Marshall Field's] wanted a jazzier name for the house, the two advertising men made a list of words they heard me use in what they thought were my most important sentences. Then they took the key words and using the most prominent syllables of the most prominent words . . . they made another list. I was permitted to throw out the most objectionable words. We were left with *dynamic*, *maximum*, and *ion*, out of which they fashioned 'Dymaxion.' Marshall Field made me a present of the name."[2]

In the course of his ongoing experiments, Fuller invented a three-wheeled *Dymaxion* car—intended for flight as well as for the road—which was exhibited in the Century of Progress International Exhibition in Chicago in 1933.

Fuller's prototype for the first prefabricated *Dymaxion* house, made of aluminum and stainless steel, was not built until 1945 in Wichita, Kansas (fig. 2).[3] However, a first prototype for a *Dymaxion* bathroom was made in 1930–31, and afterwards Fuller developed a more sophisticated model that was patented in 1940 (fig. 3).[4] A bathtub, shower, toilet and sink were all integrated into a two-chambered, plated-copper unit measuring five by five feet and weighing about 420 pounds. In one cubicle was the toilet across from the sink, and in the other a bath with a step into it. The mechanics of the plumbing, including outlets for the shower head and taps, were concealed in the partition between the two chambers. Prefabricated high walls could also be attached to the complete unit.

According to an advertisement of 1937, this bathroom could be installed in three hours by two men with a "thud, click, snap and presto."[5] Twelve prototypes of Fuller's bathroom were produced by the large copper manufacturer Phelps Dodge Corporation, New York, between 1936 and 1938. A model of Fuller's *Dymaxion* house and a bathroom prototype were included in New York's Museum of Modern Art exhibition *Art of Our Time* in 1939. The Montreal Museum's example **385** was installed during the remodelling of a brownstone house at 44 East Eighty-second Street, New York, which belonged to Fuller's friend, naval architect Jasper Morgan.[6]

Fuller later explained that copper was an easy metal to work with to create a prototype. The copper unit was die-stamped in sections and then surfaced with an alloy of tin and antimony to give the bathroom a silvery, clean look.[7] Fuller had intended the *Dymaxion* bathroom to be made in fibreglass-reinforced polyester resin, but the technology was not advanced enough in 1940. Fuller speculated that apartment dwellers could take out the bathroom unit when they moved or, as in the case of the Museum's example, when they renovated.[8]

1. This dome on Île Sainte-Hélène, Montreal, was designed by Buckminster Fuller with Sadao & Geometric Inc.

2. Quoted in *Buckminster Fuller: An Autobiographical Monologue/Scenario*, ed. Robert Snyder (New York: St. Martin's Press, 1980), p. 54.

3. K. Michael Hays and Dana Miller, eds., *Buckminster Fuller: Starting with the Universe*, exh. cat. (New York: Whitney Museum of American Art in association with Yale University Press, 2008), p. 219.

4. The drawings for the two versions of the bathroom unit, including the United States patent application, serial no. 207,518, are illustrated in *The Artifacts of Richard Buckminster Fuller: A Comprehensive Collection of His Designs and Drawings in Four Volumes*, ed. James Ward, (New York; London: Garland, 1985), vol. 2, pp. 4–51.

5. Advertisement in *The Ladle* (April 1937), published by the New York State Association of Master Plumbers. The advertisement is illustrated in Ward 1985, p. 6.

6. "The Remodelled Town House for Jasper Morgan," *The Architectural Forum* (September 1938), pp. 210–212. The plans show that two of the Fuller bathrooms were installed on the fourth floor of the house.

7. Letter from Fuller to the then owner of the house, October 12, 1979 (MMFA Archives, file D96.102.1a-c).

8. This prototype was included in the travelling exhibition *American Streamlined Design: The World of Tomorrow* (eds. David A. Hanks and Anne Hoy [Paris: Flammarion, 2005], p. 139, cat. 78).

Fig. 1
Richard Buckminster Fuller and Shoji Sadao's geodesic dome for the American Pavilion at Montreal's Universal and International Exposition, 1967.

Fig. 2
Richard Buckminster Fuller's *Dymaxion* House, 1945–46, Butler Manufacturing Company, Kansas City, Missouri.

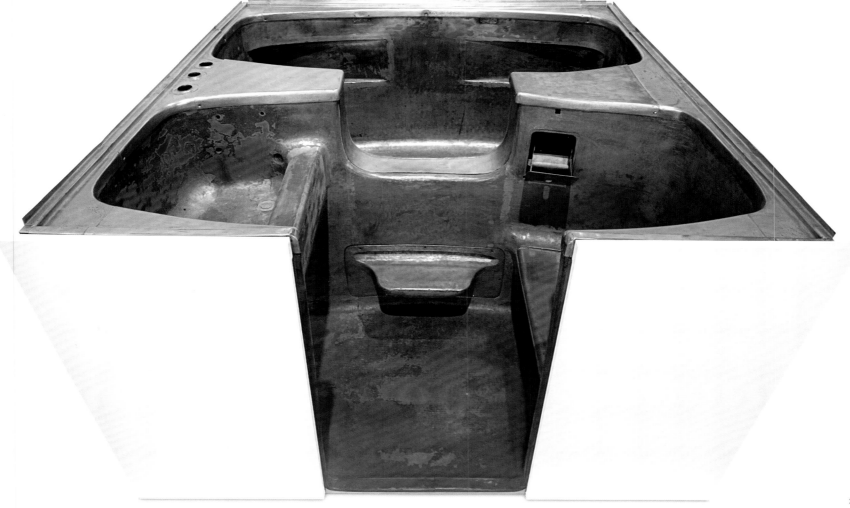

385

Richard Buckminster Fuller
Milton, Massachusetts,
1895 – Los Angeles 1983
Dymaxion **Bathroom**
1936
Tin and antimony
alloy-plated copper
75.2 x 152 x 69 cm
Gift of the American Friends
of Canada through the
generosity of Samuel L.
Rosenfeld, in memory of
June S. Rosenfeld
D96.102.1a–c

Fig. 3
Richard Buckminster
Fuller's patent drawing for
"Prefabricated Bathroom,"
United States Patent and
Trademark Office, 1938–40.

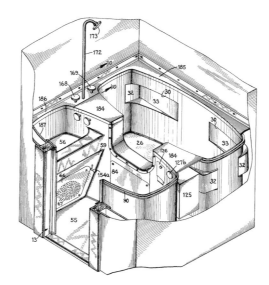

SPARE ELEGANCE FOR THE OFFICE: FURNITURE FROM THE SEAGRAM BUILDING, NEW YORK

— ROSALIND PEPALL —

New York's Seagram Building at 375 Park Avenue, between Fifty-second and Fifty-third Streets, completed in 1957, has become a landmark of American architecture (fig. 1). This bronze and glass skyscraper, set back from the street by a plaza, was the first New York building German architect Mies van der Rohe designed after he immigrated to the United States in 1938. Joseph E. Seagram & Sons, a producer of distilled spirits and wine, was built up from the 1920s into a corporate empire, headquartered in Montreal, by Samuel Bronfman (1889–1971). In the early 1950s, when Bronfman wished to commission a new building for Seagram's New York offices, he invited Mies van der Rohe to design it, on the advice of his daughter, Phyllis Lambert. American architect Philip Johnson was Mies van der Rohe's partner for the project; Kahn and Jacobs were associate architects, and Lambert was director of planning. Phyllis Lambert has written eloquently on the building, stating that its success "lay in the discipline of structure and enclosure, the quality of the materials and the refinements of the curtain wall."[1] The interior office layout and furnishings of the Seagram Building were under the direction of Philip Johnson Associates, J. Gordon Carr and Knoll Associates. After the building's completion in 1958, an *Interiors* magazine editor wrote that the interiors "very satisfactorily continue the impressions of the architecture: the amplitude of scale, the quiet luxury, the devotion to quality, the fastidiousness of detail."[2]

Most of the furniture for the Seagram offices was not designed specifically for the building, but was selected from existing models by leading designers such as Eero Saarinen, Charles Eames, Hans Wegner, Jens Risom and, most appropriately, the building's architect, Mies van der Rohe. Knoll Associates, a New York-based international furniture manufacturer and distributor, had gained a reputation for its office furniture, and provided many of the Seagram Building's furnishings. Florence S. Knoll, vice-president of the company, had established a Planning Unit to offer advice on interior design and layout to clients, which included large corporations such as the CBS New York headquarters.[3] A letter from Florence Knoll to Seagram's in 1955 laid out an itemized proposal of the services that the Knoll Planning Unit could offer, including "interior design, colors, materials, selection and coordination of furniture and furnishings."[4]

Throughout the Seagram offices, Eero Saarinen's open-back desk chair **386** on cast aluminum swivel base (model No. 71), produced by Knoll Associates, was almost a fixture (as was his four-legged model). The organic, rounded shape of the chair resulted from Saarinen's first experiments with Charles Eames in moulded-plywood forms. Saarinen developed the technology further by using a compound of fibreglass and plastic to create a fluid, sculptural shape that offset the sharp angles and severity of metal and glass furniture. This No. 71 desk chair was first used for offices in Saarinen's General Motors Technical Center in Warren, Michigan (1945–56).[5] In Seagram's major executive offices and in the reception hall, located on the fifth floor (Seagram's occupied the second to the eighth floors of the thirty-eight-storey building), Saarinen's No. 71 chair was matched with a Jens Risom desk. Risom had immigrated to the United States from his native Copenhagen in 1939, and his designs for wood chairs were first made by Knoll in 1941. In 1946, Risom established his own firm for furniture and textile design and eventually specialized in office furniture. Jens Risom Design Incorporated submitted a proposal with cost specifications for an executive desk, executive storage cabinet, secretarial desk and typewriter platform, reception desk and two conference tables for the Seagram Building in April 1957.[6] The Museum's desk **388** has an original black leather top, ebonized oak drawers, "modesty panel" to hide the legs, all supported on a "satin chrome" steel frame. Other desks by Risom had green leather tops or were made of walnut veneer rather than leather and oak.[7] An elegant, understated design in black, the desk's drawers seem suspended within the frame, and either set of drawers could be removed to give the desk a lighter appearance.

A photograph of one of the largest executive offices (fig. 2) shows a Risom-designed, ebonized oak cabinet and black upholstered (probably in leather) Saarinen desk chair, which match the tone of the black leather and stainless-steel Mies van der Rohe furniture in the rest of the room, including a leather-topped, tubular metal table—the most minimal expression of a desk—custom-made by New York metal manufacturer Treitel-Gratz Company. The mellow tones of English oak panelling in the wall partition, white fish-net curtains on the floor to ceiling windows, the light-toned ochre carpet, as well as the luminous ceiling panels, softened the dark tones of black leather and the cool sheen of the metal furniture. This office, like some others, included a corner sitting area, which featured a pair of Mies van der Rohe's *Barcelona* chairs, ottoman and square coffee table as well as three of his *Brno* armchairs **387** in black leather and flat stainless steel, all produced by Knoll Associates. The famous *Barcelona* chair and ottoman, originally designed for the German pavilion at the 1929 International Exposition in Barcelona, grouped with Mies van der Rohe's glass and metal coffee table, were especially favoured by Knoll Associates for executive office furnishings. The table and the *Brno* chairs were originally designed in 1929–30 for the Tugendhat house Mies van der Rohe built in Brno, Czechoslovakia.[8] Philip Johnson so admired these chairs in which the loop of the front arm and leg had been flattened to fit in front of a table that he used them throughout the Four Seasons restaurant on the main floor of the Seagram Building.

Another model of Mies van der Rohe's chair in the Museum's collection and used in the Seagram Building was the tubular steel *MR 40* lounge chair with arms and continuous roll and pleat leather cushion, first made in 1931.[9] This one from Knoll may have been ordered when the architecture firm of Pasanella and Klein undertook renovations and restoration of the interior furnishings for Seagram in 1978–79.[10]

Throughout the Seagram offices, the interiors lent an air of spare elegance. Large tapestries or paintings by such artists as Joan Miró, Stuart Davis and Fernand Léger provided vibrant colour to the interior space. As noted in the 1958 *Interiors* article: "Tapestries and paintings—and the dress of the human occupants—afford almost the only color throughout this neutral-hued, smoothly luminous, prodigally spacious domain."[11]

1. Phyllis Lambert, *Mies in America*, exh. cat (Montreal: Canadian Centre for Architecture [CCA], and New York: Whitney Museum of American Art; Harry N. Abrams, 2001), p. 400.
2. John Anderson, "Seagram Building: Interior in Keeping with a Masterpiece," *Interiors* (New York), vol. 118, no. 5 (December 1958), p. 76.
3. Bobbye Tigerman, "The Heart and Soul of the Company: The Knoll Planning Unit, 1944–65," in *Knoll Textiles 1945–2010*, ed. Earl Martin (New Haven; London: Yale University Press for Bard Graduate Center, New York, 2011), pp. 192–193.
4. Letter from Florence S. Knoll to Joseph Seagram and Sons, Inc., New York, December 8, 1955 (Records of the Seagram Curator's Office, Fonds Seagram Building, box 134-030, Canadian Centre for Architecture, Montreal)—(Copy in the possession of Phyllis Lambert). I would like to thank Phyllis Lambert for her help in leading me to documentation on the interior planning of the Seagram Building. Also, Roberta Prevost of the CCA was most helpful in providing me with copies of original archival records, and thanks as well to Renata Guttman.
5. R. Craig Miller, "Interior Design and Furniture," in *Design in America: The Cranbrook Vision 1925–1950* (New York: Harry N. Abrams, 1983), pp. 115–116.
6. Letter from Jens Risom to J. Gordon Carr, April 22, 1957 (Collection Seagram Company, Ltd., accession 2126, record group 2, series X, box 851, Hagley Museum and Library, Wilmington, Delaware (Copy in the possession of Phyllis Lambert). Jens Risom confirmed that the Museum's desk was designed by him, in correspondance with the author, April 5, 2012.
7. Anderson 1958, and photographs of the interiors taken by Ezra Stoller in 1958: http://www.estostock.com/swishsearch?keywords=seagrambuildingnewyork (accessed March 16, 2012).
8. Ludwig Glaeser, *Furniture and Furniture Drawings from the Design Collection and the Mies van der Rohe Archive* (New York: Museum of Modern Art, 1977), pp. 64 and 73.
9. Ibid., pp. 28–29.
10. Nicholas Polites, "The Seagram Building: Living with a Landmark" (New York: Pasanella and Klein, 1986). The furniture discussed here was transferred from the Seagram Building to the CCA Foundation office, Montreal, in 1994.
11. Anderson 1958, p. 76.

386

387

388

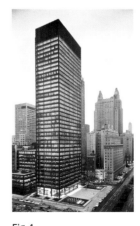

Fig. 1
Seagram Building, New York,
by Mies van der Rohe with
Philip Johnson, completed
in 1957.

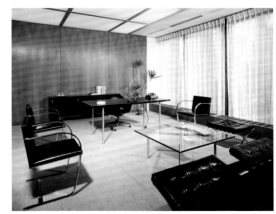

Fig. 2
Seagram Building, New York:
Seagram executive office
with furniture by Mies van der
Rohe (desk, *Barcelona* chairs
and ottoman, *Brno* chairs,
coffee table), Eero Saarinen
(desk chair) and Jens Risom
(cabinet), about 1958.

ALUMINUM AND DESIGN

— PAUL MAKOVSKY —

JACK LUCK

Canadian designer Jack Luck earned a reputation for his work in aluminum in the late 1940s and 1950s. After immigrating to Canada from England in 1930, he joined the Alcan subsidiary Aluminum Goods, in Toronto, and later moved to Alcan's head office in Montreal to become a draftsman in the engineering department. When Alcan founded Aluminum Laboratories in 1936, he joined the new division and followed it to Kingston in 1949.[1]

Luck's simple, functional design for pots and pans, kettles and coffee makers under the brand names Wear-Ever Aluminum and Mayfair produced the standard equipment of North American kitchens for years. The Museum's coffee pot `389` represents one of the first new Canadian designs introduced after the war. It was promoted by Canada's National Industrial Design Council in 1949, and was part of Canada's display in the Industrial Design Gallery of the Tenth Milan Triennale in 1954. **PM**

1. Biographical information on Jack Luck comes from Rachel Gotlieb and Cora Golden, *Design in Canada since 1945: Fifty Years of Teakettles to Task Chairs* (Toronto: Alfred A. Knopf Canada and the Design Exchange, 2001), pp. 244–245.

EGMONT H. ARENS AND THEODORE C. BROOKHART

The Ohio-based Hobart Manufacturing Company widely distributed the *Streamliner* `390`, a medium-sized electric meat slicer with a circular blade, for use in the food service industry from 1944 to 1985, testifying to the popularity of its design. Patented in 1943,[1] the design resulted from a collaboration between Egmont Arens, a New York-based industrial designer, and Hobart-employee Theodore C. Brookhart. The patent for the slicer was filed in 1942, but it was not manufactured until 1944 due to the scarcity of aluminum during World War II. The dominant style of the 1930s and 1940s in the United States, known as Streamlined design, inspired its name. The multiple elliptical curves throughout the appliance exemplify how static objects were given the aerodynamic form originally found on high-velocity vehicles such as trains and airplanes, which were synonymous with speed and modernity. While the name appears twice on this model, it is not found on later models, reflecting changes in taste and marketing concerns. Arens called his design process "industrial humaneering," which gave an object colour and contour relaxing to the eye, a texture and shape that was pleasing to the touch and a design that was "easy on the muscles." He applied it to everything, from a locomotive to a baby carriage, a jukebox to a cigarette lighter, and even an everyday meat slicer. **PM**

1. David A. Hanks and Anne Hoy, *American Streamlined Design: The World of Tomorrow* (Paris: Flammarion, 2005), p. 269, note 42 (entry pp. 104–105). 2. Don Romero, "Egmont Arens—Industrial 'Humaneer,'" *Mechanix Illustrated* (December 1946), pp. 97–102 (http://blog.modernmechanix.com/industrial-humaneer/ [accessed July 12, 2012]).

HANS CORAY

With the end of World War II, aluminum, used heavily in the war effort, was promoted for domestic use by its manufacturers as a material for making a wide array of goods that were lightweight, inexpensive and durable. Aluminum was soon found in everything from outdoor furniture and housewares to exterior cladding for buildings, and by 1958, even beer cans.[1]

The Swiss were forerunners in the development of aluminium for furnishings, for example, in this chair by Hans Coray `391`. Coray, a self-taught designer, created this lightweight stacking chair for a competition in 1938 sponsored by the Swiss Parks Authority in conjunction with the 1939 Swiss National Exhibition, the Schweizerische Landesaustellung—from which the *Landi* chair's name derives—in Zurich. Since the chairs were to have a link to Switzerland, it was decided that the material of choice be the "Swiss metal" aluminum, because it manifested both the technical progress of the country pre-World War II and it was an important Swiss export. (By 1938, Switzerland ranked sixth in the world in aluminum production, constituting five to six percent of total Swiss exports.)

The chair is made up of five components: two half-round aluminum parts bent to form the legs and armrests; two transverse connecting pieces to produce a frame; and the thin perforated plate forming the one-piece seat and backrest, which screws into the frame. Weighing in at three kilograms, the chair used the latest developments of the time in aluminum technology, both in terms of newly refined alloys and hardening treatments. The characteristic perforations of the seat, borrowed from zeppelin construction, minimize the amount of metal needed and ensure lightness. They also prevent water or snow from collecting, making the chair ideal for outdoor use. Fifteen hundred chairs were manufactured, and the model caused a sensation, provoking both acclaim and intense dislike: It was ridiculed as being aluminum-enhanced emmenthal because of its holes. The original manufacturer, P. & W. Blattmann Metallwarenfabrik, in Wädenswil, Switzerland, continued to make it for several decades.

Since the *Landi* was intended for outdoor use, no glides were originally attached to the feet. As the chair was increasingly used indoors, glides were gradually added, and they were first made of plastic wood, later of plastic, and by the late 1950s, of black or white rubber. In 1962, the original design using seven holes per row was modified to six, and since then it has been produced by several manufacturers,[1] most recently by Westermann, which has reissued the chair, since 2007, according to its original design. **PM**

1. For more on the subject, see: Sarah C. Nichols, *Aluminum by Design* (Pittsburg: Carnegie Museum of Art, 2000). 2. The chair was produced by Zanotta in Italy as the *2070 Spartana* in the 1970s and 1980s; MEWA-METALight, Wädenswil, Switzerland, produced another version between 1999 and 2001; and since 2007 the Swiss Westermann AG has been producing it.

`389`

Jack Luck
London 1912 – Toronto 1963
Coffee Pot
About 1949
Aluminum, Bakelite
25 x 22 x 14.5 cm
Produced by Aluminum
Goods, Toronto
Impressed on base:
No 990 / WEAR-EVER /
company logo /
TRADE MARK /
MADE IN CANADA
Gift of Allan Collier
2008.151.1-5

`390`

Theodore C. Brookhart
Celina, Ohio, 1898 –
Sidney, Ohio, 1942
Egmont H. Arens
Cleveland 1887 –
New York 1966
***Streamliner* Meat Slicer**
(model 195)
About 1942
Aluminum, steel, rubber
47 x 44.5 x 32.5 cm
Produced by Hobart
Manufacturing Company,
Troy, Ohio
Liliane and David M. Stewart
Collection, gift of Eric Brill
2010.1267

`391`

Hans Coray
Wald, Switzerland, 1907 –
Zurich 1991
***Landi* Armchair**
1938 (probably 1950s
example)
Aluminum, rubber
74.8 x 51.5 x 61.5 cm
Produced by P. & W.
Blattmann Metallwarenfabrik,
Wädenswil, Switzerland
Impressed on top front:
METALLWARENFABRIK
WAEDENSWIL; on rear seat
rail: *SWITZERLAND;*
label on front seat rail:
MADE IN AUSTRIA
Liliane and David M. Stewart
Collection, gift of
Galerie Metropol, New York
D87.129.1

`392`

Robert Davol Budlong
Des Moines, Iowa, 1902 –
Skokie, Illinois, 1955
***Zephir* Fan**
1936
Aluminum, painted cast iron,
steel
72 x 83.5 x 36.5 cm
Produced by Edgar T. Ward
Company, Chicago
Liliane and David M. Stewart
Collection, gift of Eric Brill
2010.1144

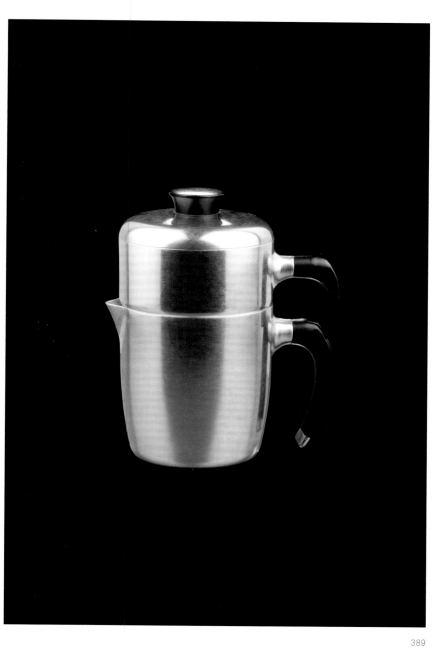

389

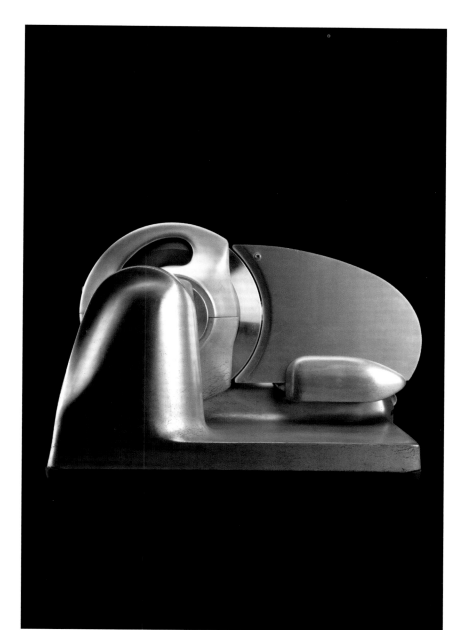

390

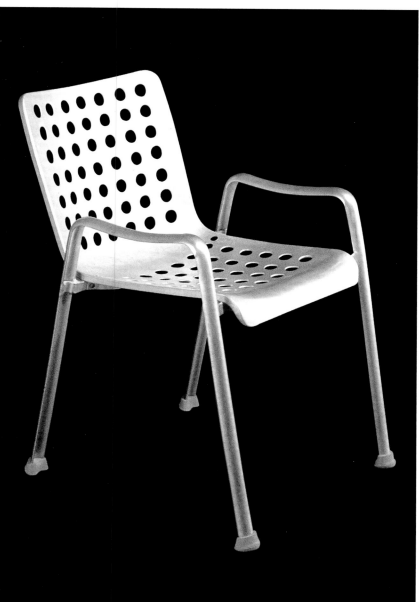

391

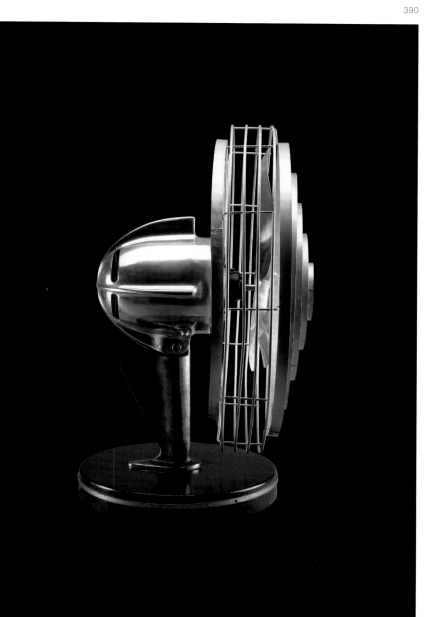

392

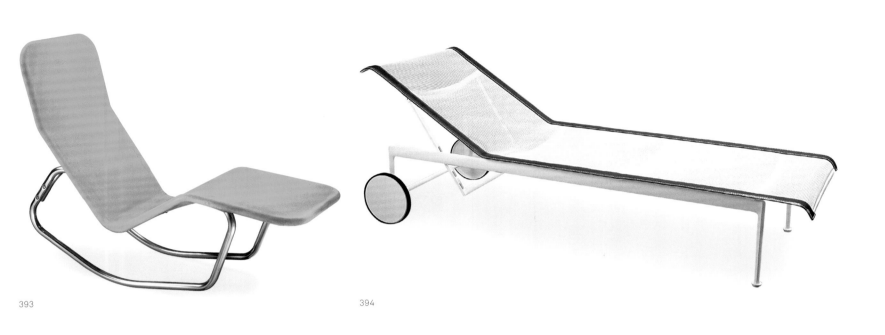

393

394

EDGAR O. BARTOLUCCI

A cross between a deckchair and a rocker, this chaise longue 393 was designed to let the sitter lean back and raise his or her legs. Due to the angle of the bottom rails, it could be used either semi-upright or tilted back. The idea for this chair design—named *Barwa,* after a combination of the designers' names—came from a freelance project for the Container Corporation of America in Chicago by Edgar Bartolucci and Jack Waldheim, who were commissioned to do the furniture for a rest area off of the company's cafeteria. Only about a dozen pieces out of plywood were ever made. After World War II, the designers began manufacturing the chaise longue using bent plywood and webbing, much like Alvar Aalto's furniture of the time, and then with one-inch (2.5 cm) steel tubing.[1] Eventually, they switched to lightweight 1 1/4-inch (3.2 cm) aluminum tubing and found local manufacturers to produce the pieces. According to Bartolucci, the designers had sold about one thousand chairs between 1945 and 1950. The design was then acquired by the Ralph Elliott Company on the west coast of the United States, which manufactured and distributed the chaise longue during the 1950s.[2] **PM**

1. Telephone conversation between the author and Edgar Bartolucci, November 11, 2010. 2. "Barwa" Scrapbook, courtesy of Edgar Bartolucci.

RICHARD SCHULTZ

This chaise longue 394 is part of the Leisure collection, a series of tables, chairs and chaises longues for indoor and outdoor use, designed by Schultz for Knoll in 1966. After studying industrial design at the Institute of Design in Chicago, Schultz took his first job in 1951 at Knoll, where he was made apprentice to Harry Bertoia, the Italian-born sculptor who created the iconic wire chairs 421 .

The idea for this collection came in the 1960s, to satisfy the request of Florence Knoll Bassett, the co-founder of Knoll, who was living in Florida. She wanted well-designed outdoor furnishings that would withstand the corrosive salt air at her home in Miami. Most outdoor furniture at the time was made of webbing and lightweight aluminum tubing, and didn't perform well in inclement weather. She tried using Bertoia's chairs outdoors but they did not hold up, as manufactured then, and, according to Schultz, came back to the company one day fuming about how Knoll's Bertoia chairs were not rustproof. "We started getting envelopes with rusty nuts and bolts or corroded parts of a chair, and notes saying, 'Why can't you make a chair that works?'" says Schultz. "Finally she asked if someone could design decent outdoor furniture. I said, 'I'd like to work on that.'"[1] In 1963, Schultz began experimenting with materials such as non-corrosive solid aluminum and convinced the Wooster Braiding mill in Massachusetts, which manufactured a woven plastic that had been used to produce women's summer shoes, to make their vinyl-coated polyester yarn stronger and more durable, and then weave it for the purposes of upholstery.[2] The production model of this chaise longue incorporated one of the first uses of nylon-Dacron mesh upholstery, applied to a solid aluminum frame coated with a weather-resistant textured plastic and stainless-steel connectors. **PM**

1. Paul Makovsky, "The Outdoorsman," *Metropolis Magazine* (May 2010). 2. Telephone conversation between the author and Richard Schultz, November 13, 2010.

RICHARD SAPPER

Form literally meets function with the *Tizio* lamp 395 , designed by the German engineer and designer Richard Sapper. He created a high-tech version of the standard desk lamp, one built with two sensitive counterweights, thus eliminating the need for springs, and allowing the user to adjust the lamp and direct the light to exactly where it is needed. Sapper engineered this cantilevered lamp for a halogen bulb, a small but incredibly powerful light used in the automobile industry. The *Tizio* is one of the first lamps to apply this type of bulb to residential lighting. Employing the aluminum arms to conduct electricity to the bulb—an innovation seen in few other lamp designs—also eliminated the need for extraneous wires, thus facilitating the precise balance of the arm. The lamp is matte black from tip to base with just a few concentrated touches of red at the switch (on the transformer base) and at the points at which the arms swivel.

The lamp was the first item designed in an intended series of three to be called *Tizio, Caio* and *Sempronio* (the Italian version of Tom, Dick and Harry). Its praying-mantis silhouette established it as a conspicuous sign of masculine yuppie consumption in the 1980s. By 1986, more than one million *Tizio* lamps had been sold worldwide since first being introduced in 1972, landing on the desks of architects, executives and those who embraced the aesthetics of minimalist design. It even became the emblem of success for Gordon Gekko's protege, Bud Fox, in the 1987 film *Wall Street*—when he strikes it rich, his decorator girlfriend outfits his penthouse with three Tizios in the bedroom alone.[1] **PM**

1. Victoria Geibel, "The Tizio Triumph: Richard Sapper's Lamp," *Metropolis* (September 1986), p. 22.

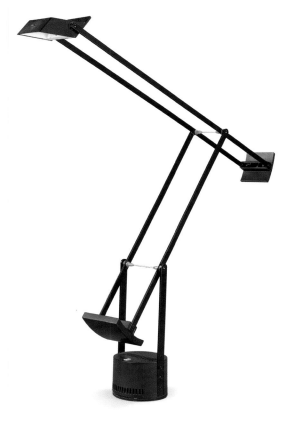

395

396

PHILIPPE STARCK

Starck made his meteoric rise as a star designer in the 1980s, following his refurbishment of Café Costes and the remodelling of François Mitterand's private apartments in the Élysée Palace in Paris, as well as the design of the Starck Club in Dallas, Texas. The idea for this sculptural stool **396** came out of a project the designer had to create an imaginary office for film director Wim Wenders. The filigree-like lines of the sand-cast aluminum biomorphic seat varnished in a pale green suggest the flowing organic form of a plant,

a mythical horn, or even an alien life form with its tentacle shapes and roots that serve as legs, and the bud that makes a footrest. The stool embodies the designer's late-1980s philosophy, emphasizing form over function, by creating a tension between beauty, usefulness and comfort. It is well-suited as a bar stool in its versatility: the sitter may choose to lean or stand against it. Of his inspiration, Starck recounts: "Wim Wenders said to me something like, 'either I sleep or I work standing up, maybe with a kind of stool.' I answered, 'You are right,

I think, goodbye' and I hung up."[1] Starck described the conceptual pieces for this project as "surrealist or Dada objects" that intended to liberate the user "from the humdrum reality of everyday life." The stool was the only design to go into limited production from this project. **PM**

1. Letter from Starck to the Montreal Museum of Decorative Arts, December 15, 1995, quoted in *Designed for Delight*, ed. Martin Eidelberg (Montreal: Montreal Museum of Decorative Arts; Paris, New York: Flammarion, 1997), p. 120.

393

Edgar O. Bartolucci
Born in Philadelphia in 1918
John J. Waldheim
Milwaukee, Wisconsin,
1920 – Pawleys Island,
South Carolina, 2002
Barwa **Rocking**
Chaise Longue
1947
Aluminum, original canvas
112.2 x 56.4 x 140 cm
Made by Ralph Elliott Co.
for Barwa Associates,
Los Angeles
Metal label, on
underside: *Ralph Elliott*
Co. / Manufacturers of
BARWA. U.S. Pat no.
2,482,306 / Los Angeles
33, California / Designed by
Bartolucci-Waldheim
Liliane and David M.
Stewart Collection,
gift of Edgar Bartolucci
D82.112.1

394

Richard Schultz
Born in the United States
in 1926
Chaise Longue
1966
Aluminum, vinyl, nylon,
Dacron
35.6 x 65 x 193 cm
Produced by Knoll
International, a division
of Heller International,
New York
Liliane and David M.
Stewart Collection,
gift of Richard Schultz
D92.123.1

395

Richard Sapper
Born in Munich in 1932
Tizio **Lamp**
1972 (example 1980s)
Enamelled aluminum,
ABS, thermoplastic resin
H. 119; Diam. 11 cm (base)
Produced by Artemide, Milan
Impressed on underside:
Milano Artemide spa /
Made in Italy / Modello Tizio
[logo] / Design R. Sapper /
0,5m [logo] / U.S.A.
Patent nr. 3.790.773 /
0006826 / 110V-60HZ
Liliane and David M.
Stewart Collection
D93.232.1

396

Philippe Starck
Born in Paris in 1949
W.W. **Stool**
1990
Painted aluminum
97 x 56 x 53 cm
Produced by Vitra,
Weil am Rhein, Germany
Signature, stamped
on underside: *STARCK*
Liliane and David M.
Stewart Collection,
gift of Vitra GmbH
D93.204.1

CANADIAN INDUSTRIAL DESIGN

— DIANE CHARBONNEAU, ALAN ELDER, PAUL MAKOVSKY —

HUGH SPENCER

Scandinavian style was introduced to Canada in the late 1950s, where it quickly became synonymous with modernity. The simple, rational approach of this new aesthetic seduced wary consumers and became the standard of Canadian taste in the 1960s—a predilection not only for objects imported from Scandinavia, but also for products and furniture in this style manufactured locally.

This spare, measured universe, dominated by teak wood, was just as soon challenged by the exuberance of the nascent Pop art. Design adopted the ostentatious graphics of this avant-garde movement as well as its bright colours, super-sized shapes, synthetic materials and simplified but immediately recognizable images, its penchant for curvilinear patterns, sensual organic metaphors and anthropomorphic allusions. At times humorous and overtly mimetic, these creations were as much inspired by Space Age inventions and children's toys as by food packaging and even nature. The 1960s were a period of rejuvenation and popularization of design. Tired of a world grown too reasonable, consumers started to dream of objects that would give them access to the "world of tomorrow."

The high fidelity (hi-fi) stereo system *Project G* **399**, designed in 1963 by British-born Canadian designer Hugh Spencer for Clairtone Sound Corporation, sports a look that is at once refined and futuristic and comprises elements of both styles: The modern line of Scandinavian-inspired rosewood furniture remains conventional, but the spherical speakers in anodized aluminum, floating on either side of the cabinet, are typical of the "space style" of the 1960s seen in so many electronic **398** and household items **397**. The brushed aluminum base mounted on wheels is another way that this piece stands apart from more traditional furniture. From a technical standpoint, this stereo was also extremely innovative at the time for its use of transistors rather than tubes. And the futuristic shape of the speakers also had a technical purpose: they can rotate 340 degrees for better sound quality.

From the start, *Project G* was intended as a product for trendsetters, and its production costs were high.[1] It would be produced from 1964 to 1967. The Museum's system, made in 1964, was third in an edition of about four hundred, and it includes a mechanism for cleaning vinyl records found only on the first examples.[2]

Praised by critics from the start, *Project G* won a silver medal at the Thirteenth Milan Triennale in 1964. The price of this stereo system could reach as high as $1,800 at Bloomingdale's and Macy's in New York. This model and others in the *Project G* series were advertised in *Life*, *Vogue* and the *New Yorker*. They also appeared in television shows and movies, such as *A Fine Madness* (1966) and *The Graduate* (1967).[3] Today, *Project G* is considered an icon of Canadian design, much sought after by collectors. **DC**

1. For more on the marketing of this product and the choice of a targeted clientele, see Nina Munk and Rachel Gotlieb, *The Art of Clairtone: The Making of a Design Icon, 1958–1971* (Toronto: McClelland & Stewart, 2008), pp. 26–27. 2. The date of its manufacture was confirmed by D. C. Hillier, a well-informed collector who examined the piece at the Museum on November 8, 2011. He also noticed this example's missing storage box for records. 3. Rachel Gotlieb and Cora Golden, *Design in Canada: Fifty Years from Tea Kettles to Task Chairs* (Toronto: Alfred A. Knopf, 2001), pp. 164–165.

JOSEPH-ARMAND BOMBARDIER

Joseph-Armand Bombardier, founder, in 1942, of Bombardier, a manufacturer of transportation and recreation products, revolutionized winter travel when he introduced the first front-engined, personal snowmobile in 1959.[1]

In his youth, Bombardier was passionate about mechanics. When he was fifteen years old, he took a propeller and the engine of a Model T Ford and placed them on runners from a sleigh. With his brother Leopold as co-pilot, Bombardier drove the contraption around his hometown of Valcourt until his father demanded he stop. He continued his exploration of winter travel, developing plywood-bodied snowmobiles that were sold to transport materials and people, notably school children and the mail.

After the war, with growing urbanization and better snow-clearing methods, demand decreased for these multi-person models, and Bombardier set about creating smaller snowmobiles that could be used by trappers and hunters, particularly those in the North. Experimentation led to a prototype in 1958, and the first production models were released the following year (the Museum's example dates from 1961) **400**. An aerodynamic, sheet-metal cab surmounted by a Plexiglas windscreen was painted safety yellow for easy visibility in the snow, and the seat and backrest were upholstered in red vinyl. Bombardier combined traditional wooden skis at the front of the vehicle with rubber components such as sprockets and rear track, all of which could sustain hard impact in cold weather.

Bombardier soon became the dominant manufacturer in the field of transportation, with its innovative front-engine design. Initially, the firm's first personal snowmobile was to be called the Sno-Dog, perhaps in reference to the dog-team-drawn sleds it was intended to replace. Legend has it that a typographic error led to its now-familiar name, the Ski-Doo. The advertising materials—with the slogan "A superb blend of power and grace" and graphic of snowflakes that morphed into mechanical gears—highlighted a side benefit of the placement of the motor: it became a source of warmth for the Ski-Doo rider. **AE**

1. Website of the Musée J. Armand Bombardier, http://www.bombardiermuseum.com/en/content/jab/biographie1959_1964.htm (accessed July 12, 2012).

MICHEL DALLAIRE

Bixi is an innovative bicycle-sharing system created to complement Montreal's public transportation network. It is solar-powered, uses wireless radio frequency identification (RFID) communication, and is easily removable when not in use during the city's harsh winter months.[1] Quebec industrial designer Michel Dallaire is responsible for the system's various components, having collaborated with Robotics Design to create the modular dock and the intelligent locking system, and with 8D Technologies for the rental mechanisms. The sleek and clean look of the sturdy and easy-to-handle aluminum bicycles, produced in the Saguenay, Quebec, by manufacturer Cycles Devinci, is carried over to the bike docks and pay stations **401**. Each bike has a chain guard integrated into its structure, thereby preventing a rider's clothing from getting dirty or damaged from the chain. A low centre of gravity provides greater stability, and the RFID tag the bike is equipped with makes it easy to track. The system, launched in Montreal during the spring of 2009, gradually expanded to four hundred stations and five thousand bikes throughout the city. By 2010, with numerous awards and no fewer than seven patents, it is now operating on three continents, in other cities including London, Melbourne, Minneapolis, Toronto and Washington, where a total of over fourteen thousand bikes are supplied. **PM**

1. Bertrand Tremblay, "Michel Dallaire, le roi du design industriel," *Le Magazine de l'aluminium*, no. 27 (June 2009), http://www.cqrda.ca/userfiles/file/publications/magazine_al13/entrevue_JUIN_2009.pdf (accessed July 12, 2012).

397

398

399

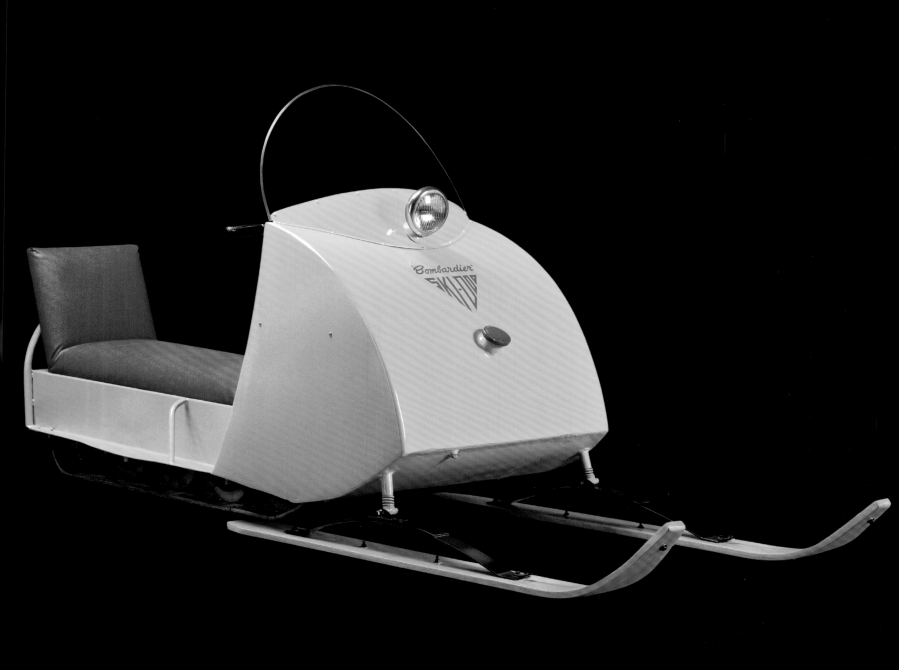

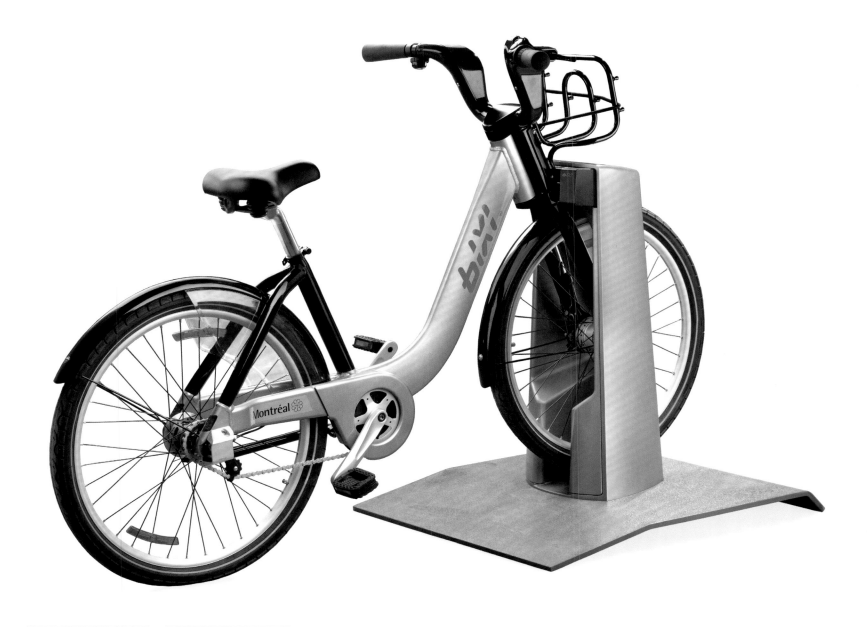

400

Joseph-Armand Bombardier
Valcourt, Quebec, 1907 –
Sherbrooke, Quebec, 1964
Ski-Doo **Snowmobile**
1958 (example of 1961)
Painted sheet metal,
varnished wood, vinyl,
rubber, Plexiglas
119.4 x 75.5 x 264 cm
Produced by Bombardier,
Valcourt, Quebec
Liliane and David M. Stewart
Collection, gift of Mrs. Claire
Bombardier Beaudoin
D89.116.1a-c

401

Michel Dallaire
Born in Paris in 1942
Michel Dallaire Design
Industriel, Montreal
In collaboration with
Cycles Devinci, Chicoutimi,
and 8D Technologies,
Montreal
Bixi **Bicycle and Dock**
2008
Bicycle and dock:
Aluminum alloys, ferrous
and thermoplastic metals
Technological base: formed
corrosion-resistant steel
108 x 177 x 67 cm
Produced by Devinci,
Chicoutimi, Quebec
On the sides: *BIXI* and
Montréal
On the handlebars:
RIO TINTO ALCAN
Gift of PBSC Urban Solutions
2012.80

THE CASTIGLIONI BROTHERS

— GIAMPIERO BOSONI —

402

403

404

Achille Castiglioni would often remind his students: "If you are not curious, then forget about it, you'll never be a designer!" It is curiosity, as well as a constant desire to discover the inner logic of things and to create simple forms that startle and surprise in contrast to their function, that lies at the heart of all Castiglioni designs.

The original creative spirit of the Castiglioni brothers can perhaps be described by the following distinguishing aspects of their approach: to look for an emotional connection beyond the function for which the object was initially imagined; to re-examine the typology of the object being designed; to consider the multiple functions of the object in context; to seek the most basic form possible to achieve technical and eloquent minimalism; to play-fully create an anti-rhetorical use for the object that seems to diminish the weight of its meaning, all the while imbuing that same object with the many typical qualities of the timeless everyday object; and to remain strongly grounded in the principles of rationalism in regards to the dominant use of three-dimensional fashioned forms, even when they do not evolve from basic geometric shapes, a skill the Castiglioni brothers perhaps learned from their sculptor father, who prized craftsmanship above all in his workshop.

The history of the Castiglioni studio begins in 1938, with the collaboration of brothers Livio (1911–1979) and Pier Giacomo (1913–1968). As numerous work opportunities presented themselves, design was also undertaken with Luigi Caccia Dominioni. In 1944, Achille (1918–2002), a recent graduate in architecture, also joined the studio. The collaboration between the three brothers continued until 1952, when Livio launched his own venture in a related sector. From then on, he only worked with Pier Giacomo and Achille on large-scale projects that required specific lighting or sound production. The collaboration between Pier Giacomo and Achille thrived until the death of the former in 1968. Achille actively continued to operate—quite successfully—the studio with the same vision until his passing in 2002. The Castiglioni brothers conceived a huge variety of objects, interiors and architectural designs, all of which masterfully expressed rationalism, a sense of irony and assemblage, as well as technological and functional minimalism. Many of these creations are

displayed in the leading design museums around the world. The Museum's collection boasts six objects by Castiglioni: the renowned *Mezzadro* stool, an oil and vinegar set produced by Alessi, and four light fixtures.

For the Castiglioni brothers, the question of light and how it is treated, and, more precisely, the technical possibilities of electricity, how it is conducted and diffused, held a symbolic fascination that extended beyond the formal associations they had to address as designers.

The types of light fixtures they produced merit a more detailed discussion. Firstly, there is a meaningful process that connects the 1955 *Luminator* floor lamp **403** with the *Toio* model of 1962 **404**. Both are the natural evolution of the floor lamp that projects light upwards to the ceiling, a concept originated by Baldessarri in 1929 with his sculptural *Luminator* model (which barely went beyond the prototype stage), and the elegant model designed by Pietro Chiesa and produced by Fontana Arte in 1936. The Castiglioni's *Luminator* came about almost as an exercise in style to create post-war "good design." There are numerous innovations with this model, starting with the new cone-shaped bulb that is faceted on the inside and frosted on the top, which acts as a built-in reflector. The simple body of the fixture is just wide enough to accommodate the socket for the upward-directed light, and comprises a stem of coloured metal with three spindly iron legs that fit into the base of the tube. The *Toio* lamp resulted from the same creative process, although the innovation in this model was the use of a low-voltage halogen headlamp for cars as the light source, which required the electric transformer cleverly arranged as a counterweight at the base of the lamp. The body is truly a work of bricolage, built using sections of mass-produced iron, and with the electric cable left in plain sight, running the length of the lamp and threading through classic fishing rings. In contrast, the *Arco* floor lamp **406** created a new precedent in overhead lighting. Without requiring holes in the ceiling, the lamp is still suspended, but from the end of a stem made up of connecting elements, like a fishing rod, held in place by a heavy yet elegant block of marble that serves as the base. The *Taccia* lamp **405** is distinctive for its semi-spherical shape of transparent glass, its opening sealed by a lenticular sheet of aluminium painted white on the downward-facing

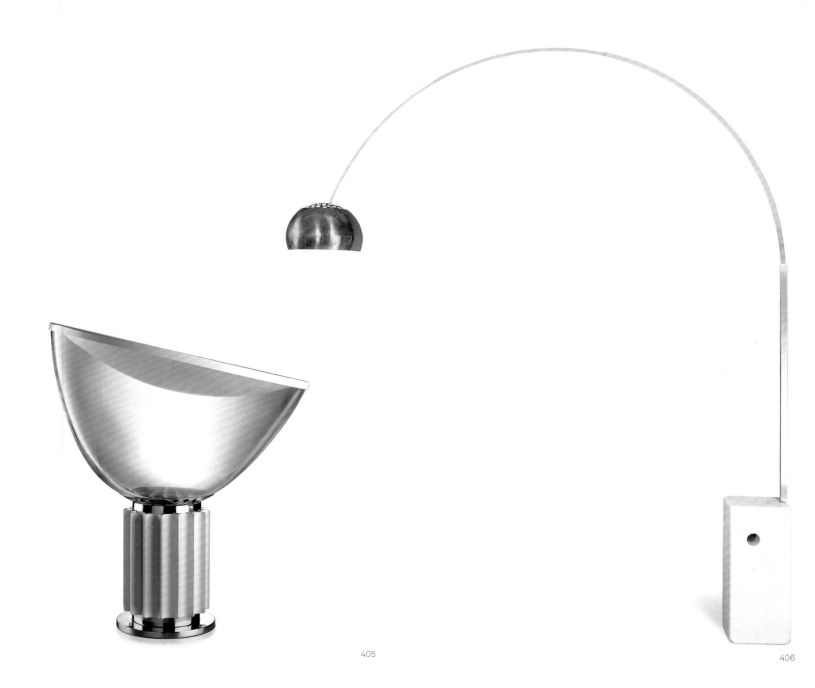

405

406

side, which directs the light downwards at a variety of angles thanks to the cylinder base, finned like a motorcycle motor and hiding a powerful light source projecting upwards. The epitome of their objective to achieve a design inspired by the ready-made or the *objet trouvé* of the Dadaists is the *Mezzadro* stool `402`, in which a tractor seat is attached to a steel stem resembling a crossbow that provides the structural support. The curved wood rod at the bottom, which stabilizes the seat, looks like it came from

a tool used in agriculture. A toggle bolt –usually found securing wheels on racing bikes—fastens the seat to the supporting bar. Together, these assembled parts produce a unique stool for the home or office.

Between 1955 and 1989, the Castiglioni brothers garnered nine *Compasso d'Oro* awards (the most prestigious award in Italian design); the first five earned by Achille and Pier Giacomo before 1967, and the last four earned by Achille after 1979.

`402`

Achille Castiglioni
Milan 1918 – Milan 2002
Pier Giacomo Castiglioni
Milan 1913 – Milan 1968

Mezzadro **Stool**
1957
Chrome-plated steel,
painted sheet steel, beech
51.4 x 48.8 x 50.8 cm
Produced by Zanotta,
Nova Milanese, Italy
Impressed on underside of
steel frame: *MEZZADRO /
DESIGN: A. CASTIGLIONI*
Liliane and David M.
Stewart Collection
D90.201.1

`403`

Luminator **Floor
Lamp (model B9)**
1955
Steel
180.3 x 48.3 x 40.6 cm
Produced by Gilardi e
Barzaghi, Milan, 1955,
Arform, Milan, 1957,
Flos, Bovezzo, 1994
Label on leg:
MADE IN ITALY
Liliane and David M.
Stewart Collection
D85.171.1

`404`

Toio **Floor Lamp**
1962
Enamelled steel, nickel-
plated brass
170 x 19.5 x 21 cm
Produced by Flos, Merano,
Italy
On the transformer: *FLOS*
Liliane and David M. Stewart
Collection, gift of Dr. Michael
Sze
2007.244.1-5

`405`

Taccia **Lamp**
1962
Aluminum, blown glass,
chrome-plated steel
H. 53.5 cm; Diam. 49.5 cm
Produced by Flos,
Merano, Italy
Label inside lamp:
*FLOS / TACCIA 121 /
DESIGN REGISTERED /
MADE IN ITALY*
Gift of Mimi and
Jacques Laurent
2004.29.1-3

`406`

Arco **Floor Lamp**
1962
Marble, stainless steel,
aluminum
241.4 x 213.4 x 30.6 cm
Produced by Flos,
Merano, Italy
Liliane and David M. Stewart
Collection, gift of
the American Friends
of Canada through
the generosity of
Barbara Jakobson
D82.104.1a-c

ALESSI: ITALIAN DESIGN'S WORKSHOP

— GIAMPIERO BOSONI —

For over thirty years, the Alessi name has been internationally hailed as the hallmark of "Made in Italy" design. Their products—some extravagant, some more classic—are available in stores around the world. Whether purchased in a high-design boutique featuring the avant-garde or a popular shop boasting practical, high-quality items at a good price, Alessi products can now be found on the tables and in the kitchens of millions of families, spanning a broad range of culinary and domestic backgrounds. It is no wonder then that the international design world truly considers Alessi's abundant and ever-expanding collection to be comprised of must-haves.

Giovanni Alessi founded the company in 1921, originally under the name "FAO (fratelli Alessi Omegna), articoli & casalinghi, metallo nichelato argentato," in the small town of Omegna, on Lake Orta. Their first products, which were still artisanal, were items for the home and table crafted from copper, brass and nickel silver, followed by nickel-, chrome- and silver-plate. Catalogues from the 1930s show solid, robust items in line with everyday common sense, but still decorated with a light yet traditional refinement clearly inspired by Art Deco.

In 1935, Carlo Alessi, trained as an industrial designer, joined the company and quickly took an active role, especially on the creative side of things. He conceived every collection until 1945, the year he presented his last piece, the *Bombé* coffee and tea service made of nickel plate and Bakelite, an archetype of Italian post-war design. Also in that year, his younger brother Ettore began working alongside him. Ettore was appointed chief executive in 1955, and turned towards external designers, including Carlo Mazzeri, Luigi Massoni and Anselmo Vitale, who were soon joined by Joe Colombo and Ambrogio Pozzi. The "Programma 4" cocktail set, designed by Massoni and Mazzeri, was selected for the Eleventh Milan Triennale in 1957, and for the first time, Alessi items appeared in an exhibition featuring creative industrial production. In turn, Alberto Alessi joined the company in 1970, becoming the promoter of the Alessi brand that we know so well today. After some initial attempts to engage the company in the artistic production of multiples, Alberto Alessi went on to establish a profitable collaboration with designers Franco Sargiani and Eija Helander. Together, they developed "Programma 8," a collection based on modular square forms that created an international sensation in housewares in the 1970s. At Alessi's request, Sargiani introduced other designers into the mix, namely Silvio Coppola, Pino Tovaglia, Franco Grignani, Giulio Confalonieri, Bruno Munari (whose projects unfortunately never really saw the light of day) and Ettore Sottsass, with whom Alessi created a strong partnership. They even succeeded in shifting the design discourse towards more visionary and, in some ways, more strategic questions that were more aligned with new cultural trends, as well as new post-industrial and global market shifts. Sotsass would become by the late 1990s the designer with the most catalogue items. This drive was part of his commitment to creating a complete set of objects for the table and kitchen 409, as inspired by Josef Hoffmann's work for Wiener Werkstätte. Between the late 1970s and the early 1980s, other bright stars from the Italian design and architecture world began working with Sottsass, most notably Richard Sapper, Achille Castiglioni, Enzo Mari, Aldo Rossi, Marco Zanuso, Paolo Portoghesi, Massimo Morozzi, Andrea Branzi and Riccardo Dalisi. The latter studied the Neopolitan coffee maker and created over two hundred prototypes between 1979 and 1987 411 -414 , reinventing the form of this traditional object multiple times 415. And then Alessandro Mendini came along, and he would become a special consultant to Alberto Alessi on matters of production, communications and the search for other designers to help develop new types of products. In 1979, the volcanic creativity of Alessandro Mendini produced an idea that would eventually materialize in 1983: to further the Postmodern debate by challenging well-known contemporary architect-designers to reinterpret the most typical production item of the Alessi line: a coffee and tea service. The collection was called "Tea & Coffee Piazza." Each of the eleven silver services were produced in a limited run of ninety-nine units, and bore the Officina Alessi trademark alongside each designer's monogram: Alessandro Mendini himself, Robert Venturi, Paolo Portoghesi, Aldo Rossi (who proposed one of his classic architectural themes: the small metaphysical theatre 410 , Charles Jenckes, Kasumasa Yamashita, Michael Graves (whom Alberto Alessi considered to be, alongside Rossi, a genuine discovery for the design world), Richard Meier, Hans Hollein, Stanley Tigerman and Oscar Tusquets. This project defined two new fundamental principles for the growth of the Alessi brand: the concept of the art "multiple" (for which Alberto Alessi was already passionate), and bringing together leading international architects and designers. The latter, strongly supported by Mendini, foretold the downward curve of "bel design italiano." Another small but significant example of Mendini's hybrid and multiform vision of design is the chocolate box 407 he created for Peyrano, a popular chocolate maker based in Turin: five thousand units of this box, crafted from 18/10 stainless steel, were produced.

Philippe Starck began collaborating with Alessi in 1986, when he was still at the beginning of his meteoric rise to international fame built almost entirely on the so-called "Italian design factory." Alberto Alessi wrote of Starck: "I cannot help thinking of Starck as the *designer terrible* of our decade. He is a living example of my dream: design, real design, is always highly charged with innovation towards the world of manufacturing and trade, bringing results that need no longer be justified solely on a technological or balance sheet level. A true work of design must move people, convey feelings, bring back memories, surprise, transgress . . . it must make us feel, intensely, that we are living our one single life . . . in sum, it has to be poetic."[1] In keeping with this discourse, Starck produced the suggestive, eye-catching and mysterious *Juicy Salif* lemon squeezer (1990), as well as the *Hot Bertaa* kettle 408 (1987) and the *Max le Chinois* colander (1990).

Although Starck's maieutic art predominates, Italian Nuovo Design plays a major role at Alessi, and is alive and well among the newer generations, represented by incredibly talented designers like Stefano Giovannoni and Guido Venturini, who issue designs that are playful, ironic and highly unconventional.

1. Alberto Alessi, *The Dream Factory: Alessi Since 1921* (Milan: Electa, 1999), p. 78.

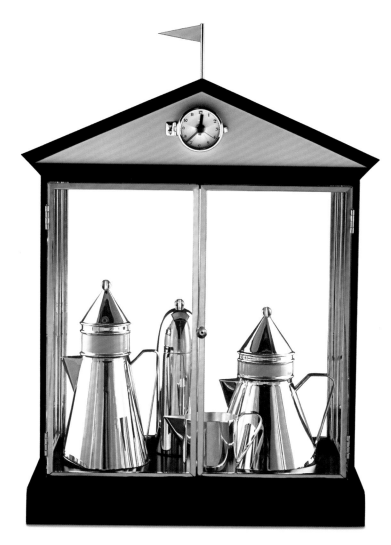

407

408

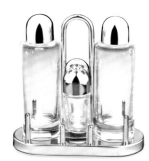

409

410

411, 412, 413

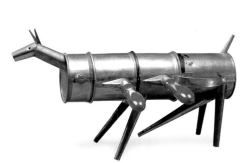

414

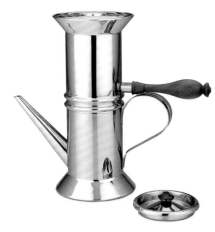

415

410

Aldo Rossi
Milan 1931 – Milan 1997
**Tea and Coffee Service
"Tea & Coffee Piazza"
Collection**
1983 (example of 2008)
Silver, enamel, quartz,
clock, 49/99
Various dimensions
Produced by Alessi,
Crusinallo, Italy
Impressed under coffee
pot: an eagle; under teapot:
OFFICINA / ALESSI; under
creamer: *AR*; under sugar
bowl: *49/99*; under spoon:
2009; under cabinet:
ALESSI / ITALY / 49/99
Purchase, gift of St-Hubert
Bar-B-Q and the Museum
Campaign 1988–1993 Fund
2008.96.1-6

411

Riccardo Dalisi
Born in Potenza, Italy, in 1931
Totò **Coffee Maker**
1987
Tin, brass, copper
32.4 x 21 x 12.1 cm
Prototype executed by
Don Vincenzo, Naples,
for Alessi, Crusinallo, Italy
Impressed on underside:
OFFICINA / ALESSI / 1987
Liliane and David M. Stewart
Collection, gift of
Vivian and David Campbell
D88.229.1a-c

412

Riccardo Dalisi
Born in Potenza, Italy, in 1931
The King **Coffee Maker**
1986
Tin, copper, brass, paint
33 x 24.2 x 12.7 cm
Prototype executed by
Don Vincenzo, Naples,
for Alessi, Crusinallo, Italy
Impressed on underside:
OFFICINA / ALESSI / 1986
Liliane and David M. Stewart
Collection, gift of
Vivian and David Campbell
D88.236.1a-c

413

Riccardo Dalisi
Born in Potenza, Italy, in 1931
Waving **Coffee Maker**
1988
Copper, tin, plastic
15.5 x 22.6 x 8.3 cm
Prototype executed by
Don Vincenzo, Naples,
for Alessi, Crusinallo, Italy
Impressed on underside:
OFFICINA / ALESSI / 1988
Liliane and David M. Stewart
Collection, gift of
Vivian and David Campbell
D88.244.1a-c

414

Riccardo Dalisi
Born in Potenza, Italy, in 1931
Coffee Maker
1986
Tin, painted wood
20.8 x 35.9 x 21.6 cm
Prototype executed by
Don Vincenzo, Naples,
for Alessi, Crusinallo, Italy
Impressed on underside
of metal box:
OFFICINA / ALESSI / 1986
Liliane and David M. Stewart
Collection, gift of
Vivian and David Campbell
D88.234.1a-d

415

Riccardo Dalisi
Born in Potenza, Italy, in 1931
**Neapolitan Coffee Maker
(model 90018)**
1988
Stainless steel, wood
25.4 x 27.4 x 9.5 cm
Produced by Alessi,
Crusinallo, Italy
Impressed on side,
near central rim: an eagle;
*OFFICIANA / ALESSI /
INOX 18 / 10 ITALY / 871054*
Liliane and David M. Stewart
Collection, gift of
Vivian and David Campbell
D88.241.1a-d

STRUCTURE
EXPOSED

— DIANE CHARBONNEAU —

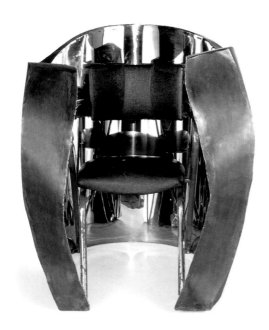

416

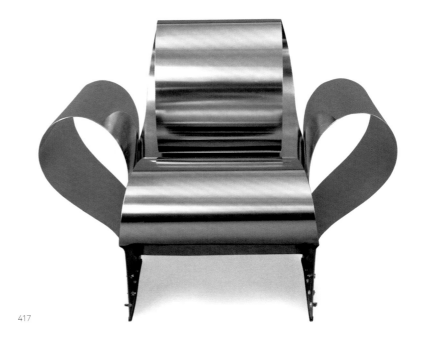

417

RON ARAD

After attending the Bezaiel Academy of Art and Design in Jerusalem, Ron Arad studied at the Architectural Association School of Architecture in London, where he went on to become one of Britain's most famous designers. Exploring the multiple facets of design and architecture since the early 1980s, he founded the design agency and production house, One Off, with Caroline Thorman, in 1981. Then, in 1989, Arad and Thorman opened the architecture and design firm Ron Arad Associates, which incorporated One Off in 1993. Arad has established an international reputation for his steel furniture produced as unique pieces or in limited editions, which are conceived as sculptures, showing his interest in the gesture, organic forms and graphic elements, but which remain nevertheless functional. His agency expertly and ingeniously explores other materials, associated with other techniques, in collaborations with Alessi, Cassina, Driade, Magis, Moroso and Vitra.

During the One Off era, Arad drew inspiration from Marcel Duchamp, Meret Oppenheim and Jean Prouvé. He sketched a first furniture series that made use of found objects, such as the *Rover Chair* designed in 1981 using a Land Rover seat. He returned to the theme in 1989 with *Chair by Its Cover* **416**, an armchair inserted into a polished stainless-steel concave case that reflects it, thus modifying its relationship with the environment and our perception of the object. In 1986, Arad reinterpreted the club armchair for Vitra with *Well Tempered Chair* **417**. In this piece, he revisits the curves of the famous armchair by bending four heat-treated steel sheets tautly held in place with bolts. Arad pursued his inquiry into

416

Ron Arad
Born in Tel Aviv in 1951
Chair by Its Cover
1989
Stainless steel,
mild steel, recycled chair
97.9 x 82 x 100.3 cm
On the top side of the metal
back: *Reflection on Another
Chair*; in metallic lettering,
on back of vinyl chair:
Why Bark
Produced by One Off, London
Liliane and David M.
Stewart Collection,
gift of Paul Leblanc
D90.131.1

417

Ron Arad
Born in Tel Aviv in 1951
Well Tempered Chair
1986 (example of 1990)
Stainless steel
79.3 x 92.3 x 80.7 cm
Produced by Vitra, Weil am
Rhein, Germany
Liliane and David M.
Stewart Collection
D90.113.1

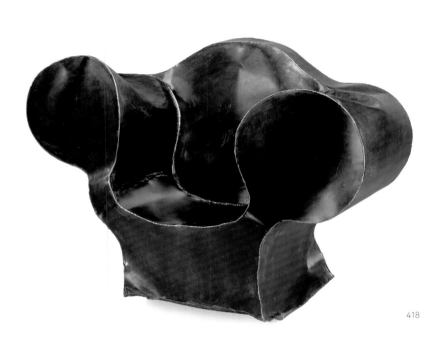

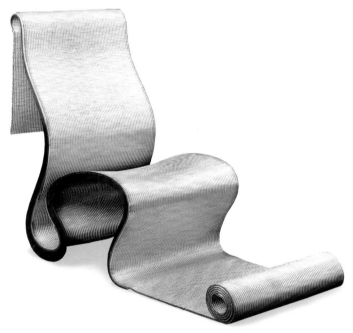

418

419

the volumes of this traditional shape with *Big Easy Volume 2* **418** , made of patinated steel sheets that are curved and welded into a cartoon-like shape inspired by the three elements of the Hebrew letter *shin*[1]: Each armchair differs depending on the welding and grinding done in the workshop. *Big Easy* became an archetype revisited several times in various shapes and materials: *Soft Big Easy* (1991) and *Big E* (2003) for Moroso, and *New Orleans* (1999) for Gallery Mourmans.

The *London Papardelle* carpet-chair **419** is basically made of stainless steel mesh, a flexible

material often found in conveyor belts used by the food industry. Welded onto partially blackened steel bands, the piece undulates like a ribbon to form a seat. The excess mesh rolls up like a foot-rest or unrolls like a carpet. The name of the chair is a tongue-in-cheek reference to a wide, slippery type of noodle served in an Italian restaurant in London. In 1994, Arad opened the Ron Arad Studio in Como, Italy, forming an association with a local manufacturer for the production of his steel works. Created in a limited series, before the contract was signed, the copy of *London Papardelle*

housed in the Museum is larger than more recent versions. **DC**

1. From 1986 to 1992, Arad completed a series of chairs based on different letters of the Hebrew alphabet. See *Design For Living 1950–2000: The Liliane and David M. Stewart Collection*, ed. Martin Eidelberg (Paris: Flammarion; Montreal: The Montreal Museum of Decorative Arts and the Montreal Museum of Fine Arts, 2000), p. 182.

418

Ron Arad
Born in Tel Aviv in 1951
Big Easy Volume 2 **Armchair**
1988 (example of 1989)
Blackened mild steel,
polished stainless steel
101.9 x 136 x 97.8 cm
Produced by One Off,
London
Liliane and David M.
Stewart Collection,
gift of Paul Leblanc
D90.200.1

419

Ron Arad
Born in Tel Aviv in 1951
London Papardelle
Carpet-chair
1992
Stainless-steel mesh,
black steel
105 x 59.6 x 273 cm
Produced by One Off, London
Liliane and David M. Stewart
Collection, anonymous gift
D93.310.1

Weightlessness and transparency are the common characteristics of furniture made from steel wire, cast rods and cross-woven wire. Although tubular steel is favoured by modern European designers, who recognize its structural applications for industrially manufactured furniture `371`, steel wire has been used by American designers Charles and Ray Eames, who created their *DKR* metallic wire chair in 1951. Sculptor and designer Harry Bertoia selected it as his material of choice for a series of chairs produced by Knoll in the early 1950s: the *Diamond* chair and armchair `421`, the *Bird* armchair, the *Asymmetric* chaise longue, as well as a side chair and a bar stool.[1]

Bertoia's interest in applying steel wire to furniture goes back to the years he was studying and teaching at the Cranbrook Academy of Art in Bloomfield, Michigan, between 1937 and 1943. In 1950, upon the invitation of Florence Schust Knoll and Hans Knoll, he started experimenting by combining formal considerations and ergonomic preoccupations. The *Diamond* armchair consists of a diamond-shaped monocoque seat, made of pre-shaped and welded steel wire, and legs of welded steel rods. It is a manifestation of Bertoia's aesthetic vision: "If you look at these chairs, they are mainly made of air, like sculpture. Space passes right through them."[2] Spareness and functionality characterize this chair, which is both a study of shape and space and an essay on the resistance and elasticity of cross-woven wire. An iconic armchair of the modern period, it is still produced semi-industrially by Knoll and in various versions with complete or partial trimming (a choice of upholstery in fabric or leather), chrome or sheathed in Rislan. The chrome version shows off its spare simplicity and filigreed look to greatest advantage.

Japanese designer Shiro Kuramata first used steel mesh in his interior designs before using it to make furniture. The *How High the Moon* armchair `423` dematerializes the traditional club armchair while challenging its function. It seems to float in space, its different volumes interlinked depending on perspective. The nickel-plated finish accentuates the transparency and ephemeral optical effects. The ultimate meditative object, the armchair reflects Kurama's minimalist approach, which aims to synthesize the Japanese creative ideal—notions of purity and Zen philosophy—with a fascination for Western culture. *How High the Moon* might be intended as a reference to the 1940 jazz composition by Nancy Hamilton and

Morgan Lewis. The armchair was produced in Japan by IDÉE, and then produced in a limited edition by Vitra Edition starting in 1987.

It is through welding that self-taught designer Tom Dixon was introduced to the world of British furniture design in the early 1980s, when Ron Arad was attracting attention with his welded-steel furniture `418` and found objects. Dixon's first chairs combining welded steel and rush `257` were produced in his studio before the Italian company Cappellini took over the industrial production in 1990. The *Pylon* chair `425` comprises a group of welded and painted steel rods. It resembles the classic electrical pylon, whose shape it mimics (feet, trunk, head) and whose frame consists of horizontal, vertical and diagonal lines that intersect to create geometric forms in space. Although the originality of *Pylon* appears destabilizing at first glance, its form also evokes that of the traditional wing chair here rendered immaterial. Cappellini has been producing the chair since 1992; today, the chair is available in a variety of colours (natural aluminum, orange, blue or plaster white).

Gravity and suspension are the concepts underlying the *Corallo*[3] chair `422` by Brazilian designers Fernando and Humberto Campana. The chair is the result of experiments undertaken by Humberto when he was introduced to sculpture in a metalwork shop in 1990. His first goal was to create a seat that defied the laws of gravity. The *Bob* chair was thus an assembly of welded iron rods that, despite its rough look and its linearity, already displayed the lightness and transparency of the *Corallo* chair. The idea of the chair was revisited in a sketch for a sculpture made by Humberto in 1989, and which the two brothers modelled in three dimensions at the request of the Italian company Edra, which began producing it in 2004.[4] It is composed of interlacing iron wires curved by hand, then welded together before being covered with an epoxy paint the colour of coral. Evoking the primordial "squiggle," it also recalls the structure and colour of coral, which was the original inspiration. Each chair is made by hand, and therefore customized within a manufacturing process that is basically industrial. **DC**

1. Bertoia received a certificate of merit from the American Institute of Architects, and he was named Designer of the Year for this collection in 1955. 2. *Innovative Furniture by Harry Bertoia.* http://www.harrybertoia.org/furniture.html (accessed January 24, 2012). 3. At the Paris Salon du Meuble in 2005, the Campana Brothers and Edra received the Nombre d'Or prize, which acknowledges the top collaboration between designers and industry. 4. Darrin Alfred et al., *Campana Brothers: Complete Works (So Far)* (New York: Rizzoli; London: Albion, 2010), pp. 109–114.

LOUISE CAMPBELL AND RICCARDO DALISI

Since its establishment in 1954, Zanotta has been furthering the Italian tradition for innovatively styled, handcrafted furniture. With its production of the Castiglioni brothers' ready-made *Mezzadro* `402` and *Sella* stools, the Neo-Liberty furniture of Gae Aulenti and the minimalist pieces by Enzo Mari, the firm quickly became a frontrunner on the international scene. The inflatable, transparent PVC armchair called *Blow* `669`, designed by De Pas, D'Urbino, Lomazzi and Scolari, simultaneously reflected the firm's taste for new and modern materials.

During the 1980s, Zanotta began producing furniture that blurs the line between art and design, encouraging creators to give free rein to their poetic inspiration. The objects in this "Edizioni" collection are also notable for the neo-craft techniques used in their fabrication. The seat and back of Riccardo Dalisi's *Mariposa* [Butterfly, in Spanish] bench `420`, for example, are highlighted with touches of white and gold hand-painted by the artist. Using the latest technology, the *Veryround* chair `424` by Anglo-Danish designer Louise Campbell, also from the series, has its source in a creative approach where functionalism is tinged with femininity. Clearly attracted by original forms, Campbell exploits all the possibilities offered by her chosen materials and production methods. *Veryround*, which sits directly on the ground, consists of 240 concentric circles cut out of a sheet of steel two millimetres thick. The way the circles grow bigger as they expand from the middle creates the volume of the piece while giving lightness to its origami-like conical form, which resembles a cornucopia or a basket. Weatherproofed by a powder-coating, *Veryround* is suitable for both indoor and outdoor use. The chair has been produced in a limited edition of about fifty signed pieces. **DC**

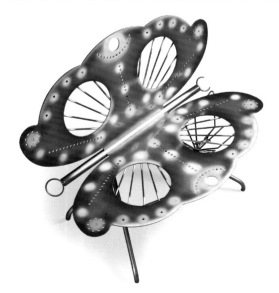

`420`

Riccardo Dalisi
Born in Potenza, Italy, in 1931
***Mariposa* Bench**
"Edizioni" Collection
1989
Painted steel, 2/9
88 x 102 x 59 cm
Produced by Zanotta,
Nova Milanese, Italy
Signed in ink, under seat:
2/9 Dalisi; impressed
on seat back: 4
Liliane and David M.
Stewart Collection
D95.164.1

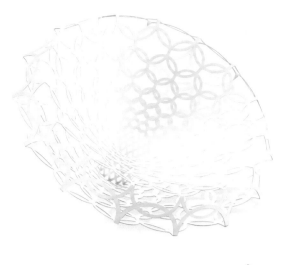

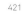
421

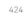
424

422

423

425

421

Harry Bertoia
San Lorenzo, Italy, 1915 –
Bally, Pennsylvania, 1978
Diamond Armchair
1952
Steel, plastic
Produced by Knoll
International, a division of
Heller International, New York
Liliane and David M. Stewart
Collection, by exchange
D98.122.1

422

Fernando Campana
Born in São Paulo in 1961
Humberto Campana
Born in São Paulo in 1953
Corallo Chair
1993
Steel wire, epoxy paint
93.9 x 140 x 102 cm
Produced by Edra,
Perignano, Italy
Metal plaque on bottom
part of chair, centre:
EDRA 12006E
Gift of Edra S.p.A.
2006.105

423

Shiro Kuramata
Tokyo 1934 – Tokyo 1991
How High the Moon
Armchair
1986
Nickel-plated steel
72.5 x 95 x 81.8 cm
Produced by Vitra,
Weil am Rhein, Germany
Liliane and David M.
Stewart Collection
D90.114.1

424

Louise Campbell
Born in Copenhagen in 1970
Veryround Armchair
(model 5701)
"Edizioni" Collection
2006
Powder-coated steel
H. 65 cm; Diam. 100 cm
Produced by Zanotta,
Nova Milanese, Italy
Signed in ink, on right:
LouCam; label:
zanotta / EDIZIONI
Purchase, the Museum
Campaign 1988–1993 Fund
2007.128

425

Tom Dixon
Born in Sfax, Tunisia,
in 1959
Pylon Chair
1991
Painted steel
126.5 x 57.3 x 55.5 cm
Produced by Cappellini,
Arosio, Italy
Liliane and David M.
Stewart Collection,
gift of Cappellini S.p.A.
D99.137.1

OSKAR ZIETA

Polish architect Oskar Zieta, a graduate of the Szczecin University of Technology in Poland, continued his studies at Zurich's Swiss Federal Institute of Technology (ETH), where he earned a doctorate from the Computer Aided Architectural Design (CAAD) Department in 2011. His thesis explored the role of digitally controlled machines in the treatment of sheet metal. More specifically, he studied the development of FiDU (Frei Innen Druck Umformung) technology: the assembly by laser-welding of thin sheet-metal cut-outs that are transformed into steady, three-dimensional objects by the injection of compressed air. In 2007, Zieta simultaneously founded Zieta Prozessdesign, a design agency in Zurich, and Steelwerk Polska, a production workshop in Wroclaw, Poland, where he applied this sophisticated technology to architecture and engineering as well as to the design of products and furniture.

His first forays into furniture date back to 2005, with the prototypes of the *Plopp* stool and the *Chippensteel* chair. Zieta quickly recognized the advantages of this rapid, precise process, whose production costs were relatively low, permitting the limited edition and customization of each piece. The *Mini Plopp* stool 426 consists of a circular seat resting on three legs. It is light but resistant, and its construction requires minimal materials. It looks like an inflatable toy and suggests the sculptures of American artist Jeff Koons. The stool, part of the "Plopp" series,[1] is currently available in three sizes, depending on height—mini, standard and bar—and in a broad range of colours. **DC**

1. The *Plopp* stool earned the Red Dot Design Award and the German Design Council Award in 2008, and the Forum AID Award in 2009.

MARTIN SZEKELY

Since the late 1970s, French designer Martin Szekely has developed an artistic practice within several spheres, from industrial to environmental design. He moves easily from the creation of experimental pieces—in single or limited editions—to the design of industrial objects. His singular approach belongs to the continuum of modern design, wherein ornamentation is considered superfluous. Materials and their composites interest him greatly, and he pushes the technical sophistication of processes to their furthest limit.[1]

At the start of his career, he almost exclusively produced furniture inspired by the pieces he had studied at the École Boulle and in various workshops, including those of a joiner, a restorer of antique furniture and the Chinese-born French architect Kwok Hoï Chan. Chan, a follower of the philosophy of Lao Tzu, influenced Szekely by teaching him that "the air around a piece of furniture is as important as the piece itself. The relationship of the void and matter echoes the functionalists' 'Less is more.'"[2] Szekely caught international attention in 1983 with the "Pi" series, created thanks to the carte blanche given him by Via (Valorisation industrielle dans l'ameublement).[3]

He designed a chaise longue 427, a pedestal table, an armchair, a bookcase and the *Carbone* chair, produced in limited series between 1985 and 1990. The chaise longue embodies the very spirit of this collection with its spare silhouette limited to straight lines and one curve, and its exposed black-lacquered steel and aluminum structure. Its graphic look recalls the work of the typographer and the printmaker, the creator's primary interest. Produced by the Néotu Gallery in a limited edition (about a hundred copies), Szekely's chaise longue is considered to be emblematic of 1980s French design. **DC**

1. *Martin Szekely. Ne plus dessiner*, educational guide, Centre Pompidou, http://www.centrepompidou.fr/education/ressources/ENS-Szekely/index.html (accessed March 12, 2012). 2. Ibid, p. 3. 3. Association founded in 1979 with the support of the French Minister of Industry.

ANDREA BRANZI

Designer and architect Andrea Branzi has been working in several domains since the 1960s: architecture, urban planning and industrial design, but also in experimental research, education, and the promotion of culture and design. In 1966, he co-founded the group Archizoom Associati 651 656 with architects Gilberto Corretti, Paolo Deganello and Massimo Morozzi, which ascribed to the radical Florentine movement of the late 1960s. Branzi is also a theorist and author of numerous articles, essays and books. He received the Compasso d'Oro in 1987 in recognition of his lifelong work.

426

427

426

Oskar Zieta
Born in Zielona Gorà, Poland, in 1975
***Mini Plopp* Stool**
From the series "Plopp"
2008
Laser-cut, robot-welded, inflated and polished sheet steel
H. 35 cm; Diam. 25 cm
Produced by Zieta, Wroclaw, Poland
Impressed on underside:
PLOPP / designed by zieta
Liliane and David M. Stewart Collection, gift in honour of the Montreal Museum of Fine Arts' 150th anniversary
2011.111

427

Martin Szekely
Born in Paris in 1956
***Pi* Chaise Longue**
1983
Steel, lacquered aluminum, foam, leather
84 x 62 x 136 cm
Produced by Galerie Néotu, Paris
Gift of Benoît Hinse
2001.32.1-2

Branzi is a proponent of "endless design," a perpetual process of research that permits the introduction of new codes, modes of expression and technologies in response to social and political charges. He uses metaphor and the notion of utopia to create meaning beyond function, thus establishing a richer, more complex relationship between object and user.[1] The "Amnesie" series, designed in 1991 for the Design Gallery Milano, demonstrates his interest in the enigmatic. The title of the exhibition refers to the difficulty we have trusting our memory, even though total memory loss is unthinkable. The objects produced in a limited edition serve as "blank spaces" in a densely occupied territory.[2] The *Piccolo albero* bookcase **429** comprises a vertical frame in lacquered steel and the trunk of a beech tree. Its visual power comes from the contrasting materials—colour and texture. It symbolizes the meeting of nature and artifice (technology) while alluding to architectural principles by being cold and hard on the outside and brushed smooth on the inside.[3] The five aluminium vases in the same group **428** are purely mnemonic emanations. Their titles—*A 28*, *A 38*, *A 46*, *A 51* and *A 56*—correspond to the number of discs pressed by digital control during factory production. **DC**

1. François Burkhardt and Cristina Morozzi, *Andrea Branzi* (Paris: Éditions Dis Voir, 1997). **2.** Andrea Branzi, *Amnesia* (Milan: Design Gallery Milano, 1991). **3.** Ibid.

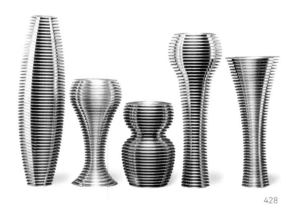

428

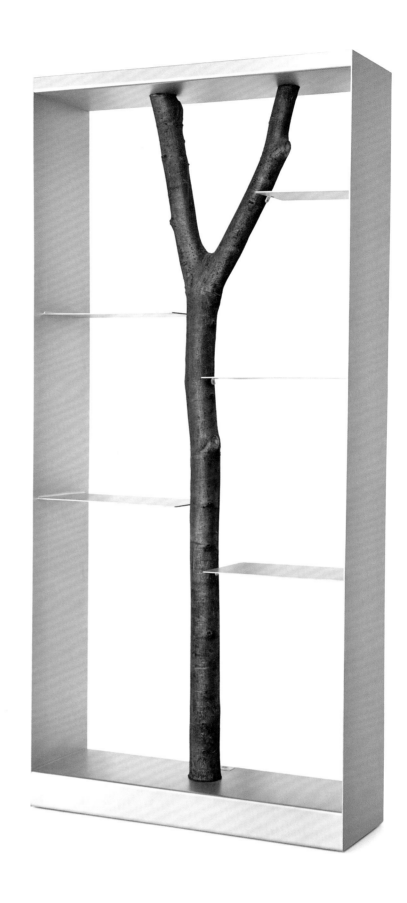

429

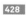

428

Andrea Branzi
Born in Florence in 1938
A 28, A 38, A 46, A 51,
A 56 Vases
From the series "Amnesie"
1991
Aluminum, 11/50
H. 44.2 cm (max.)
Produced by Design
Gallery Milano
Metallic label on underside
of each piece:
ANDREA BRANZI /
DESIGN GALLERY
MILANO, 11/50 / 1991
Liliane and David M.
Stewart Collection,
gift of Paul Leblanc
D93.297.1-5

429

Andrea Branzi
Born in Florence in 1938
Piccolo albero **Bookcase**
From the series "Amnesie"
1991
Steel, beech, 5/20
205 x 90 x 30 cm
Produced for Design
Gallery Milano
Impressed on metal label
affixed to back of base:
DESIGN G / GALLERY /
Y MILANO / AMNESIE /
by / Andrea Branzi /
1991 made in Italy 5/20
Liliane and David M.
Stewart Collection,
gift of Maurice Forget
D92.223.1

METALLIC FIBRES

— DIANE CHARBONNEAU, VALÉRIE CÔTÉ —

VANNETTA SEECHARRAN AND CLÉMENCE HEUGEL

Today, the most unlikely materials—pasta products, paperclips, recycled items—make their way into the art of jewellery. Designers tackle these new materials to uncover their intrinsic qualities. In this vein, Guyana-born Vannetta Seecharran created a necklace out of tabs from recycled cans **431** for the exhibition *Cheap Design*, held at New York's Gallery 91 in 1992. The show revealed how "good design" could be not only affordable, but also environmentally friendly. And Clémence Heugel, from France, came up with a playfully subtle take on danger, making bracelets out of safety pins **430** for her "Hérisson" [Hedgehog] collection, a dozen pieces made out of some seven hundred brass safety pins held together by two knotted elastic threads. **DC and VC**

TAMIKO KAWATA

Born in Kobe, Japan, textile artist Tamiko Kawata has lived in New York since the 1970s. She works with everyday materials like discarded cardboard rolls, toilet paper and chewing gum, on small and monumental scales.[1] Her interest in non-fibrous materials extends to the safety pin, which she first used to alter her oversized American clothing upon her arrival in the country. After interlocking them to produce weave-like effects, she then built them up to construct near two-dimensional objects and three-dimensional freestanding works.[2] *Soft Box IV* **432** challenges expectations of the very nature of the material used to fashion the piece. The safety pins, which often go overlooked, retain their character while growing in value by their sheer numbers. Repetition is recurrent in Kawata's works and construction fosters rhythm. The square soft box is made of groupings of interlocked safety pins assembled together vertically and horizontally, producing a knit-like texture. Half of the box is oxidized, which emphasizes form and embellishes its composition, while contrast shading heightens its pattern and creates a more dynamic structure. **DC**

1. Tamiko Kawata, *Statement*, http://www.tamikokawata.com/statement.html (accessed January 19, 2012). 2. Lesley Millar, *Textural Space: Contemporary Japanese Textile Art* (Surrey: The Surrey Institute of Art and Design University College, 2001), p. 56.

DENIS GAGNON

Today considered to be *the* designer of Canadian fashion, Denis Gagnon's collections display a singular, uncompromising style. After his studies in fashion at Montreal's LaSalle College, Gagnon taught at the school and designed theatre costumes. In 1999, he worked briefly with Quebec designer and stylist Yso before launching his own label in 2000. His first collection was designed for men only, but he began alternating between men and women in 2002, focusing solely on women's fashion as of 2008, although he came out with a collection for men in Fall-Winter 2011–12.[1] In 2010, in recognition of his ten-year career, the Museum presented *Denis Gagnon Shows All* (fig. 1).

Consistently audacious and rigorous, Gagnon ignores the trends, and, in the fabrication of his exclusive garments, works like an artist.[2] His approach is guided by his need to express himself through the material. Although leather is his material of choice, he is also drawn to lace, zippers, lampshade trimming and silk, which he transforms and reworks with precision. He finds inspiration in the most original places: his garden, big cities and highways, but also fashion magazines, the work of Jean Paul Gaultier, film, theatre and so much more.[3] With their precise, reinvented cuts, his silhouettes are architectural, asymmetrical and monochrome, dominated by the colour black.

Formal considerations dictate his choices. For the dress in the "Zips" collection (fig. 2), composed of brass zippers **433**, Gagnon subverts the function of the zipper. He created the mini bare-backed bustier dress by arranging a multitude of zippers, employed as material for textile construction, on a mannequin. Gagnon deconstructs the classic dress, which he presents in two pieces, due to the complexity of its assembly. He plays with contrasts by choosing a full bustier and a semi-openwork skirt. He treats the interplay of shapes, materials and textures like a sculptor. **DC**

1. "Ligne du temps / Timeline," in "Denis Gagnon," *Urbania* (Fall 2010), pp. 4–5. 2. Since 2010, Gagnon has also designed limited-edition collections for the wider public under the auspices of the Bedo chain. 3. "Influences," in "Denis Gagnon," pp. 18–19.

430

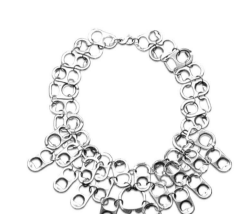

431

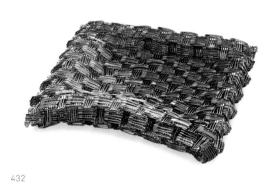

432

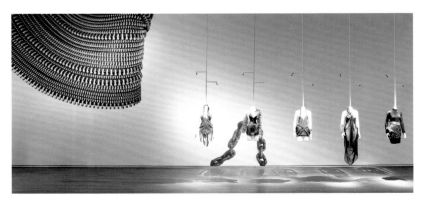

Fig. 1
Denis Gagnon Shows All exhibition at the Montreal Museum of Fine Arts, October 2010 to February 2011. Exhibition design by Gilles Saucier.

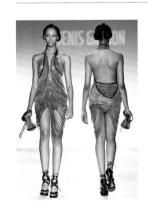

Fig. 2
Denis Gagnon, dress from the "Zips" Collection, Fall–Winter 2010–11.

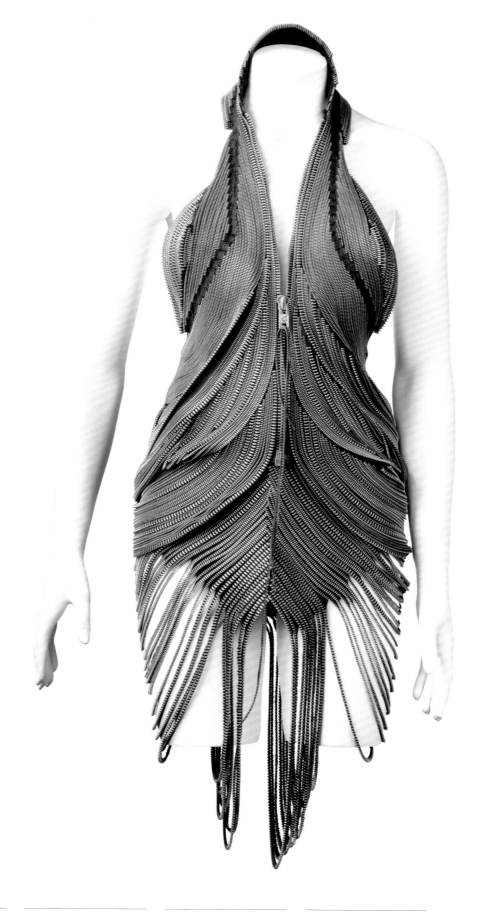

CERAMIC

adjective & noun [ORIGIN Greek *keramikos*, from *keramos* potter's earth] **A adjective**. ■ Of or relating to (the art of) pottery; designating or pertaining to hard brittle substances produced by the process of strong heating of clay etc. **B noun**. An article made of pottery.

■■■■ Every ceramic piece is made from a form of clay, the most basic of materials handcrafted from ancient times for a variety of objects. The development of European pottery and porcelain may be traced through the Museum's collection of decorative arts and design, beginning with medieval glazed earthenware tiles for hearth and floor, and denser, less fragile stoneware vessels for the table. White, translucent Chinese porcelain imported into Europe in the seventeenth and eighteenth centuries was highly valued and admired, but the special ingredient, kaolin, a china clay essential for producing porcelain, was unknown to European potters. They provided an alternative to porcelain by covering earthenware with an opaque, tin-based, shiny white glaze that provided a good background for boldly coloured decoration. This tin-glazed earthenware—described as maiolica for Italian pieces, Delftware for Dutch examples and faience for French ware—was a substitute for porcelain until the formula for making true hard-paste porcelain was discovered in Germany in 1709. This set off a century of experiments in the use of both hard- and soft-paste porcelain (made without kaolin and fired at a lower temperature) for table services and figurines in the great porcelain manufactories across Europe, like Meissen, Sèvres and Chelsea. ■■■■ Technical developments in the moulding, modelling, painted-enamel decoration, transfer-printed designs and gilding of ceramics intensified in the nineteenth century with the taste for elaborate ornamentation and a wider market for the wares. ■■■■ Today, clay is still used in its different forms by contemporary designers who delight in the plasticity of the medium and its easy availability. The Museum's extensive twentieth-century collection includes ceramic works by artists who designed for industrial mass production as well as pieces by studio potters who oversaw the creation of a work from beginning to end—manipulating the clay by hand then experimenting with the composition of glazes to achieve unforeseen results of colour and texture. RP

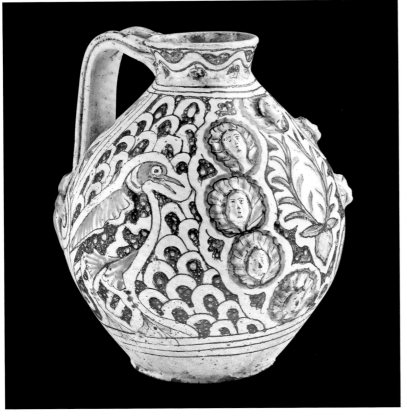

434

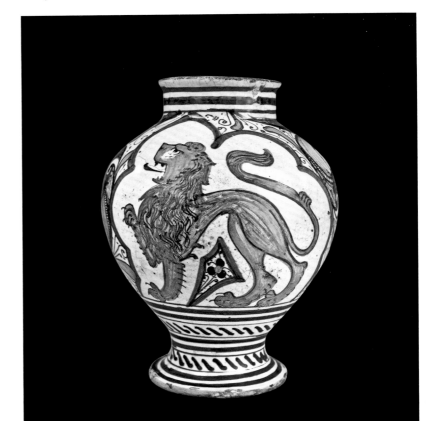

435

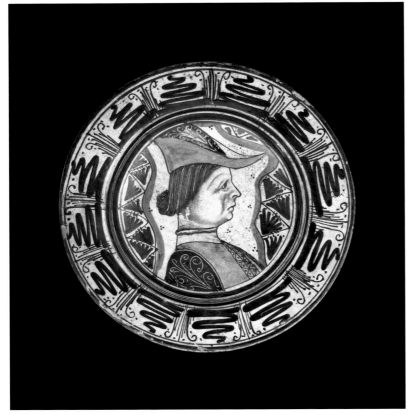

436

437

434

**ITALY, TUSCANY,
PROBABLY FLORENCE**
Jug
About 1400–50
Tin-glazed earthenware
(maiolica), painted enamel
decoration, lead-glazed
interior
H. 40 cm; Diam. 33.5 cm
Below handle: *S*
Purchase, gift of
Harry A. Norton
1939.Dp.3
PROVENANCE
Wilhelm von Bode, Berlin;
Kurt Glogowski, Berlin;
sale, Sotheby's, London,
June 8, 1932, lot 61; Arnold
Seligmann, Rey & Co., New
York; acquired by the Art
Association in 1939.

435

**ITALY,
PROBABLY NAPLES/
NAPLES REGION**
Pharmacy Jar
About 1470–1500
Tin-glazed earthenware
(maiolica), painted enamel
decoration
H. 27.3 cm; Diam. 20.3 cm
Gift of Mrs. F. Cleveland
Morgan
1957.Dp.3
PROVENANCE
Émile Gavet, Paris (?);
J. Pierpont Morgan, London
and New York; Peter A. B.
Widener and his son Joseph,
Elkins Park, Pennsylvania;
sale, Samuel T. Freeman &
Co., Philadelphia, June 20–24,
1944, lot 325; R. Stora & Co.,
New York; acquired by the
Museum in 1957.

436

ITALY, DERUTA
Dish
About 1450–80
Tin-glazed earthenware
(maiolica), painted
enamel decoration
H. 4.5 cm; Diam. 25.7 cm
Gift of Mrs. F.
Cleveland Morgan
1946.Dp.10
PROVENANCE
C. and E. Canessa, New York,
1915; Mortimer L. Schiff,
New York, 1915; sale, Schiff
collection, Parke-Bernet
Galleries, New York, May 4,
1946, lot 41; acquired by the
Art Association in 1946.

437

ITALY, DERUTA
Plate
*The Virgin Teaching
the Child Jesus to Read*
1520–25
Tin-glazed earthenware
(maiolica), painted
enamel decoration
H. 7.75 cm; Diam. 40.9 cm
Inscription on unfurled scroll
behind central motif:
PER TACERE.NON SESCORDA
Gift of F. Cleveland Morgan
1949.50.Dp.4
PROVENANCE
Mrs. R. MacD. Peterson,
Montreal; acquired by
the Museum in 1949.

ITALIAN RENAISSANCE MAIOLICA

— MICHAEL J. BRODY, ROSALIND PEPALL —

FLORENCE
Jug

The technique of maiolica or tin-glazed earthenware goes back to the eighth century in the Near East and was carried west with the Islamic conquest to Spain, where Hispano-Moresque wares featured lustrous surface effects through the application of silver and copper oxides. Málaga was one centre of production for this lusterware in the fourteenth century, and Manises (near Valencia) was a source of high-quality pieces in the fifteenth century **438** **439**. These wares were traded to Italy by way of the island of Mallorca, hence some believe the name maiolica refers to this trade route while others think the word derives from the Spanish for Málaga ware (*obra de Melica*).

Italian maiolica is characterized by its shiny white lead glaze rendered opaque by the addition of tin oxide. The painted decoration, applied before the glaze firing, was limited to the metallic pigments (blue, green, yellow, orange and purple) that could stand the high temperatures needed to fuse the glaze. By the sixteenth century, Italian Renaissance maiolica from the areas of Tuscany and Umbria, and eastern Italian towns such as Faenza and Urbino, was highly sought after and marketed across Europe.

The superb and varied decoration of this oviform jug **434** includes a stylized stag's head and horns, a simplified version of the coat of arms of the Ubaldini family of Florence,[1] eight female heads with segmented headdress (seven in relief and one painted), and a bird and dog in separate contour panels set against a scale-pattern ground. Below the ribbed handle is an inscribed "S," likely the mark of the workshop that produced the jug.[2] These decorative and documentary elements—coat of arms, unique relief decoration and workshop inscription—combined with the vessel's age, imposing size and remarkable state of conservation make it an object of exceptional rarity. Likely not employed in daily repasts, this highly decorative jug may have been used for the temporary storage of oil or wine, or pressed into use on special occasions, such as banquets.

With respect to age and manufacture, one of the few strictly comparable extant objects is a two-handled armorial jar in the Victoria and Albert Museum, London, which includes a single female head applied in relief on two sides of the vessel.[3] Notably, very few other similar wares with relief ornament and a palette restricted primarily to manganese and copper-green appear in the groundbreaking monograph on early Tuscan maiolica by the eminent art historian and director of Berlin museums, Wilhelm von Bode, who once owned this jug.[4] Although applied heads appear on a number of slightly earlier "archaic" maiolica objects—most of which were excavated and consequently fragmented—attributed to Orvieto, in Umbria, such decoration almost always appears in conjunction with applied pine cones and/or a ground of cross-hatching. The absence of such elements on the Montreal jug and the presence of a Florentine armorial strongly support a Tuscan origin. **MJB**

1. Giovan Battista Crollalanza, *Dizionario storico-blasonico delle famiglie nobili e notabili italiane* (Pisa: 1886–90), vol. 3, p. 53. For versions of the Ubaldini arms on two sixteenth-century jugs, see Bernard Rackham, *Victoria and Albert Museum: Catalogue of Italian Maiolica* (London: Published under the authority of the Board of Education, 1940), vol. 1, cat. 342, and Alessandro Alinari, *Maioliche marcate di Cafaggiolo* (Florence: Studio per Ed. Scelte, 1987), cat. 7.
2. For references to fifteenth-century Tuscan pieces inscribed "S," see Galeazzo Cora, *Storia della maiolica di Firenze e del contado. Secoli XIV e XV* (Florence: Sansoni, 1973), vol. 2, pls. 346–348.
3. Rackham 1940, cat. 33 (this jar lacks its neck). 4. Wilhelm von Bode, *Die Anfänge der Majolikakunst in Toskana unter besonderer Berücksichtigung der florentiner Majoliken* (Berlin: J. Bard, 1911), pp. 11 (figs.) and 13; pls. XII–XIII; and, for the mark, Table I.

NAPLES
Pharmacy Jar

In a contour panel on one side of this fine baluster-shaped vase **435** is a large, confidently drawn lion passant whose meaning is likely decorative rather than heraldic; surrounding the panel are stylized floral and tendril motifs. The remainder of the body is dominated by swirling, polychromatic gothic foliage that includes volutes and peacock-feather eyes. These varied decorative elements appear on wares attributed to several pottery centres, including Faenza, Pesaro and Naples; however, this distinctive vase shape with a splayed base—which Donatone notes is called *a piro* (or pear-shaped) in sixteenth-century apothecary inventories—is most closely associated with Naples.[1] While possible this vase (or jar) was used for the storage of dry pharmaceutical ingredients—jars with painted labels specifying their contents were uncommon at this early date—it is equally plausible that this vessel was intended for displaying flowers, a use documented in contemporary painting.

The vase's twentieth-century provenance[2] includes consecutive ownership by two inveterate collectors with important holdings of Renaissance

438

SPAIN, VALENCIA, MANISES
Hispano-Moresque
Pharmacy Jar ("Albarelo")
About 1450–1500
Tin-glazed earthenware, painted enamel and gold lustre decoration
H. 38 cm; Diam. 19.6 cm
Purchase, gift of Harry A. Norton
1944.Ea.21

439

SPAIN, VALENCIA, MANISES
Hispano-Moresque
Dish
Mid-15th c.
Tin-glazed earthenware, painted enamel and gold lustre decoration
H. 7.6 cm; Diam. 43.1 cm
Purchase, Annie White Townsend Fund
1951.Dp.70

440

FRANCE, NEVERS
Urn
Mid-17th c.
Tin-glazed earthenware, painted decoration
H. 27 cm; Diam. 22.8 cm
Promised gift of Mr. and Mrs. Philippe Stora
302.2010

441

ITALY, URBINO
Attributed to the "Painter of the Carafa Service"
Tazza
The Gathering of Manna
About 1550
Tin-glazed earthenware (maiolica), painted enamel decoration
H. 7.6 cm; Diam. 33.2 cm
Purchase, Horsley and Annie Townsend Bequest
1972.Dp.27
PROVENANCE
Sangiorgi gallery, Rome; Cranbrook Academy of Art, Bloomfield Hills, Michigan, 1929; sale, Sotheby Parke Bernet, New York, March 25, 1972, lot. 112; acquired by the Museum in 1972.

maiolica: J. Pierpont Morgan and Peter A. B. Widener. Immediately following Morgan's death in 1913, the vase was very likely among his objects exhibited at the Metropolitan Museum of Art;[3] subsequently, the bulk of his extensive collections was divided among the Metropolitan (about seven thousand objects), the Morgan Library, New York, and the Wadsworth Athenaeum, Hartford, Connecticut—the latter two institutions receiving, respectively, six and forty-nine pieces of maiolica. However, in 1915–16, prior to these dispersals, Duveen Brothers of New York, the principal firm supplying maiolica to the Wideners, purchased several dozen pieces of Morgan maiolica, including the Montreal vase. In 1942, the Wideners gifted over three dozen pieces of their maiolica to the newly founded National Gallery of Art in Washington, D.C., and two years later the family's remaining eleven pieces, including the Montreal vase, were sold at auction.[4] **MJB**

1. For factors favouring an attribution to Naples, see the discussion of a similar vase in the British Museum: Dora Thornton and Timothy Wilson, *Italian Renaissance Ceramics: A Catalogue of the British Museum Collection*, 2 vols. (London: British Museum Publications, 2009), cat. 53. 2. Beginning with this (unconfirmed, although plausible) early provenance given by Guido Donatone in *La maiolica napoletana del Rinascimento* (Naples: Gemini arte, 1993), pls. 153–154 (as Naples, royal workshop at Castelnuovo, last decade of the fifteenth century). 3. *The Metropolitan Museum of Art: Guide to the Loan Exhibition of the J. Pierpont Morgan Collection* (New York: The Gilliss Press, 1914–16), pp. 51–60. 4. Timothy Wilson, "Renaissance Ceramics," in *The Collections of the National Gallery of Art Systematic Catalogue: Western Decorative Arts, Part I* (Washington, D.C.: National Gallery of Art; Cambridge University Press, 1993), pp. 119–263; and Samuel T. Freeman and Company sales catalogue, Philadelphia, June 20–24, 1944 (the Montreal vase is lot 325).

DERUTA
Dishes

The centre of this shallow dish contains a contour panel outlining the bust-length profile of a man in contemporary court costume. The foliate details of the hat and sleeve—perhaps intended to mimic embroidery—are scratched through the blue to reveal the white glaze underneath. The rim is decorated with twelve thick waves called "San Bernardino rays," after the emblem the saint used on his preaching journeys. The prominent foot ring on the reverse lacks the suspension holes made in the unfired clay often found on dishes of this form (for example, a portrait dish in the Sant'Anna monastery in Foligno[1]), which seems to indicate that the dish was used in food preparation or service rather than primarily for wall display.

The distinctive pointed hat (*skiadion*) worn by the man on the Montreal dish is Eastern in origin; it is also worn by the Emperor of Constantinople in a portrait medal by the artist Pisanello of about 1440, which was the probable source for a figure in a Florentine engraving datable to about 1460–70.[2] The particular facial features of the man depicted on the dish suggest an actual portrait rather than a maiolica painter's stock figure or invention, and if so, his identity remains elusive.

One challenge to formulating accurate maiolica attributions is the wide dissemination of techniques and designs, a phenomenon partly due to the well-documented migratory habits of Renaissance potters. In fact, the dish under discussion here[3] is of a type historically attributed to Faenza or Florence, but comparison to fragments excavated at Deruta, in Umbria, leaves little doubt it was made there instead.[4] By the end of the fifteenth century, maiolica-making had become the leading industry in Deruta, but the town's renown increased markedly in the coming decades with the introduction and exploitation of the secret process by which a fine layer of resplendent golden lustre was added to the surface of maiolica; a piece in the Museum is a choice example of an early sixteenth-century lustred Deruta display plate. **MJB**

1. Giulio Busti and Franco Cocchi, eds., *La ceramica umbra al tempo di Perugino*, exh. cat. (Milan: Silvana, 2004), cat. 4. 2. See ibid., p. 52, for a full discussion of the medal and print as possible design sources for a maiolica jar in the British Museum. 3. See Seymour de Ricci, *A Catalogue of Early Italian Majolica in the Collection of Mortimer L. Schiff* (New York: privately printed, 1927), no. 53. Most recently, the dish appears in Meredith Chilton, "Maiolica in Canadian Museum Collections," in *The Potter's Art: Contributions to the Study of the Koerner Collection of European Ceramics*, ed. Carol E. Mayer (Vancouver: University of British Columbia Press, 1997), pp. 15–37 (cited and ill. p. 26, pl. 2.11). 4. Giulio Busti and Franco Cocchi, "Prime considerazioni su alcuni frammenti da scavo in Deruta," *Faenza*, vol. 73 (1987), pl. V.

URBINO
Tazza

The painting on this fluted dish is the Old Testament story Gathering of Manna (Exodus 16:14–36), which shows the Israelites collecting the food miraculously furnished them during their forty years of wandering in the desert; inscribed on the underside is *pioue dal' Ciel Man*[n]*a / Iououe è buono* ("manna raining from heaven / Yahweh is good"). No direct design source for the painting has been identified, and the scene is not based on the *Manna* woodcut in either of the two most common printed sources of Biblical scenes utilized by painters of *istoriato* (narrative) maiolica.[1]

In all likelihood, this splendid footed dish issued from the renowned Urbino workshop established in the 1520s by Guido Durantino (later known as Fontana), which for decades produced some of Italy's finest maiolica for clients who included high-ranking prelates, patricians and rulers.[2] Among the workshop's most prestigious wares were elaborate table services comprising plates, bowls, vases, wine coolers and other utilitarian objects. Contemporary evidence suggests that, due to its shape, this low-footed *Manna* dish was used to hold fruit; in addition, it probably was part of an *istoriato* table service.

The Montreal *Manna* dish may be attributed to the "Painter of the Carafa Service," so named for an *istoriato* service whose surviving pieces bear the arms of the Carafa family of Naples.[3] This talented artist was especially active in the 1560s, and appears to have collaborated on an armorial service commissioned by the Duke of Urbino, Guidobaldo II, and gifted to Fra Andrea Ghetti, an Augustinian priest.[4] Not uncommon for this period, both services contained a mixture of scenes from the Old Testament and from legend or classical history. **MJB**

1. These sources are woodcuts by Sebald Beham (which first appear in the 1533 Frankfurt edition of *Biblisch Historien*) and by Bernard Salomon (which first appear in the 1553 Lyons edition of *Quadrins historiques de la Bible*). 2. For the Durantino/Fontana workshop, see J.V.G. Mallet, "'In Botega di Maestro Guido Durantino in Urbino,'" *Burlington Magazine*, vol. 129 (1987), pp. 284–298. 3. Carmen Ravanelli Guidotti, *Ceramiche occidentali del Museo Civico Medievale di Bologna* (Bologna: Grafis Industrie Grafiche, 1985), cats. 118–121. 4. Timothy Wilson, "La maiolica a Castel Durante e ad Urbino fra il 1535 e il 1565: alcuni corredi stemmati," in *I Della Rovere nell'Italia delle corti. Vol. IV, Arte della maiolica*, ed. G. C. Bojani (Urbino: Edizioni QuattroVenti, 2002), pp. 125–131, and Appendix 1, pp. 151–153.

FRENCH FAIENCE: NEVERS
Urn

Faience is the French term for tin-glazed earthenware, which had its roots in Moorish Spain and Italy (Faenza). By the late sixteenth century, faience production had begun in the French towns of Rouen, Lyons, Nîmes and Nevers.

The development of Nevers, northwest of Lyons, as one of the greatest centres of early French faience may be credited to the Italian ceramicists Agostino Corrado, from Albisola, Savona, and Giulio Gambini, from Faenza, who formed a partnership in Nevers in 1588.[1] They were granted a royal privilege for the manufacture of faience in 1603, and produced faience after Italian models and techniques.

Among the most original faience wares from Nevers were those from the mid-seventeenth century, which were decorated with white and yellow motifs on a cobalt-blue coloured glaze. These *bleu de Nevers* works were inspired by similar wares made in Italian towns such as Castel Durante and Faenza in the early 1500s. This urn-shaped vase is an excellent example of the celebrated *bleu de Nevers*, with its delicate floral sprigs painted in white and two tones of yellow against the luminous blue ground. The rope handles (*anses torsadées*) are typical of Nevers faience. The urn's unevenness of form and the spontaneity of the painted and sometimes imperfect decoration call attention to the handcraftsmanship in its creation. During the production process, the decorative motifs were painted right onto the unfired glaze, which was very porous and powdery. With no room for mistakes, the decorator had to work rapidly and with a sure hand.

The type of floral decoration on this vase was referred to as *le goût persan*, or "the Persian style," even though it was inspired by sixteenth-century Iznik pottery from the Ottoman Empire. The vivid blue was admired for its reference to the brilliant blue of Islamic glass and to the richness of precious stones like lapis lazuli. It reminds us that faience was a luxury product in seventeenth-century France. **RP**

1. Dorothée Guillemé Brulon, *Histoire de la faïence française: Lyon & Nevers, sources et rayonnement* (Paris: Éditions Charles Massin, 1997), p. 40.

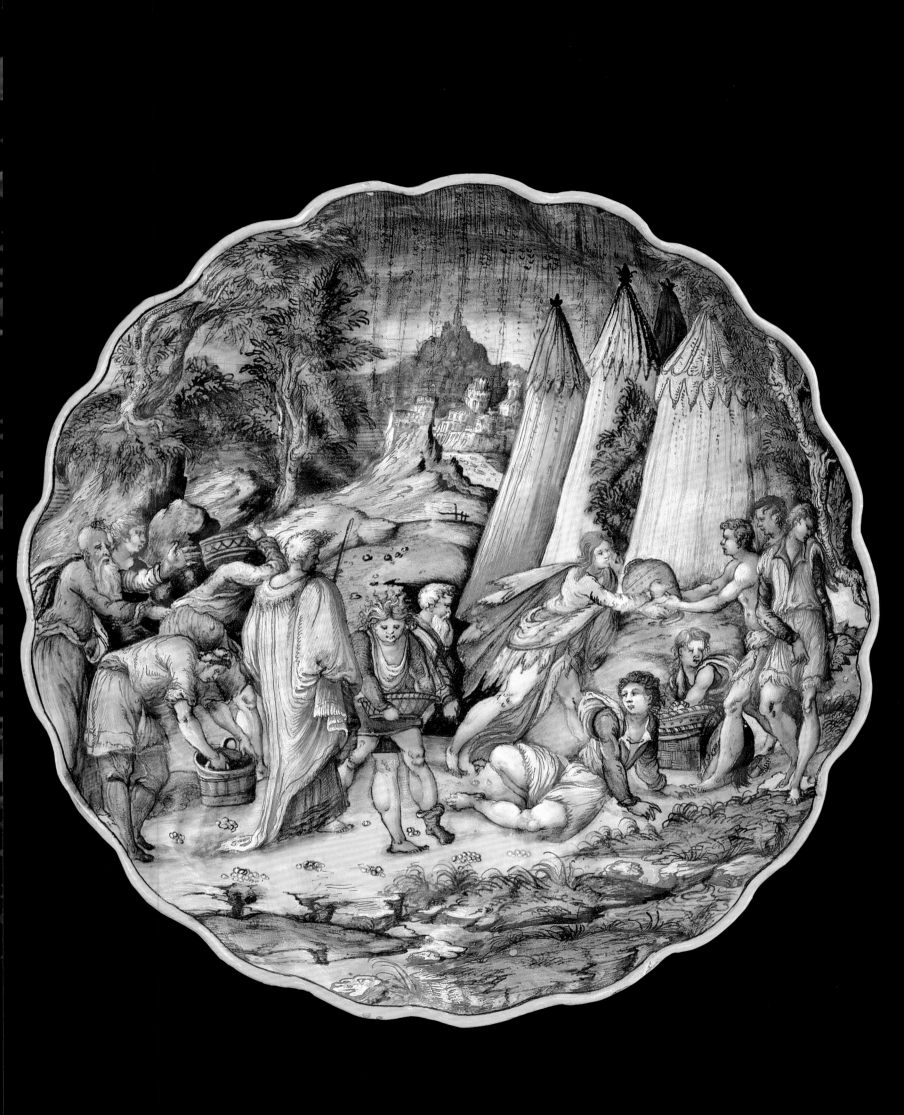

442

443

444

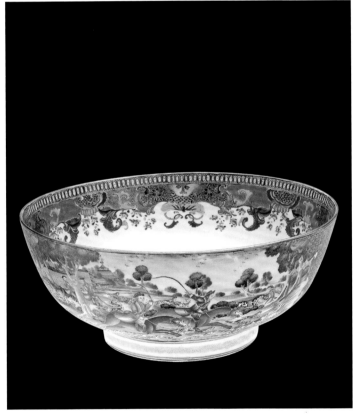

445

442

CHINA
Qing dynasty (1644–1911),
Yongzheng period (1723–1735)
**Plate with the Arms
of Goodwin of Devon
and Suffolk
About 1730**
Porcelain, painted enamel
and gilt decoration
H. 3.7 cm; Diam. 22 cm
Gift of Mrs. Neil B. Ivory
2003.305

443

CHINA
Qing dynasty (1644–1911),
Yongzheng period (1723–1735)
**Plate with the Arms of
Lee of Coton quartered
with Astley
About 1730–35**
Porcelain, painted enamel
and gilt decoration
H. 3.5 cm; Diam. 25 cm
Gift of Mrs. Neil B. Ivory
2003.288

444

CHINA
Qing dynasty (1644–1911),
Kangxi period (1662–1722)
**Imari-style Vases
About 1710–20**
Porcelain, gilt and painted
decoration in underglaze
blue and iron-red enamel
H. 45.4 cm
Gift of J. Gemmil Wilson
1972.Ee.1a-e

445

CHINA
Qing dynasty (1644–1911),
Qianlong period (1736–1795)
***Famille Rose* Punch Bowl
About 1770–1780**
Porcelain, painted enamel
and gilt decoration
H. 12.5 cm; Diam. 28.7 cm
Gift of H. Laroque
1918.Ed.3

446

**JAPAN,
HIZEN PROVINCE, SAGA
PREFECTURE**
Edo period (1615–1867)
**Pair of Imari Vases
Early 18th c.**
Porcelain, gilt and painted
decoration in underglaze blue
and overglaze polychrome
enamel
H. 100 cm; Diam. 47 cm
Purchase, gift of
William F. Angus
1939.Ee.3a-b, 4a-b
PROVENANCE
W. Scott & Sons, Montreal;
acquired by the Art
Association in 1939.

EXPORT PORCELAIN FROM CHINA AND JAPAN

— ROBERT LITTLE —

Prized as examples of rare exotica since the late Middle Ages, Chinese porcelain found its way into important European collections via long overland silk routes as a valuable by-product of the extensive silk and spice trade. During the sixteenth and seventeenth centuries, the Portuguese and, subsequently, the Dutch were able to establish sea routes and a network of trading posts at Macao, China and Batavia (now Jakarta), where they purchased the porcelain, spice and silk that commanded great interest and high prices in Europe.[1]

Since the seventh century, most Chinese porcelain was made in Jingdezhen, Jiangxi province, a city situated near deposits of the clays used in making hard-paste porcelain, the secrets of whose translucency, whiteness, hardness and impermeability were to elude the West until the early eighteenth century. Large quantities of Chinese blue and white porcelain survive as witness to this trade with the East.[2]

Civil war broke out in China in 1644, closing the country to foreign trade, and in 1675, the kilns at Jingdezhen, the main centre in the country for ceramic makers, were out of production. From the late 1650s, the Dutch procured porcelain made in Japan, primarily in the area around Arita. Much Japanese export porcelain, especially the blue and white wares, resembled Chinese export porcelain.[3] Having learned the secrets of making porcelain from the Koreans, the Japanese also developed various techniques and styles of decorating porcelain with enamel colours over the glaze, which had been initiated by the Chinese. Among the results were the Imari wares, whose underglaze blue decoration contrasted with red, black, yellow, green and aubergine overglaze enamels and gilding, and whose decorative motifs included landscapes, flowers and brocaded textile designs.[4]

The latter two were combined on the Museum's pair of large vases 446 decorated with a row of elegantly dressed women and flower carts laden with chrysanthemums and peonies, possibly derived from an *Ukiyo-e* type of print. The women appear to stand under an elaborate lappet border decorated with folding-screen motifs, the corners of which are turned back to reveal their patterned linings. The neck and lowest register are decorated with scrolling bands of peonies.

By 1683, the kilns at Jingdezhen had reopened. The Chinese continued to produce large quantities of blue and white wares along with recently developed overglaze enamels of the "famille verte" palette.[5] They successfully regained control of the export porcelain market and accommodated the demand for Imari-style decoration by producing their own "Imari" wares 444.[6] The group of five triple-gourd-shaped vases is decorated in the Imari style with prunus flowers, chrysanthemums, irises and hibiscus. Such a group would have been prominently displayed in a European interior on the top of a cabinet or mantel. Both Japanese Imari originals and Chinese copies were extensively collected by European nobility. These works had a profound impact on the stylistic development of porcelain produced at the factories at Meissen, Saint-Cloud and Worcester, contributing to the European interpretation of the Orient known as Chinoiserie.[7]

In the 1730s, a new range of coloured enamels known as "famille rose" became the dominant mode of decoration.[8] Developed in Europe about 1650–70, the predominantly rose-pink enamel of this palette was quickly adopted by the Chinese. After 1730, Western decorative styles and shapes began to influence porcelain produced for the European market. By then the English increasingly dominated the export trade,

adding porcelain to the tea, among other commodities, they traded at Canton. Recently opened to foreign traders, the Chinese established workshops there, where porcelain blanks made at Jingdezhen could be enamel-decorated to accommodate European demand.[9] Chinese export porcelain was still cheaper for the European consumer than domestic European porcelain.

European agents provided porcelain painters at Canton with images of armorial devices, accompanied by colour notations, for them to copy in order to meet the demand of clients wanting extensive dinner services personalized with their family crests, or armorials, exemplified by a plate of about 1730, decorated with the arms attributed to the Goodwin family of Devon and Suffolk 442.[10]

The range of subject matter to be copied was varied and included subjects related to the export trade itself. Grisaille depictions of the ports of Canton and London, the exit and entry ports of the English East India Company, encircle the central "famille rose" enamel-painted armorial device on a plate from a service made for the Lee of Coton family of Shropshire 443.[11] Canton is depicted as a bustling port with its trading buildings and warehouses outside the walled city. The port of London, the destination of so many of these exports, is depicted by Cantonese painters with Saint Paul's Cathedral and Chinese junks sailing on the Thames instead of barges![12]

The London view was probably derived from a printed image, as were the hunting scenes depicted on the large punch bowl 445, whose designs were taken from mezzotints related to fox hunting published in London after 1752 by Thomas Burford (1710–1774).[13] The bowl's interior border combines European and Chinese decorative motifs.

By the late eighteenth century, European ceramic production had become a well-established industry whose success, aided by protective tariffs, brought about a reduction in the export of porcelain from China. After 1800, the primary foreign market for Chinese export porcelain until the mid-nineteenth century was the United States.

1. D. F. Lunsingh Scheurleer, *Chinese Export Porcelain* (New York, Toronto and London: Pitman Publishing, 1974), pp. 21–23; F. J. B. Watson, *Chinese Porcelains in European Mounts*, exh. cat. (New York: China House Gallery, China Institute in America, 1981).
2. Lunsingh Scheurleer 1974, pp. 44–59.
3. Martin Lerner, *Blue and White Early Japanese Export Ware*, exh. cat. (New York: The Metropolitan Museum of Art, 1978), cats. 33–35; John Ayers, Oliver Impey and J.V.G. Mallet, *Porcelain for Palaces* (London: Oriental Ceramic Society, 1990), pp. 17–19.
4. Ayers et al. 1990, *Porcelain for Palaces*, pp. 25–34, 139–140, 204–205. Friedrich Reichel, *Early Japanese Porcelain* (London: Orbis Publishing, 1981), pp. 25–26, 29–31, 61–65.
5. Lunsingh Scheurleer 1974, pp. 71–84.
6. Ayers et al. 1990, pp. 233–238.
7. Reichel 1981, pp. 119–126; Ayers et al 1990, pp. 257–303.
8. Lunsingh Scheurleer 1974, p. 71.
9. Ibid., pp. 61, 64–66, 71–84, 101–109, 128–133.
10. David Sanctuary Howard, *Chinese Armorial Porcelain*, vol. 1 (London: Faber and Faber, 1974), p. 231.
11. Ibid., p. 227.
12. Geoffrey Godden, *Oriental Export Market Porcelain and Its Influence on European Wares* (London, Toronto, Sydney and New York: Granada Publishing, 1979), pp. 16–17.
13. Ibid., p. 244, and pp. 234–237, ills. 156–158.

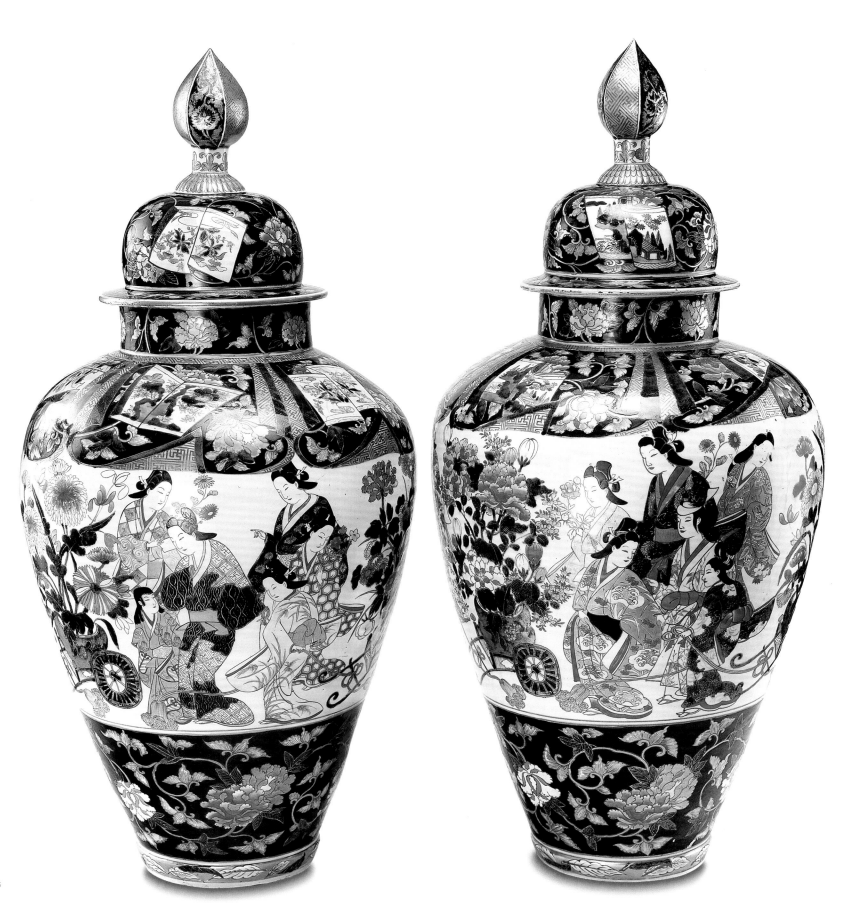

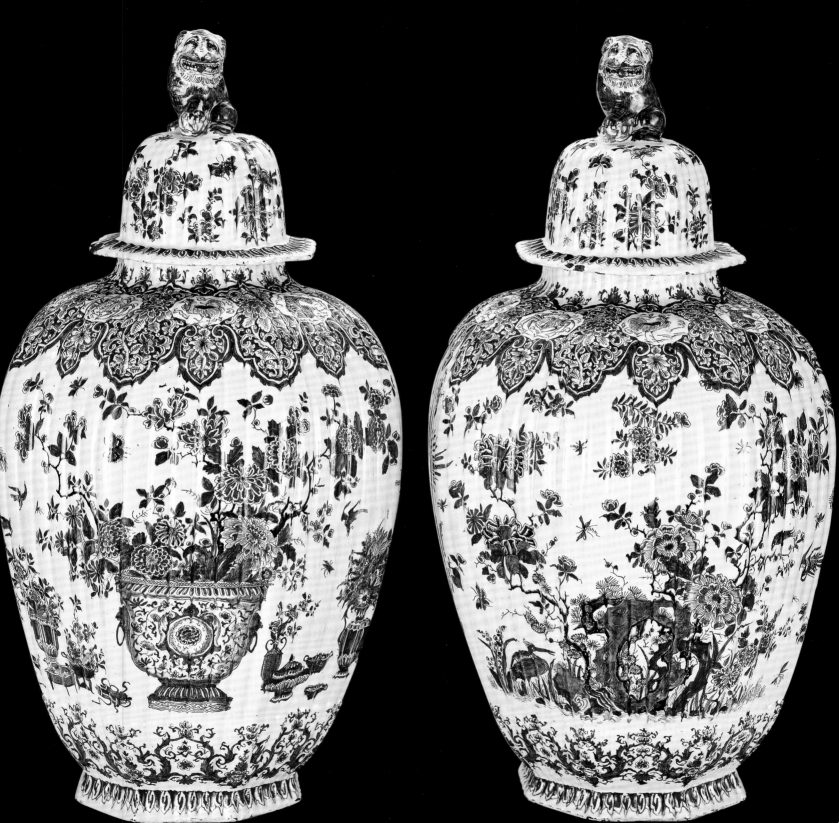

447

EAST ASIAN INFLUENCE IN 18TH-CENTURY EUROPEAN CERAMIC WARE

— MEREDITH CHILTON, BRIAN MUSSELWHITE, ROSALIND PEPALL —

DELFT

These two monumental vases **447** were possibly once part of a garniture of either five or seven vases used to ornament a mantelpiece, the top of a large cabinet or the interior of a fireplace during the summer.[1] Massed displays of Chinese porcelain and Dutch Delftware became fashionable in Holland during the reign of William of Orange, as well as in England and elsewhere in Europe.[2] They were popularized by the engravings of Daniel Marot (1661–1752) and made possible by the vast quantities of Asian materials imported by the Dutch East India Company. Not to be outdone, skilled Dutch potters imitated Chinese and Japanese porcelain in tin-glazed earthenware known as Delftware, named for the town that had become the most important centre for the manufacture of these ceramics in the mid-seventeenth century.

Perhaps in response to their patrons' desire for exotic objects that would fit into a familiar European idiom, the Dutch potters who made these vases combined Asian and European motifs. The ribbed shape, known as "Cachemire," is East Asian in origin.[3] The charming figures of lions on the lids, the rock and floral ornamentation, the various Asian birds including a magnificent male and female phoenix, and elements of the "Hundred Antiques" pattern were inspired by Chinese porcelain, whereas the polychrome palette imitates Kangxi-period *famille verte*. These elements have been successfully merged with European designs, including a depiction of a large European vase of silver form and the intricate ornamental border of lambrequins in the late-Baroque style widely disseminated by the engraved designs of Jean I Berain (1640–1711) and Daniel Marot. **MC**

1. Reinier Baarsen, Phillip M. Johnston, Gervase Jackson-Stops and Elaine Evans Dee, *Courts and Colonies: The William and Mary Style in Holland, England and America*, exh. cat. (New York: Cooper-Hewitt Museum, Smithsonian Institution, 1988). A five-piece garniture with similar decoration from the Rijksmuseum, Amsterdam, is illustrated on p. 32, fig. 31. 2. Ibid., cat. 171 and p. 32. See also Meredith Chilton, "Rooms of Porcelain," in *The International Ceramics Fair and Seminar*, London, June 12–15, 1992, printed by Nuffield Press, Oxford, for Brian and Anna Haughton (1992), pp. 24–33. 3. A pair of vases of identical shape is in the Toledo Museum of Art. See Helen Comstock, "The Connoisseur in America," in *Connoisseur Magazine* (July 1962), p. 207.

SAINT-CLOUD PORCELAIN MANUFACTORY

This bowl **448** from the Saint-Cloud factory is one of the earliest pieces of European porcelain in a Canadian museum collection, and the only one to be marked with a sun-face mark,[1] which is closely associated with Louis XIV. This mark is presumed to have been used at the factory until the king's death in 1715.[2] The Saint-Cloud factory was established outside Paris in 1666, and it first made faience (tin-glazed earthenware), followed by porcelain after about 1690. Saint-Cloud was the first commercially viable porcelain factory in Europe. It produced soft-paste porcelain, made without kaolin and fired at a lower temperature than the hard-paste porcelain of China and Japan.

Many early Saint-Cloud wares imitate European metal forms. This bowl is an excellent example; its ribbed moulding and bands of lambrequin designs on the exterior and interior rim are reminiscent of Régence-style designs found on silver. The *style rayonnant* design in the central well is often also seen on Rouen faience. The material and the underglaze blue used for the painted decoration are the only references to Asia. In 1700, the Duchess of Burgundy visited Saint-Cloud and was reported to have seen pieces painted with designs "which were more regular and better executed than those on East Asian porcelain."[3] **MC**

1. The Gardiner Museum in Toronto has other examples of Saint-Cloud porcelain of the same period, but without the sun-face mark. 2. Bertrand Rondot, ed., *Discovering the Secrets of Soft-paste Porcelain at the Saint-Cloud Manufactory ca. 1690–1766*, exh. cat. (New Haven: Yale University Press for the Bard Graduate Centre, 1999), p. 113. The sun mark may have been in use as late as 1722. 3. Quoted from the *Mercure de France*, October or December 1700, in Aileen Dawson, *French Porcelain: A Catalogue of the British Museum Collection* (London: British Museum, 1994), pp. 3–4, note 6.

MEISSEN PORCELAIN MANUFACTORY

The painted decoration on the early wares of the Meissen porcelain manufactory was directly inspired by the Chinese and Japanese porcelain that was imported in great quantities to Europe in the eighteenth century. The first true hard-paste porcelain in Europe was made in 1709 by the alchemist Johann Friedrich Böttger with the support of Augustus II, called the Strong, King of Poland (and Elector of Saxony under the name of Frederick Augustus I). This led to the establishment of the Meissen porcelain works, located just north of Dresden, in 1710. Augustus was a great collector of Asian porcelain and built a "Japanese" palace, which he filled with porcelain ordered from Meissen.

Meissen became the leading manufacturer and exporter of porcelain in Europe in the mid-eighteenth century. Known for its Chinoiserie, small flower designs and, later, its porcelain figures by chief modeller Johann Joachim Kändler (from 1731 to 1775), Meissen wares were copied by both Continental and English porcelain manufactories.

Meissen pieces inspired by East Asian porcelain were most popular during the lifetime of Augustus, who died in 1733. This tea service **449**, dating from about 1730–35, is decorated in a Japanese Imari style, named for the Japanese Arita porcelain exported from the port of Imari. The decoration consists of painted underglaze blue motifs and overglaze enamel chrysanthemum and peony blooms in brick red with gilding, set against the glistening whiteness of the porcelain.[1] **RP**

1. A similar teapot in shape and decoration is illustrated in Ulrich Pietsch, *Early Meissen Porcelain: The Wark Collection from the Cummer Museum of Art and Gardens* (Jacksonville, Florida: The Cummer Museum of Art and Gardens, in association with D. Giles Ltd., London, 2011), cat. 323, p. 309.

CHELSEA PORCELAIN MANUFACTORY

Established in 1743 in Chelsea, London, this was the first major porcelain manufactory in England.

This fluted Chelsea bowl **450** with a scalloped rim is decorated with a depiction of an episode from the legendary story of the young Sima Guang (1019–1096), the Chinese Song Dynasty statesman and historian. The scene frequently appears on Japanese porcelain made in the Kakiemon kilns at Arita in the late seventeenth and early eighteenth centuries. Kakiemon wares—known for their milky white porcelain body and distinctive palette of overglaze enamels, including iron red, blue, turquoise, black, yellow and gold—were exported from Japan to England via Dutch traders, and appeared in the 1688 inventory of Burghley House and also in the collection of Queen Mary at Hampton Court Palace.[1]

Sima Guang is shown rescuing a young friend drowning in a huge water storage jar by smashing the vessel with a rock. This legend was unknown in England and the motif came to be called "Hob in the well," probably after a scene in a popular ballad opera called *Flora, or Hob in the Well*, first performed at Lincoln's Inn Fields on April 17, 1729.[2] In the play, a young tenant farmer called Hob was beaten and thrown into a well by his unscrupulous landlord, but was rescued when his mother heard his cries. Wares with Hob-in-the-well patterns first appear in the Chelsea porcelain sales catalogue of 1755.[3]

Although similar wares with representations of this legend are known in Meissen porcelain, which was also imported to England, the translucent turquoise and the highly refined style of painting make it almost certain that this Chelsea bowl was copied directly from a Japanese prototype. The fluted shape follows a Japanese form inspired by the chrysanthemum blossom, and the border inside the rim, consisting of peonies, chrysanthemums and ferns, also copies a Kakiemon design.[4] **MC**

1. Oliver Impey, *The Burghley Porcelains: An Exhibition from the Burghley House Collection and Based on the 1688 Inventory and 1690 Devonshire Schedule*, exh. cat. (New York: Japan House Gallery; Atlanta: High Museum of Art, 1986), pp. 39–42. Impey notes that Japanese porcelain was sold in the early eighteenth century by merchants in London. 2. Colley Cibber, Timothy J. Viator and William J. Burling, eds., *The Plays of Colley Cibber*, vol. 1 (Cranbury, New Jersey; London and Mississauga: Associated University Presses, 2001), p. 14. 3. William King, *Chelsea Porcelain* (London: Benn Brothers, 1922), p. 109. Several Hob-in-the-well decorated wares appear in the 1755 catalogue, including no. 77 in the Appendix of sale on March 10, 1755: "Twelve octagon soup plates Hob in the well." Other dishes with different enamelled designs are described as "scollpt." 4. See Impey 1986, no. 100, p. 242, for similar design on an octagonal Kakiemon dish of the Edo period in the Burghley House collection.

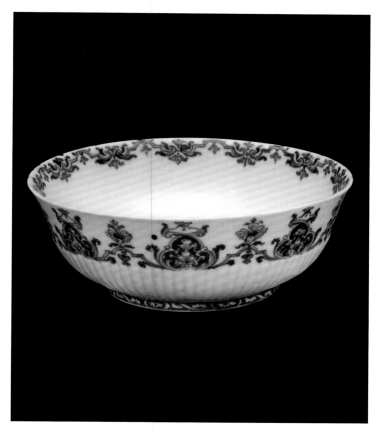

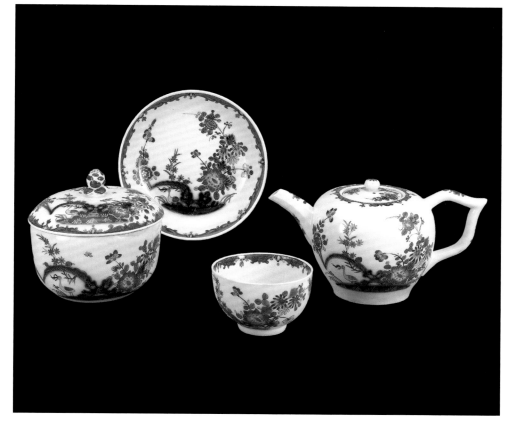

448

449

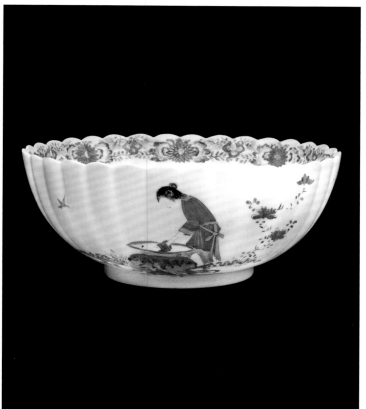

450

451

(450, detail)

SÈVRES PORCELAIN MANUFACTORY

The royal French porcelain manufactory of Sèvres, established in 1756, was purchased by Louis XV—a major shareholder—in 1759. It was the pre-eminent European producer of porcelain in the second half of the eighteenth century. Chinoiserie pieces in the form of figures, flowers and landscapes were part of the Sèvres repertoire throughout this period. Here, however, is an example of the Neoclassical inspiration that marked Sèvres design from its inception.

Cups and socketed saucers appear to have been used mostly to serve hot milky drinks to people who were sick—the deep saucer helped to hold the cup in place.[1] They were first recorded in 1762, when Madame de Pompadour ordered three. Following her death in 1764, *gobelets et soucoupes enfoncées* were primarily ordered by members of the French royal family or by nobles at court. They were usually produced individually, and were often embellished with particularly fine decoration.[2]

This example 452 has a tour-de-force ground with an intricate mosaic pattern in polychrome enamels and gilding applied by Jean-Pierre Boulanger the elder. Boulanger was recorded as a gilder at Sèvres from 1764, and by 1768 he was also working in colours, and painted "petit mosaique legere or et couleurs [sic]," most likely the description of the ground of this cup and saucer.[3] Inside the cartouches are trophies of objects that reflect the delights of the outdoors, including weapons for hunting, musical instruments and a charming straw hat. They could have been painted by Louis-Gabriel or possibly Charles Buteux the elder.[4] The cartouches are framed with tooled gilt chevron borders. MC

1. See Rosalind Savill, *The Wallace Collection Catalogue of Sèvres Porcelain* (London: Trustees of the Wallace Collection, 1988), vol. 2, pp. 674–675, for a complete study of this shape. 2. Ibid., p. 675. Savill notes that they were sometimes made with lids. Pairs are occasionally found; they were rarely matched with other items. 3. For a complete biography of Boulanger, see ibid., vol. 3, pp. 1004–1005. 4. With thanks to Rosalind Savill for the attributions of the painter of the trophies. Chulot painted 280 trophies in overtime between 1767 and 1769: see ibid., vol. 2, p. 630. Buteux was also a prolific painter of trophies at this time: see ibid., vol. 3, pp. 1007–1008.

WORCESTER MANUFACTORY

Chinamania, the craze for collecting Chinese porcelain, swept Europe in the late seventeenth and early eighteenth centuries. This led many Europeans to the dream of making porcelain that imitated the Chinese originals, because huge profits could be made if only the secret formula for porcelain could be discovered. Many tried but few succeeded, and it is all the more astonishing that, in the town of Worcester, where there was no local clay and no source of coal to fuel the kilns, the founders of the Worcester Porcelain Company not only succeeded but created a business that, even with various owners, rival factories and mergers, has lasted for well over 250 years.

The original June 4, 1751, Deed of Partnership, with fourteen investors, was formed to create the Worcester Tonquin Manufactory. Two of the investors, Dr. John Wall, a medical doctor, and William Davis, a chemist, are credited with discovering the formula for the first Worcester porcelain. Unfortunately, it had a high frit content, which made firing difficult. To save their investment, the investors acquired the declining Bristol porcelain factory of Lund and Miller. Lund's porcelain formula used a type of steatite known as soaprock.[1] This was just what was needed and, within a year, items made with this formula were being sold. Porcelain made until the death of Dr. Wall in 1776 is now referred to as "First Period" or "Dr. Wall period," and most of the 190 pieces of Worcester porcelain in the Museum's collection are from this period 453 - 456.

For the form of its pieces, Worcester, like other English porcelain factories, looked at contemporary English Rococo silver for inspiration. Sauceboats and creamers quickly became a specialty at Worcester, combining in porcelain the elegance of silver shapes with hand-painted, enamelled Oriental figures in landscapes. This chinoiserie decoration depicted fanciful images of China as imagined by Europeans. Worcester also triumphed with its teapots. The English, for many years, preferred Chinese porcelain teapots, as they were resistant to boiling water and did not crack. The addition of soaprock allowed the Worcester teapots to hold the boiling water, and they quickly replaced their Chinese counterparts.

The fashion for underglaze blue and white wares that dominated the early years of the manufactory was quickly followed in the mid-1750s by hand-painted, polychromed enamels and underglaze blue transfer prints and overglaze black and later mauve transfer prints, sometimes highlighted with hand-painted enamels.

The severe economic depression in England in the 1770s led to the company's near collapse until it was purchased in 1783 by Thomas Flight, its London agent. Under his direction, and with the royal visit of George III in 1788, the granting of a royal warrant, and the opening of a shop in London in 1789, Worcester regained its former position of prestige and profitability. A new business partner, Martin Barr, joined in 1793, and for the next forty-seven years, members of both families successfully ran the company.[2] During these later years, some of the most sumptuous gilded and hand-painted porcelains were produced. In 1840, the company merged with its rival Chamberlain and Co. and formed the Worcester Royal Porcelain Company. BM

1. John Sandon, *Worcester Porcelain* (Oxford: Shire Publications, 2009), p. 7. 2. Flight & Barr (1792–1807); Barr, Flight & Barr (1804–1813), Flight, Barr & Barr (1814–1840).

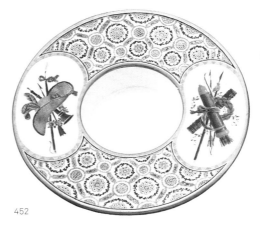
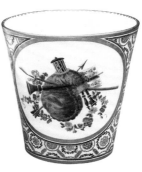

452

452

Sèvres Porcelain Manufactory
Sèvres, France,
founded in 1756
Decoration attributed
to Charles Buteux the elder
(1719–1782) or
Louis-Gabriel Chulot
(active 1755–1799/1800)
Gilding: Jean-Pierre Boulanger
the elder (1722–1785)
Cup and Socketed Saucer
(*Gobelet et soucoupe
enfoncée*)
1768
Soft-paste porcelain, painted
enamel decoration, gilding
Cup: H. 8.9 cm; Diam. 8.8 cm
Saucer: H. 3.2 cm;
Diam. 15.5 cm
Monogram, painted in blue
on underside of both pieces:
LL [interlaced] with date letter
P (for 1768) and letter *B*
(for Jean-Pierre Boulanger
the elder)
Purchase
1940.Dp.26a-b

453

Worcester Manufactory
Worcester, England
Dr. Wall period (1751–1776)
Sugar Bowl and Stand
About 1765
Soft-paste porcelain,
underglaze blue and
overglaze polychrome enamel
and gilt decoration
Sugar bowl with cover:
H. 7.5 cm; Diam. 12 cm
Stand: H. 4 cm; Diam. 18.3 cm
Gift of Mrs. Neil B. Ivory
2000.27.1-3

454

Worcester Manufactory
Worcester, England
Dr. Wall period (1751–1776)
Teapot
About 1770
Soft-paste porcelain,
underglaze blue and
overglaze polychrome enamel
and gilt decoration
14.2 x 18 x 11.3 cm
Gift of Lucile E. Pillow
1964.Lp.100a-b

455

Worcester Manufactory
Worcester, England
Dr. Wall period (1751–1776)
Dish
About 1770
Soft-paste porcelain,
overglaze painted decoration
4.65 x 26.5 x 36 cm
Gift of Lucile E. Pillow
1964.Lp.73

456

Worcester Manufactory
Worcester, England
Dr. Wall period (1751–1776)
Covered Vase
About 1765
Soft-paste porcelain,
underglaze painted
decoration
H. 25.4 cm; Diam. 12 cm
Manufactory's mark, painted
in underglaze blue on
underside: [hatched crescent]
Gift of Lucile E. Pillow
1964.Lp.24a-b

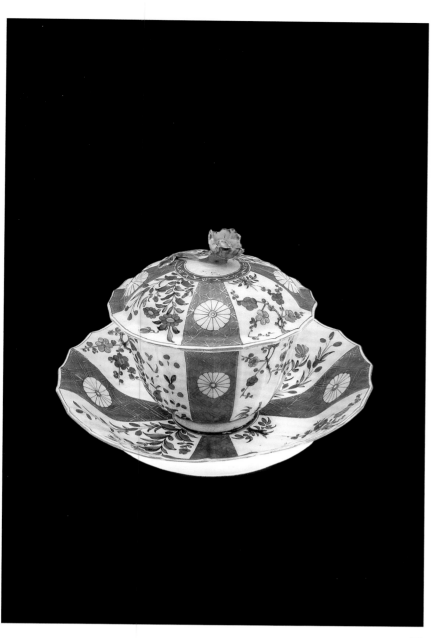

453

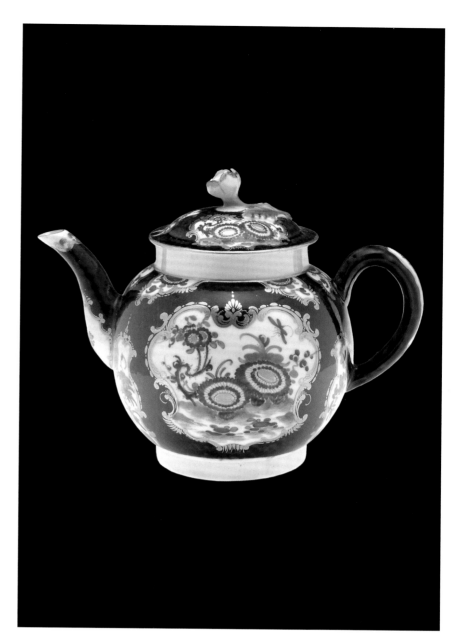

454

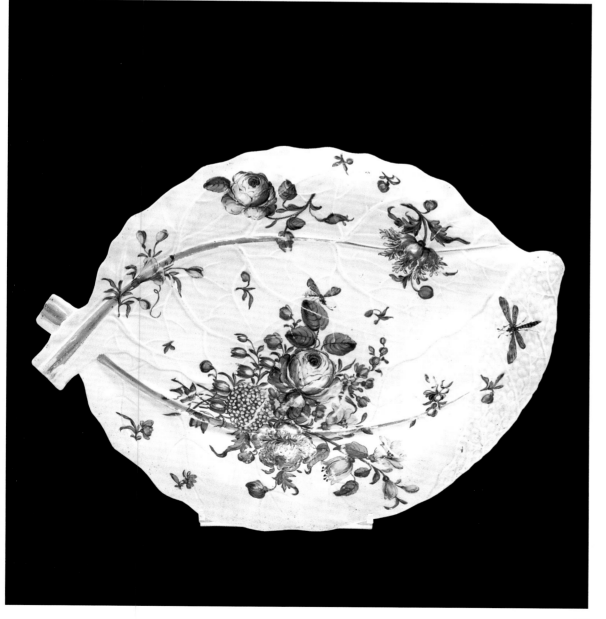

455

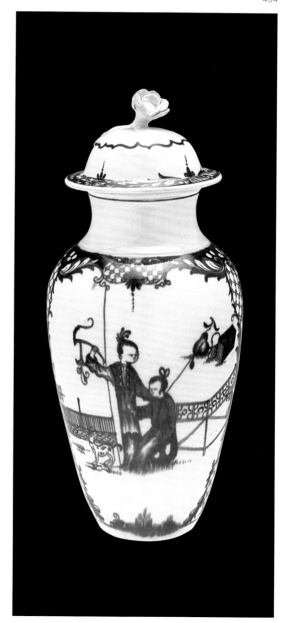

456

DEVELOPMENTS IN EARTHENWARE AND STONEWARE

— NATHALIE BONDIL, BRIAN MUSSELWHITE, ROSALIND PEPALL —

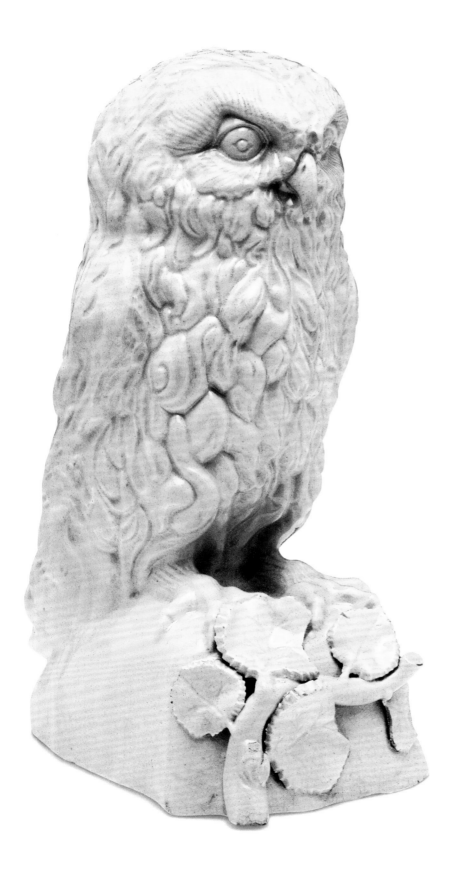

STAFFORDSHIRE
Figurine

On June 9, 1751, Sir Charles Hanbury-Williams, the British envoy to the Saxon court in Dresden, informed Henry Fox, at Holland House, Kensington, that he had given permission to Sir Everard Fawkener, a financial backer of the Chelsea Porcelain Factory, "to take away any of my china from Holland House, and to copy what you like."[1] His "china" was an extremely important collection of Meissen porcelain presented to him by Augustus III, King of Poland and Elector of Saxony. His carefree attitude towards copies could only have existed in a time before copyright and patent protection. The Museum's moulded, cream-coloured earthenware tawny owl 457 coated in a clear lead glaze from an as yet unidentified English factory is an example of such a copy.

Cream-coloured earthenware was developed in Staffordshire during the 1740s–1750s and had a number of advantages over porcelain. It was cheaper to make and its calcined flint body made it durable and allowed for thin potting. Many surviving ceramic owls from the early eighteenth century were made of thickly potted slipware, without the detailing of specific features such as feathers. Most were made in the shape of jugs with a detachable head that formed a drinking cup. It is possible that this particular model of earthenware owl is derived from a porcelain example of a type produced by a number of porcelain factories. It is a close copy of the *Tawny Owl* produced in enamelled soft-paste porcelain at the Bow Porcelain Factory about 1755–60.[2] From time to time, the Bow factory copied models of the Chelsea Porcelain Factory which, in turn, were frequently copied from Meissen porcelain examples.[3] **BM**

1. Elizabeth Adams, *Chelsea Porcelain* (London: Barrie and Jenkins, 1987), p. 64. **2.** Ross E. Taggart, *The Frank P. and Harriet C. Burnap Collection of English Pottery* (Kansas City: Nelson Gallery–Atkins Museum, 1967), p. 123, pl. 490. **3.** The Meissen Porcelain Factory did produce at least two models of tawny owls, native to Eurasia, although neither is similar to this example: Samuel Wittwer, *Die Galerie der Meißener Tiere* (Munich: Hirmer Verlag, 2004), pp. 105, 146, 319. An almost identical owl is in the collection of the Musée Ariana, Geneva; see the collection catalogue by Roland Blaettler (Geneva: Banque Paribas; L'Institut suisse pour L'étude de l'art, 1995), p. 84.

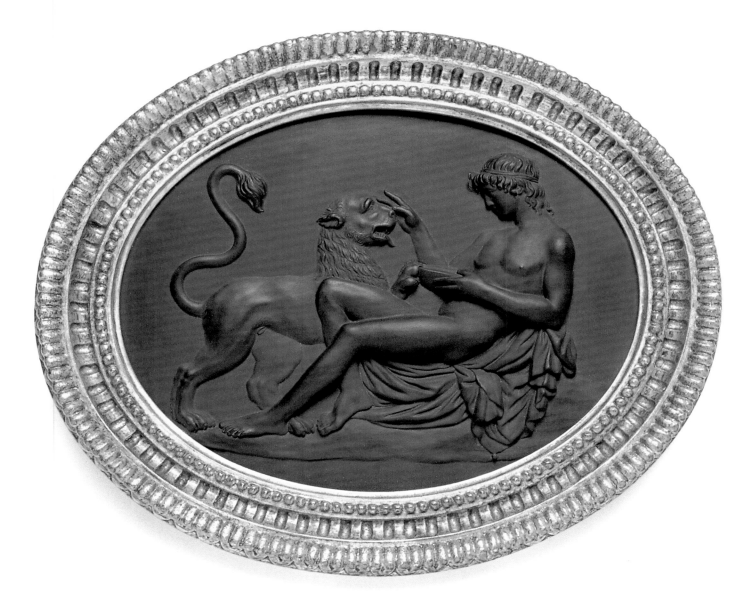

458

JOSIAH WEDGWOOD AND THOMAS BENTLEY

"The black is sterling and will last forever," wrote Josiah Wedgwood to his partner Thomas Bentley in 1774. Basalt, a very hard, fine-grained stoneware, was perfected by Wedgwood in his factory at Stoke-on-Trent, Etruria, in Staffordshire. Produced as early as 1766, it was not commercially available until August 30, 1768.[1]

The rediscoveries of Herculaneum in 1738 and Pompeii in 1748 helped to fuel a renewed archeological interest in the ancient Greek and Roman worlds that evolved into the Neoclassical style. Wedgwood quickly saw an opportunity for all things Neoclassical, not only teapots and other tableware, but also architectural plaques that could be set into mantels or walls.

The first model of this medallion **458** appears to have been made in November 1772 for Wedgwood's great patron, Sir Watkins Williams Wynn.[2] The source of the subject may be traced to Nicholas Revett and James "Athenian" Stuart's first of four volumes of *The Antiquities of Athens*, published in 1762.[3] Copies were probably acquired by Wedgwood for his library, although he is not listed as a subscriber in the first volume. In Chapter four, describing "The Choragic Monument of Lysicrates," Wedgwood would have noted Plate X, the illustration of the rectangular engraving by C. Grignion depicting "Bacchus and his Tyger [sic]" (not a panther as is usually noted), a segment from the continuous architrave bas-relief

frieze illustrating the story of "Bacchus and the Tyrrhenian Pyrates [sic]." Grignion's engraving (fig. 1) illustrates the section placed directly over the inscription on the frieze. Except for making minor changes and a slight horizontal tightening of the subject, Wedgwood appears to have made a faithful copy of the engraving. **BM**

1. Diana Edwards, *Black Basalt, Wedgwood and Contemporary Manufacturers* (Woodbridge, Suffolk: Antique Collectors' Club, 1994), p. 25. 2. Ibid., p. 71. 3. Nicholas Revett, James Stuart, *The Antiquities of Athens* (London: John Haberkorn, 1762).

457

ENGLAND, STAFFORDSHIRE
Owl
About 1760–70
Cream-coloured earthenware
22.7 x 9.3 x 15.7 cm
Purchase
1955.Dp.20

Fig. 1
C. Grignion, *Bacchus and his Tyger* [sic], pl. X in *The Antiquities of Athens; Measured and Delineated by James Stuart and Nicholas Revett, Painters and Architects.*

458

Wedgwood & Bentley
Stoke-on-Trent, England
Partnership between 1769 and 1780
Plaque
Bacchus and His Tiger
About 1772–75
Black stoneware (basalt)
14.9 x 20.3 cm
Purchase, Molson Fund
1924.Dp.49

459

JULES ZIEGLER

Official painter, innovative ceramicist, pioneer of photography, indefatigable researcher, Jules Ziegler was a fascinating character and a leading player in the history of ceramics in nineteenth-century Europe. His career coincided with the period of the July Monarchy (1830–51) and the beginning of the Second Empire in France until his sudden death in 1856 at the age of fifty-two. His biographer, Jacques Werren, describes him thus: "Obsessed his whole life by his search for the oneness of all arts, to some extent Ziegler represented the embodiment of the ideal of the Romantic artists of his day."[1] By conferring the dignity of art on the humblest of objects, this visionary creator sought to raise the level of public taste and to transform a lowly material—stoneware—so that it expressed a harmonious aesthetic.

His scholarly curiosity aroused by German Renaissance stoneware, Ziegler decided to found a stoneware manufactory producing artistic pottery. Having read the works of French ceramicist Bernard Palissy, he established the factory in Voisinlieu in Oise, near Beauvais, a region with a long history of pottery making. He ran the business for only four years, from late 1838 to August 1843, but during that time he revived the tradition of salt-glazed stoneware in Europe and of stoneware in France long before the fashion for Japonisme. He built up a team of professional sculptors and moulders, some of them from Germany. Théophile Gautier recalled, "There he was, surrounded by his clay mixers, his potter's wheels, his moulds, his kilns, his crucibles, as passionate as Bernard Palissy about *rustic figulines* [earthenware vessels] . . . he was looking for a metallic glaze for his vases (which he found later), to give the stoneware colour and hardness without masking the delicate detail of the decoration."[2] His intricate creations immediately appealed to wealthy clients and sold well in his elegant, Grand Boulevards boutique in Paris.

Stoneware, a dense, hard and impermeable material made of clay with a high silica content,

vitrified at high temperatures, was used for industrial items and kitchenware. This vase 459 was composed of carefully selected and prepared materials to be turned on the wheel or to be moulded in exquisitely detailed relief (moulded in several sections). Impressed patterns could be transferred, as in the handles, moulded separately and then attached by hand (here at a slight angle). This is why some repeated, impressed patterns such as the winged dragon are found on less ornamented objects. To soften the initial rough surface with the application of a smooth glaze, salt is thrown into the kiln during firing (hence the name "salt-glazed" stoneware). It vaporizes instantly on contact with the heat, forming a glossy transparent film and then a characteristic bronze lustre that can be darker or lighter in colour (the uniformity here makes it a particularly accomplished piece).

Ziegler, who had a passion for history and archeology, borrowed motifs from various civilizations—Chinese symbols, Hispano-Moresque arabesques, German Renaissance decoration—to produce an early manifesto in favour of eclecticism. Through his friend Alexandre Brongniart, Director of the Sèvres Porcelain Manufactory, he was given permission to mould some of the elements of a *Flemish Vase* executed in 1833 by the ornamentalist Claude-Aimé Chenavard, which provided the inspiration for the foot and the horned lions' heads of the handles. Ziegler explained, "In imitation of the architects of our cathedrals, I embroidered an openwork rose on the rounded body."[3] He emphasized that the stellated motif was based on designs in the Alhambra. With its graceful lines and the delicate ornamentation made possible by the hardness of stoneware, this vase is a tour de force in terms of technique. The daintily perforated double body is evidence of the level of skill attained by Ziegler in a relatively short time.

This model, known as a perfume-brazier, was praised by Théophile Gautier: "The unusual thing about this double-bodied amphora is

that it can contain water even though it is perforated."[4] Shown at the 1844 Exposition des Produits de l'Industrie in Paris and then at the Great Exhibition in London in 1851, it was also illustrated in publications by Philippe Burty and Brongniart. Ziegler donated his best specimens for study to the Musée de Sèvres and the Musée des Arts et Métiers in Paris. His reputation spread across Europe, where his style was widely imitated. In 1844, his works intended for industrial production were applauded in England, in an issue of *The Art Union Magazine*, and by Henri Cole, the future head of collections at London's Victoria and Albert Museum (which today holds a number of his pieces). By the mid-1840s, English potteries were producing large quantities of porcelain in the "Beauvais style." Following the fashion for the *Altdeutsch* style, imitations of Ziegler's model attested to a continuing enthusiasm for his work in Germany in the 1860s to 1880s, in a surprising return to the past.

This vase, which bears the trademark of the Ziegler years (1839–1843), came from descendants of the family of François Henri Guéneau de Mussy, doctor to the Orléans royal family. Copies exist, some in a smaller format (29.5 cm) and some in polychrome. NB

1. Jacques Werren, *Jules Ziegler peintre, céramiste, photographe* (Le Mans: Éd. de la Reinette, 2010). 2. Théophile Gautier, "Nécrologie. Ziegler," *L'Artiste* (January 4, 1857), p. 51. 3. Jules Ziegler, *Études céramiques : recherche des principes du beau dans l'architecture, l'art céramique et la forme en général, théorie de la coloration des reliefs* (Paris, 1850), p. 99 (quoted in Werren 2010, p. 132). 4. *Revue de Paris*, Nouvelle série, 1842, vol. II (February 1842), pp. 253–259.

WILLIAM DE MORGAN

William De Morgan's name is associated with his close friend, William Morris (1834–1896), the central figure in the English Arts and Crafts Movement. De Morgan was never part of the Morris firm, but early in his career he provided designs for tiles and stained glass for Morris & Co.

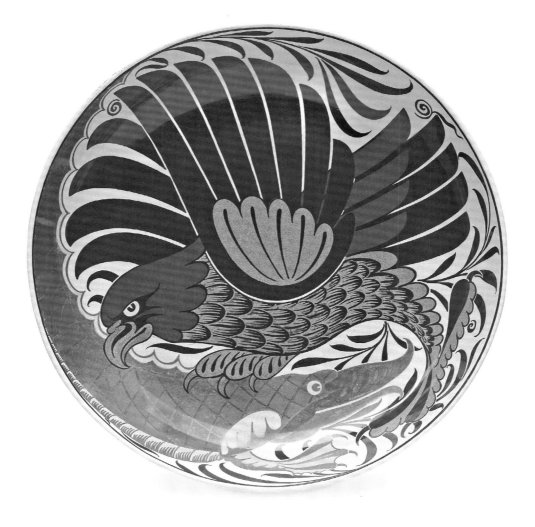

interiors. Trained in painting, De Morgan's real interest lay in the art of ceramics, and in 1872 he opened his first workshop in Chelsea and continued to produce tiles and pots until 1907. "De Morgan achieved for earthenware what Morris was doing for textiles and wallpapers," as ceramic historian Elizabeth Collard has noted.[1]

De Morgan was a man of his era in his eclectic borrowing from a wide array of sources, including medieval and Renaissance art, natural history engravings and, most notably, Islamic pottery, with its vivid turquoise, blue and green colours. What was most distinctively De Morgan was his delight in creating wondrous beasts and elaborately plumed birds to decorate his pieces, as is evident in the Museum's dish **460**. He employed craftsmen to throw his pots so he could concentrate on the decoration, and he

sometimes used ready-made blanks from other manufacturers, in this case, Wedgwood. The decoration was painted after De Morgan's design by Charles Passenger, who began working with De Morgan in 1877 and became a partner in 1898.

Across the surface of the dish, an eagle with its wings splayed out neatly within the parameters of the plate swoops down on a fantastical, web-footed creature, its tail swirling around the dish's rim. The original drawing for the dish (fig. 1) is in the Victoria and Albert Museum.[2] The bold design and rich colour set against a white ground call attention to the graphic quality of De Morgan's decoration. The rich ruby reds and warm browns are highlighted by a fine film of copper and silver lustre applied to the surface of the dish. An exacting technique, the use of metallic lustres over the glaze had a long history in Islamic pottery, and

De Morgan was a pioneer in the English revival of these lustrous surface effects. **RP**

1. Elizabeth Collard, "Ceramics," in *The Earthly Paradise, Arts and Crafts by William Morris and His Circle from Canadian Collections*, exh. cat., eds. Katharine A. Lochnan, Douglas E. Schoenherr and Carole Silver (Toronto: Art Gallery of Ontario, 1993), p. 192. The Museum's dish is illustrated on p. 184, cat. H:13. **2.** The drawing is illustrated in Martin Greenwood, *The Designs of William De Morgan* (Shepton Beauchamp, Somerset: Richard Dennis and William E. Wiltshire III, 1989), p. 43, no. 1263.

459

Jules Ziegler
Langres, France, 1804 –
Paris 1856
**Two-handled Perforated
Decanter Bottle or
Perfume-Brazier Vessel**
About 1840
Salt-glazed stoneware
51.5 x 29.1 x 16.5 cm
Monogram JZ stamped on
either side of body
Purchase, Claire Gohier Fund,
gift in memory of Dr. Alicja
Lipecka Czernick and her
husband, Dr. Stanislas
Czernick, gifts of Neil Rossy
and Mark Anthony Brands.
146.2012
PROVENANCE
Guéneau de Mussy family,
passed down.

Fig. 1
Design by William De Morgan
for a circular dish depicting an
eagle attacking a grotesque
lizard, late 19th century,
Victoria and Albert Museum,
London.

460

William De Morgan
London 1839 – London 1917
Dish
1888–97
Glazed earthenware,
lustre decoration
H. 4.9 cm; Diam. 26.5 cm
Decoration painted by
Charles Passenger (active
with William De Morgan
between 1877 and 1907)
Monogram, in red lustre
on back: *C* encircled by
W.D.M.-FULHAM; stamped:
WEDGWOOD / DVB DVB T
Gift of Graham Drinkwater
1921.Dp.4

CERAMICS AT THE TURN OF THE CENTURY

— ROSALIND PEPALL, FRANCE TRINQUE —

SÈVRES PORCELAIN MANUFACTORY

In 1891, the Sèvres Porcelain Manufactory set out a new program to revitalize its production by improving techniques and commissioning new modern designs instead of recreating imitations of past styles. The *Fenouil* [Fennel] coffee service 462 designed by sculptor Léon Kann illustrates this new direction.[1]

The organic shapes and sinuous lines of this service epitomize the French Art Nouveau style, which reached its peak about 1900. As befits its title, each piece is decorated with overlapping leaves of the fennel plant in a matte tawny green glaze that contrasts with the glistening white porcelain. The curvilinear form of the tray and the high swirl of the coffee pot handle are in keeping with the rhythmic movement of Art Nouveau motifs inspired by nature. Kann's realistic depiction of the insects decorating the lids and the tray handles reveals his keen observation of nature.

The individual pieces of the service were made and decorated at different dates, according to the marks on each work, which give the initials of the modeller, the month and year of its creation, and the year of decoration. The Sèvres Porcelain Manufactory recorded the number of examples of each piece made in a month; for example, in August 1902, the modeller Alexandre Dubois was paid for "3 serving plates by Kann (dragonflies)."[2] The modeller Léon Rigollet was paid in July 1905 for "4 *Fenouil* coffee pots by Kann" and for "4 sugar bowls from the *Fenouil* service."[3] The records indicate that a milk jug was made in the *Fenouil* pattern, but complete sets of this Kann service are rare.

Little is known of Kann, who is documented as exhibiting at the Salons of the Société des Artistes Français, first in 1896 and then almost annually from 1901 until 1912.[4] He is also listed among the French sculptors whose work was cast in bronze by the Siot-Decauville founder, in Paris.[5] His designs in bronze show similar enveloping of the main vessel in broad leaves of different plants. The design of this service may be compared with the Museum's Dutch Rozenburg vase 461

by Jurriaan J. Kok in the Art Nouveau style that inspired design throughout Europe at this time. **RP**

1. "Créations récentes de la Manufacture nationale de Sèvres," *La Décoration Moderne*, vol. 13 (May 19, 1906), pp. 25–26, pl. 55. 2. Manufacture nationale de Sèvres, archives, Registre Va'89 (travaux des pâtes, 1901–1902), fol. 167. We are grateful to Tamara Préaud for providing this information. 3. Ibid., Registre Va'91 (travaux des pâtes, 1905-1907), fol. 57. 4. Archives of the Société des Artistes Français, Paris (MMFA Archives). 5. Harold Berman, *Bronzes, Sculptors and Founders 1800–1930* (Chicago: ABAGE Publishers, 1974–1980), vol. 1 (1974), pp. 178–179; vol. 3 (1977), p. 780; vol. 4 (1980), p. 1003.

THÉODORE DECK

The originality and excellence of the production of Alsatian artist Théodore Deck has earned its place in the history of French nineteenth-century ceramics. The Museum's plate 463, from the former collection of famous Paris antique dealer François Fabius, is a perfect example of Deck's tin-glazed earthenware with Iznik-style decoration: a swirling six-petal rosette from which radiates foliage and flowers with red stigmas and white petals, such as those of the *Frieze of Archers* from the Persian Palace of Darius I (Paris, Musée du Louvre).

From the early years of his career, Deck was fascinated by the Islamic East. He developed a body with a high silica content that he covered in white alkaline enamel, which he dubbed "Persian slip."[1] A colourist, Deck looked for a technique that would enable him to preserve the brightness of colours.

"The Persian tin-glazed earthenware that came to us from the Orient and from Rhodes enabled me to study this manufacture, to apply it to our needs and to create products that, with their bright, appealing colours, could be compared to the most beautiful of the Eastern wares. At least, that is what I think,"[2] he would later write in his book entitled *La faïence*, in which he revealed the basic elements of his art and displayed his vast knowledge of the history of ceramics.

Deck's first "Rhodes" tin-glazed earthenware pieces, presented at the Exposition des

Arts Industriels in Paris in 1861, were a triumph. "Mr. Deck has dedicated himself to the production of faience art for only the past three years, yet he has already become a master," commented Paul Dalloz in the *Moniteur universel* on December 7, 1861.[3] In Dalloz's mind, "the stunning shades [of these pieces] seem to gleam with electricity." He went on to say that Deck "must have sought out the secrets of ancient Chinese and Persian faience to obtain the pink tones of the Aurora Borealis, the blues of the Egyptian sky, the emerald greens infused with this magical glow."[4]

In 1863, at the ceramic-art exhibition in Nevers, the artist presented his first pieces decorated with the famous turquoise blue from the "countries of Islam,"[5] hitherto unknown emanations called "Deck blue." **FT**

1. Pierre Kjellberg, "Théodore Deck," *Connaissance des arts*, no. 331 (September 1979), p. 99. 2. Théodore Deck, *La faïence* (Paris: Ancienne maison Quantin, Librairies-imprimeries réunies, 1887), p. 245. The term "Rhodes faience" is old and contested, as it in fact designates the ceramics produced in Iznik, Turkey. 3. Cited by Deck 1887, p. 246. 4. Ibid. 5. Antoinette Faÿ-Hallé, *Théodore Deck ou l'éclat des émaux 1823-1891*, exh. cat. (Marseilles: Musées de Marseille: Centre la Vieille Charité, 1994), p. 17.

ÉMILE GALLÉ

"Let it be said that Émile Gallé is not just the shaper of his material, and the one who infuses it with infinite seductive properties; he wants it to speak to the spirit, to excite long reveries, and under his hand, it becomes supremely suggestive and evocative."—Roger Marx[1]

Roger Marx was a Paris art critic who greatly admired and collected Émile Gallé's ceramics and glass. He wrote eloquently on Gallé's earthenware pieces, which he felt were a prelude to the artist's inventiveness and creativity in glass, for which he gained international recognition in the late nineteenth century.

Gallé took over his family's faience and crystal business in Nancy in 1877, and at the same time carried out his personal experiments in ceramics. The Museum's earthenware jug 464 was created during the short period between

461

Jurriaan J. Kok
Rotterdam 1861 –
The Hague 1919
Decoration:
Samuel Jacobus de Smit,
Sluis (1874–?)
Vase
1901
Porcelain, painted
enamel decoration
21.5 x 16.2 x 11.5 cm
Produced by Rozenburg,
The Hague
Painted in black on the
left of the vase: [an ant],
and on the right: [a square].
490 / 011; stamped in black
on underside: [a crown] /
ROZENBURG / [a stork
with worm] / *den Haag*
Liliane and David M. Stewart
Collection
D94.121.1

462

**Sèvres Porcelain
Manufactory**
Sèvres, France, founded
in 1756
Designed by
Léon Kann (1859–1925)
Fenouil
Coffee Service
1898–1912
Hard-paste porcelain
Coffeepot: 18.5 x 18 x 9 cm
Sugar bowl:
10.6 x 10.4 x 8.6 cm
Cups: 6.3 x 7.7 x 5.7 cm
Saucers: Diam. 13.1 cm
Tray: 42 x 31.2 cm
Initials and date, incised
on underside of cups:
AD 12 98 PN (for Alexandre
Dubois, modeller, active
1897–1915, December 1898,
pâte nouvelle); date of
decoration stamped in black:
S / 98 [in an oval]

Initials and date, incised
under saucers: *JC-11-01 AC /
PN* (for Jules A.F. Chemin,
modeller, active 1898–1906,
November 1901, AC(?), *pâte
nouvelle*); date of decoration
stamped in black: *S / 1902*
[in a triangle] Initials and
date, incised under coffee pot
and sugar bowl: *RL 05 7 PN*
(for Léon Rigollet, modeller,
1900–1935, July 1905, *pâte
nouvelle*); date of decoration
stamped in black: *S / 1912*
[in a triangle]
Initials and date, incised
under tray: *AD 7-02 PN* (for
Alexandre Dubois, modeller,
active 1897–1915, July
1902, *pâte nouvelle*); date of
decoration stamped in black:
S / 1902 [in a triangle]
Liliane and David M. Stewart
Collection
D94.300.1-7

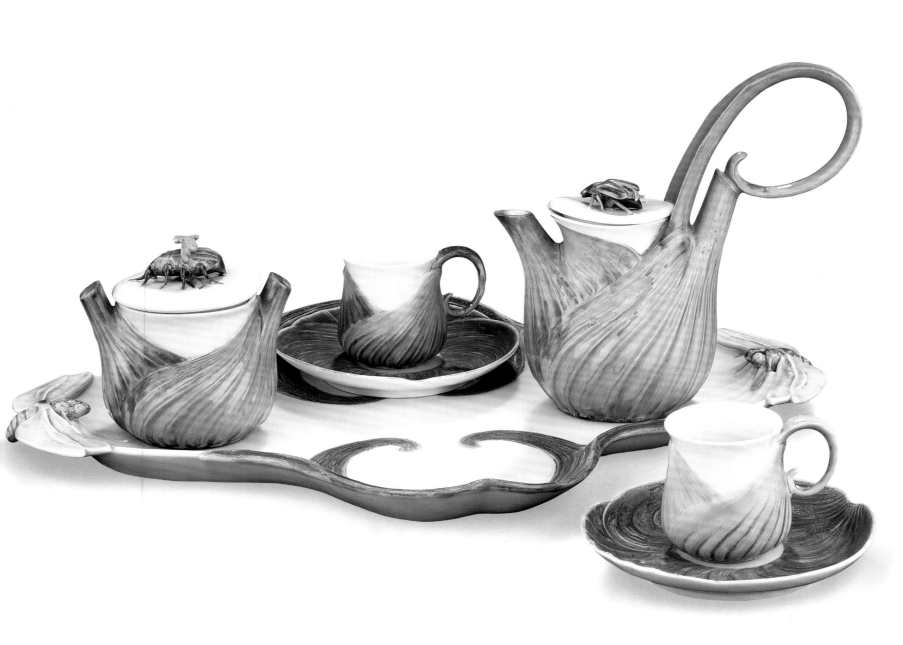

the years 1884 and 1889, when his attention was focused on his experiments with the clay medium, after which he devoted himself exclusively to glass production.

Well acquainted with Symbolist writers and artists of the *fin-de-siècle* years, Gallé's handling of his medium to evoke emotion reflected the Symbolist mood and revealed his close observation of nature. On this jug, the giant-sized moth, suggesting the passing of the moment and the transience of life, hovers in mid-flight, at once a threatening and mysterious creature with large globular eyes and outstretched black feelers. The flower too is not a pretty, naturalistic rose or tulip, but rather a spiky papyrus flower with leaves like tentacles. Gallé also expressed the Symbolist aesthetic through his treatment of the medium—its texture, colour and form. In this jug, the white clay slip or *barbotine*, covered with an aquamarine glaze, flows dramatically over the dark red clay body of the piece. It represents the celestial cloak of night descending upon the vessel, bringing with it the *papillon de nuit*, or moth. Gallé has added daubs of gold droplets; in his own words a "pluie de paillons d'or" [a shower of golden spangles] to enliven the surface of the piece. The unique shape, with its vertical spout, globular body and loop handle, was used by Gallé for other works both in glass and ceramic inspired by Islamic forms and decoration.[2] The intentionally dented sides of the jug suggest an imperfect, experimental piece, reminiscent of the asymmetrical, irregular forms of Japanese pottery, which were under close study in France at the time. **RP**

1. Roger Marx, "Émile Gallé : psychologie de l'artiste et synthèse de l'œuvre," *Art et Décoration*, vol. 30 (August 1911), p. 243.
2. Françoise-Thérèse Charpentier and Philippe Thiébault, *Gallé*, exh. cat. (Paris: Éditions de la Réunion des musées nationaux; Musée du Luxembourg, 1985), p. 170.

RICHARD RIEMERSCHMID

Richard Riemerschmid was a central figure in the German movement to reform design in the early twentieth century. Trained as both an artist and an architect, he is best known for his furniture, metalwork, glass and ceramic designs that combine organic *Jugendstil* lines with simple shapes emphasizing function and economy of form.

In 1907, Riemerschmid was a founding member of the Deutscher Werkbund, which brought together German artists, politicians and industrialists in a collaborative venture to promote cooperation between art and industry in the field of design. The Werkbund, with leading figures like Peter Behrens and Bruno Paul, promoted reform based on the principles of functional design and quality material and workmanship. Riemerschmid expressed these ideals through his teaching at the Munich Kunstgewerbeschule (arts and crafts school), where he was director from 1913 to 1924, and as the chairman of the Deutscher Werkbund from 1921 to 1926. At the same time, he worked with industrial manufacturers, and designed works such as the Museum's punch bowl **465** made by the Reinhold Merkelbach firm in Grenzhausen.

Designed in 1902–4, this model of punch bowl was exhibited at the *Deutsche Kunstgewerbe* exhibition in Dresden in 1906, along with other examples of Riemerschmid's ceramic works. It was made in two colours: the stylized plant fronds around the body of the bowl were always in blue, while the randomly scattered rosettes were sometimes in green.[1] It has been suggested that these tiny floating motifs call to mind the

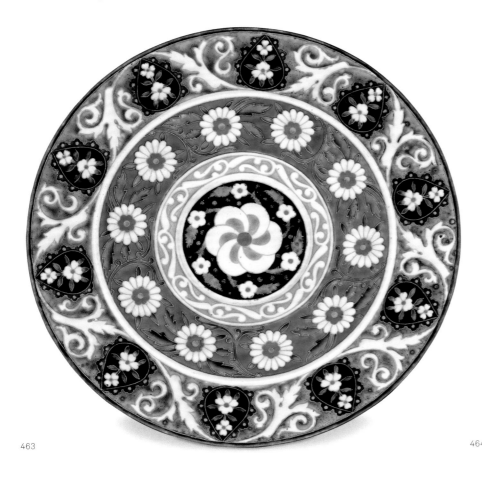

463

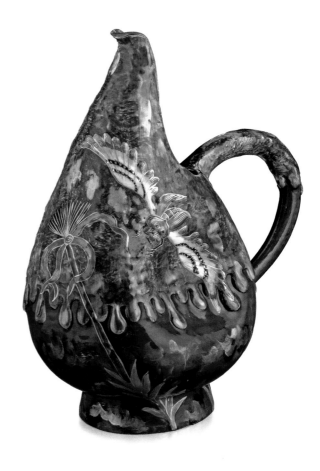

464

463

Théodore Deck
Guebwiller, Alsace, 1823 – Sèvres 1891
Large Dish
About 1870–80
Tin-glazed earthenware, painted enamel decoration
Diam. 46 cm
Signature, impressed, on back: *TH DECK*
Purchase, the Frothingham Bursary Fund
2011.200
PROVENANCE
François Fabius, Paris; sale, Sotheby's, Paris, 2011; acquired by the Museum in 2011.

464

Émile Gallé
Nancy 1846 – Nancy 1904
Jug
Between 1884 and 1889
Lead-glazed earthenware, slip, painted decoration
29.2 x 24.7 x 16.1 cm
Label on underside: *FAIENCES & VERRERIE D'ART / EMILE GALLÉ, NANCY-PARIS*
Purchase, the Montreal Museum of Fine Arts' Volunteer Association Fund
2009.56

movement of bubbles rising up in an effervescent beverage, a most appropriate motif for a punch bowl.[2]

Like other design reformers of this period, Riemerschmid had an eye on the past, as this piece demonstrates. Stoneware vessels with cobalt blue decoration were a traditional ceramic form in German vernacular applied arts, but the spherical shape, abstracted decorative motifs, and the bowl's non-studio production place it in the sphere of contemporary design. **RP**

1. A similar version of this punch bowl was included in the exhibition celebrating the one hundred years of the Deutscher Werkbund in 2007. See Winfried Nerdinger, *100 Jahre Deutscher Werkbund 1907/2007*, exh. cat. (Munich: Ernst von Siemens Kunststiftung; Robert Bosch Stiftung, 2007), ill. p. 39, fig. 17.

2. Beate Dry von Zezschwitz, catalogue entry for a similar punch bowl in Kathryn Hiesinger, *Art Nouveau in Munich*, exh. cat. (Philadelphia: Philadelphia Museum of Art, 1988), p. 145.

MAX LAEUGER

Max Laeuger trained in painting from 1881–84 at the School of Applied Arts in Karlsruhe, and worked in the local potteries at the nearby town of Kandern. A year of study, between 1892 and 1893, at the Académie Julian in Paris gave him the opportunity to observe contemporary developments in the field of ceramics. In 1895, he returned to Germany to teach at his former school in Karlsruhe, and he became the director of the craft pottery Tonwerke Kandern.

His links with Paris put him in touch with Paris art dealer Siegfried Bing, who sold Laeuger's vases decorated with swirling, curvilinear floral motifs so typical of Art Nouveau or German *Jugendstil* design. Laeuger's ceramics were also sold in Julius Meier-Graefe's Paris gallery, La Maison Moderne, opened in 1899. Laeuger's first years in ceramics proved to be a success, and he exhibited his pieces at the Paris Exposition Universelle in 1900 and the Saint Louis World's Fair in 1904. In Germany too, he was at the centre of new developments in design as one of twelve artist-founders of the Deutscher Werkbund in Munich in 1907, along with Peter Behrens, Josef Hoffmann and Richard Riemerschmid. From 1916 to 1944, Laeuger had a studio at the Karlsruhe Majolica-Manufaktur.

This vase 466 dates from about 1906–9, when Laeuger was associating with some of the important architects and designers of the Deutscher Werkbund. It no longer reflects the swaying plant forms associated with French Art Nouveau but offers a more modern approach to design.[1] The vase has an unusual, hand-thrown, ovoid shape and stands on four short, columnar legs attached to a round base. The main body of the piece has a thin veil of transparent glaze with a greenish tinge laid over a thick cream-coloured slip, resulting in a faint marbling of tones that gives the surface of the bowl both depth and richness. The only decoration is the wide, black band dotted with tiny squares of gold glass mosaic laid out in an even pattern. The overall emphasis on geometrical form, the contrast of cream and black, highlighted with the glitter of gold mosaic, look to German decorative art design of the first decade of the twentieth century in such places as Darmstadt and Vienna. The vase brings together Laeuger's early Paris experience with new directions in German applied art. **RP**

1. For a similar model, see Elisabeth Kessler-Slotta, *Max Laeuger 1864-1952: Sein Graphisches, Kunsthandwerkliches und Keramische Oeuvre* (Saarbrücken, Germany: Saarbrücker Druckerei und Verlag, 1985), p. 276, no. 352.

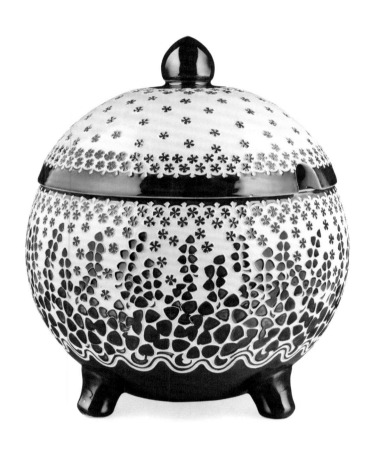

465

466

CLASSICAL FORMS
AND FIGURES OF ART DECO

— ROSALIND PEPALL —

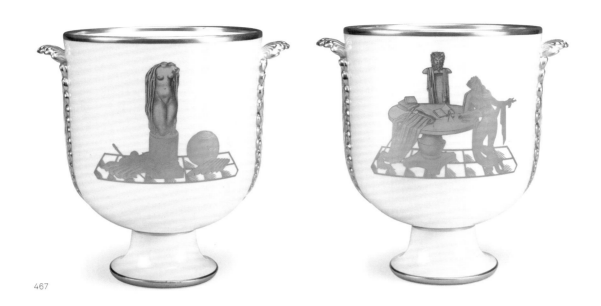

467

GIO PONTI

A 1930 catalogue of the Società ceramica Richard-Ginori included in its selection of modern art ceramics these two works from the Museum's collection.[1] Their designer, the architect Gio Ponti, had been hired as art director of the historic ceramic manufactory in 1923 specifically to introduce modern designs and to improve the artistic quality of the mass-produced ceramic wares of the firm. Extraordinarily productive, Gio Ponti was a dominant force in Italian design, guiding its development from craft-based workshops to industrial production.[2] "Industry is the *style* of the twentieth century," he wrote in 1925.[3] Ponti revolutionized the production of the Richard-Ginori firm, and such was its reputation that in 1933 the Museum bought three porcelain works and four tiles directly from the company.

From early in his career, Ponti was drawn to the classicism of Italian and French traditions. The urn-shaped vase bears the title *La conversazione classica* 467, referring to the classical figures and motifs that decorate many of Ponti's ceramic works.[4] On one side of the vase, a draped female torso symbolizes the arts; on the other, an architect carrying a scroll leans against a table on which lie a cloak and walking stick, as well as the architectural attributes of books and compasses. A letter from Ponti to the firm, dated June 26, 1926, gives a rough drawing of the vase's urn shape with a feather pattern running up the sides.[5] This vase design, referred to as *con piume* [with feathers], was first produced in 1927. The decoration in gold set against the glistening white of the porcelain enhances the refinement and luxury of the piece. The porcelain figure depicting *Il Maestro di Danze* 468, after a design by Ponti, is similarly highlighted with gold, reflecting the sober yet elegant taste of neoclassical design. **RP**

1. Società ceramica Richard-Ginori, *Ceramiche Moderne D'Arte*, catalogue, Milan, 1930, pp. 29, 41 and 43. 2. Ponti was founder and editor of the magazine *Domus* from 1928 until his death in 1979 (with the exception of the years from 1942 to 1948). 3. Cited in Lisa Licitra Ponti, *Gio Ponti* (Cambridge, Massachusetts: MIT Press, 1990), p. 25. 4. For a discussion of the classical motifs in Ponti's work, see Loris Manna, *Gio Ponti: le maioliche* (Milan: Biblioteca di via Senato, 2000), pp. 101–105, 112. 5. Copy of letter from G. Ponti to M. Tazzini of Richard-Ginori, June 26, 1926 (MMFA Archives, file 1933.Dp.4).

ROYAL COPENHAGEN PORCELAIN MANUFACTORY

The Scandinavian exhibits at the Paris Exposition International des Arts Décoratifs et Industriels Modernes of 1925 brought international attention to such companies as the Royal Copenhagen Porcelain Manufactory, whose glistening white porcelain decorated with muted underglaze colours drew admirers and inspired imitators. This historic company, established as a royal manufactory in 1775, rose to prominence after its privatization in 1868, and after the appointment in 1885 of architect and painter Arnold Krog as artistic director.[1]

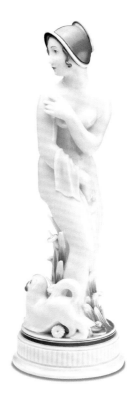

468

469

470

The Royal Copenhagen Porcelain's wares were much sought after when F. Cleveland Morgan was scouting for works for the decorative art collection of the Museum in 1931 and purchased four porcelain figurines directly from the company's London office and showroom at 6 Old Bond Street. *The Studio* magazine of London had published an article on the manufactory in their January 1931 issue, and the firm handed out copies of it to prospective clients.[2] In fact, the Museum purchased three of the works illustrated in the article: Gerhard Henning's *Man and Woman* 469, Arno Malinowski's *Susanna* 470, a modern-day Venus, and Hans Hansen's *Medusa Head* 471.[3] The manufactory referred to these wares as "Art Porcelain" to distinguish them from its functional tableware, and, as a selling point, always credited the designers of the figures, who were well-recognized sculptors.

Under the direction of Arnold Krog, the whiteness and smoothness of the porcelain body

was given prominence in the design of Royal Copenhagen's figures. This lack of colour suited the neoclassical taste of the 1920s, and the firm's porcelain figurines could be ordered in *blanc de Chine*, or decorated with overglaze colours, which, in the case of Malinowski's *Susanna*, meant just a touch of taupe with gold and black for emphasis. However, the manufactory had revived the use of overglaze colours by the late 1920s, as is evident in Gerhard Henning's *Man and Woman*. Compact in composition, and modern in its spare rounded forms, it is typical of Henning's figural groups, which also looked back to eighteenth-century models in their delicacy, colour and sense of the exotic.

The sculptor Hans Hansen was the firm's chief modeller, and his classically inspired *Medusa Head* was a prized piece, a model of it being on permanent display in the factory's museum.[4] The celadon glaze was a result of the company's experiments in reproducing ancient Chinese glazes and developing a lustrous, soft green glaze

modelled after Song period celadon wares. In Hansen's dramatic *Medusa Head*, the glaze has been cleverly applied so that it thinly covers areas of high relief, allowing the white porcelain to show through, while in the crevices the glaze has pooled, giving a darker green tone. **RP**

1. Bodil Busk Laursen and Steen Nottelmann, eds., *Royal Copenhagen Porcelain 1775–2000* (Copenhagen: Nyt Nordisk Forlag Arnold Busck A/S, 2000). **2.** C. G. Holme, "Copenhagen Porcelain," *The Studio*, vol. 101, no. 454 (January 1931), pp. 25–30. A special offprint of the article is in the MMFA Archives (file 1931.Dp.5). **3.** At the same time, Morgan purchased Malinowski's figurine *The Bride*, dated about 1930. **4.** Xenius Rostock, *The Royal Copenhagen Porcelain Manufactory and the Faience Manufactory Aluminia: Past and Present* (Copenhagen: Det Berlingske Bogtrykkeri, 1939), p. 65.

468

Gio Ponti
Milan 1891 – Milan 1979
After a model by
Geminiano Cibau (1893–1969)
Il Maestro di Danze
About 1930
Hard-paste porcelain,
gilt decoration
27.9 x 15 x 7.7 cm
Produced by Società ceramica
Richard-Ginori, Milan,
Doccia Manufactory, Tuscany
Signature, stamped in
underglaze green on
underside: *RICHARD GINORI*
Stamped in overglaze grey:
MADE IN ITALY, and stamped
on gold ground: *RICHARD-
GINORI / PITTORIA / DI DOCCIA*
Purchase
1933.Dp.2

469

**Royal Copenhagen
Porcelain Manufactory**
Founded in 1775
After a model by Gerhard
Henning (1880–1967)
Man and Woman
1916, decoration 1927
Hard-paste porcelain,
painted enamel decoration
23 x 20.6 x 16.3 cm
Manufactory's mark painted
in underglaze blue, on
underside: [three wavy lines
surmounted by a crown];
modeller's mark, date of
decoration and decorator's
initials painted in red on
underside: [crown over heart].
22.8.27. / AF (unidentified
decorator); incised on top
of base: [crown over heart];
incised on underside:
1796 (model number)
Purchase
1931.Dp.7

470

**Royal Copenhagen
Porcelain Manufactory**
Founded in 1775
After a model by Arno
Malinowski (1899–1976)
Susanna
About 1930
Hard-paste porcelain,
overglaze polychrome
decoration
H. 28.3 cm; Diam. 9.1 cm
Manufactory's mark,
painted in underglaze on
underside: [three blue wavy
lines surmounted by a green
crown]; painted in grey on
underside: *CN*; incised: *12454*
Purchase
1931.Dp.6

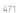

471

ÉDOUARD CAZAUX

Both Édouard Cazaux's father and grandfather were potters in a family enterprise in the production of utilitarian ceramic wares. This heritage provided Édouard Cazaux with the background to set out on a career of his own as a potter, establishing a workshop in 1920 in La Varenne, France. Cazaux made his name as a ceramicist in the period between the two world wars, building on the traditions of French ceramic artists of the previous generation like Ernest Chaplet, Auguste Delaherche and Edmond Lachenal, the latter under whom Cazaux worked at the beginning of his career. The first ceramics he exhibited in 1922 were of stoneware decorated with geometric shapes and lines in cool tones of white, grey or brown. Later, he took an interest in traditional French tin-glazed earthenware, which opened up possibilities for brighter colour and painterly figurative decoration.

This vase 472 from the 1930s maintains its functional aspect, but is decorated overall with raised relief designs of leafy bunches of grapes and dancing figures that recall the dancing female nudes of Matisse. Cazaux drew his inspiration from many sources, whether painting, sculpture or the works of other contemporary French ceramicists like André Metthey or René Buthaud. Cazaux gained recognition for his ceramics in the annual Salons des Artistes Décorateurs and at the large international exhibitions in Paris in 1925 and 1937.

Cazaux's diverse interests led him to create works of sculpture and to design glassware for the Cristalleries de Compiègne, using models that could serve for his earthenware pieces as well. An identical model of this vase with dancing figures was made about 1930–35 in blown and moulded glass.[1] RP

1. Mireille Charon-Cazaux et al., *Édouard Cazaux, céramiste-sculpteur Art Déco* (Saint-Rémy-en-l'Eau: Éditions d'Art Monelle Hayot, 1994), p. 86.

471

Royal Copenhagen Porcelain Manufactory
Founded in 1775
After a model by Hans
Hendrik Hansen (1894–1965)
Medusa Head
About 1930
Hard-paste porcelain,
celadon glaze
26.6 x 29.5 cm
Manufactory's mark and
modeller's monogram painted
in underglaze blue on back,
near base: [three wavy lines]
HHH 1 / 2950
Gift of Miss Mabel Molson
1931.Dp.5

472

Édouard Cazaux
Cauneille, France, 1889 –
La Varenne, France, 1974
Vase
About 1930–35
Tin-glazed earthenware
H. 28 cm; Diam. 19 cm
Signature, incised underglaze
on underside: *CAZAUX*
Liliane and David M. Stewart
Collection, gift of
Mireille Charon-Cazaux
D96.100.1

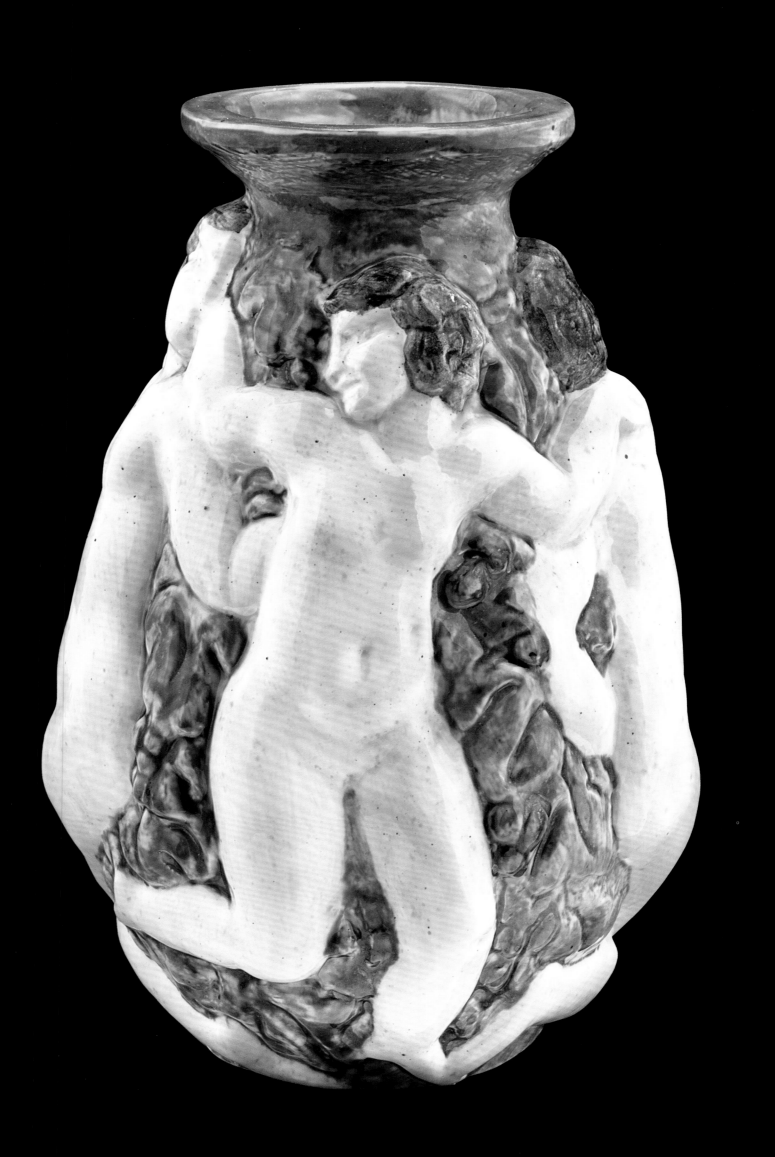

DESIGNING FOR INDUSTRY: SUZANNE LALIQUE, CLARICE CLIFF AND EVA ZEISEL

— CHERYL BUCKLEY —

Prominent figures in three different countries—France, Britain and the United States—Suzanne Lalique (1892–1989), Clarice Cliff (1899–1972) and Eva Zeisel (1906–2011) addressed similar design issues in their long careers. They worked with mainstream commercial ceramic manufacturers rather than small-scale art or studio potteries, and each produced designs that came to epitomize modernity and modernism in their respective countries.

By the mid-twentieth century, there was a plethora of women working as designers in a range of industries, including fashion and textiles, furniture and, product design, graphics and illustration, costume and film design, as well as glass and ceramics. As further research and scholarship has revealed, women's involvement in design was multi-faceted and complex, and, as recent historians have shown, this was not confined to the West. Significantly, women had worked in the ceramics industries in all three countries from the eighteenth century onwards, and by 1910–1920, when Lalique, Cliff and Zeisel began to forge their respective careers, there were established routes into pottery design for women, although patriarchal attitudes and work practices lingered.[1]

Of particular interest in relation to the work of all three designers is the way they interpreted the decorative aspects of pottery design, particularly during a period dominated by modernity and modernism. Recourse to the decorative realm, described as modernism's "Other," was paradoxical within the context of emerging modernism, but it remained an essential feature of design, and it was harnessed by all three designers. Lalique and Cliff strongly engaged with pattern-making, and they brought differing, although intrinsically modern approaches to its use in their domestic tableware for Haviland Porcelain, in Limoges, and A. J. Wilkinson, in Tunstall, Stoke-on-Trent. In contrast, in her work for Red Wing Pottery, in Minnesota, and Castleton China, in Pennsylvania, Zeisel's style was extremely minimalist, although she too was well versed in the use of decorative patterning as seen in her designs for Hall China, in East Liverpool.

Lalique's soup tureen and plate 474, designed for the 1925 Exposition Internationale des Arts Décoratifs in Paris, is typical of her work in that it marshalled the decorative exuberance characteristic of Art Deco and combined it with the simplicity and abstraction of modernism. She designed a range of decorative patterns based on close observation of nature that were abstracted for application to streamlined ceramic shapes. Her palette relied on simple combinations of two or three colours to produce exquisite designs that captured the modern age with lightness and delicacy for consumers in France and the United States.

Working at the same time as Suzanne Lalique was Clarice Cliff, whose earthenware designs were assertively geometric with abstracted, brightly coloured patterns based either on rectilinear forms or drawn from nature, as in the 1933 *Coral Firs* tureen and tea and coffee service 473 . These motifs were applied to hard-edged angular shapes, including the oblong and square plates of the *Biarritz* range, begun in 1933, which had been inspired by the work of the French designer Jean Tetard. Cliff's work unquestionably responded to the imagery of the "Jazz Age," and A. J. Wilkinson benefited from the increased affluence of the burgeoning middle-class consumers in Britain, who were prepared to pay for novelty, flamboyance and wit at their dining table. Although Cliff remained in Britain working as a designer at A. J. Wilkinson for all of her professional life, Lalique's career was more varied, as she had worked as a stage designer, painter and ceramic designer in France (at Haviland and Sèvres).

Eva Zeisel, who continued to design past her one hundredth birthday, worked as a ceramic designer in Hungary (where she was born), Germany, the Soviet Union and the United States.[2] As an émigré to the United States in 1938, she brought with her a profound understanding of modernism that eschewed the functionalist rhetoric of many modernist theorists at the time, as evidenced in her *Town & Country* dinnerware 475 designed for Red Wing Pottery about 1945. These biomorphic designs show an understanding of modernism's re-engagement with organic forms and natural materials, a combination to which was added solid single colours.

Viewing the careers of these three women from the twenty-first century, what is apparent is the visual diversity of their work and the differences in their career paths given that they worked in roughly the same historical period and in relatively similar social, economic and cultural contexts. Unquestionably shaped by modernity and modernism, their work was extremely successful in addressing the needs of the marketplace as well as making a major contribution to twentieth-century industrial ceramic design.

1. See Cheryl Buckley, *Potters and Paintresses: Women Designers in the Pottery Industry, 1870–1955* (London: The Women's Press, 1990); Cheryl Buckley, "'Quietly Fine,' Quietly Subversive: Women Ceramic Designers," in *Women Designers in the USA 1900–2000: Diversity and Difference*, ed. Pat Kirkham (New Haven; London: Yale University Press, 2000).
2. At a meeting with the designer in her home in New York in April 2009, Eva Zeisel showed the author a range of prototypes of her latest designs.

473

Clarice Cliff
Tunstall, Stoke-on-Trent, Staffordsire, England, 1899 – Stoke-on-Trent, 1972
***Coral Firs* Tea and Coffee Service, and Soup Tureen**
About 1933
Lead-glazed earthenware
Teapot: 18.7 x 16.8 x 7.5 cm
Coffee pot: 17 x 22 x 8.5 cm
Sugar bowl: 9.6 x 11.5 x 5.6 cm
Creamer: 9.1 x 15.5 x 5.3 cm
Soup Tureen:
14.5 x 20.1 x 13.2 cm
Produced by
Arthur J. Wilkinson,
Burslem, England

Stamped in black on underside of coffee pot: *Clarice Cliff / WILKINSON LTD / ENGLAND / REGD. NO. / 776243*; on underside of sugar bowl and creamer: *Clarice Cliff / WILKINSON LTD / ENGLAND / REGD. NO. / 776243 / MADE IN ENGLAND*; under teapot: *HAND PAINTED / Bizarre / by / Clarice Cliff / WILKINSON LTD / ENGLAND / MADE IN / ENGLAND*; on underside of tureen: *Clarice Cliff / WILKINSON LTD / ENGLAND / The Biarritz / a crown / Royal Staffordshire / Great Britain / REGD No. 784849*; handwritten in black on underside of tureen: *6/99*
Liliane and David M. Stewart Collection, gift of the American Friends of Canada through the generosity of Geoffrey N. Bradfield
D95.170.1-5a-b

474

Suzanne Lalique
Paris 1892 –
Bédoin, France, 1989
Soup Tureen and Plate
1925
Porcelain, overglaze enamel decoration
Tureen: 15.8 x 30.1 x 27.4 cm
Plate: 4.4 x 40.4 x 32.1 cm
Produced by Theodore Haviland, Limoges
Stamped in underglaze green, on underside of tureen: *THEODORE HAVILAND / FRANCE*, and in overglaze grey: *Décor de / Suzanne Lalique*

Stamped in overglaze red, on underside of cover: *Théodore Haviland / Limoges / FRANCE*, and in overglaze grey: *Exposition des A.D. / Paris 1925*
Stamped in underglaze green, on underside of plate: *THEODORE HAVILAND / FRANCE*, in overglaze red: *Théodore Haviland / Limoges / FRANCE / Exposition des A.D. / Paris 1925*, and in overglaze grey: *Décor de / Suzanne Lalique*
Gift of John L. Russell
1967.Dp.1a-c

475

Eva Zeisel
Budapest 1906 –
New City, New York, 2011
***Town & Country* Dinnerware**
1945–50
Glazed earthenware
Teapot: 13 x 29.5 x 18.1 cm
Creamer: 12.2 x 9 x 8.5 cm
Sugar bowl: H. 9.3 cm;
Diam. 10.3 cm
Cruet: 13.4 x 13 x 9.3 cm
Salt shaker: 11.5 x 7.7 x 5.8 cm
Pepper shaker:
8.3 x 3.9 x 5.1 cm
Produced by Red Wing Pottery, Red Wing, Minnesota
Liliane and David M. Stewart Collection, gift of Mr. and Mrs. Charles D. O'Kieffe, Jr. in memory of Mr. and Mrs. Charles DeWitt O'Kieffe, by exchange
D88.133.6, .2
D90.119.1a-b, .4a-b
D88.133.3, .4

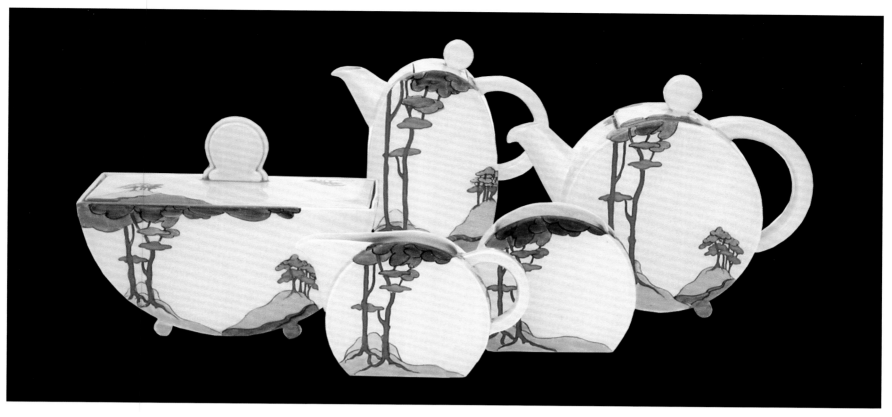

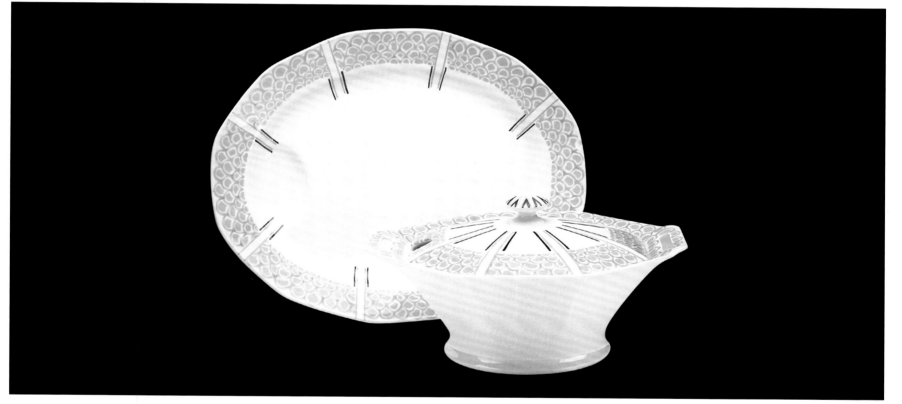

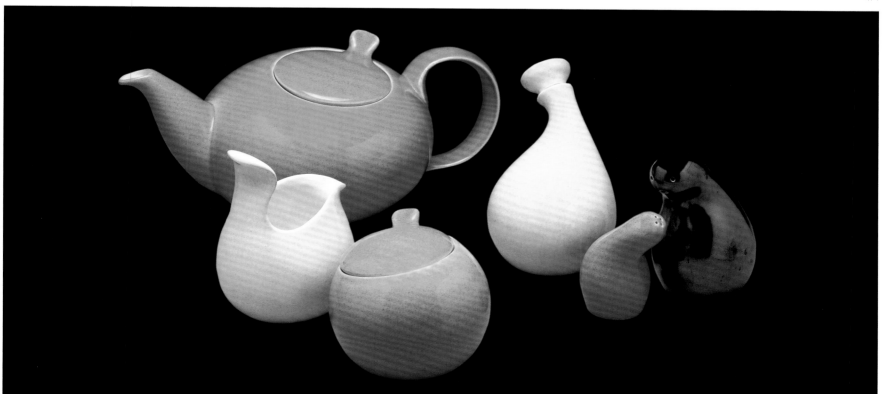

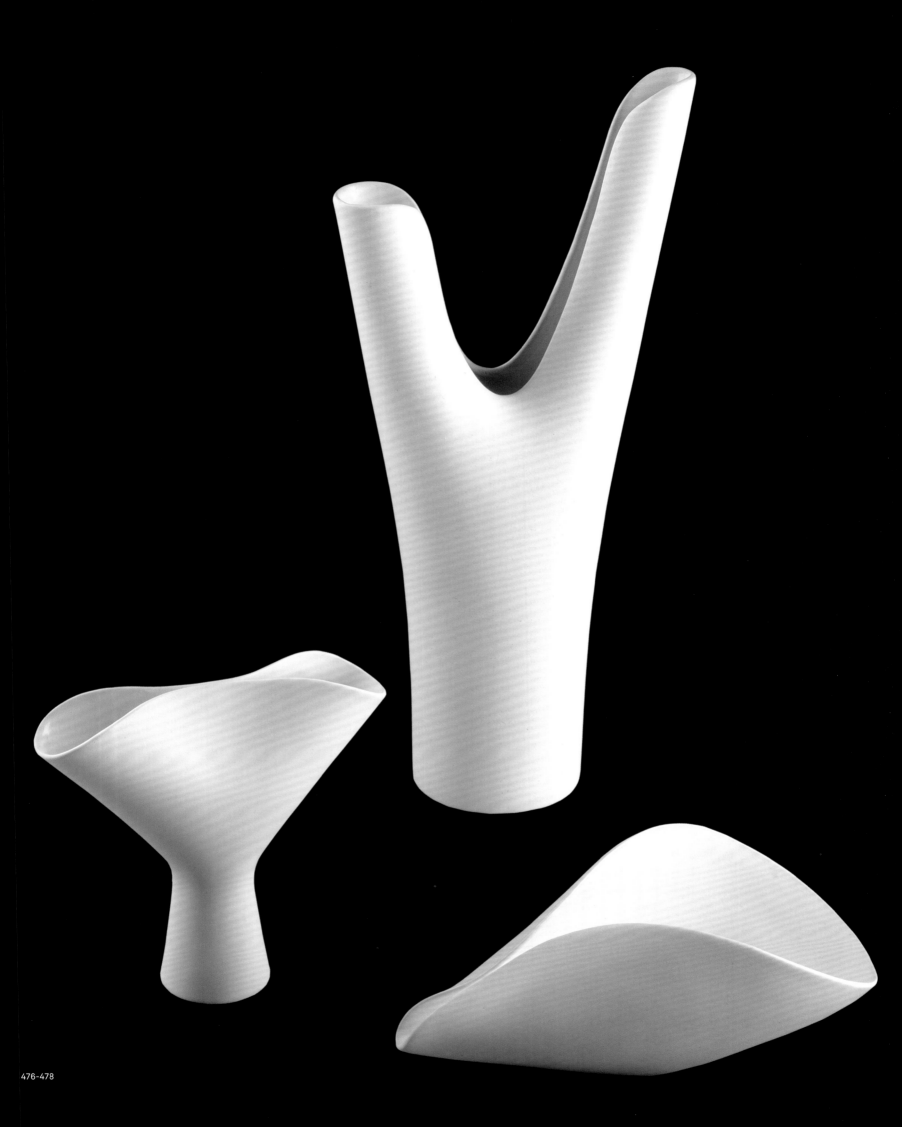

476-478

SCANDINAVIAN CERAMICS AT MID-CENTURY

— MARTIN EIDELBERG —

"When you look at Scandinavian design, you see that it scatters flowers before your feet
and lays the pale colors and mild beauty of the Nordic summer before your eyes. Less apparent is the truth
that this sunny effect is achieved against a background of darkness, cold, ice, and snow."
—Ulf Hård af Segerstad[1]

"The popular view persists of a group of countries consisting of lakes and pine trees,
peopled with design-conscious healthy blonds. . . . Their year is neatly divided into short winter days
with brilliant crisp snow and endless summers spent in summer houses dotted among the
pine forests and in boats drifting on the myriad lakes. There are elements of truth in this enviable
picture and, indeed, many Scandinavians themselves cherish this image.
Nevertheless, to the more critical observer. . . . the picture is considerably more complex."
—Jennifer Hawkins Opie[2]

Defining the nature of mid-century Scandinavian ceramics is a challenge on several counts: It presumes that the Northern European countries acted in concert, which they did not, and that all the ceramicists were of the same mindset, which they were not. Some, including Scandinavians themselves, would have us believe that their crafts and design are profoundly influenced by the northern climate—brief summers and icy, long winters—but this too seems more mythic than real. Many scholars contend that there was a specific mid-century style or, at least, a monolithic Scandinavian style, but writers often prefer to rearrange history into such neat, sequential blocks. However, that is not the way that art was created or that history actually transpired. Indeed, diversity of tastes was perhaps a chief defining characteristic of the modern spirit.

One of the most common conceptions about Scandinavian ceramics is that it responded to the functionalist ideals of "good design." That is to say, it conformed to traditional, efficient shapes and eschewed all decoration. There is no better example of this than Gertrud Vasegaard's tea service for the Danish firm of Bing & Grøndahl 480. The clean-lined, architectural quality of the design is established by the hexagonal form of the teapot and the contrasting circular forms of the saucers and handleless tea bowls. Glazed a subtle light grey, the service's thin border of iron oxide gives a delicate accent. Certainly the concept is not as severe as Modernist designs of the pre-war years. Mid-century modernism was not intrusive or aggressive, but quite the contrary. Moreover, the overt references to traditional Chinese forms give these pieces a comfortable quality. One can well understand why Vasegaard's tea and dinner service was awarded a gold medal at the Eleventh Milan Triennale, 1957.

Yet it would be misleading to think that controlled, restrained design is representative of all Scandinavian post-war ceramics. Stig Lindberg takes another approach altogether 482. His large, brightly painted vase for Gustavsberg represents a very different tendency. In contrast to Vasegaard's sobriety, Lindberg represents playful fantasy. One side of the vase shows the highly stylized, wistful face of a young woman. Her hand is cupped behind her ear, indicating that she is listening to the modern-day Papageno on the reverse side who, leaning nonchalantly out of a tree, serenades her with his flute. The style of this colourful narrative is tangentially related to the paintings of Marc Chagall but is perhaps more closely related to popular illustration. Whatever its stylistic origin, the urge to decorate reflects a premise just as prevalent in Scandinavian ceramics as Spartan whiteness.

The issues are made further complex because these seemingly opposite modes often converged. Despite its painted decoration, Lindberg's vase conforms to mid-century modernism in its extended, globular form, the absence of mouldings at the lip and base, and its overall whiteness. On the other hand, Vasegaard's teapot was offered with a decorative blue, geometric pattern. A great many other Scandinavian ceramic pieces in the Museum's collection share such intermediate stylistic positions. Lindberg's whimsical *Veckla* vases 476 - 478 —unadorned white forms that are folded or cut into playful "free-forms"—belong in this middle ground. So, too, Friedl Holzer-Kjellberg's white porcelain vases 484, delicately pierced with decorative translucent rice-grain patterns, establish another midway idea.

These are not the only alternatives. Wilhelm Kåge's *Surrea* vase 483, made specially for an exhibition in 1940, shows a straightforward Cubist play of sliced volumes and overlapping silhouettes of a sort that can be traced back to Kazimir Malevich's famed teapot designed for the Lomonosov Porcelain Factory of 1923, and to Georges Braque's still-life paintings. Charming rather than avant-garde, *Surrea* was put back into production in 1953, and again recently, yet this Cubist concept of reconstructing reality never became a mainstream feature in Scandinavian ceramics.

We also should consider the exceptional work of Axel Salto. Here is an artist whose oeuvre is dramatic and emotionally charged—traits not generally associated with Scandinavian design. Starting in the 1930s and continuing into the 1950s, Salto created organically shaped vases representing "budding" and "sprouting" forms. Some are representational with recognizable leaves and fruit, but generally they have abstracted knobs and protrusions intended to represent the forces of nature. As can be seen in the Museum's two examples, the taller vase 479 is fruit-like in its general form, although it would be difficult to identify the exact species. The stem at the top and the overall pear-shape body are naturalistic elements, but the many teardrop forms surging outward like a multi-breasted Diana of Ephesus suggest the fecundity of nature in an abstract way. Although Salto's spherical vessel 481 is not particularly fruit-like, the warty surface does resemble certain gourds and citrons and, again, the "budding forms" suggest an emerging life force. The rich matte glazes of the two pieces are related to those introduced at the Gustavsberg factory as far back as the 1910s, and here they help sustain the notion of an organic substance. Salto's forceful vision was much admired, yet stands somewhat apart from the norm of mid-century "good design." On the other hand, his credo of an organic, nature-based art prepared the ground for designers such as Tapio Wirkkala, who merged such ideas with sleek industrial minimalism. Later, ironically, Wirkkala also assumed this more personal and expressive mode.

In short, there was as much diversity as there was unity in Scandinavian design. Compared with Italian ceramics of the same period, which are generally flamboyant and intensely coloured, Scandinavian wares seem distinctively cool. Yet when Scandinavian ceramics are compared with English and North American pottery, a more international code seems apparent.

A most interesting aspect of Scandinavian mid-century pottery is the social and economic aspects of its organization. There was a marked division between studio pottery and industrial production in most Western countries, yet the dividing line was less fixed in Scandinavian countries, and the two areas tended to merge. Independent potters often worked in studios supported by large firms such as Bing & Grøndahl, Royal Copenhagen, and Rörstrand, and their work was integrated into the companies' offerings. Industry supported personal creativity and, in turn, artistic creativity spurred the companies' production. This is a significant and distinctive feature that should not be overlooked.

1. Ulf Hård af Segerstad in David Revere McFadden, ed., *Scandinavian Modern Design 1880–1980* (New York: Harry N. Abrams, 1982), p. 25.

2. Jennifer Hawkins Opie, *Scandinavian Ceramics and Glass in the Twentieth Century* (London: Victoria and Albert Museum, 1989), p. 9.

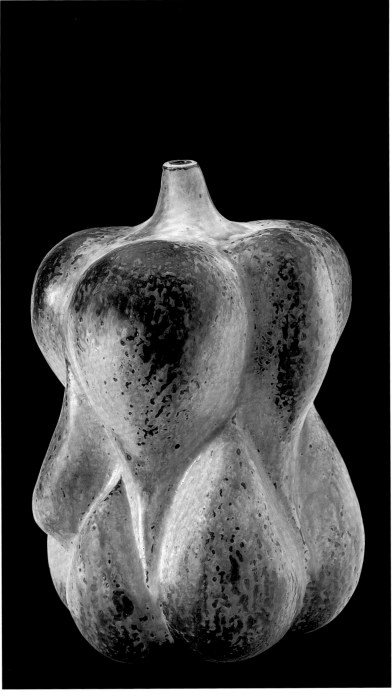

479

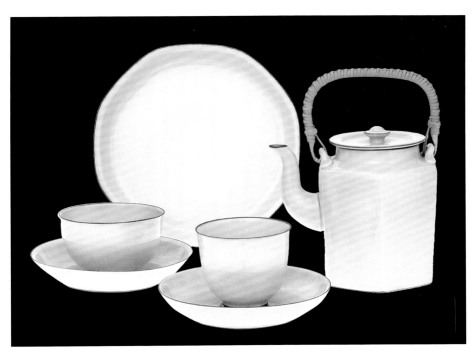

480

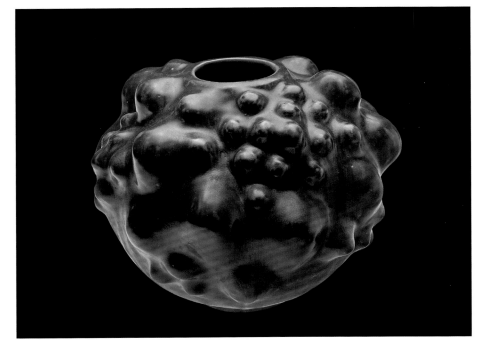

481

476	**477**	**478**	**479**	**480**	

Stig Lindberg
Umeå, Sweden, 1916 –
San Felice Circeo, Italy, 1982
Veckla Vase
About 1950–60
Porcelain
14.6 x 15.6 x 5.8 cm
Produced by AB Gustavsberg,
Sweden
Impressed on underside:
GUSTAVSBERG [an anchor]
SWEDEN, and incised: *244*
Liliane and David M. Stewart
Collection, gift of
Kathryn Vaughn in memory
of Joanne Smith Vaughn
D99.219.1

Stig Lindberg
Umeå, Sweden, 1916 –
San Felice Circeo, Italy, 1982
Veckla Vase (model 236)
About 1949
Porcelain
35.5 x 17.4 x 8.3 cm
Produced by AB Gustavsberg,
Sweden
Impressed on underside:
GUSTAVSBERG [an anchor]
SWEDEN, and incised: *236*
Label on underside: [a hand
imposed over G] / *STUDIO* /
VECKLA / *CARRARA* / *236*
Liliane and David M. Stewart
Collection, gift of the
American Friends of Canada
through the generosity
of Geoffrey N. Bradfield
D86.144.1

Stig Lindberg
Umeå, Sweden, 1916 –
San Felice Circeo, Italy, 1982
Veckla Vase
About 1950–60
Porcelain
7.8 x 12.6 x 20.5 cm
Produced by AB Gustavsberg,
Sweden
Impressed on underside:
GUSTAVSBERG [an anchor]
SWEDEN, and incised: *240*
Label on underside: [a hand
imposed over G] / *STUDIO* /
VECKLA / *CARRARA* / *240*
Liliane and David M. Stewart
Collection, gift of
Kathryn Vaughn in memory
of Joanne Smith Vaughn
D99.220.1

Axel Salto
Copenhagen 1889 –
Copenhagen 1961
Vase
About 1940
Glazed stoneware
32.7 x 22.8 x 22.8 cm
Produced by the Royal
Copenhagen Porcelain
Manufactory
Signature, impressed: *SALTO*
Manufactory's mark painted
in underglaze blue, on
underside: [three wavy lines]
Liliane and David M. Stewart
Collection
2001.17

Gertrud Vasegaard
Rønne, Denmark, 1913 –
Frederiksberg, Denmark,
2007
Tea Service
1955–57
Porcelain
Teapot
(with handle extended):
20.6 x 15.9 x 11.1 cm
Saucers: H. 2.9 cm;
Diam. 15.6 cm
Teacup: H. 7 cm; Diam. 8.6 cm
Coffee cup: H. 6.4 cm;
Diam. 10.1 cm
Cake plate: H. 3.2 cm;
Diam. 21.3 cm
Produced by Bing &
Grøndahl, Copenhagen

Printed in green under
teacup and saucers:
[three towers] / *B&G* /
KJOBENHAVN / *DENMARK* /
GV [in monogram]; under
coffee cup: *COPENHAGEN*
PORCELAIN / [three towers] /
B&G / *BING & GRONDAHL* /
DENMARK / *473* / *GV*
[in monogram]; under teapot:
COPENHAGEN PORCELAIN /
[three towers] / *B&G* /
MADE IN DANMARK / *654* /
GV [in monogram]; under
cake plate: *COPENHAGEN*
PORCELAIN / [three towers] /
B&G / *MADE IN DANMARK* /
304 / *GV* [in monogram]
Liliane and David M. Stewart
Collection, gift of Royal
Copenhagen/Bing & Grøndahl
D89.105.1-6

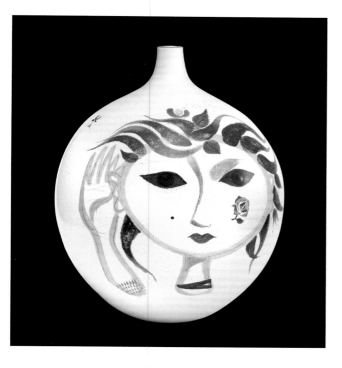

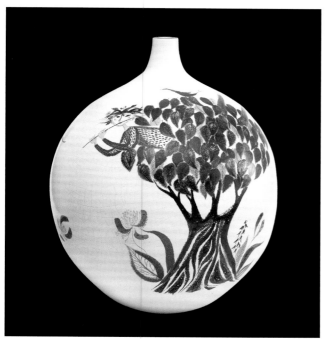

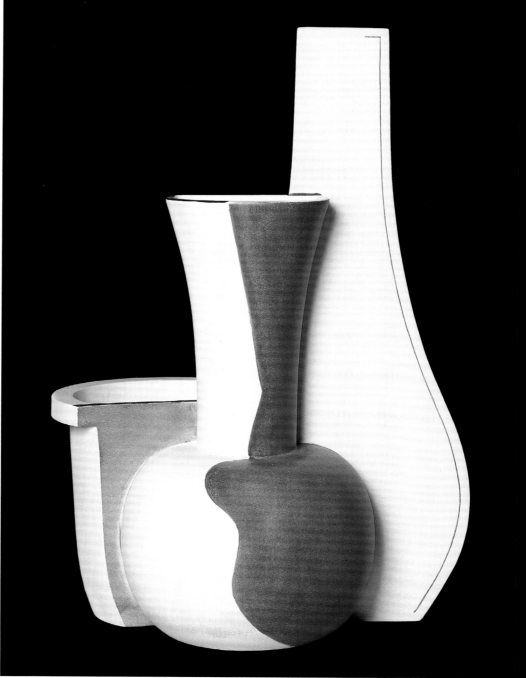

482

483

481

Axel Salto
Copenhagen 1889 –
Copenhagen 1961
Vase
About 1944
Glazed stoneware
20.8 x 26.4 x 26 cm
Produced by the Royal
Copenhagen Porcelain
Manufactory
Signature, impressed: *SALTO*
Manufactory's mark painted
in underglaze blue, on
underside: [three wavy lines]
Liliane and David M. Stewart
Collection
2001.16

482

Stig Lindberg
Umeå, Sweden, 1916 –
San Felice Circeo,
Italy, 1982
Vase
1948
Glazed earthenware
H. 40.4 cm; Diam. 34 cm
Produced by
AB Gustavsberg, Sweden
Painted in blue, on underside:
*GUSTAVSBERG /
SWEDEN / Stig L. /*
[a hand imposed over G]
Liliane and David M. Stewart
Collection
D83.102.1

483

Wilhelm Kåge
Stockholm 1889 –
Stockholm 1960
***Surrea* Vase**
1940
Glazed stoneware
47.5 x 33 x 25.5 cm
Produced by
AB Gustavsberg, Sweden
Stamped on underside:
GUSTAVSBERG / [an anchor] /
KÅGE, and impressed: *S*
Liliane and David M. Stewart
Collection
D93.274.1

484

Friedl Holzer-Kjellberg
Loeben, Austria, 1905 –
Finland 1993
***Oksa* Vase**
About 1942
Porcelain
17.3 x 15.7 x 15.4 cm
Produced by Arabia, Helsinki
Incised on underside:
ARABIA / F.H.K. / 7
Liliane and David M. Stewart
Collection
D87.177.1

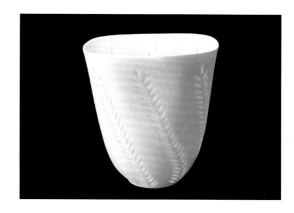

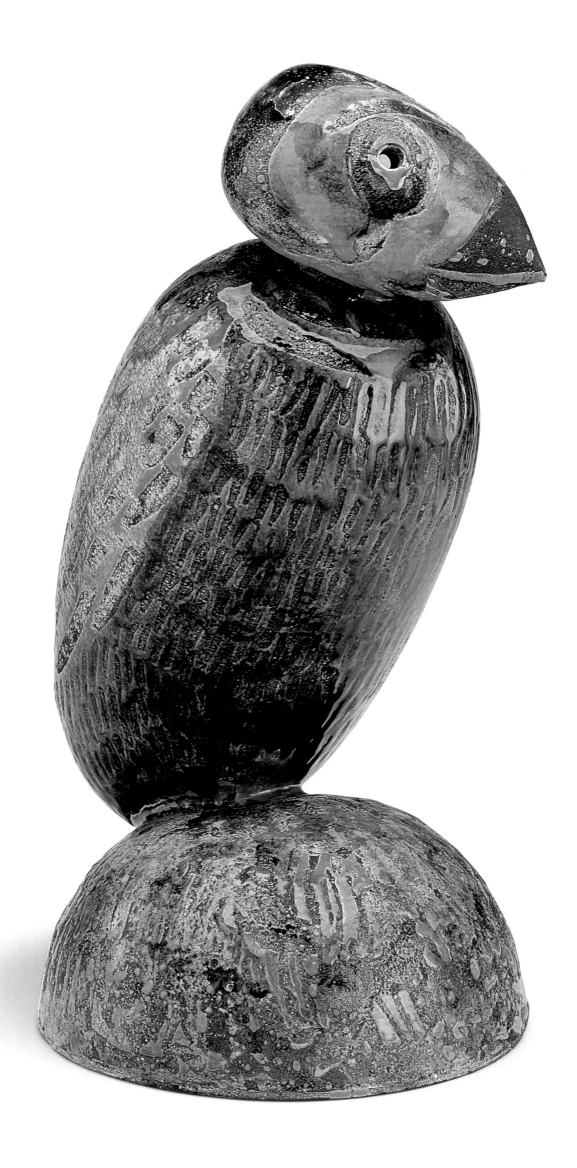

485

THE ART OF THE POTTER: FRANCE AND ENGLAND

— SUSAN JEFFERIES, ROSALIND PEPALL —

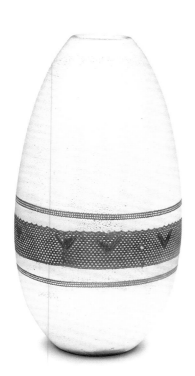

486

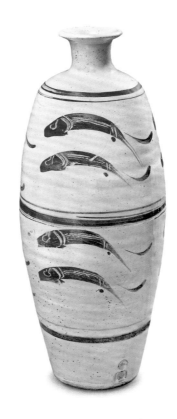

487

488

JEAN BESNARD

French ceramic art in the late nineteenth century was marked by great names in the development of studio pottery, for example, Jean Carriès, Auguste Delaherche and Georges Hoentschel. Jean Besnard continued the tradition of the artist-potter in the period between the two World Wars.

The son of painter Albert Besnard and sculptor Charlotte Dubray, Jean Besnard's interest in ceramics developed from his close observation of the rural pottery of the Haute-Savoie, where he often stayed, in the family residence in Tailloires. After a period of apprenticeship, he set up a workshop in Paris and exhibited his ceramics for the first time at the Salon des Artistes Décorateurs in 1923.[1] He gained recognition for his simple forms, bold designs in a vigorous working of the clay, and lustrous white glaze. The sheen of Besnard's glazes, termed *crispé*, because they did not adhere overall to the body of the piece, contrasted with the earthy tones of the rough pottery ground.

In the Museum's large ovoid vase `486`, the white glaze emphasizes the purity of the form. It is ornamented around the lower half by three reserve bands, which Besnard called his *décor dentelles*,[2] as the motif was created by impressing a lacy material into the wet clay body before firing. The sculptural forms of Besnard's work bring to mind the classical, spare lines of Brancusi's sculpture, and the deeply incised linear ornamentation he favoured on many works is so basic in design that Besnard is often referred to as a primitive. It is a word he himself used in 1927, when he expressed surprise that top French decorators incorporated his rough, textured pottery into their luxurious interiors: "With ceramic, I feel like a primitive and yet my pieces are selected to decorate refined interiors."[3]

Another Besnard piece, *The Bird* `485`, also stands out for its severe geometry. The turquoise blue of the bird's plumage is set against a remarkable grainy surface of yellow, mauve, white and red glazes. Even though *The Bird* recalls Picasso's ceramic bird forms of 1947–48, Besnard had already relied on the geometry of the oval shape to create his own bird forms in the 1930s.[4] **RP**

1. Karine Lacquemant, "Jean Besnard," in *Céramiques XXᵉ siècle*, ed. Béatrice Salmon (Paris: Les Arts décoratifs, 2006), p. 60. **2.** Besnard himself noted this title on the photograph of the work he sent to F. Cleveland Morgan, May 11, 1933 (MMFA Archives, file 1933.Dp.5). **3.** *Les Échos des industries d'art*, 1927, cited by Karine Lacquemant, "Jean Besnard, primitif modern," *L'Œil*, vol. 548 (June 2003), p. 99. **4.** Jacques Mathey, "Les céramiques de Jean Besnard," *Plaisir de France*, vol. 34 (July 1937), pp. 13–14.

`485`

Jean Besnard
Paris 1889 – Paris 1958
The Bird
Early 1950s
Lead-glazed earthenware
43.5 x 21.5 x 25.5 cm
Gift of Hélène C. Bossé
1998.65
PROVENANCE
Jean Cartier, Montreal;
acquired by the Museum
in 1998.

`486`

Jean Besnard
Paris 1889 – Paris 1958
Vase
1932
Salt-glazed stoneware
H. 36 cm; Diam. 19 cm
Signature and date,
incised on underside:
Besnard / 1932
Purchase
1933.Dp.5

`487`

Bernard Leach
Hong Kong 1887 –
Saint Ives, England, 1979
Vase
About 1931,
made about 1962
Glazed stoneware
H. 39 cm; Diam. 16 cm
Made at Leach Pottery,
Saint Ives
Monograms, impressed on
underside: *BL / SI*
Liliane and David M. Stewart
Collection, gift of the
American Friends of Canada
through the generosity of
Jay Spectre
D84.169.1

`488`

Bernard Leach
Hong Kong 1887 –
Saint Ives, England, 1979
Plate
Pagoda in the Hills
About 1925
Glazed
earthenware, slip
H. 5.6 cm;
Diam. 31.5 cm
Made at Leach Pottery,
Saint Ives
Monograms,
impressed on back:
BL / SI
Gift of F. Cleveland
Morgan
1926.Dp.6

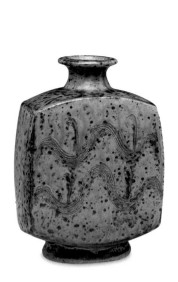

490

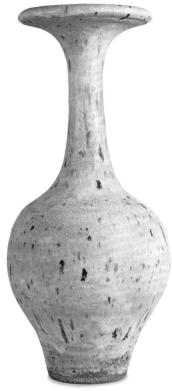

491

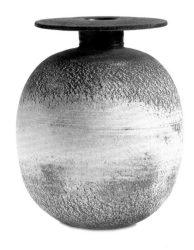

BERNARD LEACH

Bernard Leach was one of the most influential ceramic artists of the last century. *A Potter's Book*, his treatise on pottery-making, first published in 1940, reflected a philosophy of life and work that defended the "handmade" during a time of increased industrialization.

Leach was born of British parents in Hong Kong and spent the first ten years of his life in Asia. Educated in London, he attended the Slade School of Art, and he studied etching at the London School of Art. Upon returning to Japan in 1909, he spent eleven years learning the art of ceramics, and decided to pursue a career working in this medium.[1] Leach absorbed many skills and ideas from Japanese potters, and then, in 1920, went back to England. He was accompanied by one of his young Japanese friends, Shoji Hamada, who helped him establish Leach Pottery at Saint Ives in Cornwall.[2] Together, they sourced the clay and wood for firings, and built a studio and a *noborigama* (many-chambered) kiln.

The first works by Leach to enter the Museum's collection were gifts of F. Cleveland Morgan in 1926, three tiles and a *Pagoda in the Hills* plate 488 , which had been presented in an Arts and Crafts exhibition at Burlington House, London, in February 1926. At the time of the purchase, Leach wrote to Morgan, who apparently had been critical of the ceramicist's Japanese-inspired work, referring to it as being "almost too good." In his letter, Leach replied, "I want to say that not only do I never 'copy' but that the influence of the East (where I was born) or the West does not matter to me, *provided vitality is in the result*," and went on to say that he hoped to unite the two traditions in his works.[3]

The Museum's vase decorated with leaping fish 487 , one of Bernard Leach's signature ceramic works, illustrates his skill in brushwork resulting from his training in etching. The spirited rendering of the fish creates a sense of movement within the classical Chinese form. Another Leach work in the collection 489 reflects an Asian inspiration in its simple incised decoration representing a mountain and tree motif. The attractive speckled appearance is a result of the iron in the clay becoming visible during the firing, when the oxygen in the kiln is severely reduced.

Through his publications and lectures, Leach promoted and strengthened the cultural ties between Asia and the West. His ideas inspired potters around the world, especially in Britain, North America, Australia and New Zealand.
SJ and RP

1. Bernard Leach, *Beyond East and West: Memoirs, Portraits and Essays* (New York: Watson-Guptill, 1978), pp. 55–56. **2.** For original footage of the pottery with narration by Warren Mackenzie, see *The Leach Pottery, 1952*, DVD (Toronto: Marty Gross Film Productions, 2010). **3.** Letter from Bernard Leach, Saint Ives, to F. C. Morgan, February 22, 1926 (McGill University, Rare Books and Special Collections, Morgan Family Papers, Ms 647).

LUCIE RIE

One of the foremost studio potters working in England after World War I, Lucie Rie had grown up in her native Vienna in a cultured, well-to-do family. From 1922 to 1926, she was enrolled at the Kunstgewerbeschule (School of Applied Arts), studying with Michael Powolny, professor of the ceramic workshops. The architect Josef Hoffmann, who was also on staff at the school, noticed her work, and, in 1923, he selected several of her pieces to be placed in his architectural masterpiece, the Palais Stoclet, Brussels.[1]

In 1938, as a result of the political events in Austria, Rie fled the country and settled in London. There she worked with compatriot Fritz Lampl in the Bimini glass studio and went into the business of making ceramic buttons for haute couture. After the war, she hired Hans Coper as her assistant in the production of ceramics for

489

Bernard Leach
Hong Kong 1887 –
Saint Ives, England, 1979
Bottle-vase
About 1955
Glazed stoneware
19.6 x 13.6 x 9 cm
Made at Leach Pottery,
Saint Ives
Monograms, impressed
on underside: *BL / SI*
Purchase
1983.Dp.1

490

Lucie Rie
Vienna 1902 –
London 1995
Vase
About 1958
Glazed stoneware
40.3 x 17.5 x 18 cm
Monogram, impressed on
underside: *LR*
Liliane and David M. Stewart
Collection
D97.113.1

491

Hans Coper
Chemnitz, Germany, 1920 –
Frome, England, 1981
Vase
About 1960
Glazed stoneware
H. 22.9 cm
Monogram, impressed
on underside: *HC*
Liliane and David M. Stewart
Collection
D83.139.1

492

Michael Cardew
Wimbledon, England,
1901 – Wenford Bridge,
Cornwall, England, 1983
Wine Jar
About 1938
Lead-glazed
earthenware, slip
H. 108.5 cm; Diam. 45.5 cm
Made at Winchcombe
Pottery, Gloucestershire,
England
Monograms, impressed
on underside: *WP*
(for Winchcombe Pottery) /
MC (for Michael Cardew),
and painted in black:
MADE / IN / ENGLAND, and
labels: *THE ELSIE / PERRIN /
WILLIAMS / MEMORIAL / ART
MUSEUM / LONDON, CANADA*
and *Arts and Crafts / U.S.A.*

Incised on jar, between Adam
and Eve, on top: *SERPENS /
MY A LEVER / DHYS AN CAS /
RAG BOS DHEDHA / IOY MAR
VRAS / HA MY PUP UR / OW
LESKY* [Snake / I will tell you
the fact; / Because they had
great Happiness, / And I was
always burning.]; between
Adam and Eve, bottom:
*ADAM / PREDERYS PEB /
A Y WORFEN / FETTYL ALLO /
GORFENNA* [Adam / Let every
one think on the end of it, /
How it can end.]; between
Eve and Snake, bottom:
*EVA / [AV]EL D[E]W / NY A VIA /
BIS VENYTHA / NA S[O]RREN*
[Eve / Greater than God
we should be, /
Nor be troubled forever.]
Purchase
1945.Dp.9

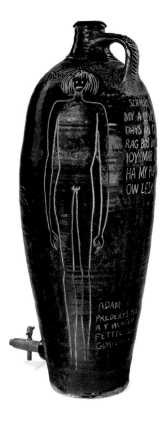
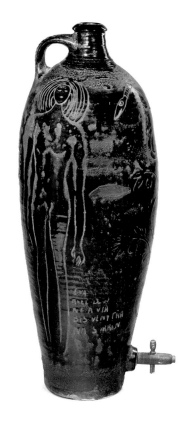

the tableware market. The life-long friendship and support of Hans Coper was important in the development of her career. In her mature work, Rie combined the directness of traditional ceramic craftsmanship with the modern clean lines of contemporary design and architecture.

This stoneware vase **490** was made in sections and assembled when "leather-hard." Rie omitted the usual bisque firing and glazed the "raw" stoneware before its firing.[2] The elongated, flared neck and small base suggest avian and human forms. In later work, she repeated this same shape in porcelain, sometimes combined with coloured clays. As her work progressed, it became ever more refined, often decorated with strong colours and a trademark bubbly glaze.

Lucie Rie gained an international reputation through her exhibitions and sales, and, in 1991, she became a Dame Commander of the Order of the British Empire. **SJ**

1. Cyril Frankel, *Modern Pots: Hans Coper, Lucie Rie and Their Contemporaries* (Norwich, United Kingdom: University of East Anglia, 2000), pp. 67–68. **2.** Margot Coatts, ed., *Potters in Parallel*, exh. cat. (London: Herbert Press, 1997), pp. 36–50. Emmanuel Cooper's essay discusses technical questions.

HANS COPER

This vase, combining a disk with a spherical form and a richly textured surface highlighted by the use of manganese brown **491**, is typical of Hans Coper's work. His use of various thrown parts is a study in the ways in which scale and colouring can radically change the impact of a ceramic work of art.

German-born Hans Coper escaped from Nazi Germany in 1939 and fled to England, where he was interned as an "enemy alien." His career began after the war in London, when he was hired by Lucie Rie as a studio assistant. Up to this point, Coper had received little training in ceramics, and at Rie's urging, he studied pottery with Heber Matthews at the Woolwich Polytechnic. Exceptionally adept at throwing pots, Coper helped Rie in producing functional ceramic wares. His interest in tribal art, Cycladic figures and the spare geometry of Brancusi's sculpture are reflected in his later distinctive body of sculptural work, which he developed at the Digswell studio he set up in 1959.[1] According to his widow, "He admired anyone working towards essence rather than effect."[2]

Coper and Rie's lifelong friendship was a source of strength professionally and personally

for both of them. Although their mature work differed greatly, they both offered ceramic artists an alternative modernist vision, stressing simple, geometric forms and austere surfaces. Coper exhibited widely, often with Rie, including an exhibition in 1986 with Henry Moore and Barbara Hepworth. Coper's work, like Rie's, was a major influence on the next generation of British ceramic artists. **SJ**

1. Tony Birks, *Hans Coper* (Norwich, United Kingdom: Sainsbury Centre for Visual Arts, 1983), p. 27. **2.** Jane Coper in personal correspondence with the author, July 23, 2001.

MICHAEL CARDEW

Among the contemporary works selected for acquisition by the Museum in 1945 was this tall, 108.5-centimetre, dark-brown earthenware wine jar **492** by Michael Cardew, one of the leading English ceramicists of the period. It was acquired by the Museum directly from the travelling *Exhibition of Modern British Crafts*, sent to North America in 1942 by the British Council during the war to boost support for England.[1] The exhibition was presented at the Art Association of Montreal, in October 1943.

Michael Cardew had learned to throw pots in the countryside of North Devon during his years as a university student. Resolving to make ceramics his career, he sought a wider experience at Bernard Leach's Saint Ives pottery in Cornwall in 1923, where he apprenticed for three years. In 1926, he set up his own workshop in a disused pottery near Winchcombe, Gloucestershire. His aim was to revive early English slipware pottery, using traditional methods. This jar was made at Winchcombe Pottery just before Cardew returned to his Cornish roots and opened a pottery at Wenford Bridge, Cornwall, in 1939. In 1942, Cardew went to the former British colony of the Gold Coast, Africa (now Ghana), to teach pottery at Achimota College, and when it closed three years later he set up his workshop at Vumé on the River Volta. Ill health took him back to England in 1948, but not for long, as he was offered a position with the Nigerian colonial government to manage a pottery training centre in Abuja. From 1950 until 1965, he would spend ten months a year in Nigeria and two at his pottery in Wenford Bridge.[2]

Cardew was an artist-potter in the true sense, using local clays and turning his own wares, which were inspired by the traditions of English country pottery and the teachings and

writings of Bernard Leach. This earthenware jar with a wooden spigot could be used for the storage of draft beer, homemade wine or cider. It has the Winchcombe seal and reflects very well Cardew's work before he went to Africa, where he began using stoneware for his vessels. A rugged, earthy-looking piece, its glazed surface is rough and blistered in areas, due to Cardew's traditional wood-burning kiln. Impressive in size, the full-length figures of Adam and Eve, together with a serpent entwined around a leafy branch, have been incised into the sides of the clay body in spare lines. These drawings have been cut deeply enough through the dark-brown slip to reveal the reddish earthenware underneath. Under the figures, Cardew inscribed Cornish lines of verse that correspond to the words from *The Ancient Cornish Drama*, published in 1859.[3] The jar is a masterful piece, selected especially to show the best of English craft to North America in the early 1940s—a contemporary work, steeped in the tradition of English slipware pottery. **RP**

1. Letter from Muriel Rose, Crafts Exhibition Secretary, to F. Cleveland Morgan, June 27, 1945 (MMFA Archives, file 1945. Dp.9). **2.** Biographical details on Cardew from Oliver Watson, *Studio Pottery: Twentieth Century British Ceramics in the Victoria and Albert Museum Collection* (London: Phaidon Press, in association with the Victoria and Albert Museum, 1993), pp. 159–165. Tanya Harrod is completing a book on Cardew to be published in 2012. **3.** Edwin Norris, ed., *The Ancient Cornish Drama* (Oxford: Oxford University Press, 1859), pp. 16–19, 24–25. My thanks to Manon Pagé, who tracked down this possible source for Cardew's inscription.

PICASSO'S CERAMICS

— PAUL BOURASSA —

Pablo Picasso's foray into the world of ceramics was for a long time considered trivial, an episode in which the master entertained himself by playing the sorcerer's apprentice to produce a few amusing pieces, without any real interest. Although some ceramicists viewed Picasso's work as heresy, others were quick to find it an immediate source of regeneration.[1] It would nevertheless take several years before the true value of his contribution was recognized.

Picasso became interested in ceramics at an early age, decorating some plates in the 1890s, and then returning to the medium in 1906 with the assistance of his friend Paco Durrio, and, in 1929, by associating with Jean van Dongen, brother of artist Kees van Dongen. We also know of Picasso's keen interest in "primitive" ceramics, appreciated by his friends at the magazine *Cahiers d'art*.[2]

In the summer of 1946, while visiting the annual pottery exhibition in Vallauris, Picasso was invited to create a few pieces. Upon his return to the coast the following summer, he worked daily at the Madoura studio of Georges and Suzanne Ramié. With the help of potter Jules Agard, he designed and fashioned a series of ovoid, zoomorphic and anthropomorphic sculptures (bull, kid, wading bird, amphora women and more), and then started to decorate the studio's current output, particularly the oval plates, completing hundreds of unique pieces in just a few months.

However, in the spirit of his political commitment to the Communist Party, Picasso wanted to make art accessible to all.[3] With his blessing began the Madoura editions, named for the Vallauris studio that created the copies of his pieces. One of the first items produced was "a plate decorated with a dove."[4] Three versions of this plate exist, including the Museum's, which is normally called *Dove at the Dormer* 493 , the title alluding to the rays of light seen above the bird.[5] It is one of the "authentic replicas," that is to say the identical copies made by the Madoura studio from a Picasso original. It is not surprising to find the dove as a subject in Picasso's work at the same time that this symbol of peace was chosen as an emblem of the First International Peace Conference, in April 1949.[6]

The Madoura editions also include "empreintes originales." For these reproductions, the press-moulding technique was used to reproduce the motifs incised and in relief with the aid of a mould made from a Picasso

original. This was the case for *Vase with Goats* 495 of 1952, which exists in various versions. The Museum's example, painted with oxides on white enamel, differs from the known copies, which feature the use of slip and more matte colours. It may be a unique model decorated by Picasso himself, as the work comes from the collection of Jacqueline Picasso, his last wife.[7] One side is decorated with the head of a goat, the other with the animal gambolling, the two motifs separated by a tree.

In the *Cavalier and Horse* wine jug 494 of 1952,[8] the decoration conforms to the shape of the vessel in an original way. The body of the animal is painted on the side of the jug's body, while the rider is depicted on the tall spout, standing before his steed. Overhead, on the arched handle, float stylized clouds.

Finally, the most important work of this group is probably the tripod vase 496 of 1951.[9] Suzanne Ramié designed this shape based on a reproduction in the *Encyclopédie photographique de l'art* (1935–38) of a Cypriot vase from 3000 B.C.[10] It is possible that Picasso led her to this source, knowing of her interest in this type of ceramics. A photograph of Françoise Gilot, Picasso's companion at the time, shows her crouching between two of these vases, her hands on her cheeks, in a posture inspired by the piece's decoration (fig. 1).

1. Paul Bourassa et al., *Picasso and Ceramics* (Paris: Hazan, 2004), pp. 15 and 244.
2. Ibid., pp. 27–41.
3. Gertje R. Utley, *Picasso: The Communist Years* (New Haven; London: Yale University Press, 2000).
4. Jean Dragon, "Picasso chez Madoura à Vallauris," *Nice-Matin*, July 19, 1949, cited in Utley 2000.
5. Alain Ramié, *Picasso. Catalogue de l'œuvre céramique édité 1947-1971* (Vallauris: Madoura, 1988), no. 78.
6. Ibid., no. 157.
7. Picasso sometimes redid his own editions to make "artist's proofs" (see *Picasso and Ceramics*, pp. 49–54).
8. Ramié 1988, no. 138.
9. Ibid., no. 125.
10. Bourassa et al. 2004, *Picasso and Ceramics*, pp. 128–129 and 194–196.

Fig. 1
Françoise Gilot posing between two tripod vases, about 1951.

493
Pablo Picasso
Málaga, Spain, 1881 –
Mougins, France, 1973
Dove at the Dormer Plate
1949
Glazed earthenware,
painted decoration
38 x 31.5 x 3.5 cm
Produced by Poterie Madoura,
Vallauris, France
Painted on back:
EDITION / PICASSO / 98 / 200 /
MADOURA, and impressed
on back: *MADOURA /*
[a flame] / PLEIN / FEU
Liliane and David M. Stewart
Collection, anonymous gift
D90.185.1

494
Pablo Picasso
Málaga, Spain, 1881 –
Mougins, France, 1973
Cavalier and Horse
Wine Jug
1952
Glazed earthenware,
painted decoration, 260/300
20.5 x 18.3 x 13.8 cm
Produced by Poterie Madoura,
Vallauris, France
Stamped on underside:
EDITION / PICASSO / 260 /
300 / MADOURA, and
impressed: *MADOURA /*
[a flame] / PLEIN / FEU /
EDITION / PICASSO
Gift of Freda and Irwin Browns
2005.63

495
Pablo Picasso
Málaga, Spain, 1881 –
Mougins, France, 1973
Vase with Goats
1952
Glazed earthenware, stamped
and painted decoration
H. 19 cm; Diam. 22.5 cm
Produced by Poterie Madoura,
Vallauris, France
Date, impressed in
decoration, underglaze: *6.6.52*
Impressed on underside:
MADOURA /
FEU (twice) */ EMPREINTE /*
ORIGINALE DE / PICASSO
Anonymous gift
2004.156
PROVENANCE
Jacqueline Picasso; acquired
by the Museum in 2004.

496
Pablo Picasso
Málaga, Spain, 1881 –
Mougins, France, 1973
Tripod Vase
1951 (example about 1952)
Glazed earthenware,
painted decoration
72.7 x 26.7 x 29.5 cm
Produced by Poterie Madoura,
Vallauris, France
Impressed on underside of
the two front supports:
EDITION / PICASSO, and on
underside of right support:
MADOURA / [a flame] / PLEIN /
FEU; painted near base of
rear support: *4 / 75*
Liliane and David M. Stewart
Collection
D96.109.1

493

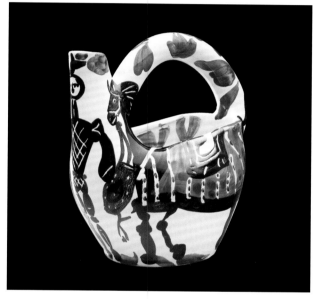

494

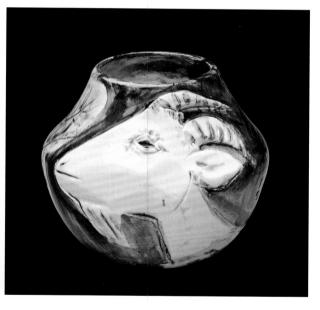

495

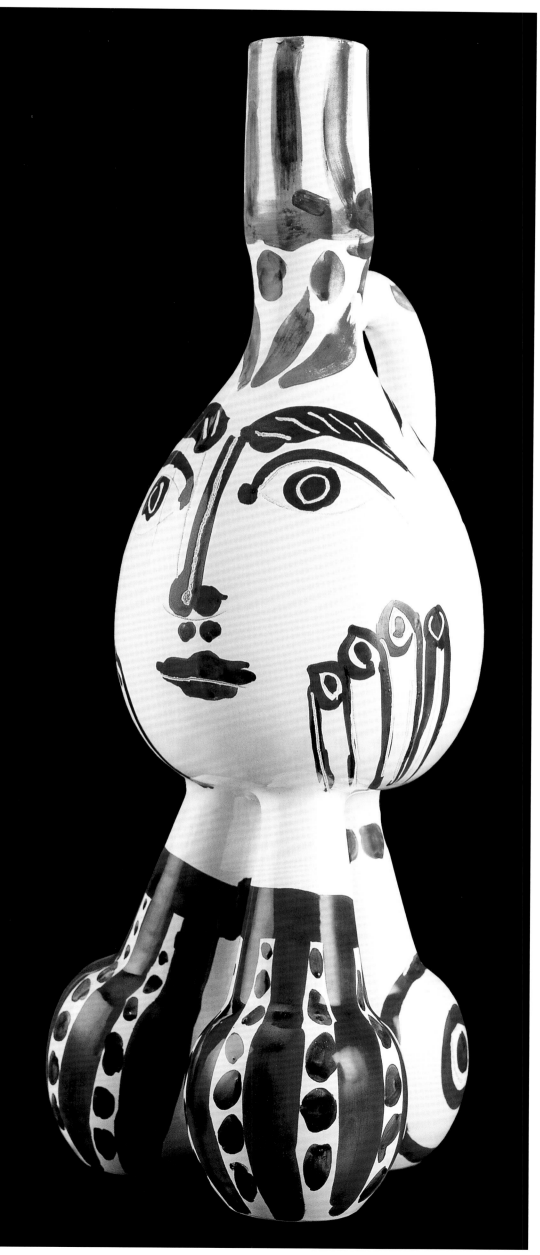

496

ITALIAN CERAMICISTS OF THE 1950s

— ROSALIND PEPALL —

In 1955, an article in the English *Studio* magazine entitled "Handicrafts from Italy" began: "Italian craftsmen today, as in past centuries, are producing works of originality and real beauty in small *botteghe* where quality of finish is considered of more account than speed of repetition."[1] The article underlined the traditional craft role of the Italian artist-potter, far removed from the demands of industrial production, which by the next decade had propelled Italian design to an international level.

After World War II, when Italy lay defeated, artists had few funds for materials. Clay was cheap, easily available and required little space for working, and so many artists put their creative energies into ceramics. This brought about a flourishing renewal of the art form in the late 1940s and 1950s. At the time, *Domus*, the leading magazine of architecture and design in Italy, under the editorship of Gio Ponti, featured monthly articles on Italian ceramics by artists such as Guido Gambone, Leoncillo Leonardo, Salvatore Meli and, above all, Lucio Fontana and Fausto Melotti. The latter two, as sculptors, took the approach that ceramics was a form of visual expression equal to painting and sculpture.

Fausto Melotti had a close association with painters of the Italian abstract movement, and, in the 1930s, created minimalist, geometric reliefs and sculptures. After the war, he concentrated on ceramics for almost twenty years, creating spare vases, almost architectural in their geometry, alongside elaborately crafted human figures, "wavering between the abstract and the figurative."[2] The Art Institute of Chicago curator Meyric R. Rogers, who directed a large touring exhibition of Italian applied art across the United States in 1950, wrote perceptively of Melotti's exhibits: "The peculiar abstract qualities resulting from the construction of forms out of sheets of clay rather than by moulding or mass modeling give a unique character to the bowls, mirror frames, and figurines devised by the sculptor Melotti of Milan."[3] Melotti's work was given further recognition in 1951, when he won the Grand Prize in ceramics at the Ninth Milan Triennale for his tall handcrafted vases. In 1954, *Domus* illustrated a series of his *fumaiòli* vases, which included the Museum's piece **497** (fig. 1).[4]

This vase was built up by hand into a tall, irregular-shaped cylinder with a slight pouring lip. The imprint of the manual working of the medium is evident, and the form is simple with no applied ornamentation. Around the sides are abstract *taches* of black and white that have been added against a pink ground in a painterly treatment of the glaze. Handcraftsmanship and spontaneous expression are emphasized, in contrast to the mathematically calculated linear forms of Melotti's 1930s sculptures. The almost surprising height of this vase and the delicate thinness of the clay body show a lack of concern for function. A clay pot has become a work of sculpture.[5]

Of all the studio potters working in Italy in the 1950s, Guido Gambone was perhaps the most familiar to North Americans, and his work was often illustrated in the pages of *Domus*.[6] For the shapes and decoration of his ceramics, Gambone explored various sources, ranging from Italian and South American traditional pottery to contemporary painting and sculpture. Especially notable was the influence of Picasso ceramics from the late 1940s on Italian studio potters. The native Sicilian ceramicist Salvatore Meli readily admitted that "young artists were almost all a little Picassoesque after the war . . . I greatly admired Picasso as a sculptor and as a painter."[7] The irregular, fantastical shapes of Meli's vessels, with swollen handles and long necks, are decorated with painted Picasso-inspired figures and boldly coloured motifs.[8] The attenuated human forms on the Museum's ewer **498** are as contorted as the shape of the piece, the bodies bending and leaning to conform with the lines of the jug. Meli's unique vessels were laboriously built up from coiled lengths of clay. This technique stressed the individual creation of each piece, and his works became more and more abstract and sculptural through the decade.[9] The function of the work was a minor consideration.

The relevance of contemporary art to these studio potters is also evident in the work of Marcello Fantoni. He worked in Florence, independent of any large commercial ceramic enterprise. Drawing on his versatile background in painting, sculpture and graphic art, he regarded ceramics as an art form through which he could create his hand-assembled, inventive designs. Fantoni drew inspiration from eclectic sources for his motifs, drawing from both abstraction and figurative painting after such artists as Arturo Martini, Gio Ponti, Picasso and Georges Braque.[10] The Museum's very tall vase with wide flaring rim **499** is decorated with painted stylized figures and structures in coloured enamels set against a grainy black ground. Contrasts of surface texture were an integral part of Fantoni's work in clay.

By the late 1950s, commercial concerns increasingly overtook the flourishing art of the studio potter. Some, like Melotti, returned to sculpture, whereas others chose to work on large architectural commissions. These ceramicists, however, had contributed to the creative energy of Italy's post-war revival of the arts, which set the country on a path to becoming a leader in international design.

1. "Handicrafts from Italy," *The Studio*, vol. 150 (December 1955), p. 182.
2. Micaela Martegani Luini, "The Revival of Glass and Ceramics," in *The Italian Metamorphosis 1943–1968*, exh. cat., ed. Germano Celant (New York: Guggenheim Museum, 1994), p. 227.
3. Meyric R. Rogers, *Italy at Work: Her Renaissance in Design Today*, exh. cat. (Rome: Compagnie Nazionale Artigiana, 1950), p. 31.
4. Anonymous, "Nello studio di Melotti 1954," *Domus*, vol. 292 (March 1954), p. 53.
5. Of special note for Canadians is the provenance of this work, which was owned by Quebec ceramicist Claude Vermette, who met Melotti on visits to Italy in 1952 and 1954.
6. In 1950–51, F. Cleveland Morgan presented the Museum with two Guido Gambone vases.
7. Vincenzo Mazzarella and Alessandra Ambrosini, "Intervista al Prof. Salvatore Meli," in *Artisti in ceramica e Ceramica di Artisti, 1947-1964* (Parma: Mercantinfiera, 1985), p. 15.
8. "Come un vasaio preistorico," *Domus* (February 1952), p. 38; "Vasi comme maschere," *Domus* (November 1953), p. 45.
9. Joseph Pugliese, "Meli," *Craft Horizons*, vol. 18 (November–December 1958), pp. 30–31.
10. Gian Carlo Bojani, "Maestri Contemporanei Della Ceramica: Il Fiorentino Marcello Fantoni," *Bollettino Museo Internazionale delle Ceramiche, Faenza*, vol. 81, nos. 1–2 (1995), p. 44.

Fig. 1
"Melotti's Studio 1954,"
Domus (March 1954).

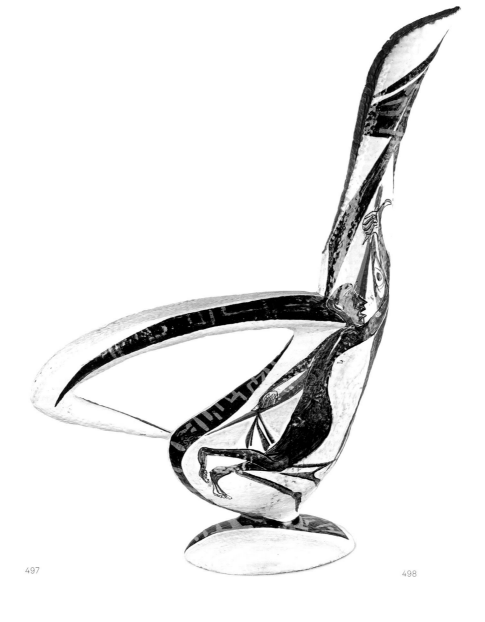

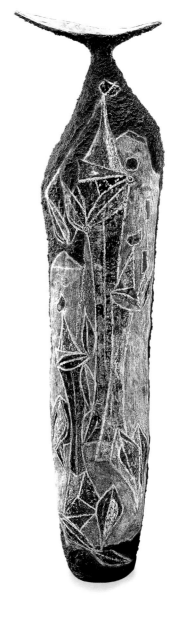

497

498

499

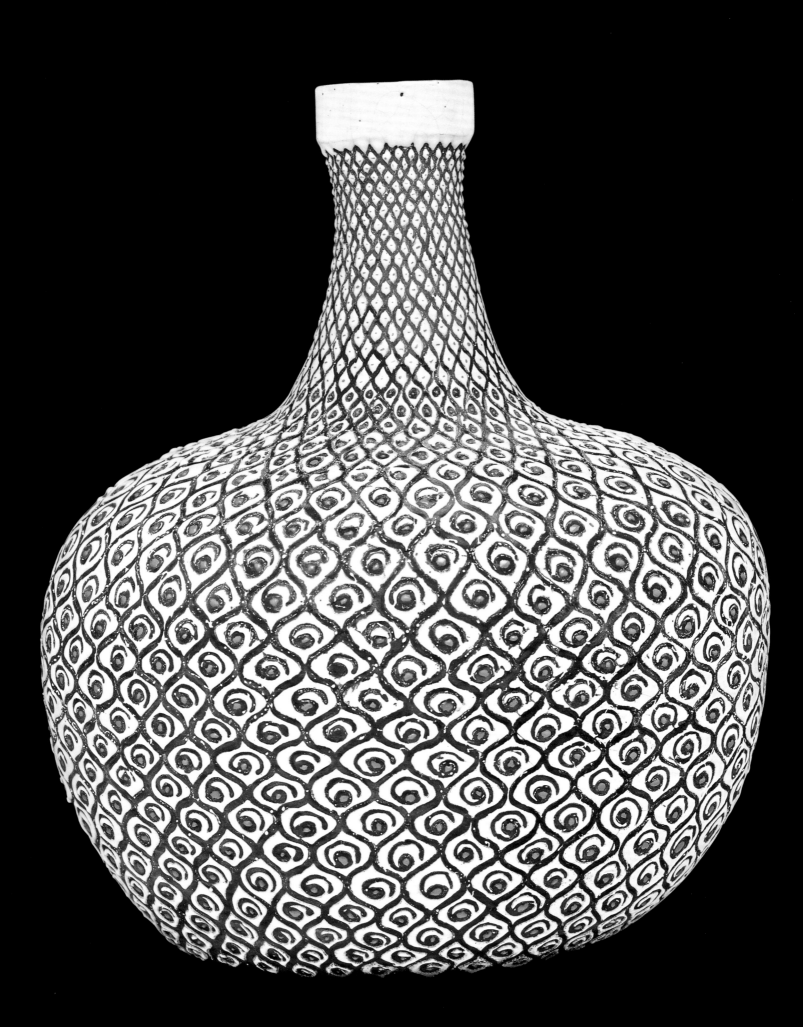

A CERAMICS RENAISSANCE IN QUEBEC: LOUIS ARCHAMBAULT, JEAN CARTIER, JORDI BONET

— PAUL BOURASSA —

Pierre-Aimé Normandeau's establishment of a ceramics department at the École des Beaux-Arts de Montréal, on March 3, 1936, marked the beginning of a pottery-art renaissance in Quebec. Louis Archambault would graduate from the second class in 1939. After a short stint in Saint-Jean-d'Iberville at Central Pottery,[1] destroyed by fire, he taught ceramics at McGill University's Macdonald College, and then, from 1947 to 1957, at the École du Meuble, which had inherited the ceramics program from the École des Beaux-Arts.

In the late 1940s and early 1950s, Archambault led a double career as a sculptor and ceramicist. However, he stopped working in ceramics after completing his mural composition for the Canadian Pavilion at the Brussels World's Fair in 1958, also the same year he put an end to his teaching career. Starting in 1951, he confirmed his preference for sculpture,[2] except that, as he himself said, "ceramics sells quickly, sculpture does not." Archambault was no less a pioneer of the ceramic-art movement in Quebec, exploring "free" asymmetrical forms, playing with the contrasts between shiny glazes and matte surfaces and developing a linear graphic language, often with the human figure and the bird as subject. The Museum's platter **503** is typical: a birdman lies spread-eagled in a five-pronged star, his stylized head and limbs surrounded by an interplay of parallel lines. The design, consisting of incised decoration (*sgraffito*) on a thin layer of white slip, is quite close to Archambault's studies for his ceramic screen at the 1958 Canadian Pavilion.

Another notable figure of 1950s ceramics is Jean Cartier, who was a student at the École du Meuble when Archambault was teaching there. Cartier would complete his training in Paris between 1949 and 1951, particularly with renowned ceramicist Jean Besnard, from whom he learned to attend to the treatment of surfaces—much neglected, according to Archambault, by Quebec ceramicists.[3]

The Museum's three pieces **500**-**502** are perfect examples of Cartier's careful execution of complex geometric decoration using the wax-reserve technique. On his urn of 1954 built by coils (a technique that permits irregular forms), the manganese glaze, almost black, outlines a motif of struck-through concentric circles incised in the wax of the reserves. The plate of 1955 displays an even more complex use of reserves with a slightly tinted lead glaze that accentuates the effect of the crazing.

Jordi Bonet, who moved to Quebec in 1954, was introduced to ceramics in Jean Cartier's studio at the École du Meuble in 1956, and then, in the summer, he assisted ceramicist Claude Vermette in Sainte-Adèle. His first mural decorations were made of enamelled tiles (his biggest project was the facade of the Université Laval's science faculty, in 1962), but he abandoned this "surface" treatment to plunge into working with matter. He undertook large-scale compositions, such as *Tribute to Gaudi*, consisting of thick slabs of porcelain brutally pummelled with bottles and various objects lying around the studio. In this vein he completed the Museum's fireplace facade **507**, a gift of Laurent Lamy, one of the first collectors interested in Quebec's applied arts. In 1966, Lamy would describe Bonet's work this way: "He uses his strength to dig into the thick, greasy clay, to give it ever more pronounced relief. . . . Upon bare, clear, unified modern constructions, Jordi Bonet contrasts rich textures and natural colours that speak of the sun-scorched earth, the bluish shadows of night, the light yellowed and veiled by fog."[4]

Together, these works in the Museum's collection summarize the history of ceramics in Quebec in the 1950s and 1960s, a period of affirmation and boundless creativity.

1. Pierre Normandeau, "Pottery in Quebec," *Journal of the Canadian Ceramic Society*, vol. 15 (1946), p. 74.
2. Robert Ayre, "The Birds of Louis Archambault," *Canadian Art*, vol. 13, no. 1 (Fall 1955), pp. 195–196.
3. Rodolphe de Repentigny, "Jean Cartier. Artiste et potier," *Arts et pensée*, no. 17 (May–June 1954), p. 143.
4. Laurent and Suzanne Lamy, *La renaissance des métiers d'art au Canada français* (Quebec City: Ministère des Affaires culturelles, 1967), p. 49.

500

Jean Cartier
Saint-Jean-sur-Richelieu,
Quebec, 1924 –
Montreal 1996
Vase
1956
Glazed stoneware,
slip decoration
46 x 39.2 x 29.2 cm
Signature and date,
incised on underside:
Cartier 56
Gift of Paule and Guy
Plamondon in memory of their
parents, Germaine Bruchési
and Gérard Plamondon
2001.191

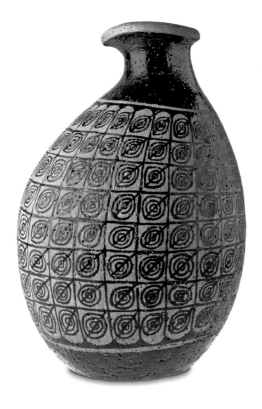

501

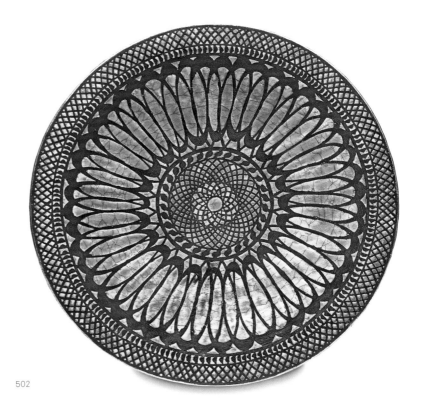

502

503

504

501

Jean Cartier
Saint-Jean-sur-Richelieu,
Quebec, 1924 – Montreal 1996
Urn
1954
Lead-glazed earthenware
H. 38.1 cm; Diam. 24.1 cm
Signature, incised on
underside: *Jean Cartier*
Liliane and David M. Stewart
Collection
D87.112.1

502

Jean Cartier
Saint-Jean-sur-Richelieu,
Quebec, 1924 – Montreal 1996
Plate
1955
Glazed stoneware,
slip decoration
H. 9.5 cm; Diam. 55.9 cm
Signature and date, incised
on back: *Cartier / 55 / Canada*
Gift of Geneviève Bazin in
memory of her parents,
Thérèse and Jules Bazin
2000.177

503

Louis Archambault
Montreal 1915 –
Montreal 2003
Platter
About 1951
Earthenware, slip decoration
5.7 x 46.6 x 39.9 cm
Signature, incised
on underside:
Archambault / CANADA
Gift of the
Louis Archambault
family
2003.109

504

Jacques Garnier
Plessisville, Quebec, 1943 –
Saint-Jean-Port-Joli,
Quebec, 1998
Ruisseau de Belœil
Bowl
1961
Lead-glazed earthenware
H. 17.7 cm; Diam. 51.9 cm
Signature, date and title,
incised, on underside:
*Garnier 61 / Ruisseau de /
Beloeil*, and artist's mark,
impressed:
[a triangle] *G* [a triangle]

Purchase, Serge Desroches,
Hermina Thau, David R.
Morrice, Mary Eccles,
Jean Agnes Reid Fleming,
Geraldine C. Chisholm,
Margaret A. Reid, F. Eleanore
Morrice Bequests
1999.7
PROVENANCE
Micheline d'Astous; Roger
d'Astous, late 1960s; acquired
by the Museum in 1999.

CLAUDE VERMETTE

Claude Vermette is recognized for his ceramic installations in major public and private buildings in Quebec, including schools, hospitals, and religious institutions, as well as twelve Montreal metro stations. Trained in painting under Paul-Émile Borduas (1905–1960) and Frère Jérome (1902–1994), Vermette began working in clay early in his career. A study tour of Europe in 1952 confirmed the direction he took in integrating ceramics into architecture. On this trip, he met architects and ceramicists, notably Gio Ponti and Fausto Melotti, in Italy. Looking back on his visit, Vermette said: "It was my time in Italy, in particular, that opened the most doors for me. In that country, I saw ceramics used in a way very much in line with my concerns: ceramics allied with architecture, in terms of floor and wall coverings."[1]

505

Back in Montreal, Vermette progressed quickly in his chosen field and presented a solo exhibition of over fifty ceramic works at the Agnes Lefort gallery in 1952, when he was only twenty-two years old. During the 1950s, a revival of ceramics was in full swing in Quebec under such artists as Pierre-Aimé Normandeau, Louis Archambault and Jean Cartier, among others. Like these artists, Vermette embraced the clay medium, but he went beyond studio pottery to develop the serial production of ceramic tiles. He was especially well placed to respond to the boom in school and church construction in the province, which prompted a revival of religious decoration. Vermette worked directly with architects on commissions for tile decoration, and collaborated frequently with his long-time friend the artist Jean-Paul Mousseau, most notably on the decoration of the Peel Street metro station (1964–66).

Two works in the Museum's collection represent Vermette's handcrafted ceramics. A cylindrical vase 505, executed in Paris in 1952, is made up of clay "coils" and then glazed with a painterly application of large daubs of yellow and white on a black background. This very early piece shows Vermette—trained as a non-figurative painter—exploring his medium, inspired by the expressive ceramic forms of Fausto Melotti,[2] whom he greatly admired.

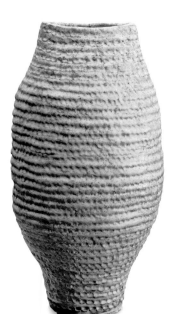

506

The second vase 506, from 1967, is an example of Vermette's best mature work. Also built up into an innovative, irregular form using the "coil" technique, the textured rings of clay are in this case left visible through a thinly applied white glaze. Although industrial ceramic design adapted to contemporary life and economics was the direction Vermette took in his career, in these works, one sees his pleasure in crafting the clay, giving it surface texture, and investigating the chemistry of glazes to achieve unexpected effects of colour. These experiments in colour were carried over into his ceramic installations, which were all about subtle changes of tone and the balance of colour under different intensities of light. RP

1. René Viau, "Claude Vermette et la céramique architecturale," *Décormag* (April 1968), pp. 74–78. My thanks to the artist's sister, Luce Vermette, for her help in this research. 2. The Melotti vase in the Museum's collection 497 belonged to Claude Vermette.

JACQUES GARNIER

For many years, Jacques Garnier was an active and respected figure in the development and teaching of ceramics in Quebec. After receiving his early training in this field with Jean Cartier at Montreal's École du Meuble (1956–57), he went on to teach at the Institut des arts appliqués (1962–70) and then the CEGEP du Vieux-Montréal. He is best known for the workshop and community he founded about 1957, called l'Argile Vivante, near Saint-Marc-sur-Richelieu, Quebec. It operated out of a 150-year-old farm called "Ruisseau de Belœil," and under the direction of Garnier, the ceramicists specialized in architectural ceramics, for example, large bas-reliefs and statues for churches and schools.

This bowl 504 was made by Garnier in 1961, and is signed with the name of the property "Ruisseau de Belœil." Simple in form, it is impressive for its size and the rich red earthenware body, rough in texture and covered with a clear glaze with streaks of yellow and brown. The bowl's form and colour recall the early red earthenware pieces made in Quebec throughout the nineteenth century. The bowl was in the collection of the architect Roger d'Astous, with whom Garnier collaborated on a number of architectural commissions. Garnier continued to experiment with different ceramic mediums, regarding himself as a "sculpteur-céramiste."[1] RP

1. Guy Boulizon, "Jacques Garnier, sculpteur-céramiste," *Vie des Arts*, vol. 23, no. 94 (1979), pp. 54–56.

505

Claude Vermette
Montreal 1930 –
Sainte-Agathe-des-Monts,
Quebec, 2006
Vase
1952
Glazed earthenware
H. 34 cm; Diam. 9 cm
(approx.)
Signature and date,
incised on underside:
Claude / Vermette / Paris 1952
Anonymous gift
2010.859

506

Claude Vermette
Montreal 1930 –
Sainte-Agathe-des-Monts,
Quebec, 2006
Vase
1967
Glazed earthenware
H. 30 cm; Diam. 16 cm
(approx.)
Initials and date,
in felt pen on underside:
CV 67
Anonymous gift
2010.861

507

Jordi Bonet
Barcelona 1932 –
Montreal 1979
Fireplace Facade
1965
Glazed earthenware
83.2 x 160 cm
Incised, upper left:
CANTA
Liliane and David M.
Stewart Collection,
gift of Laurent Lamy
D92.211.1a–d

BEYOND FUNCTION: FORM AND MATERIAL

— AMY GOGARTY —

ROBERT ARNESON

Best known for his association with the Funk movement, of which he was a principal proponent, Californian Robert Arneson, often quoted well-known artworks in his ceramics to break down what he saw as artificial distinctions between art and craft. In 1972, he began using his self-portrait to explore themes of identity that ranged from satirical attacks on the art world to more introspective approaches to his personal struggles.

Describing the Diameter 508 takes the form of a charger, a large platter traditionally decorated with domestic or didactic imagery. For the ideal male nude of Leonardo da Vinci's *Vitruvian Man*, about 1490, Arneson substitutes his own stocky and decidedly non-ideal figure, whose outstretched arms and legs form the familiar decorative device of radial symmetry. The flatness of the charger is countered by the physicality of the figure, modelled firmly and outlined in blue sgrafitto. The hands gently lift where they slide under the rim of the charger, introducing a tension between image and frame more commonly found in painting. In a sly reference to Peter Voulkos, who famously gouged and tore holes in his work, Arneson emasculates the figure by piercing a hole through its genitals. Arneson asserts ceramics' capacity to address conceptual concerns by acknowledging a luminary of the fine arts canon while simultaneously challenging the hierarchy that excludes ceramics from serious consideration in the art world. **AG**

RODNEY BLUMENFELD

Born and raised in Durban, South Africa, Rodney Blumenfeld engages in the region's creative artistic renaissance. He trained as an architect at the University of Natal and practised the profession prior to studying ceramics at the Natal Technikon in Durban. His background in architecture is evident in his clean, structural forms and strategic use of ornamentation, much of which also derives from traditional KwaZulu-Natal designs and artifacts. As with other contemporary ceramicists working in the new South Africa, Blumenfield turns to local tribal traditions with powerful cultural links between ceramics, community and cosmology. He reinterprets these influences within a universal context of contemporary art, craft and design, applying patterns that fuse Western geometry with the tribal motifs of his homeland. Press-moulded from earthenware, his pots are subtly embellished with an all-over matrix of impressions suggesting cultivated fields or weaving.

The tall, flattened and unglazed walls of the Museum's vessel 509 contrast with the crescent-shaped, black-slipped neck. Gracing one side is a narrow vertical strip of black and white inlaid slip decoration. The geometric design recalls Western and transnational tribal designs, including those of the American Southwest (Pueblo artists), ancient Mesopotamia and Africa. This piece pays tribute to ancient and contemporary aesthetics, assimilating them within a global context of multi-ethnic, multi-layered identity. **AG**

ROSELINE DELISLE

Working in white porcelain banded with black or cobalt slip, Roseline Delisle, a Quebecer living in California, produced vessels of rare economy and sophistication. Their titles are based on the number of their components: the finial, the dome-shaped top and the striped base. Most of her pieces are surmounted by banded finials. She was influenced by early masters of modernism including Russian Constructivists and Bauhaus artist Oskar Schlemmer, whose costumes for the *Triadisches Ballett* [Triadic Ballet], which toured widely in the 1920s, transformed the dancers' bodies into swirling patterns of geometric design. Starting with sketches, Delisle honed her porcelain forms to precise profiles.

The lower portion of *Quadruple 9.89* 510 rises from a small foot, swells gently to the hip and incurves slightly to a broad waist. Five black bands alternating with white reserves of similar width create a cool and grounding rhythm. Surmounting this is a spherical form of vibrant cobalt topped with a black and white banded cone set in a black base. The overall shape generates strong vertical energy countering the horizontal rhythm of the stripes. Though suggestive of architecture, figures or even insects, Delisle's vessels are ultimately abstract sculptures with energetic buoyancy, visual puzzles that animate and delight. **AG**

508

Robert Arneson
Benicia, California, 1930 –
Benicia 1992
Describing the Diameter
Charger
1977
Glazed earthenware
H. 3.8 cm; Diam. 47.6 cm
Signature and date, incised
on back: *Arneson / 1977*
Liliane and David M. Stewart
Collection, gift of
Jean Boucher
D93.306.1

509

Rodney Blumenfeld
Born in Durban,
South Africa, in 1953
Vessel
1998
Earthenware,
inlaid slip decoration
71.5 x 34 x 16 cm
Liliane and David M. Stewart
Collection
D98.162.1

510

Roseline Delisle
Rimouski, Quebec,
1952 – Santa Monica,
California, 2003
Quadruple 9.89
1989
Unglazed porcelain,
bands of slip
H. 51.8 cm; Diam 22.1 cm
Signature and title, painted
on underside: *Roseline Delisle*
QUADRUPLE 9.89
Purchase, the Montreal
Museum of Fine Arts'
Employee Fund
1991.Dp.1a-b

509

510

PETER VOULKOS

The American Peter Voulkos had established himself as a pottery artist producing competent yet conventional vessels influenced by Scandinavian and Japanese models. An opportunity to teach at the prestigious Black Mountain College in North Carolina and travel to New York in 1953 introduced him to members of the international avantgarde. He moved to Los Angeles in 1954 to join the faculty of the Otis Art Institute, and encountered an array of new sources of inspiration including experimental music, beat poetry and Zen Buddhism. Picasso's ceramics, with their innovative manipulation of surface and shape, informed Voulkos' experiments with decoration. An avid student of the history of ceramics, Voulkos looked to the achievements of the Japanese, finding in the fissures, cracks and kiln accidents characteristic of Shigaraki and Bizen wares devices to incorporate into his own work. Improvisational jazz and classical flamenco guitar, which he played, nurtured his appreciation for spontaneous, expressive form and syncopation, paving the way for his stacked pieces and non-vessel sculpture begun in 1957.

This barrel-shaped, deep-footed covered jar 511 dates from 1956, an important point in its maker's early career. With its collaged calligraphic-like slabs, textured surface and impressive scale, it exemplifies Voulkos' synthesis of all these disparate influences. The vessel references the cultural climate in which the artist and a select group of students forged a new ceramic vocabulary, pioneering a "clay revolution" that transformed the nature of studio ceramics in North America. **AG**

WAYNE HIGBY

American ceramicist Wayne Higby approaches the vessel as a three-dimensional canvas with which to explore formal and emotional concerns relating to landscape. Ceramics of all ages, particularly those from Asian and Islamic cultures, appeal to him more for their intellectual and aesthetic qualities rather than their functional uses. His covered jar *Calico Mountain* 512 recalls Han Dynasty hill pots, which allude to the mythical abodes of Daoist deities, or the exquisite Kenzan-style covered boxes of Edo, Japan, which combine decorative motifs with evocations of literary landscapes. *Calico Mountain*, a slab-constructed, raku-fired container, depicts a cloud-wreathed mountain traversed by a sparkling river. The sepia brown sides have non-linear bases, and the crisply delineated edges suggest steep cliffs rising to a narrow, irregular cap. A cloud-like form,

functioning as a handle, billows above. A bead of slip runs down and across the container from shoulder to base, where it piles in parallel wavy lines to recall a river lapping against canyon walls. This is the landscape of the artist's boyhood as remembered by him from his studio, separated by time and space. Like the mountain it conjures, the vessel conceals secrets. Pairing opposites of light and dark, smooth and rough, near and far, Higby's works are metaphorical objects of contemplation born from memory and fire. **AG**

STEVEN HEINEMANN

The Canadian ceramicist Steven Heinemann's delicate and materially sensuous vessels are "containers for ideas," rather than functional objects of daily use. A universal and familiar form, the bowl offers unlimited potential for signification. Heinemann slip-casts his forms using multiple layers of naturally coloured earthenware clays. A passionate draftsman, he confronts each new layer as an opportunity for expressive play. He employs stencils, resist and sgraffito to expose and build on layers. He also varies the density of slips to build up a mottled, textured surface. As the piece evolves slowly over time and through numerous firings, it reveals the conditions of its own making, assuming the ancient, time-worn quality of a palimpsest.

The thin walls of *Floral Apparition* 513 are emphasized by the sharp curve of the bowl's rimless lip. The smooth and polished exterior contrasts with the sheltered interior in which lobed floral forms emerge from a subtly patterned ground. An integral component of the same layering process that constructs the bowl, the organic shapes exist in dynamic tension with the matrix in which they are embedded. Heinemann's negotiation of pattern, motif and symbol reflects his early interests in fossils and the painted pottery of ancient peoples. Visually and intellectually appealing, *Floral Apparition* speaks to the ephemeral beauty of nature. **AG**

BETTY WOODMAN

Having started in functional pottery, Betty Woodman developed skills that served her well as she moved towards a more radical understanding of ceramic form and function. A sojourn in Italy in 1966 exposed her to Mediterranean ceramics, particularly maiolica, which made a profound impression on her. She moved to New York in 1980, where she came into contact with contemporary

feminism and painting related to the Pattern and Decoration movement. The vibrant colours and patterns that embellish her vessels derive from historical examples of ceramics, textiles and abstract paintings. The artist exploits this rich repertoire to reconcile pictorial concerns with her exuberantly sculptural forms.

Kyoto Kimono 514 is a vase diptych from her "Kimono" series begun in 1989. By throwing and stretching clay, Woodman created organic slabs, which she fashioned into dramatically exaggerated handles, spouts and fins. These additions disrupt the symmetry of the robustly thrown cylinders to which they are attached, creating a dynamically shaped space between the two components of the piece. Pictorially, the vases have two distinct sides that are decorated differently on the surface; three-dimensionally, they exist as forms in space. Walking around the work presents the viewer with a constantly changing array of negative and positive spaces. The artist sees the vases as figures "wearing kimonos, moving, gesturing and responding to each other,"[1] reflecting the vessel's dual nature as container and subject. **AG**

1. Betty Woodman, unpublished artist's statement, November 4, 1991 (MMFA Archives).

511

512

513

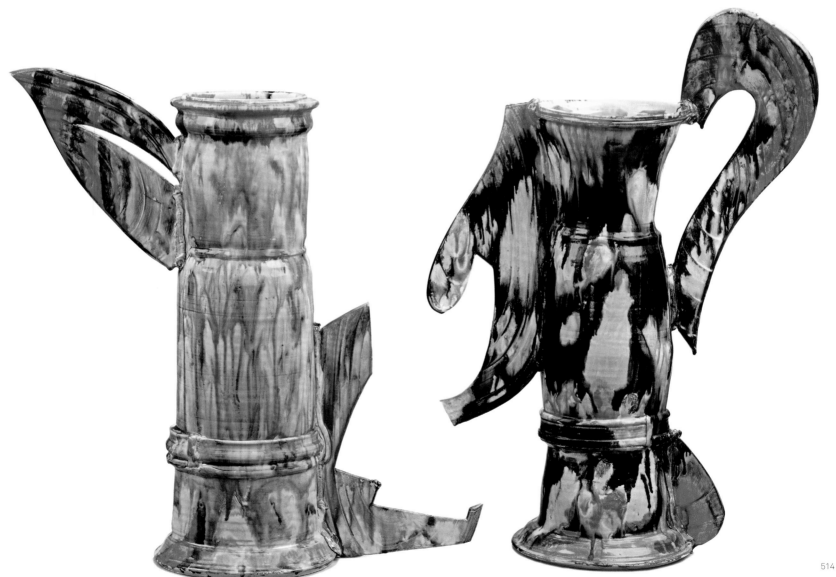

514

CERAMICS BY SOTTSASS

— DIANE CHARBONNEAU AND ALBERT LECLERC* —

Ettore Sottsass designed his first ceramic objects in 1956 for New York importer Irving Richards, who doggedly supported the distribution of "modernistic" design on the American market. At his invitation, Sottsass sketched the ceramics, but without really knowing what to do exactly and without really believing in this kind of cultural expression. The ceramics did not sell well, and the collaboration ended in fiasco.

Seduced by the expressive qualities of ceramics, the designer nevertheless returned to the studio Bitossi Ceramiche in Montelupo Fiorentino. He quickly developed a formal language that reflected his own interest in the medium and colour, and in geometric and architectonic, even "archetypal," shapes. The first pieces were produced in limited editions for the Milan gallery Il Sestante, starting in 1958 515 516 .

Following a stay in the United States, Sottsass designed another series of ceramics that clearly show the pictorial influence of Abstract Expressionism, Pop art and Colour-field painting. The series "Menhir, Ziggurat, Stupas, Hydrants and Gas Pumps" (1964–65) presented large-scale proportions imbued with a symbolism exceeding the pieces' decorative function. It took shape in the Bitossi studios in 1966 and was exhibited in the Milan gallery Sperone in 1967, then in the showroom of the Poltronova ceramics company under the title *Ceramiche sbagliate.* In the exhibition texts, Sottsass' wife, Fernanda Pivano, recounts the series' genesis: "One day, I said to him, 'Why don't you make some of those nice little white and gold bowls to give as presents to our friends?' He gave me one of those looks, half surprised, half offended, so I figured I could just forget about the bowls. But I had no way of knowing that from that moment on, he would make only two-metre-high ceramics. . . . As he told me later, he made them that big because he wanted to go beyond the dimensions of common-use objects, of furnishings, like vases and ashtrays; he wanted to enter into a larger dimension and define space through ceramics."[1] Sottsass designed another equally large-scale series for Poltronova, the "Mirabili." The *Odalisca* totem 523 juxtaposes a wood base covered in white laminate with twelve glazed earthenware elements—discs and cylinders—creating a geometric decoration. The Museum's totem, a unique piece from 1967, was produced in 1986 in twenty-nine numbered examples.

After a trip to India, ceramics became for Sottsass a spiritual experience, giving rise to a new approach inspired by Eastern philosophy and the theories of Carl Jung, as demonstrated by the series "Yantra" (1969) 518 and "Tantra" (1968), as well as the six teapots from the series "Indian Memory" (1972). The latter illustrates the designer's aspiration to rethink the object beyond its function. Each of the teapots has a distinct shape, texture and colour. They are called *Lapislazzuli, Cinnamon, Basilico* 517 , *Pepper, Cardamon* 521 and *Cherries* 519 ;[2] the second edition, to which the Museum's example belongs, was produced by Alessio Sarri in 1987.

Founder of the Memphis group (1981), Sottsass designed a trio of vases for the 1983 collection: *Nilo, Tigris* 520 and *Euphrates*, the names of the Middle East's three mythic rivers. Each porcelain vase is comprised of several apparently industrial elements that were in fact turned by hand: three colours of glaze unify them in a collage-like assemblage.

A decade later, in 1992, Sottsass riffed on the theme of ruins in the series "Rovine," produced by Flavia for the Design Gallery Milano. At the time of the exhibition, Sottsass admitted that "at the moment, now more than ever, the word 'ruin' seems to describe how I feel."[3] The monochrome, architectonic pieces of the series, such as the *Fastosi Progetti* vase 522 , were modelled in white clay before being glazed. In this same period, Sottsass began a collaboration with the Sèvres porcelain factory. He provided twenty original designs to the prestigious factory between 1993 and 2006.

Although experts generally ignore this output, the fact remains that Sottsass revolutionized ceramics by approaching the medium like an architect/designer with the rich perspective of a cultural anthropologist. Sottsass maintained that there was a major difference between art, industrial design and architecture. He considered himself to be a designer and architect fascinated by domestic interiors. He claimed that art was far from being one of his preoccupations, particularly in relation to his ceramics: "But if you look carefully, you can put a flower or something else in any of my ceramic pieces. I don't do art! I get pissed off when they tell me I'm an artist."[4] His production spanned some forty years and constitutes an important body of work that not only set the bar, but is also internationally recognized in the design world and collected by major museums.

1. Cited in Fulvio Ferrari, *Ettore Sottsass: tutta la ceramica* (Turin: Umberto Allemandi, 1996), p. 23.
2. The original designs of these ceramics were reproduced in lithographs signed by Sottsass in 1973.
3. Bruno Bischofberger, *Ettore Sottsass: Ceramics* (San Francisco: Chronicle Books, 1996), p. 165.
4. Giampiero Bosoni, "Conversation with Ettore Sottsass," in *Il Modo Italiano: Italian Design and Avant-garde in the Twentieth Century*, exh. cat., ed. G. Boroni (Montreal: The Montreal Museum of Fine Arts; Milan: Skira, 2006), p. 329.

* Quebec designer Albert Leclerc studied in Montreal, London and Paris, then completed his training in Italy with Gio Ponti in the 1960s. He joined Ettore Sottsass' studio in the early 1970s and, notably, worked on Sistema 45 furniture (1973) and the typewriters A5, A7 and Lexikon 90 (1975). He also worked with other Italian firms, including Lorenz (clocks), Planula and Tecno (furniture), and Velca (office items). Although he carved out his career in Italy, he always maintained contact with Quebec's design milieu. In 1992, Université de Montréal named him head of the École de design industriel. Today, Albert Leclerc divides his time between Milan and Montreal.

515

Ettore Sottsass
Innsbruck, Austria,
1917 – Milan 2007
Covered Jar (model 192)
About 1959
Partially glazed earthenware,
cotton
H. 10.3 cm; Diam. 14.2 cm
Made by Cav. G. Bitossi & Figli,
Montelupo Fiorentino, Italy,
for Il Sestante, Milan
Signature, painted
underglaze, on underside
of jar: *192 / IL SESTANTE /*
SOTTSASS / ITALY
Gift of Joseph Menosky in
memory of his wife, Diane,
and of Shiva and Shelby,
in honour of the Montreal
Museum of Fine Arts'
150th anniversary
2010.92.1-2

516

Ettore Sottsass
Innsbruck, Austria,
1917 – Milan 2007
Covered Jar (model 191)
About 1959
Partially glazed
earthenware, hazel
H. 18.8 cm; Diam. 11.6 cm
Made by Cav. G. Bitossi & Figli,
Montelupo Fiorentino, Italy,
for Il Sestante, Milan
Signature, painted
underglaze, on underside:
191 / IL SESTANTE /
SOTTSASS / ITALY
Gift of Joseph Menosky in
memory of his wife, Diane,
and of Shiva and Shelby,
in honour of the Montreal
Museum of Fine Arts'
150th anniversary
2010.93.1-2

517

Ettore Sottsass
Innsbruck, Austria, 1917 –
Milan 2007
***Basilico* Teapot**
From the series
"Indian Memory"
1972 (example of 1987)
Partially glazed earthenware
20 x 19.5 x 18 cm
Produced by Alessio Sarri
Ceramiche, Sesto Fiorentino,
Italy
Signature, stamped:
Ettore Sottsass
Stamped on underside:
A [company logo] S /
·ALESSIO·SARRI·
CERAMICHE
Gift of Albert Leclerc in
honour of the Montreal
Museum of Fine Arts'
150th anniversary
2010.118.1-2

517

518

519

520

521

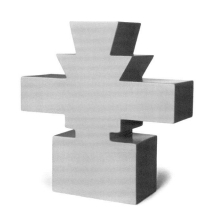

522

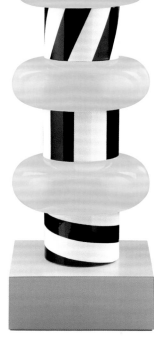

523

518

Ettore Sottsass
Innsbruck, Austria,
1917 – Milan 2007
Vase (model Y23)
From the series
"Yantra di terracotta"
1969 (example about 1970)
Glazed earthenware
51 x 29.8 x 20.2 cm
Produced by Ceramica
Toscana, Figline di Prato, Italy
Signature, painted on
underside: *Sottsass / Y / 23*
Liliane and David M. Stewart
Collection, gift of Mr. and
Mrs. Charles D. O'Kieffe,
Jr., in memory of Mr. and
Mrs. Charles DeWitt O'Kieffe,
by exchange
D87.194.1

519

Ettore Sottsass
Innsbruck, Austria, 1917 –
Milan 2007
Cherries Teapot
From the series
"Indian Memory"
1972 (example of 1987)
Partially glazed earthenware
27.5 x 20.8 x 12.3 cm
Produced by Alessio Sarri
Ceramiche,
Sesto Fiorentino, Italy
Signature, stamped:
Ettore Sottsass
Stamped on underside:
A [company logo] *S /
·ALESSIO·SARRI·
CERAMICHE*
Gift of Albert Leclerc in
honour of the Montreal
Museum of Fine Arts'
150th anniversary
2010.121.1-2

520

Ettore Sottsass
Innsbruck, Austria, 1917 –
Milan 2007
Tigris Vase
1983
Porcelain
40 x 18 x 15 cm
Made by Porcellane
d'Arte San Marco, Nove,
Italy, for Memphis, Milan
Signature, stamped on
underside: *E. Sottsass /
per / MEMPHIS*
Liliane and David M. Stewart
Collection, gift of
Dr. Michael Sze
2007.249

521

Ettore Sottsass
Innsbruck, Austria, 1917 –
Milan 2007
Cardamon Teapot
From the series
"Indian Memory"
1972 (example of 1987)
Partially glazed earthenware
20 x 22.7 x 19 cm
Produced by Alessio Sarri
Ceramiche,
Sesto Fiorentino, Italy
Signature, stamped:
Ettore Sottsass
Stamped on underside:
A [company logo] *S /
·ALESSIO·SARRI·CERAMICHE·*
Gift of Albert Leclerc in
honour of the Montreal
Museum of Fine Arts'
150th anniversary
2010.120.1-2

522

Ettore Sottsass
Innsbruck, Austria, 1917 –
Milan 2007
Fastosi Progetti Vase
From the series "Rovine"
1992
Glazed earthenware, 8/9
45.4 x 42.6 x 14.6 cm
Made by Flavia, Montelupo
Fiorentino, Italy,
for Design Gallery Milano
Signature and date,
painted overglaze,
on underside:
Sottsass / 1992 / 8/9
Liliane and David M. Stewart
Collection, gift of
Paul Leblanc
D93.302.1

523

Ettore Sottsass
Innsbruck, Austria, 1917 –
Milan 2007
Odalisca Totem
From the series "Mirabili"
1967 (example of 1986)
Glazed earthenware,
laminate on wood (base), 8/29
205 x 40.5 x 40.5 cm
Produced by Bitossi,
Montelupo Fiorentino,
Italy, for Mirabili
Arte d'Abitare, Florence
Signature, painted on bottom
cylinder: *SOTTSASS 8/29*
Gift of Joseph Menosky in
memory of his wife, Diane,
and of Shiva and Shelby,
in honour of the Montreal
Museum of Fine Arts'
150th anniversary
2010.75.1-14

POETRY
AND PLAY

— DIANE CHARBONNEAU, VALÉRIE CÔTÉ —

HELLA JONGERIUS

Dutch designer Hella Jongerius is part of a minority of women who have been distinguishing themselves internationally since the 1990s. After studying at the Design Academy Eindhoven, Jongerius worked for a time with the Droog collective, overseeing the manufacturing and distribution of their products, before going on to establish her own studio for research and production, the Jongerius Lab.[1] She also designs furniture, ceramics and fabrics for companies such as Maharam, the Royal Tichelaar Makkum, Vitra and Galerie Kreo.

Jongerius departs from industrial production standards by fusing craft with technology, both past and present. She is interested in the creation of functional objects, even if she inverts the canon when producing unique pieces. She appropriates archetypal shapes, which she transforms through her choice of materials, methods and even colours. During a residence at the EKWC (European Ceramic Workcentre) in 's-Hertogenbosch in 1997, Jongerius worked with fragments of medieval porcelain urns from the collection of the Museum Boijmans Van Beuningen, assembling them with epoxy glue to create seven prototypes. The *Red White Vase* 525 and the *Big White Pot* 524 made by the Royal Tichelaar Makkum were the results of this research. Produced in unglazed porcelain, they simulate the imperfections of handmade objects with the obvious joints serving as decoration, and, as is the case with medieval vases, they bear Jongerius' thumbprint. The *Red White Vase* is partially covered in red Toyota industrial spray paint—a choice that confirms the designer's wish to combine traditional and contemporary techniques, although it was also partly informed by the ban on using cadmium pigments, considered toxic, in coloured glazes. DC

1. Jongerius founded her own firm in Rotterdam in 1993, transferring it to Berlin in 2008.

MARCEL WANDERS

A number of contemporary designers are exploring industrial ceramics, triggering something of a renaissance in the field with their innovative products and technical inventions. Marcel Wanders, a graduate of the fine arts school in Arnhem, creates objects that fuse craft and modern technology— pieces where cultural currency takes precedence over commercial considerations. For a collaborative 1997 project linking Droog Design and Rosenthal, he took a new approach to the design of ceramic objects by forgoing plaster moulds in order to fully reveal the density, hardness and purity of white porcelain.

Injecting elements of humour, poetry and the environment into his work, the Dutch designer makes use of both natural and industrial elements. The shape of the *Egg Vase* 526 is achieved by stuffing a latex condom with hardboiled eggs and then immersing it in the liquid porcelain before firing. This vase comes in three formats, each more exuberantly deformed than the last. It is produced and distributed by Moooi, the design firm co-founded by Wanders in 2001. DC

STUDIO JOB

Job Smeets and Nynke Tynagel, the Belgian-Dutch duo known as Studio Job, produce largely handmade objects in limited editions. Both graduates of the renowned Design Academy Eindhoven, they approach their work as artists rather than designers, allowing expression to predominate over function.[1] Their sources of inspiration are diverse and often historical, even a touch nostalgic. But while Smeets and Tynagel create objects whose forms and motifs are drawn from collective memory, they often infuse them with a spirit of luxury or extravagance.

In 2006, Studio Job designed its "Biscuit" collection for the Dutch pottery manufactory Royal Tichelaar Makkum. The series consists of nine

plates and five centrepieces in biscuit porcelain, all decorated in relief with imaginary figures and allegorical motifs that include skeletons, garlands of bones, poodles and peace signs. The shapes of the centrepieces are also allusive: the ziggurat form of the *Vase of Babel* 527, for example, is a clear reference to the story of the Tower of Babel, as told in the Book of Genesis.

The following year, the series was brought up a notch when Studio Job launched a new edition of objects covered in 24-carat gold. For its "Golden Biscuit" series, the designers revisited the porcelain objects from "Biscuit," but had them painted in gold in their studio. Each piece is signed and numbered in a limited edition of eight. The *Cake of Peace* 528 centrepiece resembles a traditional cake stand, but the cover mimics a cake decorated all over with peace symbols made of icing, while the knob is a hand making the universal sign for peace. DC

1. Robert Preece, "Designeridentikit. Studio Job," *Azure* (July-August 2004), pp. 52–53.

TAMSIN VAN ESSEN

Tamsin van Essen holds a degree in physics and philosophy from Balliol College, Oxford, and is also a graduate of Central Saint Martins College of Arts and Design. Arising from a creative vision informed by art, design and science, her approach to ceramics is essentially conceptual. In the "Medical Heirlooms" series, she explores attitudes to disease and the contemporary obsession with perfection. Formally speaking, the vessels in this series echo those used by English apothecaries during the seventeenth and eighteenth centuries, but each one bears signs of an illness (such as cancer, psoriasis or acne) or evidence of a medical intervention (sutures). Van Essen adroitly inverses the notions of content and container, for here the function of the jar, which traditionally held the remedy, is thrown into question: it becomes

524

Hella Jongerius
Born in De Meern, Netherlands, in 1963
Big White Pot
1997
Unglazed porcelain
36 x 30 cm
Produced by the Royal Tichelaar Makkum, Netherlands
Stamped on underside:
HELLA / JONGERIUS / makkum /
[crowned T in a shield]
Purchase, George R. MacLaren Fund
2011.186

525

Hella Jongerius
Born in De Meern, Netherlands, in 1963
Red White Vase
1997
Unglazed porcelain, lacquer spray paint
H. 41 cm; Diam. 17 cm
Produced by the Royal Tichelaar Makkum, Netherlands
Stamped on underside:
HELLA / JONGERIUS / makkum /
[crowned T in a shield]
Purchase, George R. MacLaren Fund
2011.187

526

Marcel Wanders
Born in Boxtel, Netherlands, in 1963
Egg Vase
1997
Partially glazed biscuit porcelain
15.3 x 10 x 11 cm
Produced by Moooi, Breda, Netherlands
Stamped on underside: *moooi*
Liliane and David M. Stewart Collection, gift in honour of the Montreal Museum of Fine Arts' 150th anniversary
2011.99

527

Studio Job
Founded in Antwerp in 1998
Vase of Babel
From the series "Biscuit"
2006
Unglazed porcelain
H. 27.5 cm; Diam. 23 cm
Produced by the Royal Tichelaar Makkum, Netherlands
Stamped on underside:
STUDIO / JOB / makkum /
[crowned T in a shield]
Liliane and David M. Stewart Collection, gift in honour of the Montreal Museum of Fine Arts' 150th anniversary
2011.106

528

Studio Job
Founded in Antwerp in 1998
Cake of Peace Centrepiece
From the series "Golden Biscuit"
2007
Porcelain painted in gold
H. 22.5 cm; Diam. 25.5 cm
Produced by the Royal Tichelaar Makkum, Netherlands, and painted by Studio Job, Antwerp
Stamped inside cover and on underside: *STUDIO / JOB / makkum /*
[crowned T in a shield]
Purchase, the Museum Campaign 1988–1993 Fund
2008.160.1-2

529

Tamsin van Essen
Born in London in 1976
Cancer (5-cell)
From the series "Medical Heirlooms"
2007 (example of 2009)
Earthenware, slip decoration
10.7 x 21.6 x 12.7 cm
Purchase, Edith Low-Beer Bequest
2010.101

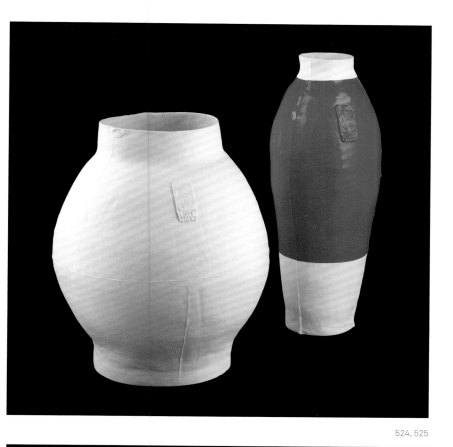

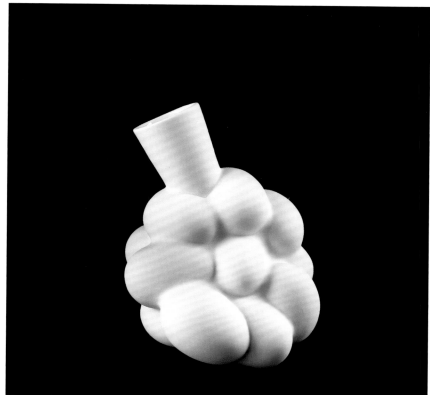

524, 525

526

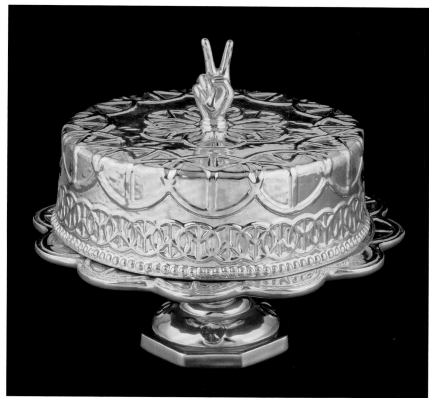

527

528

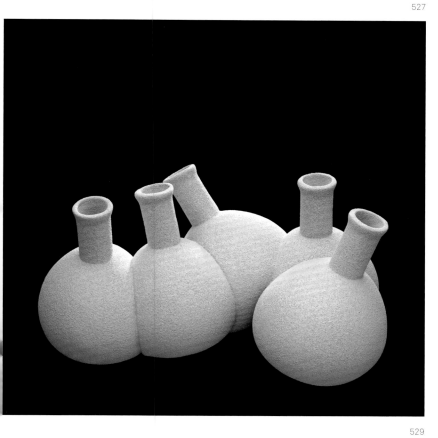

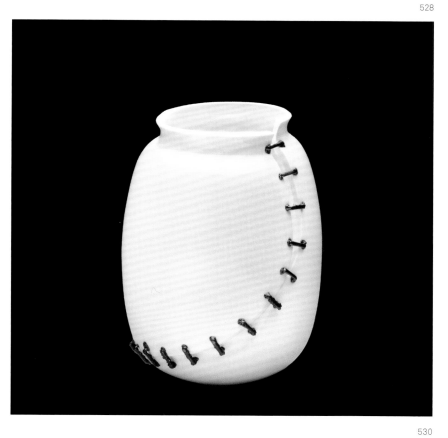

529

530

a symbol of abnormality but also of inheritance, the passing down through the generations of both heirlooms and ill health.[1]

Van Essen generally employs white clay of British origin. The jars are moulded and their forms reworked before the first firing, while the various surface treatments take place at a later stage. *Scars (Suture)* `530` shows signs of how it was made—damage and repair. *Cancer* `529` is composed of a group of five medicine bottles that were moulded individually and then fused together to mimic the proliferation of cancer cells. Their rough texture is achieved through the application of multiple layers of slip. DC

1. Tamsin van Essen, "Medical Heirlooms," http://www.vanessendesign.com/page5.htm (accessed May 25, 2012).

MAARTEN BAAS

Dutch designer Maarten Baas has been an international design sensation since the launch of his collection "Where There's Smoke" at the Moss gallery in New York in 2003. Rather than espousing a particular philosophy, he follows his intuition, gleefully playing with forms and materials. In 2005, he teamed up with a collaborator, Bas den Herder, with whom he has devised a division of labour: Baas basically creates the designs, while Den Herder makes the prototypes, before moving on to production.

In 2006, Baas launched a new furniture collection, "Clay Furniture," which created a stir in the press when it was presented at the Salon del mobile in Milan. The series includes a chair, a shelf, an occasional table, a stool and a fan. Each piece is formed by a metal framework—after an original drawing by Baas—and covered in a clay composite lacquered in a bright colour. Each handcrafted piece is one of a kind, bearing the traces of hands-on modelling. Bass reimagines the industrial object and changes the framework within which it is made by adopting the modelling technique traditionally used in sculpture for depictions of the human figure. Despite its strange appearance, this furniture is nevertheless stable and functional. The floor fan `535` includes a grill, to which three blades are affixed, resting on spider-like legs that enhance its sculptural rather than playful appearance. The fan is available in three sizes in an array of bright colours. The version covered in a chrome lacquer was introduced in 2007. Produced in a limited edition of eight copies, the fan bears the name *Wind*, and the series "Chromed Clay Furniture." DC

LORENA BARREZUETA

American designer and ceramicist Lorena Barrezueta is known for her originality and the popularity of her Gourmet porcelain dishware. Designed in 2003, this set notably imitates the form and texture of aluminum cookware and disposable containers associated with takeout food. The idea goes back to her time as a young student of design at Parsons School of Design in New York: "When I was at Parsons . . . I saw a lot of waste in the trash can, because we would all get takeout for lunch. . . . And I longed for a home-cooked meal. So I took these forms out of the garbage and appreciated the beauty of the machine quality of the form and imagined how it would look in porcelain—such a sterile, natural material. I thought it would be beautiful."[1] Using moulds based on these various aluminum containers, Barrezueta injects new life into dishware while simultaneously critiquing modern eating habits. Although she conjures values of the "homemade," she also elevates—with a note of humour—containers usually destined for the garbage. Despite appropriating an industrially made object all too common in North America, Barrezueta draws attention to craft. Production rates may have gone up, but every piece is made in her studio.[2]

The Gourmet Collection consists of some forty models from three different series: "Classic," "Fresh" and "Lush."[3] The "Classic" series recalls the elegance of the traditional white porcelain dinner service, highlighted in this case with a golden rim. The "Fresh" series features vibrant colours and extravagance. Consisting of dishware in striking hues of blue, yellow, red and green and bearing suggestive names like *Mac'n Cheese* `533`, *Finger Food* `532`, *Square Meal* and *Munch* `531`, this "refreshing" series awakens the taste buds. The *Triple Dip* dish `534` from the "Lush" series presents more richly coloured ware, as its name implies. All of these pieces illustrate the spirit of the Gourmet Collection, which comments on urban living and revisits the art of tableware. DC and VC

1. Lisa Curtis, "Dinnerware To-go," *The Brooklyn Papers* (August 13, 2005). 2. To date, over one thousand pieces of the Gourmet Collection have been issued from the studio. 3. Artist's website: http://www.lorenabarrezueta.com (accessed July 24, 2012).

531

532

533

534

`530`

Tamsin van Essen
Born in London in 1976
Scars (Suture)
From the series "Medical Heirlooms"
2007 (example of 2008)
Glazed earthenware
H. 13.8 cm; Diam. 9.8 cm
Initials and date painted on underside: *TVE. 2008*
Purchase, Edith Low-Beer Bequest
2010.102

`531`

Lorena Barrezueta
Born in New York in 1979
Munch Dish
From the series "Fresh"
Gourmet Collection
2003
Porcelain
3.3 x 17.5 x 13 cm
Impressed, on underside:
Gourmet Collection /
HANDMADE BY / LORENA
BARREZUETA
Gift of Lorena Barrezueta-Carlo and family
2012.74

`532`

Lorena Barrezueta
Born in New York in 1979
Finger Food Plate
From the series "Fresh"
Gourmet Collection
2003
Porcelain
H 1.8 cm; Diam. 28.3 cm
Impressed, on underside:
Gourmet Collection /
HANDMADE BY / LORENA
BARREZUETA
Gift of Lorena Barrezueta-Carlo and family
2012.77

`533`

Lorena Barrezueta
Born in New York in 1979
Mac 'n Cheese Dish
From the series "Fresh"
Gourmet Collection
2003
Porcelain
4 x 21.3 x 14.9 cm
Impressed, on underside:
Gourmet Collection /
HANDMADE BY / LORENA
BARREZUETA
Gift of Lorena Barrezueta-Carlo and family
2012.75

`534`

Lorena Barrezueta
Born in New York in 1979
Triple Dip Dish
From the series "Lush"
Gourmet Collection
2003
Porcelain
3.4 x 24 x 8.5 cm
Impressed, on underside:
Gourmet Collection /
HANDMADE BY / LORENA
BARREZUETA
Gift of Lorena Barrezueta-Carlo and family
2012.73

`535`

Maarten Baas
Born in Arnsberg, Germany, in 1978
Floor Fan
From the series "Clay Furniture"
2006
Lacquered synthetic clay, metal
152.4 x 48.3 x 48.3 cm
Produced by Baas & den Herder, 's-Hertogenbosch, Netherlands
Signature, in metallic letters, on underside of a support: *BAAS*
Liliane and David M. Stewart Collection
2007.601

ELUDING
TRADITION

— DIANE CHARBONNEAU —

RICHARD MILETTE AND LÉOPOLD L. FOULEM

Canadian ceramicists Léopold L. Foulem and Richard Milette see their art as just one form of aesthetic expression among many.[1] As creators of sculptures rather than of vessels, they assert the specificity of ceramics with its distinct vocabulary and concepts: material culture, historiography, terminology, typology and volumetry. They challenge the container/content dichotomy inherent in the concept of the vessel, which they endeavour to reproduce while depriving it of its function. Although demonstrating great mastery of technique and composition, their works incorporate humour and parody in their use of the repertoire of historical ceramics, turning the decorative towards the narrative.

Richard Milette creates complex pieces such as the *Pair of Semi-ovoid Vases with Banana-shaped Handles* 536. These two vases, identical in shape and based on a model depicted in *La porcelaine tendre de Sèvres* (1891) by Édouard Garnier, form a pair like the mantelpiece ornaments typical of Sèvres production in the eighteenth and nineteenth centuries. The decoration consists of white and celestial blue grounds, an assemblage of false shards floating above the vase's outer walls, and handles and false mounts painted gold.[2] Like mnemonics, the shard transfer-prints are drawn from a variety of sources. The bananas (the ultimate phallic symbol) that serve as handles form a strong contrast to the elaborate perfection of these supposedly Sèvres vases. The nail collars around the top rim and the feet of the vases add to the erotic connotations and also raise questions of gender and identity. Milette makes pastiches of French aristocratic taste by mixing it with contemporary design, exposing the artificiality of Western society in the late twentieth century.[3] Moreover, under the covers of both vases one discovers that the openings have been sealed and painted in matte black enamel, suggesting a physical manifestation of the void.

Léopold L. Foulem's work combines a taste for provocation with extensive knowledge of the history of ceramics, but also the history of art and the decorative arts. He appropriates the strategies of the ready-made and the found object,[4] of bricolage and assembly, kitsch and Pop art, always preferring works made by hand in the execution of his subject-based sculpture series, each of which constitutes a new formal and conceptual challenge. *Yellow Neoclassical Vase with Bouquet of Pink Peonies* 537, made of white clay fired at a low temperature, is composed of thrown elements assembled and then decorated with transfer prints, enamel, commercial glazes and gold lustre. Both pictorial and sculptural, it can be read as the depiction of a Neoclassical vase resting on a gilded base and a bulbous bouquet (painted), and not as an example of the *beau ideal* associated with the Neoclassical movement (about 1760–1830). References abound, for example, the yellow ground and cartouche, both typical of Meissen production, the polychrome floral decoration in bunched bouquets within a circular motif (traditionally a laurel wreath), as well as the peony motif reminiscent of East India Company china. The gilding of the oversized base recalls the bronze mounts that adorned certain luxury objects in that era. It also borrows from the shapes of ordinary salt and pepper shakers. *Yellow Neoclassical Vase with Bouquet of Pink Peonies*, like all the pieces in Foulem's series "Vases & Bouquets," exemplifies the issue of ceramics as an art form in its own right. **DC**

1. Léopold L. Foulem, *Ceramics Paradigms and Paradigms for Ceramics*, Third Annual Dorothy Wilson Perkins Lecture, Schein-Joseph International Museum of Ceramic Art at Alfred University, October 24, 2000. http://ceramicsmuseum.alfred.edu/perkins_lect_series/foulem/ (accessed May 25, 2011). **2.** These mounts were traditionally made of chased metal and reserved for luxury objects. **3.** T. Piché, *Four Quebecers in Syracuse*, exh. cat. (Syracuse, New York: Everson Museum of Art, 1993). **4.** Foulem finds a variety of unusual objects in second-hand shops and flea markets.

536

Richard Milette
Born in L'Assomption, Quebec, in 1960
Pair of Semi-ovoid Vases with Banana-shaped Handles
1993
Ceramic
41 x 25 x 14 cm (each)
Signature, incised on underside of each vase: *milette 1993*; initials and date, painted: *RM 1993* [within monogram of Louis XV, two interlaced letter "L"]
Purchase, the Canada Council for the Arts' Acquisition Assistance Program and the T. R. Meighen Family Fund
2011.242.1-4

537

Léopold L. Foulem
Born in Bathurst, New Brunswick, in 1945
Yellow Neoclassical Vase with Bouquet of Pink Peonies
From the series "Vases & Bouquets"
2002–4
Ceramic
H. 35.5 cm; Diam. 22.2 cm
Monogram, incised on underside: *LF*, date, incised: *02* and painted: *04*
Purchase, the Canada Council for the Arts' Acquisition Assistance Program and the T. R. Meighen Family Fund
2011.243

538

539

540

SHARY BOYLE

A dual preoccupation with form and concept lies at the heart of the practice of Toronto-based multidisciplinary artist Shary Boyle, a graduate of the Ontario College of Art and Design. Since 2003, Boyle has been reinterpreting the porcelain figurine, a traditional form of so-called decorative ceramics that she expands through her choice of subject—the female body and its treatment—by adopting a feminist point of view. Freely blending periods and genres, the artist draws inspiration from diverse sources, including vintage American illustration, European folklore, popular music and historical fashion. She combines personal observation with a poetic imagination to reveal the vulnerability of women.

Boyle visited Germany, in 2005, to research the history and tradition of Saxon porcelain figurines. She visited several factories in Meissen, Dresden and Sitzendorf, and studied the work of Johann Joachim Kändler, sculptor and master modeller in Meissen in the eighteenth century. Kändler's imagination and talent, the impeccable modelling of his animal and human figures—shepherds, hunters, *commedia dell'arte* characters, monkey musicians—elevated the porcelain figurine to an art form in its own right.

Shary Boyle's *Snowball* **538** perfectly illustrates her ability to update a traditional skill.

Boyle produced the work herself by assembling the moulded parts of the body,[1] which she then costumed, decorated and fired several times before painting. This piece borrows a technique long associated with Meissen: lacework porcelain, made by dipping lace into porcelain slip and then draping it on the figurine. She also makes allusion to a particular type of porcelain produced at Meissen from the eighteenth century on: the "snowball" vases, featuring encrustations of small white flowers (referencing the hydrangea cluster bloom) and animal and plant ornamentation. Boyle's dream-like figurine shows a woman transmuting from or into flowers: she is covered from head to toe with 575 yellow-centred white flowers, punctuated here and there with birds, butterflies and vegetation. The pointed, beak-like nose and the bird's talon emerging from the skirt's lacy folds undermine the figure's mannered charm and make it something of a monstrosity—a metaphorical fusion of Beauty and the Beast.

The Lute Player **539** evokes a work by Kändler from about 1765 entitled *Hearing* (fig. 1), one of a group of allegorical figurines representing the five senses. It depicts a nymph playing a lute, a deer kneeling and a singing putto, all united on a rococo-style base. This model inspired British modellers towards the end of the eighteenth

century **541**. In this piece, Boyle pursues the subject of sexuality as homage to the female folk musicians who have inspired her, depicting a nude woman with long hair covering her face (in the manner of classic male rock 'n' roll affectation) playing the electric guitar seated on a tree trunk (a variant of another recurring decorative element found in Kändler's work). Eschewing the animal world, the artist connects the guitar to the amplifier with glass beads. The flowers are also a nod to the German master, as is her use of polychrome and colour—dark tones between large surfaces left a lustrous white—to highlight certain parts of the body or decorative elements. **DC**

1. Boyle used existing moulds to create a first group of fifteen figurines (2003–6), including *Snowball*.

JAIME HAYON

The Spanish artist and designer Jaime Hayon is noted for a hybrid, transversal approach that blurs the lines between art, design and decoration. Working out of his Barcelona studio, he is a major contributor to the innovative production methods and visual codes that challenge the very parameters of design. He gives himself free rein, designing a range of objects (from toys to furniture), while also working on interior decoration and art installations. His imagination,

Fig. 1
Hearing: one of the five Meissen porcelain figurines representing the senses, about 1765, by Johann Joachim Kändler (1706–1775).

538

Shary Boyle
Born in Scarborough, Ontario, in 1972
Snowball
2006
Porcelain
26 x 17 x 16.5 cm (approx.)
Purchase, T. R. Meighen Family Fund
2006.94

539

Shary Boyle
Born in Scarborough, Ontario, in 1972
The Lute Player
2010
Glazed porcelain, lustre, beads, 1/2
26 x 24 x 24 cm
Initials and date, incised on underside: *S / 0 9 / B* [within a quartered circle]
Purchase
236.2011

540

Jaime Hayon
Born in Madrid in 1974
The Family Portrait
From the series "The Fantasy Collection"
2008
Porcelain, painted wood (base)
34 x 35 cm
Sculpted by Marco Antonio Noguerón
Produced by Lladró, Tavernes Blanques, Spain
Stamped on underside:
[a flower] / *LLADRÓ / JCO 20 / HAND MADE IN SPAIN / © DAISA 2008* / [a diamond] / *the fantasy* / [a heart] *collection* [a diamond] / *by jaime hayon*
Purchase, Ruth Jackson Bequest
2011.18

541

Derby Manufactory
Derby, England, about 1750–1848
Lady with Lute
About 1770
Soft-paste porcelain, overglaze enamel decoration
18.5 x 9 x 9 cm
Gift of Margaret Fountaine Brown
1934.Dp.70b

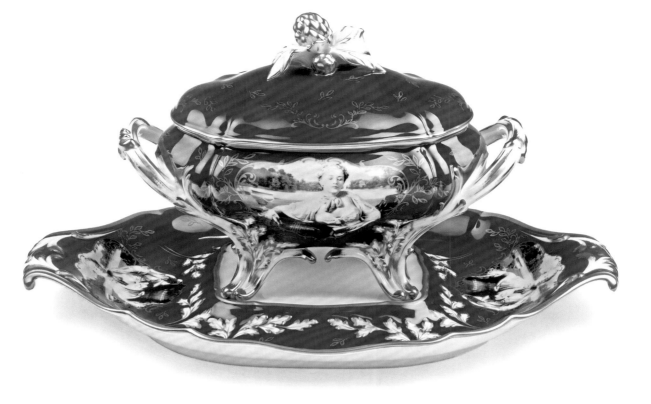

nourished by personal references and borrowings from the history of design, seems inexhaustible. While technical expertise and craftsmanship are evidently a priority, his practice is infused with humour and fantasy.

Appointed artistic director of Lladró, Valencia, in 2008, Hayon breathes new life into the traditional production of this porcelain factory with a first series of figurines under the name "Fantasy Collection." Love, the family, childhood and circus magic are the main sources of inspiration for these playful figurines that border on kitsch, reminiscent of Jeff Koon. *The Family Portrait* 540 revisits a universal subject often broached by Lladró, that of family harmony in the intimacy of the home. The group presents a contemporary family surrounded by various objects, including several miniatures of products previously designed by Hayon: the *Josephine* lamp, with its metallic finish, for Metalarte, Camper shoes and a teddy bear from the "Qee" series for Toy2R. The realistic modelling of the scene is attributed to Marco Antonio Noguerón, a sculptor at Lladró. **DC**

CINDY SHERMAN

Photographer Cindy Sherman is known for her musings on society and its various modes of representation, especially female iconography and its stereotypes. Sherman's images combine staging, self-portrait and parody in a way that reveals the artifice used to portray women in painting, film, advertising and magazines. The artist herself assumes many different identities, altering her appearance by means of period costumes, heavy makeup and prostheses.

In 1989, when the New York firm Artes Magnus invited Sherman to design ceramic tableware, she made a series of porcelain vessels decorated with images of Madame de Pompadour (née Jeanne Antoinette Poisson, 1721–1764). This preoccupation with Louis XV's mistress was triggered both by the way the courtesan constructed her own identity and her keen interest in the fine and decorative arts. Fascinated by porcelain, the Marquise de Pompadour encouraged its development by giving her support to the founding of the royal porcelain manufactory at Sèvres, which went on to produce table services, large garden vases and countless figurines. The palette of colours generally employed—"Pompadour pink," royal blue, yellow, apple green and grass green— became characteristic of the Pompadour style.

Sherman designed the *Madame de Pompadour (née Poisson)* tea set and the *Madame de Pompadour (née Poisson)* dinner service 542 . Her soup tureen with stand is inspired by pieces commissioned from the Sèvres royal manufactory by Madame de Pompadour in 1756. Made at the former royal manufactory in Limoges, Sherman's tureen and its platter were produced in yellow, pink, royal blue and apple green, in a limited edition of twenty-five. The particular tone of royal blue used, known as "Sèvres blue," is said to have been the Marquise's favourite colour.

In creating this work, Sherman appropriated an historical form and decorated it with reinterpretations of the Rocaille style.[1] The cartouches, which bear parodic portraits of the marquise, were transferred onto the porcelain using a transfer-print process requiring up to sixteen photo-silkscreens; the pieces were then hand-painted and fired four times before being individually signed and numbered.

Inside the tureen is an imitation silver platter containing various types of fish with bulging eyes that serves as an ironic reminder of Madame de Pompadour's maiden name (*poisson*, the French word for fish). **DC**

1. Jorunn Veiteberg, "Loaded Manipulations," in *Object Factory: The Art of Industrial Ceramics*, exh. cat. (Toronto: Gardiner Museum, 2008), p. 49, ill. 91; Sarah D. Coffin et al., *Rococo: The Continuing Curve, 1730–2008* (New York: Cooper-Hewitt, National Design Museum, 2008), p. 232.

542

Cindy Sherman
Born in Glen Ridge,
New Jersey, in 1954
***Madame de Pompadour
(née Poisson)***
Soup Tureen and Stand
1990
Porcelain, photo-silkscreen
transfer decoration
(cartouche), and painted
decoration, 12 B /25
Tureen and stand:
29.3 x 56.5 x 37.2 cm
Made by the Ancienne
Manufacture Royale de
Limoges for Artes Magnus,
New York

Stamped on underside
of tureen and stand,
and inside cover:
*Madame de Pompadour /
Née Poisson (1721-1764) / by /
CINDY SHERMAN / for /
ARTES / MAGNUS / 12 B 25 /
Ciy Sh / Silkscreened and /
handpainted at / ancienne
manufacture / ROYALE /
fondée en / 1737 /
LIMOGES FRANCE*
Liliane and David M. Stewart
Collection
2009.3.1-3

(detail, inside tureen)

BLUE
AND WHITE

— DIANE CHARBONNEAU —

Delftware's blue decoration on a white ground has been part of the collective imagination since the seventeenth century, although it is easy to forget its place of origin. It immediately evokes a particular type of production consisting of plates and tiles **543** ornamenting walls, and designs that have become so familiar, like seascapes, urban or rural landscapes, and floral patterns—sometimes a profusion of flowers. However, the windmill motif remains the most emblematic, having inspired artists since the seventeenth century. Several contemporary creators have appropriated this imagery, their approaches serving as unique reflections on Delftware's pictorial and material qualities, as well as on how it is regarded.

Belgian artist Wim Delvoye is known for the caustic irony of his works and the universal reach of their social commentary. He revisits the devices of kitsch and the ready-made, without becoming dogmatic, and works with association and collage, confronting the symbols, uses, practices and techniques from cultural worlds that are often incompatible or outdated. He commandeers the banal, the decorative, the handmade, and leads us to question their status, but also conventional taste. Since the late 1980s, Delvoye has been salvaging steel gas canisters from the Gandagas company[1]—which he paints with red figures on a black ground similar to the vessels of ancient Greece—or those from the Butagaz[2] company, decorated according to the pictorial tradition of Dutch tin-glazed earthenware, with its blue pattern on white ground. *Butagaz Shell 53 No. G38526* **547**[3] is a gas canister decorated with three windmills in rocaille cartouches. Here, populist function and elitist ornamentation collide, the rocaille style having been associated with an aristocracy that, under Louis XV, became fickle and libertine despite knowing it was in its death throes.

The art-glass maker Richard Meitner, originally from the United States, has chosen blown glass as a means of expression. The surprising poetry and ambiguity of his objects make us reflect on the images evoked, forcing us to reconsider their meaning. *Delft Blue Fin* **545** attests to the artist's fertile imagination while paying tribute to his adopted country. Meitner takes his inspiration from the ship in a bottle, the ultimate decorative object, making a pastiche of the blue monochrome decoration. Here, a fish is suspended for all eternity in a milky-toned, borosilicate glass bottle, recalling the legacy of Netherlanders as great sailors, at once great whale hunters and herring fishermen. The fish itself bears a blue and white decoration: a flowery basket, a windmill and floral motifs. The bottle's neck is also decorated with floral motifs, as well as Chinese-style, flowery or stylized reserves and the geometric patterns ornamenting the rims of plates.

Dutch designer Kiki van Eijk favours artisanal know-how, allusions to the past and natural materials. Her objects might suggest lightheartedness, but appearances can be deceiving. Van Eijk takes her inspiration from the traditional tile with painted decoration for a furniture set comprising a chaise longue and six stools grouped under the title *Modern Dutch Tile*. Each unique piece is decorated with a contemporary iconographic scheme. The Museum's stool **546** has a square maple base topped by a pillow covered in a wool fabric with flock-printed blue motifs on white ground.[4] At first glance, the central decorative medallion seems to harken to the past of another time, but it is actually quite current, the picturesque windmill having been replaced by a nuclear reactor. The motif at the corners could be purely decorative, but they become disturbing once we make out two semi-automatic pistols, the Nike and McDonald logos, a mosque and a B-2 stealth bomber dropping its load. These same motifs reappear on the bogus tiles placed side by side along the four sides of the cushion.

Since its founding in Stockholm in 2003, the Front collective[5] has been rethinking the creation of products and furniture starting from innovative concepts and modes of production that make use of animals as well as new technologies. The object's emotional potential is also an essential aspect of their approach. Front members were interested in the relationship between an old object and its contemporary incarnation when they created the *Blow Away* vase **544**. They looked to a traditional form of eighteenth-century Delftware, a baluster vase with cut-off corners. With the help of a graphic designer, Luxembourger Hervé Steff from the Insideko agency, the vase was digitized, then deformed by a simulated gust of wind. Several three-dimensional prototypes were completed before the definitive configuration was found. This was modelled and painted by hand by craftsmen from the Royal Delft factory for Moooi. Two alternating cartouches decorate the body of the vase: an urban view and a landscape with a bridge and a span of water. Two reserves with stylized floral motifs adorn the base of the body, and a sawtooth pattern decorates the edges of the neck and foot. The various blue shades accentuate the unique shape of the piece.

1. A Belgian gas company based in Ghent.
2. French distributor of gas by the bottle and the tank since 1931.
3. The word "Shell" in the title is a reminder of the fact that the company belonged to the Shell group at the time the artist was creating the work.
4. Flock printing is the application of cotton, nylon or synthetic fibres (flock) to a tacky surface cut according to the desired pattern. This printing technique in a single colour on a fabric is often employed for sportswear and equipment, such as shirts or bags. It is ideal for small series and customized production.
5. The founding members of the group are Sofia Lagerkvist, Charlotte von der Lancken, Anna Lindgren and Katja Sävström.

543

HOLLAND
Tile
1780–1820
Tin-glazed earthenware
13.7 x 13.1 cm
Gift of Major J. D. Morgan
1918.Dp.7

544

Front
Founded in Stockholm
in 2003
***Blow Away* Vase**
2008
Porcelain, hand-painted
blue decoration
30.5 x 32 x 26 cm
Made by Royal Delft, Delft,
for Moooi, Breda, Netherlands
Stamped in ink on underside:
moooi & Royal / Delft / -1653-
[crowned] / *Design by front*
Liliane and David M. Stewart
Collection, gift in honour
of the Montreal Museum of
Fine Arts' 150th anniversary
2011.104

545

Richard Meitner
Born in Philadelphia,
Pennsylvania, in 1949
Delft Blue Fin
1997
Blown borosilicate glass,
enamel
H. 73.7 cm; Diam. 13 cm
Signature and date, engraved
on underside: *R. Meitner 97*
Gift, Anna and Joe Mendel
Collection
2007.148

546

Kiki van Eijk
Born in Tegelen,
Netherlands, in 1978
***Modern Dutch Tile* Stool**
2004 (example of 2005)
Maple, wool,
flock-printed base, 6/6
48 x 41 x 41 cm
In ink on underside: 6;
label inside stool: *Title:*
modern dutch tile stool /
year : 2004 / designer:
kiki van eijk, nl / edition:
collectors item /
signature: Kik! '05
Purchase, the Museum
Campaign 1988–1993 Fund
2009.1

547

Wim Delvoye
Born in Wervik,
Belgium, in 1965
Butagaz Shell 53
No. G38526
1989
Enamel paint on gas canister
H. 56 cm; Diam. 30 cm
In felt pen on underside:
BUTAGAZ / 53 SHELL /
N° G.38526 / WDelvoye
Purchase, the Museum
Campaign 1988–1993 Fund
2010.100

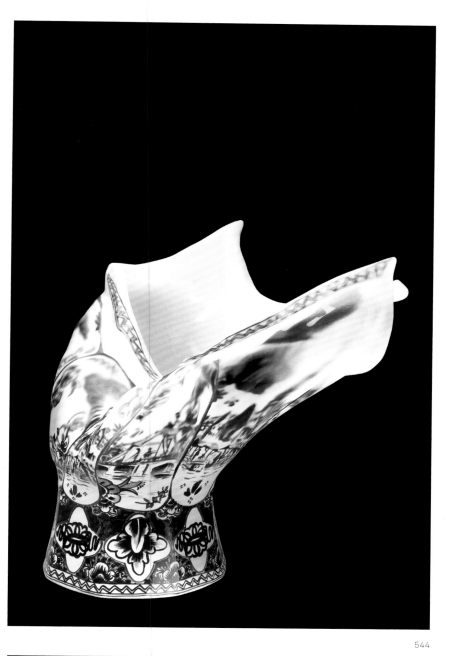

544

545

546

547

CERAMICS . . . ALMOST

— DIANE CHARBONNEAU, VALÉRIE CÔTÉ —

ETTORE SOTTSASS AND MICHELE DE LUCCHI

Generally speaking, ceramics is understood as the art of making objects out of earthenware, a practice that goes back to the Paleolithic age. Yet marble and other, decorative stones (like travertine) have also been quarried and made part of the history of art objects and furniture since the times of ancient Greece. Italian architects and designers Ettore Sottsass and Michele De Lucchi make use of such noble and luxurious materials and, meeting the challenges posed by colour, decoration and form, treat them in the spirit of the radical group Memphis 552 553 . They capitalize on Italian artisanal know-how while also reintegrating these materials in contemporary furniture design. Related to both earth and rock, concrete (a mix of cement, sand, gravel and water) was used as a building material by the ancient Romans, yet it was Modernist architects like Le Corbusier who lent it noble stature. Today, the concrete aesthetic—an unornamented spare style—has been inducted into the field of design in the form of countertops, fireplaces, and even radiators 548 and pieces of furniture 549 - 551 . DC

JORIS LAARMAN

Dutch designer Joris Laarman attended the prestigious Design Academy Eindhoven, where his prototype of the modular radiator *Heatwave* 548 earned him his degree in 2003 and international renown. Originally named *Reinventing Functionality*, this model would go on to be produced in a limited series in collaboration with Droog and Jaga.

Fascinated by the technological properties of the radiator, Laarman audaciously blends ornamentation and functionality. *Heatwave* revises the traditional form of the heating device, imbuing it with a noble air. Its curvilinear pattern, inspired by the acanthus leaf often associated with the Rococo, has a whimsicality that has been attracting the notice of contemporary creators. The radiator is made of polyconcrete (a blend of minerals and synthetic minerals), and the water circulates in a flexible stainless-steel pipe that hugs the curves. Offered in several sizes and two colours (slate grey and matte black), it attaches to the wall like a work of art instead of being relegated to the floor or underneath the windows. Its branching structure facilitates the distribution of heat, and its decorative shape denotes a particular taste for design.

Starting in 2003, Joris Laarman opened his studio, concentrating on architecture and product design and adopting an approach that is at once conceptual and poetic. He has attracted attention once again with a collection of chairs replicating the complexity and proportions of a skeleton. The rocking chair *Bone Rocker* 549 is the fourth chair in the "Bone" series—a cross between technology, science and design. Its design is based on an algorithm that translates the principles guiding the growth of the human skeleton or the branches of a tree into the shape of an object.[1]

The *Bone Rocker* comprises a series of limbs of varying sizes that ensures optimal resistance and better weight distribution, while eliminating surplus materials. It is made of a combination of crushed black Mazy marble and resin that was poured into a mould made of 170 elements produced by rapid prototyping. The assembly of the mould, the pouring, the drying and the polishing (more than 300 hours) were spread out over several weeks in Laarman's studio, which produced the rocking chair in a limited edition of twelve copies and three artist proofs. DC and VC

1. The algorithm developed by German scientist Claus Matthek was adopted by the automotive company Opel, in order to increase the resistance of car components while saving on materials.

KONSTANTIN GRCIC

German designer Konstantin Grcic basically works for industry. Between 2003 and 2008, at the invitation of Magis, an Italian firm specializing in plastic furniture, Grcic explored the properties of cast aluminum in the "Family_One" series—a bench, four chairs, a stool and two tables—whose success led the manufacturer to use new materials and develop new product lines. *Chair_One* is the result of three years of research, from the first sketches to the prototypes. The seat's structure suggests a soccer ball: the angled assembly of multiple flat planes (hollow, in this case) creates a three-dimensional form.[1] The second chair 550

in the series, designed in 2004, differs in its cone-shaped concrete base coated in a transparent, colourless varnish for outdoor use. The source of its unique character is the contrast between the heaviness of the base and the visual lightness of the seat. Emblematic of the designer's work and an instant icon, the chair combines geometric simplicity with industrial materials, making it highly ergonomic.[2] The chair comes in fixed and pivoting versions, and in several colours (white, metallic anthracite grey, black and red), as well as in polished aluminum. DC

1. *Chair_One/Chair/Magis/2004*, http://konstantin-grcic.com/ (accessed February 27, 2012). 2. The chair has won the following awards: Award for Good Design, Chicago Athenaeum (2004); Premio Oderzo Azienda e Design (2005); and the Silver Design Award from the Federal Republic of Germany (2006).

ÉTIENNE HOTTE

According to Quebec designer Étienne Hotte, choosing concrete for a chair conveys an express interest in exploiting mineral matter subject to the laws of nature, as opposed to plastic or steel, materials subject to industrial constraints in the case of furniture production.[1]

Designed in 2008 and produced in a limited edition, his *Alban* chair 551 [2] represents years of formal research.[3] Its monolithic shape, sharp edges and curved lines lend the piece a certain elegance both indoors and out. It is available in both lightweight and natural concrete—with a variety of treatments, coatings and bases (hollow or solid)—in "found" wood or composite materials. The Museum chair produced in untreated, porous concrete with a hollow base, weighing about 60 kilograms, represents the essence of the designer's minimalist approach tinged with poetry: "Weight abandoned / From bygone days / Maybe a chair . . . Peaceful artifact / Resting among the foliage / Beneath the trees / It will survive us / Witness to love."[4] DC

1. Correspondence with the designer, November 16, 2011. 2. The title is derived from the contraction of "L'banc (le banc)." Correspondence with the designer, November 24, 2011. 3. The chair won the Grands prix du design (Quebec) Residential Furniture Award in 2011. 4. Correspondence with the designer, November 24, 2011.

548

Joris Laarman
Born in Borculo,
Netherlands, in 1979
Heatwave **Radiator**
2003
Polyconcrete
100 x 200 x 6.5 cm (approx.)
Produced by Jaga,
Diepenbeek, Belgium
Purchase, the Montreal
Museum of Fine Arts'
Employee Fund and
Galerie Arte Montréal Fund
2010.41.1-5

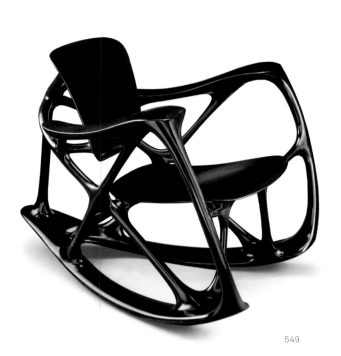
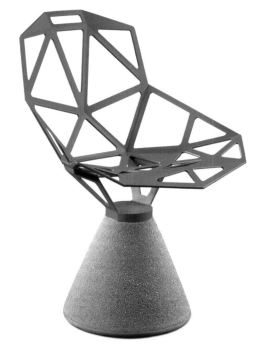
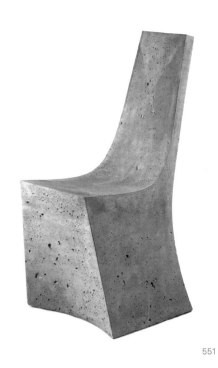

549

550

551

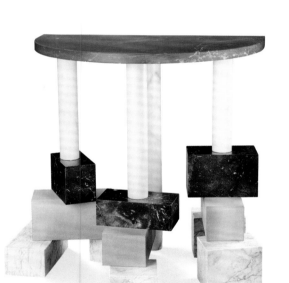

552

553

549

Joris Laarman
Born in Borculo,
Netherlands, in 1979
Bone Rocker
From the series "Bone"
2008
Cast marble resin, 10/12
68 x 88 x 92 cm (approx.)
Signature, stamped under
seat: *Joris Laarman 10/12*
Purchase,
Edith Low-Beer Bequest
2010.96

550

Konstantin Grcic
Born in Munich in 1965
Chair_One **Chair**
From the series
"Family_One"
2004 (example of 2011)
Die-cast aluminum treated
with fluorinated titanium,
painted in polyester powder,
concrete base
82 x 55 x 59 cm
Produced by Magis,
Torre Di Mosto, Italy
Purchase, Cecil and
Marguerite Buller Fund
2011.37.1-2

551

Étienne Hotte
Born in Buckingham,
Quebec, in 1972
Alban **Chair**
2008 (example of 2012)
Concrete
94 x 41 x 50 cm
Produced by Objet Béton,
Montreal
Purchase, George R.
MacLaren Fund
725.2011

552

Ettore Sottsass
Innsbruck, Austria, 1917 –
Milan 2007
Coming back from an
Apartment in West Berlin
Console
1987
Marble, stone
95.3 x 95.3 x 74.3 cm
Produced by Ultima Edizione,
Massa, Italy, for Blum Helman
Gallery, New York
Liliane and David M.
Stewart Collection,
gift of Jean Boucher
D94.320.1a-m

553

Michele De Lucchi
Born in Ferrara in 1951
Coffee Table
About 1982
Mortar, Serena stone, marble,
travertine
40 x 100 x 100 cm
Produced by Up & Up, Massa,
Italy
Gift of Joseph Menosky in
memory of his wife, Diane, and
of Shiva and Shelby, in honour
of the Montreal Museum of
Fine Arts' 150th anniversary
2010.79.1-5

PAPER

noun & adjective [ORIGIN Anglo-Norman *papir*, Old French & mod. French *papier* from Latin *papyrus* **PAPYRUS**] **A** *noun* **1** ■ Material in the form of thin flexible (freq. white) sheets made from the pulp of wood or other fibrous matter which is dried, pressed, bleached, etc.

■■■ Appearing in China in the second century A.D., paper would become the traditional support of artistic creation in the West. Painters and sculptors would draw on paper the preparatory studies and sketches for their finished works. Associated at the end of the fourteenth century first with engraving, then with print publishing, paper facilitated the distribution of art reproductions and ornamental design. In the nineteenth century, it became a decorative element in its own right in the form of wallpaper, but also in objects and furniture, with papier-mâché sometimes replacing wood. In the late nineteenth century, thanks to the new printing processes, it combined illustration and typography in poster art. ■■■ During the twentieth century, paper remained integral to the creative process in decorative arts. A number of domestic and industrial applications were also found—including packaging, clothing, jewellery, furniture-making and architecture. Its plastic properties even made it a new material for sculpture. ■■■ Paper is made from cellulose vegetable fibres such as bamboo, wood, hemp, flax and blackberry shrub. Supple and lightweight, it is nevertheless strong and lends itself to a variety of treatments: it can be coloured, printed or laminated; it can be glued, sewn, creased, crumpled, folded, cut (these days, with the help of a computer); it can be transformed into corrugated board or a cardboard tube. Recyclable and biodegradable, paper reconciles ecological concerns with economic benefits. It possesses a wide range of qualities, textures and colours that have been exploited by many artists and designers, particularly the Japanese. Their preferred aesthetic is minimalist, based on the creative potential of a low-cost and often underestimated material, and their creations attest to the important role paper has played in contemporary design. DC

PAPIER-MÂCHÉ FURNITURE

— YASMIN ELSHAFEI —

True "papier-mâché," made from pulped paper pressed into dies, was used in the Orient from roughly the second century A.D. onwards. Beginning in the late eighteenth century, however, the French term for the process was adopted by numerous English craftsmen to market "chewed paper" or "paper wares" fashioned from large sheets of paper pasted and layered in stages, then moulded over wood or metal frames to obtain the desired forms. Most often lacquered, in imitation of Oriental lacquerware, these objects were also known as japanned wares and, although initially billed as affordable and durable alternatives to goods made entirely of wood, their early appeal seemed to lie in Europe's increasing interest in the exotic.

The two most recognized firms amongst countless English papier-mâché manufacturers and dealers were Clay and Company (1770–1860)—working in Birmingham and, after 1802, in London—and Jennens and Bettridge (1816–about 1864)—from Birmingham. These manufacturers built their reputations on commissions from royalty and the nobility, at home and abroad. Queen Charlotte, wife of George III, owned a japanned papier-mâché and wood sedan chair, along with a set of console tables, all made by Henry Clay.[1] In the 1840s, the Queen of Spain ordered a dressing case from Jennens and Bettridge, affirming international interest in goods from Birmingham.[2]

Until the late 1840s, the majority of papier-mâché items available to the public remained small in scale. Larger furnishings such as this elegant lacquered and gilded papier-mâché and wood balloon-back chair **556** were still relatively uncommon, although its ornamentation conformed to the period's aesthetic. In a London journal dated May 1849, the writer praises Jennens and Bettridge's "superb bouquet of flowers, the high lights [sic] of which are produced by the brilliant reflexions [sic] of the mother-of-pearl, inlaid by a species of haphazard process in the japanning of the surface."[3] As the century progressed, manufacturers were often criticized for their overly wrought mother-of-pearl decoration on every manner of object. The Museum's chair, however, strikes a fine balance between this ornamentation and its black lacquer surfaces.

By the 1850s, papier-mâché furnishings were at the height of fashion. Tea trays and snuff boxes became virtually ubiquitous, while newer items such as candlesticks and breadbaskets were introduced. Larger items—fire screens, dressing tables, chairs and sofas—also appeared, as exemplified by the numerous objects displayed at the Great Exhibition of 1851 in London. The Museum's sewing table **555** is a good example of the lacquered and gilded papier-mâché items available at the time. Its mother-of-pearl inlay and brass detailing suggest a Near Eastern aesthetic, and attest to the growing range of exotic motifs then in vogue.

By the early twentieth century, papier-mâché furniture had declined in quality and had lost its popular appeal in the face of less elaborate modern designs.

1. Shirley Spaulding DeVoe, *English Papier Mâché of the Georgian and Victorian Periods* (Middletown, Connecticut: Wesleyan University, 1971), p. 41.
2. "Miscellaneous," *Journal of Design and Manufactures*, vol. 1, no. 4 (June 1849), p. 119.
3. Ibid., vol. 1, no. 3 (May 1849), p. 87.

554

ENGLAND
Portable Escritoire
About 1840–50
Papier-mâché,
mother-of-pearl
11.4 x 38.1 x 29.2 cm
Stamped on inside lock fitting:
crowned *VR* and *patent*
Gift of Grace B. Norris Estate
1964.Df.14

555

ENGLAND
Sewing Table
About 1840
Lacquered and gilded
papier-mâché and wood,
mother-of-pearl inlay, brass
H. 83.5 cm; Diam. 40 cm
Gift of Grace B. Norris Estate
1964.Df.12a-b

556

LONDON OR
BIRMINGHAM
Chair
About 1840
Lacquered and gilded
papier-mâché and wood,
mother-of-pearl inlay, caning
83.5 x 42.9 x 49.2 cm
Stamped on back of
underframe, front:
*MAKERS TO THE QUEEN /
LONDON, BIRM / T.R.*,
and on each back leg, top: *T.R.*
Gift of Grace B. Norris Estate
1964.Df.13

555

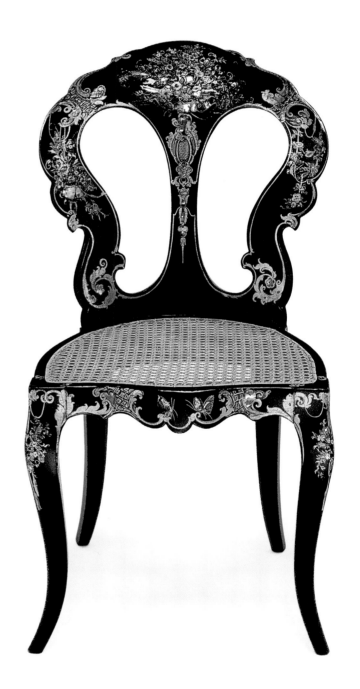

556

STUDIES AND PREPARATORY DRAWINGS

— ROSALIND PEPALL —

GEORGES DE FEURE

The wallpaper design *The Swans* **557** was created about 1897–98, when Georges de Feure had already gained a reputation as a graphic artist and illustrator in Paris.[1] Born of a Dutch father and a Belgian mother, De Feure spent periods of his youth in both Holland and Belgium. In 1889, he finally settled in Paris, where he associated with artists and writers of the Symbolist movement and exhibited alongside such artists as Carlos Schwabe, Eugène Grasset, Toulouse-Lautrec and Alphonse Mucha. A frequent subject in many of De Feure's works during this period was the image of the female, depicted in characteristic Symbolist mood as mysterious, malevolent or sexually evocative.[2]

Inspired by the English Arts and Crafts philosophy that the artist be involved in every aspect of the arts, De Feure turned his attention to designing furniture, wallpaper, textiles, stained glass and ceramics, in addition to his painting. The horizontal composition of this gouache study suggests that it was designed as a wall frieze. Stylized flat forms with well-defined silhouettes could be read easily from a distance and were most appropriate for wallpaper design. The use of a decorative frieze treatment, either in stencilling or in wallpaper, was especially characteristic of English Arts and Crafts architects and designers such as Walter Crane, M. H. Baillie Scott and Charles F. Voysey.

The two-dimensional forms with bold outlines of *The Swans* also demonstrate the influence of Japanese woodblock prints, which were greatly admired in France at that time. Typical of De Feure's work are the large, stylized flowers

arranged prominently across the foreground, serving as a framework through which one views the background scene. Swans occur frequently in Symbolist imagery at the turn of the century, and their elegant forms with curving necks were especially well-suited to the Art Nouveau style. The predominance of nature in De Feure's compositions, and the organic, curvilinear treatment of line link his work with Art Nouveau design, which was prevalent among the French exhibits at the Paris Exposition Universelle in 1900. At this fair, De Feure painted exterior murals for Paris dealer Siegfried Bing's L'Art Nouveau pavilion and designed furniture, wall coverings and porcelain for Bing's display of room interiors.[3]

The combination of stylistic influences in this wallpaper study makes it an excellent example of the multiple tendencies in decorative design at the end of the nineteenth century, not only in France but throughout Europe. **RP**

1. This design was illustrated under an erroneous name in *L'Art Décoratif*, no. 11 (August 1899), p. 185, but has been attributed to De Feure (Correspondence from Ian Millman, Paris, July 22, 2002, to R. Pepall, MMFA Archives). 2. See Ian Millman, *Georges de Feure, maître du symbolisme et de l'Art nouveau* (Paris: ACR Édition, 1992). 3. Gabriel P. Weisberg, Edwin Becker and Évelyne Possémé, eds., *The Origins of L'Art Nouveau: The Bing Empire*, exh. cat. (Amsterdam: Van Gogh Museum, 2004), pp. 205–221.

NATACHA (ANNE) CARLU

In the late 1920s, the T. Eaton Company of Toronto was one of Canada's largest department-store chains. Wishing to appeal to a cosmopolitan

clientele, Eaton's promoted the latest Parisian Art Deco style of interior furnishings, and, in 1930, hired the French architect Jacques Carlu (1890–1976) to design a restaurant and an auditorium for its College Street store in Toronto, and a large dining room for the ninth floor of its Montreal store on Saint Catherine Street.[1]

Trained in architecture at the École des Beaux-arts de Paris, Carlu taught at the Massachusetts Institute of Technology in Cambridge, commuting from Paris, in the years 1924 to 1932.[2] He introduced French decorative design to America through the interiors he created for the Ritz-Carlton hotel in Boston and Stewart's department store on Fifth Avenue in New York. For Eaton's in Montreal, he created a restaurant (fig. 1) for six hundred diners that was inspired by the main dining room of the French luxury ocean liner of 1927, the *Île-de-France*. The Montreal restaurant was about forty metres long with a central dining hall lit from above by a row of windows. Beige and pink fabric covered the walls, and pink and grey marble pilasters supported the clerestory level. Other furnishings included impressive alabaster, urn-shaped lamps and bas-reliefs by French sculptor Denis Gelin. Each end of the room featured an imposing mural by Jacques Carlu's wife, Natacha (also known as Anne), a self-trained artist who collaborated with her husband on a number of projects.[3]

This gouache **558** is a colour study for Natacha Carlu's mural entitled *Pleasures of the Hunt*, which depicts a scene of women riding

557

Attributed to
Georges de Feure
Paris 1868 – Paris 1943
The Swans
Study for wallpaper
About 1897–98
Gouache
47.2 x 79.2 cm
Purchase, Marguerite Fiset
Barrière Bequest and
the Museum Campaign
1988-1993 Fund
2002.11

horses in a setting of forests and lakes, deer and birds. The subject, the stylized, two-dimensional treatment of the figures, the shallow perspective, and the forms arranged in succession, one above the other, are all characteristic features of French decorative paintings of the period by artists such as Jean Dupas or Gustave Jalmes. Painted in tones of silver-grey, pink and green, the mural was "in perfect harmony with the interior treatment of the room," noted the reviewer from the *Journal* of the Royal Architectural Institute of Canada.[4] The Carlu study for the mural documents a central element in the decoration of one of Canada's most impressive Art Deco interiors. **RP**

1. Isabelle Gournay, "Jacques Carlu et le style paquebot outre-atlantique," *Monuments Historiques*, no. 130 (December 1983), pp. 71–74. The restaurant has been closed since 1999, but the interior and its furnishings have been given heritage status by the Quebec government. **2.** Carlu is best known for the Palais de Chaillot (with architects L. H. Boileau and L. Azéma), built at the time of the 1937 Paris Exposition Internationale des Arts et Techniques dans la Vie Moderne, and later for the former NATO headquarters building in Paris, 1955–59. **3.** Among Natacha Carlu's most notable commissions was the theatre curtain at the Palais de Chaillot, 1936–37. She was also responsible for the murals in Eaton's Toronto restaurant. **4.** "The New Restaurant in the T. Eaton Company Building, Montreal," *The Journal, RAIC* (May 1931), p. 186.

558

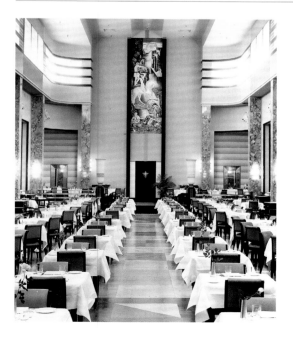

Fig. 1
Ninth-floor restaurant at Eaton's department store, Montreal, designed by Jacques Carlu, about 1931.

558

Natacha (Anne) Carlu
France, 1895–1972
Study for *Pleasures of the Hunt*, Mural Panel in the Dining Room of Eaton's, Montreal
About 1930
Gouache, coloured pencil underdrawing, traces of graphite
57.2 x 24.3 cm
Signed and handwritten in ink on left edge, bottom: *Natacha CARLU - / Dining room - T. EATON. / Montreal.- Canada*
Purchase, grant from the Government of Canada under the terms of the Cultural Property Export and Import Act, and Société Générale / Fimat Fund
2006.19

559

560

561

OSKAR EHRENZWEIG

In an age of computer-generated designs, the patterns by Viennese fabric designer Oskar Ehrenzweig are wonders of meticulously hand-rendered designs for clothing fabrics. They were destined for commercial production, as Ehrenzweig worked for textile manufacturing firms in Germany, Austria and England throughout his career.

From 1921 to 1925, he studied in his native Vienna at the Höhere Gewerbeschule an der Bundeslehranstalt für Textilindustrie (a federal school for the textile industry).[1] After working for various firms,[2] in 1932 Ehrenzweig became chief designer for Stern & Loewenstein, the leading shirt manufacturer in Bocholt, Westphalia, one of the centres of the German textile industry. He continued to provide designs for this firm, which became Kersten and Sohn, even after he moved to London in 1938 and right up until his retirement

in 1965. In England, Ehrenzweig supplied shirt designs to Manchester cotton manufacturers such as Ashton Brothers and Haslams.

The eight gouache studies 559 - 561 in the Museum's collection are undated. Some of these hand-painted patterns may have been created as part of Ehrenzweig's training in Vienna, where he would have been aware of the textile designs produced by the Wiener Werkstätte, which was at the centre of modern Viennese decorative design in the first two decades of the twentieth century.[3] By the late 1920s, Wiener Werkstätte textile designs featured geometric abstraction inspired by the progressive movements in non-figurative painting of the period.

Ehrenzweig's studies for textile patterns show a dense repetition of motifs, bold contrasts of colour and juxtapositions of form. In a number of patterns, the radial motifs derived from

machine shapes and the interlocking rectangles punctuated by small circles recall designs by Wiener Werkstätte artists.[4] Later patterns have free-floating motifs on a uniform ground in a limited palette of no more than three colours. These studies reveal the range of Ehrenzweig's visual imagination in creating designs for fabrics that reflect so well the modern period of European textile design. **RP**

1. Biographical details of Ehrenzweig's life are taken from family papers, Montreal. A record book of his designs as a student is in London's Victoria and Albert Museum collection. 2. These firms included the Czech silk manufacturer Herzfel & Fischl, Hermann Pollack's Söhne in Vienna, and Charles Mieg & Cie in Mulhouse, France. 3. See Angela Völker, *Textiles of the Wiener Werkstätte: 1910–1932* (London: Thames and Hudson, 1994). 4. For example, Camille Birke or Clara Posnanski (Ibid., pp. 117, 131, 189).

559

Oskar H. Ehrenzweig
Vienna 1906 – London 1988

Textile Design
1920s
Ink, gouache on paper
22.8 x 17.4 cm
Gift of John Lucas
2007.277

560

Textile Design
1920s–30s
Gouache, graphite on paper
17.6 x 12.6 cm
Gift of John Lucas
2007.283

561

Textile Design
1930s–40s
Gouache, graphite on paper
21.2 x 15.2 cm
Gift of John Lucas
2007.280

562

563

564

565

566

567

PETER TODD MITCHELL

The Museum's collection of over eighty drawings for wallpaper and textile designs by American designer Peter Todd Mitchell 562 - 567 offers a wide range of motifs that reflect the period of the 1950s, when bold wallpaper was fashionable and fun. Trained as a painter at the Yale University School of Art and at the Academia de Bellas Artes in Mexico City, Mitchell spent much of his career in Paris and Spain, or simply travelling. He supplemented his income in the early 1950s by providing wallpaper and textile designs for major American manufacturers such as Katzenbach and Warren or Scalamandre in New York. In addition to the gouache drawings for wallpaper, measuring about thirty by forty centimetres, the Museum has a few textile samples, some scarves, as well as fashion drawings by Mitchell.[1]

Many of the designs represent abstract, fragmented shapes or constellations floating in space. Other designs are bound by geometry, and still others have rhythmic lines that evoke visual sound waves. These bold, playful patterns suited the informal style of American houses in the 1950s and the trend for using two complementary or contrasting wallpaper motifs in the same room.

Other Mitchell designs are more closely related to his years in Paris, where he settled in 1947, and circulated in the theatre and fashion world of Jean Cocteau and the Neo-Romantic painters.[2] These wallpaper designs feature baroque *trompe-l'oeil* motifs, classical swags and figures, or fantasy landscapes that look like Surrealist theatre sets with odd juxtapositions of architectural elements and broken fragments of pottery. Reviewers who saw his paintings exhibited in the Carstairs Gallery or the Griffin Gallery in New York in the 1950s commented on the theatrical quality of his paintings,[3]

or as one writer put it, his compositions had "a Renaissance feeling for drama."[4] RP

1. Lenore Newman and Jan L. Spak, "Flights of Fantasy," in *Designed for Delight: Alternative Aspects of Twentieth-century Decorative Arts*, ed. Martin Eidelberg (Montreal: Montreal Museum of Decorative Arts; Paris: Flammarion, 1997), pp. 250–251. 2. Martin Eidelberg, ed., *Design 1935–1965: What Modern Was* (Montreal: Musée des arts décoratifs de Montréal; New York: Harry N. Abrams, 1991), pp. 276–277, 387. 3. "Reviews and Previews," *Art News*, vol. 54, no. 9 (January 1956), p. 56. 4. "Reviews and Previews," *Art News*, vol. 65, no. 9 (January 1967), p. 16.

562

Peter Todd Mitchell
New York 1924 –
Barcelona 1988

Wallpaper or Textile Design
About 1950–60
Gouache on paper
37.6 x 29 cm
Liliane and David M. Stewart
Collection, gift of
Priscilla Cunningham
D89.112.20

563

Wallpaper or Textile Design
About 1950–60
Gouache on paper
45.3 x 30 cm
Liliane and David M. Stewart
Collection, gift of
Priscilla Cunningham
D89.111.2

564

Wallpaper or Textile Design
About 1950–60
Gouache on paper
15.2 x 32.8 cm
Liliane and David M. Stewart
Collection, gift of
Priscilla Cunningham
D89.112.6

565

Wallpaper or Textile Design
About 1950–60
Gouache on paper
15.3 x 19 cm
Liliane and David M. Stewart
Collection, gift of
Priscilla Cunningham
D89.112.4

566

Wallpaper or Textile Design
About 1950–60
Gouache on paper
32 x 45 cm
Liliane and David M. Stewart
Collection, gift of
Priscilla Cunningham
D89.112.31

567

Wallpaper or Textile Design
About 1950–60
Gouache on paper
12.1 x 11.6 cm
Liliane and David M. Stewart
Collection, gift of
Priscilla Cunningham
D89.144.10

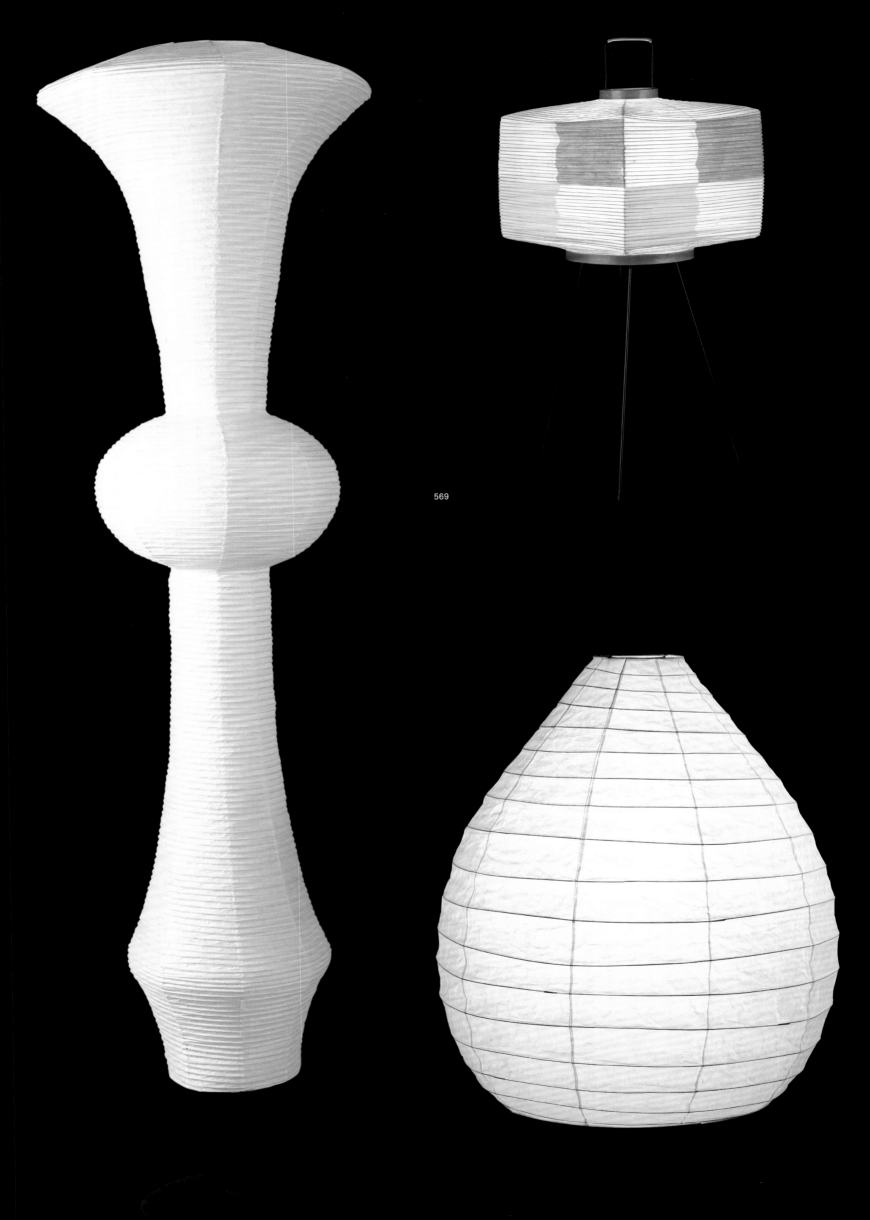

568

569

570

ISAMU NOGUCHI'S
AKARI LAMPS

— MATTHEW KIRSCH —

An iconic entry in twentieth-century modernism, Isamu Noguchi's *Akari* light sculptures effectively obscure the distinction between fine and functional art, reflecting a decidedly Eastern perspective that utilitarian crafts, from vases to bamboo seats, could be appreciated on their own terms as art objects. Noguchi adapted the traditional Japanese collapsible paper lantern, or *chōchin*, with a modernist vocabulary. His designs negotiated a new identity for an object that had been reduced to a largely decorative role in its original culture by the time he created his first versions in 1951, introducing a form of affordable and ephemeral sculpture that served the purpose in everyday life of being, in his words, "elegant people's art."[1]

The son of renowned Japanese poet Yonejiro Noguchi and American writer Leonie Gilmour, Isamu Noguchi was already a reputable international artist when he arrived in the town of Gifu in the spring of 1951 to view a night of cormorant fishing in the Nagara River, illuminated by paper lanterns and braziers mounted on each boat to lure fish to the surface. Once Japan's leading producer of lanterns, Gifu had already begun to lose its dominance due to the widespread production of cheap lanterns in Japan and abroad before suffering the devastation of World War II. During Noguchi's visit, the mayor of Gifu appealed to him to help revitalize the town's lantern industry—the artist responded later that same night with two designs. After establishing contact and planning prototypes with Ozeki and Company, a manufacturer that had produced *chōchin* for generations, Noguchi's first *Akari* light went into production in 1952.

Noguchi found an ally in Isamu Kenmochi, whom he had met on a previous tour of Japan in 1950. Kenmochi was an industrial designer who had already formulated his belief that by rejecting exoticism and assimilating traditional materials and techniques into new modern forms, Japanese cultural identity could be revitalized. Taking advantage of both Gifu's bamboo spiral ribbing and the locally produced, high-quality *washi*, a handcrafted paper renowned for its strength and pliability, Noguchi was able to achieve a variety of complex forms. He sensibly substituted electric lights for the candles used in traditional lanterns, thus modernizing the lantern and reinventing it as a practical item rather than a largely ceremonial object.

The term "Akari" was chosen by Noguchi to mean "light as illumination" and to connote a sense of weightlessness suggestive of his view of lanterns as delicate sculptural presences. When he introduced *Akari* at an exhibition held by the Museum of Modern Art in Kamakura in 1952,

Noguchi displayed them alongside the abstract sculptural ceramics he had produced while in Japan, signalling his lifelong disregard for any easy categorization of his creative output.

Noguchi designed countless shapes, sizes and permutations of *Akari*, and the variability of their form and installation over the years echoed the spatial and conceptual concerns he explored in his metal and stone sculpture. Early versions, such as model 7A **569**, retained the wood rim, or *wa*, of traditional *chōchin* and incorporated polychromatic designs on the ribbed paper surface. By adding colour and script, Noguchi was responding to a Japanese cultural association of white lamps with death and veneration. Standing bases varied from simple poles to slender armatures that accentuated the floating quality characterizing table variations, like the asymmetrical model 23N **570**. Likewise, for ambitious columnar shades, such as model E **568**, he briefly experimented with fluorescent tubes to resolve the problem of hot spots resulting from multiple incandescent light bulbs.

Noguchi's interest in illuminated sculptures had begun as early as the 1930s, when he envisioned a sound-making sculpture, *Musical Weathervane*, that was to glow when played. He later returned to the idea with his "lunar" sculptures of the early 1940s, which incorporated light elements into playful biomorphic constructions made from industrial magnesite. His 1951 visit to Gifu had followed an extensive tour of public spaces throughout Europe, Asia and the Far East as part of a Bollingen Foundation Grant awarded in 1949 for a proposed book on the "environment of leisure." In visiting spaces and monuments of a distinctly civic, pre-industrial nature, his abiding belief in a socially constructive exchange and interaction between art and public was reinforced. With *Akari*, he found a vehicle that expressed his own cross-cultural inheritance as a Japanese-American and embraced his intention "to bring sculpture into a more direct involvement with the common experience of living."[2] This ambitious logic, which drew criticism that occasionally compromised Noguchi's reputation as an artist, endured in the form of over one hundred *Akari* variations over thirty-five years, earning him international acclaim.

1. John Christensen, "In an Artist's Light," *Sunday Star—Bulletin and Advertiser* (Honolulu), October 1, 1978, p. C-12.
2. Isamu Noguchi, *A Sculptor's World* (New York: Harper and Row, 1968), p. 159.

568

Isamu Noguchi
Los Angeles 1904 –
New York 1988

Akari **Floor Lamp
(Stand model E)
1962**
Shade (model H)
About 1954
Mulberry-bark paper,
bamboo, cast iron, steel
191 x 57.7 x 57.7 cm
Produced by Ozeki,
Gifu, Japan
Mark on underside
of stand: *JAPAN*
Liliane and David M. Stewart
Collection
D86.245.1a–b

569

Akari **Table Lamp
(model 7A)
About 1951**
Mulberry-bark paper,
bamboo, iron, steel, wood
69 x 40 x 40 cm
Produced by Ozeki,
Gifu, Japan
Maker's mark on underside of
shade: [circle and crescent]
Liliane and David M. Stewart
Collection, gift of
Dr. Huguette Rémy
by exchange
D91.341.1a–e

570

Akari **Floor Lamp (model 23N)
About 1968 (example of 1995)**
Mulberry-bark paper,
bamboo, iron, steel
H. 118.5 cm; Diam. 83 cm
Produced by Ozeki,
Gifu, Japan
Maker's mark: [circle and
crescent] / *JAPAN*, and
facsimile signature on
underside of shade: *I. Noguchi*
Liliane and David M. Stewart
Collection
D95.188.1a–e

FURNITURE AND PAPER

— DIANE CHARBONNEAU, DAVID A. HANKS, ROSALIND PEPALL —

571

PIERO FORNASETTI AND GIO PONTI

The Italian designer Piero Fornasetti was a master at superimposing printed motifs onto three-dimensional forms, whether a porcelain plate, an umbrella stand or a piece of furniture. He delighted in covering everyday objects, or even room interiors, with designs that he applied as lithographic prints **571**. Drawing ideas from many sources, Fornasetti's inspiration was rooted in the Italian traditions of mural painting, *trompe l'oeil* decoration and classical architectural drawing. He was also attracted to the work of Surrealist artists like Giorgio de Chirico, Max Ernst and René Magritte, who transformed banal objects into enigmatic, often humorous, forms.

A high point of Fornasetti's career was his collaboration with the Italian architect Gio Ponti in the early 1950s. Together, they carried out furniture designs and commissions for interior decoration.[1] The form of this *Architecture* secretary **572** was designed by Ponti in the spare lines of mid-twentieth-century Italian modernism. Fornasetti, with his skill as a draftsman, eye for fantasy, and sense of graphic design, transformed the piece into a witty celebration of *trompe l'oeil* by covering the secretary with prints after his own drawings, using black and white for optimal effect. Like a theatre set, the doors open out—revealing glass shelves on either side of a central niche for a sculpture—and the front leaf drops down to display grand illusionistic spaces of classical Italian architecture. **RP**

1. For the range of Fornasetti's work, see Patrick Mauriès, *Fornasetti: Designer of Dreams* (London: Thames and Hudson, 1991).

571

Piero Fornasetti
Milan 1913 – Milan 1988
***Maggia Domestica* Screen**
About 1952
Lithographs mounted on wood panels, brass-plated steel, steel, rubber
212 x 800 x 3 cm
Produced by
Piero Fornasetti, Milan
Handwritten in ink on label on terminal edge:
[P]*ARAVENTO 2 x 2 /*
[DU]*OMO SOMMERSO /*
[D]*ETRO: /* [obliterated letters]
GIA DOMESTICA
Liliane and David M. Stewart Collection
D89.178.1

572

Gio Ponti
Milan 1891 – Milan 1979
Piero Fornasetti
Milan 1913 – Milan 1988
***Architecture* Secretary**
1950
Lithographs mounted on board, painted wood, sheet metal, glass, brass, felt, neon
218 x 80 x 40.5 cm
Produced by Piero Fornasetti, 1951–97, and Immaginazione, from 1989, Milan
Round label inside first drawer: [hand holding a paintbrush] /
FORNASETTI / MILANO
Liliane and David M. Stewart Collection, gift of Senator Alan A. Macnaughton, Sr.
D97.172.1a-k

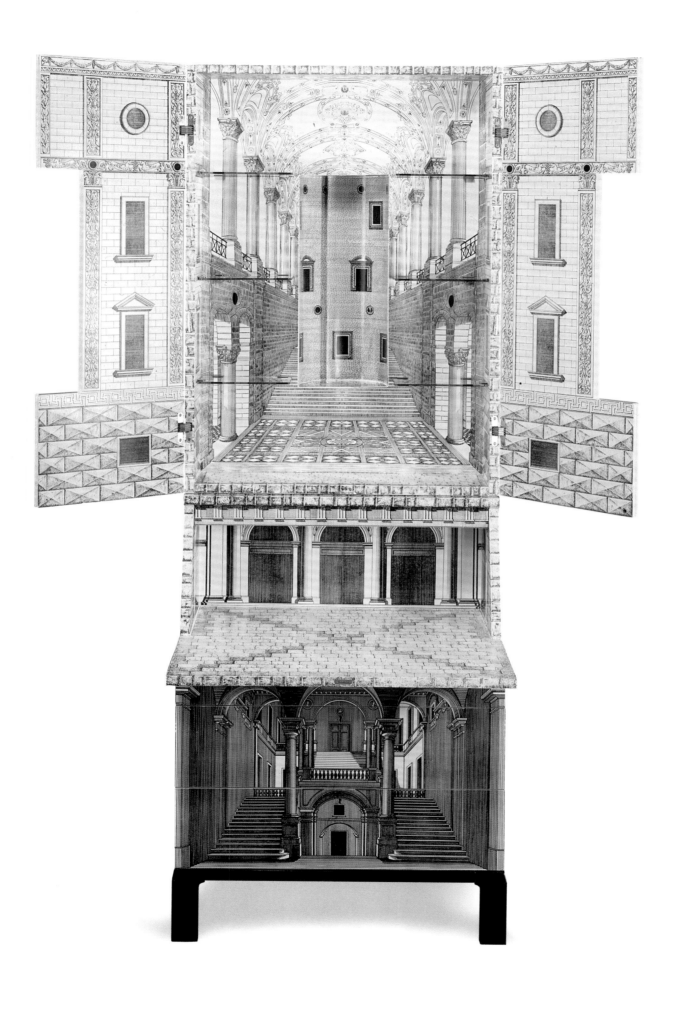

574

574

MATHIAS BENGTSSON

The young Danish designer Mathias Bengtsson is enthusiastic about technology and the virtual world, especially about the ability of both to generate innovative ways of living and working. He is also interested in their influence on the production of new objects and original environments. The *Vertical Sliced* chair **573**, designed in 2001 and produced in a limited edition of twenty, demonstrates Bengtsson's interest in innovation, in this case by employing a production process usually associated with heavy industry. The shape of each chair is first designed by hand and then digitized. The digital pattern is used to determine the laser cut of each sheet of corrugated cardboard. Each of the resulting 388 three-millimetre-thick layers is finally assembled and affixed together. The strata in the finished chair calls to mind eroded rock.

The *Vertical Sliced* chair recalls the equally sculptural furniture designed by Frank Gehry in the 1970s, several examples of which are housed in the Museum. However, Bengtsson moves away from the rectilinear shapes of Gehry's "Easy Edges" **575** series as well as the rough shapes of his "Experimental Edges" **574**, to arrive at an elegant and brilliantly designed chair, a state-of-the-art object. **DC**

FRANK O. GEHRY

Frank Gehry's "Easy Edges" series of 1970 was not the first furniture mass-produced in cardboard, nor was the material's eco-friendliness foremost in the designer's mind, although 1970 saw the first Earth Day. Rather, Gehry was making disposable chairs for window displays when "someone from Bloomingdale's saw them and suggested I develop them."[1] Over three months, he and his studio assistants made the designs durable—and variously amusing—using layers of die-cut cardboard glued into strong, lightweight forms, inspired by contoured architectural models composed of stacked cardboard. "Architecture takes so long to make," Gehry said, but furniture design was "instant gratification."[2] The seventeen "Easy Edges" furniture designs, introduced in 1972, were a commercial success. The sales catalogue for the series, in contrast to the luxurious presentations of most contemporary designs, was a simple paper fold-out. The publicity surrounding the series was not altogether positive from Gehry's perspective: "I was not then well known as an architect, yet there I was talking furniture sales with [retail consultant] Marvin Traub. That was not how I wanted to be seen, so I stopped."[3]

In 1979, with growing international recognition for his architecture, Gehry felt confident enough to return to furniture, creating a series called "Experimental Edges." Whereas the first series was linear and relatively smooth-surfaced, the second series was irregular, comparable to Gehry's architectural forms, and shaggy.

In both series, Gehry transformed the humble material into unexpectedly sturdy and comfortable seating and also modified conventional chair forms with Pop-inflected humour: the *Wiggle* chair **575** of the "Easy Edges" series resembles ribbon candy, and *Little Beaver* **574**, of the "Experimental Edges" series, recalls the ballooning forms of 1930s overstuffed easy chairs with hassocks. Gehry explored cardboard as a common industrial material, like the corrugated steel and chain-link fencing of his early, edgy architecture.

"Experimental Edges," designed between 1979 and 1982, was not put into commercial production until 1986. Although Gehry hoped to produce low-cost furniture for this line as he had for "Easy Edges," the manufacturing process made this impossible, and the chairs were expensive, like other "art furniture" by contemporary architects. Today, Gehry continues to explore the

573

Mathias Bengtsson
Born in Copenhagen in 1971
Vertical Sliced **Chair**
2001
Corrugated cardboard, 1/20
83.5 x 95 x 70 cm
In pencil on lower left side:
163B, and on lower right: *388*
Liliane and David M. Stewart
Collection
2003.279

574

Frank Gehry
Born in Toronto in 1929
Little Beaver **Armchair**
and Ottoman
From the series
"Experimental Edges"
1979
Corrugated cardboard, 33/100
Armchair: 86.3 x 85.6 x 104.1 cm
Ottoman: 43.2 x 49.5 x 55.9 cm
Produced by New City
Editions, Venice, California
Signed in pinprick, on the
armchair: *Gehry / Joel Silver*
Inscribed in ink on label,
on underside of armchair:
LIL / BEAV / 33 / 100
Liliane and David M. Stewart
Collection, by exchange
D92.132.1a-b

575

Frank O. Gehry
Born in Toronto in 1929
Wiggle **Chair**
From the series "Easy Edges"
1970
Corrugated cardboard
83 x 38 x 61 cm
Produced by Stitch Pack Co.,
Toronto
Liliane and David M. Stewart
Collection, Gift of
Luc d'Iberville-Moreau
D92.213.1

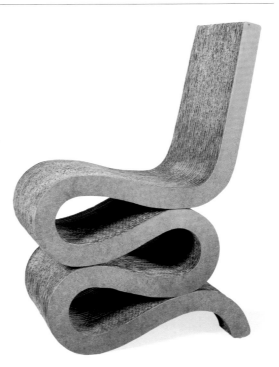

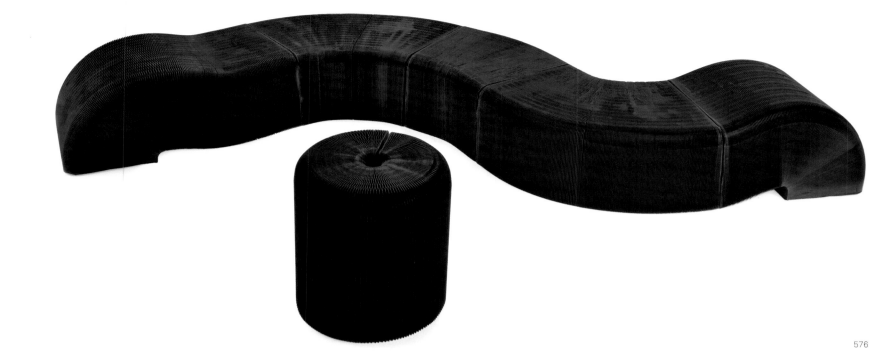

forms and ideas of his evolving architecture in furniture and other decorative arts, but these early designs remain landmarks in their humour and metamorphosis. **DAH**

1. Frank Gehry, interview with David A. Hanks, May 24, 1991, cited in *Frank Gehry: New Bentwood Furniture Designs*, exh. cat. (Montreal: Montreal Museum of Decorative Arts, 1992), p. 42. 2. Ibid. 3. Ibid.

MOLO DESIGN

Since 1994, the collaboration of Canadian architects Stephanie Forsythe and Todd MacAllen has extended beyond architecture to encompass product design. Their practice is informed by a taste for experimentation, a respect for materials—with a preference for glass and paper—and the importance assigned to manufacturing procedures. Inspired by their productive working relationship, Forsythe and MacAllen co-founded the Molo Design studio with Robert Pasut in 2003. The studio designs, manufactures and distributes its own products to clients throughout Canada and around the world.

The furniture designed by Forsythe and MacAllen unifies simplicity and intimacy while keeping in mind the configuration of the space.

Although their *Softseating* from the "Soft"[1] series is not far removed from architects' and designers' research over the last forty years into the intrinsic qualities of cardboard and paper (lightness and resistance), they also address new preoccupations by embracing the principles of ecodesign. Made of honeycomb kraft paper in a natural, unbleached, earthy brown or dyed a bamboo charcoal black, *Softseating* **576** pieces are a hundred percent recyclable.[2] They are also modular, permitting multiple permutations (serpentine bench, stool and coffee table) depending on the user's space, needs or imagination. The small magnets at the ends of each module allow them to be connected according to a selected configuration. These pieces are the ultimate tactile objects: the patina resulting from use only increases their value.[3] **DC**

1. The "Soft" series includes the *Softwall* screens, *Softseating* pieces and *Softlight* lights. It was originally conceived for an architectural project, *Softrooms*, presented in 2003 at Design beyond East and West Housing, in Korea, where it earned the Golden Prize. Forsythe and MacAllen then developed *Softwall* and *Softseating*, which they presented at the International Furniture Fair in New York in 2006. 2. In addition to kraft paper, *Softseating* also comes in white polyethylene (Tyvek), and is available in a wide range of sizes. Tyvek, which is a hundred percent recyclable,

resembles paper and is commonly used in the construction industry. It is light, permeable and UV resistant. 3. *Softseating* was made available to visitors to the galleries of the exhibition *Expanding Horizons: Painting and Photography of American and Canadian Landscape 1860–1918*, at the Montreal Museum of Fine Arts in 2009.

ANDREA BRANZI

Branzi's *Wireless* **577** is a combination of shelving, lighting unit and room divider, yet its appearance is less functional than poetic and sculptural. Eleven open compartments provide settings for freeform lamps, each different and covered with crushed handmade rice paper. The light glows from within these forms without any external wiring: the lamps are powered by rechargeable batteries concealed in the central compartment at the base. Without concern for access to electrical outlets, the unit is mounted on casters so it can be moved easily. *Wireless*, Branzi explained, is an object that corresponds "to a condition of existence in which we all live today: a condition where the 'ties' of the old knowledge systems are breaking, where the 'wires' of the old ideologies have disappeared."[1] **DAH**

1. Andrea Branzi, quoted in François Burkhardt and Cristina Morozi, *Andrea Branzi* (Paris: Dis Voir, 1996), p. 77.

576

Molo Design
Stephanie Forsythe
Born in Kentville,
Nova Scotia, in 1970
Todd MacAllen
Born in Vancouver in 1966
Softseating
Stool and Bench
From the series "Soft"
2003 (example of 2010)
Dimpled cardboard,
fabric, magnets
Various dimensions
Produced by Molo Design,
Vancouver
Embossed mark on
each piece: *MOLO*
Gift of the designers,
Stephanie Forsythe and
Todd MacAllen
2010.99.1-7

Paper is a traditional material in Japanese interiors. For example, *shoji*—screens used to divide spaces (sliding panels, partitions, folding screens)—are made from *washi* paper. Shigeru Ban carries on this tradition by using cardboard (in the form of tubes) as the basic material in the buildings he designs. He first employed the cardboard tube in 1986, when he worked on the exhibition design for a show on Alvar Aalto at the Alexis gallery in Tokyo. He incorporated it again in 1989 in a small pavilion he worked on for a local exhibition held in Nagoya. It was in 1995, however, that he gained renown for his disaster-relief projects, including the paper log houses and the Takatori Catholic church,[1] built following the Kobe earthquake, as well as the temporary shelters in Rwanda. His most recent projects include the information and press centre at the 2006 Singapore Biennale, and, following the 2008 Sichuan earthquake in China, three temporary classroom buildings for Hualin elementary school in Chengdu.

In 1998, Ban designed a furniture series called "Carta" (paper) **580 581** for Cappellini, applying the different uses for cardboard tubes he had explored in his building projects. He is an advocate for minimalist designs that essentially exploit the intrinsic qualities of the materials he employs. His lines are spare, the only pattern in his unadorned pieces resulting from the undulating forms produced by the tubes. Both light and resilient, his pieces are also affordable and environmentally friendly, as the material is easily recyclable.

Tokujin Yoshioka's various creations illustrate his keen interest in invention, his desire to charm and his exacting approach. He gained distinction for interior designs and commercial installations that alter spatial perceptions—striking and intelligent settings worthy of his masters, Shiro Kuramata and Issey Miyake. Yoshioka also tried his hand at furniture design, outdoing himself with every piece. His first work, which garnered international attention, was the *Honey-pop* armchair **578** made of honeycomb paper resembling the accordion-folded paper used in Chinese lanterns. The result of skilful cutting and folding, this limited-edition chair is distributed by the Yoshioka studio. Cut out of a roll of honeycomb paper and carefully opened out, each chair is ultimately imprinted by the weight of the first person to sit on it, retaining the shape ever after.

Brilliant design and environmental sensitivity characterize the *Cabbage* chair **579** designed by Oki Sato, of the Nendo agency.[2] Invited by Issey Miyake to participate in the 2008 exhibition *XXIst Century Man* in Tokyo, Sato was to create furniture made from paper waste used in the clothing of the brand Pleats Please. The chair consists of a roll of pleated paper that, once cut, peels open like cabbage leaves, hence its name. **DC**

1. The paper church was disassembled in 2005, after ten years of service to its community, and sent to a Catholic congregation in Taiwan affected by an earthquake some years before. **2.** The design agency Nendo, founded in Tokyo in 2002, promotes multidisciplinary work, graphic arts and the design of interior furnishings.

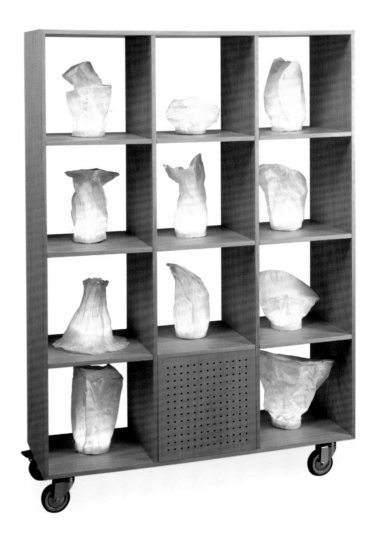

577

577

Andrea Branzi
Born in Florence in 1938
Wireless Light Bookshelf
1996
Walnut, rice paper, metal,
5/20
137.2 x 95.2 x 29.8 cm
Produced by Design
Gallery Milano
Signed, dated and numbered,
on central panel, bottom left:
ANDREA BRANZI 1996 5/20
Liliane and David M. Stewart
Collection
D97.100.1a-m

578

Tokujin Yoshioka
Born on the island of Kyushu,
Japan, in 1967
Honey-pop Armchair
2000 (example of 2002)
Dimpled paper
81.5 x 70.5 x 76 cm
Produced by Tokujin Yoshioka
Design, Tokyo
In graphite on the back:
13 sep 2002 Tokujin 049/300A,
and: *13 sep 2002 Tokujin
050/300A*
Liliane and David M. Stewart
Collection
2003.283

579

Oki Sato
Born in Canada in 1977
Cabbage Chair
2007
Paper, resin
71 x 74 x 67 cm
Produced by Nendo, Tokyo
Liliane and David M. Stewart
Collection, gift in honour
of the Montreal Museum of
Fine Arts' 150th anniversary
2011.108

580

Shigeru Ban
Born in Tokyo in 1957
Carta Bench
1998
Recycled cardboard tubes,
plywood
37 x 60 x 185 cm
Produced by Cappellini,
Arosio, Italy
Liliane and David M. Stewart
Collection, gift of
Cappellini S.p.A.
2001.44

581

Shigeru Ban
Born in Tokyo in 1957
Carta Folding Screen
1998
Recycled cardboard tubes,
fabric
180 x 247 x 4.5 cm
Produced by Cappellini,
Arosio, Italy
Liliane and David M. Stewart
Collection, gift of
Cappellini S.p.A.
2001.45

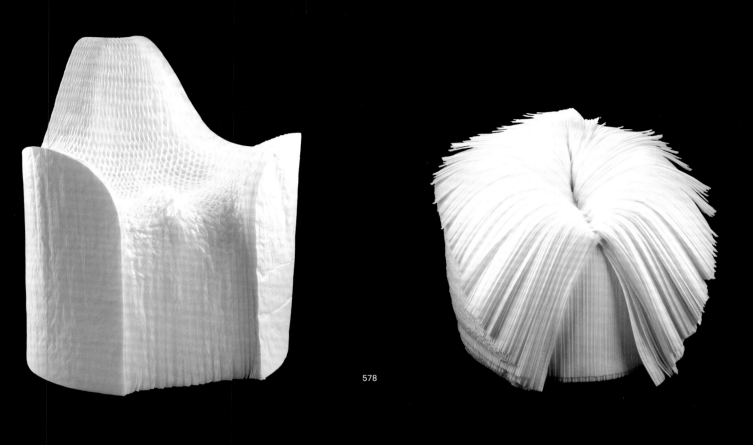

578

579

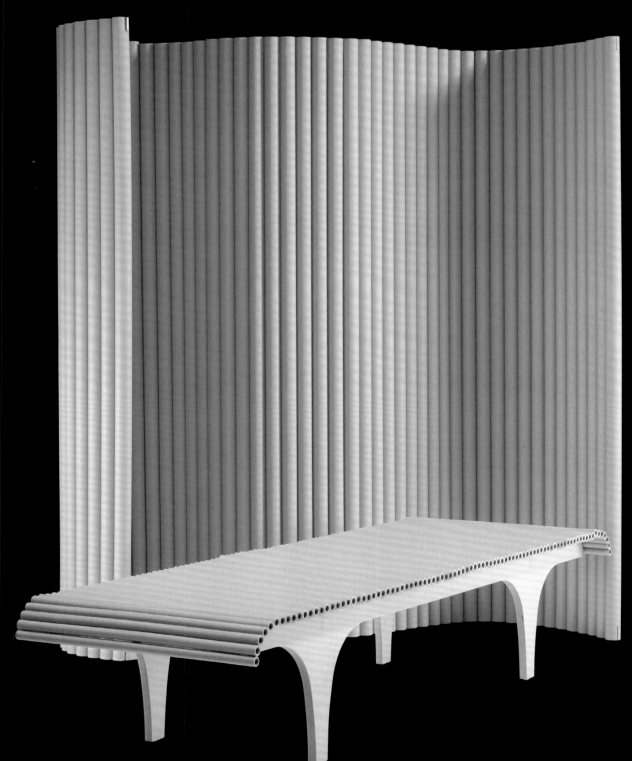

580, 581

THE POSTER: A NEW ART FORM

— NATHALIE BONDIL, FRANCE TRINQUE —

EUGÈNE GRASSET

A pioneer of Art Nouveau, Eugène Grasset devoted his creative energies to the industrial arts, adopting the motto of the Brussels-based artistic society Libre Esthétique, "Art in Everything," to create "a popular, humanistic and socially relevant art." Although William Morris and the Arts and Crafts Movement were influences, Grasset distanced himself from their artisanal approach, taking instead a modernist stance. Specialized in printmaking and illustration, he collaborated on a number of prestigious magazines in Europe and the United States, where he was particularly admired. With the rise of industrialization and an expanded middle-class, the poster became a new artistic genre, thanks to the invention of chromolithography in 1847 and larger and faster presses. By 1885, Grasset was recognized for his advertising, tourism and culture-related posters.

In America, the art poster was used by "quality" literary and art magazines, often associated with publishing houses. Grasset's work was often exhibited at the Grolier Club in New York, home to a famous circle of bibliophiles, beginning in 1890. Nicknamed the "French Walter Crane," his decorous, Pre-Raphaelite style appealed to a puritanical public. He influenced Art Nouveau, advertisers henceforth favouring aesthetic imagery over text 585.

The *Century Magazine* approached him for the promotion of the *Life of Napoleon Bonaparte* by William Milligan Sloane (1850–1928), an extended biography published as a series between 1894 and 1896: Americans were fascinated by the destiny of this self-made man. In 1893, Grasset received the commission for *The Sun of Austerlitz* 582, commemorating the famous victory of December 2, 1805. The emperor on his white steed, decked out in his grey corporal's riding coat and iconic bicorne hat, assumes a steadfast position on a promontory facing the powerful sun piercing the morning mist—or the smoke rising off the battlefield—an enemy's cannonball lying on the ground. Although the pose is in keeping with academic norms, the horse's wild mane invokes the Art Nouveau style. The stained-glass effect, characteristic of Grasset, who outlined his motifs in black, and (particularly in this case), the sun's

rays were a tremendous success, marking the birth of the so-called "art" poster.

Its popularity was so great that, in 1895, the publisher launched a still legendary competition, administered by Boussod, Valadon & Cie, for the next poster. Twenty-one illustrators submitted their proposals to a hand-picked jury; a minor poster-maker was chosen for the January 1896 issue. Could it have been the underwhelming reception of this somewhat overladen composition that led the magazine to approach Grasset once more for the poster of June 1896? Equally effective and admired, although less sensational than his first, Grasset's second poster portrays the young *Napoleon in Egypt* 583 on the day of the Battle of the Pyramids, July 21, 1798, against the Mamluk cavalry, depicted in the distance. Napoleon's gesture towards the pyramids alludes to his historic speech: "Forward! Remember that from those monuments yonder forty centuries look down upon you." Long overlooked in France, these two memorable posters would go on to have a lasting influence on commercial art in America. **NB**

HENRI DE TOULOUSE-LAUTREC

In 1891, Toulouse-Lautrec designed the Moulin-Rouge poster that earned him widespread recognition in commercial illustration. His output, which spanned nine years, until 1900, confidently bears the mark of modernity while evoking *fin-de-siècle* Paris' dance halls and nightlife.

The very next year, Lautrec created the poster for Victor Joze (1861–1933) that would accompany the publication of the latter's novel *Reine de joie* [Queen of Joy]. In 1894, Joze commissioned a poster for a new novel, *Babylone d'Allemagne* [German Babylon] 584, which was reproduced for the book's cover. A satire of Berlin's middle class, the novel was roundly denounced by the German ambassador in Paris. Lautrec, however, had chosen a military theme—the subject of a chapter in the novel—in order to avoid reference to the Berliners' immoral and depraved lifestyles, as described by the author. Nevertheless, the allusion to the humiliations of the Franco-Prussian War of 1870–71 was perceived to be both a moral and a political affront, as well as a critique of Prussian

militarism, very nearly provoking a diplomatic incident. Although Lautrec, amid the controversy, had to assume the printing costs of the poster, he also managed to engage the public's interest. With its limited colour palette, some notes of yellow and red embellishing the overall monochrome green, this image caused a sensation: "demanding and holding the gaze, the original and powerful design found covering walls everywhere." **FT**

1. Théodore Duret, *Lautrec* (Paris: Bernheim-Jeune, 1920), p. 113.

582

583

584

VERDOUX, DUCOURTIOUX & HUILLARD, SC.

585

586

**Cassandre (Adolphe
Jean-Marie Mouron)**
Kharkiv, Ukraine, 1901 –
Paris, 1968
Italia
1935
Photolithograph
99 x 60.7 cm
Printed by ENIT for Officina
Grafica Coen, Milan
Monogram, upper right:
AMC; signed in ink,
lower right: *A.M.Cassandre*
Printer's mark, lower left:
ENIT [in a wreath], and
monogram, lower right: *SF*
Lower left: *OFF. GRAF. COEN &
C. – MILANO*, and lower right:
PRINTED IN ITALY BY THE ENIT
Liliane and David M. Stewart
Collection
D87.171.1

POSTERS: THE MODERN ERA, POLAND AND CUBA

— ALAIN WEILL —

A few iconic works from the turn of the twentieth century preface the Museum's collection of about six hundred posters, which, for the most part, covers the second half of the twentieth century: these include *Babylone d'Allemagne* [German Babylon] 584 by Toulouse-Lautrec, the poster for Grafton gallery, London, by Eugène Grasset 585, father of Art Nouveau, and *Italia* 586 by Cassandre, the most influential graphic artist of the Art Deco period. Amassed through gifts and purchases, the collection represents a well-chosen selection of works from the modernist repertoire, extending from the very beginnings of the pre-war era to the 1970s, as well as an exceptional body of Polish and Cuban poster work.

The modern poster, born of prevailing influences like the Bauhaus, incorporated photography, which henceforth replaced hand-drawn designs and rigorously arranged lettering. With the rise of Nazism forcing avant-garde artists to emigrate, the art of poster design went on to flourish in the United States and Switzerland.

Graphic artists were initially recruited for the war effort: *Give 'em Both Barrels* by Jean Carlu 587, *He's Watching You* 589 by Glenn Grohe and the photomontages by Leo Lionni in *Keep 'em Rolling!* 588. They were later called upon by the leading advertisers: Herbert Bayer (for Thomas Carlyle) 594, Erik Nitsche (for General Dynamics) 593 and Massimo Vignelli (for Knoll) 597. Paul Rand was one of the first great artistic directors to be born on American soil (he worked for New York Subways Advertising Company and, most notably, IBM) 602.

Switzerland was dominated by two exacting schools that explored constructivist theories in graphics under two leaders: in Zurich, Josef Müller-Brockmann (responsible for the iconic *Proteggete i bambini!* 591), and in Basel, Armin Hofmann (the Museum houses a dazzling series by him 596). They used photography extensively but not exclusively. Walter Ballmer went to Italy and designed for Olivetti 595. The use of the photographic travel poster, pioneered by Herbert Matter before the war 590, was creatively expanded in the series by Schulthes et Frei for Swissair.

France remained more traditional and closer to the visual arts: Air France turned to the painter Georges Mathieu 592, while the visual gag predominates in Raymond Savignac's advertising poster. These were followed by Pop art, with posters by Roy Lichtenstein 601 for Leo Castelli. The Museum houses the rare collection of "Summer Picnic" 603 by Steve Frykholm for Herman Miller, as well as the psychedelic work of Peter Max 604. Germany is represented by Günther Kieser 600 and Heinz Edelmann 599.

Central to the Museum's poster collection are designs by the Polish and Cuban schools, which profoundly influenced the graphic arts of the past century.

The origins of both coincided with the rise to power of a Communist state, yet under radically different circumstances: Poland became—reluctantly, for the most part—a satellite of the U.S.S.R., while the Cuban people enthusiastically swept Fidel Castro into power. A wide gulf separated the two in terms of artistic creation. The "líder máximo" declared in 1977 that "imperialism is the enemy, not abstract art," while, in Poland, a counterculture reacting to state-backed Socialist Realism arose from within the specialized milieu of poster production. Indeed, the long tradition of graphic art in Poland—which Cuba had not enjoyed—turned out to be its saving grace, as were a few exceptional figures like Henryk Tomaszewski, who accepted an invitation from the state monopoly, Polskifilm, while refusing to design "American-style" posters. His was a response laden with meaning, considering that Socialist Realism did not deviate far from the narrative realism prevalent around the world at the time. Cuban and Polish poster artists truly overturned the established standards of poster design, with repercussions that reached far beyond their borders.

Resorting to the evocative, the symbolic, was the approach favoured by both groups, but obviously with radically different flavours, as seen in posters for the same films. Generally speaking, poster design in Poland was characterized by metaphor and romanticism, while Cuban works were more sensual and rather Pop.

Henryk Tomaszewski exerted a tremendous influence through his teaching. His minimalist style was emphatically revolutionary. The early 1950s saw the rise of new talents impossible to describe fully here. Jan Lenica, with his powerful graphics, worked for opera 605 and film before dedicating himself to animation. He left early on for France, as did Roman Cieslewicz, who moved from drawing 609 to photography and photomontage. Josef Mroszczak 607 disappeared from the scene prematurely, and Waldemar Swierzy specialized in music 610, namely jazz. Then came Jan Młodożeniec, with his colours and lightheartedness, and Franciszek Starowieyski 606 and Mieczyslaw Górowski 608, the figureheads of a fantasy-meets-surrealism tendency so characteristic of Polish posters.

In Cuba, ICAIC (the Cuban Film Institute, established in 1959) commissioned posters. The art form was starting from scratch because, until then, posters were, like films, imported from the United States, which explains the adoption of silkscreening, a simple and inexpensive printmaking technique. The Museum houses prints of three leading artists: René Azcuy, Félix Beltrán and Olivio Martínez.

Cuban and Polish posters alike were disseminated around the world, becoming cultural propaganda tools.

Yet Cuba clearly went further, as the country's leading artists were also engaged in the political arena, which was not the case in Poland, where the movie poster itself was anti-establishment.

Editora Política (for domestic production) and OSPAAAL (Organization for Solidarity of the People of Africa, Asia and Latin America, whose director, Alfredo Rostgaard, also designed posters) issued effigies of Che Guevara and lent support to anti-Capitalist revolts around the world.

The most original posters arising from this body of work are probably those destined for the domestic market, two extraordinary examples of which are illustrated here: *Clik* 612 by Beltrán, who, with one word, commented not only on electricity consumption but also on Cuba's oil dependency; and the magnificent series of ten designs for panels by Martínez that championed the campaign to harvest ten million tons of sugar 611. Only eight of these panels were even produced, because the campaign's goal was never met. For this series, Martínez borrowed from the Pop aesthetic, including the work of Robert Indiana, the "American painter of signs," who was known for his hard-edge compositions of words and numbers. In Martínez's series, there is "no real image, but play with the numbers, the layout and colour."[1] Both Beltrán and Martínez found original solutions to difficult problems with direct, eye-catching, immediately recognizable images exemplifying the power of visual communication.

The Museum's collection also has posters representative of Montreal's art scene. It goes without saying that the Museum would be the perfect guardian of such masterful works as the series created by Nelu Wolfensohn for the Institute of Design Montreal 598.

And so ends this overview of salient works in a collection so well rounded that it serves as an invaluable research resource.

1. Alain Weill, *The Poster: A Worldwide Survey and History* (Boston: G. K. Hall and Company, 1985, p. 344.

587

588

589

590

591

592

587

Jean Carlu
Bonnières, France, 1900 –
Nogent-sur-Marne,
France, 1997
Give 'em Both Barrels
1941
Offset halftone lithograph
73.3 x 101.7 cm
Printed by the U.S.
Government Printing Office,
Washington, D.C.
Signed, lower left:
JEAN / CARLU
Lower right: *DIVISION
OF INFORMATION* [eagle
and shield] / *OFFICE FOR
EMERGENCY MANAGEMENT
/ WASHINGTON, D.C.* / [star]
*U.S. GOVERNMENT PRINTING
OFFICE: 1941-0-430380*
Liliane and David M. Stewart
Collection, gift of the
American Friends of Canada
through the generosity of
Geoffrey N. Bradfield
D84.187.1

588

Leo Lionni
Amsterdam 1910 –
Rome 1999
Keep 'em Rolling!
1941
Offset halftone lithograph
Printed by the U.S.
Government Printing Office,
Washington, D.C.
102.6 x 76.6 cm
Signed and dated, right,
beneath flag: *Lionni '41*
Lower right: *DIVISION
OF INFORMATION* [eagle
and shield] / *OFFICE FOR
EMERGENCY MANAGEMENT /
WASHINGTON, D.C.*,
and lower left: [star]
*U.S. GOVERNMENT
PRINTING OFFICE: 1941*
Liliane and David M. Stewart
Collection
D85.157.1

589

Glenn Grohe
Chicago 1912 – Palo Alto,
California, 1956
He's Watching You
1942
Offset halftone lithograph
99.1 x 69.7 cm
Printed by the U.S.
Government Printing Office,
Washington, D.C.
Lower left: [eagle and
shield] / *DIVISION OF
INFORMATION / OFFICE FOR
EMERGENCY MANAGEMENT /
WASHINGTON, D.C.*,
and lower right: [star]
*U.S. GOVERNMENT PRINTING
OFFICE: 1942-0-455330*
Liliane and David M. Stewart
Collection
D87.109.1

590

Herbert Matter
Engelberg, Switzerland, 1907 –
Southampton, New York, 1984
*All Roads Lead to
Switzerland*
1935
Photogravure
101.3 x 64.1 cm
Produced by the Swiss
National Tourist Office
Signed, lower left:
herbert matter
Insignia, lower left:
[winged wheel] / *SNTO*
Lower left: *fretz*
Printed in Switzerland
Liliane and David M. Stewart
Collection
D87.147.1

591

Josef Müller-Brockmann
Rapperswil, Switzerland,
1914 – Zurich 1996
Photo: Ernst A. Heiniger
(1909-1993)
Proteggete i bambini !
[Keep Children Safe!]
1952–53
Offset halftone lithograph
127.9 x 90.2 cm
Printed by Lithographie &
Cartonnage, Zurich, for the
Automobile Club Svizzero
Signed, lower left: *Heiniger/
Müller-Brockmann*
Lower left:
*Druck: Lithographie &
Cartonnage AG. Zürich*
Liliane and David M. Stewart
Collection
D85.167.1

592

Georges Mathieu
Boulogne-sur-Mer, France
1921 – Boulogne-Billancourt,
France, 2012
Grande-Bretagne
1966
Photogravure
100 x 60.2 cm
Produced by Air France
Signed, lower left: *Mathieu*
Liliane and David M. Stewart
Collection, gift of Miljenko
and Lucia Horvat
D91.299.1

593

594

595

596

597

598

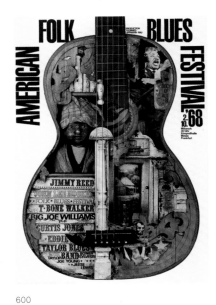

599

600

601

602

603

604

605

606

607

608

609

610

611

611

Olivio Martínez
Born in Santa Clara, Cuba,
in 1941
**Designs for Panels from
the Series "Vallas de la
zafra de los 10 millones"**
[Campaign of the Ten-
million-ton Cane Harvest]
1969–70, print 2002
a. *One Million*
b. *Two Down*
c. *Third*
d. *Four Already*
e. *Half Way There*
f. *Six*
g. *Seventh*
h. *Eight Down*
i. *One to Go*
j. *10! TEN. TEN. 10!*
Purchase, the Museum
Campaign 1988-1993 Fund
2008.18.1-10

10 silkscreens, 7/7,
artist's proofs
38.2 x 57 cm (approx.)
On each of the 10 designs:
blind stamp, upper left, and
inscribed in graphite beneath
image, centre: *Secuencia
de vallas de la zafra de los
10 millones*

Beneath image, lower right:
a. *Primer millón 23-12-69*
b. *Segundo millón 19-01-70*
c. *Tercer millón 11-03-70*
 [2 over 3]
d. *Cuarto millón 05-03-70*
e. *Quinto millón 26-03-70*
f. *Sexto millón 16-04-70*
g. *Séptimo millón 15-05-70*
h. *Octavo millón 11-06-70*
i. *Noveno millón ~*
j. *Décimo millón ~*

612

Félix Beltrán
Born in Havana in 1938
*Clik. Ahorro de
electricidad es
ahorro de petróleo*
[Click. Saving
Electricity Saves Oil]
1968
Silkscreen on cardboard
54.7 x 33.3 cm
Produced by Instituto
Cubano del Petróleo,
Havana
Gift in memory of
Vera J. Bala
2002.30

CLIK

AHORRO DE ELECTRICIDAD ES AHORRO DE PETROLEO

PAPER CLOTHES, JEWELLERY AND SCULPTURE

— DIANE CHARBONNEAU, CYNTHIA COOPER, TONI GREENBAUM —

WALTER LEFMANN AND RON DE VITO

While paper garments have been a novelty since the late nineteenth century,[1] the most high-impact paper clothing fad held sway from 1966 to 1968. Several popular culture phenomena of the moment converged in the widespread enthusiasm for paper dresses.

These very two-dimensional garments with minimal shaping and stitching were first manufactured by the Scott paper company in March 1966. A novel promotional product not intended to have any longevity on the fashion market, paper dresses were well received by a public imbued with a space-age optimism about new technology, and a penchant for futuristic projection. Their appeal lay in their expendability, and they were seen as harbingers of an era when fashion would require little outlay and could be discarded on a whim.

Paper dresses were manufactured from a thick non-woven textured paper, originally developed for disposable protective clothing, with a hand similar to several layers of paper-towelling. Their lack of fitting and slightly trapezoidal or "A-line" shape simplified the already pared-down aesthetic of 1960s dress design, and made them an ideal support for images and, by extension, Pop art and Op art graphics. For instance, one of graphic artist Harry Gordon's famous "poster" series of dresses famously featured a large blow-up of an eye.

Time magazine co-opted the medium of the paper dress as a promotional vehicle. The idea of two employees in *Time*'s promotions department, Walter Lefmann and Ron De Vito, the dress **613** was featured in the February 10, 1967, issue of the magazine, as well as in a photograph of all female staff in the business and promotions department wearing it in the company's internal newsletter,

FYI. A paper dress packaged in a red rectangular box was sent to all clients on the consumer promotions list.

The *Time* paper dress features the minimal construction typical of these garments, its only finishing element a seam binding around the neckline and armscyes. The oversized serialization of the magazine's name makes it a readily recognizable advertisement for a widely known publication, but also serves as an ironic commentary on the garment's temporality. The graphic design cleverly overlays Pop art's annexation of language with Op art's interplay of negative and positive space. This object captures a blurring of the lines between advertising, art, popular culture and fashion. **CC**

1. Paper collars and cuffs were commonly used in the clothing of lower-middle-class men because they could be easily and cheaply replaced when soiled.

ISSEY MIYAKE

Since the early 1970s, Issey Miyake has been at the forefront of an avant-garde fashion movement identified with Japanese designers. While their body of work is firmly entrenched within the Western fashion system, they have subverted its precepts by eschewing Western conceptions of the body, tailoring traditions and popular-culture design references. The collective creative vision of these designers is often attributed to their Japanese origins and worldview, a contested positioning. Arguably, more than any preoccupation with a national or regional identity, it is Miyake's explorations of the abstract properties of cloth and other materials that characterize his work. He is known for reinventing garment forms and their relationship to the body, and for blurring

boundaries between fashion design and conceptual art production, through radical experimentation and exhibitions in museums and galleries.

While Miyake has gained renown for his collections of pleated fabrics, which he began in the early 1990s, this jacket **614** stands out as an earlier example of his experimentation with materials. In 1982, Miyake first appropriated *kamiko*, handmade Japanese mulberry paper, to recontextualize it in a collection featuring shirts, jackets, skirts and pants. The visual impact of the paper is not unlike that of crushed cotton, although its less flowing and more rigid hand would become apparent on a body in movement. Unlike with earlier paper prototypes in Western fashion, here there are none of the construction shortcuts that a non-woven textile allows. The paper has been treated as fabric; flat-felled seams, double rows of topstitching on the pockets and welted edges speak to the irony of a couture ethos applied to a material with connotations of ephemerality. A complex cut, particularly in the shaping of the armscyes through an arrangement of gussets both over and under the sleeve, shows a more thoughtful conceptualization of the relationship of the garment to the body than might initially appear.

The novelty of the Japanese fashion movement was perhaps most celebrated in the 1980s, when this jacket was created. The relevance of *kamiko* within Miyake's production is confirmed by its inclusion in his "Permanente" line, launched in 1988, to feature his most representative pieces from the preceding decade. The same year, *kamiko* garments also appeared in Irving Penn's collection of photographs of Miyake's work.[1] **CC**

1. Nicholas Calloway, ed., *Issey Miyake: Photographs by Irving Penn* (New York: New York Graphic Society, 1988), pls. 13–14.

613

Walter Lefmann
Ron De Vito
Time Dress
1967
Ink on embossed paper
86.6 x 64.6 cm
Produced by *Time* magazine,
New York
Liliane and David M. Stewart
Collection, gift of the
American Friends of Canada
through the generosity of
Toni and Wesley Greenbaum
D94.176.1

614

Issey Miyake
Born in Hiroshima in 1938
Kamiko Jacket
1988
Mulberry paper
73 x 148.6 cm
Produced by Issey Miyake
Permanente, Tokyo
Woven label sewn inside
collar: *ISSEY MIYAKE /
PwRMANwNTw*
Liliane and David M. Stewart
Collection, gift of
Yvonne Brunhammer
D94.207.1

615

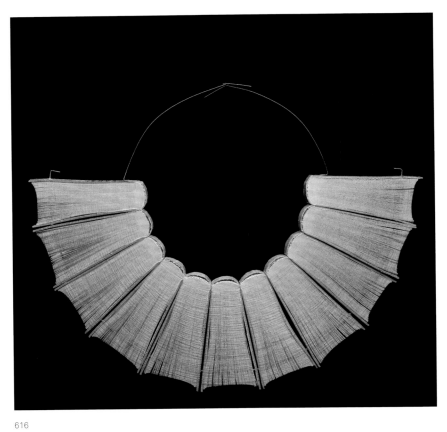

616

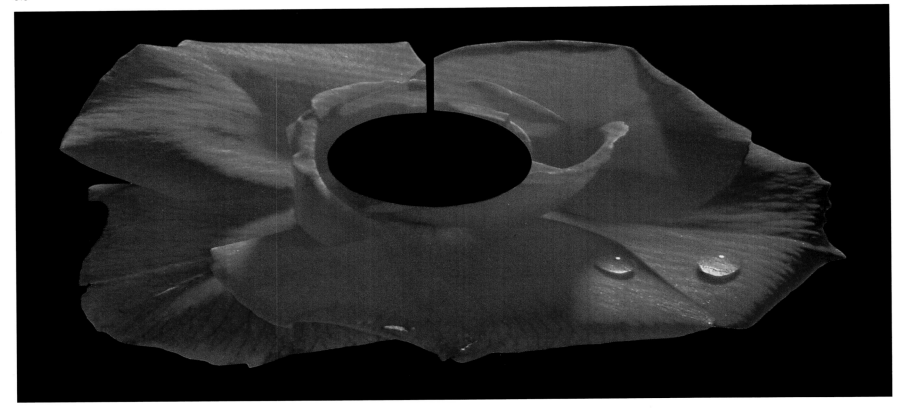

617

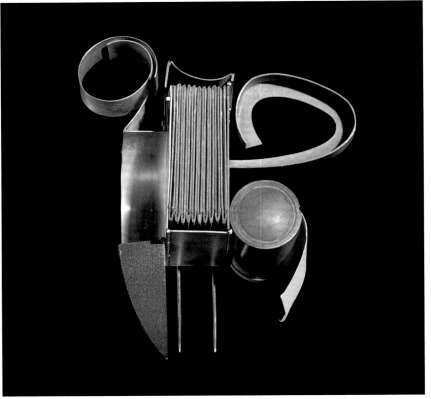

618

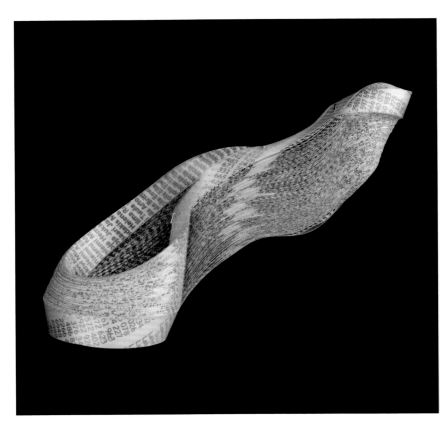

619

NEL LINSSEN

Dutch jeweller Nel Linssen's elegant pieces fall within the sphere of "sacred geometry," that rarefied place where forms, metaphysics and mathematics cohabit. Through seemingly infinite repetition and the most gradual colour progressions possible, Linssen achieves lyrical grace in her gently undulating necklaces and bracelets. Paper is her medium of choice, specifically *Elefantenhaut* [elephant hide], an industrial paper available in an array of colours. It lends itself particularly well to her process, which involves the repetitive folding and twisting of paper, then stringing the resultant formations so tightly on elastic cord that the configuration seems almost solid.

Of her work, Linssen states: "[It] arises intuitively and in an empirical way. I am continually trying to discover logical constructions, inspired by rhythms and structures in a botanical world."[1] Although her aesthetic centres on paper, other media have informed her journey. Linssen originally worked with textiles after studying at the Academy of Fine Arts in Arnhem. From fabrics she graduated to semi-gloss, plastic-coated and packaging papers, before settling on *Elefantenhaut*. In 1994, she did a residency at the European Ceramics Work Centre in 's-Hertogenbosch, the Netherlands. The sculptural ceramic forms that Linssen worked on there strongly influenced her subsequent output. The manipulation of heavy clay discs translated into piercing, folding, stacking and rotating techniques for paper that would define her mature work.

The Museum's necklace 615, made of plastic-reinforced paper (*gewapend kraft*), is a prime example of jewellery made during the year of Linssen's immersion in ceramics. It displays the structural methods and gentle colour gradations of glazed clay yet the softness, fluid surface and tactile quality harkens back to her experimentations with textiles as well. **TG**

1. Nel Linssen, curriculum vitae, http://www.nellinssen.nl (accessed May 21, 2010).

JANNA SYVÄNOJA

Originally a furniture and interior designer, for which she holds a Master's degree from the University of Industrial Arts in Helsinki, Finn Janna Syvänoja began her career in jewellery while a student in the late 1980s, when she sold brooches and necklaces made from telephone directories and newspapers at local markets, to earn extra income. She has stated that she was also bored, "bored enough to tear up telephone

books . . . to take the shredded paper and twist it into strangely suggestive shapes."[1] By recycling such refuse, her material costs were nil, a great advantage to an impecunious student. The instant success of these surprising original objects encouraged Syvänoja to develop an art form that combines the ordinary, everyday and even thrown away with wit, nostalgia and a gentle critique of ecological issues.

Although Syvänoja has used found materials such as fishnet, tar paper, leaves, seeds, wood and birchbark, arguably her most potent pieces are made from discarded pages of text. Working serendipitously, she layers sheaf after sheaf of sawn or torn printed paper, sometimes adding stiff board and/or fibre, and then splaying the bundle around a steel-wire armature for wearability. The resultant pieces are layered in form, content and meaning. Syvänoja comments on the cycle of life in the way that her objects "grow," and so resemble trees, which produce wood, which produces paper. Finding poignancy in decay, Syvänoja honours the "usage patina" of an aging product while emphasizing the sustainability of such ordinary and fragile substances. She often conceals the original function of her found objects in abstract shapes, such as spirals or semi-spirals, but sometimes also in recognizably related images. The former approach is seen in the folded brooch 619. The latter vein is exemplified by the necklace *Books* 616 (one of three extant examples), which is constructed from actual slices of a book. Verbal messages, of additional importance to Syvänoja, whether enigmatic, as on the end pages of *Books*, or more easily discerned, as with the brooch, are achieved through surface patterning created by the original printed words. **TG**

1. Alice Pfeiffer, "The Delicate Art of Tearing Up Books," *The New York Times*, May 2, 2009, http://www.nytimes.com/2009/05/02/fashion/02iht-acajshred.html (accessed June 14, 2010).

GIJS BAKKER

Gijs Bakker is undoubtedly one of the most outspoken theorists to have emerged from the Dutch avant-garde between the 1960s and 1980s. An all-embracing artist, his designs include home accessories and household appliances, furniture, interiors, public spaces, exhibitions and jewellery, for which he is, perhaps, best known. Bakker's interdisciplinary career has encompassed aesthetics, design and industry to a greater extent than most of his contemporaries. Nonetheless, he is an iconoclast. As design critic and former director of

the Netherlands Design Institute, Gert Staal, has said of him: "[Gijs Bakker] is both the jewellery designer who dislikes jewellery and the industrial designer with a deep-rooted mistrust of industry."[1]

The *Dewdrop* neckpiece 617, arguably one of Bakker's most salient pieces, illustrates his provocative departure from an earlier emphasis on non-objective geometric abstraction. Although, as with all of his jewellery, it relates to the body and its surrounding space, *Dewdrop* exemplifies Bakker's expanded concept of jewellery as a medium for opportunistic artistic expression that, moreover, may carry controversial messages. Having formerly used impersonal industrial metals such as stainless steel and aluminum for jewellery, Bakker turned to huge laminated paper images to provide a mockingly emotional link to the wearer, who was to be part of an evocative, staged "scene." *Dewdrop* is among the earliest pieces of this fictive tableau. He says of the neckpiece: "I used a cheap Verkerke poster. The title was deliberately in English because it conveys the sentimentality so much better."[2] Seminal in concept, *Dewdrop* led to other monumental neckpieces including the "Queens" and "Gold Leaf" series and the groundbreaking *Dahlia* necklace.

From time to time, Bakker has used commonplace materials to comment on fine jewellery. *Dewdrop* calls to mind historical flower brooches and pendants, carved from semi-precious stones and accented with diamond "dew drops," crafted by some of the prominent European jewellery houses, as well as faux versions made commercially worldwide. This dialogue between fine, costume and imaginary jewellery has been one of Bakker's most determined pursuits, one in which he still ardently engages to the present day.[3] **TG**

1. Gert Staal, *Gijs Bakker, vormgever. Solo voor een solist*, exh. cat. (The Hague: SDU uitgeverij, 1989), p. 19. 2. Yvônne G.J.M. Joris, *Gijs Bakker and Jewelry* (Stuttgart: Arnoldsche Art Publishers, 2005), pp. 34–35. 3. For an excellent discussion of Bakker's battle with fine versus fake jewellery, see Glenn Adamson, *Thinking through Craft* (Oxford; New York: Berg, 2007), pp. 32–36.

LUCY SARNEEL

Dutch designer Lucy Sarneel's artistic approach has been shaped by her studies in visual arts at the Maastricht Academy of Fine Arts and Design and her training in jewellery-making at the Gerrit Rietveld Academie in Amsterdam. Sarneel is among those jewellers whose pieces express an emotion, convey an idea or even tell a story. Her agenda-brooch *Datebook* 618 is the result of

615

Nel Linssen
Born in Mook, Netherlands, in 1935
Necklace
1991 (example of 1994)
Plastic-reinforced paper, rubber
H. 6 cm; Diam. 18 cm
Signed and dated in felt pen, near attachment: © / Nell.'94
Liliane and David M. Stewart Collection, gift of Dr. René Crépeau
D96.131.1

616

Janna Syvänoja
Born in Helsinki in 1960
***Books* Necklace**
1990
Hardcover book, metal
29.7 x 36.9 x 1 cm
Impressed on an outer edge: *VAHAN*
Liliane and David M. Stewart Collection
D92.155.1

617

Gijs Bakker
Born in Amersfoort, Netherlands, in 1942
***Dewdrop* Neckpiece**
1982
Plastic-coated offset halftone
48.9 x 55.6 cm
Signed in ink, on underside: *G Bakk*[er]
Titled, dated and numbered in ink on underside: *"dew drop" 1982 nr 34*
Liliane and David M. Stewart Collection
D90.100.1

618

Lucy Sarneel
Born in Maastricht, Netherlands, in 1961
***Datebook* Brooch**
About 1993
Silver, zinc, gold, iron, paper
11.6 x 9 x 5 cm
Liliane and David M. Stewart Collection, gift of Dr. René Crépeau
D96.139.1a-b

619

Janna Syvänoja
Born in Helsinki in 1960
Brooch
1997
Recycled paper (telephone directory), steel
2.7 x 13.2 x 3.5 cm
Liliane and David M. Stewart Collection
D98.156.1

construction and assembly, and includes several geometric elements in silver, gold, zinc and iron. The central element encases a miniature accordion file made of paper. Another cylindrical case contains a slit through which a roll of paper contained inside emerges. This agenda, so mysterious, is perfect for secret rendezvous. **DC**

RITSUKO OGURA

Japanese jeweller Ritsuko Ogura, who studied silversmithing with master Japanese sculptor/ jeweller Minato Nakamura, began gaining recognition in the early 1980s. The corrugated cardboard pieces for which she is best known resonate with both her Japanese heritage and her times. The former is manifest in her choice of paper, a traditionally "valuable" material in Japanese culture— found in everything from elegant writing tablets and exquisitely wrapped gifts to delicate origami pieces—the latter is illustrated by her environmentally conscious decision to recycle something common and ultimately endangered.

With the humble nature of her chosen material, as well as the simple and direct shapes of her works, Ogura maintains a strong connection with Mingei, a mid-twentieth-century folk crafts movement spearheaded by the philosophy of Muneyoshi Yanagi. This Japanese thinker and critic's dedication to preserving indigenous folk craft traditions led to an influential decorative art ideology. Ogura's re-evaluation of a lowly substance such as corrugated cardboard is consistent with Mingei practitioners' desire to poeticize physical aspects of the base materials used for making objects, while at the same time celebrating the prosaic and anonymous.

Ogura has stated: "I use [cardboard because it] is cheap, non-precious, popular and . . . of standard manufacture. . . . There is nothing special about it . . . and because we use it as packaging it never attracts people's attention for itself. Its destiny is to be thrown away . . . so it is totally different from Japanese paper, which is very beautiful and artistic in itself. I was fascinated and inspired by the idea of making it into jewellery and how I might give it power, brilliance, dignity and grace."[1] Despite the technical challenges corrugated cardboard poses, Ogura has chosen to work with the recalcitrant medium. It does not cut easily and she has had to devise ways to carve the layered mass by hand into the desired form, a constriction that has often dictated the end result and ultimately led this resourceful jeweller to new creative expressions.

The brooches **620** **621** are a fine example of process engendering product. Red, a sacred colour in Japan, was exposed during the carving, as Ogura shaped the piece from previously paint-treated paper. **TG**

1. Ritsuko Ogura, "Artist's Statement," in *Contemporary Japanese Jewellery*, exh. cat., Simon Fraser and Toyohiro Hida (London: Merrill, 2001), p. 90.

JULIA MANHEIM

Julia Manheim made a name for herself in the early 1980s on the art-jewellery scene in Great Britain with her wearable, large-scale sculptures, somewhere between clothing and jewellery. Soon dissatisfied with the limitations of jewellery design, she gave it up for sculpture and installation in 1984.

In her sculpture making, Manheim began to use newsprint—which would become her favourite medium—making it into papier mâché, a process that appeared in the West as early as the eighteenth century. To start, she creates small objects like this *Scarlet and Grey Vase with Collar* **622**, based on the shape of the vase but not its function. She sometimes mixes her visual references, suggesting bodies in motion or the human form, especially that of the female, as is the case here.

The acrylic paint and wax applied to the surface lend the piece a rich and intense quality that enhances its individuality. Manheim is interested not only in transforming a seemingly functional object, but also in transmuting the newsprint medium. Once painted, all association with paper disappears, imbuing the material with an aesthetic value that contradicts its expected lifespan, which is usually over the moment the next day's edition has hit the newsstands. **DC**

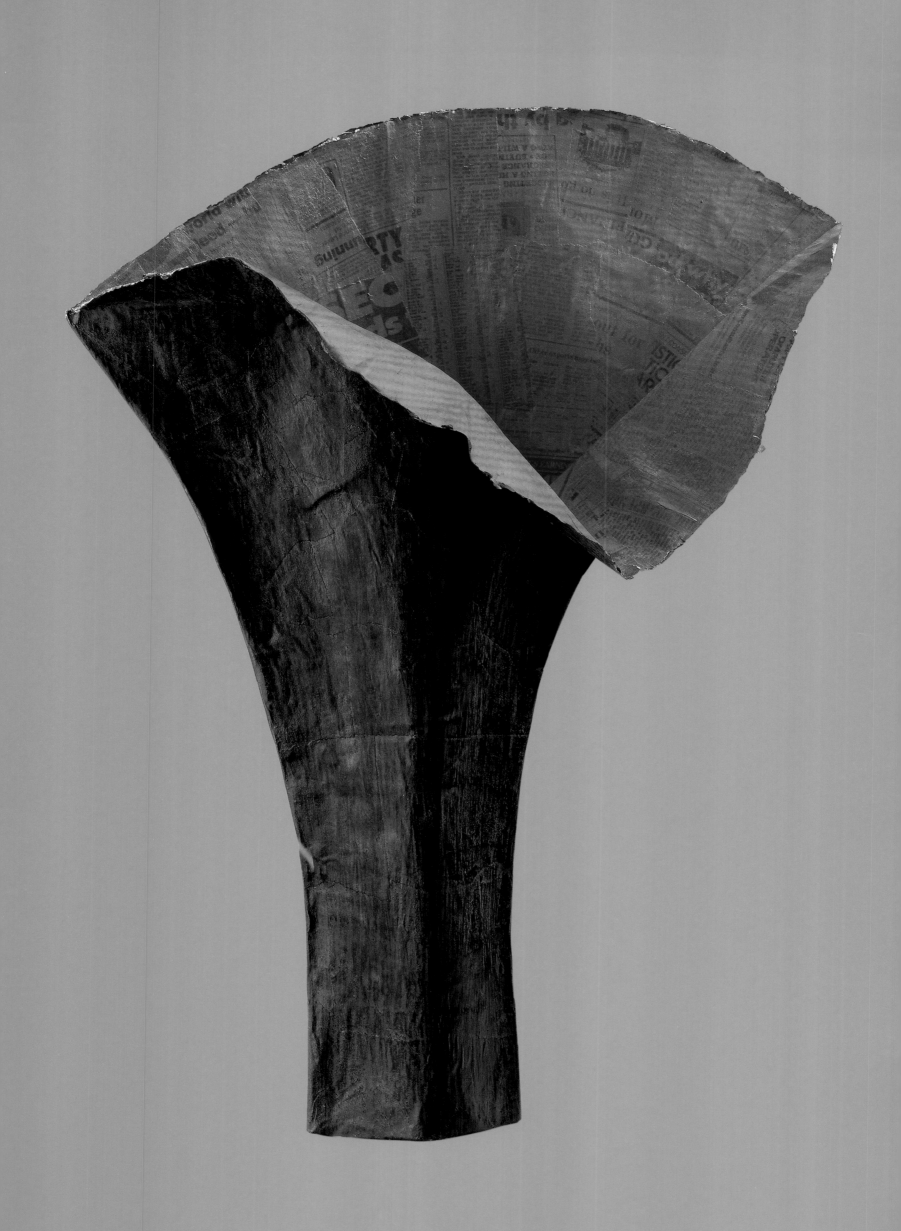

PLASTIC

■■■■ *adjective & noun* [ORIGIN French *plastique* or Latin *plasticus* from Greek *plastikos*, from *plastos . . . plassein*, to mould, to form . . .] **A** *adjective*. **1** Characterized by or capable of moulding or shaping clay, wax, etc. . . . **B** *noun* **3** ■ Any of a large class of substances which are polymers based on synthetic resins or modified natural polymers, and may be moulded, extruded, or cast while soft or liquid, and then set into a rigid or slightly elastic form, usu. by heating or cooling; material of this kind, esp. when not in fibrous form.

■■■■ The history of plastic materials and composites is closely linked to that of industrial design and consumer society. Since the early twentieth century, different plastics—Bakelite, ColorCore, melamine, polyvinyl chloride (PVC), polyurethanes, ABS resins—have conquered the domestic world, often replacing traditional materials such as glass, wood and metal. Plastic is integral to the manufacturing of radios, television sets and electronics of all kinds, as well as tableware and furniture. The ultimate innovative material, symbol of progress, it is inexpensive, flexible, waterproof, insulating and strong. Lending itself to all sorts of transformations (by extrusion, injection, moulding or thermoforming, among other industrial processes), it has bred a number of items emblematic of modern living. ■■■■ Plastic materials and experimentation came together after World War II, when the United States discovered the monocoque seat and Tupperware containers. Their multiple composites and varied textures inspired Italian designers and manufacturers in the 1960s and 1970s, who could create, thanks to polyurethane foam, furniture liberated from the constraints of traditional construction. As employed by Italian Postmodernists, plastic appeared in laminates, in bright colours and patterns that were deliberately kitsch—and it challenged the banality of the mass-produced household object. ■■■■ Today, many designers are exploring the most recent technological innovations that make use of plastic materials, such as rapid prototyping. These techniques have enabled them to recast their formal vocabulary through objects produced in limited editions that convey meaning rather than serving a purpose. Jewellery and fashion designers are also displaying a marked interest in the malleability and versatility of plastic, helping raise the status of this new material. DC

NEW TECHNOLOGIES: PLASTICS

— DIANE BISSON —

The history of plastic is inseparable from that of design and the phenomenon of consumption. Even today, plastic still serves as an innovative material, whose possibilities seem endless given its ability to be transformed with every technological and scientific advance. In the course of a century, plastic has contributed to our changing relationship with the material world and democratized design. At the turn of the twentieth century, most plastics were already at an initial phase of development. These first plastics were semi-synthetic, but the industry would truly take off with the creation of entirely synthetic materials. Bakelite, the first liquid synthetic resin, was invented in 1907 by Belgian-born American chemist Leo Hendrick Baekeland. Produced by the condensation of phenol and formaldehyde, this heat-resistant resin would serve as insulation in multiple electronic applications. Bakelite Type C, suitable for the manufacture of moulded pieces, would mostly be used for its durability, malleability and thermal properties. Radio and telephone casings unequivocally represented the most emblematic objects of the period. In 1937, the Zenith Radio Corporation, already a pioneer in radio manufacturing, introduced the *Radio Nurse*, an intercom designed by American-Japanese artist Isamu Noguchi. The kidnapping of Charles Lindbergh's son a few years earlier, still very fresh in the public's mind, opened up a large market for this shortwave radio transmitter, which enabled parents to keep a long-distance eye on their baby. The *Radio Nurse* short-wave radio transmitter **625**, moulded in Bakelite, borrowed its shape from Japanese kendo masks, offering the purest expression of the Streamline aesthetic. During the 1930s, Bakelite came in varying degrees of quality imitating more noble materials. The eventual arrival of its closest relative, urea-formaldehyde, permeable to pigments, led to the adoption of a multitude of colours in thermoset plastics. These plastics would quickly become the miracle material, manifesting the twentieth century's optimism and dynamism.

At the end of World War II, the growing demand for consumer products accelerated the development of plastics. Formica, nylon (polyamide 6.6), Plexiglas and Perspex (polymethyl methacrylate), silicon, polyethylene and polystyrene were among the most used plastics. Already by 1941, melamine formaldehyde tableware was a commercial success. Melamine is a hard resin. Resistant to heat, fire, light and abrasion, it is also unbreakable, unlike ceramics. The company American Cyanamid, having used it to manufacture table items for the American navy, expanded its applications to domestic products in the 1940s. Sets of melamine dishes, which came in a wide variety of shapes and colours, filled post-war kitchens and retained their popularity for more than twenty years. Melamine addresses all the requirements of lightness, easy maintenance and simple standardization of all kitchen items. Massimo Vignelli's melamine dish set **627** is a remarkable example of the exploration of the stackable item, which was then of great interest to designers. Vignelli would be awarded the Compasso d'Oro in 1964 for this set, which nevertheless marks the end of the melamine era. Its geometric, minimalist lines convey Vignelli's adherence to Neo-Rationalist thinking shared by many designers over the following decade. After the war's end, melamine would gradually be replaced by polyethylene, the new material of choice. Used in an infinite number of products, it was part of the profound lifestyle changes then underway. This thermoplastic resin, available as a powder and moulded by injection, was the most versatile of the new plastics in current use. Polyethylene restored plastic's image, eroded by bad press due to the imminent degradation of the first generations. More than any other object, it was the Tupperware food container that would introduce plastic into homes. Its inventor, engineer and chemist Earl Tupper, wanted to create a malleable plastic for the manufacture of consumer products. He developed a flexible, resistant, non-porous and translucent plastic with the polyethylene residues from oil refining, which he collected from DuPont. The Tupperware container, translucent, stackable, and leak- and air-tight **626**, would revolutionize domestic organization. Direct selling to the home—"Tupperware Parties"—would become the symbol of the emerging consumer society.

In connection with the functionalist, but, above all, democratic ethos of the period, the *DAR* armchair **629** by Charles and Ray Eames illustrates the shared aim of governments, large companies, industries and designers to develop accessible products and respond to the immediate needs of consumers. Charles and Ray Eames would actively participate in exploring the possibilities provided by the new materials developed during the war. The *DAR* armchair, made with fibreglass and unsaturated polyester, produced as of 1950 by Herman Miller, represents the economical and lighter version of the prototype produced in 1948 for the Competition for Low Cost Furniture Design. This event, organized by the Museum of Modern Art, which undertook the promotion of "good design" principles, opened the way for the use of plastics in domestic furniture. Following the exhibition, the design of the *DAR* armchair would be revised in order to get the most out of the properties of fibreglass. The process of forming fibreglass made it possible for several designers to meet the challenge they had set for themselves: to produce a low-cost, light, organically shaped single-hulled chair, with no assembly required. The *DAR* armchair, with its exposed structure, fluid form shaped to the body's contours and multiple interchangeable legs, has infiltrated our institutional and domestic environments, illustrating the most remarkable mid-twentieth-century ideal.

During the 1960s, the arrival of new soft polymers and a better understanding of the mechanisms of polymerization would help nourish the scientific utopia of progress. Plastics alone made possible the free forms and saturated, lustrous colours of the period. Designers displayed a modernity that distanced itself from the moralist dogma of the preceding decade. From then on, the aesthetic aligned itself with mass culture, dominated by the media, music and pop art. Plastic was now the ephemeral material. The novelty of Verner Panton's shapes was inspired by futurist, if not utopian, visions, which were disrupting previously held views about living space. Although he associated with designers such as Poul Henningsen and Arne Jacobsen in Denmark, who made wood the signature material of the modern Scandinavian style, Panton would instead be seduced by the malleability of plastics. He would make use of synthetic materials such as fibreglass, Perspex, transparent film (PVC), which he would use for his inflatable stool—precursor to an entire generation of inflatable furniture—and, finally, polyurethane foam, which would serve in the creation of his fantastical environments. The chair known as Panton is an important milestone of the period. It was the first cantilevered chair produced from a single piece made entirely of plastic. It alone illustrates through its re-editions the numerous advances, as well as the challenges, encountered by the plastic-furniture industry. Already sketched as a prototype in the early 1950s, the first model moulded in fibreglass and polyester, given the lack of technical means, would only be launched by Vitra in 1967. The manufacturer collaborated on perfecting the model in order to arrive at a chair that was stackable and more stable by varying the thickness of the hull—an alteration only possible with plastic. Later editions initially used

624

625

626

627

628

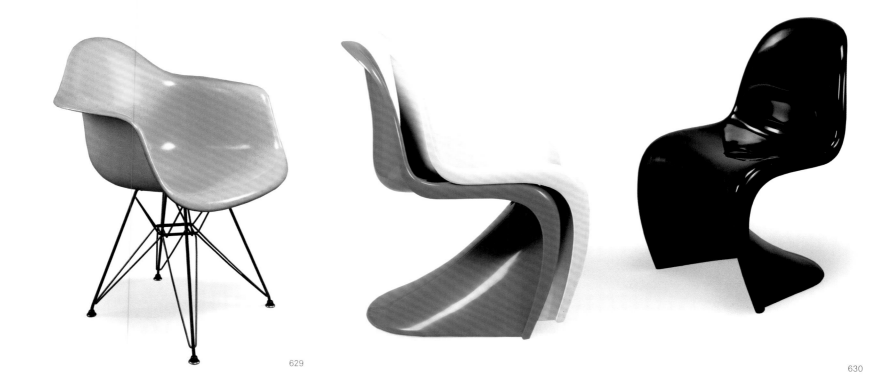

629

630

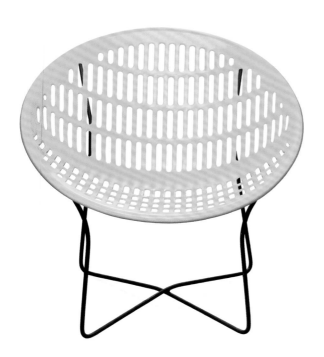

631

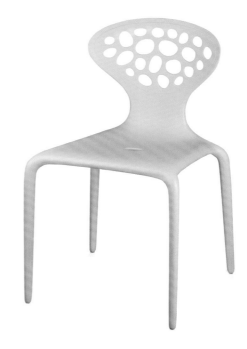

632

painted rigid polyurethane foam, still employed today in the re-edition of a classic model, followed by the coloured Luran-S polystyrene of the Museum's pieces **630** and, more recently, by coloured polypropylene, for the standard model.

From the 1950s to the 1970s, Italy dominated the design scene thanks to an industrial boom in which plastics processes played a major role. The "Italian miracle" was a period of monetary stability, economic growth and extraordinary inventiveness **636** -**641** . Italian designers were critical of the impoverishment of aesthetic language engendered by enterprise capitalism. Their production and manifestos fed the debate, often expressing a radical vision of the role of design, such as the vision of the living environment proposed by Joe Colombo. Colombo's practice was informed by his reflections on the capacity of design to rethink habitat and define new living spaces. He would dub his concept "anti-design," aiming to denounce the reduction of design's field of battle to the sole production of industrial objects, and to put the designer's skills to work devising interiors. He would set himself apart with his modular furniture as well as his living spaces. Painter, sculptor and designer, he asserted as an absolute the principle of space as a total artwork. Produced in 1970, the *Boby* caddy **635** , manufactured in ABS (acrylonitrile butadiene styrene copolymer), fits into this quest for modular, flexible and multifunctional components for the home. Made to be either stackable or movable by way of wheels, each side of the module had open or closed storage spaces, including a series of three drawers one on top of the other on the same pivot, making them accessible at the same time.

At the end of the twentieth century, a third generation of plastics, new technical or engineering resins, made its appearance, providing results hitherto not seen. These resins are more versatile and economical, possessing optimized thermomechanical properties.

Formica's decorative laminates are among those constantly innovating plastic products. Already recognized for its veneers in the late 1920s, Formica put the finishing touches on ColorCore, a laminate with solid colour throughout, in 1982. The first laminates were made by layering sheets of paper saturated with phenolic resin. ColorCore eliminates the dark base coat characteristic of the traditional laminates. It represents an unprecedented innovation in the creation of machinable plastic laminates. The sheets could now be processed, milled or engraved. A second product for surfacing, Surell, introduced on the market some years later, is composed of an acrylic resin and mineral filler that could also be worked with solid colour throughout. These products expanded the field of application for plastic-sheeting design. To make full use of the qualities inherent in these new materials, Formica launched a series of design contests in the 1980s. The unique works of designers, architects and artists like Daniel Friedman became the subject of exhibitions held across the United States. Friedman's *Fountain* table **623** appeared in the exhibition *From Table to Tablescape*, which launched Surell in 1988. Friedman's work, which combines ColorCore and Surell, reveals their sculptural potential. Imbued with humour and personality, this piece borrows from the ideals of the Italian Memphis group that formed around Ettore Sottsass. Identifying with the architectural character of Postmodern furniture, the *Fountain* table belongs to a new type of object that resists the conventions of visual language.

Invented in the last century, polycarbonate has had numerous applications since the 1950s. Polycarbonate is an object of fascination for its incredible shock-resistance and transparency, properties that make it a good substitute for glass. The *iMac* computer **624** illustrates the properties of this technical resin perfected in the 1990s. A revolutionary product in the computer industry, as much for design as for technology, the *iMac* is the first model of the series of G3 computers combining the screen and computer in the same casing. Created by Jonathan Ive, Apple's design-team director since 1996, the *iMac* radically broke away from the shapes and neutral shades of the computers then dominating the market. With its translucent blue-green shell evoking the waters on Bondi beach in south Australia, the first *iMac* was dubbed "Bondi blue." The object's size and ovoid shape ensure that it can be easily incorporated into living and work spaces. The computer is also remarkable from a technological standpoint for its new type of USB (universal serial bus) peripheral cable and its integrated disk drive. Apple would offer an entire range of products in bright colours that would elevate the status of translucent plastic.

The *Supernatural* chair **632** designed by Ross Lovegrove in 2005 is another example of the constant innovations in plastics, which in this case have made it possible to create an incredibly light chair. The reinforced polyamide of the first version was replaced by polypropylene, also reinforced with fibreglass, one of the most high-performance materials currently used in many applications. The polypropylene is gas-injection moulded, a recent technology that makes it possible to create rigid, hollow pieces. Lovegrove takes full advantage of this process' way of discharging superfluous material. The perforated back eliminates surplus material and lightens up the chair while responding to structural requirements. The organic, elegant lines are the result of another technological advance that marked the early twenty-first century: digital modelling. The new shapes that characterize Lovegrove's work are the direct result of the digital exploration of bionic forms.

The twenty-first century witnessed the arrival of intelligent plastics, which, mirroring the biological world, react to their environment, and, above all, organic plastics. The pollution caused by the ever-increasing consumption of plastic products has led to innovations and to a tendency towards materials and production methods that conform to the principle of sustainable development. Since the first oil crisis of 1973, which showed the limitations of hydrocarbon reserves, the industry has been attempting to reduce the amount of plastic used. It is exploring the economic and technological advantages of recycled plastic, new composites and organic materials employed as plastic substitutes. The first thermoplastics made of biodegradable plant material were introduced in the late 1980s. These biodegradable materials have slowly made their way onto the landscape of disposable items, particularly in the food industry. Under the direction of Daniela Danzi, the Italian company Pandora has become a leader in the design of tableware with Mater-Bi (produced by Novamont). Mater-Bi is provided in granular form, and its properties and processing techniques are similar to those of plastics, while being entirely biodegradable and compostable. The Mater-Bi disposable utensil **628** , created by Giulio Iacchetti and Matteo Ragni for Pandora, was awarded the Compasso d'Oro in 2001. This object, serving as both a spoon and a fork, met with great success on the international market. Its matte texture and translucent, naturally amber colour presented an entirely new materiality henceforth considered an aesthetic quality particular to biodegradable plastic.

633

Monika Mulder
Born in the Netherlands in 1972
Vållö Watering Cans "PS" Collection
2001
Polypropylene
32.9 x 34.5 x 12.6 cm (each)
Produced by IKEA, Sweden
On underside of pink, orange, black and green watering cans: *IKEA / PS / Designed by Monika Mulder / VÅLLÖ / 17312 / MADE IN POLAND*; on underside of red and blue watering cans: *IKEA / PS / Designed by MONIKA MULDER / VÅLLÖ / 12246 / MADE IN SWEDEN*
Liliane and David M. Stewart Collection
2007.31.1-6

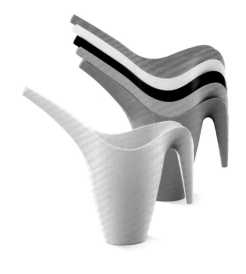

634

Matali Crasset
Born in Châlons-en-Champagne, France, in 1965
Artican Wastebasket
1999
Polypropylene, polymethacrylate, aluminum
61 x 41.9 x 41.9 cm
Produced by Matali Crasset Production, Paris
Liliane and David M. Stewart Collection
2011.171

635

Joe Colombo
Milan 1930 – Milan 1971
Boby Storage Unit
1970
ABS, steel
73.5 x 43.4 x 42.7 cm
Produced by Bieffeplast, Padua, Italy
On underside: *bo / by / produzione bieffeplast padova italia / designer joe colombo / [logo] / PATENTED*
Liliane and David M. Stewart Collection
D99.136.1a-d

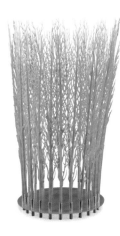

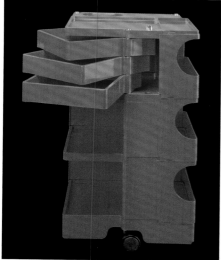

635

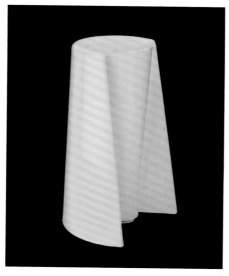

636

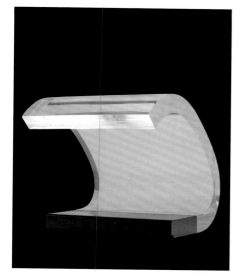

637

638

639

640

641

KARTELL

— GIAMPIERO BOSONI —

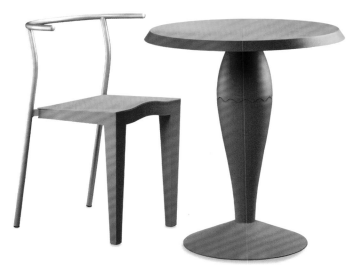

642, 643

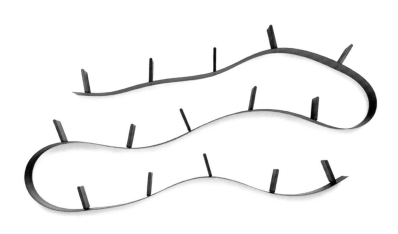

644

In Italy, plastics only began to be heavily used in the production of domestic items in the early 1950s. In 1949, engineer Giulio Castelli and some associates co-founded Kartell, which quickly became one of the leaders of post-war Italian design. Between 1939 and 1947, Castelli studied chemical engineering with Giulio Natta, who was awarded the 1963 Nobel Prize for Chemistry for his discovery of polypropylene. Even more than his university career, it was his father who contributed to Castelli's interest and practical experience in the plastics sector, having built a lab before the war where he made items from Bakelite.

Initially, the first items produced by Kartell were for the automobile accessory industry, and the company acquired a certain reputation with the Pirelli patented ski rack designed by Roberto Menghi in collaboration with the engineer Barassi, who was a technician for Pirelli Monza and inventor of the Nastricord elastic band. In the early 1950s, Castelli began importing the first polyethylene containers and tubs from England. Unfortunately, because they were so new, the costs were excessively high. Kartell also began producing plastic items for the home in 1953, launching the collaboration, first externally and then internally, in the engineering and design department, between Gino Colombini and Franco Albini, who would work together for some twenty years (1933–1954). Colombini

designed almost the entire range of Kartell products between 1953 and 1962, before officially ending the relationship in 1969. During this period, however, Colombini designed more than two hundred new domestic items, for which he was awarded the Compasso d'Oro four times, in addition to fifty-four honourable mentions recognizing the best Italian design from the same body. Among Colombini's pieces is the KS 1068 standing dustpan (1957) **646**, notable for its sweeping, elegant lines and the technologically innovative use of shock-resistant polystyrene to coat two elements subsequently glued together.

In 1958, at the height of Kartell's rise, two major new divisions were launched: one to provide technical tools for laboratories (Labware, still active today) and another to create lighting solutions (closed in 1981, shortly after the last days of the domestic goods department in 1979). This expansion led to collaborations with new designers, such as Asti and Favre, Giotto Stoppino, Gae Aulenti, the Castiglioni brothers, Roberto Menghi, Joe Colombo, the Monti brothers and Marco Zanuso. With these designers, Kartell truly took off in the furniture sector. In fact, in 1963, the company confronted the subject of furniture head-on, launching a Habitat division. Marco Zanuso and Richard Sapper's famous—and award-winning—chair for children made from low-density polyethylene came out in

642

Philippe Starck
Born in Paris in 1949
Dr. Glob Chair
1988
Tubular steel, polypropylene
73 x 47 x 46 cm
Produced by Kartell, Milan
On underside of seat:
*CHAIR / Dr Glob® / by /
STARCK / for / Kartell® /
MADE IN ITALY*
Liliane and David M.
Stewart Collection
D95.198.1

643

Philippe Starck
Born in Paris in 1949
Miss Balù Table
1988 (example about 1995)
Sheet-moulded polypropylene
composite and moulded
polypropylene
H. 72 cm; Diam. 63.5 cm
Produced by Kartell, Milan
On underside of tabletop:
*TABLE / Miss Balù® /
by / STARCK / for /
Kartell® / MADE IN ITALY*
Liliane and David M.
Stewart Collection
D95.196.1

644

Ron Arad
Born in Tel Aviv in 1951
Bookworm Bookshelf
1993
Thermoplastic
technopolymer
8 m
Produced by Kartell, Milan
Liliane and David M.
Stewart Collection
D95.202.1

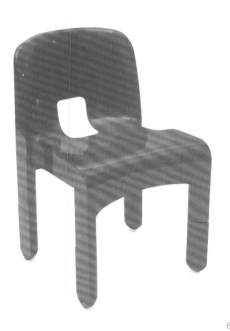

645

646

647

1964, followed by the equally well-known stackable chair **645** made of ABS designed by Joe Colombo. At the same time, inspired by the possibilities offered by technological advances, Anna Castelli Ferrieri was inventing innovative products to accompany the lifestyle changes of the time. Thus, in 1967, multi-use, stackable containers were introduced (the round-based version dates to 1969), followed soon thereafter by planters on casters.

In 1972, Kartell participated in the exhibition *Italy: The New Domestic Landscape* at the Museum of Modern Art in New York, presenting three prototypes for avant-garde solutions in the home designed by Gae Aulenti, Ettore Sottsass and Marco Zanuso. In 1973, Kartell joined its production operations with Centrokappa, a study and research centre that brought together experts in design and communications. In 1977, under the impetus of Centrokappa, events were organized or sponsored around reflections on the origins of Italian design, including an exhibition entitled *Il design italiano degli anni '50*, and the launch of *Modo* magazine that same year, which would serve both as the catalyst for and the critical consciousness of 1980s Italian design. In 1976, Anna Castelli Ferrieri was appointed artistic director of all production at Kartell.

In the 1990s, the company surrounded itself with several new designers, including Antonio Citterio, Ferruccio Laviani, Alberto Meda and Paolo Rizzatto from Italy; Philippe Starck from France; and Israeli-born Ron Arad from England. This team would invent numerous other household items, marketed in large quantities with a "cash and carry" strategy. In this context, Starck's first project was the *Dr. Glob* chair **642**, paired with the *Miss Balù* table **643**, both of which marked a major turning point in Kartell's production. For the first time, Kartell added other materials to plastics (which were becoming more solid), abandoning not only its signature fluid forms and glossy finishes, but also the usual colours of synthetic materials. Ron Arad broke from the linear qualities of the common household bookcase with his multifaceted, curvilinear, almost spiral *Bookworm* bookshelf **644**. With their container system on Mobil wheels, the *Mobil* storage unit **647**, Antonio Citterio and Glen Oliver Löw worked on a neo-industrial furniture concept that, with its stainless-steel frame and translucent polymethyl methacrylate drawers, creates an impression of dematerialization.

In 1988, Giulio Castelli passed the reins of the company over to his son-in-law Claudio Luti, Kartell's current president.

648

649

650

INFORMAL
SEATING

— DIANE CHARBONNEAU, VALÉRIE CÔTÉ —

ROBERTO MATTA

In 1966, upon the invitation of visionary manufacturer Dino Gavina, Chilean Surrealist artist Roberto Matta explored the formal properties of a relatively new material, polyurethane foam, to create the *Malitte* seats and ottoman `648`. The five curvilinear modules are cut from a single block of foam and then covered in a stretchy wool fabric, blue for the seats and cream for the ottoman. Their configurations recall the biomorphic wood reliefs painted by Jean Arp, more than the figurative abstraction of Matta's own paintings. The group bears the name of Matta's second wife.

This informal seating provides flexibility and freedom, and invites us to reconsider our relationship with our body, the space around us and other people by offering an endless number of possible configurations. The various elements fit together like the pieces of a puzzle, either for storage purposes or to conserve space. Thus assembled, they compose an abstract square-shaped sculpture. Initially produced by Gavina (Foligno, Italy) from 1966 to 1968, they were then produced by Knoll International (New York) from 1968 to 1976. DC

GIOVANNI LEVANTI

Initially adopting the decorative principles of the Memphis group or the more symbolic aspects of Andrea Branzi's, architect and designer Giovanni Levanti quickly took a more neo-minimalist path when he opened his own studio in 1991.[1] In step with design's eclectic and hybrid trends since the mid-1990s, he developed a poetic and deeply personal style with reassuring, comforting shapes that charmed several Italian and foreign manufacturers. The *Xito* chaise longue `650` is an excellent example of his work for Campeggi. Shortlisted for a Compasso d'Oro in 2001, it is defined by the negative—"No armchair, no sofa, no bed, no chaise longue, no carpet."[2] Multipurpose and multifunctional, the piece is readily adapted to the needs of users. Placed directly on the ground, *Xito* is as inviting to sit on as it is to lie on.

Minimalist in style, the chaise longue is basically made up of a circle for the seat and a semicircle for the back. The latter, which is accompanied by a pillow attached with snaps, can be raised or lowered using a concealed mechanism. Laid flat, *Xito*'s shape resembles the sole of a shoe, calling to mind both its movability inside the house and its adaptability to everyday situations. DC

1. From 1985 to 1990, Levanti collaborated with Andrea Branzi and participated in the Memphis group's activities, for which he designed the *Nastassja* (1987) and *Alfonso* (1987) chairs in leather and metal. 2. *Xito*, at http://www.giovannilevanti.com (accessed March 3, 2012).

ARCHIZOOM ASSOCIATI

The Florentine collective Archizoom Associati (1966–1974)[1] specialized in design, architecture and urban planning at a moment when creators were mobilizing and drawing attention to the socio-historic dimensions of their role and its cultural significance. Championing the transformation of society through design and architecture, the collective challenged, from a formal standpoint, the supremacy of functionalism—from whence comes the notion of antidesign. The group criticized design's dependence on industry as well as the excesses of consumer society. In this vein, between 1966 and 1973, it designed modular and multifunctional furniture for Poltronova that demanded a new spatial configuration and promoted social interaction. The *Superonda* sofa (1966) `656`, made of polyurethane trimmed with PVC, invites lounging rather than sitting. It comprises two wave-shaped elements that can be joined together to form a seat and back, or be separated, depending on the taste or needs of the consumer. With its stylized flower shape in fibreglass-reinforced polyester and faux leopard upholstery,[2] the *Safari* sofa (1968) `651` makes fun of "good design" and also recalls 1950s kitsch as much as 1960s Pop art. Its modular format proposes a "new domestic landscape" that stimulates the imagination and creativity. DC

1. Founded in Florence in 1966, then active in Milan until 1974, the group included architects Andrea Branzi, Gilberto Correti, Paolo Deganello and Massimo Morozzi, as well as designers Dario and Lucia Bartolini. 2. The covering fabric (seat and floor) of this example is not of the period.

648

Roberto Matta
Santiago 1911 –
Civitavecchia, Italy, 2002
Malitte Modular
Seating System
1966
Polyurethane foam,
 wool upholstery
160 x 160 x 63 cm
Produced by Gavina,
Foligno, Italy /
Knoll International,
New York
Liliane and David M.
Stewart Collection
D89.137.1a-e

649

Piero Gilardi
Born in Turin in 1942
Seat/Mat
1968
Painted polyurethane foam
73 x 71 x 85 cm (approx.)
Prototype produced by
Gufram, Balangero, Italy
Gift of Joseph Menosky in
memory of his wife, Diane
2007.421

650

Giovanni Levanti
Born in Palermo in 1956
Xito Chaise Longue
1999
Polyurethane foam,
polyester fibre, fabric
65 x 212 x 137 cm (back raised)
13 x 212 x 137 cm (flat)
Produced by Campeggi,
Anzano del Parco, Italy
Gift of Campeggi Company
2007.117

651

Fig. 1
Still from Denys Arcand
and Adad Hannah's video,
Safari, shot for the
Big Bang exhibition at
the Montreal Museum of
Fine Arts, November 2011
to January 2012.

651

Archizoom Associati
Active in Florence then Milan,
1966–74
Safari **Sectional Couch**
1967–68
Fibreglass, latex foam,
cotton, synthetic
leopard-print upholstery
64 x 261 x 216 cm
Produced by Poltronova,
Montale, Italy
Liliane and David M.
Stewart Collection
2004.20.1-5

652

653

654

655

656

657

652

Piero Gilardi
Born in Turin in 1942
Mela Chair
1971 (example of 2000)
Painted polyurethane foam
99 x 67 x 63 cm (approx.)
Signature and date, on
underside: *Gilardi 2000*
Gift of Joseph Menosky in
memory of his wife, Diane,
and of Shiva and Shelby,
in honour of the Montreal
Museum of Fine Arts'
150th anniversary
2010.87

653

Gruppo DAM
Milan, 1969–75
Studio Gruppo 14
Founded in Milan in 1967
Libro Chair
1970
Polyurethane foam, vinyl,
jute, steel, 12/99
78.5 x 84 x 132 cm (approx.)
Produced by Gruppo
Industriale Busnelli,
Misinto, Italy
On the jute strap:
12/99 / By Modernoriato
Gift of Joseph Menosky in
memory of his wife, Diane,
and of Shiva and Shelby,
in honour of the Montreal
Museum of Fine Arts'
150th anniversary
2010.64

654

Giorgio Ceretti
Born in Domodossola,
Italy, in 1932
Pietro Derossi
Born in Turin in 1933
Ricardo Rosso
Pratone Seating
[The Big Meadow]
**From the series
"I Multipli"**
1971 (example of 2004)
Polyurethane foam,
Guflac paint, 50/200
95 x 140 x 140 cm
Produced by Gufram,
Barolo, Italy
On front of base:
PRATONE
Liliane and David M.
Stewart Collection
2006.54

655

Jonathan De Pas
Milan 1932 – Florence 1991
Donato D'Urbino
Born in Milan in 1935
Paolo Lomazzi
Born in Milan in 1936
Joe Sofa
1970
Polyurethane foam, leather
94 x 191 x 120 cm
Produced by Poltronova,
Montale, Italy
Signatures, left, near centre
of little finger: *DePas /
D'Urbino / Lomazzi*;
at top, on little finger: [a star]
Liliane and David M. Stewart
Collection, gift of the
American Friends of Canada
through the generosity of
Eleanore and Charles Stendig
in memory of Eve Brustein
and Rose Stendig
D95.163.1

656

Archizoom Associati
Active in Florence then Milan,
1966–74
Superonda Sofa
1966
Polyurethane foam, PVC
89.5 x 237.5 x 36 cm
Produced by Poltronova
for Archizoom Associati,
Montale, Italy
Liliane and David M. Stewart
Collection, gift of the
American Friends of Canada
through the generosity of
Jay Spectre
D90.221.1a-b

657

Gianni Ruffi
Born in Pistoia, Italy,
in 1938
La Cova Sofa
1973
Sofa: polyurethane
foam, wool and cotton
upholstery, metal
Cushions: polyurethane
foam, polyester upholstery
Sofa: H. 73 cm;
Diam. 200 cm (approx.)
Cushions: 61 x 37 x 35 cm
Produced by Poltronova,
Montale, Italy
Gift of Joseph Menosky in
memory of his wife, Diane,
and of Shiva and Shelby,
in honour of the Montreal
Museum of Fine Arts'
150th anniversary
2010.63.1-4

658

659

ITALY: POP ART AND DESIGN

The appearance of Italian design on the international scene in the mid-1960s corresponded to the era when design was rejuvenating and becoming more popular, and when Pop art and plastics were of a pair. The Pop aesthetic liberated the object from all traditional canons, while plastic facilitated radical innovation. Designers and manufacturers recognized the qualities of polyurethane, a versatile material used in the manufacture of military equipment and in the auto industry, which permitted great formal freedom and yielded unusual furniture inspired by the most diverse sources 654 655.

The Turin-based firm Gufram launched the "Multipli" collection in 1967, giving carte blanche to designers, artists and architects. Piero Gilardi designed a series of prototypes for a chair/mattress produced in two versions that could be rolled up or unrolled as needed. *Flag-Chiocciola* is covered in fabric and accompanied by two straps, while *Chiocciola* is black and "decorated" with straps painted red and yellow on the polyurethane. The Museum's prototype 649 is of a unique piece that was never produced. It is made of red-painted polyurethane that has been rolled up and held in place by a yellow strap. Less known, and rather rare, it remains a major piece of avant-garde Italian design from the turn of the 1970s. In 1971, Gilardi created for Studio 65 the *Mela* chair, a prototype that is impossible to find today. He recreated the chair in 2000, at the request of American collector Joseph Menosky 652. This small child's chair represents an apple, as indicated by its name in Italian. The seat is carved out of the material, like a bite out of the apple.

The *Libro* easy chair 653 is indubitably the best-known work by Gruppo DAM (Designer Associati Milano),[1] active between 1969 and 1975. It was designed in collaboration with two architects from Studio Gruppo 14, Giovanni Pareschi and Umberto Orsoni. Its playful shape is inspired by an open book, hence the chair's name. The position of the seat for this giant book

is adjustable due to the hinge system that permits one to "turn the pages." Produced by Busnelli, this chair has ten unstretchable polyurethane "pages" covered in vinyl. The DAM group favoured the use of polyurethane without chlorofluorocarbons (CFCs).[2] The *La Cova* easy chair 657, designed by Gianni Ruffi for Poltronova, recreates the shape of a bird's nest containing three egg-shaped pillows, the brood. This sofa (or daybed) is a good illustration of the influence of Pop art in terms of the use of humour to challenge the primary meaning of the form. Ruffi explores the physical and visual properties of polyurethane, which he covers with pieces of felt evoking, with their colours and their placement, the construction of a bird's nest made of twigs. This original use of salvaged fabric recalls the practices of Arte Povera, which made an impression on Ruffi. **DC and VC**

1. Born of the association with designers Alberto Colombi and Ezio Didone. 2. Used notably as blowing agents in the foams of plastic materials, CFCs are, as we now know, the chemical compounds responsible for the depletion of the ozone layer.

GUNNAR ANDERSEN

The maxim that could well describe the *Portrait of My Mother's Chesterfield* chair 658 designed by Danish architect, artist and designer Gunnar Andersen would be "form follows material." Made of poured polyurethane, *Portrait of My Mother's Chesterfield* might evoke a traditional armchair, but in an organic, almost repulsive interpretation. Contrary to his colleagues at the time, Andersen introduced the element of chance and gambled on the process of creation, thus ensuring the individuality of each chair. The material is an unusual and noxious liquid composition of polyurethane, water and Freon, which, when exposed to the air, hardens and forms a solid foam. The liquid spills onto the ground in a dripping mud, and then it expands layer by layer, until the desired form is achieved. According to Andersen, this process recalls the concentric circles of a tree's growth.

Andersen offers an aesthetic quite far from the more Pop sensibilities of the Italians of the anti-design movement, such as Gruppo Strum or Roberto Matta 648. His chair foreshadowed the visceral sculptures of American artist Lynda Benglis who, in the late 1960s, used toxic and hard-to-handle materials, including polyurethane. Produced in just a few copies between 1964 and 1965 in the studios of the Dansk Polyether Industi in Frederikssund, the chair could be manufactured, but the fragility of the material soon became evident, essentially putting an end to its production. **DC**

CESARE LEONARDI AND FRANCA STAGI

Italian architects and industrial designers Cesare Leonardi and Franca Stagi combined their expertise in the early 1960s,[1] collaborating on several architecture, urban design and industrial design projects. They have created various products and pieces of furniture, including the most well-known, the *Dondolo* rocking chair in fibreglass-reinforced polyester 659, designed for Bernini in 1967.

Fibreglass-reinforced polyester combines resistance and lightness. Extremely versatile, it lends itself to multiple applications in architecture, furniture and transport materials. Furniture designers adopted it in the late 1940s because it enabled them to design more organic shapes, such as Charles and Ray Eames' *DAR* armchair 629. The *Dondolo* rocking chair is one of the many examples of a single-hulled chair composed of a single material created in the 1960s, the most legendary of which is the chair by Verner Panton 630. Produced from a sketch by Leonardi, the rocking chair took shape thanks to the ingenuity of Bernini technicians, who made solid the fluidity of its graphic configuration. Without the smallest decorative effect, it comes in a uniform colour—white, grey or pale blue. The contrasting surfaces, smooth on top and ridged underneath, are purely functional: on one side is comfort, on the other,

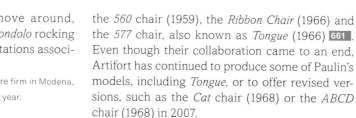

660

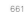

661

structural resistance. Easy to move around, eschewing legs and armrests, the *Dondolo* rocking chair unravels the traditional connotations associated with this type of furniture. **DC**

1. In 1961, Leonardi opened his own architecture firm in Modena, where Stagi became an associate the following year.

PIERRE PAULIN

French designer Pierre Paulin and the Dutch firm Artifort are icons of innovation in twentieth-century furniture each in their own right, sharing the same interest in unusual forms, new technologies and original materials. The designer's unconventional ideas drew the attention of Kho Liang Ie, Artifort's head designer, in 1958. This meeting marked the beginning of a collaboration that would persist until the early 1970s. Paulin created several emblematic seats for the firm, including

the *560* chair (1959), the *Ribbon Chair* (1966) and the *577* chair, also known as *Tongue* (1966) **661**. Even though their collaboration came to an end, Artifort has continued to produce some of Paulin's models, including *Tongue*, or to offer revised versions, such as the *Cat* chair (1968) or the *ABCD* chair (1968) in 2007.

Designed by Paulin in 1966, the *577* chair was first rejected by Harry Wagemans, Artifort's president, who tried it out and had trouble getting up. But his son and his friends were more enthusiastic. The seat, quickly nicknamed *Tongue*, met with great success as soon as it was issued in 1967, responding to the needs of young consumers who sought more explosive, innovative forms far from the conventional comforts of their parents. With its sculptural take on the form that earned it its nickname, the stackable seat is composed

of a tubular-steel frame trimmed with latex foam and covered in polyester jersey or wool. It rests directly on the ground, its shape and low height inviting the sitter to relax. The Museum's seat comes from the estate of Montreal architect Claude Beaulieu, who bought it at Montreal's Universal and International Exhibition in 1967. The jersey wool cover is original, having been chosen at the point of purchase. **DC**

658

Gunnar Andersen
Ordrup, Denmark, 1919 –
Dronningmølle,
Denmark, 1982
Portrait of My Mother's Chesterfield **Chair**
1964–65
Polyurethane
69.8 x 100.5 x 100.5 cm
Made by Dansk Polyether
Industri, Frederikssund,
Denmark
Liliane and David M.
Stewart Collection
D87.182.1

659

Leonardi-Stagi Architetti
Founded in Modena in 1962
Dondolo **Rocking Chair**
1967
Fibreglass-reinforced
polyester
76.8 x 174.9 x 40 cm
Produced by Elco, Venice
Label on left of seat rail:
ELCO / SCORZE / Made in Italy
Liliane and David M. Stewart
Collection, gift of the
American Friends of Canada
through the generosity
of Geoffrey N. Bradfield
D87.154.1

660

Olivier Mourgue
Born in Paris in 1939
Bouloum **Chaise Longue**
1968
Fibreglass, urethane foam,
steel, nylon jersey
66.1 x 76.2 x 142.9 cm
Produced by Arconas,
Mississauga, Ontario
Liliane and David M.
Stewart Collection,
gift of William Prévost
D93.257.1

661

Pierre Paulin
Paris 1927 – Montpellier 2009
577 **Chair, called** *Tongue*
1966 (example of 1967)
Steel, latex foam, jersey wool
61.5 x 88.5 x 92.5 cm
Produced by Artifort,
Maastricht, Netherlands
Liliane and David M. Stewart
Collection, gift of
Réjean Tétreault in memory
of Claude Beaulieu
2007.254

PLASTIC WEAR

— CYNTHIA COOPER —

BETH LEVINE

Beth Levine ranks among the most influential shoe designers of the twentieth century. She began her career as a foot model for a shoe company and rose up the ranks to become a designer. She went on to work for a company run by Herbert Levine, and the two married shortly thereafter, going into business together in 1948. While the firm was known by her husband's name, Beth Levine was at the design helm. Their commercially successful company increased production tenfold in the first seven years, and ran until 1976.

Beth and Herbert Levine are known for a number of footwear design innovations. Stretch boots and the Spring-o-lator sole that kept mules in place on the foot were among popular novel products.

Beth Levine felt that her partnership in an independent company allowed her to exercise a great deal of creative freedom, liberating her from the need to produce only commercially successful designs. With her strong interest in visual arts, she extended the firm's shoemaking craft to explore the potential of footwear as a medium of artistic expression. Her *No-Shoe* of 1957 consisted of only a sole with a high heel, requiring adhesive to hold it to the foot. A "Barefoot in the Grass" series from the mid-1960s featured Astroturf footbeds.

Beth Levine created the "Racing Car" series of shoes for an article in *Harper's Bazaar*, in 1967, the same year she won the Coty American Fashion Critics Award. Taking inspiration from Marshall McLuhan's statement, "The wheel is an extension of the foot," from *The Medium Is the Message*, published that year, Levine designed a series of shoes imitating cars, with headlights and transparent vinyl windshields, and some with wheel motifs. This particular pair of racing-car shoes 663 did not go into production; only two copies were made. The material is transparent vinyl, on which is appliquéd a number "1," and a vinyl border outlines a windshield at the front, with a miniature embroidered wiper. While the "Herbert Levine" label is present inside the shoe, the designer has left her mark with her name "Beth" appliquéd prominently on the outside, running in opposite directions on each shoe with flame-like motifs extending from the letters, echoed around the "headlights."

The Metropolitan Museum of Art featured a retrospective of the Levines' work during the year following the firm's closure, confirming their status as a shoe company that transcended commercial concerns to establish a significant presence within the artistic realm. CC

PACO RABANNE

Paco Rabanne is best known for his experimental "chain mail" garments from the late 1960s, although he also produced a range of clothing and accessories in other fabrics and media. A mesh structure of disks and other thin, hard geometric shapes of different types of plastic and metal, pierced and held together with metal rings, became Rabanne's iconic medium through which he reinvented women's clothing and the techniques for its construction. Rabanne's background and technique in fact place him at the intersection of fashion and jewellery design. Instead of cutting and shaping an existing textile structure, he employed an additive strategy, building fabric and garment simultaneously with a pair of pliers rather than a needle.

After earning an architecture degree at the École de Beaux-Arts in Paris, Rabanne was engaged in a family business providing the Parisian couture with buttons, accessories, jewellery and other items. In 1965, his collection of rhodoid jewellery and accessories, including earrings, hairbands and belts, led to his first recognition as an artist with both commercial and media success. In February of 1966, Rabanne held a fashion show of dresses, entitled "Douze robes expérimentales et importables en matériaux contemporains" [Twelve Experimental and Unwearable Dresses in Contemporary Materials]. With this title, Rabanne positioned himself significantly outside the realm of mainstream fashion as a nonconformist, a creator of avant-garde clothing and an artist.

The short, boxy shift silhouette fashionable in the late 1960s was ideal for such experimentation (fig. 1). If unwearable, as Rabanne claimed, the chain-mail dresses nonetheless developed a following, figuring in films like *Barbarella* and in photo shoots of actresses and pop-culture icons like Françoise Hardy and Brigitte Bardot. The instantly recognizable visual identity of his work gave Rabanne a lasting presence in the canon of 1960s futuristic designers. Although media attention waned, his chain mail continued to be made through subsequent decades. By the 1990s, Rabanne was offering kits that came in a plastic case, complete with disks, pliers and rings, enabling one to construct one's own dress.

This panel of chain-mail "fabric" 664 fits into the early phase of Rabanne's production in the late 1960s. Its metre-square dimension suggests that it may be a sample. Rather than the more typical metal rings as connectors, plastic "staples" link together the metallic plastic squares. The panel shows a simple and uniform treatment of these novel materials, before translation into items of clothing with greater complexity. CC

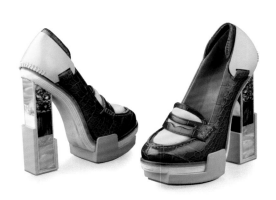

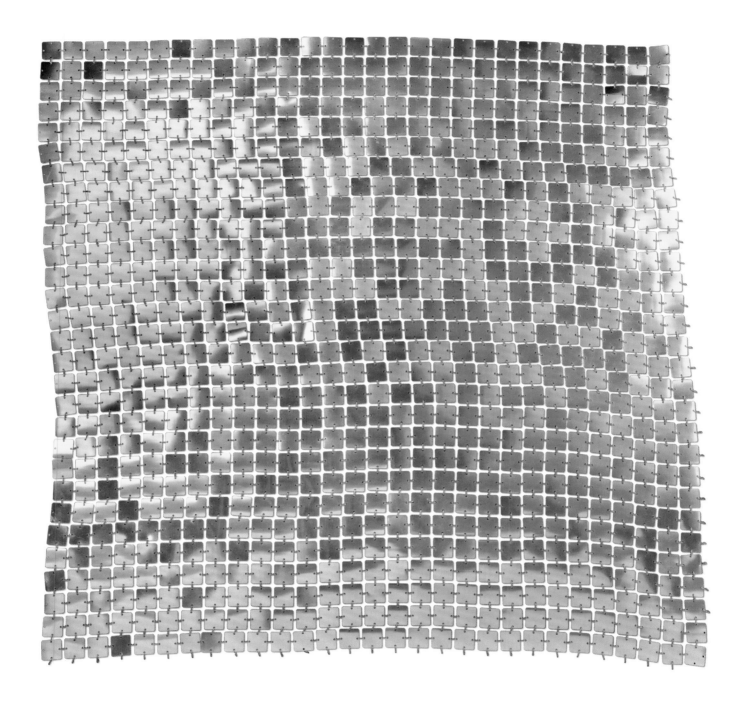

Paco Rabanne
Born in San Sebastian,
Spain, in 1934
***Chain-mail* Fabric**
About 1967
Plastic
101.6 x 101.6 cm
Produced by Paco
Rabanne, Paris
Liliane and David M.
Stewart Collection,
gift of Louise and
George Beylerian
D91.441.1

Fig. 1
Woman modelling a
Paco Rabanne chain-mail
dress, April 1967.

NIKI DE SAINT PHALLE

— DENISE DOMERGUE —

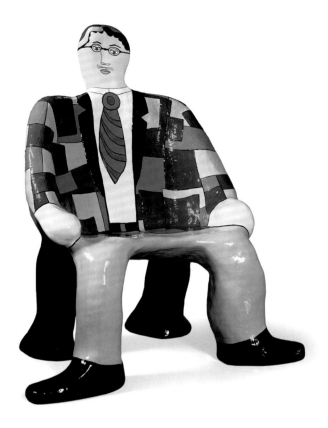

665

Best known for her monumental Nanas and the *Stravinsky Fountain* next to the Centre Pompidou in Paris (a 1982 collaboration with Jean Tinguely), Franco-American artist Niki de Saint Phalle came of age creatively during the turbulent 1960s. Largely self-taught, she fuelled her artistic output with a fertile imagination defiant of academic constraints and categorization. Her work encompassed performance, drawing, printmaking, collage, assemblage, writing, film, set design, plays, sculpture, playhouses, installations, garden follies, sculptural architecture and furniture. Every creation sprang from the same poetic, emotional source. "I bring to life my desires, my feelings, my contradictions, longings, forgotten memories, shadows, visions, from some other place," Saint Phalle said.[1] Inspiration also came from the art of Picasso, Dubuffet, Art Brut, Gaudí's Parc Güell, and the traditions of Egypt, India and Meso-America. In these cultures, she explained, "I found human figures and those of animals and fabulous creatures used for all kinds of functional and ritualistic objects. In the themes of my own work, the forms of woman or animal or man or monster recur again and again and have been adapted for everything from architectural spaces to the design of flower vases."[2]

In 1961, in psychological sync with the rebellious ferment of the times, she joined the Nouveaux Réalistes and became the only woman in a group of avant-garde artists that included Yves Klein, Arman and Jean Tinguely, who would become her second husband and collaborator. She made a notorious splash on the international art scene with her *Tirs* or "shooting paintings," which literally exploded into colour as the bullets aimed at them from a .22 calibre rifle struck hidden bags of paint embedded in the plaster reliefs. These theatrical demonstrations were her cheeky woman's answer to Jackson Pollock's cathartic action paintings. "I shot at my art because it was fun and it made me feel great. . . . I shot for that moment of magic. Ecstasy,"[3] she said.

Although magic and ecstasy continued to be incentives for Niki de Saint Phalle, her subsequent, more inner-directed sculptural work resonated with the burgeoning feminist movement in a less edgy way. With intuitive immediacy, she openly grappled with the inner demons of a traumatic childhood. She began making colourful animalia, monsters, totems and archetypal female forms out of plaster, polyester resin and glass. Because, against all odds, she was a self-described optimist, the imagery of her catharsis was exultant, communicating joyous abandon, a liberated female authenticity and primal power.

It was also in the early 1960s, for her home in Soisy, France, that the life-long furniture-making aspect of the artist's work began. Her friend

665

Niki de Saint Phalle
Neuilly-sur-Seine 1930 –
San Diego, California, 2002
Charly Armchair
1981–82
Painted polyester, 5/20
134 x 119 x 84.8 cm
Produced by Plastiques d'art
R. Haligon, Périgny-sur-
Yerres, France
Signature, on underside
of seat: *Niki / 5/20*;
and: *PLASTIQUES /
D'ART / R. HALIGON*
Liliane and David M. Stewart
Collection, gift of Esperanza
and Mark Schwartz
D91.420.1

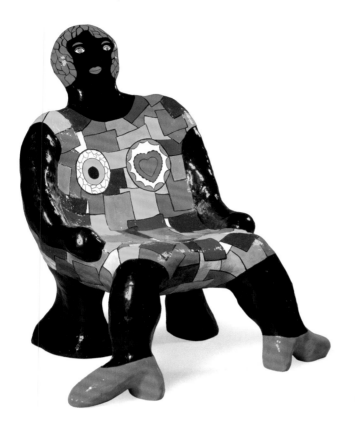

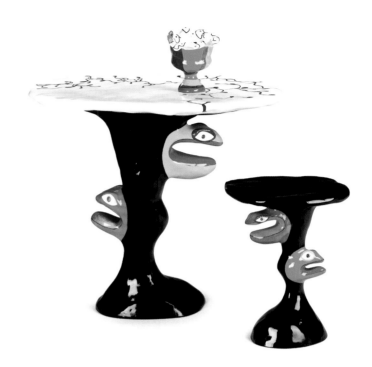

666

667

Clarice Rivers—wife of American artist Larry Rivers and subject of the *Clarice* armchair **666**—whose pregnant 1963 silhouette inspired Saint Phalle to make her first Nanas, recounts how she would personalize her environment, finding the furnishings available on the market too staid and boring. Rivers remembers Saint Phalle busily refashioning mirrors with papier-mâché and chicken wire, making "snake" chairs and vases, and populating her New York studio with animistic contrivances.

In *Traces*, her autobiography, Saint Phalle recounts how her older brother, John, placed a dead snake in her bed, eliciting the desired response of pure horror. She wrote: "I wonder if my fascination with snakes stems from then? How many snakes have I made?"[4] Serpents are indeed frequent elements in her sculptures and furniture pieces, but in her little table and stool **667** she has clearly domesticated them. The two snakes intertwined around each base have become comic, unthreatening pets, examples of Saint Phalle's psychological alchemy, the transmutation of childhood fear into whimsy.

Likewise, the *Charly* **665** and *Clarice* armchairs amiably offer up their laps, symbolic of ever-available parents. Saint Phalle said she liked the "fact that they bring to mind childhood memories of comfort or awkwardness when sitting in the lap of an adult."[5] Through her work,

she transformed pain into whimsy, and the armchairs—avuncular and maternal, respectively—serve as amusing testament to the resolution of a wistful yearning. The ferociously poetic workaholic that was Niki de Saint Phalle left an abundant, inclusive and interactive legacy for the world to enjoy.

1. Niki de Saint Phalle, *Niki de Saint Phalle – Bilder, Figuren, Phanastische Garten*, exh. cat. (Munich: Kunsthalle and Prestel-Verlag, 1987), p. 45.
2. Quoted in Martin Eidelberg, ed., *Designed for Delight: Alternative Aspects of Twentieth-century Decorative Arts*, exh. cat. (Montreal: Montreal Museum of Decorative Arts; Paris; New York: Flammarion, 1997), p. 55.
3. Niki de Saint Phalle, *Traces, An Autobiography: Remembering 1930–1945* (Lausanne: Acatos Publisher, 1999), p. 24.
4. Ibid., p. 27.
5. Quoted in Eidelberg 1997, p. 55.

666

Niki de Saint Phalle
Neuilly-sur-Seine 1930 –
San Diego, California, 2002
Clarice **Armchair**
1981–82
Painted polyester, 2/20
120 x 112.5 x 88.9 cm
Produced by Plastiques
d'art R. Haligon,
Périgny-sur-Yerres, France
Signature, on underside
of seat: *Niki / 2/20*, and:
*PLASTIQUES / D'ART /
R. HALIGON*
Liliane and David M. Stewart
Collection, gift of Esperanza
and Mark Schwartz
D91.420.2

667

Niki de Saint Phalle
Neuilly-sur-Seine 1930 –
San Diego, California, 2002
Table and Stool
1980
Polyester, paint
Table: H. 80 cm; Diam. 60 cm
Stool: H. 40 cm; Diam. 30 cm
Produced by Plastiques
d'art R. Haligon,
Périgny-sur-Yerres, France
Signature, on underside
of each piece: *Niki*; and:
*PLASTIQUES / D'ART /
R. HALIGON*
Liliane and David M. Stewart
Collection, gift of Esperanza
and Mark Schwartz
D89.202.1-2

TRANSPARENCY

— DIANE CHARBONNEAU, CATHERINE CHORENZY —

STEFAN LINDFORS

At once an architect-decorator, designer and sculptor, Stefan Lindfors is a Finnish creator working across multiple disciplines. He established his studio in 1988, and quickly made a name for himself on the international stage with the *Scaragoo* table lamp (1988), which resembles a fantastical insect, designed for the Munich-based manufacturer Ingo Maurer. The *MX 200* armchair `668`, which recalls the shape of a butterfly, is composed of steel rods welded together and clad in a membrane of semi-transparent polyester resin. With its "handmade" look, it is more akin to sculpture than furniture. It was part of a series of unique pieces made by the designer for New York's Gershwin Hotel and for a show at the Material ConneXion Gallery, also in New York, in 2000. DC

DE PAS, D'URBINO AND LOMAZZI

Milanese architects Jonathan De Pas, Donato D'Urbino and Paolo Lomazzi, who founded their architecture and design firm in 1966, soon garnered attention for their inventive, Pop-inspired furniture, such as the *Joe* sofa `655` in the shape of a baseball glove designed, in 1970, for Poltronova. Three years earlier, when the *Blow* armchair `669` caused a sensation among young consumers, the designers and manufacturer Zanotta were trailblazers.[1] The inflatable armchair would be reproduced several times over, appearing in movies and inspiring the design of similar pieces.

Made of PVC plastic, this armchair is the first inflatable piece of furniture commercially produced for home use, either indoors or out.[2] Its creation was made possible thanks to a new plastic technology, high-frequency welding, which sealed the seams and assembled the different parts of the object. It could be inflated or deflated, depending on the user's needs. Light and completely transparent, it fits into the realm of disposable ephemera associated with the culture of the time, in direct defiance of the idea of durability so entrenched in bourgeois furniture. DC

1. Zanotta has regularly re-issued the chair since its launch in 1967. **2.** Its conception is derived from rubber dinghies. About 1966–67, inflatable constructions also figured in the utopias then preoccupying architects.

SHIRO KURAMATA

With the revolutionary approach he developed in his furniture and interiors, Shiro Kuramata became a major figure of Japanese design in the mid-1960s. He invented a vocabulary at once very personal and typically Japanese. He drew inspiration from his childhood memories, but also from the mischievous irony of Marcel Duchamp's ready-mades and the minimalist sculptures of Dan Flavin and Donald Judd, without forgetting his association with Memphis, the Milan-based group of designers, from 1981 to 1983. Transcending the function of daily objects to revisit them under the banner of Surrealism and Minimalism, he ingeniously appropriated industrial materials, such as cable and steel mesh `423`, glass, aluminum and acrylic.

Kuramata started to use acrylic in 1968, but it was not until the late 1980s that he fully exploited its potential. His *Miss Blanche* chair `670` displays artificial roses floating in the acrylic. Initially created for KAGU Tokyo Designer's Week '88, the chair evokes the corsage worn by Vivien Leigh in the role of Blanche DuBois in the film adaptation of Tennessee Williams' *A Streetcar Named Desire*. After several attempts to create the illusion of flowers floating in space, the liquid acrylic was cast in moulds before the roses were positioned with the help of small tweezers.[1] The exploration of transparency and dematerialization pursued by Kuramata culminated in *Acrylic Stool (with Feathers)* `671`, in which the simple yet elegant silhouette has been imbued with poetry. In this piece it is the feathers that flutter, suspended for eternity, as though whisked away by a breeze. DC

1. The chair was produced between 1989 and 1998, in fifty-six copies.

CHRISTIAN FLINDT

Danish designer Christian Flindt's approach combines the exploration of materials with the examination of the future needs and functions of furniture and lighting. In 2004, Flindt developed various prototypes of stackable and nestable pieces of furniture, including *Between Earth and Sky* in transparent acrylic encasing Japanese grass; the *Goldilock* stools made from injection-moulded plastic; and the *Parts of a Rainbow* chairs `672` composed of

sheets of double-sided satin acrylic, which have received the most acclaim. The latter overlap laterally rather than vertically,[1] which not only makes them easy to store but also allows them to form a bench. Produced in ten colours and in a limited edition—to date, thirty-four examples have been made—they call to mind, as the name indicates, a rainbow. The semi-transparency of the material allows light to shine through and alter the colours when the pieces are side-stacked. This critically acclaimed design earned Flindt design awards from *Bo Bedre* magazine and the Copenhagen International Furniture Fair in 2005. DC and CCh

1. According to the designer, these are the first side-stackable chairs: *Parts of a Rainbow*, http://www.flindtdesign.dk/Limited Editions/PartsofaRainbow/ (accessed May 31, 2011).

PHILIPPE STARCK

French designer Philippe Starck is characterized by his technological ingenuity and his aesthetic, which flirts with silliness. A prolific creator in the areas of architecture and design, he excels at revising classic styles. Inventive and creative, his objects are also charged with emotion. For Kartell, in the late 1980s, Starck developed the first group of *Dr. Glob* stackable chairs `642` and the *Miss Balù* table `643`, pieces composed of polypropylene and steel. Then, in 1998, Starck created the *La Marie* chair, a single-moulded, translucent polycarbonate piece.

From this first experiment with transparency was born the *Louis Ghost* chair `673`, whose medallion back recalls the shape of a Louis XVI armchair `119`. The Starck armchair is injection-moulded and produced in several shades, but always translucent. The chair is comfortable, weather-proof, shock- and scratch-resistant, and stackable. Very popular with consumers for its discreet elegance, it is as easily incorporated into contemporary interiors as classic or modern settings. Since the chair's launch in 2002, Starck has created a family of "Ghost" pieces, including the *Victoria Ghost* chair (2005) and the *Charles Ghost* stool (2006), which are just as inventive. DC

668

Stefan Lindfors
Born in Mariehamn,
Finland, in 1962
MX 200 **Armchair**
2000
Steel, fibreglass-reinforced
polyester
94.5 × 87 × 82 cm
Liliane and David M.
Stewart Collection
2002.90

669

Jonathan De Pas
Milan 1932 – Florence 1991
Donato D'Urbino
Born in Milan in 1935
Paolo Lomazzi
Born in Milan in 1936
Carla Scolari
Born in Marchirolo,
Italy, in 1937
Blow **Armchair**
1967
PVC
76 × 83 × 98 cm
Produced by Zanotta,
Nova Milanese, Italy
Around both valves:
POLTRONOVA ZANOTTA
Liliane and David M.
Stewart Collection
D99.134.1a-c

670

Shiro Kuramata
Tokyo 1934 – Tokyo 1991
Miss Blanche **Armchair**
1988
Acrylic, artificial roses,
tinted aluminum pipe
94 × 63 × 64 cm
Produced by Ishimaru,
Tokyo
Liliane and David M.
Stewart Collection
D98.144.1a-e

671

Shiro Kuramata
Tokyo 1934 – Tokyo 1991
*Acrylic Stool
(with Feathers)*
1990
Acrylic, anodized
aluminum, feathers
54 × 30.9 × 40.5 cm
Produced by Ishimaru,
Tokyo
Liliane and David M.
Stewart Collection
D98.145.1

672

Christian Flindt
Born in Denmark
in 1972
Parts of a Rainbow
Side-stackable Chairs
2004
Double-sided satin acrylic
88 × 56 × 42 cm
Produced by Christian Flindt,
Denmark
Liliane and David M.
Stewart Collection
2011.175.1-3

673

Philippe Starck
Born in Paris in 1949
Louis Ghost **Armchair**
2002 (example of 2008)
Polycarbonate
92.8 × 54.3 × 56.5 cm
Produced by Kartell, Milan
On the back edge of chair:
[grid], [recycling symbol
with *PC* in the centre],
*LOUIS GHOST design
S+ARCK, by KARTELL,
MADE IN ITALY*;
on the bottom end
of back left leg: *2008/24*
Liliane and David M.
Stewart Collection
2008.24

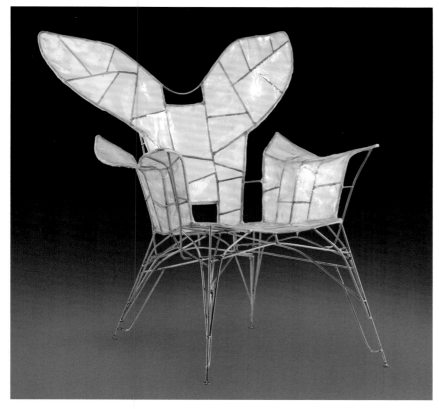

668

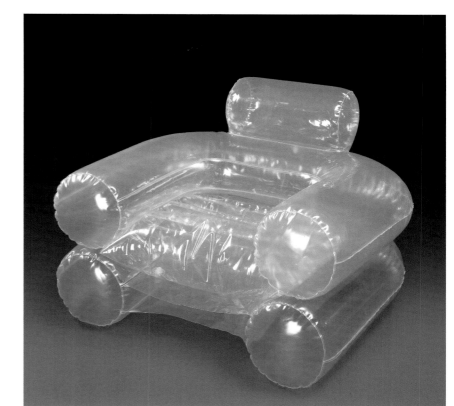

669

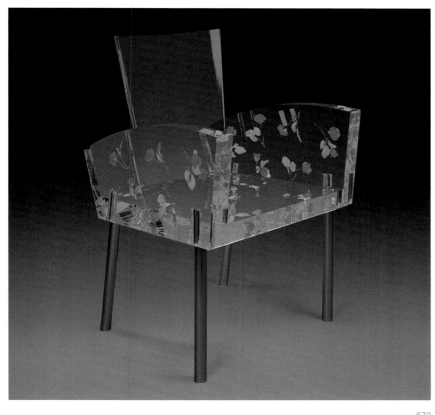

670

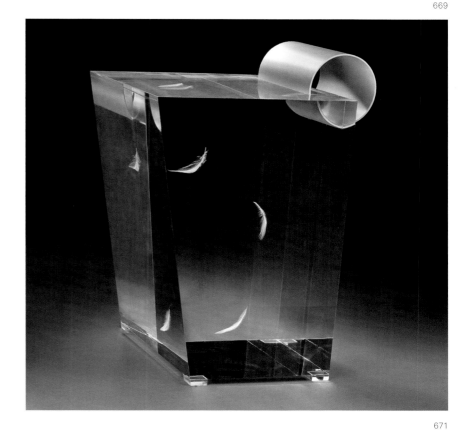

671

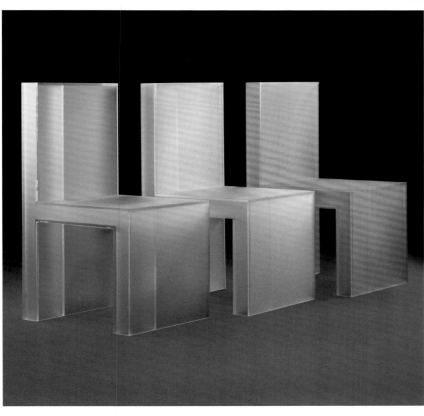

672

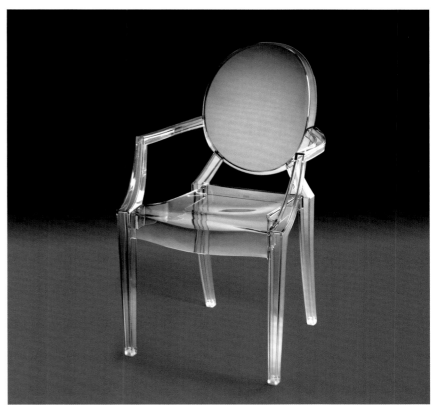

673

GAETANO PESCE

— GIAMPIERO BOSONI —

In the broad spectrum of international design, spanning the 1960s to today, Gaetano Pesce stands out for his profound and personal explorations into new materials—particularly plastics. Beyond this extraordinary and tangible engagement, Pesce's originality comes largely from his ability to interpret numerous existential questions of contemporary man and shed light on the deep anthropological truths of how we live in the world and the objects we use in it. Gaetano Pesce's conceptual experimentation with design is founded on numerous principles that had a profound impact on how his work developed: design as political—as well as a certain religious—expression, the crossroads in new languages between figuration and abstraction closely tied to his experimentation with materials, the use of feminine and masculine traits to drive design, the exaltation of the senses, the dialectics between Beauty and Ugliness, and, above all, Gaetano Pesce's particular fascination for the personalized series. This idea, as Fordist as it is Marxist, seeks to turn the concept of the serially made product, with every unit being the same, on its ear, allowing instead for the concept of diversified production. This idea is the innovative keystone to Pesce's approach to industrial design.

Born in La Spezia in 1939, Gaetano Pesce spent his formative years in Padua and Florence. His vocation as an artist presented itself early in life. Between 1959 and 1967, Pesce worked as an avant-garde artist and independent filmmaker and was a founding member of Gruppo N, a collective dedicated to furthering the concept of kinetic and serial art. Group N worked with Gruppo T in Milan, Paris' Groupe de Recherche d'Art Visuelle and Group Zero from Germany. It was his partner in art—and life—Milena Vettore who convinced Pesce to attend Venice's Istituto Superiore di Disegno Industriale, where he received his degree in 1965, and where Franco Albini, Carlo Scarpa and Ernesto Nathan Rogers, among others, were teaching.

Another important turning point in this period was his and Vettore's meeting with entrepreneur Cesare Cassina in 1964, who would introduce Pesce to the hitherto unknown world of industry; "a world that is not romantic, in the sense that art is still linked to a past historical moment[1]."

The first phase of his experiments with design began with the vacuum packing of polyurethane foam, which led to the "Up" series (1969) **681** of padded seating for C & B (Cassina & Busnelli, from 1966–1973, then B & B). These experiments carried out with Francesco Binfaré, the head of technological innovation at Cassina, led to the opening of the Centro Richerche Cesare Cassina in 1969–70. Now with a flexible and high-quality research laboratory at his disposal, Gaetano Pesce went on to imagine several more designs, including the *Golgotha* chair (1972), the *Sit Down* armchair and ottoman (1975), the *Dalila* [Delilah] series of chairs (1979–80), and the *Sunset in New York* sofa (1980) **682** . The *Sansone* [Samson] table (1980) **680** also dates from this period. Made from cast

polyester resins, this was a table "which the workers had to make, not me. They had to decide on the colours, they had to decide on the outline. The creativity that had been stifled by the Ford or Soviet concept of industry had to be brought out in this case."[2] Pesce moved his home and work from Venice to Helsinki, and shortly thereafter to London and Paris (1972–73). It was in 1972 that he joined with Cassina, Binfaré and Mendini in establishing a small centre for experimental production called Bracciodiferro [Iron Arm]: "a periscope to help see far," where they would start to produce the *Golgotha* chair, the *Moloch* desk lamp, and the stuffed glove-shaped armchair *Guanto*.

In the early 1970s, Pesce was recognized as one of the leaders in Radical Design. He took part in the exhibition *Italy: The New Domestic Landscape* at New York's Museum of Modern Art in 1972, presenting a series of "archeological documents" for an imaginary settlement from the "plague era." Then, in 1975, the Palais du Louvre's Musée des Arts décoratifs dedicated a show to Pesce entitled *Le futur est peut-être passé?* [Maybe the Future Is Over?]. Pesce moved to New York in 1980, and for the next few years threw himself into teaching (at Cooper Union, Yale, Université du Québec à Montréal). Throughout the years, in addition to his ongoing design experiments with studio prototypes, Pesce also established important collaborations with Italian entrepreneurs such as Bernini, Zerodisegno and Meritalia. With Bernini, Pesce created numerous products, including the *543 Broadway* series of chairs **675** , which feature a back and seat in polyurethane resin, splashes of colour that are never the same from one chair to the next, and a thin frame of iron bars rising from strange, springed feet that act as shock absorbers. It was in 1995 that Pesce founded the Fish Design agency in New York (closed in 1999 and then revived in Milan in 2003). Fish Design produced housewares in limited editions—"a polyhedric collection of artifacts"[3]—using coloured resins after his drawings, including the *Amazonia* vases **674** . Sticking to this path, Fish Design proposes to speak to the "uniqueness as the evolution of the standard. Of the humanity of the defect, of its beauty, of joy, of tactility, of sensuality, of sympathy, of elasticity, of colour, of femininity, of innovation."[4]

1. Interview with Gaetano Pesce on http://www.educational.rai.it/lezionididesign/.
2. Giampiero Bosoni, "Conversazione con Gaetano Pesce," in *Made in Cassina* (Milan: Skira, 2008), p. 277; English ed. "A Conversation with Gaetano Pesce," in *Made in Cassina* (Milan: Skira, 2008), p. 276.
3. "Chi siamo – Gaetano Pesce, 2004," on the website: www.fish-design.it (Who We Are), Gaetano Pesce, 2004.
4. Ibid.

674

Gaetano Pesce
Born in La Spezia,
Italy, in 1939

Amazonia Vases
1995
Polyurethane resin
26.7 x 27 x 27 cm
Produced by Fish Design,
New York
On underside of top rim:
FISH / DESIGN / 264
Liliane and David M.
Stewart Collection
D95.207.1-2

675

543 Broadway Chair
About 1990–93
Polyurethane resin,
stainless steel, nylon
74.3 x 56 x 40 cm
Produced by Bernini,
Ceriano Laghetto, Italy
On underside of seat:
DES. GAETANO PESCE
[manufacturer's logo]
BERNINI ITALY
Liliane and David M.
Stewart Collection
D98.160.3

676

Greene Street Chair
1984
Fibreglass-reinforced
polyester, stainless steel
94.3 x 54.3 x 57.6 cm
Produced by Vitra,
Weil am Rhein, Germany
Liliane and David M.
Stewart Collection
D90.112.1

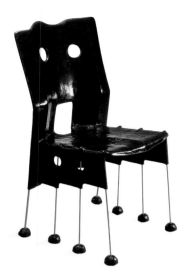

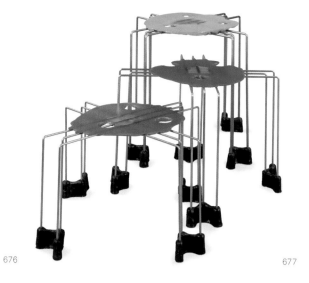

676

677

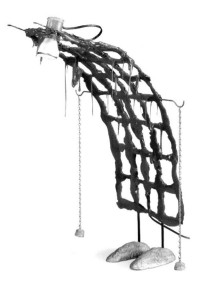

678

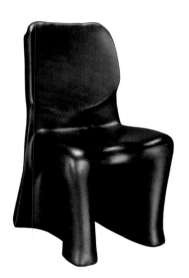

679

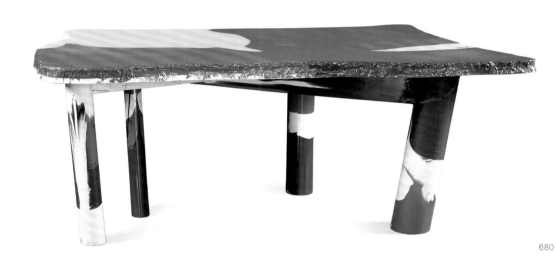

680

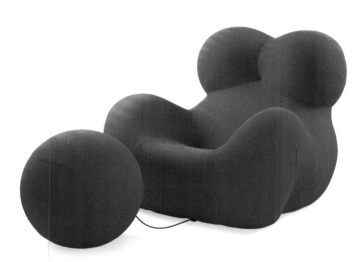

681

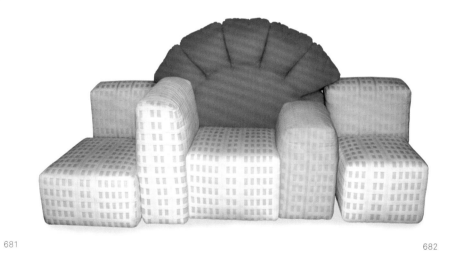

682

677

Triple Play **Nesting Tables**
1995
Polyurethane resin,
steel, rubber, 39/1000
38.2 x 42.3 x 44 cm (yellow)
31.2 x 43.3 x 42 cm (blue)
24.2 x 42.1 x 42.1 cm (red)
Produced by Fish Design,
New York
Liliane and David M.
Stewart Collection
D95.208.1-3

678

Verbal Abuse **Table Lamp**
1993
Polyurethane resin, lead,
graphite fishing poles, steel
65 x 37 x 63 cm
Prototype produced by
Fish Design, New York
Liliane and David M.
Stewart Collection
D98.169.1

679

Dalila Uno **Chair**
1980
Hard polyurethane resin,
epoxy resin
85.5 x 49 x 55 cm
Produced by Cassina,
Meda, Italy
Liliane and David M.
Stewart Collection
D97.165.1

680

Sansone **Table**
1980
Polyester resin
77.5 x 190.8 x 117.5 cm
Produced by Cassina,
Meda, Italy
Liliane and David M.
Stewart Collection,
by exchange
D91.416.1

681

La Mamma **Armchair**
and *Up 5* **Ottoman**
From the series "Up"
1969 (examples of 1984)
Polyurethane foam,
viscose, nylon, Lycra
Armchair:
100 x 113.7 x 125.1 cm
Ottoman: Diam. 59.1 cm
Produced by B & B Italia,
Novedrate
Liliane and David M.
Stewart Collection,
gift of B & B Italia
D84.179.1-2

682

Sunset in New York **Sofa**
1980
Polyurethane foam,
Dacron, plywood, metal
116.9 x 231.7 x 90.9 cm
Produced by Cassina,
Meda, Italy
Liliane and David M.
Stewart Collection
D91.415.1a-j

ALCHIMIA AND MEMPHIS

— GIAMPIERO BOSONI —

In the winter of 1980–81, an international group of young architects and designers, all under the age of thirty, united around Ettore Sottsass and drew inspiration from a Bob Dylan song—"Stuck Inside of Mobile with the Memphis Blues Again"—to put a name to their ideas ("an urgent need to reinvent an approach to design, to plan other spaces, to foresee other environments, to imagine other lives"[1]), thus laying down the basis of a revolution in the language of design: the Memphis phenomenon was born. The group initially comprised the following members from the very start: Michele De Lucchi, Aldo Cibic, Marco Zanini, Matteo Thun, Martine Bedin, George Sowden, Nathalie du Pasquier and Barbara Radice, who would go on to become Memphis' artistic director. Over the next eight years, many other collaborators, some still green and others veterans, would join the original cell.

Some months later, on September 18, 1981, upon the occasion of Milan's Twentieth Salone Internazionale del Mobile, the group unveiled its first furniture collection in the Arc '74 showroom. Memphis' first exhibition of highly coloured, decorated, totem-like (for example, Ettore Sottsass' *Carlton* bookcase **685** and, the following year, Masanori Umeda's *Ginza Robot* cabinet **688**), fun, provocative, anti-modern, eccentric and radical furniture and objects was a milestone in the history of design that coherently crystallized the most innovative trends defining that decade's Nuovo Design.

In order to put the Memphis phenomenon into historical context, the fundamental principles behind Radical Design in the 1960s must be looked at—see the wardrobe **690** designed by Sottsass in 1966 for an example. We must also take into consideration key factors in the pre-Memphis period that would prove significant, including the work of Sottsass and Branzi, who in 1977–78 designed a furniture and lighting line for Croff Casa (a large furniture chain) that very much foreshadows Memphis designs, and later on, the collaboration of Sottsass, Branzi, De Lucchi, Mendini and Navone in 1979–80 with Studio Alchimia, which would prove to be a trial run for the future Memphis collective. In fact, it was during this period—in 1979—that Sottsass designed *Le Strutture Tremano* [The Trembling Structure] table **687** . However, it soon became apparent that Sottsass and Mendini espoused different artistic visions, diverging on the relationship between avant-garde design and pure artistic exploration, as well as on the question of mass production versus the creation of artistic prototypes for an elite group of collectors. It was this conflict that brought about a split with Alchimia, and led to the idea of a collection based on new principles, especially in terms of production.

One of Memphis' most significant innovations, perhaps the major contribution it made to changing the look of contemporary furniture altogether, was the introduction of plastic laminates—especially decorative laminates—into the group's designs.

"The story of this project," recalls Ettore Sottsass, "really dates back to the mid-1970s. The person that helped motivate these encounters was Guido Jannon, who at the time was responsible for promoting and updating the colour catalogue for Abet Print [the same laminate manufacturing company that made all the decorative laminates used by Sottsass and other Memphis designers]. . . . At the time, I was designing furniture [series of wardrobes **690** designed by Sottsass in 1966] painted with vertical stripes, and from this starting point came the first laminates decorated with pinstripes, like the ones on shirts."[2] Fifteen years later, when Memphis was taking its very first steps, the idea was still alive and kicking: "The basic idea was clearly to respond to the necessity of giving the object a sensorial quality, to move beyond that long-held notion that the surface is a mathematical, intellectual and logical thing, and once again embrace the idea that the surface corresponds to a material—to matter. This type of decoration—like the Bacterio pattern, for example [see the bases of the *Carlton* bookcase and the *Tahiti* table lamp **684** , both designed by Sottsass in 1981]—was none other than an attempt to transform the surface of an object into something quite different. Virtually all of the first decorative elements were taken from Letraset transfers [see the *Kristall* end table **683** designed by Michele De Lucchi in 1981]: they were not strictly speaking decoration, but rather small neutral accents to make the surfaces more vibrant, to take them in another direction. And that's probably why plastic laminate is still the main thing that people remember from the early Memphis period."[3]

In 1988, when Ettore Sottsass sensed that the enthusiasm and zeal of the first few exploratory years was waning, he declared the death of Memphis. As a symbolic gesture to mark the end of this cultural phenomenon, he proposed inviting the international press to take part in a huge bonfire to burn the Memphis pieces that remained in storage. However, president Gismondi[4] preferred to preserve this design (and business) legacy, and pass the Memphis baton on to others who might be interested in continuing the story: Memphis would be acquired by the Post Design Gallery in 1996.

1. Barbara Radice, *Memphis, Ricerche, esperienze, risultati, fallimenti e successi del Nuovo Design* (Milan: Electa, 1984), p. 23; English ed.: Barbara Radice, *Memphis: Research, Experiences, Results, Failures, and Successes of New Design* (New York: Rizzoli, 1984), p. 23.
2. From an interview between Giampiero Bosoni and Ettore Sottsass about Memphis' use of assorted decorative laminates, in Giampiero Bosoni and Fabrizio Confalonieri, *Paesaggio del design italiano 1972-1988* (Milan: Edizioni di Comunità–Mondadori, 1988), p. 120.
3. Ibid.
4. It is not by chance that, after the initial idealism and utopian visions faded and the time came to launch the company, Ernesto Gismondi, already head of the renowned lighting company Artemide, came aboard the Memphis rocket as president and major shareholder.

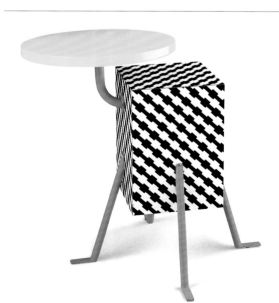

683

Michele De Lucchi
Born in Ferrara in 1951
Kristall **End Table**
1981
Plastic laminate,
lacquered wood, metal
61 x 55 x 53 cm
Produced by Memphis,
Milan
Liliane and David M.
Stewart Collection
2002.86

684

Ettore Sottsass
Innsbruck, Austria, 1917 –
Milan 2007
Tahiti **Table Lamp**
1981
Enamelled metal,
plastic laminate
63 x 10 x 41 cm
Produced by Memphis, Milan
Liliane and David M.
Stewart Collection
D99.168.1

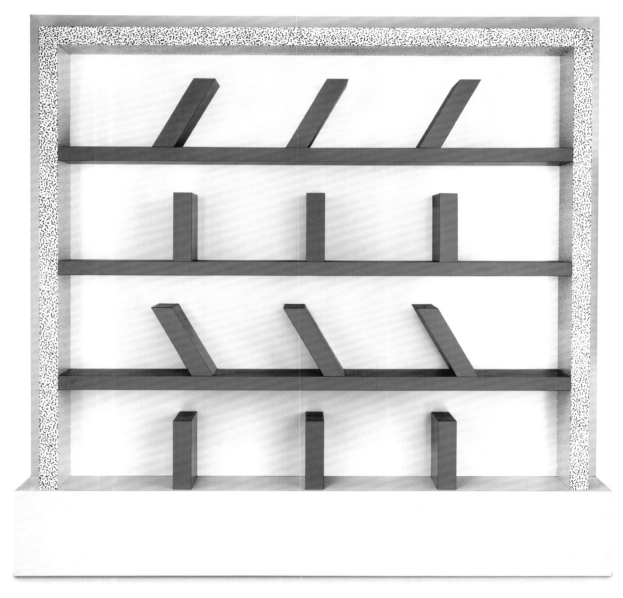

686

687

688

685

Ettore Sottsass
Innsbruck, Austria, 1917 –
Milan 2007
Carlton Bookcase
1981
Wood, plastic laminate
197.5 x 190 x 40 cm (approx.)
Produced by Memphis,
Milan
Gift of Mieczyslaw and
Jadwiga Marcinkiewicz
2008.193

686

Ettore Sottsass
Innsbruck, Austria, 1917 –
Milan 2007
Suvretta Bookcase
1981, No. 17
Wood, plastic laminate
(Abet Laminati)
199.4 x 204.5 x 35 cm
Made by Renzo Brugola
for Memphis, Milan
Metal label, on back:
*MEMPHIS / MADE IN ITALY
MILANO / ETTORE
SOTTSASS / 1981, No 17*
Gift of John C. Waddell
D96.156.1

687

Ettore Sottsass
Innsbruck, Austria, 1917 –
Milan 2007
Le Strutture Tremano Table
[The Trembling Structure]
From the series "Bau.Haus I"
1979
Wood, plastic laminate,
enamelled steel, rubber,
glass
116 x 50.3 x 50.3 cm
Made by Kumewa for
Studio Alchimia, Milan
Gift of Joseph Menosky in
memory of his wife, Diane,
and of Shiva and Shelby,
in honour of the Montreal
Museum of Fine Arts'
150th anniversary
2010.73.1-2

688

Masanori Umeda
Born in Kanagawa,
Japan, in 1941
Ginza Robot Cabinet
1982
Wood, plastic laminate
170 x 150 x 42 cm
Produced for Memphis,
Milan
On underside:
*Ginza / ein Masanori
Umeda-Kabinett*
Metal label, on back:
*MEMPHIS / MADE IN ITALY
MILANO / MASANORI
UMEDA / 1982, N° 01*
Liliane and David M.
Stewart Collection
D99.170.1-3

689

690

689

Alessandro Mendini
Born in Milan in 1931
Alessandro Guerriero
Born in Milan in 1943
Bookcase
"Ollo" Collection
1984
Wood laminate, painted wood
220 x 24 x 43.1 cm
Made by Consorzio
Esposizione Mobili for
Studio Alchimia, Milan
Gift of Joseph Menosky
in memory of his wife, Diane,
and of Shiva and Shelby,
in honour of the Montreal
Museum of Fine Arts'
150th anniversary
2010.80

690

Ettore Sottsass
Innsbruck, Austria, 1917 –
Milan 2007
Wardrobe
1966 (example of 1988)
Plywood, plastic laminate,
chromed steel
215.3 x 83.8 x 83.8 cm
Produced by Renzo
Brugola, Milan
Liliane and David M.
Stewart Collection,
gift of Paul Leblanc
D90.207.1a-b

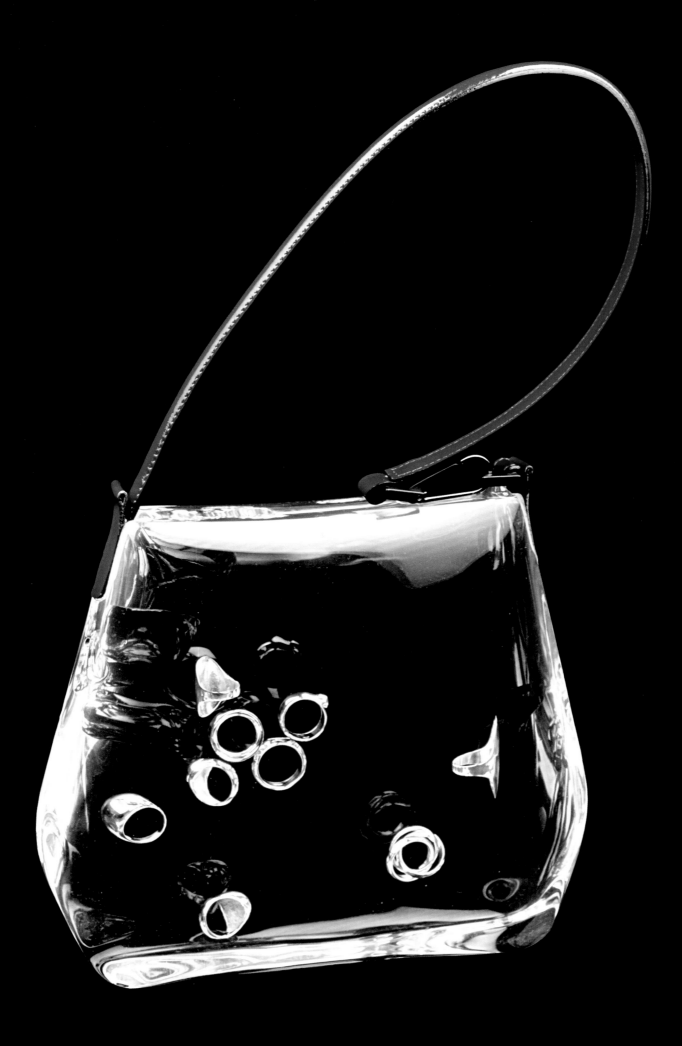

691

CONTEMPORARY
JEWELLERY

— DIANE CHARBONNEAU, VALÉRIE CÔTÉ, TONI GREENBAUM —

TED NOTEN

Not your typical jeweller, Dutch designer Ted Noten was a bricklayer and psychiatric nurse before first learning about jewellery-making from an itinerant metalsmith while on a trip to Greece. He attended the Academy of Applied Arts in Maastricht, the Netherlands, and then the prestigious Gerrit Rietveld Academie in Amsterdam, where he graduated in 1990 at the age of thirty-four. His works fall somewhere between nostalgia and playful disregard for social conventions, as he invariably seeks to undermine the power of the status symbol. He imbues his pieces with irreverent humour and political commentary. Consistent in life, as in art, his business invoices have been known to state: "Ted Noten is a disgrace."[1]

Noten is a provocateur with radical opinions about jewellery. He declares in his Manifesto: "Contemporary jewellery is dead . . . an illusion . . . autistic . . . superfluous."[2] He admonishes jewellery to "forget the psychoanalysis of the studio . . . [to] be shamelessly curious. . . to attack and neglect its defenses . . . [to] use traditional codes in order to break them . . . [to] ignore all prescription."[3] That is just what he has done with his cast acrylic jewellery, sculpture and "handbags," in which found objects, such as a dead mouse wearing a pearl necklace, a gun, medical equipment, or a jeweller's tools, are embedded, as though in suspension.

The *I Love Modern Rings But I Hate Wearing Them* handbag `691` exemplifies Noten's iconoclasm along with his ambivalence towards jewellery, as aptly defined by the title. He often uses rings in his works, emotionally charged symbols as well as simply tiny objects of beauty. These particular rings were purchased from the Bijenkorf department store in Amsterdam, one of the oldest upscale emporiums in the Netherlands. At the time the piece was made, in 1998, it represented a huge expense for Noten. By "freezing" these high-end goods, en masse, in clear acrylic, Noten immortalizes them, but also places them in a common context, removing their mystique. He "doesn't so much query the symbol itself as our perception of it. . . . He debunks their essence, then reinvents them back into reality. In affecting and infecting symbolic values he actually reveals their unmistakable intangibility."[4] **TG**

1. Mijke van Welsenes, "Having a Laugh about Dutch Design with Ted Noten," in *Made in Holland*, http://hollandtrade.com/search/ShowBouwsteen.asp?bstnum=2836&location=%2Fsearch%2FShowResults%2Easp%3Ftekst%3Dted%2Bnoten%26sortering%3DPublicatiedatum%2BDESC&highlight=ted noten (accessed July 17, 2010). **2.** Gert Staal, *CH2=C(CH3)C(=0)OCH3 Enclosures and Other TN's*, exh. cat. (Rotterdam: 010 Publishers and Museum Boijmans van Beuningen, 2006), pp. 113–115. **3.** Ibid., p. 116. **4.** Ibid., unpag.

SUSANNA HERON

For the greater part of a forty-five-year career, English conceptual artist Susanna Heron has experimented with jewellery's dynamic potential to extend the body in motion by using tilted planes encroaching on space. After studying jewellery-making as a teenager in her native Cornwall with British artist and jeweller Breon O'Casey, Heron went on to graduate from the Central School of Art and Design in London. In the late 1960s, she was greatly influenced by the revolutionary body pieces made by Gijs Bakker and Emmy van Leersum in the Netherlands, along with dance costumes of the 1930s by Bauhaus visionary Oskar Schlemmer for *Triadisches Ballett* [Triadic Ballet] and, particularly, *Slat Dance*, as well as designs by French artist Sonia Delaunay. Since then, Heron has become a prominent member of the British avant-garde in jewellery.

From her earliest investigations, Heron has explored different types of plastic as a medium that could offer suitable rigidity, translucency and colour. Her "Jubilee" neckpieces were made from acrylic and resin to mark the Victoria and Albert Museum's Jubilee exhibition, in 1977. In the catalogue for her *Bodywork* exhibition, held at London's Crafts Council Gallery in 1980, she stated: "[T]he V&A show gave me an opportunity to see how wide I could make a flat circle without it becoming unwearable. The bright resin lines are intended to unbalance the pieces visually."[1]

The *Neck-curve* neckpiece `692`, a seminal piece in the Museum's collection, grew out of the "Jubilee" pieces as well as broader experimentation with cardboard spirals. Heron and her husband, photographer David Ward, were doing a fellowship in the United States for most of 1978, the year this neckpiece was made. An array of exciting plastics was readily available in America, allowing her to cut asymmetrical "comma" shapes from flat sheet that, when slightly twisted, sat comfortably on the neck and chest. In order to define the shape further and add punch, Heron spray-painted the edge. "Shape, colour, light, aperture," she said of the Neck-curves, "out they come like gunshots—bang, bang, bang. Statements of 'modern' thought and response."[2] **TG**

1. Susanna Heron, quoted in Sarah Osborn, *Susanna Heron: Bodywork*, exh. cat. (London: Crafts Council Gallery, 1980), p. 11. **2.** Ibid, unpag.

PETER CHANG

Although he is the creator of mind-blowing bracelets and brooches, British artist Peter Chang came to jewellery not as a goldsmith but as a trained graphic designer and sculptor. The son of an English mother and Chinese father, he spent his formative years in the 1960s studying in Liverpool, Paris and London. His output, whether painting, works on paper, sculpture, furniture, tabletop objects or jewellery, has been consistently informed by the Surrealism of renowned English painter and printmaker Stanley William Hayter, with whom he studied at the latter's Atelier 17 in Paris. To this background add Chang's personal brand of bizarre biomorphism, his take on the flash of Liverpool's vital Chinatown and homegrown Beatles music, mixed with the riotous psychedelic visuals of the 1960s, and one grasps what is behind the bombastic explosions of colour and wildly proportioned formats that are Peter Chang's jewels.

Chang begins with hand-carved wood or polystyrene foam cores, to which he adds layers of polyester resin mixed with fibreglass. He then applies acrylic and uses heat to mould the piece into shape. The surface is often cut away, so that he may insert bits of plastic that he recycles from common items such as toothbrushes, rulers and pens.[1] Chang loves plastic because it is anonymous and expresses our age of expendability: "I like the irony of making a permanent statement . . . an object to last, from materials designed to be thrown away."[2]

This bracelet `693`, packed with metamorphic symbolism and contradiction, speaking of both the organic and synthetic, is a superlative example of Chang's aesthetic. It boasts red and yellow, typical Chinatown colours as well as nature's warning hues, along with the fractured images the jeweller so loves—he has always been fascinated by mathematical patterns occurring in nature, such as honeycombs or the complex tracery of a fly's optical system.[3] The overall triangular form, whose tessellated surface recalls the work of Catalan architect Antoni Gaudí, is based on a recurring motif that suggests a serpent's head at the top. The effect is, nonetheless, softened by the bracelet's rounded corners. **TG**

1. Clare Henry, "Sculptor? Jeweller? Designer? Craftsman?," in *Peter Chang: Jewellery, Objects, Sculptures* (Stuttgart: Arnoldsche, 2002), p. 124. **2.** Peter Chang, artist's statement, www.peterchang.org (accessed June 1, 2010). **3.** Alyson Pollard, "Fascination with Color," in *A Life in Plastic*, exh. cat. (Liverpool: National Museums, 2010), excerpt from website: http://www.liverpoolmuseums.org.uk/walker/exhibitions/peterchang/life_in_plastic.asp (accessed June 1, 2010).

RAMÓN PUIG CUYÀS

Spanish jeweller Ramón Puig Cuyàs was educated at the Massana School in Barcelona, an institution where he now heads the prestigious jewellery program. He spent his formative years in a small beach town on the Costa Brava. As a child, he would observe fishermen returning from the sea with treasure troves of archeological wonders and brilliant red coral, "extracted from the deep waters, from dark underwater caves, from the 'other world.'"[1] Indeed, his enigmatic jewellery exists somewhere between dreams and reality.

In 1984, Puig Cuyàs began working with silver and painted Perspex, depicting colourful anthropomorphic figures inspired by mythological creatures, particularly those connected with the ocean, such as mermaids, fish or starfish. He thinks metaphorically. To him, water connotes lightness and spontaneity, the states achieved through swimming: motion is suggested in the S-curve of a mermaid's arms and curved lower body. To the present day, such symbols return consistently in Puig Cuyàs' oeuvre.

A true romantic, Puig Cuyàs often creates pieces in response to personal occurrences in his life, both joyful and sad. *The Choral Mermaid* `694`, an exquisite brooch in the Museum's collection, is part of a group of works commemorating happiness at the birth of his first son. The jeweller

wished to liken childbirth to the legend of the mermaid, a life coming from the sea, emanating out of a deep "fossil memory." He envisioned the brooch as a "sacred object" or, even more so, a "small toy"; nonetheless, Puig Cuyàs describes it also as something of a private joke in the substitution of plastic for natural material.[2] Puig Cuyàs wished to suggest his beloved coral through the use of Formica's red ColorCore, an industrial plastic he acquired through the generosity of American jeweller Robert Ebendorf. Puig Cuyàs welcomed this material for its brilliant colours, as only dull greys were available in Spain at that time. **TG**

1. Ramón Puig Cuyàs, email to Toni Greenbaum, March 15, 2010. **2.** Martin Eidelberg, ed., *Designed for Delight: Alternative Aspects of Twentieth-century Decorative Arts*, exh. cat. (Montreal: Montreal Museum of Decorative Arts; Paris and New York: Flammarion, 1997), p. 259.

BARBARA STUTMAN

For over a decade, Montreal jeweller Barbara Stutman has been known for her staunch feminism. Her necklaces, brooches, rings and earrings have touched on such subjects as rape, childbirth, and male obsession with breasts, to name a few. Her chosen techniques, the typically female practices of knitting and crocheting, have infused her subversive narrative of cultural issues facing modern women with an irony that is fundamental to her oeuvre.

Stutman learned to knit and crochet as a child from a beloved grandmother who, incidentally, wore dramatic jewellery. After studying the work of jewellers Mary Lee Hu and Arline Fisch—American masters of using textile techniques in metalwork—Stutman adapted their processes to suit her own personal aesthetic. Her education in art history and anthropology, along with extensive travels and intelligent outspokenness, are constants in her output, which often contains coded messages, as in the "Royale" piece 696 . Stutman had visited India, and the extravagantly excessive jewels worn by the maharajahs and other members of the court, seen in a panoply of royal portraiture, deeply affected her. Large colourful stones, bright high-karat gold and multiple layers of enormous bracelets, rings, neck and headpieces led Stutman to contemplate the very nature of preciousness and opulence.

Stutman surely displays a reverence for the astounding beauty, extravagance and craftsmanship of Indian jewellery in her appropriation of its large-scale and glowing colours. On the other hand, she chooses commonplace materials—hot-pink vinyl lacing for the bracelet's cuff, topped by a huge "stone" fashioned from lavender and green anodized copper threads and peppered with tiny glass beads. Stutman questions the very concept of worth in the "Royale" series by inventing "visually rich pieces whose value does not depend on the presence of gold, platinum or actual gemstones."[1] **TG**

1. Artist's statement, n.d. (MMFA Archives).

LILY YUNG

Having completed her doctorate in immunology in Edmonton, Canadian jewellery designer Lily Yung, born in Hong Kong, took up printmaking and jewellery-making in the 1980s. Her imagination and formal approach led her to create one-of-a-kind and limited-edition pieces in such materials as stainless steel, copper, felt and plastics. At first, her pieces were crafted through assembly or textile techniques like crochet. Then, in 2005, her output changed radically after receiving a grant from the Artists-in-Residence for Research (AIRes) program[1] and a residency at the National Research Council of Canada's Integrated Manufacturing Technologies Institute in London, Ontario.[2] Lily Yung then turned her attention towards the plasticity afforded by new industrial materials as well as the application and development of new manufacturing technologies. Using Rhino-3D software as a design tool, she explored different rapid-prototyping processes to create jewellery that easily catered to her clientele's tastes. The *Triovoid* bracelet 697 was produced using a ZCorp 3D colour printer. This piece with "microbiological" motifs calls to mind the designer's academic studies. **DC**

1. The AIRes program is co-financed and administered by the Canada Council for the Arts and the National Research Council. These grants are intended to foster collaboration and exchanges between artists and researchers in sciences and engineering. **2.** This organization contributes to developing the Canadian manufacturing industry.

BEPPE KESSLER

In the mid-late 1970s, Dutch artist Beppe Kessler attended the prestigious Gerrit Rietveld Academie in Amsterdam, where she specialized in textile design. She also became a skilled painter, as evidenced in the sensitivity to colour, shape and texture shown in the textiles she designed for industrial production, as well as in jewellery, her eventual medium of choice. The materials and format found in Kessler's oeuvre have been extremely varied over the course of her career. By her own admission, process is of paramount importance to lead her to the perfect ingredients with which to complete each piece—examples have included precious and semi-precious metals and stones, exotic woods, PVC, acrylic fibre, push-pins, foam, alabaster, fabric and paint. Captivated by texture, Kessler has been known to burn or sand a surface in order to achieve the desired result.

Kessler views herself as a painter who makes jewellery, stating, "my work moves between the functional and the autonomous. . . . Ideas for collars have been generated by painting. . . . By being cut in a way which has a logical bearing on its presentation, the picture becomes a collar."[1] German art historian Antje von Graevenitz has justly pointed out that jewellery's links with sculpture are far more palpable than with painting.[2]

Kessler's painted collars relate strongly to both disciplines. Her mature body pieces from the late 1980s, of which this neckpiece 698 of about 1987 is a prime example, are reminiscent of Dutch "Wild Painting" of about the same period, combined with spatial concerns. The thick brushstrokes are at the forefront of the piece, camouflaging the body beneath, which is treated as simply an armature for display of the piece, verging on costume.[3] **TG**

1. Beppe Kessler, artist's statement in *Point of View: Dutch Contemporary Jewelry and Design*, exh. cat., ed. Charon Kransen (New York: MonkeyCat Books, 1990), p. 36. **2.** See Antje von Graevenitz, "Communicating Mentalities: A Rhetoric of Dutch Jewelry 1950–2000," in *Jewels of Mind and Mentality: Dutch Jewelry Design 1950–2000*, ed. Yvònne G.J.M. Joris (Rotterdam: Het Kruithuis and Museum of Contemporary Art, 's-Hertogenbosch, 2000), p. 34. **3.** Ibid, p. 35.

YAEL KRAKOWSKI

Israeli-born Canadian jewellery designer Yael Krakowski began working with gold and silver while studying at the Belzalel Academy of Art and Design in Jerusalem. She made elaborate pieces in metal, but also explored the possibilities suggested by less common materials like rubber, paper, nylon thread and glass beads. Painstakingly crafted over long periods of time, her designs feature the union of like elements and the harmony of colour. She employed the crocheting technique for her *Gummi* necklace 699 , in which hundreds of coloured rubber elastics are attached to a ring of polyester thread. Although Krakowski makes use of modest materials, the sensual integrity of her pieces is in no way compromised. **DC and VC**

691

Ted Noten
Born in Tegelen,
Netherlands, in 1956
*I Love Modern Rings But
I Hate Wearing Them*
1999
Acrylic, leather, silver rings
51 x 26.3 x 7 cm
Liliane and David M.
Stewart Collection
D99.216.1

692

Susanna Heron
Born in Welwyn Garden City,
England, in 1949
Neck-curve
Neckpiece
1978
Painted acrylic
L. 26.5 cm; W. 19 cm
Liliane and David M.
Stewart Collection
2004.148

693

Peter Chang
Born in Liverpool in 1944
Bracelet
1987
Acrylic, PVC
6.4 x 16.5 x 15.9 cm
Liliane and David M.
Stewart Collection
D90.204.1

692

693

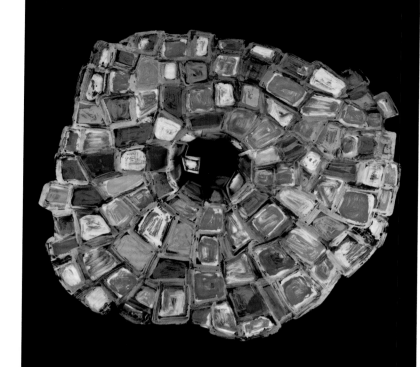

698

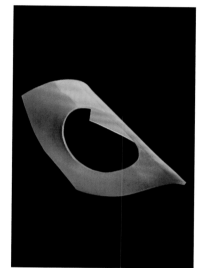

694

695

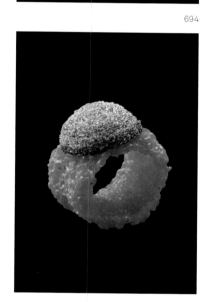

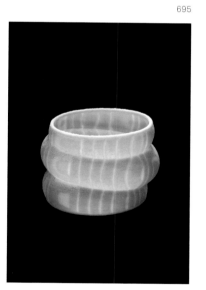

696

697

699

NEW
DIRECTIONS

— DIANE CHARBONNEAU, VALÉRIE CÔTÉ —

PATRICK JOUIN

French designer Patrick Jouin combines the traditional and the contemporary in a most inventive way. He is fascinated with technology, and his association with Materialise,[1] a leader in the production of objects by rapid prototyping—particularly the AFL process of layering—is sure to be a key factor in the creation of furniture for which manufacture by moulding will be a thing of the past. Under the banner of .MGX by Materialise, Jouin has discovered new applications for cutting-edge technology initially used exclusively in the manufacture of prototypes and small-scale models. The furniture from the "Solid" series[2] comprises a limited edition of two chairs (*C1* and *C2*), a table (*T1*) and a stool (*S1*) made using stereolithography.[3] Jouin explains, "The laser beam makes the model, building the chair in a vat of liquid resin. This technology makes it possible to manufacture objects that would have seemed impossible before now, which really changes things for designers."[4] The shape of the *C2* chair **700**, which evokes blades of grass or interlaced ribbons, is a true copy of the original 3D design. The designer has become the craftsperson of his own product, altering the relationship between the design of the object and its manufacture—two normally discrete aspects of the furniture industry. DC

1. Materialise was founded in 1990 by Wilfried Vancraen in collaboration with the Catholic University of Leuven, Belgium. **2.** The "Solid" collection was launched in September 2004 at the Maisonneuve gallery, in Paris, then presented in 2005 at the VIA booth at both the Salon Maison & Objet and the Salon du Meuble in Paris; and, at both the VIA and .MGX by Materialise booths at the Salone del mobile in Milan and the European Design Show in London. **3.** The stereolithography process: "Starting from a 3D file, a part is built slice by slice from bottom to top, in a vessel of liquid polymer that hardens when struck by a laser beam": http://www.materialise.com/stereolithography (accessed December 13, 2011). **4.** Cited by Mario de Castro, "1997-2007 : les designers de la décennie," *L'Express*, January 23, 2007: http://www.lexpress.fr/mag/tentations/dossier/design/dossier.asp?ida=455009 (accessed March 12, 2008, p. 1).

MICHAEL EDEN

British ceramicist Michael Eden has been using digital technology since 2008, having familiarized himself with the new modes of design when he studied at the Royal College of Art in London. For his university research project, he designed a series pairing an object—a cream-coloured earthenware soup tureen reproduced in a Wedgwood catalogue from 1817—and a process—rapid prototyping.[1] He thus completed a corpus of twenty unique pieces united under the name "Wedgwoodn't Tureen," including that of the Museum, *A Tall Yellow Oval Wedgwoodn't Tureen* **701**. These pieces are at once mock reproductions of the original object and an illustration of the potential presented by the new process, which makes it possible to shape ceramics without using traditional methods.

Eden believes that his practice recalls the era of the Industrial Revolution and the scientific advances made by Josiah Wedgwood, from the standpoint of material composition as much as production techniques. *A Tall Yellow Oval Wedgwoodn't Tureen* is the result of complex work undertaken with the help of modelling software (Rhino 3D and FreeForm) and a 3D ZCorporation[2] printer. The three-dimensional printing was done by Axiatec, Limoges, which also oversaw the finishing of the piece using the Ceral process, a non-fired eco-ceramic. The openwork treatment and fragile look of the piece evoke natural elements, including bones, which Wedgwood and several of his contemporaries used in ceramic decoration. Eden also took inspiration from the texture and patterns of the artificial bones used in medicine.[3] For colours, he first sought the effect of Wedgwood's "basalt" black biscuit porcelain before developing his own palette at Axiatec.

Eden is also reopening the debate on the "vessel" and its primary function, which is to contain. *A Tall Yellow Oval Wedgwoodn't Tureen* is a cross between art, contemporary handicraft and design. DC

1. This research and development project was brought to fruition through the support of the Rapidform Department of the Royal College of Art. **2.** Three-dimensional printing makes it possible to produce an object by accumulating successive layers of plastic matter using the standard technology of an inkjet printer. This production method is known as ALM (Additive Layer Manufacturing). **3.** Artificial bones are also produced by 3D printing.

FRONT

Not exactly artists nor designers, the members of Sweden's Front collective use digital technology to transgress the limits of industry and art. The group began in Stockholm in 2003 with Sofia Lagerkvist, Charlotte von der Lancken, Anna Lindgren and Katja Sävström reinventing everyday objects, their creations proliferating on the international scene.

The Front's designs are the result of teamwork, each member participating in the initial discussions, formulating ideas and developing the final product. The approach involves transmitting a story to the public through thoughtful, humour-inflected inventiveness. The narrative usually addresses the process of creation or design conventions. But it can also function as a simple statement on the materials used.

In keeping with the trend towards computer-assisted production, Front designed the "Sketch" series **702** while in residence in Tokyo in the fall of 2005. After some intensive months researching, the designers presented a furniture collection rendered by an innovative method, combining two techniques that make it possible for objects drawn in the air to materialize: motion capture and rapid prototyping. The pieces of furniture were created during a performance presented during Tokyo Design Week. Using a "pen" whose tip recorded the designers' sweeping strokes, the furniture item suddenly appeared in thin air (fig. 1). The movements were captured using Motion Capture software, normally used in video games and

Fig. 1
Stockholm's Front collective designing for the "Sketch" series using motion capture technology, Tokyo 2005.

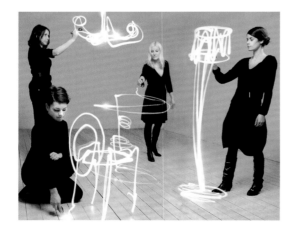

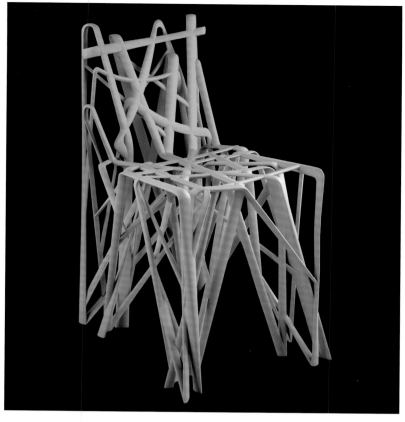

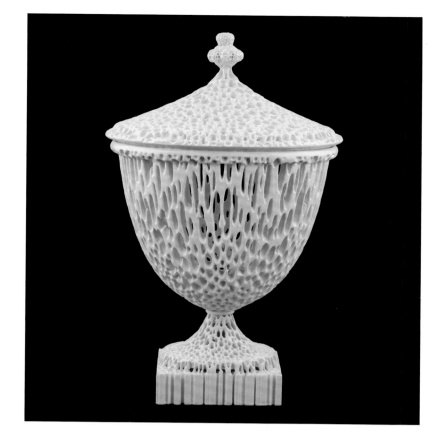

700

701

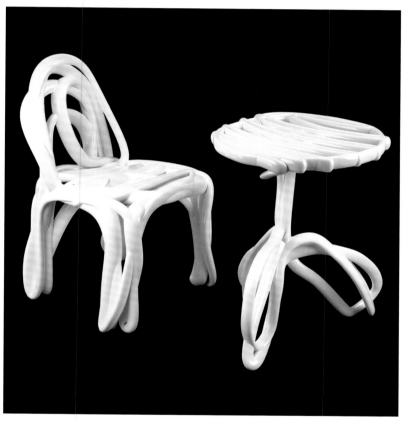

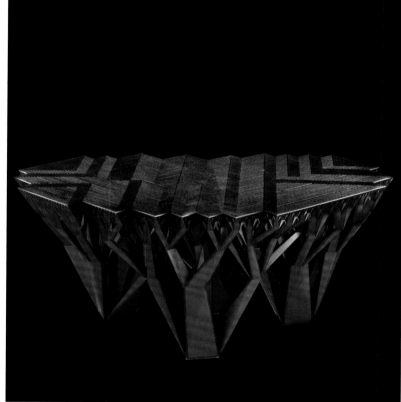

702

703

animation. These digital 3D files were transmitted to a laser, which, using rapid prototyping, slowly caused a liquid resin to harden into a solid shape. Three copies of each piece of "Sketch" furniture—two chairs, one table and a hanging lamp—were produced. This sort of limited edition is characteristic of a current trend, which individualizes normally mass-produced products. **DC**

WERTEL OBERFELL PLATFORM

Technological processes and advances are part of the conceptual considerations of the London design studio Wertel Oberfell Platform.[1] Both originally from Germany, partners Gernot Oberfell and Jan Wertel use computer-assisted design not only as a tool, but also as a source of inspiration. The *Fractal* coffee table,[2] designed in collaboration with German architect Matthias Bär, is the result of their interest in fractals' ability to replicate themselves in incrementally smaller repeated shapes, a phenomenon readily expressed in mathematical models. The coffee table suggests the composition and growth of a tree, from its trunk to its crown. The base, composed of several trunks, branches out to form the grid underpinning the tabletop. The coffee table was first produced as a single piece in white epoxy resin by stereolithography. In 2009, the two designers reworked the tabletop, unifying the various branches in order to create a more complex geometric pattern. This new version, *Fractal.MGX* **703**, was produced, in Havana brown, by Materialise in a limited edition of twenty-five. **DC**

1. Wertel Oberfell Platform was founded in 2007. **2.** The table was presented at the Salone del mobile in Milan in 2008.

INGO MAURER

Among the contemporary designers interested in lighting, none has had as big an influence as Ingo Maurer, recognized for his unique visual language. After the design of his first lamp in 1966, he launched his company so as to assume control of the design as well as the production of lamps and lighting systems. He skilfully combines the quality of handicraft with industrial technology, and his products are appealing for their playful connotations and emotional charge.

The image of the electric light bulb—invented by Thomas Edison about 1880—remains a featured element of Maurer's work. After *Bulb* (1966), the luminous bulb was equipped with a pair of wings in *Lucellino* (1992), then went virtual in the hanging lamp *Wo bist du, Edison, …?* (1997) **704** and *Holonzki* (2000), a wall lamp created in

collaboration with Eckart Knuth. The hanging lamp *Wo bist du, Edison, …?* displays an original use of holography, the process of photographing in relief, which, in this case, makes it possible to create a three-dimensional representation of a bulb. Producing a hologram is complex, but it is rendered by hand, which assures the uniqueness of each lamp. The socket displays the continuous profile of Edison. A tribute to Edison and to his invention, the lamp has taken on a new significance with the phasing out of this energy-consuming product. **DC and VC**

SAM BUXTON

For British designer Sam Buxton, the constant introduction of new materials and technologies is generating a new formal vocabulary. His artistic practice adeptly engages with current issues facing the technological arts and experimental design. A graduate of the Royal College of Art, London (1999), he collaborated for a time with designer Mathias Bengtsson **573** before going off on his own. Considered by his peers to be a genuine "prospector of design," Buxton draws inspiration from the most recent advances in technoscience to create distinctly experimental objects. He has shown a particular fascination for electroluminescence, a type of technology used for the backlighting of liquid crystal displays (LCDs) (alarm clocks, cellphones, sound systems, car dashboards). Buxton subverts the original function of this light source and uses its aesthetic potential to create a series of prototypes that he describes as Surface Intelligent Objects (SIOS). *Clone Chaise* **705**[1] displays the functioning of the human body. With this metaphor, Buxton reinterprets the chaise longue by giving it the shape of a supine male body.[2] The body's many organs are made visible by an electroluminescent device. Each of the chaise longue's components lights up one after the other, in a loop, starting with the heart and followed by the different systems in turn—cardiovascular, nervous, digestive, endocrine, reproductive, respiratory and urinary—until the end of the cycle, when they are all alight. Assembled in the artist's studio in 2011 specially for the Museum's collection, this *Clone Chaise* is the first chaise longue in a limited series of six. **DC and VC**

1. This piece has attracted attention since its conception, whether it was exhibited or simply reproduced. The prototype of the first version was presented in Tokyo under the aegis of the British Council in 2004, and then in Istanbul the same year. **2.** That of the designer, without actually being an exact replica.

704

704

Ingo Maurer
Born in Reichenau,
Germany, in 1932
Wo bist du, Edison, …?
Hanging Lamp
[Where are you, Edison?]
1997
Hologram, acrylic glass,
aluminum
H. 24 cm; Diam. 45.3 cm
Produced by Ingo
Maurer GmbH, Munich
Liliane and David M.
Stewart Collection
2006.39

705

Sam Buxton
Born in London in 1972
Clone Chaise
2005 (example of 2011)
Acrylic, electronic
components, 1/6
80 x 200 x 80 cm (approx.)
Purchase, anonymous gift
2011.279

FIBRE

EARLY TAPESTRY
`P. 144–147`

PRIAM RECEIVES ULYSSES AND DIOMEDES AT THE GATES OF TROY

Fig. 1
Coëtivy Master, *The Trojan War: Death of Penthesilea and Treachery of Antenor and Aeneas*, 1465, pen and ink, watercolour highlights, 30.7 x 57.3 cm.
Musée du Louvre, Paris
Photo Réunion des Musées Nationaux / Art Resource, NY / Thierry Le Mage

MODERN ARTIST-DESIGNED TEXTILES
`P. 152–157`

RAOUL DUFY
Fig. 1
Raoul Dufy, *The Dance*, 1910, wood-block print, 31.5 x 31.4 cm.
Inv. Am 10892 GR (118)
Dépôt du Musée national d'art moderne au musée des Beaux-Arts de Nice
Legs de Mme Raoul Dufy (Paris) en 1963
Copyright Adagp, 2011,
Ville de Nice
Photo Muriel Anssens

HENRI MATISSE
Fig. 1
Henri Matisse, paper cut-out design for the *Mimosa* carpet, 1949.
Ikeda Museum of 20th Century Art, Itoh City, Japan.

JACK LENOR LARSEN: DEAN OF AMERICAN TEXTILE DESIGN
`P. 164–165`

Fig. 1
The exhibition *Jack Lenor Larsen: Creator and Collector* at the Montreal Museum of Fine Arts,
June to August 2005.
Photo MMFA, Brian Merrett

FURNITURE: COVERINGS AND STRUCTURE
`P. 178–189`

BABICHE
Fig. 1
Wood chair with babiche seat, Quebec, mid-19th century.
Musée de la civilisation, Quebec City
Inv. 42-2
Photo Amélie Breton, Perspective

METAL

19th-CENTURY INNOVATIONS
`P. 210–213`

ELKINGTON, MASON & CO.
Fig. 1
A table and other objects by Elkington, Mason & Co. of Birmingham (lithograph, pl. 79 in Matthew Digby Wyatt's *The Industrial Arts of the Nineteenth Century. A Series of Illustrations of the Choicest Specimens Produced by Every Nation, at the Great Exhibition of Works of Industry, 1851*).
New York Public Library, Stephen A. Schwarzman Building / Art and Architecture Collection, Miriam and Ira D. Wallach Division of Art, Prints and Photographs
Photo NYPL Digital Library

MODERN QUEBEC SILVER AND GOLD
`P. 234–237`

Fig. 1
Stages in the crafting of a sterling-silver spoon by Carl Poul Petersen, Montreal, n.d.
Library and Archives Canada / National Film Board of Canada fonds / PA-213577

THE ADVENT OF TUBULAR-STEEL FURNITURE
`P. 238–241`

Fig. 1
Marcel Breuer's *Wassily* Chair (model B3), 1925, example of 1926–27 by Standard Möbel Lengyel & Co., Berlin, nickel-plated tubular steel, polished-yarn fabric, 72.5 x 76.5 x 69.5 cm.
Vitra Design Museum, Weil am Rhein
Photo Thomas Dix, courtesy Vitra Design Museum Archiv & Bibliothek

Fig. 2
Alfred Barr's living room, Beekman Place, New York with Philip Johnson's chair and Mies van der Rohe's table, about 1933–34.
Photo courtesy of Victoria Barr

Fig. 3
Tubular metal furniture in André Biéler and Jeanette Meunier Biéler's apartment, Peel Street, Montreal, 1933.
MMFA, Biéler Archives

AMERICAN INDUSTRIAL DESIGN: 1930s AND 1940s
`P. 242–243`

Fig. 1
Raymond Loewy's S1 Locomotive for Penn Central Corporation, 1939.
Collection of Pennsylvania RR Negatives
Hagley Museum and Library, Wilmington, Delaware
Photo © Hagley Museum and Library Pictorial Collections

CERAMIC

RICHARD BUCKMINSTER FULLER'S *DYMAXION* BATHROOM
`P. 244–245`

Fig. 1
Richard Buckminster Fuller and Shoji Sadao's geodesic dome for the American Pavilion at Montreal's International and Universal Exposition, 1967.
Photo from Pierre Dupuy's memory book *Expo 67* (Montreal: 1967).

Fig. 2
Richard Buckminster Fuller's *Dymaxion* House, 1945–46, Butler Manufacturing Company, Kansas City, Missouri.

Fig. 3
Richard Buckminster Fuller's patent drawing for "Prefabricated Bathroom," United States Patent and Trademark Office, 1938–40.
United States Patent and Trademark Office website.
http://www.uspto.gov

SPARE ELEGANCE FOR THE OFFICE: FURNITURE FROM THE SEAGRAM BUILDING, NEW YORK
`P. 246–247`

Fig. 1
Seagram Building, New York, by Mies van der Rohe with Philip Johnson, completed in 1957.
Photo Ezra Stoller © Esto.
All rights reserved

Fig. 2
Seagram Building, New York: Seagram executive office with furniture by Mies van der Rohe (desk, *Barcelona* chairs and ottoman, *Brno* chairs, coffee table), Eero Saarinen (desk chair) and Jens Risom (cabinet), about 1958.
Photo Ezra Stoller © Esto.
All rights reserved

METALLIC FIBRES
`P. 266–267`

DENIS GAGNON
Fig. 1
The exhibition *Denis Gagnon Shows All*, designed by Gilles Saucier, at the Montreal Museum of Fine Arts, October 2010 to February 2011.
Photo MMFA, Christine Guest

Fig. 2
Denis Gagnon, dress from the "Zips" Collection, Fall–Winter 2010–11.
Photo Kim Payant and Luc Lavergne from LavergnePhotographe

CERAMIC

DEVELOPMENTS IN EARTHENWARE AND STONEWARE
`P. 282–285`

JOSIAH WEDGWOOD AND THOMAS BENTLEY
Fig. 1
C. Grignion, *Bacchus and his Tyger* [sic], pl. X in *The Antiquities of Athens; Measured and Delineated* by James Stuart and Nicholas Revett, Painters and Architects, 1762.
Royal Ontario Museum, Toronto
Reproduced with permission of the Royal Ontario Museum
© ROM

WILLIAM DE MORGAN
Fig. 1
Design by William De Morgan for a circular dish depicting an eagle attacking a grotesque lizard, late 19th century, pencil and wash, Diam. 19 cm.
Victoria and Albert Museum, London
Photo © V&A Images / Victoria and Albert Museum, London

PICASSO'S CERAMICS
`P. 304–305`

Fig. 1
Françoise Gilot posing between two tripod vases, about 1951.
Collection Alain Ramié

ITALIAN CERAMICISTS OF THE 1950s
`P. 306–307`

Fig. 1
"Nello studio di Melotti 1954," *Domus*, vol. 242 (March 1954), p. 53.
Photo reproduced by kind permission of Archivio Fausto Melotti

ELUDING TRADITION
`P. 322–325`

SHARY BOYLE
Fig. 1
Hearing: one of five Meissen porcelain figurines representing the senses, about 1765, by Johann Joachim Kändler (1706–1775).
Private collection
Photo © Christie's Images / The Bridgeman Art Library

PAPER

STUDIES AND PREPARATORY DRAWINGS
`P. 334–337`

NATACHA (ANNE) CARLU
Fig. 1
Ninth-floor restaurant at Eaton's department store, Montreal, designed by Jacques Carlu, about 1931.
MMFA, Jacques and Natacha Carlu Archives

PLASTIC

INFORMAL SEATING
`P. 372–377`

ARCHIZOOM ASSOCIATI
Fig. 1
Still from Denys Arcand and Adad Hannah's video, *Safari*, shot for the *Big Bang* exhibition at the Montreal Museum of Fine Arts, November 2011 to January 2012.
HD colour video, 16:9, 6 min, 41 s
Photo © Denys Arcand and Adad Hannah, 2011

PLASTIC WEAR
`P. 378–379`

PACO RABANNE
Fig. 1
Woman modelling a Paco Rabanne chain-mail dress, April 1967.
Photo Keystone Features / Hulton Archive / Getty Images

NEW DIRECTIONS
`P. 394–397`

FRONT
Fig. 1
Stockholm's Front collective designing for the "Sketch" series using motion capture technology, Tokyo, 2005.
Image Courtesy Front Design

INDEX
OF ILLUSTRATED
WORKS

INDEX OF NAMES

PHOTO CREDITS

Photos MMFA:
Jean-François Brière
Denis Farley
Christine Guest
Alex Kempkens
Brian Merrett
Giles Rivest
Richard-Max Tremblay

p. 171 (cat. 243):
David Arky

p. 350 (cat. 598): Illustration:
Nelu Wolfensohn

DECORATIVE ARTS AND DESIGN
The Montreal Museum of Fine Arts' Collection Volume II

Translation
Jill Corner
Alexis Diamond
Cecilia Grayson
Adriana Palanca
Judith Terry

Proofreading
Alexis Diamond
Jane Jackel

Copyright
Linda-Anne D'Anjou

Research and documentation
Manon Pagé

Documentation and cataloguer
Natalie Vanier

Technical support
Magdalena Berthet

© The Montreal Museum of Fine Arts 2012
ISBN The Montreal Museum of Fine Arts:
978-2-89192-359-0
Legal deposit:
4rd quarter 2012
Bibliothèque et Archives nationales du Québec
National Library of Canada
All rights reserved.
The reproduction of any part of this book without the prior consent of the publisher is an infringement of the Copyright Act, Chapter C-42, R.S.C., 1985.
PRINTED IN CANADA

The Montreal Museum of Fine Arts
P.O. Box 3000
Station H
Montreal, Quebec
Canada
H3G 2T9
www.mmfa.qc.ca

International distribution

ABRAMS
THE ART OF BOOKS SINCE 1949
115 West 18th Street
New York, NY 10011
www.abramsbooks.com

En français sous le titre :
ARTS DÉCORATIFS ET DESIGN
La collection du Musée des beaux-arts de Montréal
Tome II
© Musée des beaux-arts de Montréal 2012
ISBN The Montreal Museum of Fine Arts:
978-2-89192-358-3
Distribué par Les Éditions de la Martinière
www.editionsdelamartiniere.fr

PUBLISHED IN 2011
QUEBEC AND CANADIAN ART
The Montreal Museum of Fine Arts' Collection
Volume I
ISBN: 978-2-89192-355-2
Distributed by Abrams, an imprint of ABRAMS
www.abramsbooks.com

En français sous le titre :
ART QUÉBÉCOIS ET CANADIEN
La collection du Musée des beaux-arts de Montréal
Tome I
ISBN : 978-2-89192-354-5
Distribué par Les Éditions de la Martinière
www.editionsdelamartiniere.fr

FORTHCOMING PUBLICATION, 2013
WORLD CULTURES AND FINE ARTS
The Montreal Museum of Fine Arts' Collection
Volume III
ISBN: 978-2-89192-357-6
Distributed by Abrams, an imprint of ABRAMS
www.abramsbooks.com

En français sous le titre :
CULTURES DU MONDE ET BEAUX-ARTS
La collection du Musée des beaux-arts de Montréal
Tome III
ISBN : 978-2-89192-356-9
Distribué par Les Éditions de la Martinière
www.editionsdelamartiniere.fr

The definitions at the beginning of each chapter are drawn from the *Shorter Oxford English Dictionary on Historical Principles*, 6th ed., 2007.